Art for Yale

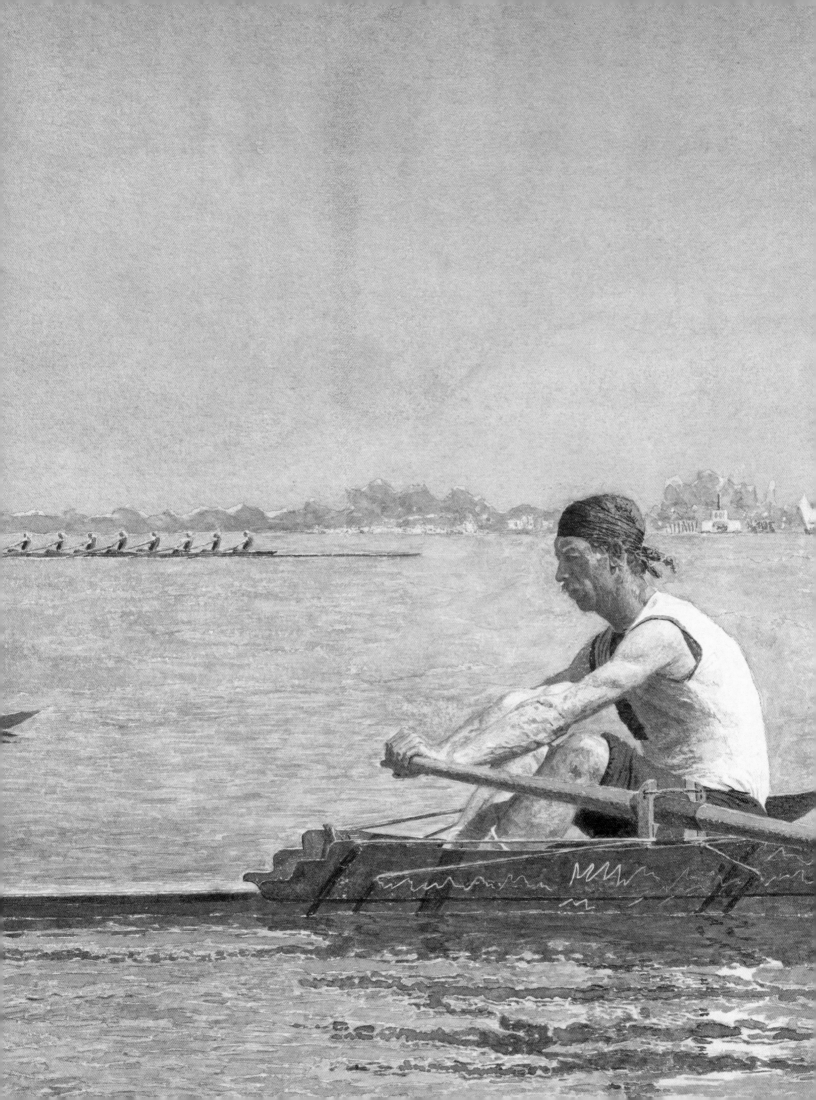

Art for Yale

COLLECTING FOR A NEW CENTURY

CELEBRATING THE 175TH ANNIVERSARY OF THE YALE UNIVERSITY ART GALLERY
AND THE CENTENNIAL OF PAUL MELLON'S BIRTH

YALE UNIVERSITY ART GALLERY

NEW HAVEN, CONNECTICUT

Published with assistance from the
Robert Lehman Endowment and Janet and Simeon
Braguin Funds, with additional support provided by
Carolyn H. Grinstein and Gerald Grinstein, B.A. 1954,
Dr. Jane Frank Katcher and Gerald Katcher, LL.B. 1950,
H. Christopher Luce, B.A. 1972,
Jan Perry Mayer and Frederick R. Mayer, B.A. 1950,
Anna Marie Shapiro and Robert F. Shapiro, B.A. 1956,
The Patrons of Yale University Art Gallery, and an
endowment created with a challenge grant from the
National Endowment for the Arts.

First published in 2007 by the
Yale University Art Gallery
P.O. Box 208271
New Haven, CT 06520-8271
www.artgallery.yale.edu

Published in conjunction with the exhibition *Art for Yale:
Collecting for a New Century*, organized by the Yale University
Art Gallery. Exhibition and publication organized by
Jock Reynolds, Susan B. Matheson, and Joshua Chuang.

September 18, 2007–January 13, 2008

Editor: Tiffany Sprague
Copyeditor: Joyce Ippolito
Designed by Katy Homans
Set in Yale Design, designed by Matthew Carter
Printed by Meridian Printing, East Greenwich, R.I., under the
supervision of Daniel Frank

Unless otherwise noted, dimensions in this catalogue are given
as follows:
For three-dimensional objects, height precedes width precedes
depth. For miniatures, dimensions of the ivory support are given.
Platemark is given for etchings and engravings, sheet size for
drawings, and image size for photographs.

The Department of Asian Art at the Yale University Art Gallery
uses the era designators C.E. ("of the Common Era") and B.C.E.
("before the Common Era") corresponding to A.D. (*anno Domini*,
"in the year of the Lord") and B.C. ("before Christ").

Library of Congress Cataloging-in-Publication Data
Yale University. Art Gallery.
Art for Yale : collecting for a new century : celebrating the 175th
anniversary of the Yale University Art Gallery and the centennial
of Paul Mellon's birth.
p. cm.
Catalog of an exhibition at the Yale University Art Gallery,
Sept. 18, 2007–Jan. 13, 2008.
Includes index.
ISBN 978-0-89467-969-8 (alk. paper)
1. Yale University. Art Gallery—Exhibitions. 2. Art—
Connecticut—New Haven—Exhibitions. I. Title.
N590.A54 2007
708.146'8—dc22
2007030400

10 9 8 7 6 5 4 3 2 1

Jacket illustrations: (*front*) Plate 240; (*back*) Plate 242
Frontispiece: Detail of plate 27
Endpapers: Details of plate 142

Table of Contents

DONORS, LENDERS, AND FUNDERS OF ARTWORKS IN THE EXHIBITION

9

ACKNOWLEDGMENTS

12

INTRODUCTION

JOCK REYNOLDS

15

PLATES

29

CONTRIBUTORS TO THE CATALOGUE

346

ENTRIES ON SELECTED WORKS

347

INDEX

415

PHOTOGRAPH CREDITS

421

YALE UNIVERSITY ART GALLERY COLLECTION ENHANCEMENT INITIATIVE
COMMENCED IN 1998

Honorary Chairman:

Paul Mellon, B.A. 1929, L.H.D. Hon. 1967

Cochairs:

Robert F. Shapiro, B.A. 1956

John Walsh, B.A. 1961

Chuck Close, B.F.A. 1963, M.F.A. 1964, D.F.A. Hon. 1996

THIS PUBLICATION IS DEDICATED TO THE MEMORY OF THESE
GOVERNING BOARD MEMBERS AND PATRONS:

Arthur G. Altschul, B.A. 1943

Henry A. Ashforth, Jr., B.A. 1952

Richard Brown Baker, B.A. 1935

Walter Bareiss, B.S. 1940s

Charles B. Benenson, B.A. 1933

George Hopper Fitch, B.A. 1932

N. Lee Griggs, Jr., B.A. 1951

Dr. Benjamin Attmore Hewitt, B.A. 1943, PH.D. 1952

Susan Morse Hilles

Allan S. Kaplan, B.A. 1957

William S. Kilroy, Sr., B.S. 1949

Frederick R. Mayer, B.A. 1950

Paul Mellon, B.A. 1929, L.H.D. Hon. 1967

Thomas T. Solley, B.A. 1950

Allen Wardwell, B.A. 1957

DONORS, LENDERS, AND FUNDERS OF ARTWORKS IN THE EXHIBITION

Jan and Warren Adelson

Arthur G. Altschul, B.A. 1943

Elizabeth Ames, B.A. 1979

Mr. and Mrs. Henry A. Ashforth, Jr., B.A. 1952

Julia Childs and Harrison H. Augur, B.A. 1964

Richard Brown Baker, B.A. 1935, Collection

Estate of Richard Brown Baker, B.A. 1935

John Barclay, B.A. 1936, by exchange

Molly and Walter Bareiss, B.S. 1940s

Bruce W. Benenson

Charles B. Benenson, B.A. 1933, Collection

Lawrence B. Benenson

Dawoud Bey, M.F.A. 1993

Janet and Simeon Braguin Fund

Doris M. Brixey and Nathalie Penrose Swetland,
by exchange

Doris Bry Inadvertent Collection

Audrey Lam Buchner, B.A. 1994

Jean M. Buist, D.V.M.

Jay E. Cantor

Allan Chasanoff, B.A. 1961

James H. Clark, Jr., B.A. 1958

Walter H., B.A. 1951, and Margaret Dwyer Clemens Fund

Leslie and Chuck Close, B.F.A. 1963, M.F.A. 1964,
D.F.A. Hon. 1996

Lois Conner, M.F.A. 1981

Peter B. Cooper, B.A. 1960, LL.B. 1964, M.U.S. 1965,
and Field C. McIntyre American Decorative Arts
Acquisition Fund

Mr. and Mrs. Frank J. Coyle, LL.B. 1943, Fund

Celia Faulkner Crawford

Olive Louise Dann, by exchange

Peggy and Richard M. Danziger, LL.B. 1963

Ruth and Bruce B. Dayton, B.A. 1940

Georgia and Michael H. de Havenon, B.A. 1962

Davida Tenenbaum Deutsch and Alvin Deutsch, LL.B. 1958

Richard and Elizabeth Devereaux, B.A. 1981

Philip-Lorca diCorcia, M.F.A. 1979

Jane Davis Doggett, M.F.A. 1956

Evelyn H. and Robert W. Doran, B.A. 1955

Dr. Lawrence Dubin, B.S. 1955, M.D. 1958, and
Regina Dubin

Mr. and Mrs. James E. Duffy, B.S. 1951

Mr. and Mrs. Myron S. Falk, Jr., B.A. 1928

Family, colleagues, and friends of Katherine Atwater Folds

Jerald Dillon Fessenden, B.A. 1960

George Hopper Fitch, B.A. 1932, and Denise Fitch

Arthur Fleischer, Jr., B.A. 1953, LL.B. 1958

Joseph G. Fogg III, B.A. 1968

Helen Frankenthaler, D.F.A. Hon. 1981

Mrs. Robert R. French, by exchange

Lee Friedlander

Mr. and Mrs. Edward A. Friedman, B.A. 1971

Mr. and Mrs. Gary D. Friedman, B.A. 1973

Friends of American Arts at Yale

Friends of E. B. Smith, Jr., B.A. 1966

Mabel Brady Garvan Collection, by exchange

Lionel Goldfrank III, B.A. 1965

Frederick Goldstein, B.A. 1955

Mr. and Mrs. Andrew J. Goodman, B.S. 1968

Frank H. Goodyear, Jr., B.A. 1966

Ethne and Clive Gray Family Collection

Maitland F. Griggs, B.A. 1896, Fund

Nina Griggs

Mr. and Mrs. N. Lee Griggs, Jr., B.A. 1951

Carolyn H. and Gerald Grinstein, B.A. 1954

Polly W. Hamilton, M.A. 1941, PH.D. 1948

Leonard C. Hanna, Jr., Class of 1913, Fund

Loomis Havemeyer, PH.B. 1910, M.A. 1912, PH.D. 1915,
by exchange

Iola S. Haverstick Fund for American Art

Dwight B. and Anna Cooper Heath

Heinz Family Fund

Dr. Benjamin Attmore Hewitt, B.A. 1943, M.A. 1950,
PH.D. 1952

Leonard F. Hill, B.A. 1969

Susan Morse Hilles

Mr. and Mrs. S. Roger Horchow, B.A. 1950

Raymond J. and Margaret Horowitz

Erika and Thomas Leland Hughes, B.A. 1945,
LL.B. 1949

Archer B. Huntington, M.A. 1897

George C. Hutchinson, B.A. 1957

Thomas Jaffe, B.A. 1971

The Japan Foundation Endowment of the Council
on East Asian Studies

Alice Kaplan

Estate of Alice M. Kaplan

Betsy Karel

Jane and Gerald Katcher, LL.B. 1950

Mr. and Mrs. George M. Kaufman

Mrs. William S. (Jeanie) Kilroy, Sr.

Mr. and Mrs. Gilbert H. Kinney, B.A. 1953, M.A. 1954

Lisa Koenigsberg, M.A. 1981, M.PHIL. 1984, PH.D. 1987,
and David Becker, B.A. 1979

Steven M. Kossack, B.A. 1972

Werner H. and Sarah-Ann Kramarsky

Saundra B. Lane

Natalie H. and George T. Lee, Jr., B.A. 1957

President Richard C. Levin Discretionary Funds

Sol LeWitt

The LeWitt Collection

Barbara and Robert Liberman, B.A. 1965

Mr. and Mrs. Herbert Libertson

Misses Emilie L. and Olga V. Loebig, by exchange

Rosemarie and Leighton R. Longhi, B.A. 1967

Pamela Lord

H. Christopher Luce, B.A. 1972

The Henry Luce Foundation

Mrs. John D. MacDonald

Sylvia Plimack Mangold, B.F.A. 1961, and
Robert Mangold, B.F.A. 1961, M.F.A. 1963

Dana K. Martin, B.A. 1982

Jane and Arthur Mason

Jan Mayer

Alexander K. McLanahan, B.A. 1949

Robert L. McNeil, Jr., B.S. 1936s

Everett V. Meeks, B.A. 1901, Fund

Paul Mellon, B.A. 1929, L.H.D. Hon. 1967

Estate of Paul Mellon, B.A. 1929, L.H.D. Hon. 1967

Daniel Merriman, by exchange

John R. Monsky, B.A. 1981, and Jennifer Weis Monsky,
B.A. 1981

John Hill Morgan, B.A. 1893, LL.B. 1896,
M.A. Hon. 1929, Fund

Mrs. Paul Moore, by exchange

The Neisser Family, Judith Neisser, David Neisser,
Kate Neisser, and Stephen Burns

Eliot Nolen, B.A 1984, and Timothy Bradley, B.A. 1983

Katharine Ordway Collection, by exchange

Katharine Ordway Fund

Mary and James H. Ottaway, Jr., B.A. 1960

Mr. and Mrs. Sidney W. Peloubet, by exchange

Kathryn E. Pennicuik, by exchange

Thomas P. Perkins III, B.A. 1957

Acknowledgments

This is an exhibition like no other—first and foremost for the extraordinary art now under our roof and the extraordinary donors whose generosity makes it possible for these treasures to come permanently to Yale. Our gratitude, and that of Yale University's faculty, students, and staff present and future, to these generous friends and patrons is profound.

"An exhibition like no other," though, is a phrase we have heard most often from the Yale University Art Gallery's staff during the nine years the exhibition has been in the making—the Gallery's dedicated and talented staff, who supported the endeavor wholeheartedly no matter how many times they were surprised by another wonderful gift, change in the exhibition layout, or hike in the budget—and it is to them that we offer our special thanks here.

We are deeply indebted to curators and curatorial assistants David Barquist, Suzanne Boorsch, Helen A. Cooper, Elizabeth C. DeRose, Erin E. Eisenbarth, Susan Greenberg Fisher, Robin Jaffee Frank, Pamela Franks, John Stuart Gordon, Jennifer Gross, Elisabeth Hodermarsky, Patricia E. Kane, Laurence B. Kanter, Frederick John Lamp, Amy Kurtz Lansing, Russell Lord, John J. Marciari, William E. Metcalf, Sadako Ohki, Christine Paglia, David Ake Sensabaugh, and Takeshi Watanabe, for the productive years spent building relationships with the Gallery's friends and patrons and matching their generosity to the Gallery's mission of teaching from the best original works of art; for the knowledge and passion they have brought to their purchases; for their invaluable contributions to this catalogue; and for their patience and counsel on many levels. We thank Anna Hammond, Deputy Director for Education, Programs, and Public Affairs, for her enthusiastic commitment to this project as central to the educational mission of the Gallery.

We offer our sincere thanks to our dedicated Gallery conservators Mark Aronson, Patricia Sherwin Garland, Theresa Fairbanks-Harris, and Irma Passeri, and contract conservators Susan Holbrook, Sarah Nunberg, and Susan Schussler, who with sensitive eye and consummate skill have ensured that each work of art is safe to exhibit and looks its very best.

We are truly grateful to the registrars, Lynne Addison and Amy Dowe, who tracked the exhibition lists and managed the complex loan arrangements with precision, patience, and sensitivity, and to Carol DeNatale, Director of Collections and Technology, for her unfailing support.

Our indispensable right arm throughout the project has been Megan Doyon, Senior Museum Assistant in the Department of Ancient Art, who with consistent good humor put aside her "ancient" hat to sustain this Gallery-wide endeavor in countless ways.

The Installations Department staff has been heroic, adapting with the utmost flexibility and patience to our informal team approach to exhibition design. We want especially to thank Clarkson Crolius, Installations Manager, for skillfully overseeing and managing the whole process, and Jeremy Bell, Peter Cohen, Margot Curran, Christina Czap, Anna Daegele, Paul Daniel, Jason DeBlock, Elizabeth Gray, Burrus Harlow, Rachel Hellerich, Sue Kiss, David Norris, Thomas Phillips, Jessica Smolinski, Nancy Valley, and Alicia Van Campen for impecca-

bly carrying through with every detail. Diana Brownell, Museum Preparator, undertook the matting and framing with her perennial expertise. Christopher Sleboda, Director of Graphic Design, gave the exhibition graphics their elegant air, and Tiffany Sprague, Associate Editor, admirably ensured the accuracy and consistency of the texts. Grateful recognition is due to the staff of the Gallery's Security Department, whose vigilance protected these treasured works of art and whose warm welcome engaged the exhibition's visitors.

Jill Westgard, Director of Development, helpfully guided us with our donors and lenders. Her Development colleague Carol Clay Wiske and Kevin Johnson, Assistant Financial Administrator, obligingly untangled many thorny endowment issues. Jan Jones, Administrative Associate to the Director, and administrative assistant Antoinette Brown were unfailingly helpful. Louisa Cunningham, Deputy Director of Finance and Administration, and Charlene Senical, Assistant Business Manager, adeptly kept the complex and ever-changing finances for the project in order, and we thank them sincerely. We are grateful to Amy Jean Porter, Associate Director of Communications, for effectively publicizing the exhibition, and to Laurie Laliberte, Special Events Coordinator, for creating such worthy celebrations.

The catalogue could not have been written without the scholarly acumen of our curators, faculty, and students past and present. We are especially grateful to professors Edward Kamens and Mary E. Miller and emeritus professors Richard M. Barnhart and Walter Cahn; and to current and former Yale College and graduate students: Dennis A. Carr, Richard A. Grossmann, Nathaniel Jones, Benjamin Lima, Colleen Manassa, Matthew M. McCarty, Megan E. O'Neil, Matthew H. Robb, Ingrid Schaffner, and Robert Slifkin, who all contributed catalogue entries. Our special thanks to Elise K. Kenney, Gallery Archivist, who provided indispensable information and saved us from many errors. Most of the beautiful images in the book were produced by the Gallery's Visual Resources Department, under the direction of John ffrench, who was assisted by Janet Sullivan. The book was copyedited by Joyce Ippolito with exceptional care and dedication. Katy Homans responded immediately to the joy of these extraordinary works of art and with the three of us created the book's exquisite design, and Daniel Frank and his colleagues at Meridian Printing realized it with their unfailing sensitivity and skill.

If this is, indeed, an exhibition like no other, it is only so because of the dedication and generosity of all those who contributed to it. We hope that this volume will stand as a lasting record of a special defining moment in the Gallery's history and celebrate the promise for the future of this historic university museum.

JOCK REYNOLDS
THE HENRY J. HEINZ II DIRECTOR

SUSAN B. MATHESON
CHIEF CURATOR AND THE MOLLY AND WALTER BAREISS CURATOR OF ANCIENT ART

JOSHUA CHUANG
MARCIA BRADY TUCKER ASSISTANT CURATOR OF PHOTOGRAPHS

Introduction

In the spring of 1998, shortly after President Richard Levin announced my appointment as the new Henry J. Heinz II Director of the Yale University Art Gallery, I received a call from Paul Mellon's office in Virginia, asking whether I might be able to meet Mr. Mellon in New Haven for lunch and a tour of the Gallery. Needless to say, his was an invitation to be accepted with pleasure, coming as it did in the wake of some wonderful meetings and discussions I had already had with Frederick Mayer, the Gallery's dynamic Governing Board chairman, as well as his immediate predecessor, Walter Bareiss, and fellow board member Charles Benenson. The devotion of these great collectors to their alma mater's teaching museum was legendary, and yet I was still amazed to find them reaching out to me with offers of assistance, doing so many months before I was to leave the directorship of the Addison Gallery of American Art at Phillips Academy, Andover, to become a freshman of sorts at Yale.

When Mr. Mellon arrived in New Haven two weeks later, for what proved to be his last visit to campus, Helen Cooper, then the Gallery's acting director and also its Holcombe T. Green Curator of American Paintings and Sculpture, and I had the pleasure of cohosting Mr. Mellon for the day. He arrived in high spirits, possessing abundant energy for a man in his ninetieth year of life, and briefly regaled us with an account of the effort already under way to restore the Louis Kahn building that housed the Yale Center for British Art. It was one of Mr. Mellon's many magnificent gifts to Yale, opening to the public in 1978, and containing his remarkable collection of British art. Mr. Mellon, a longtime member of the Gallery's Governing Board, was keenly interested to learn something of the programming being envisioned for the Gallery's long-anticipated renovation and expansion, especially the renovation of its Louis Kahn building, which had preceded the Center's Kahn building by twenty-five years and whose construction had been undertaken under the direction of Charles Sawyer, the visionary director of Yale's Division of the Arts and dean of its School of Fine Arts from 1946 to 1957. Sawyer happened to be not only Paul Mellon's Yale classmate of 1929 but also the man who had opened the Addison Gallery of American Art as its first director in 1931, doing so at the tender age of twenty-four.

Another matter that concerned Yale's greatest individual benefactor that day was the subject of collection enhancement, which was very much on his mind. And given Mr. Mellon's strong personal interests in historical British, European, and American art, it was fascinating to have him query Helen Cooper and me as to whether the Gallery might wish to acquire more works by Marcel Duchamp to add to its fabled Société Anonyme Collection of modern art. This led to a broader conversation of how the Gallery's holdings might be enhanced across all of its curatorial departments and a brief discussion of the possibility of mounting a quiet "art drive" to bring more outstanding works of art into Yale's possession through outright, fractional, and promised gifts from its alumni and friends.

After Mr. Mellon departed, I had occasion to delve a bit more deeply into the Gallery's history on this score, discovering that Charles Sawyer, along with John Marshall Phillips and Lamont Moore, had earlier set a precedent for such an endeavor at Yale. Back in 1950, they had mounted an exhibition entitled *French Paintings of the Latter Half of the Nineteenth Century* (fig. 1), assembled from the collections of alumni and friends of Yale, with a specific purpose that Sawyer wrote of in the exhibition's catalogue:

> Certainly, the casual visitor will share with the faculty and student body a feeling of a great void between the impressive riches of the Garvan collections of eighteenth- and early nineteenth-century American art and the pioneer collections of the Société Anonyme, which represent so well the advanced and experimental phase of European art of the twentieth century. The Directors of the Art Gallery and the teaching faculty are in agreement as to the importance of filling this vacuum if our students and our public at large are to see and comprehend with some perspective the art of their own time.

Although this exhibition was organized with loans from alumni and friends, rather than gifts, the presence of great French modern and Impressionist masterworks by the likes of Manet, van Gogh, Cézanne, Pissarro, Monet, Degas, Toulouse-Lautrec, Renoir, Corot, and others on Yale's campus from April 17 to May 21, 1950, produced the largest public attendance to date in the Gallery's history. Some 10,452 people attended the exhibition, and later, individual works within its checklist, as well as others by the artists represented in the show, migrated into Yale's holdings through outright gifts and bequests. The exhibition also enjoyed a shared venue at the National Gallery of Art and the Phillips Collection in Washington, D.C.

Figures 2–3
*Pictures Collected by
Yale Alumni*, 1956

This endeavor was followed six years later in 1956 by another even more ambitious effort, *Pictures Collected by Yale Alumni* (figs. 2–3), overseen and organized by Charles Sawyer, Lamont Moore, Theodore Sizer, Charles Seymour, Jr., George Heard Hamilton, and numerous student assistants. This exhibition set forth a staggering array of 250 paintings and drawings loaned to the Gallery from many of the greatest private collections in America and abroad. More than 29,000 visitors poured into the Gallery over six weeks to view the show, which received worldwide attention. From it arose numerous future gifts and bequests that were to transform the breadth and quality of Yale's art collections.

The 1960s heralded the advent of even greater alumni involvement in collection building when Andrew Ritchie arrived at Yale from the Museum of Modern Art and assumed the Gallery's directorship. In rapid succession, and throughout the remainder of the decade, Ritchie and his curatorial colleagues organized eight major exhibitions of loans, gifts, and bequests from a multitude of loyal Yale alumni and friends. *Paintings, Drawings, and Sculptures Collected by Yale Alumni*, which consisted of 165 artworks created from the fifteenth century to the present day, led off this series in 1960. It was followed a year later by *Recent Acquisitions and Purchases*, a showcase of one hundred objects including selections owned by James and Mary Cushing Fosburgh, a major collection gift that would come to the Gallery in 1979. *The Stephen C. Clark '03 Bequest* (fig. 4), an exhibition that debuted in the fall of 1961, consisted of forty paintings, sculptures, and drawings gifted to the Gallery by one of Yale's greatest alumni collectors of the twentieth century, thirty-three of which, including masterworks by Hals, Corot, van Gogh, Manet, Copley, Homer, Eakins, Bellows, and Hopper, came to the Gallery directly after Clark's death. These works were added to his early 1930s gift, originally anonymous, of paintings by

Figure 4
*The Stephen C.
Clark '03 Bequest,*
1961

contemporary American artists. To this day, almost every one of these magnificent gifts hangs in public view continuously, with van Gogh's *Night Café* being for many visitors the signature work representing the greatness of Yale's art collections.

As the members of the Gallery's Governing Board grew ever more involved in the central mission of Yale's teaching museum, selections from their collections were displayed and the stewardship of many distinguished collectors continued under Ritchie's tenure as Gallery director. *Two Modern Collectors: Susan Morse Hilles and Richard Brown Baker* brought fifty-three works of modern painting and sculpture to campus in 1963, almost all of which later came to the Gallery as outright gifts and bequests, and a number of which are represented in this catalogue. In 1965, *English Paintings and Drawings in the Paul Mellon Collection* provided the Yale community with a major opportunity to contemplate a survey of British painting from 1700 to 1850 with a sharing of more than two hundred artworks from Mr. Mellon; all of these would eventually come to Yale via a gift that established his alma mater as the greatest center for British art beyond London itself. *German Expressionist Prints* from the collection of Walter Bareiss kept the transatlantic focus in Gallery exhibitions percolating right along when, in 1967, this generous and voracious alumnus collector shared a huge trove of his great print collection with the Gallery. Bareiss showered the Gallery with further gifts under Alan Shestack's distinguished tenure as the Gallery's director, a practice he would expand throughout the remainder of his long life with myriad donations of ancient, African, Asian, early European, American, modern, and contemporary art to his alma mater. Shestack also brought to the Gallery its first important gifts of photography, a now broadly acknowledged medium for artistic expression that is well represented with new acquisitions within this catalogue.

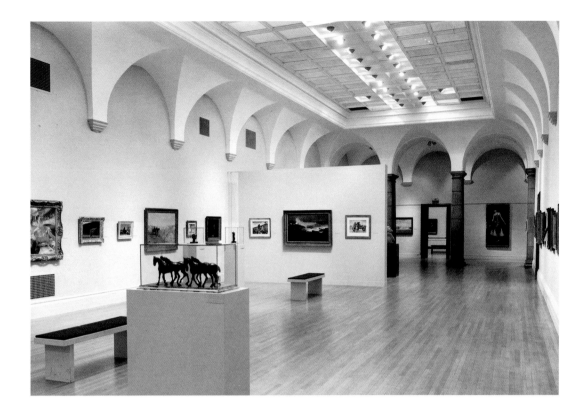

In 1968, the Gallery's third major exhibition devoted to a wide array of alumni collectors debuted. *American Art from Alumni Collections* (fig. 5) was organized by Jules Prown with the assistance of curator Theodore Stebbins, and assembled 144 works from sixty-five private collections, with art produced from 1711 to 1913, the year the groundbreaking Armory Show in New York brought modern art to the fore in America. More than ten thousand visitors coursed through the Gallery during the first three weeks of the show, creating yet again broad national notice of Yale's ongoing efforts to assemble, exhibit, and collect the best artwork available from its growing constituency of alumni and friends.

There is no doubt that exhibition projects such as those I have only briefly described in the preceding paragraphs raised the sight and ambitions of many Gallery donors. And it is clearer still that Paul Mellon's deepening involvement with the arts at Yale was stirred by the fine scholarship and teaching of Jules Prown, who was later invited to serve as the first director of the Yale Center for British Art when Mr. Mellon decided, early in the 1970s, not only to give and bequeath the great bulk of his British art collection to Yale but also to provide his alma mater with the financial support needed to construct Louis Kahn's second museum building on Chapel Street, providing with it ample funds to generously endow its staff, operations, and collections.

Such thoughts were surely on Mr. Mellon's mind in the spring of 1998 during his last visit to Yale, for a mere week later, he sent the Gallery his great Thomas Eakins, *John Biglin in a Single Scull* (pl. 27), as a gift in Jules Prown's honor, offering it forth as the first gift to commence the *Art for Yale: Collecting for a New Century* project. And shortly thereafter, Mr. Mellon also agreed to lend his good name as the honorary chairman of the very quiet art drive the Gallery had launched, one that has since been cochaired by Robert Shapiro, John Walsh, and

Figure 5
American Art from Alumni Collections,
1968

Chuck Close, all of whom have made wonderful contributions to this collection enhancement effort while also encouraging others to partake in it.

Responding almost immediately to Mr. Mellon's initial gift offering were alumnus/a artists Robert Mangold and Sylvia Plimack Mangold, friends of Chuck Close's from their years at the Yale School of Art, and good friends of their fellow Yale-trained artist, Eva Hesse, whose first retrospective had been curated by Helen Cooper at the Yale University Art Gallery. The Mangolds donated a beautiful little Hesse sculpture (pl. 286) to the Gallery in Helen Cooper's honor and Eva Hesse's memory, the first example of Hesse's work to enter her alma mater's collection and the first of many donations made by the Mangolds that have significantly fortified the Gallery's contemporary art holdings. Shortly thereafter, Anna Marie and Robert Shapiro gifted Sol LeWitt's *Wall Drawing #11* (pl. 281) to the Gallery, bringing a major early work of his from the 1960s into dialogue with the work of Hesse and creations from the Mangolds' own studio practice. Thereafter, they, too, continued to shower the Gallery with important gifts of contemporary art by the likes of Christian Boltanksi (pl. 310), Richard Artschwager (pl. 307), and Richard Tuttle (pl. 301) that helped to set a philanthropic pace for other collectors and artists to match. And so commenced a large, long, and quiet nine-year collection-building effort, undertaken from 1998 to the present, one that would eventually fill many voids, add strength to strength, and open new horizons of collecting for Yale's venerable teaching museum, all with the purpose of securing works of the highest quality for active study, display, and public enjoyment.

During this same period, as the Gallery's staff planned and then executed the first two phases of its ambitious museum renovation and expansion master plan, it also reflected on other exhibitions it had mounted during the 1970s and 1980s. Many of these projects had brought attention to the great historical gifts of American art to Yale's Gallery, especially the huge offerings bestowed by Francis P. Garvan but also those of other loyal alumni donors such as Stanley Woodward, George Hopper Fitch, Richard Brown Baker, Henry Geldzahler, and John Axelrod, who further enhanced the Gallery's historical and contemporary holdings of American art in important ways. The vital creative role that the Yale School of Art has long played in training prominent American artists was celebrated in a landmark exhibition entitled *Yale Collects Yale 1950–1993*, which curator Sasha Newman organized during the tenure of Gallery director Mimi Gardner Neill, now Mimi Gardner Gates. Gates's important curatorial and directorial role in the expansion of Asian art at Yale was also reconsidered in 1982 through *The Communion of Scholars: Chinese Art at Yale*, a well-researched survey exhibition of cultural treasures donated to Yale by John Hadley Cox, Ada Small Moore, and other benefactors. It traveled beyond campus not only to the China Institute in New York but also to the Museum of Fine Arts, Houston, serving to kindle the interest of other Asian art collectors in the Gallery's collecting and teaching mission, the fruits of which are very evident today.

With Yale's tercentennial warranting a noteworthy celebration in 2001, the Gallery's entire curatorial staff, led by Helen Cooper, turned its attention to producing a major exhibition entitled *Art for Yale: Defining Moments* (fig. 6). It set forth a riveting visual survey of artworks

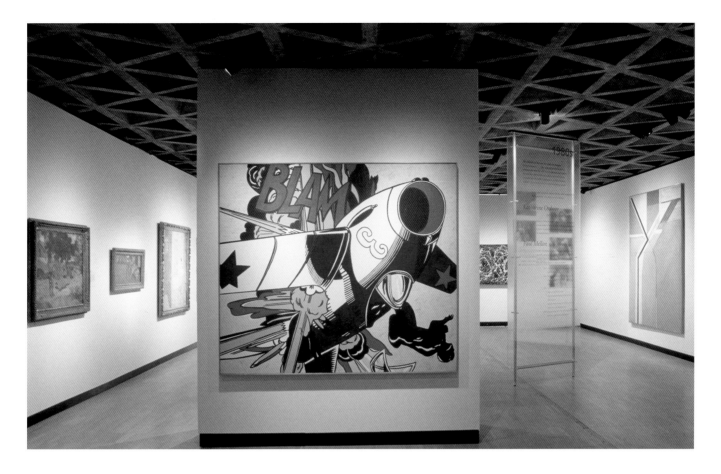

Figure 6
Art for Yale:
Defining Moments,
2001

drawn from the entirety of the Gallery's holdings (then some 85,000 works), displaying selections from a wide array of gifted and purchased collections in the chronological order in which they had arrived at the Gallery since the founding in 1832 of the first collegiate teaching museum in America (doing so by accepting the Revolutionary War and portrait paintings of artist Colonel John Trumbull, who also designed the Gallery's first art building on Old Campus, occasionally meeting and teaching students there in the ensuing years). At this same tercentennial moment, Susan Matheson, chief curator and the Molly and Walter Bareiss Curator of Ancient Art, devoted herself to authoring a major book entitled *Art for Yale: A History of the Yale University Art Gallery*. It not only documented the glorious exhibition that Cooper and her fellow museum colleagues had installed throughout the entire first floor of the Gallery's Swartwout and Kahn buildings, it also provided the Gallery with its first comprehensive written history, one carefully researched by Matheson with the able assistance of archivist Elise Kenney. This volume still stands as a key reference work for all those seeking to better understand how Yale's remarkable commitment to the visual arts began long ago, and how it has since been sustained and nurtured into the beginning of this new century.

One of the key purposes of the Gallery's art drive has been to strengthen areas of the Gallery's art holdings that really needed bolstering. In this regard no alumnus in recent years has done more than Charles Benenson to expand the quality of the Gallery's departmental collections in dramatic fashion. His recent gift to endow the Frances and Benjamin Benenson Foundation Curator of African Art, later followed with a bequest of 585 works of African art, helped establish

an entire new department for the Gallery, one that was also brought to life by major gifts from Laura and James Ross, Labelle Prussin, Ellen and Stephen Susman, Erika and Thomas Leland Hughes, Anna and Dwight Heath, Thomas Jaffe, and the Wardwell family. An additional cash gift from Charles Benenson and his family's foundation will name the Gallery's new modern and contemporary galleries in the soon-to-be-renovated Egerton Swartwout building, where, by 2011, many of the great paintings and sculptures in Benenson's collection of more than two hundred works of modern and contemporary art will reside. Other works will be exhibited and available for study in the new James E. Duffy Gallery and Study Room on the fourth floor of the Gallery's newly restored Louis Kahn building, and the enlarged, newly named Margaret and Angus Wurtele Sculpture Garden behind the Gallery's Kahn building. In time, other sculptural works will be sited elsewhere at Yale, for all those who wish to enjoy them on walking tours of campus.

Augmenting Charles Benenson's transformational bequest of modern and contemporary art are other important collections and objects that have recently been willed, gifted outright, or promised to Yale to better represent the art of the twentieth and twenty-first centuries. Within this catalogue you will surely take note of a rich sampling from Richard Brown Baker's major bequest of contemporary art to his alma mater, selected examples of Thurston Twigg-Smith's copious gifts of contemporary art, representative works from Susan Morse Hilles's recent bequest of modern and contemporary art, and many major modern and contemporary works and funds in this field offered by couples and individuals such as Molly and Walter Bareiss, Anna Marie and Robert Shapiro, Carolyn and Jerry Grinstein, Margaret and Angus Wurtele, Evelyn and Robert Doran, Denise and George Hopper Fitch, Ann and Gilbert Kinney, Peggy and Richard Danziger, Susan and Jeffrey Shamos, Monika and Herbert Schaefer, Mary and Jon Shirley, Jill and John Walsh, Celia Faulkner Crawford, Thomas Solley, Jonathan Rinehart, Samuel Pryor, Reid White, and Francis Williams. A number of individuals have also offered wonderful gifts of modern and contemporary art and funds in memory of departed spouses and parents: Georgia Ashforth in honor of Henry Ashforth, Jr., the Neisser family in honor of Edward Neisser, and Polly W. Hamilton in honor of George Heard Hamilton. Other alumni, such as James Clark, Jr., and Thomas Jaffe, have promised key artworks to Yale that they each inherited from their parents, continuing philanthropic traditions at the University that now span generations and mean a great deal to each of them.

Contemporary artists, often with their spouses, have been similarly generous in offering the Gallery gifts of their own outstanding works of photography, printmaking, and drawing, which can now more readily be shared with students and faculty. Within this catalogue and the exhibition are wonderful works given and promised by the likes of Chuck Close, Sol LeWitt, Robert Mangold, Sylvia Plimack Mangold, Joel Shapiro, Helen Frankenthaler, Richard Serra, John Szarkowski, Lee Friedlander, Phillip-Lorca diCorcia, Dawoud Bey, Judith Joy Ross, and Lois Conner. A number of these artistic contributions that have been created in the media of photography, printmaking, and drawing have significantly strengthened areas of the Gallery's contemporary holdings that truly needed attention and can now be more readily shared with

students and faculty. In that regard, this exhibition includes strong offerings of photographs, prints, and drawings donated to the Gallery from important collections assembled by Doris Bry, Allan Chasanoff, Dorothy and Eugene Prakapas, the Ethne and Clive Gray Family Collection, Jules and Harrison Augur, Elizabeth and Richard Devereaux, Pamela Lord, Regina and Lawrence Dubin, Ted Stebbins, Sally and Werner Kramarsky, and an anonymous donor. Saundra Lane and Betsy Karel and the Trellis Fund also willingly served as the key benefactors who helped make the mammoth acquisition of Robert Adams's master sets of photography possible (see pls. 72–75). Many other singular gifts of highly desired modern and contemporary works on paper have also been offered forth by a broad array of devoted alumni and friends of the Gallery, including Arthur Fleischer, Jr., George Hutchinson, Muffy and Alexander McLanahan, Thomas Perkins, Robert Whittemore, John Mark Rudkin and members of his class of 1951, as well a number of younger alumni such as Eliot Nolen and Tim Bradley, who are just beginning to collect in a concerted way. Happily, some 45,000 works on paper are now readily accessible to faculty members, students, and independent scholars for firsthand independent study.

Many donors have chosen to establish endowed acquisition funds for the Gallery, while others have preferred to place funds for use at the director's discretion. Since 1998, in fact, some nineteen named acquisition funds have been endowed. They've been added to the roster of twelve previously endowed acquisition funds that have, for many years prior to 1998, enabled important purchases of art to be made by Gallery curators upon approval by its Governing Board's Collections Committee and the Gallery's director. In the arena of contemporary art, for example, major works by John Baldessari (pl. 297), Lewis Baltz (pls. 77–78), Mel Bochner (pl. 290), Roni Horn (pl. 324), Tod Papageorge (pls. 81–82), and William T. Wiley (pl. 305) have come to Yale via the Janet and Simeon Braguin Fund, which very generously supports the purchase of work from living American artists over the age of forty. Important acquisitions for the Department of Ancient Art have likewise been secured through major purchases made possible by the bountiful Ruth Elizabeth White Fund, notably the marble portrait of Emperor Commodus as a boy (pl. 198) and the distinguished collection of Roman coins acquired recently from Leonore and Peter Robert Franke. Working productively, all together, the knowledge and abilities of many passionate individual art collectors continue to mingle in very fruitful ways with the visual expertise and teaching interests of Gallery curators and Yale faculty members who depend on the availability of original works in the Gallery's increasingly encyclopedic holdings.

In this regard, the realm of Asian art has particularly flourished at Yale in recent years, during a time when Yale's engagement with universities in China, Japan, India, and other countries throughout Asia has been expanding under President Richard Levin's leadership of this increasingly global university. It's now widely known that all Yale College students are expected to spend at least one academic semester or summer studying abroad during their undergraduate years, and the Gallery has been especially fortunate to have the support of generous donors such as Ruth and Bruce Dayton, Peggy and Richard Danziger, Molly and Walter Bareiss, Kit Luce, Audrey Lam Buchner, Georgia and Michael de Havenon, Pauline Falk, Rosemarie and

Leighton Longhi, Simone Schloss, Mrs. John D. MacDonald, the Wu family, the Nathan Rubin—Ida Ladd Foundation, The Japan Foundation, the Carpenter Foundation, and the Rosenkranz Charitable Foundation during this very lively time, helping to broaden Yale's cultural horizons. These devoted alumni and friends of Yale, led by Ruth and Bruce Dayton's generous endowment of David Sensabaugh's senior curatorship, as well as the naming of the Asian art galleries, have all come forward to provide numerous gifts of acquisition and programmatic funds, as well as many magnificent artworks that are now being shown, researched, and taught with regularly.

The Gallery's Department of Ancient Art has also been the beneficiary of an array of important gifts, including the transfer of Yale's coins and medals collection from the Sterling Memorial Library to the Gallery (holdings comprising some 95,000 objects). This collection has grown in recent years under William Metcalf, who became the Gallery's first Ben Lee Damsky Curator of Coins and Medals, as well as Professor of Classics at Yale. With the enthusiastic support of Susan Matheson, the Molly and Walter Bareiss Curator of Ancient Art, Metcalf has brought major new holdings of Greek and Roman coins into the Gallery's collection, complementing the purchase of the Franke collection through outright and promised gifts from Mary and Jim Ottaway, as well as through astute individual purchases. Matheson has also expanded the holdings of her departmental collection with major bequests, outright gifts, and promised gifts of Egyptian, Greek, Roman, and Precolumbian art from Molly and Walter Bareiss, Jan Mayer, William Kelly Simpson, Jane Davis Doggett, Erika and Thomas Leland Hughes, Harold Strickland, Jr., Joan Davidson, Peggy and Richard Danziger, Thomas Solley, Thomas Jaffe, Cornelius Clarkson Vermeule, and the Ruth Elizabeth White Fund. Many of these adventurous collectors have also gifted or promised artworks to two, three, and sometimes even four of the Gallery's curatorial departments, which is evident by a careful viewing of this exhibition's checklist.

Early European art has long been a strong foundation of the Gallery's collection since the great James Jackson Jarves collection of Italian paintings was purchased by Yale in 1871, later augmented with major gifts from the Maitland Griggs, Robert Lehman, and Hannah and Louis Rabinowitz collections in the twentieth century. Recently, this discipline has thrived anew since being supported by Lionel Goldfrank, Jr., and Nina Griggs, who provided the funds needed to name the senior and associate curatorial positions now held respectively by Laurence Kanter and John Marciari. Both Goldfrank and Griggs have also provided significant funds and promised gifts to the department, as has the Robert Lehman Foundation. This now highly revitalized arena within the Gallery, which possesses spectacular collections spanning the thirteenth to mid-nineteenth century, has also attracted a number of other important donors, notably Robert Liberman, Edmund Pillsbury, Richard Feigen, John Tracey and Darcy Beyer, Mrs. and Ambassador Joseph Verner Reed, Jr., and Jill and John Walsh.

In the departments of American Paintings and Sculpture, as well as American Decorative Arts, in which the Gallery has long been privileged to have two of the best museum

departments and collections extant in the field of American art, the philanthropic offerings that have come the Gallery's way during this collection enhancement effort have been extraordinary. The great works by Thomas Eakins that Paul Mellon has gifted are supremely rare and bolster the Gallery's already great Eakins holdings, while promised gifts that an anonymous donor and Leslie and Joe Fogg have made of two superb works by Winslow Homer (pls. 28, 32) have added great strength to the Gallery's outstanding holdings of Homer watercolors and oil paintings. Other major paintings by the likes of Martin Johnson Heade (pl. 26), Sanford Gifford (pls. 29, 31), Robert Dunning (pl. 25), Edward Lamson Henry (pl. 34), Everett Shinn (pl. 96), Walt Kuhn (pl. 95), Charles Sheeler (pl. 67), Gerald Murphy (pl. 240), Stuart Davis (pls. 260–64, 266–67), and Ralston Crawford (pl. 68) have also entered the Gallery's department of American Paintings and Sculpture owing to the generosity of Jerald Dillon Fessenden, an anonymous donor and Leslie and Joe Fogg, Teri and Andy Goodman, Arthur Altschul, Carolyn and Roger Horchow, Alice Kaplan, Mary Jo and Ted Shen, Joann and Gifford Phillips, and Georgia and Henry Ashforth, as well as the Iola S. Haverstick Fund for American Art and the Katharine Ordway Fund. Additionally, the renowned collection of American portrait miniatures in the Department of American Paintings and Sculpture has been greatly broadened with a magnificent array of works given and promised by Davida Tenenbaum Deutsch and Alvin Deutsch, as well as a choice trio of miniatures donated by Leonard Hill. And the latest American painting proactively offered to the art drive during the spring of 2007 was a magnificent American folk portrait, *Comfort Starr Mygatt and Lucy Mygatt* by John Brewster, Jr. (pl. 1), now the promised gift of Jane and Gerald Katcher, who earlier chose to significantly enrich the holdings of the Gallery's Department of American Decorative Arts with the promised gift of a spectacular Baltimore album quilt (pl. 6) and Goddess of Liberty weathervane (pl. 5), both of which fill important gaps in the Gallery's American art holdings. Other major collectors of American decorative art, notably Lulu and Tony Wang, Linda and George Kaufman, Benjamin Attmore Hewitt, Natalie and George Lee, Jennifer and John Monsky, Jane and Arthur Mason, Elizabeth Ames, Jean Buist, Jay Cantor, Stewart Rosenblum, Susannah Keith Scully, Nancy Stiner, Ruth and David Waterbury, Celia and Robert Wheeler, and an anonymous donor have gifted and promised very beautiful and important examples of American furniture, turned wood, ceramics, silver, and jewelry to the Department of American Decorative Arts. A stunning stained-glass window created by John LaFarge (pl. 20) has also come the Gallery's way through a purchase made possible by more than thirty donors, many of whom are longtime members of the Gallery's Friends of American Art. And very happily, as well, Lulu and Tony Wang are naming the new galleries of American decorative arts, while Jane and Richard Manoogian are doing the same for Yale's new galleries of American paintings and sculpture, both of which will be installed in historic Street Hall, once its renovation is completed in the fall of 2010.

And so, the art holdings in all eight of the Gallery's collecting departments continue to grow and flourish. By working together in closer partnership, curators and collectors have been implementing new ways to increase the overall scope and quality of the Gallery's art holdings.

As a teaching museum, the Gallery has been fortunate to have patrons who provide works that exemplify how an artist's creative process evolves, say from a study drawing to a finished painting. Thanks to several generous donors, the Gallery has acquired the study drawing (pl. 98) for the great George Bellows oil portrait of *Lady Jean*, long extant in the Gallery's collection, and more recently, the acquisition of Colonel John Trumbull's study for *The Death of General Warren at the Battle of Bunker's Hill* (pl. 30), making possible the pairing of one of Trumbull's most superlative drawings with one of his great history paintings from the Gallery's founding collection of 1832. Joann and Gifford Phillips's generosity enabled the acquisition of the five key works by Stuart Davis (pls. 261–64, 266) that now compose a family of visual images with the great Davis *Combination Concrete #2* (pl. 265) oil painting left to the Gallery by Charles Benenson and the seminal Davis gouache *Ana* (pl. 260), which Mary Jo and Ted Shen have offered, ensuring that students can more readily understand the artist's working process via the photographs and study drawing that led up to the gouache's creation. The generosity of James Clark, who has promised both the great Josef Albers Bauhaus-era painting on glass entitled *Skyscrapers A* (pl. 289) and the study drawing (pl. 287) that inspired it, honors one of the Yale School of Art's most formidable deans and teachers, also making his creative process more evident to those who wish to study his art. Profoundly important as well are artworks that signal the pioneering achievements of major Yale alumna/us artists. And thus how fitting it was that Carol and Sol LeWitt have chosen to share three early works they own by Eva Hesse (pls. 282–84) with the Gallery, coupling their offerings with the first Hesse work given to Yale by their close artist friends, Robert and Sylvia Plimack Mangold (pl. 286). Hesse, after all, really found her creative muse at Yale under Josef Albers's tutelage, and then became a great creative colleague of Sol LeWitt, the Mangolds, and many other formidable artists of their generation. And how appropriate it seems to be able to place Gerald Murphy's great 1926 painting *Bibliothèque* (pl. 240) on the cover of this book, calling attention to one of the most notable early twentieth-century artists to have graduated from Yale and then become a pioneering creative force in the transatlantic avant-garde movement that helped set the stage for a great century of American visual art, music, theater, dance, and writing. This glorious painting is redolent with imagery symbolic of a life of learning, and it came to the Gallery through a major gift offered by Alice Kaplan, in memory of her late husband Allan Kaplan, one of the Gallery's most devoted Governing Board members. Her kind generosity was matched with acquisition funds from the Gallery's long-ago established Leonard C. Hanna, Jr., Fund, whose donor, by wonderful circumstance, was one of Gerald Murphy's close friends when the two studied together in Yale College as members of the classes of 1912 (Murphy) and 1913 (Hanna). Such pleasant serendipity, I'm pleased to say, has also arisen in so many of the relationships and acquisition opportunities that have made this collection enhancement effort such a success and pleasure for all those associated with it.

Let me conclude by saying that when one works and teaches at a institution such as Yale University, within which the educational and cultural value of art has so long and consistently been deemed an essential ingredient of a undergraduate liberal arts education, as well as

offering outstanding graduate school opportunities for those wishing to pursue professional careers in the arts, one feels very privileged. And with such privilege resides a solemn responsibility, a duty to continuously acknowledge the generosity and accomplishments of all those who have come before us, and a duty to share Yale's great art holdings broadly with its students and faculty, its New Haven community, and the world at large. And at a time when many of America's artistic and cultural resources are costing more and more for its citizenry and others from around the world to attend, see, and hear, we give thanks to all of the Yale University Art Gallery's enormously loyal donors. It is they who have, without hesitation, enhanced not only the quality and breadth of this venerable teaching museum's collections, but also the facilities and financial endowments that now enable the Gallery's dedicated staff to better care for its remarkable art holdings while also boldly expanding its exhibition, publication, and educational programs. All of us working here at Yale are now able to teach with original works of art more readily and broadly across many academic disciplines. And working together, all of us will continue to ensure that the Gallery's now vast array of visual artworks will remain publicly accessible, free of charge, to all those who wish to enjoy and learn from them.

JOCK REYNOLDS
THE HENRY J. HEINZ II DIRECTOR

The mission of the Yale University Art Gallery is to encourage appreciation and understanding of art and its role in society through direct engagement with original works of art. The Gallery stimulates active learning about art and the creative process through research, teaching, and dialogue among communities of Yale students, faculty, artists, scholars, alumni, and the wider public. The Gallery organizes exhibitions and educational programs to offer enjoyment and encourage inquiry, while building and maintaining its collections in trust for future generations.

Plates

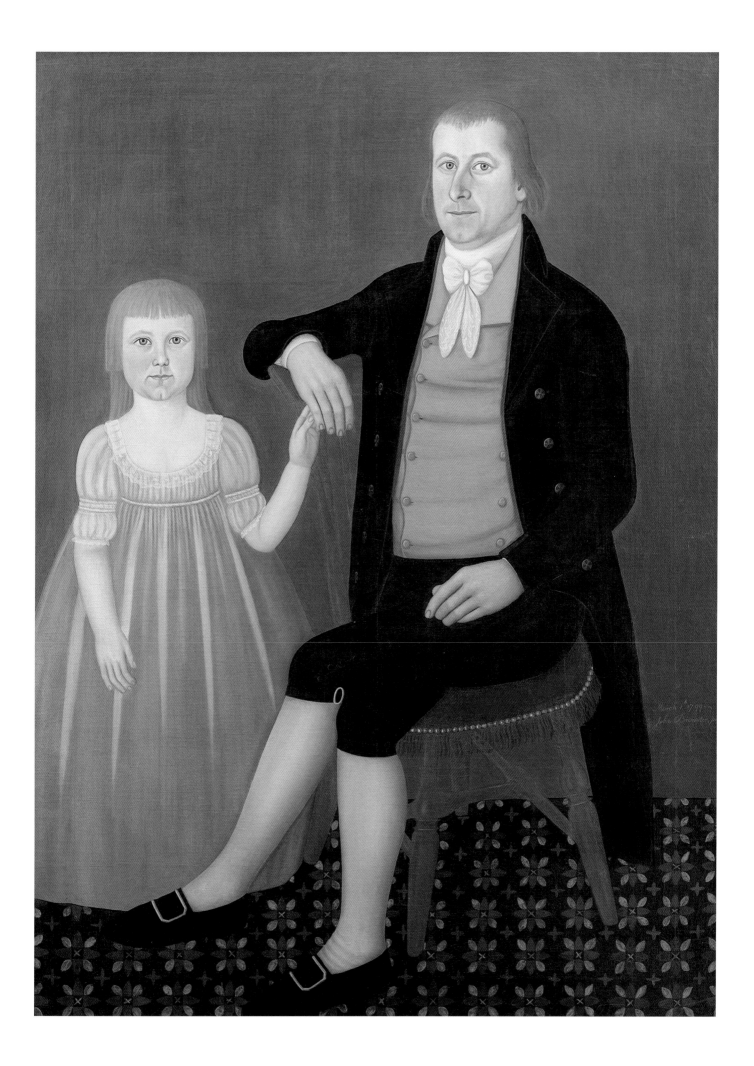

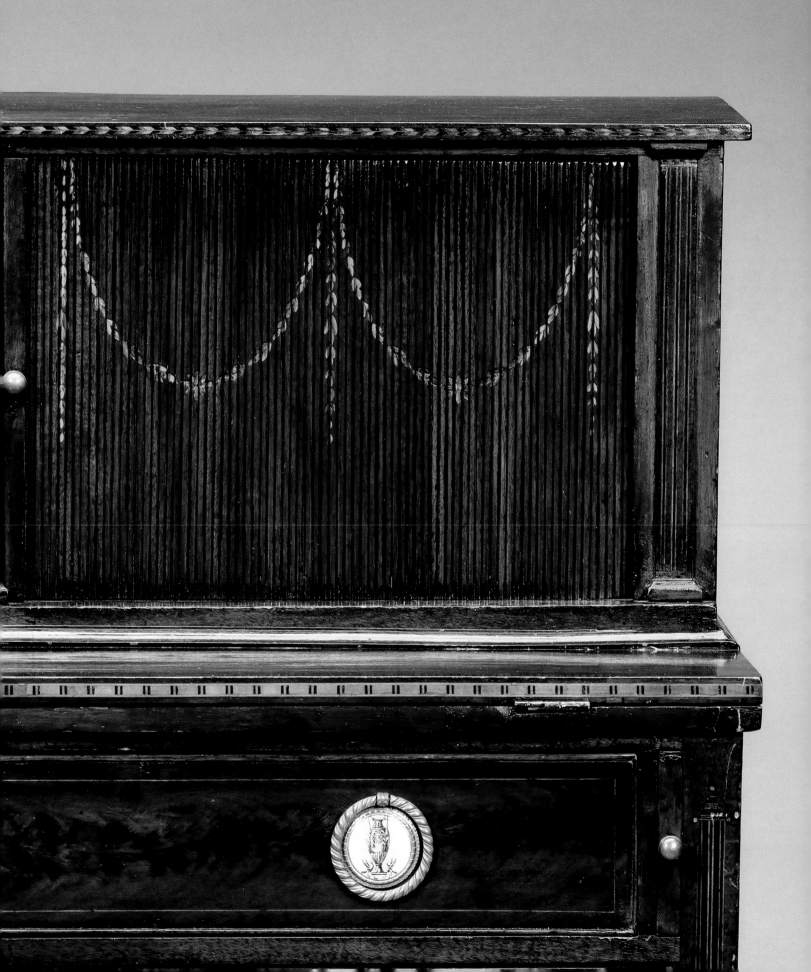

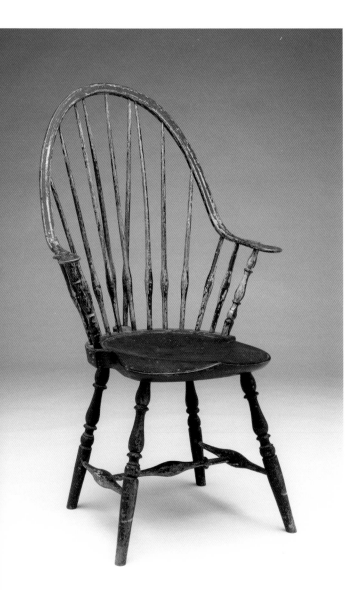

PLATE 2
Attributed to Jedediah Browning (American, 1767–unknown)
Continuous Bow-Back Windsor Chair
Eastern Connecticut or Rhode Island, ca. 1790–1810
Oak, maple, poplar, and pine, 40¼ x 23½ x 24 in.
(102.2 x 59.7 x 61 cm)
Gift of Susannah Keith Scully, fifth-generation descendant of
Jedediah Browning

PLATE 3
Attributed to Holmes Weaver (American, 1769–1848)
Card Table
Newport, Rhode Island, 1790–1810
Mahogany, white pine, and cherry, 28⅝ x 34⅝ x 17⅛ in.
(72.7 x 88 x 43.5 cm)
Bequest of Dr. Benjamin Attmore Hewitt, B.A. 1943, M.A. 1950,
PH.D. 1952

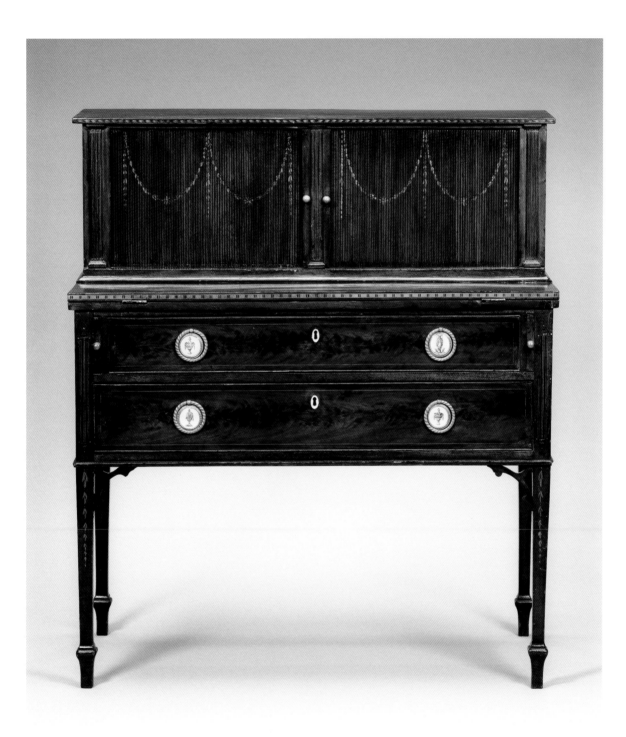

PLATE 4 (detail pages 32–33)
John Seymour and Son (American, 1794–1804)
Tambour Desk
Boston, Massachusetts, ca. 1800
Mahogany, light and dark wood inlays, and white pine,
41 x 36¼ x 19½ in. (104.1 x 92.1 x 49.5 cm)
Promised anonymous bequest

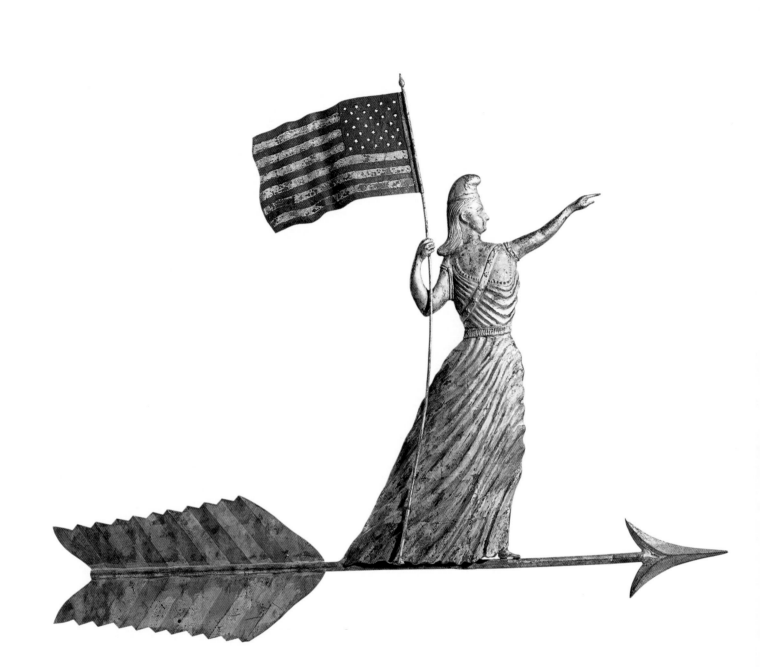

PLATE 5
Goddess of Liberty Weathervane
Manufactured by J. L. Mott Ironworks (1828–1903)
New York, New York, 1880–1900
Copper, zinc, gilding, and painted decoration, 38 x 52 in.
(96.5 x 132.1 cm)
Promised gift of Jane and Gerald Katcher, LL.B. 1950

PLATE 6
Sarah Burke Pool (American, 1824–unknown)
Mary J. Pool (American, 1826–unknown)
Design attributed to Mary Heidentroder Simon (American,
born Germany, active 1844)
Album Quilt
Baltimore, Maryland, 1845–55
Appliquéd cotton fabrics with ink details, 8 ft. 10 in. x 8 ft. 11 in.
(269.2 x 271.8 cm)
Promised gift of Jane and Gerald Katcher, LL.B. 1950

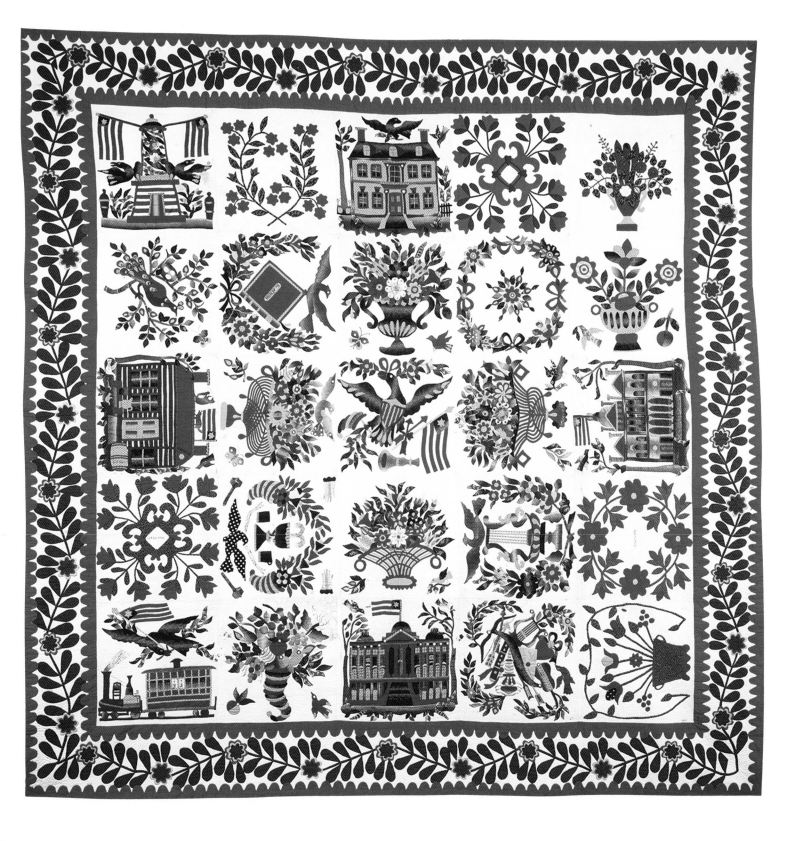

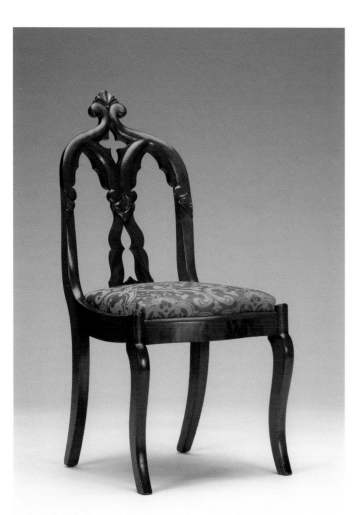

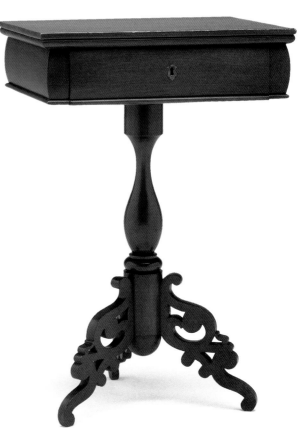

PLATE 7
Side Chair
Probably New York, New York, ca. 1835–50
Mahogany, mahogany veneer, and pine, 37¼ x 17¾ x 17½ in.
(94.6 x 45.1 x 44.5 cm)
Promised gift of Jay E. Cantor

PLATE 8
Attributed to Johann Michael Jahn (American, 1816–1883)
Sewing Table
New Braunfels, Texas, 1870–80
Walnut and yellow pine, 30½ x 20½ x 16¾ in. (77.5 x 52.1 x 42.6 cm)
Gift of Natalie H. and George T. Lee, Jr., B.A. 1957

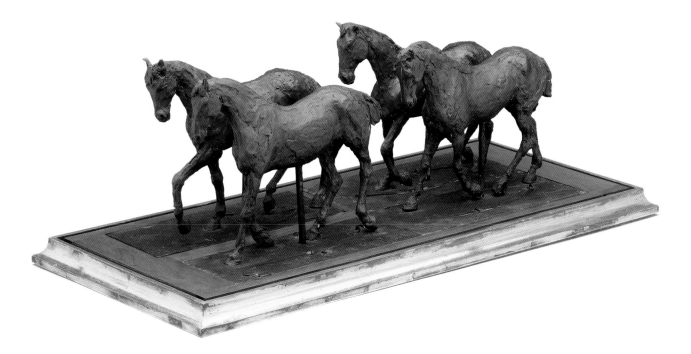

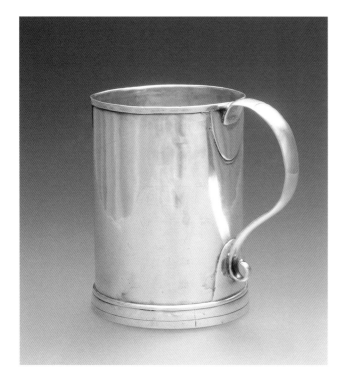

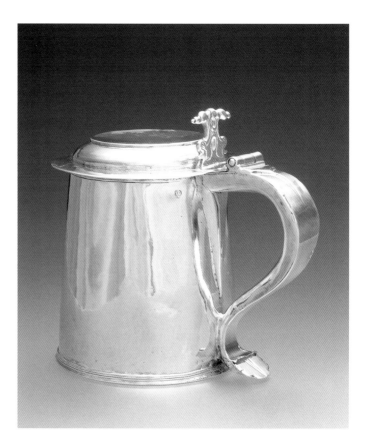

PLATE 10
Antoine Danjen (American, 1781–1827)
Cup
Saint Louis, Missouri, ca. 1810
Silver, 5³⁄₁₆ x 5⅝ x DIAM. (foot) 4 in. (13.2 x 14.3 x 10.2 cm),
498 gm
Josephine Setze Fund for the John Marshall Phillips Collection

PLATE 11
Jeremiah Dummer (American, 1645–1718)
Tankard
Boston, Massachusetts, ca. 1690
Silver, 6¹⁄₁₆ x 7⅞ x DIAM. 5³⁄₁₆ in. (15.4 x 20 x 13.2 cm), 680 gm
Anonymous gift in loving memory of Daniel Catlin

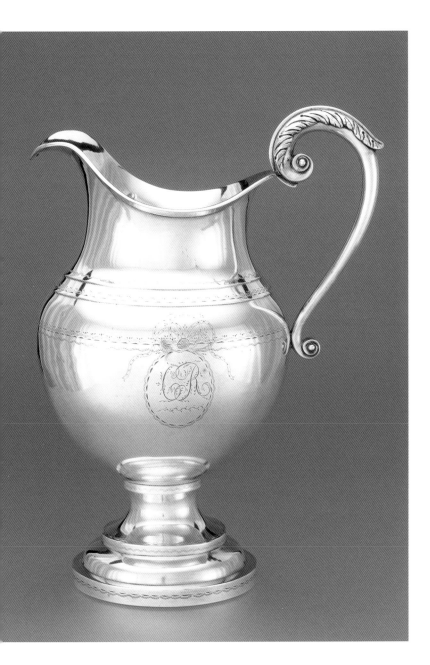

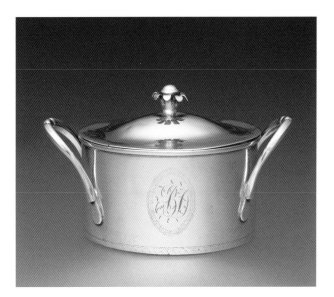

PLATE 12
Antoine Oneille (American, ca. 1764–1820)
Pitcher
Sainte Genevieve, Missouri, 1810–15
Silver, 11¼ x 8⁹⁄₁₆ x DIAM. (foot) 4⅝ in. (28.6 x 21.7 x 11.8 cm),
1058 gm
Josephine Setze Fund for the John Marshall Phillips Collection

PLATE 13
Louis Robitaille (American, 1765–after 1821)
Sugar Bowl and Cover
Sainte Genevieve, Missouri, 1797–1804
Silver, 3¾ x 6³⁄₁₆ x 3⅝ in. (9.5 x 15.7 x 9.2 cm), 331 gm
Josephine Setze Fund for the John Marshall Phillips Collection

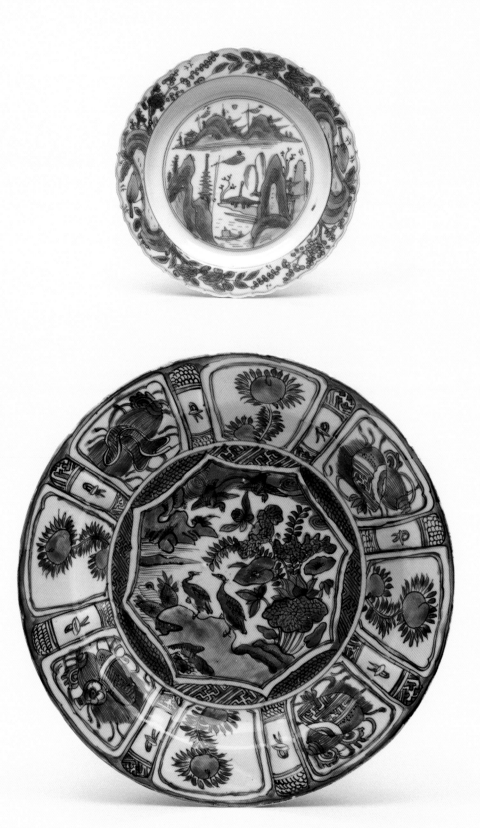

PLATE 14
Plate
China, before 1600
Porcelain painted with underglaze blue, DIAM. 7¾ in. (19.7 cm)
Gift of Professor Robert George Wheeler, PH.D. 1955, and
Celia Whorf Wheeler

PLATE 15
Dish
China, ca. 1620
Porcelain painted with underglaze blue, DIAM. 14¼ in. (36.2 cm)
Gift of Professor Robert George Wheeler, PH.D. 1955, and
Celia Whorf Wheeler

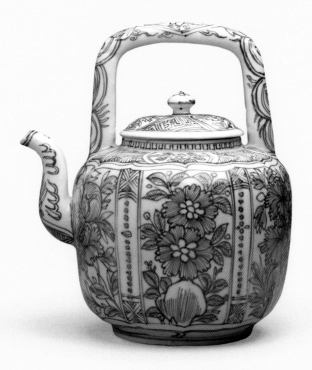

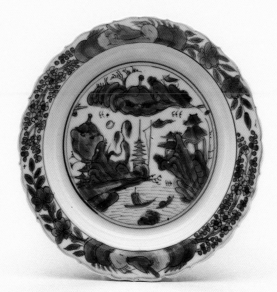

PLATE 16
Wine Ewer and Cover
China, 1600–1625
Porcelain painted with underglaze blue, 7½ x 6¾ x DIAM. (foot)
5⅜ in. (19.1 x 17.2 x 13.7 cm)
Gift of Professor Robert George Wheeler, PH.D. 1955, and
Celia Whorf Wheeler

PLATE 17
Plate
China, before 1600
Porcelain painted with underglaze blue, DIAM. 8 in. (20.3 cm)
Gift of Professor Robert George Wheeler, PH.D. 1955, and
Celia Whorf Wheeler

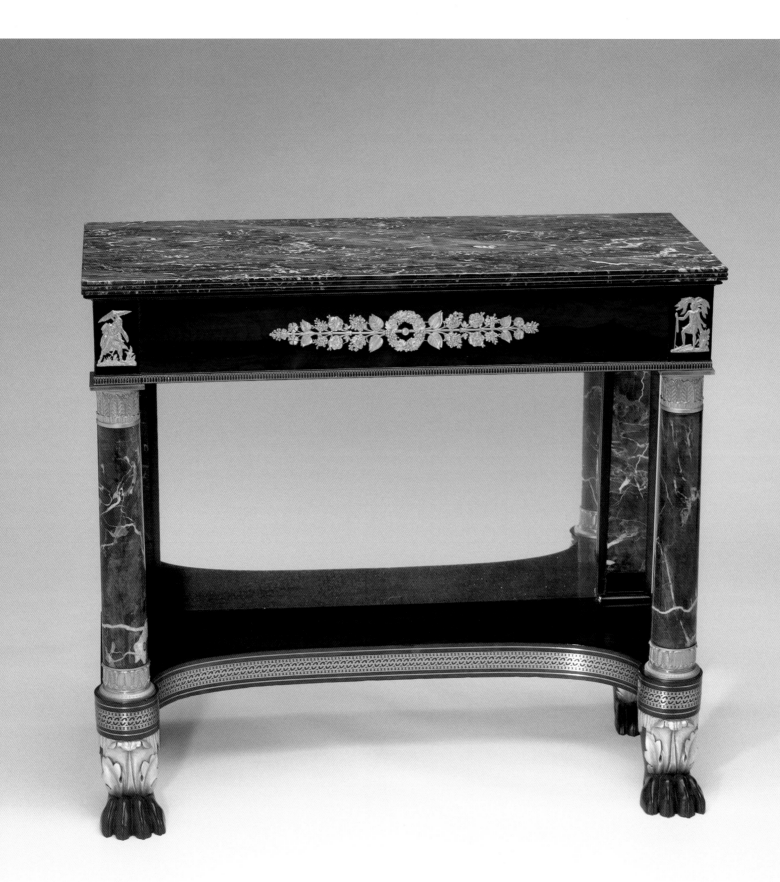

PLATE 18
Pier Table
New York, New York, 1810–30
Black marble, rosewood, brass, yellow poplar, pine, and glass,
37 x 42 x 18 in. (94 x 106.7 x 45.7 cm)
Gift of Mr. and Mrs. George M. Kaufman

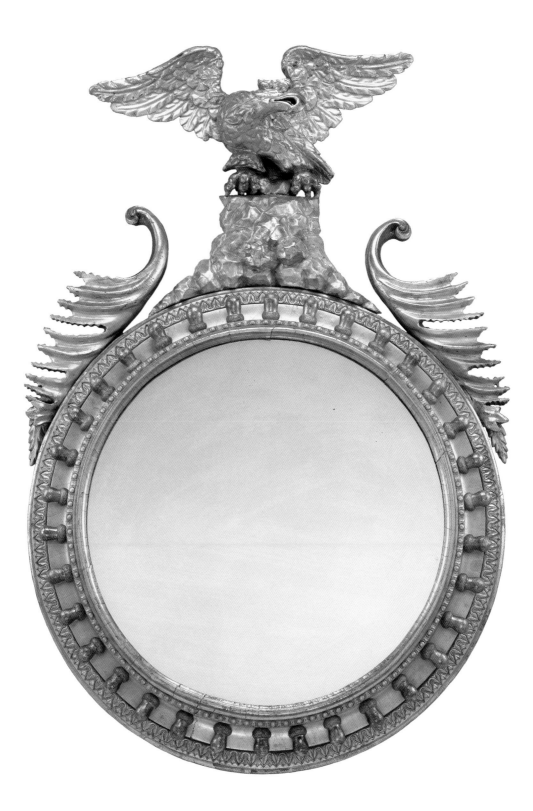

PLATE 19
Looking Glass
England, 1825–40
Gilded pine and glass, 51 x 36 in. (129.5 x 91.4 cm)
Gift of Jean M. Buist, D.V.M.

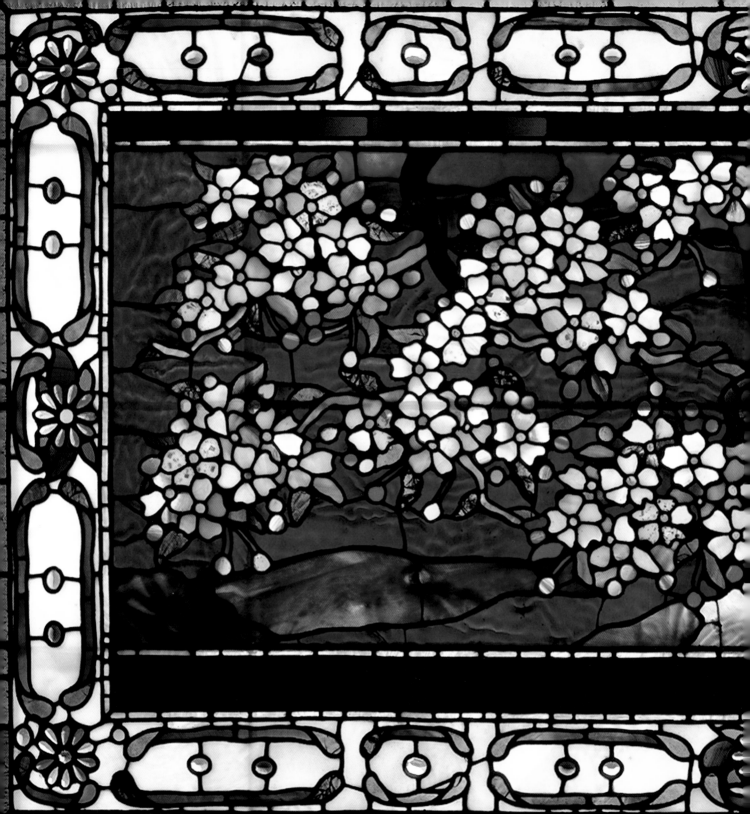

PLATE 20
John La Farge (American, 1835–1910)
Cherry Blossoms against Spring Freshet
New York, New York, 1882–83
Opalescent, antique, and confetti glass, and pressed-glass jewels,
in lead cames with plating, 30½ x 60 in. (77.5 x 152.4 cm)

Purchased with gifts from: Friends of American Arts at Yale; Mr.
and Mrs. James E. Duffy, B.S. 1951; the family, colleagues, and
friends of Katherine Atwater Folds in her memory; and friends of
E. B. Smith, Jr., B.A. 1966. Purchased with funds established by:
Iola S. Haverstick; Peter B. Cooper, B.A. 1960, LL.B. 1964, M.U.S.
1965, and Field C. McIntyre; Mr. and Mrs. Frank J. Coyle, LL.B.

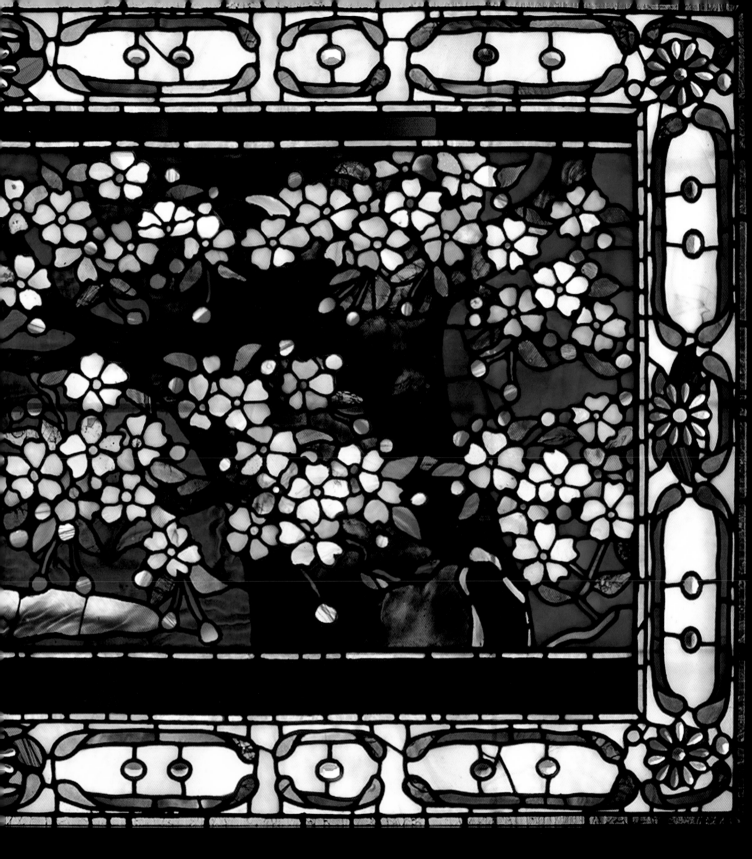

1943; and Leonard C. Hanna, Jr., B.A. 1913. Purchased by exchange from art donated by: Doris M. Brixey and Nathalie Penrose Swetland; J. Davenport Wheeler, B.A. 1858; Edith Malvina K. Wetmore; Mrs. Harvey K. Smith; Loomis Havemeyer, PH.B. 1910, M.A. 1912, PH.D. 1915; Mrs. Robert R. French; Olive Louise Dann; Mr. and Mrs. Sidney W. Peloubet;

Mrs. Paul Moore; Charles Stetson, B.A. 1900; Mrs. Thomas Walter Swan; Misses Emilie L. and Olga V. Loebig; Mrs. Norman Williams; Daniel Merriman; John Barclay, B.A. 1936, in memory of Benjamin R. Sturgis, B.A. 1931, LL.B. 1934; Kathryn E. Pennicuik in memory of James E. G. Fravell, Class of 1919; and the Katharine Ordway and Mabel Brady Garvan Collections,

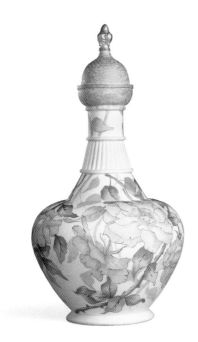

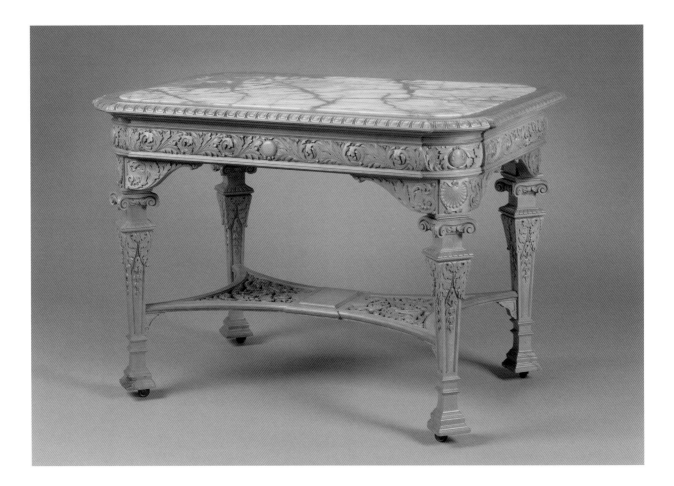

PLATE 21
Vase
Decorated by M. B. G. (19th century)
Manufactured by Faience Manufacturing Company (1881–92)
Greenpoint, Brooklyn, New York, ca. 1891, decorated June 1891
Soft-paste porcelain with painted decoration and gilding, H. 18 x
DIAM. (waist) 8¼ x DIAM. (foot) 5³⁄₁₆ in. (45.7 x 21 x 13.2 cm)
Gift of Nancy Stiner

PLATE 22
Center Table
Probably New York, New York, ca. 1885
Satinwood and maple with an onyx or alabaster top,
29⁵⁄₁₆ x 42⁵⁄₁₆ x 30¹⁄₁₆ in. (74.5 x 107.4 x 76.4 cm)
Promised gift of Stewart G. Rosenblum, J.D. 1974, M.A. 1974,
M.PHIL. 1976, in memory of his parents, Elmer M. and
Harriet G. Rosenblum

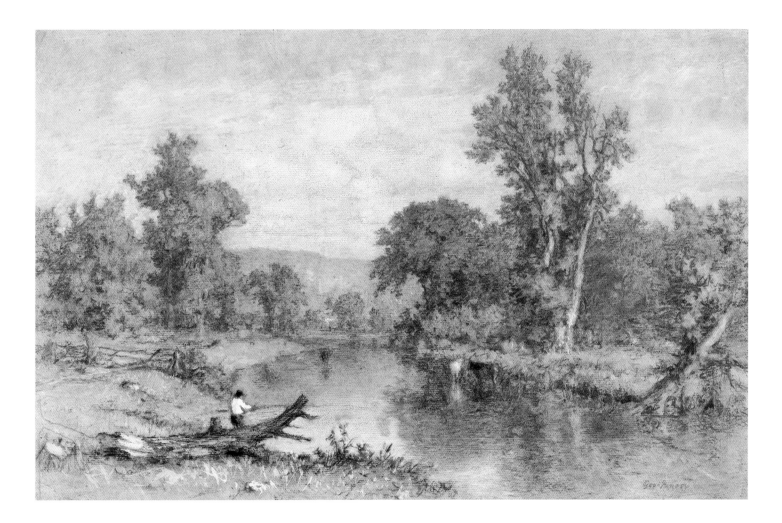

PLATE 23
George Inness (American, 1825–1894)
Milton, New York, ca. 1860–70
Charcoal, white wash, and gouache over graphite on gray paper,
irreg. 11⅞ x 18 in. (30.2 x 45.7 cm)
Gift of Theodore E. Stebbins, Jr., B.A. 1960, in memory of
Charles F. Montgomery

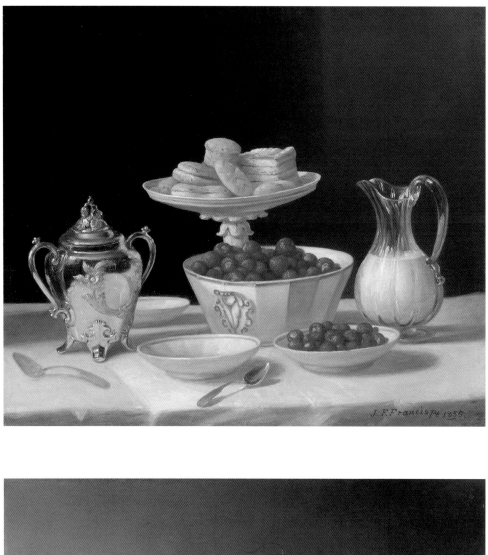

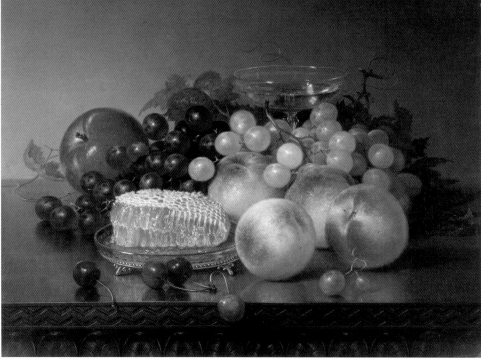

PLATE 24
John F. Francis (American, 1808–1886)
Dessert Still Life, 1855
Oil on canvas, 20 x 24 in. (50.8 x 61 cm)
Partial and promised gift of Mr. and Mrs. Andrew J. Goodman,
B.S. 1968

PLATE 25
Robert Spear Dunning (American, 1829–1905)
Still Life with Honeycomb, ca. 1880
Oil on canvas, 13 x 17 in. (33 x 43.2 cm)
Promised bequest of Andrew J. Goodman, B.S. 1968

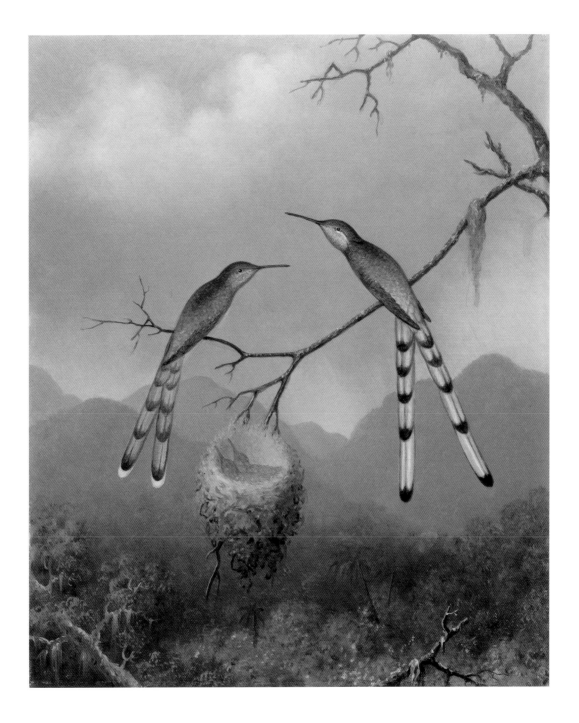

PLATE 26
Martin Johnson Heade (American, 1819–1904)
Two Hummingbirds with Their Young, ca. 1865
Oil on canvas, 13 x 11 in. (33 x 27.9 cm)
Promised bequest of Jerald Dillon Fessenden, B.A. 1960

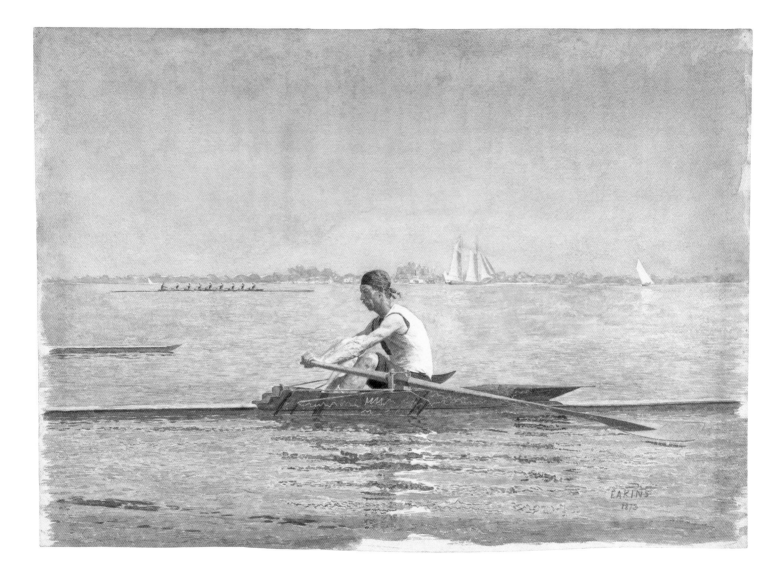

PLATE 27
Thomas Eakins (American, 1844–1916)
John Biglin in a Single Scull, 1873
Watercolor, 16⅞ x 23¹⁵⁄₁₆ in. (42.9 x 60.8 cm)
Gift of Paul Mellon, B.A. 1929, L.H.D. Hon. 1967, in honor of
Jules D. Prown, the first Director of the Yale Center for British Art

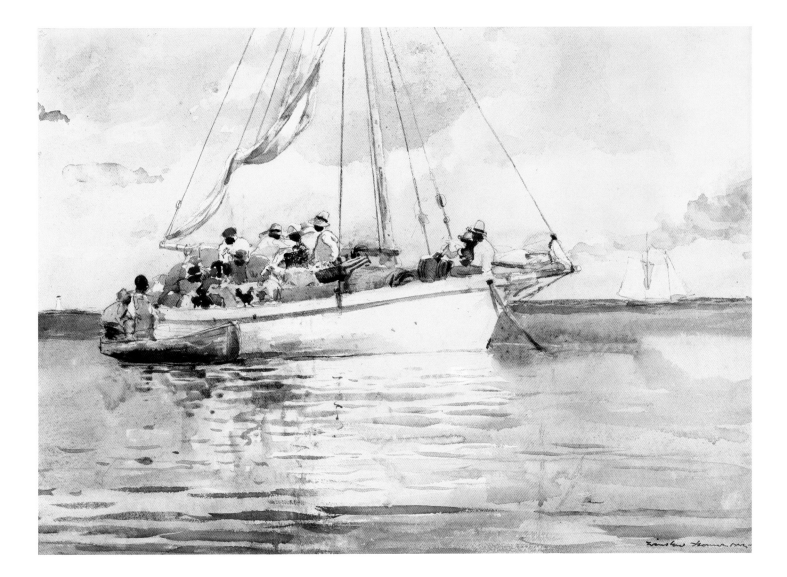

PLATE 28
Winslow Homer (American, 1836–1910)
At Anchor, 1885
Watercolor and graphite, 14 x 20 in. (35.6 x 50.8 cm)
Promised anonymous bequest

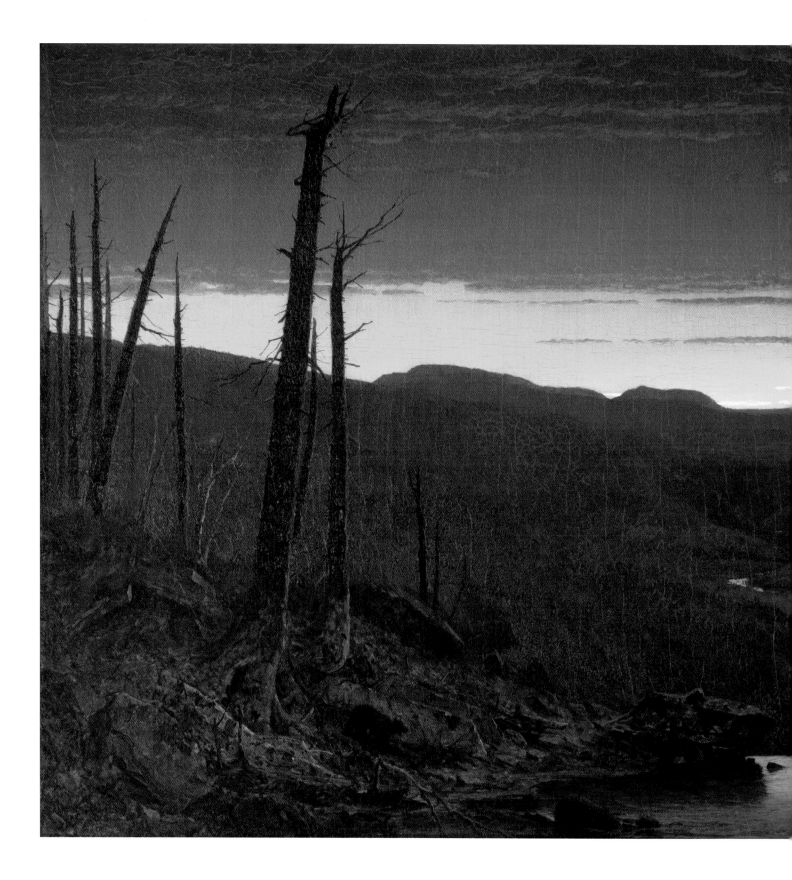

PLATE 29
Sanford Robinson Gifford (American, 1823–1880)
A Twilight in the Catskills, 1861
Oil on canvas, 27 x 54 in. (68.6 x 137.2 cm)
Promised anonymous gift

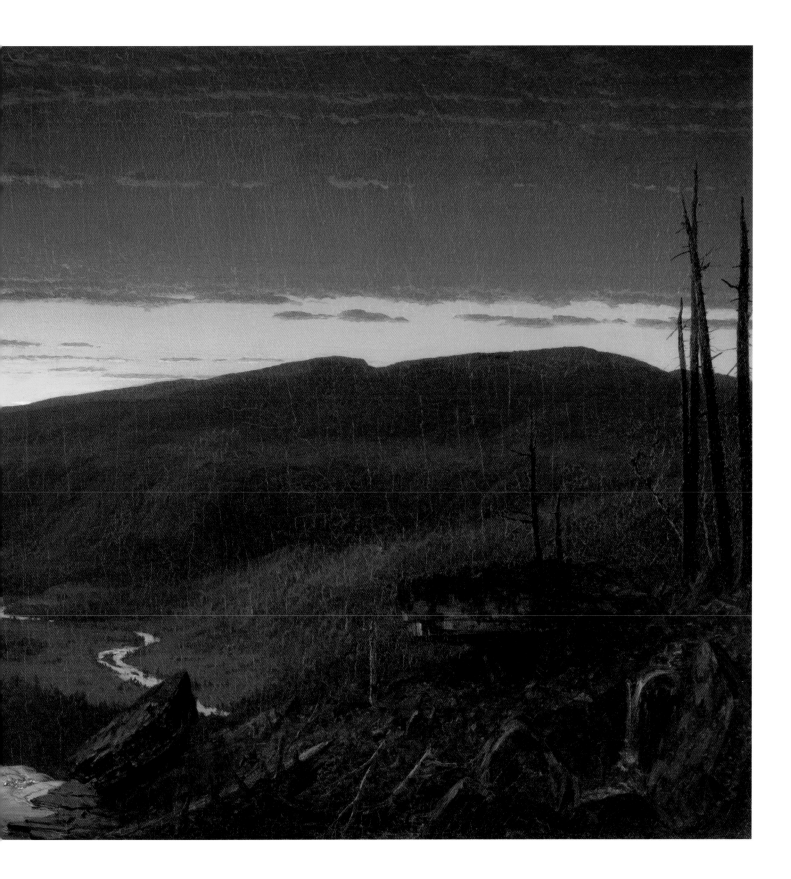

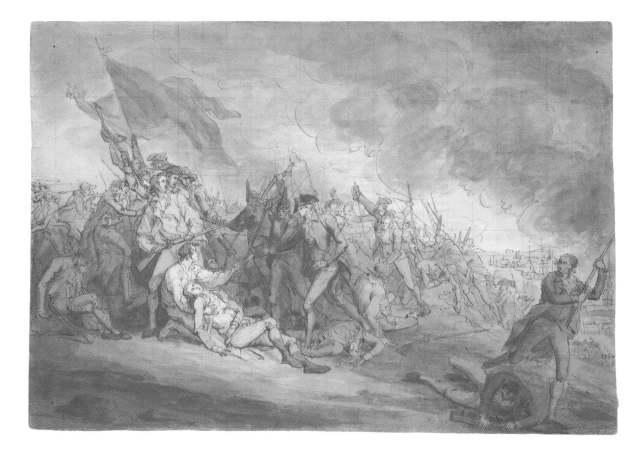

PLATE 30
John Trumbull (American, 1756–1843)
Study for *The Death of General Warren at the Battle of Bunker's Hill, June 17, 1775*, 1785–86
Pen and brown ink with gray and brown ink washes, squared for transfer in graphite, 5½ x 8⅛ in. (14 x 20.6 cm)
Purchased with a gift from Robert L. McNeil, Jr., B.S. 1936s, and the John Hill Morgan, B.A. 1893, LL.B. 1896, M.A. Hon. 1929, Fund

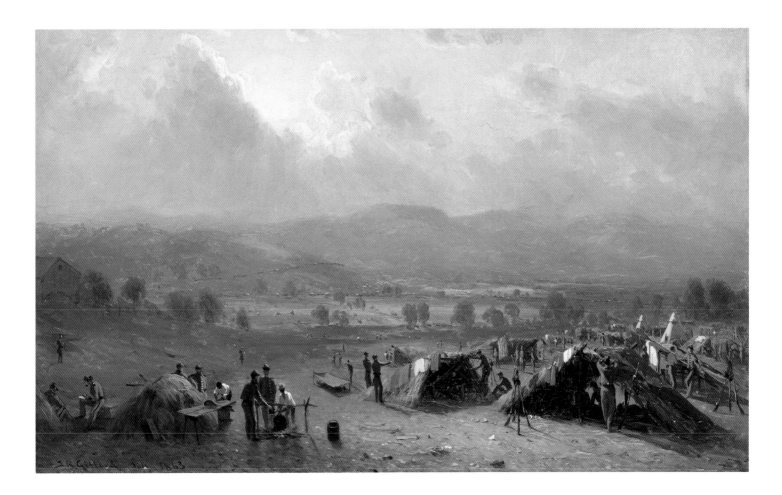

PLATE 31
Sanford Robinson Gifford (American, 1823–1880)
Study for *Camp of the Seventh Regiment, near Frederick, Maryland, in July 1863*, 1863
Oil on canvas, 9½ x 15½ in. (24.1 x 39.4 cm)
Promised bequest of Joseph G. Fogg III, B.A. 1968

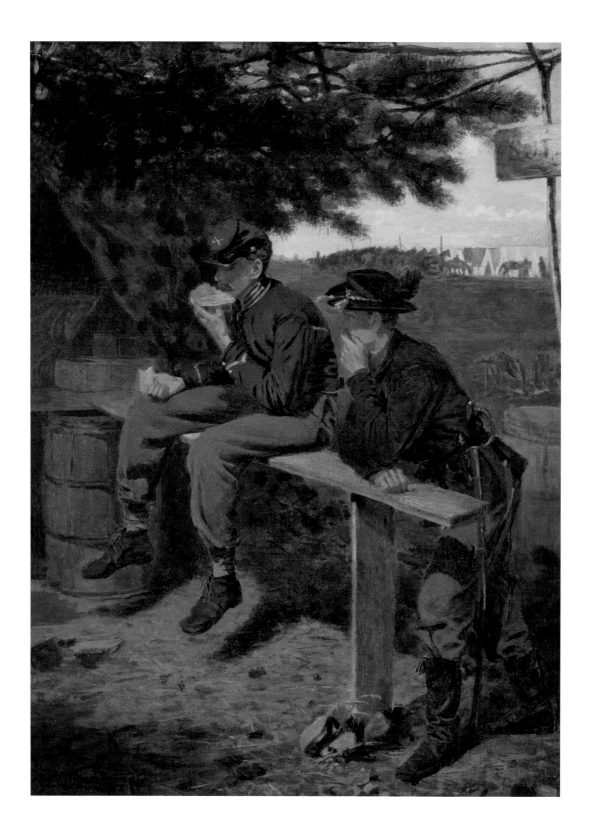

PLATE 32
Winslow Homer (American, 1836–1910)
The Sutler's Tent, 1863
Oil on canvas, 16½ x 12 in. (41.9 x 30.5 cm)
Promised bequest of Joseph G. Fogg III, B.A. 1968

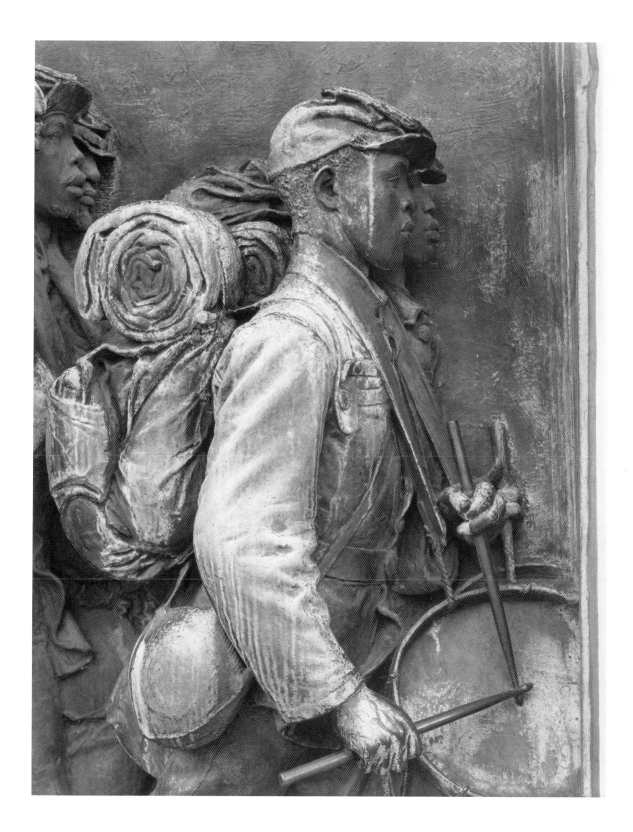

PLATE 33
Richard M. Benson (American, born 1943)
Untitled, from *Lay This Laurel*, 1972
Platinum-palladium print, 12⅝ x 9⅞ in. (32.1 x 25.1 cm)
Purchased with discretionary funds from Yale University
President Richard C. Levin in honor of Richard Benson,
Dean of the Yale University School of Art

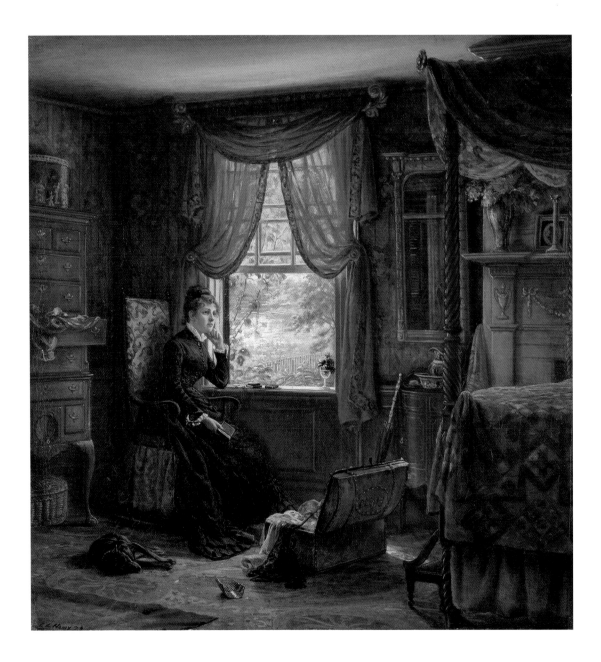

PLATE 34
Edward Lamson Henry (American, 1841–1919)
Memories, 1873
Oil on canvas, 12 x 11 in. (30.5 x 27.9 cm)
Partial and promised gift of Mr. and Mrs. Andrew J. Goodman,
B.S. 1968

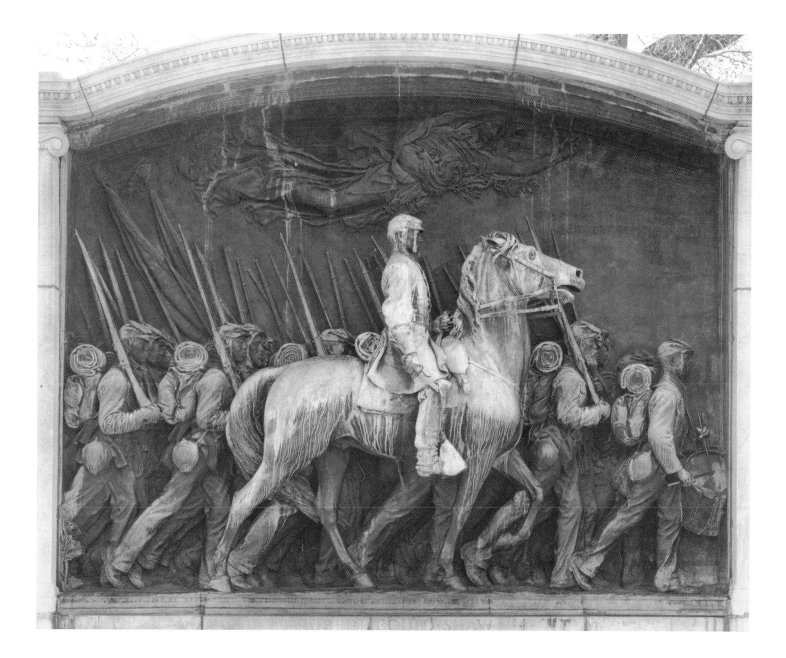

PLATE 35
Richard M. Benson (American, born 1943)
Untitled, from *Lay This Laurel*, 1972
Platinum-palladium print, 10⅛ x 12½ in. (25.7 x 31.8 cm)
Purchased with discretionary funds from Yale University
President Richard C. Levin in honor of Richard Benson,
Dean of the Yale University School of Art

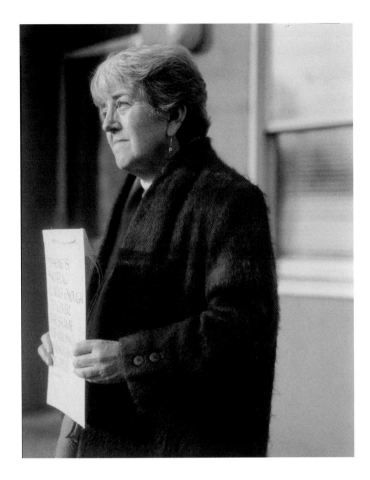

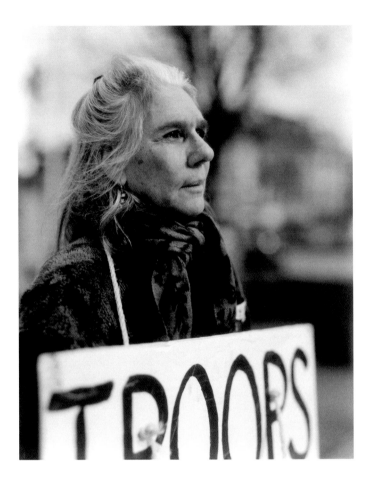

PLATE 36
Judith Joy Ross (American, born 1946)
Nancy Tate, Protesting the War in Iraq, Bethlehem, Pennsylvania, 2006
Gold-toned gelatin silver print, 9⅝ x 7¹¹/₁₆ in. (24.5 x 19.5 cm)
Gift of the artist in honor of Richard Benson

PLATE 37
Judith Joy Ross (American, born 1946)
Susan Ravitz, Protesting the War in Iraq, Easton, Pennsylvania, 2006
Gold-toned gelatin silver print, 9⅝ x 7¹¹/₁₆ in. (24.5 x 19.5 cm)
Janet and Simeon Braguin Fund

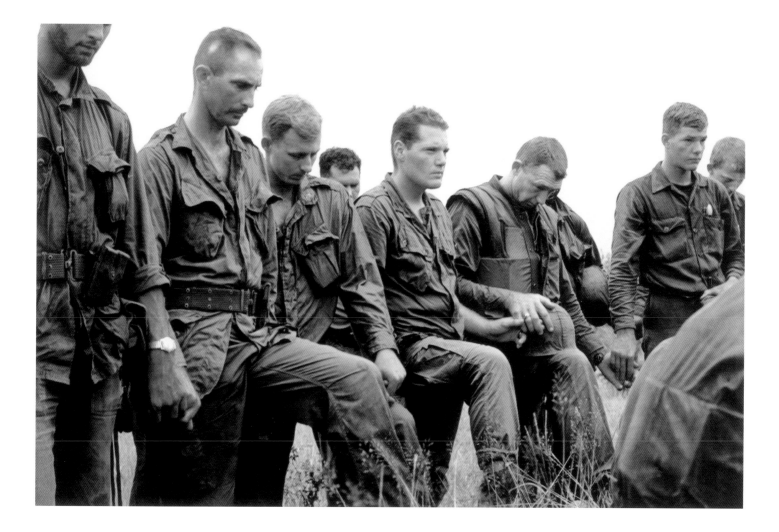

PLATE 38
Larry Burrows (British, 1926–1971)
In Prayer, Operation Prairie, near Dong Ha, Vietnam, 1966, printed 2005
Dye transfer print, 11¾ x 17¹⁵⁄₁₆ in. (29.9 x 45.6 cm)
Purchased with The George A., Class of 1954, and Nancy P. Shutt
Acquisition Fund and the Heinz Family Fund

PLATE 39
Robert Frank (American, born Switzerland, 1924)
City Fathers—Hoboken, New Jersey, from *The Americans*, 1955–56,
printed later
Gelatin silver print, 9⅝ x 13³⁄₁₆ in. (24.5 x 33.5 cm)
Purchased with a gift from Alexander K. McLanahan, B.A. 1949,
in honor of his wife, Mary Ann C. McLanahan

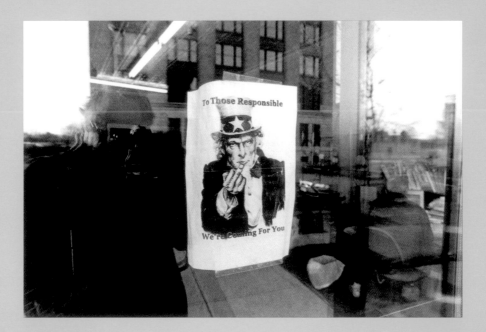

PLATES 40–41
Nathan Lyons (American, born 1930)
Untitled, from *After 9/11*, 2001
Gelatin silver prints, each 4½ x 6¾ in. (11.4 x 17.2 cm)
Purchased with the Leonard C. Hanna, Jr., B.A. 1913, Fund
and gifts from Arthur Fleischer, Jr., B.A. 1953, LL.B. 1958, and
Betsy Karel

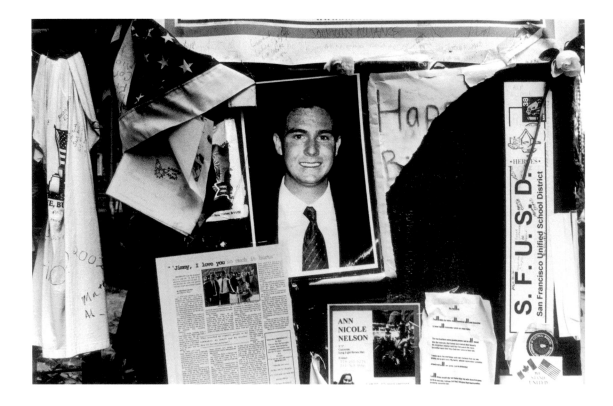

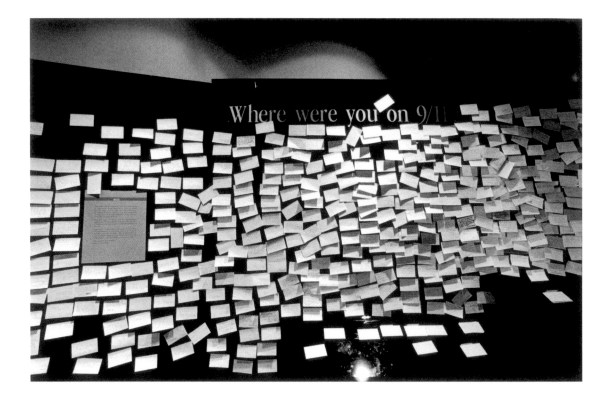

PLATES 42–45
Nathan Lyons (American, born 1930)
Untitled, from *After 9/11*, 2001
Gelatin silver prints, each 4½ x 6¾ in. (11.4 x 17.2 cm)
Purchased with the Leonard C. Hanna, Jr., B.A. 1913, Fund
and gifts from Arthur Fleischer, Jr., B.A. 1953, LL.B. 1958, and
Betsy Karel

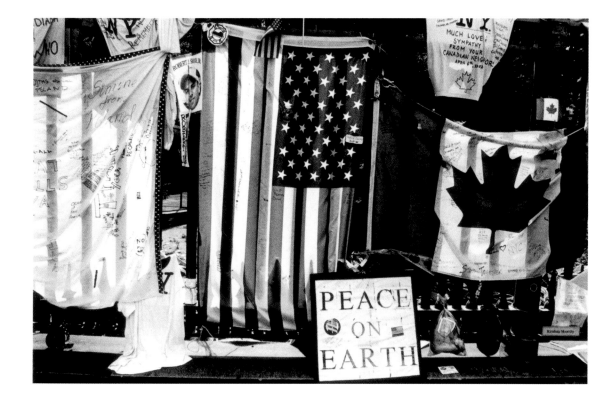

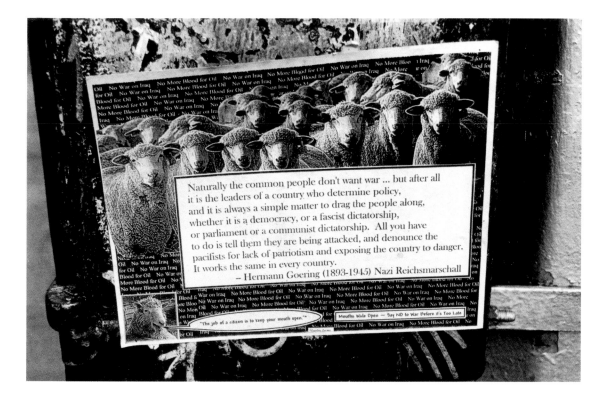

PLATE 46
Mourning Embroidery
Susanna Rowson's Academy (1797–1822),
Boston, Massachusetts, ca. 1799
Silk thread, silk, watercolor, and paper, 24¾ x 19½ in. (62.9 x 49.5 cm)
Gift of Elizabeth Ames, B.A. 1979, in loving memory of Margaret A.
Ames

PLATE 47 (obverse and reverse)
Unidentified artist
Memorial for Solomon and Joseph Hays, 1801
Watercolor, pearls, gold wire, beads, and locks of blond and
brown hair (natural, chopped, and dissolved) on ivory, 1⅞ x
1¹³⁄₁₆ in. (4.8 x 4.6 cm); on reverse, blond and brown hair plaid
and gold cipher
Promised bequest of Davida Tenenbaum Deutsch and Alvin
Deutsch, LL.B. 1958, in honor of Kathleen Luhrs

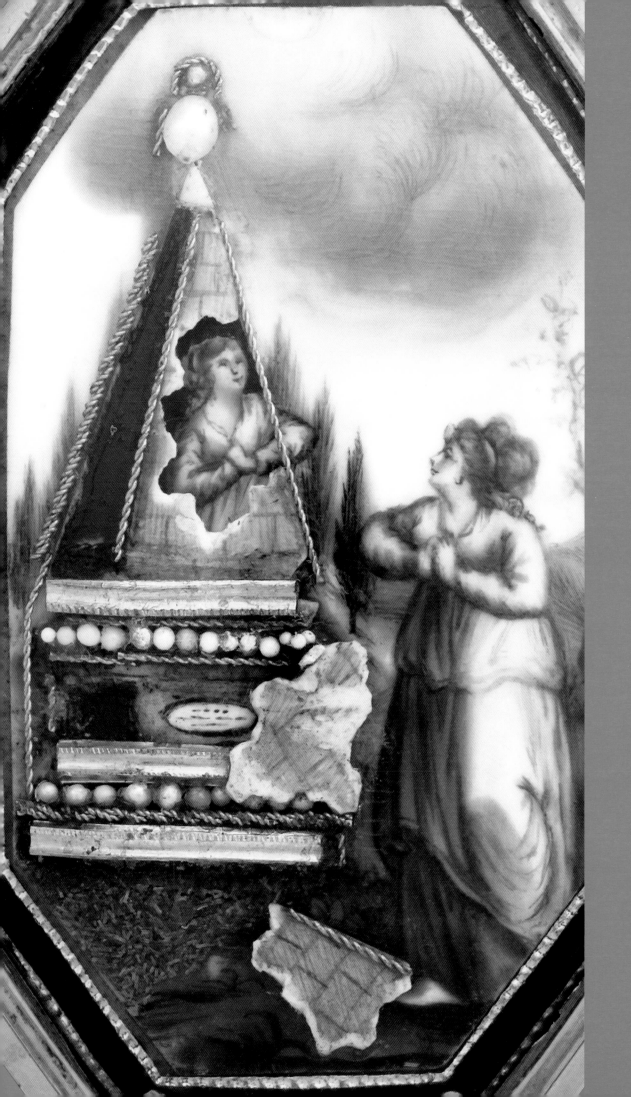
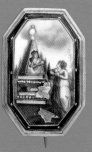

Opposite:
PLATE 48 (detail far left)
Unidentified artist
Memorial for S. C. Washington, ca. 1789
Watercolor, chopped hair, gold wire, pearls, and applied ivory
on ivory, 1¹⁄₁₆ x ¹¹⁄₁₆ in. (2.7 x 1.75 cm)
Promised bequest of Davida Tenenbaum Deutsch and Alvin
Deutsch, LL.B. 1958, in honor of Kathleen Luhrs

Above left:
PLATE 49 (obverse and reverse)
Elkanah Tisdale (American, 1768–1835)
William Brown (1779–1805), between 1800 and 1805
Watercolor on ivory, 2¹³⁄₁₆ x 2¼ in. (7.1 x 5.7 cm); on reverse,
cut gold initials "W B" over woven hair
Promised bequest of Davida Tenenbaum Deutsch and Alvin
Deutsch, LL.B. 1958, in honor of Robin Jaffee Frank, PH.D. 1994

Above right:
PLATE 50 (obverse and reverse)
Elkanah Tisdale (American, 1768–1835)
Ann Brown (Mrs. John Vernet) (1780–1859), between 1798 and 1802
Watercolor on ivory, 2¾ x 2¼ in. (7 x 5.7 cm); on reverse, two
locks of hair with gold wire and seed pearls
Promised bequest of Davida Tenenbaum Deutsch and Alvin
Deutsch, LL.B. 1958, in honor of Robin Jaffee Frank, PH.D. 1994

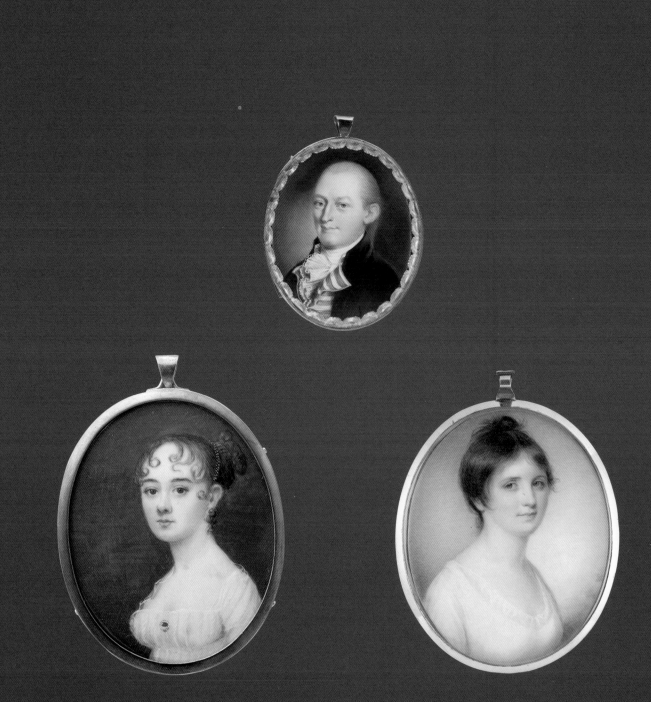

PLATE 51
John Ramage (British, born Ireland, ca. 1748–1802,
active in America, 1775–94)
Elbridge Gerry (1744–1814), ca. 1785
Watercolor on ivory, 2 x 1½ in. (5.1 x 3.8 cm)
Promised bequest of Davida Tenenbaum Deutsch and Alvin
Deutsch, LL.B. 1958, in honor of Robin Jaffee Frank, PH.D. 1994

PLATE 52
William M. S. Doyle (American, 1769–1828)
Young Lady in a Sheer White Dress, ca. 1805
Watercolor on ivory, 2¾ x 2³⁄₁₆ in. (7 x 5.5 cm)
Gift of Davida Tenenbaum Deutsch and Alvin Deutsch,
LL.B. 1958, in honor of Kathleen Luhrs

PLATE 53
Edward Greene Malbone (American, 1777–1807)
Mary Hooper (Mrs. Alexander Schaw, Mrs. James Fleming)
(1779/80–1831), probably 1802
Watercolor on ivory, 2¹¹⁄₁₆ x 2¼ in. (6.8 x 5.7 cm)
Gift of Davida Tenenbaum Deutsch and Alvin Deutsch,
LL.B. 1958, in honor of Kathleen Luhrs

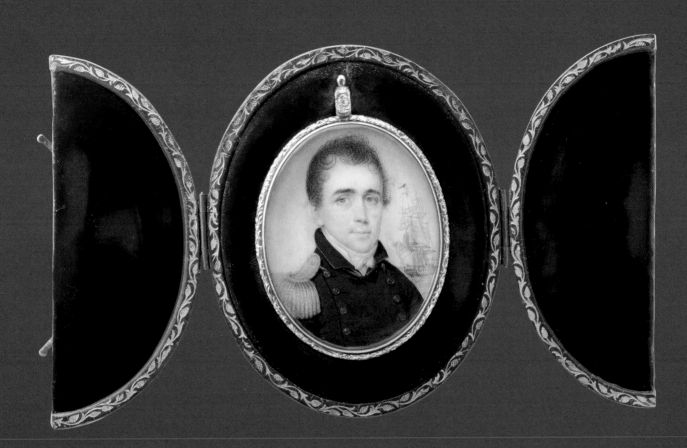

PLATE 54
Raphaelle Peale (American, 1774–1825)
Commander Samuel Woodhouse (1784–1843), 1816 or 1817
Watercolor on ivory, 2⁷⁄₁₆ x 2 in. (6.2 x 5.1 cm)
Gift of Davida Tenenbaum Deutsch and Alvin Deutsch,
LL.B. 1958, in honor of Kathleen Luhrs

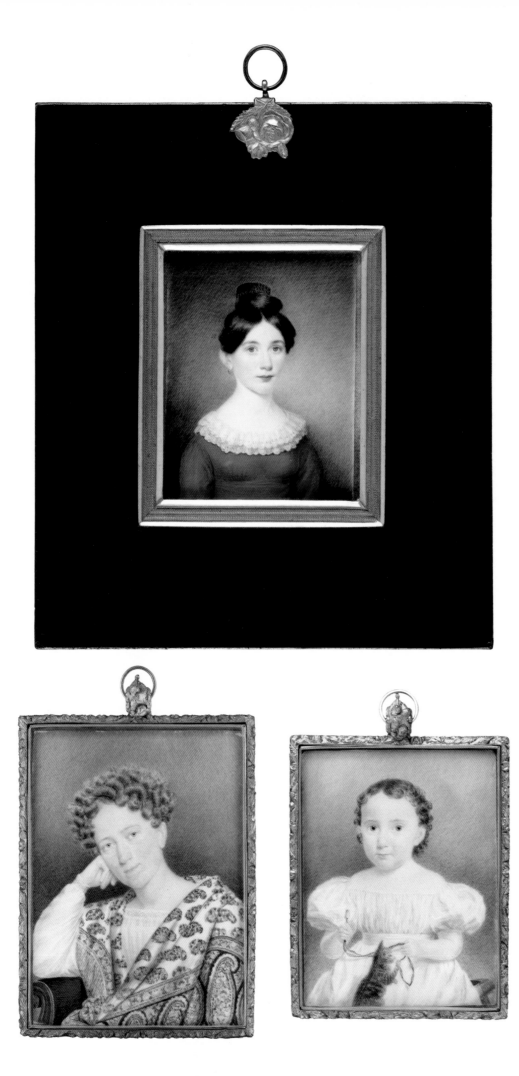

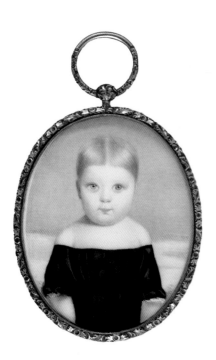

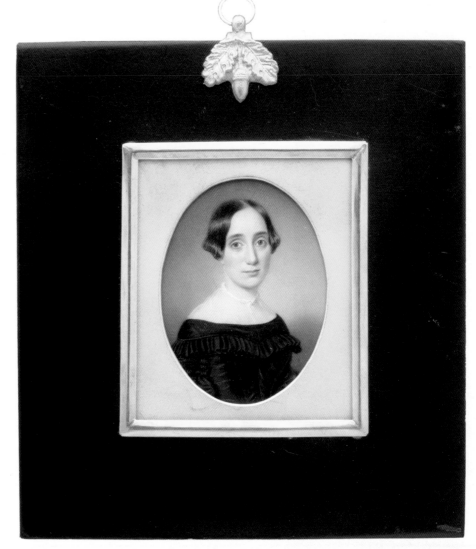

Opposite, clockwise from top:
PLATE 55
Sarah Goodridge (American, 1788–1853)
Anna Powell Mason Perkins (Mrs. Henry Bromfield Rogers)
(1805–1880), between 1821 and 1824
Watercolor on ivory, 3¹⁄₁₆ x 2½ in. (7.8 x 6.4 cm)
Gift of Davida Tenenbaum Deutsch and Alvin Deutsch,
LL.B. 1958, in honor of Kathleen Luhrs

PLATE 56
Eliza Goodridge (American, 1798–1882)
Julia Porter Dwight (1830–1869), ca. 1832
Watercolor on ivory, 2¹¹⁄₁₆ x 2¼ in. (6.8 x 5.7 cm)
Gift of Leonard F. Hill, B.A. 1969

PLATE 57
Eliza Goodridge (American, 1798–1882)
Elizabeth Russell Fiske (ca. 1799–1833), ca. 1832
Watercolor on ivory, 3⁹⁄₁₆ x 2¹¹⁄₁₆ in. (9 x 6.8 cm)
Gift of Leonard F. Hill, B.A. 1969

Above, left to right:
PLATE 58
Edward Samuel Dodge (American, 1816–1857)
Harriet E. Hulse (Mrs. William J. Felthousen) (1840–1921), 1842
Watercolor on ivory, 2¼ x 1¾ in. (5.7 x 4.5 cm)
Gift of Davida Tenenbaum Deutsch and Alvin Deutsch, LL.B.
1958, in honor of Kathleen Luhrs

PLATE 59
John Wood Dodge (American, 1807–1893)
Mrs. Ezra Nye (Nancy Freeman Fessenden) (1799–1874), 1837
Watercolor on ivory, 3¼ x 2⅞ in. (8.3 x 7.3 cm)
Promised gift of Leonard F. Hill, B.A. 1969

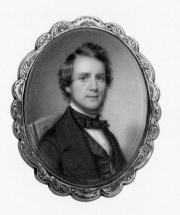

PLATE 60 (obverse and reverse, detail opposite)
John Wood Dodge (American, 1807–1893)
Self-Portrait, 1848
Watercolor on ivory, 1⅝ x 1¼ in. (4.1 x 3.2 cm); on reverse,
"To / Juliette" below compartment containing brown hair plaid
John Hill Morgan, B.A. 1893, LL.B. 1896, M.A. Hon. 1929, Fund

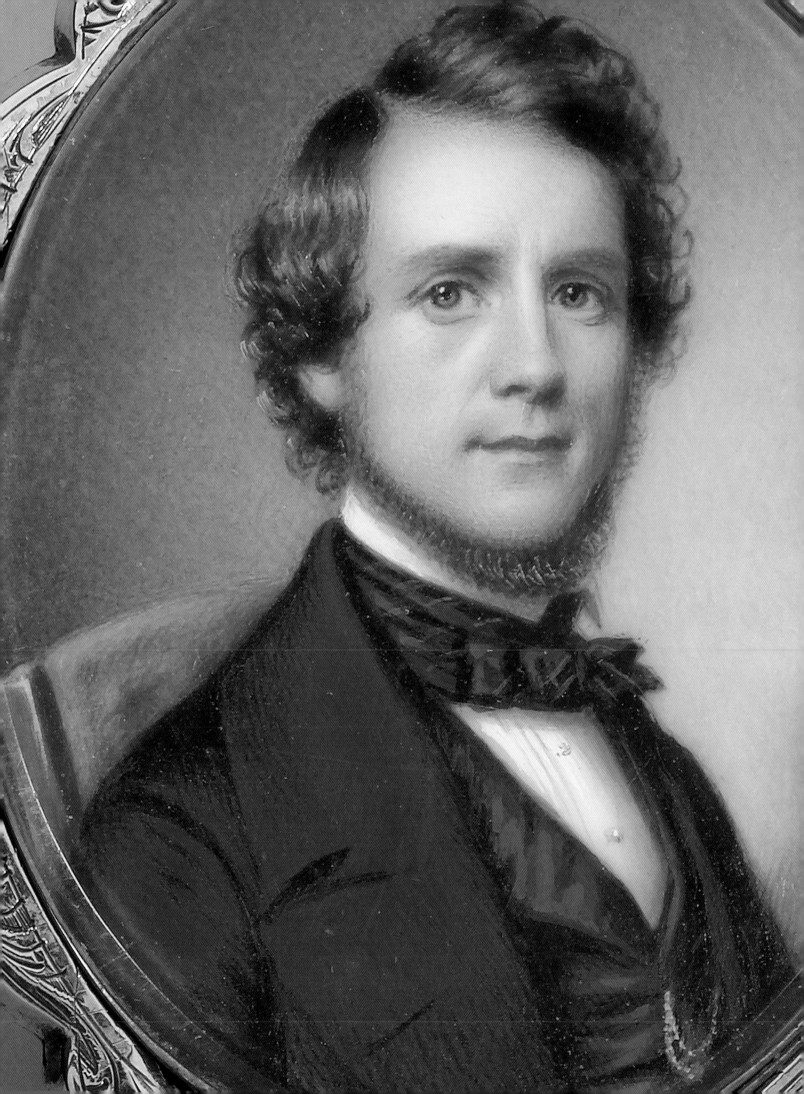

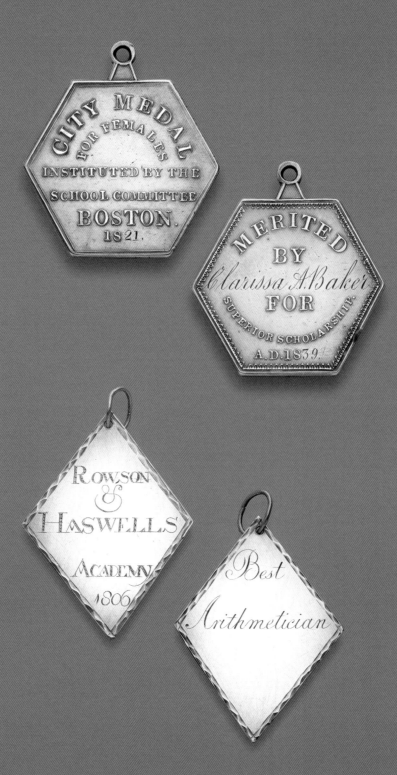

PLATE 61 (obverse and reverse)
City Medal for Females
Boston, Massachusetts, 1839
Silver, 16.25 gm, 12:00, 44 mm
Promised bequest of Davida Tenenbaum Deutsch and Alvin
Deutsch, LL.B. 1958, in honor of Robin Jaffee Frank, PH.D. 1994

PLATE 62 (obverse and reverse)
Rowson and Haswell's Academy Medal
Boston, Massachusetts, 1806
Silver, 5.3 gm, 12:00, 37 mm
Promised bequest of Davida Tenenbaum Deutsch and Alvin
Deutsch, LL.B. 1958, in honor of Robin Jaffee Frank, PH.D. 1994

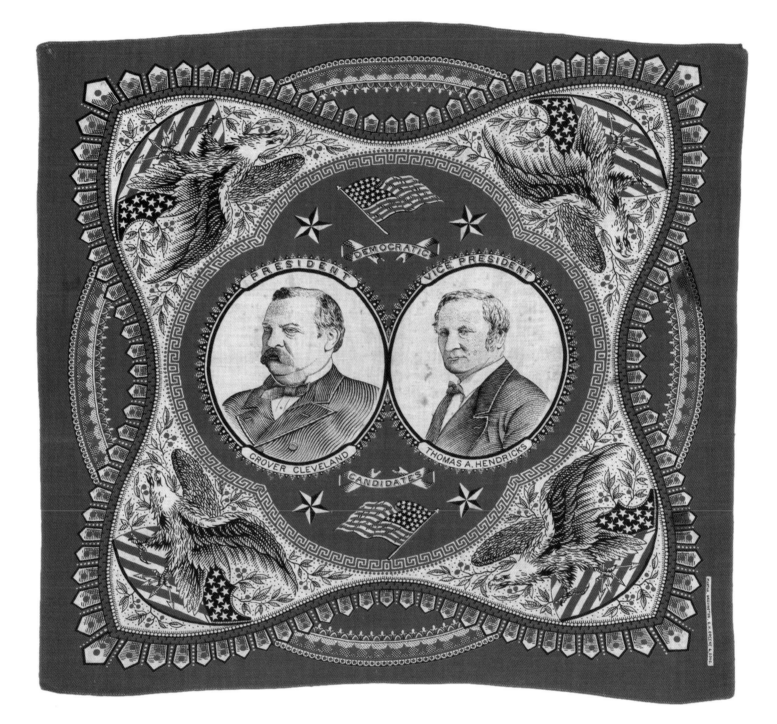

PLATE 63
Grover Cleveland and Thomas A. Hendricks Bandanna
Manufactured by S. H. Greene and Sons (1865–1926)
Warwick, Rhode Island, 1884
Printed cotton, 20 x 20 in. (50.8 x 50.8 cm)
Gift of John R. Monsky, B.A. 1981, and Jennifer Weis Monsky, B.A. 1981

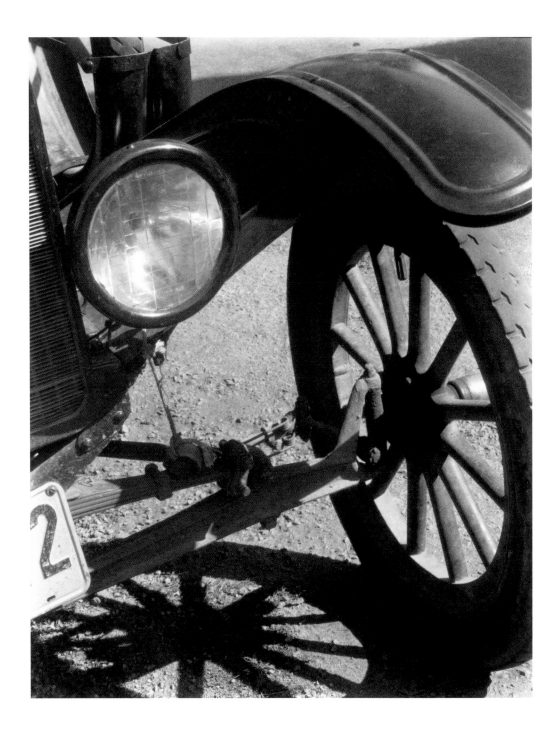

PLATE 64
Ralph Steiner (American, 1899–1986)
Automobile Wheel and Headlight, 1929, printed 1979
Gelatin silver print, 10 x 8 in. (25.4 x 20.3 cm)
Doris Bry Inadvertent Collection

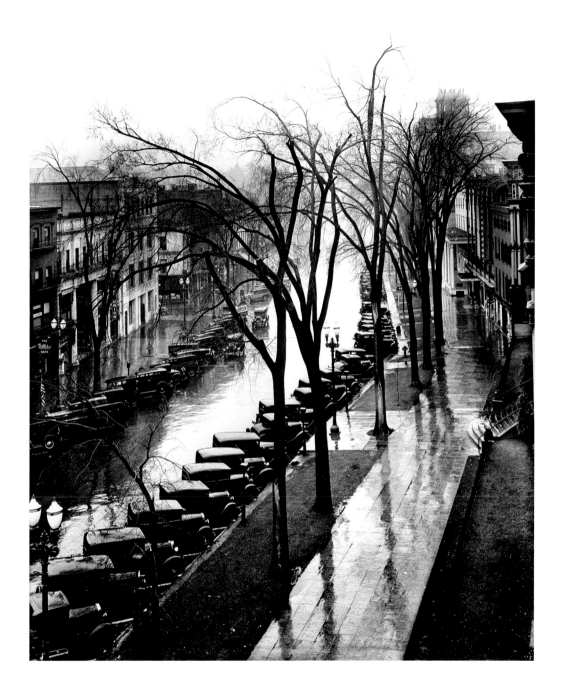

PLATE 65
Walker Evans (American, 1903–1975)
Main Street, Saratoga Springs, New York, 1931, printed 1971
Gelatin silver print, 8¹⁄₁₆ x 6⁵⁄₁₆ in. (20.5 x 16 cm)
Purchased with a gift from Alexander K. McLanahan, B.A. 1949,
in honor of his wife, Mary Ann C. McLanahan

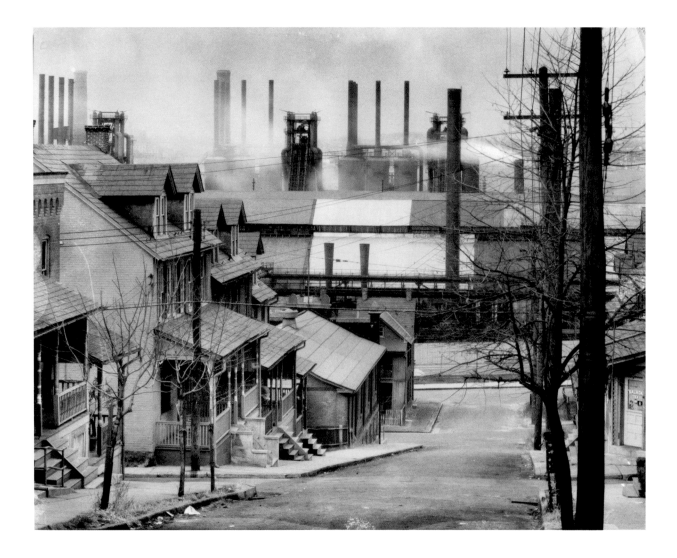

PLATE 66
Walker Evans (American, 1903–1975)
Steel Mill Workers' Houses, 1936, printed 1971
Gelatin silver print, 7½ x 9½ in. (19.1 x 24.1 cm)
Purchased with a gift from Eliot Nolen, B.A. 1984,
and Timothy Bradley, B.A. 1983

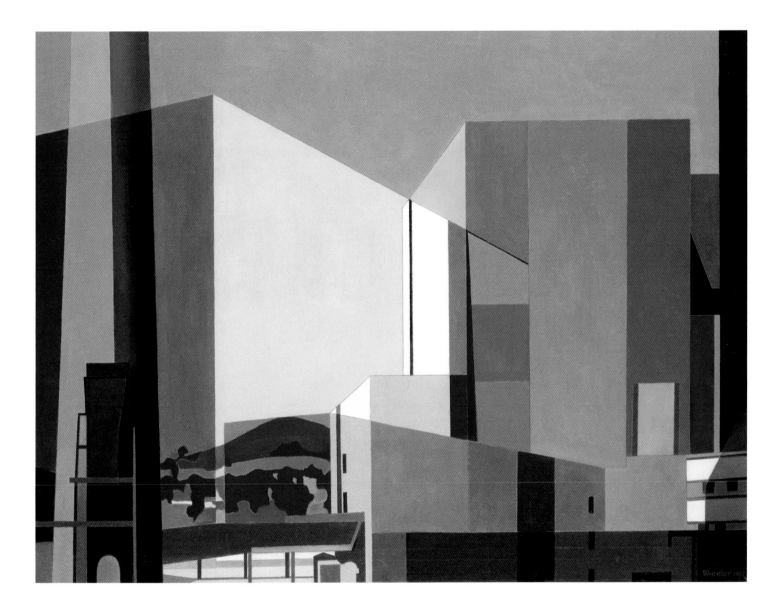

PLATE 67
Charles Sheeler (American, 1883–1965)
California Industrial, 1957
Oil on canvas, 25 x 33 in. (63.5 x 83.8 cm)
Gift of Mr. and Mrs. S. Roger Horchow, B.A. 1950

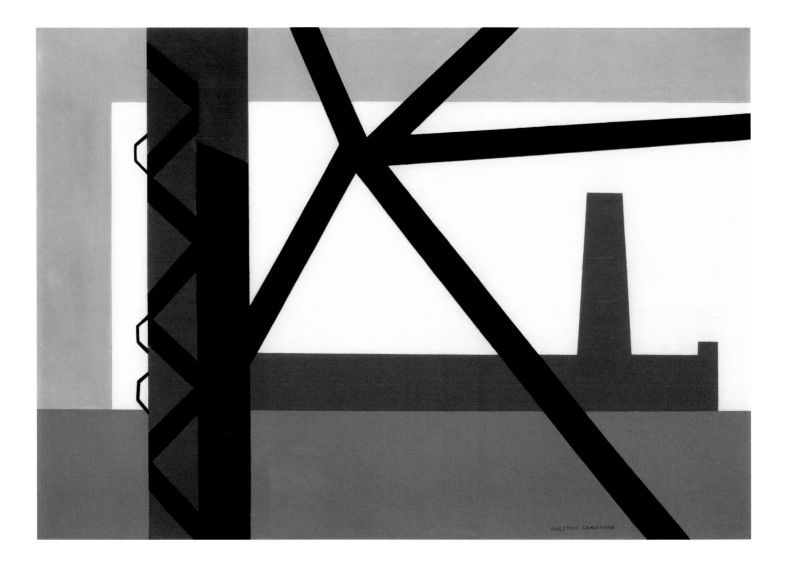

PLATE 68
Ralston Crawford (American, born Canada, 1906–1978)
From the Bridge, 1942
Oil on canvas, 27⅞ x 39¾ in. (70.8 x 101 cm)
Purchased with the Iola S. Haverstick Fund for American Art and
the Katharine Ordway Fund

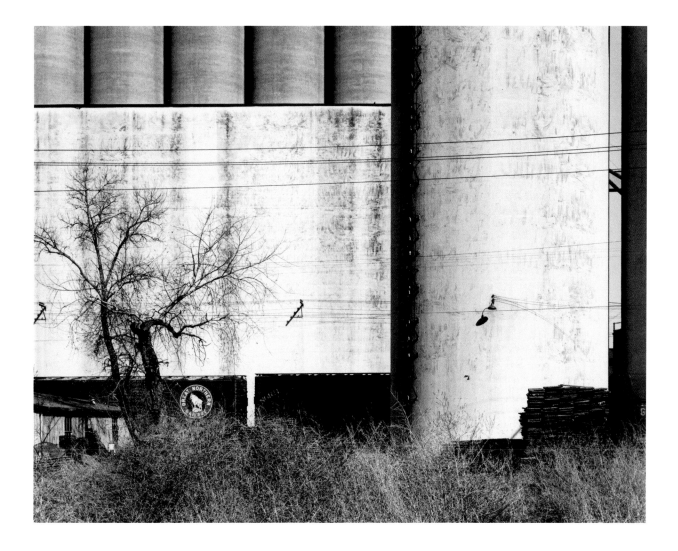

PLATE 69
John Szarkowski (American, 1925–2007)
Grain Elevators I, Minneapolis, 1949
Gelatin silver print, 10¼ x 13¹⁄₁₆ in. (26 x 33.2 cm)
Gift of the artist in honor of Richard Benson

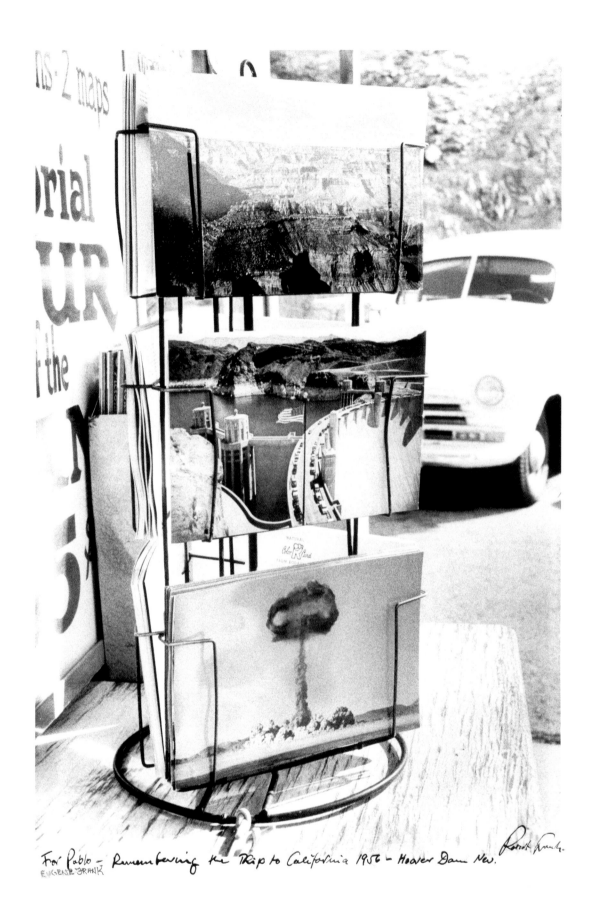

For Pablo – Remembering the Trip to California 1956 – Hoover Dam Nev.
EUGENE FRANK Robert Frank.

PLATE 70
Robert Frank (American, born Switzerland, 1924)
Hoover Dam, Nevada, 1955, printed later
Gelatin silver print, 14⅞ x 10¹/₁₆ in. (37.8 x 25.5 cm)
Purchased with a gift from George C. Hutchinson, B.A. 1957

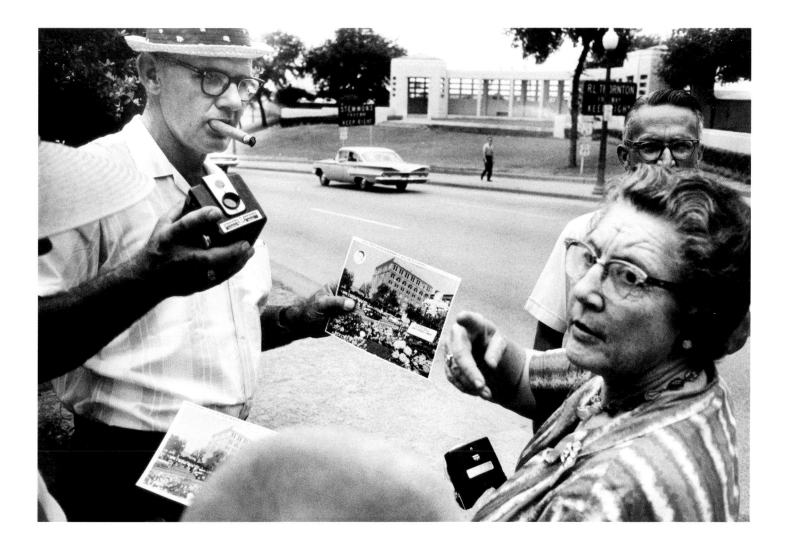

PLATE 71
Garry Winogrand (American, 1928–1984)
Dealey Plaza, Dallas, 1964
Gelatin silver print, 9⅛ x 13½ in. (23.2 x 34.3 cm)
Purchased with a gift from George C. Hutchinson, B.A. 1957

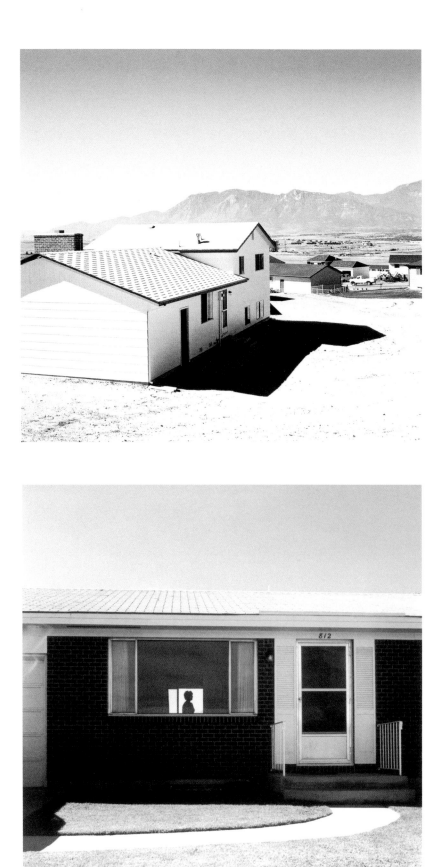

PLATE 72
Robert Adams (American, born 1937)
Newly Completed Tract House, Colorado Springs, Colorado,
from *The New West*, 1968
Gelatin silver print, 5¹¹/₁₆ x 6 in. (14.4 x 15.2 cm)
Purchased with a gift from Saundra B. Lane, a grant from the
Trellis Fund, and the Janet and Simeon Braguin Fund

PLATE 73
Robert Adams (American, born 1937)
Colorado Springs, Colorado, from *The New West*, 1968
Gelatin silver print, 5¹⁵/₁₆ x 5¹⁵/₁₆ in. (15.1 x 15.1 cm)
Purchased with a gift from Saundra B. Lane, a grant from the
Trellis Fund, and the Janet and Simeon Braguin Fund

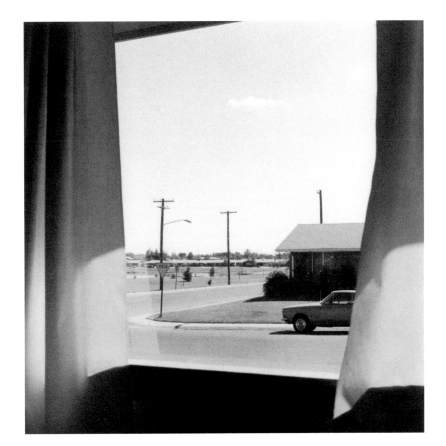

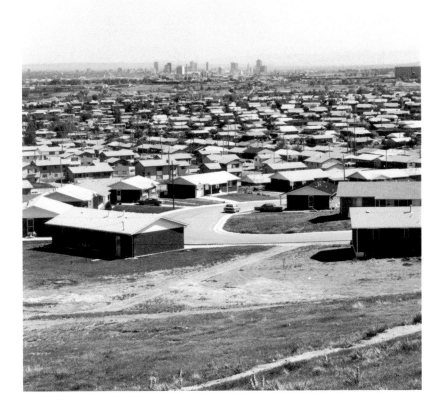

PLATE 74
Robert Adams (American, born 1937)
Out a Front Window, Longmont, Colorado,
from *The New West*, 1968–71
Gelatin silver print, 5^{15}/$_{16}$ x 5^{15}/$_{16}$ in. (15.1 x 15.1 cm)
Purchased with a gift from Saundra B. Lane, a grant from the
Trellis Fund, and the Janet and Simeon Braguin Fund

PLATE 75
Robert Adams (American, born 1937)
The Center of Denver, Ten Miles Distant,
from *The New West*, 1968–71
Gelatin silver print, 5¾ x 5^{15}/$_{16}$ in. (14.6 x 15.1 cm)
Purchased with a gift from Saundra B. Lane, a grant from the
Trellis Fund, and the Janet and Simeon Braguin Fund

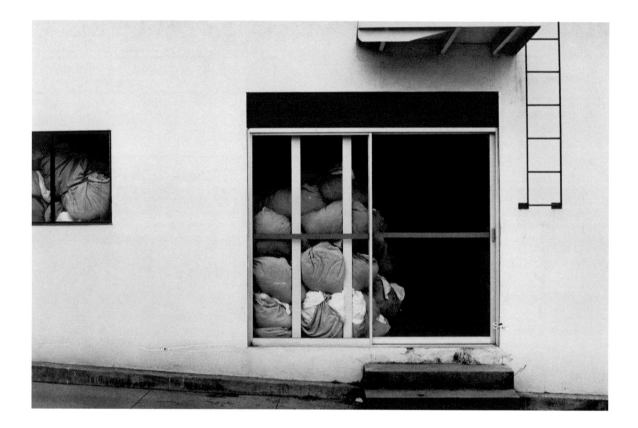

PLATE 76
Lewis Baltz (American, born 1945)
Pacific Grove, from *Public Places*, 1969
Gelatin silver print, 5 x 7¾ in. (12.7 x 19.7 cm)
Gift of Arthur Fleischer, Jr., B.A. 1953, LL.B. 1958

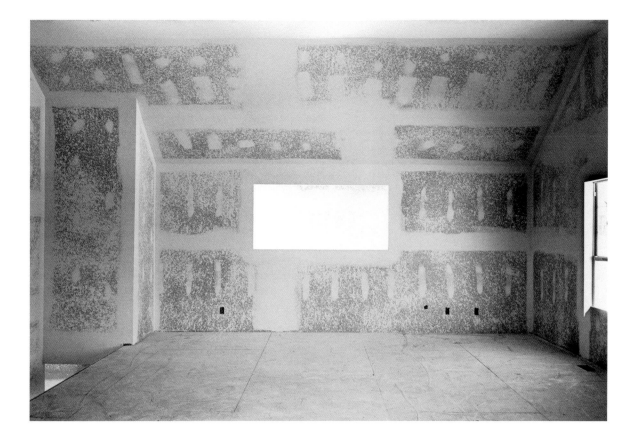

PLATE 77
Lewis Baltz (American, born 1945)
Interior, 33, from *Park City*, 1978–79
Gelatin silver print, 9½ x 6½ in. (24.1 x 16.5 cm)
Purchased with a gift from Frank H. Goodyear, Jr., B.A. 1966,
and with the Janet and Simeon Braguin Fund

PLATE 78
Lewis Baltz (American, born 1945)
Interior, 34, from *Park City*, 1978–79
Gelatin silver print, 9½ x 6¼ in. (24.1 x 15.9 cm)
Purchased with a gift from Frank H. Goodyear, Jr., B.A. 1966,
and with the Janet and Simeon Braguin Fund

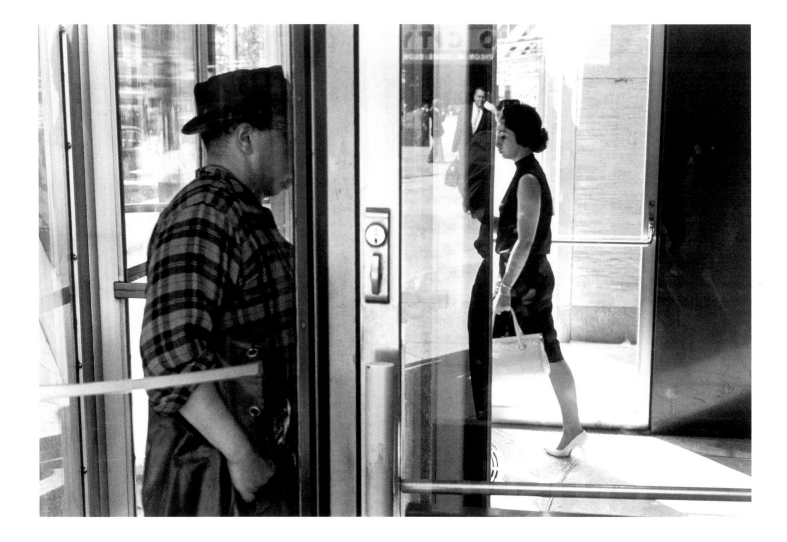

PLATE 79
Lee Friedlander (American, born 1934)
New York City, 1963, printed 2006
Gelatin silver print, 12¼ x 18⁷⁄₁₆ in. (31.1 x 46.8 cm)
Gift of the artist in honor of Richard Benson

PLATE 80
Philip-Lorca diCorcia (American, born 1951, M.F.A. 1979)
Tokyo, 1998
Chromogenic print, 25⁹⁄₁₆ x 37¹³⁄₁₆ in. (64.9 x 96 cm)
Gift of the artist in honor of Richard Benson

PLATE 81
Tod Papageorge (American, born 1940, M.A. Hon. 1979)
Opening Day, Yankee Stadium, from *American Sports, 1970*,
1970, printed 2006
Gelatin silver print, 8⅜ x 12⅝ in. (21.3 x 32 cm)
Janet and Simeon Braguin Fund

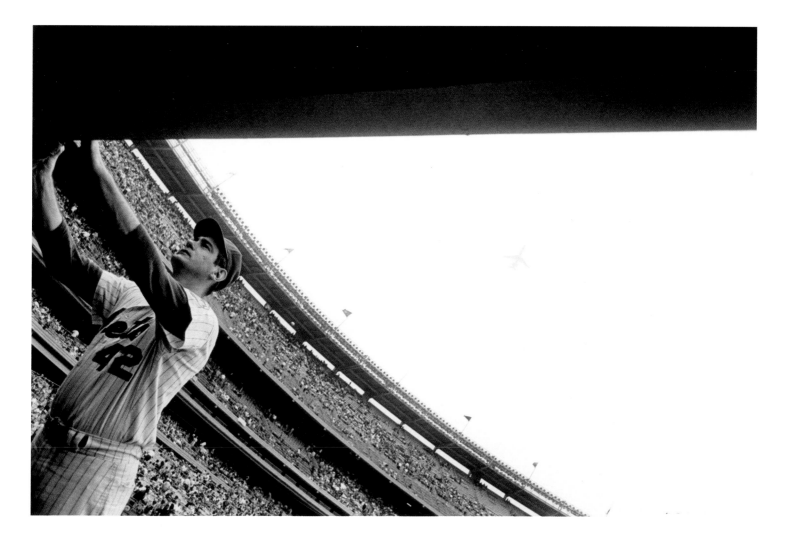

PLATE 82
Tod Papageorge (American, born 1940, M.A. Hon. 1979)
From the Mets Dugout, Shea Stadium, from *American Sports, 1970*,
1970, printed 2006
Gelatin silver print, 8¼ x 12⅝ in. (21 x 32.1 cm)
Janet and Simeon Braguin Fund

PLATE 83
Ralph Eugene Meatyard (American, 1925–1972)
Untitled, 1960
Gelatin silver print, 7½ x 7⅜ in. (19.1 x 18.7 cm)
The Ralph Eugene Meatyard Collection, Gift of Allan Chasanoff,
B.A. 1961

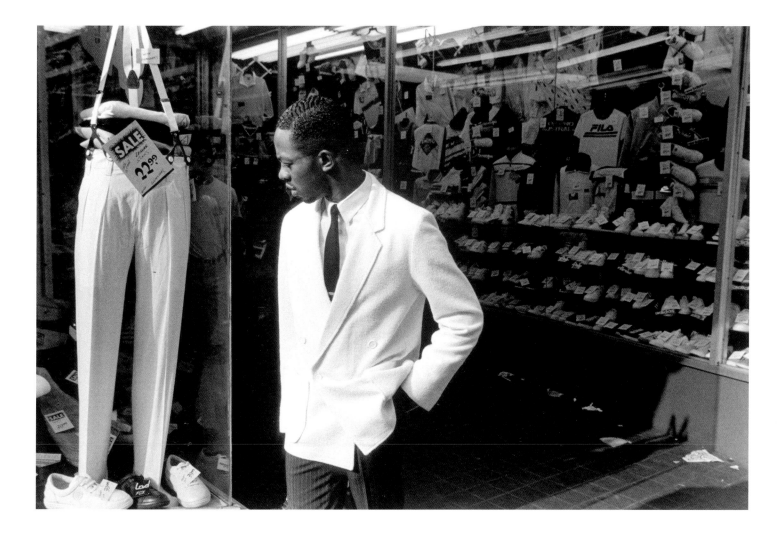

PLATE 84
Dawoud Bey (American, born 1953, M.F.A. 1993)
Man Looking at Pants on Fulton Street, Brooklyn, NY, 1989
Gelatin silver print, 14½ x 22 in. (36.8 x 55.9 cm)
Gift of the artist, M.F.A. 1993, in memory of his father,
Dr. Kenneth R. Smikle

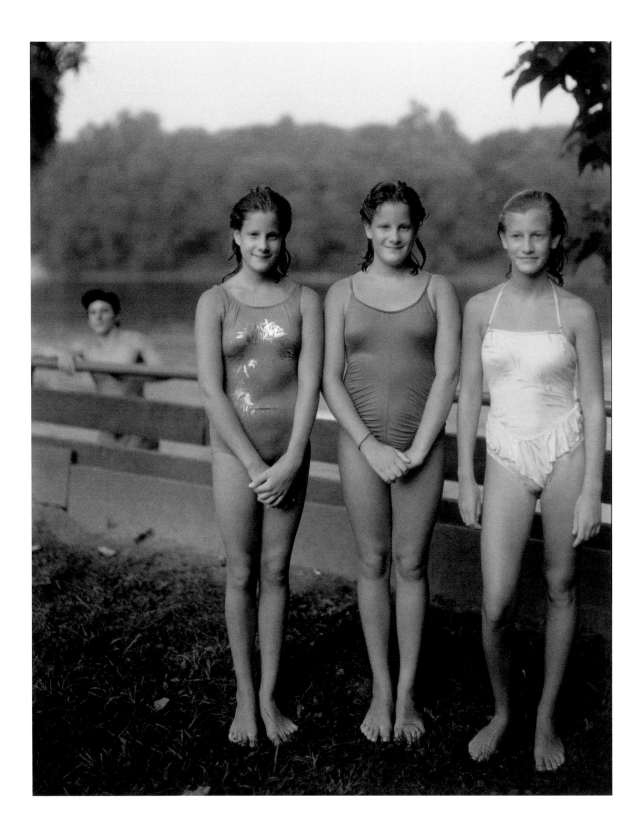

PLATE 85
Judith Joy Ross (American, born 1946)
Untitled, from *Easton Portraits*, 1988
Gold-toned gelatin silver print, 9⅝ x 7⅝ in. (24.5 x 19.4 cm)
Janet and Simeon Braguin Fund

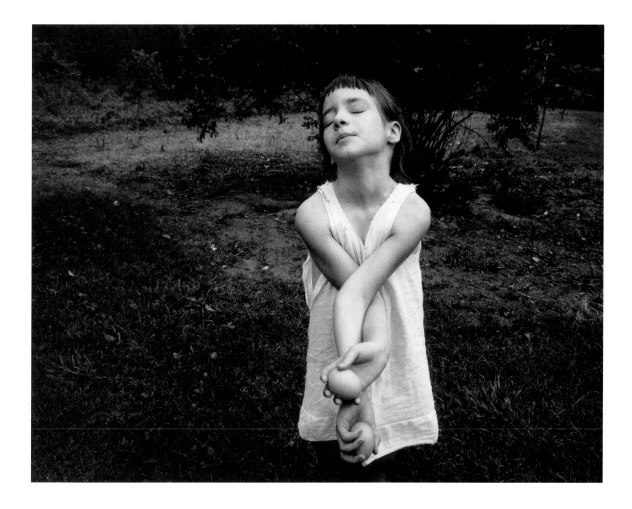

PLATE 86
Emmet Gowin (American, born 1941)
Nancy, Danville, Virginia, 1969, printed later
Gelatin silver print, 5½ x 7 in. (14 x 17.8 cm)
Janet and Simeon Braguin Fund

PLATE 87
Lewis W. Hine (American, 1874–1940)
Cotton Pickers, Denison, Texas, 1913
Gelatin silver print, 4¼ x 6¼ in. (10.8 x 15.9 cm)
Gift of Pamela Lord

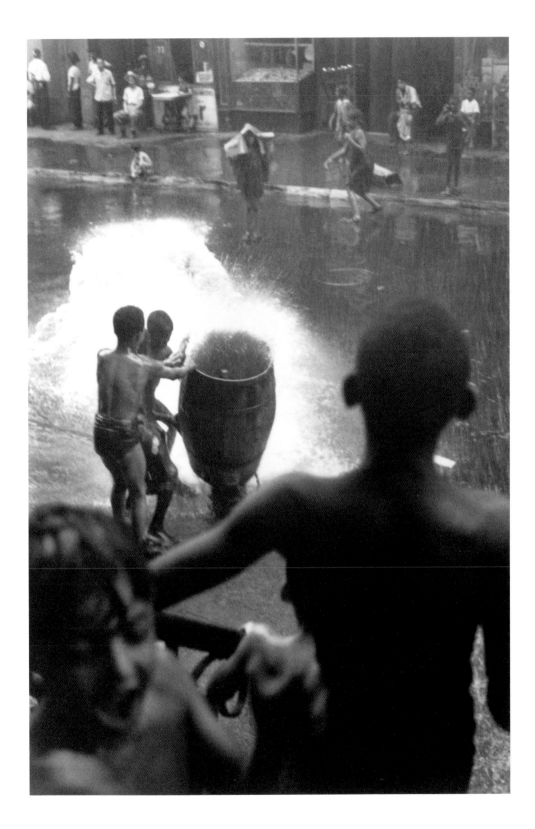

PLATE 88
Helen Levitt (American, born 1918)
New York, ca. 1940, printed later
Gelatin silver print, 10¼ x 6⅞ in. (26 x 17.5 cm)
Gift of Richard and Elizabeth Devereaux, B.A. 1981

PLATE 89
Eugène Atget (French, 1857–1927)
Capucines (Nasturtiums), 1921–22
Albumen print, 8⅝ x 6⅝ in. (22 x 16.8 cm)
Everett V. Meeks, B.A. 1901, Fund

PLATE 90
Lois Conner (American, born 1951, M.F.A. 1981)
Mirrors, Paris, France, 1979
Platinum-palladium print, 9⅝ x 7⅝ in. (24.5 x 19.4 cm)
Gift of the artist in honor of Richard Benson

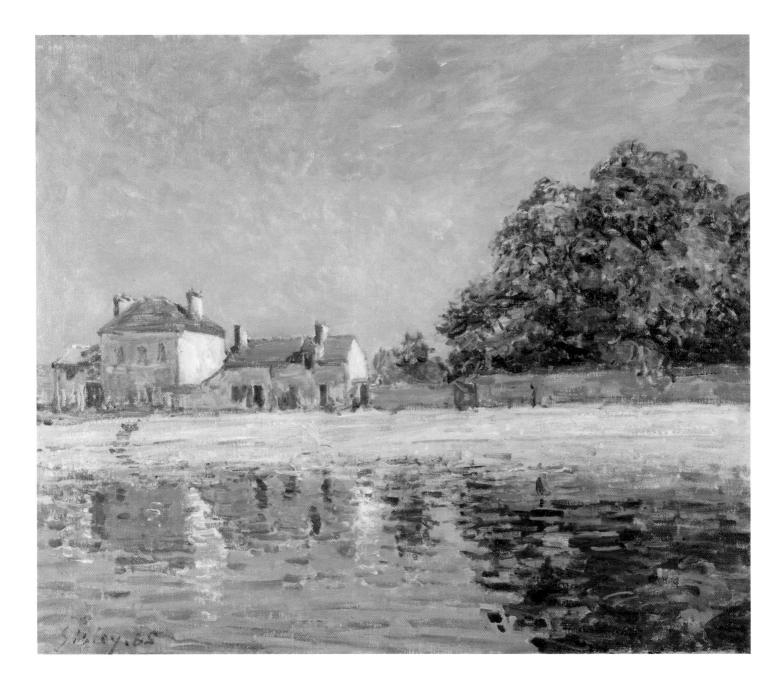

PLATE 91
Alfred Sisley (French and British, 1839–1899)
*Bords du Loing, Saint-Mammès (The River Loing at
Saint-Mammès)*, 1885
Oil on canvas, 18½ x 22 in. (47 x 55.9 cm)
Promised gift of Jonathan Rinehart, B.A. 1952

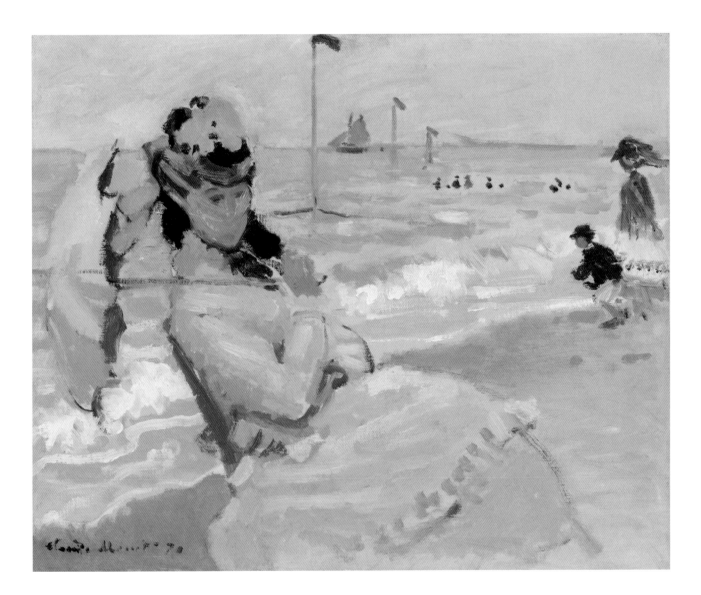

PLATE 92
Claude Monet (French, 1840–1926)
Camille on the Beach at Trouville, 1870
Oil on canvas, 25 x 28¼ in. (63.5 x 71.8 cm)
Collection of Mr. and Mrs. John Hay Whitney, B.A. 1926,
M.A. Hon. 1956

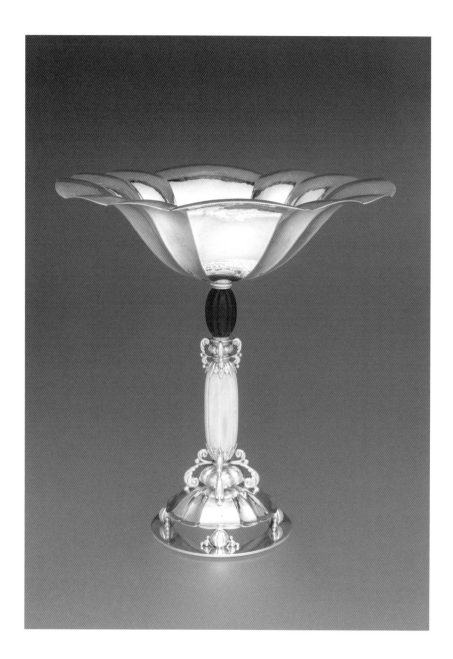

PLATE 93
Erik Magnussen (Danish, active in America, 1884–1961)
Compote
Providence, Rhode Island, 1927
Sterling silver, ivory, and ebony, 11⅛ x 10⅝ x DIAM. (base)
4¹³⁄₁₆ in. (28.3 x 27 x 12.2 cm)
Mabel Brady Garvan Collection, by exchange

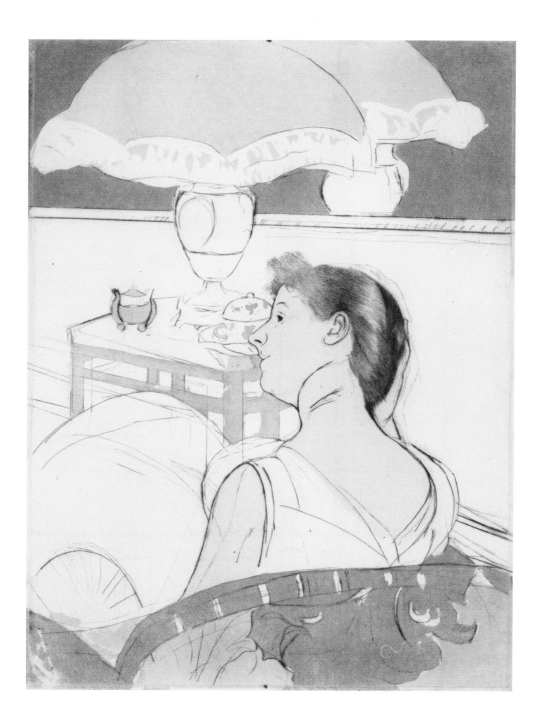

PLATE 94
Mary Cassatt (American, 1844–1926)
The Lamp, 1890–91
Drypoint, soft-ground etching, and aquatint, from two plates,
12⅝ x 9⅞ in. (32.1 x 25.1 cm)
Gift of Jan and Warren Adelson, Mr. and Mrs. N. Lee Griggs, Jr.,
B.A. 1951, Anthony M. Schulte, B.A. 1951, John Mark Rudkin,
B.A. 1951, and purchased with the Everett V. Meeks, B.A. 1901, and
the Walter H. and Margaret Dwyer Clemens, B.A. 1951, Funds

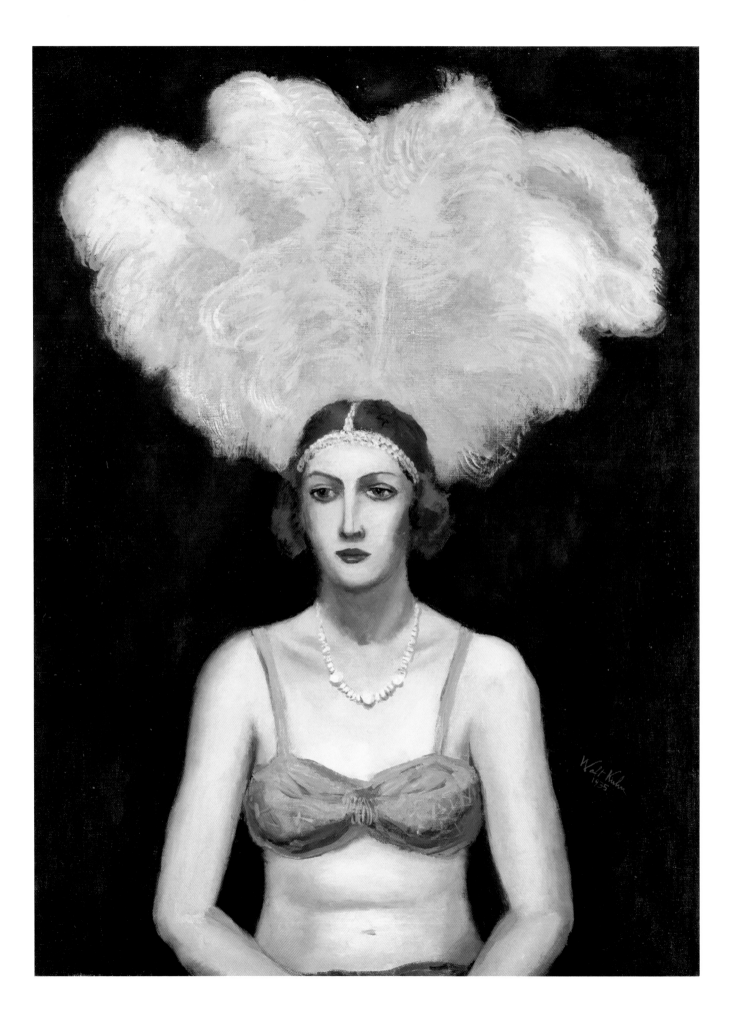

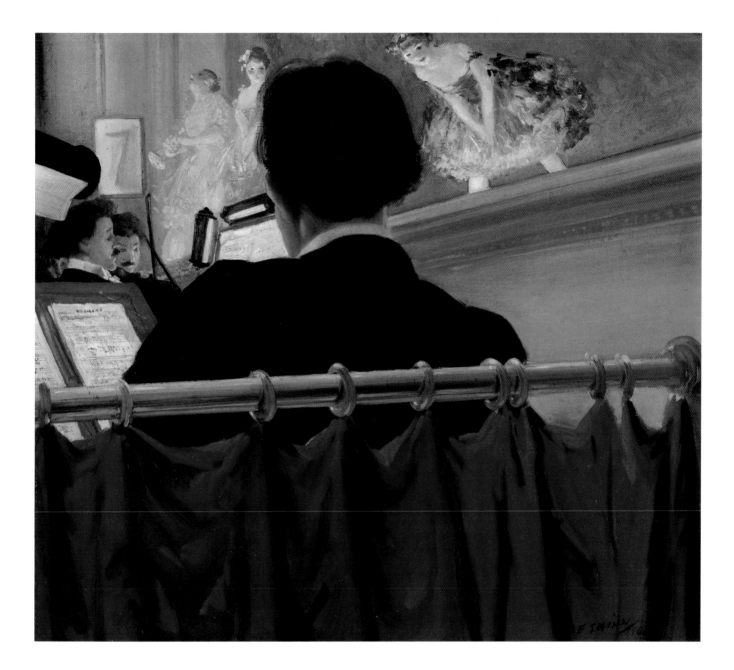

PLATE 95
Walt Kuhn (American, 1877–1949)
Chorus Captain, 1935
Oil on canvas, 40 x 30 in. (101.6 x 76.2 cm)
Katharine Ordway Fund

PLATE 96
Everett Shinn (American, 1876–1953)
The Orchestra Pit, Old Proctor's Fifth Avenue Theatre, 1906
Oil on canvas, 17⁷⁄₁₆ x 19½ in. (44.3 x 49.5 cm)
Bequest of Arthur G. Altschul, B.A. 1943

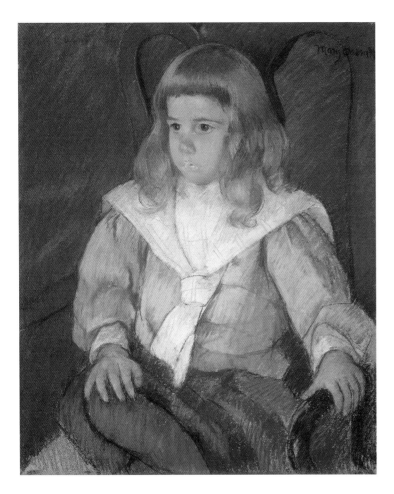

PLATE 97
Mary Cassatt (American, 1844–1926)
Boy with Golden Curls (Portrait of Harris Whittemore, Jr., B.A. 1918),
1898
Pastel on paper, mounted on canvas, 21½ x 19½ in.
(54.6 x 49.5 cm)
Gift of Robert N. Whittemore, B.S. 1943

PLATE 98
George Bellows (American, 1882–1925)
Lady Jean, 1924
Graphite, 20¹³⁄₁₆ x 10¹¹⁄₁₆ in. (52.8 x 27.2 cm)
Gift of Mr. and Mrs. Warren Adelson

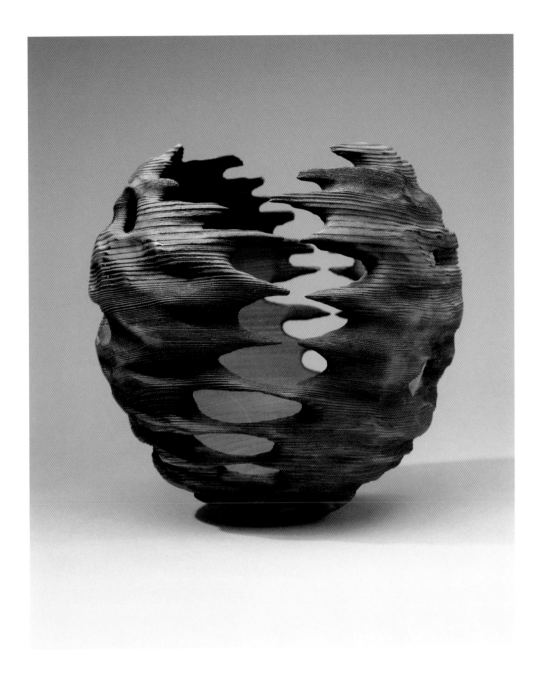

PLATE 104
Hap Sakwa (American, born 1950)
Open Vessel
Sebastopol, California, 1990–95
Scorched and dyed wood, H. 9 in. (22.9 cm), DIAM. 9 in. (22.9 cm)
Promised gift of Jane and Arthur Mason

PLATE 105
Jake Cress (American, born 1945)
"Oops" Chair
Fincastle, Virginia, 1991
Cherry and paint, 37¼ x 30 x 23¼ in. (94.6 x 76.2 x 59.1 cm)
Promised gift of Lulu C. and Anthony W. Wang, B.A. 1965

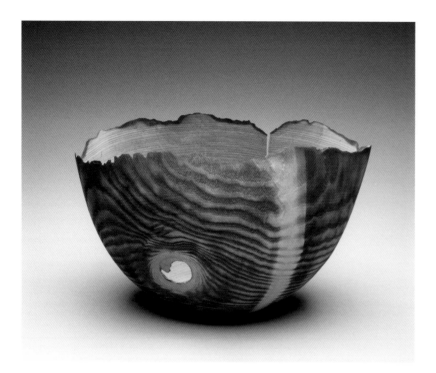

PLATE 101
David Ellsworth (American, born 1944)
Intersphere in Green, from the *Solstice* series
Quakertown, Pennsylvania, 1991
Scorched ash with red and green dye, 7½ x 13 x 7½ in.
(19.1 x 33 x 19.1 cm)
Gift of Jane and Arthur Mason, in memory of George Z. Mason,
Yale M.F. 1911

PLATE 102
Ronald Hayes Pearson (American, 1924–1996)
Pendant
Rochester, New York, ca. 1955
Sterling silver and plique-à-jour enamel, 3 x 1 in. (7.6 x 2.5 cm)
Promised gift of Jane and Arthur Mason

PLATE 103
Todd Hoyer (American, born 1952)
X Series
Bisbee, Arizona, ca. 1991
Arizona cedar, 13¾ x 13½ x 13 in. (34.9 x 34.3 x 33 cm)
Promised gift from the Collection of Ruth and David Waterbury,
B.A. 1958

113

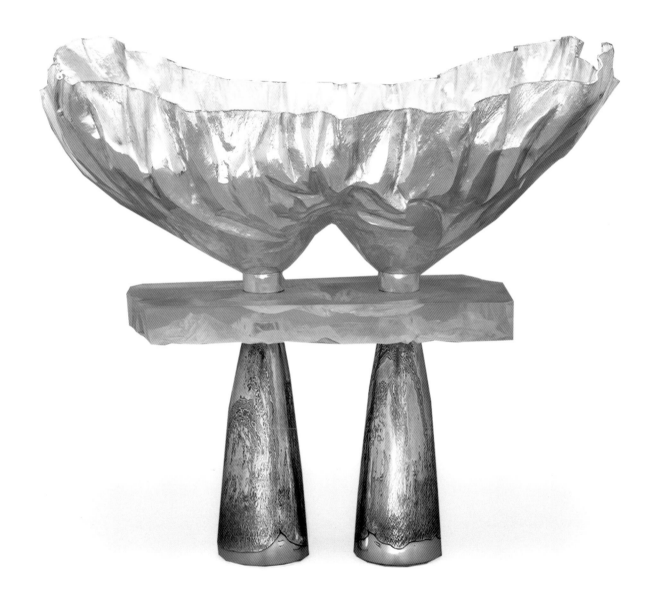

PLATE 100
John Marshall (American, born 1936)
Yale Bowl
Edmonds, Washington, 2001
Silver, *mokume gane* (.925 silver and copper), and acrylic,
26⅛ x 28½ x 15⅜ in. (66.4 x 72.4 x 39.1 cm)
Purchased with gifts from Lisa Koenigsberg, M.A. 1981, M.PHIL.
1984, PH.D. 1987, and David Becker, B.A. 1979, and Archer B.
Huntington, M.A. 1897, in memory of his mother, Arabella D.
Huntington (by exchange), and with the Janet and Simeon
Braguin Fund

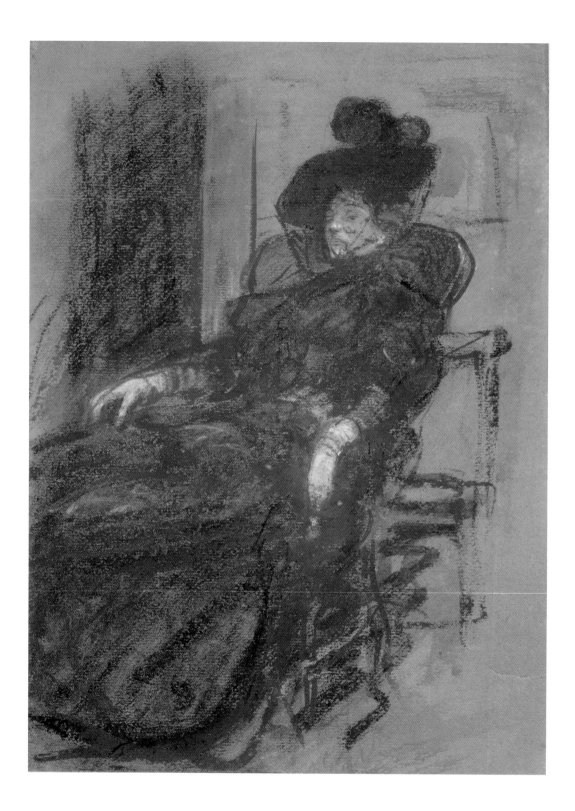

PLATE 99
William J. Glackens (American, 1870–1938)
Seated Woman, ca. 1902
Ink wash and charcoal, heightened with pastel, 18⅝ x 14¾ in.
(47.3 x 37.5 cm)
Gift of Raymond J. and Margaret Horowitz

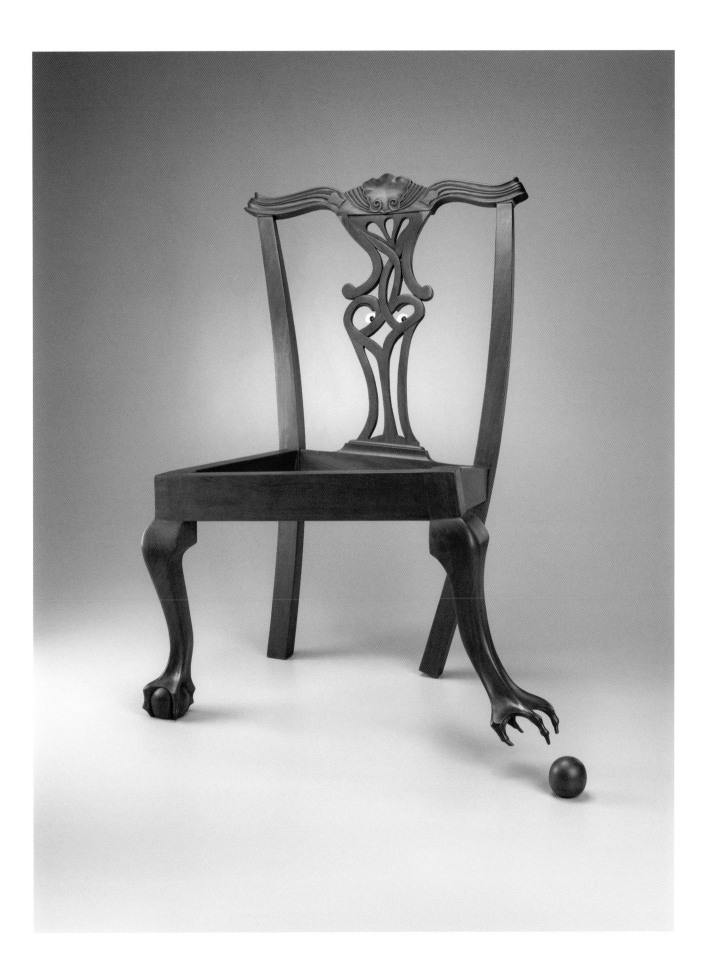

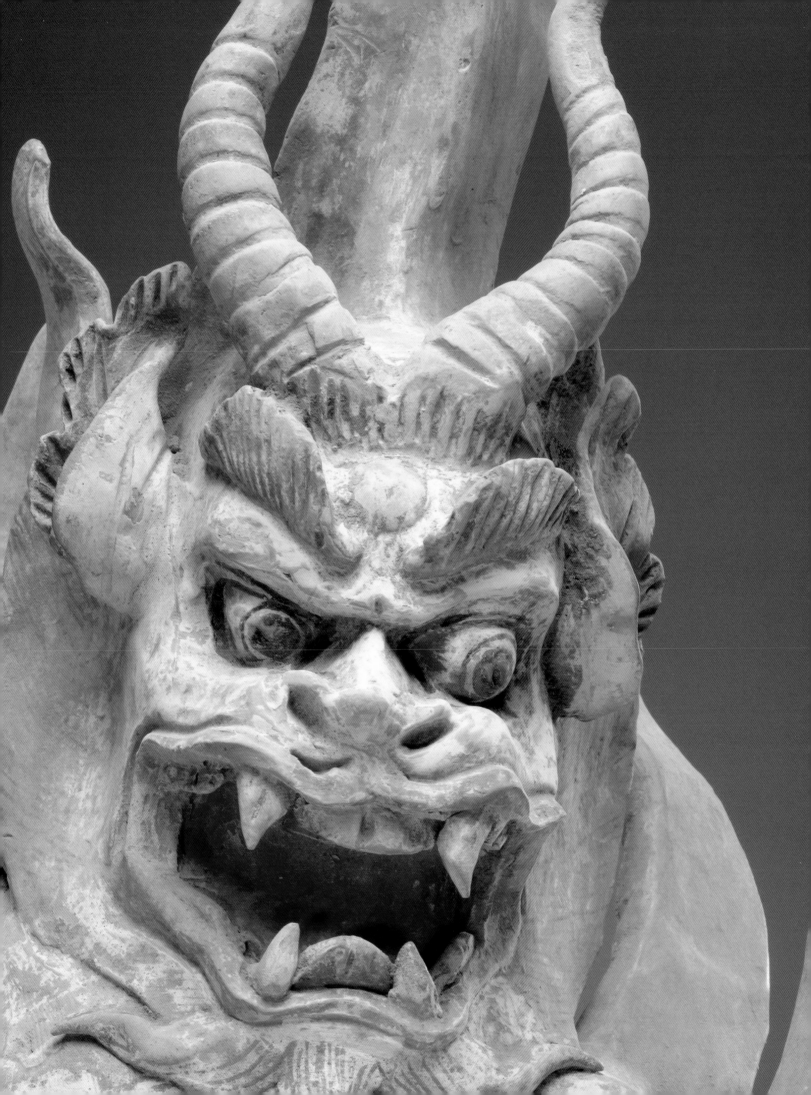

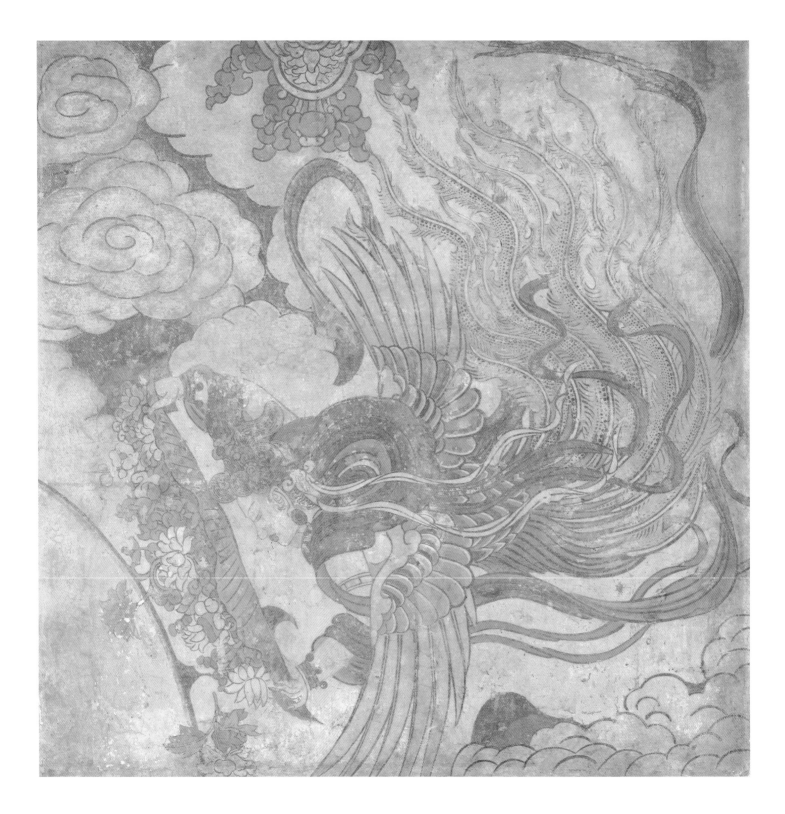

PLATE 106
Flying Attendant
Chinese, Yuan dynasty, 14th century
Wall painting; ink and color on plaster, 50 x 50 in. (127 x 127 cm)
Bequest of Mr. and Mrs. Myron S. Falk, Jr., B.A. 1928

PLATE 107 (detail pages 116–17)
Tomb Guardian Creature (Zhenmushou)
Chinese, Tang dynasty, ca. 740 C.E.
Earthenware with traces of pigment, H. 23 in. (58.4 cm)
Purchased with a gift from Ruth and Bruce B. Dayton, B.A. 1940

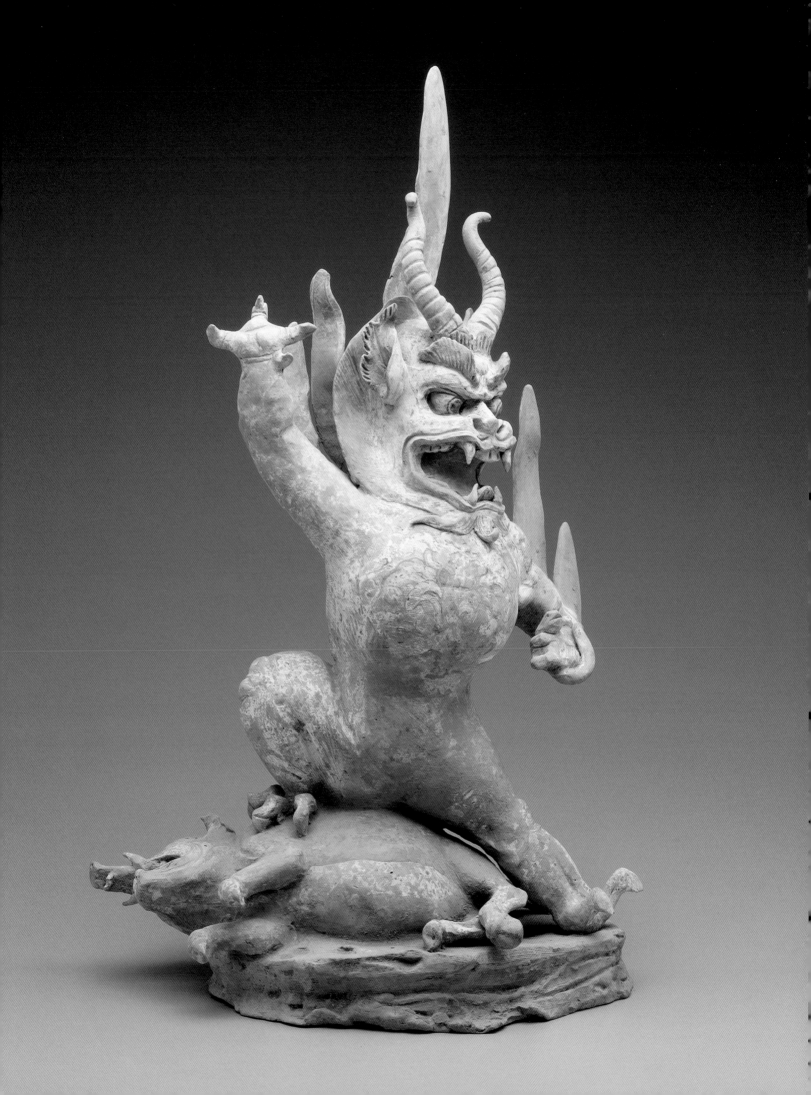

Above:
PLATE 108
Zither (Se)
Chinese, Eastern Zhou dynasty, Warring States period,
5th–3rd century B.C.E.
Lacquered wood, 4⅜ x 12⅞ x 26⅝ in. (11.1 x 32.7 x 67.6 cm)
Gift of Audrey Lam Buchner, B.A. 1994

Opposite, top left:
PLATE 109
Wine Vessel (Zhi)
Chinese, Eastern Zhou dynasty, Warring States period,
4th–3rd century B.C.E.
Lacquered wood, H. 8⅞⁄₁₆ in. (21.4 cm)
Gift of Audrey Lam Buchner, B.A. 1994

Top right:

PLATE 110

Wine Vessel (Zhi)

Chinese, Western Han dynasty, 2nd–1st century B.C.E.

Lacquered wood and bronze, H. 7½ in. (19.1 cm)

Gift of Audrey Lam Buchner, B.A. 1994

Bottom:

PLATE 111

Cylindrical Box with Cover

Chinese, Warring States period or Qin dynasty, 3rd century B.C.E.

Lacquered wood and bronze, DIAM. 13¾ in. (34.9 cm)

Gift of Audrey Lam Buchner, B.A. 1994

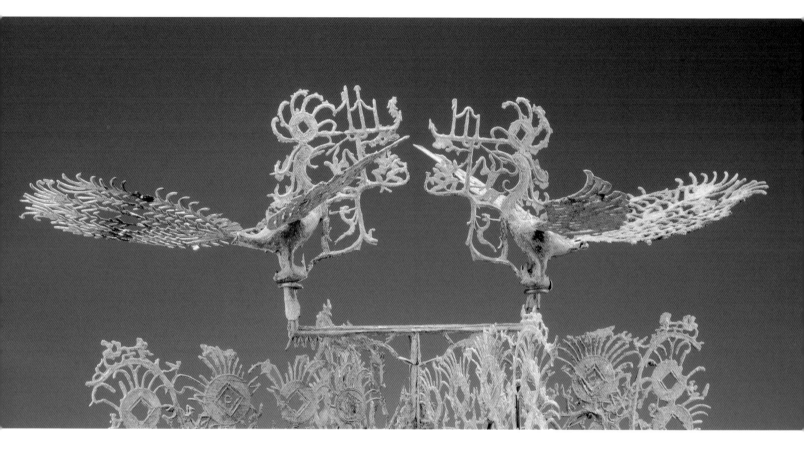

PLATE 112 (detail above)
Money Tree (Qian Shu)
Chinese, Eastern Han dynasty, ca. 2nd century C.E.
Bronze and earthenware, H. 55¼ in. (140.3 cm),
DIAM. 23½ in. (59.7 cm)
Gift of the Nathan Rubin–Ida Ladd Family Foundation under the
bequest of Ester R. Portnow

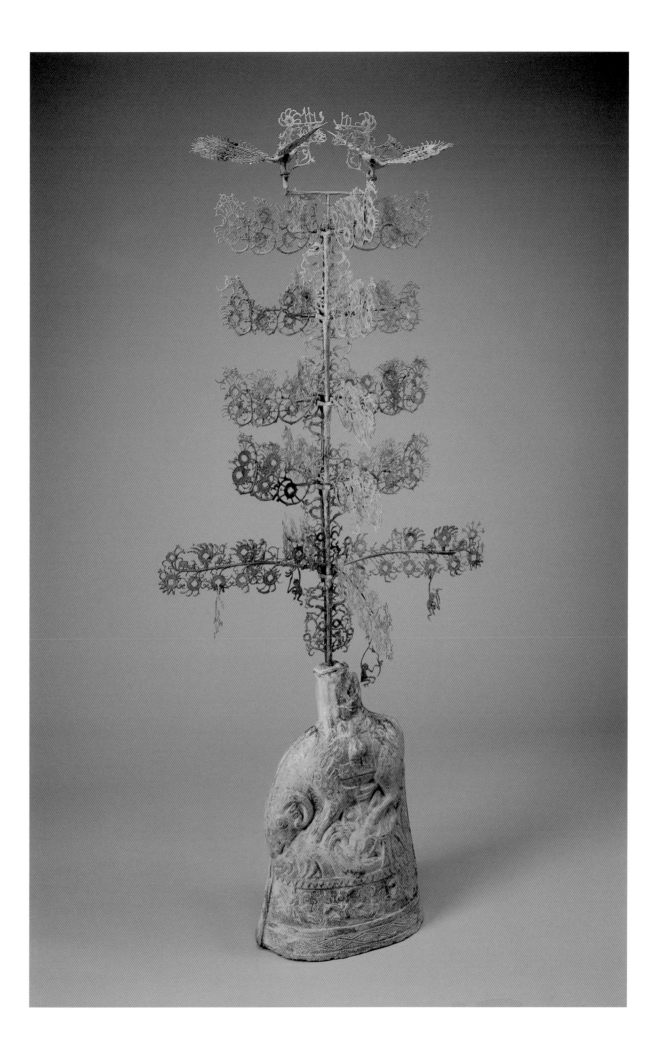

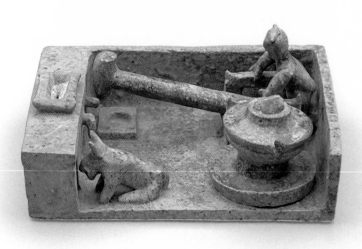

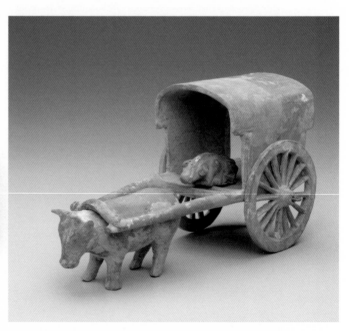

PLATE 113
Well Head
Chinese, Eastern Han dynasty, 1st–2nd century C.E.
Earthenware with yellowish lead-fluxed glaze, H. 14 in. (35.6 cm)
The Schloss Collection, Gift of Simone Schloss

PLATE 114
Grain Processing Workshop
Chinese, Eastern Han dynasty, 1st–2nd century C.E.
Reddish earthenware with green lead-fluxed glaze,
4½ x 9 x 6¼ in. (11.4 x 22.9 x 15.9 cm)
The Schloss Collection, Gift of Simone Schloss

PLATE 115
Goat Pen
Chinese, Eastern Han dynasty, 1st–2nd century C.E.
Earthenware with green lead-fluxed glaze, 5¾ x 10 x 10½ in.
(14.6 x 25.4 x 26.7 cm)
The Schloss Collection, Gift of Simone Schloss

PLATE 116
Cart with an Ox and a Pig
Chinese, Eastern Han dynasty, 1st–2nd century C.E.
Gray earthenware with white slip and traces of pigment,
H. 5 in. (12.7 cm)
The Schloss Collection, Gift of Simone Schloss

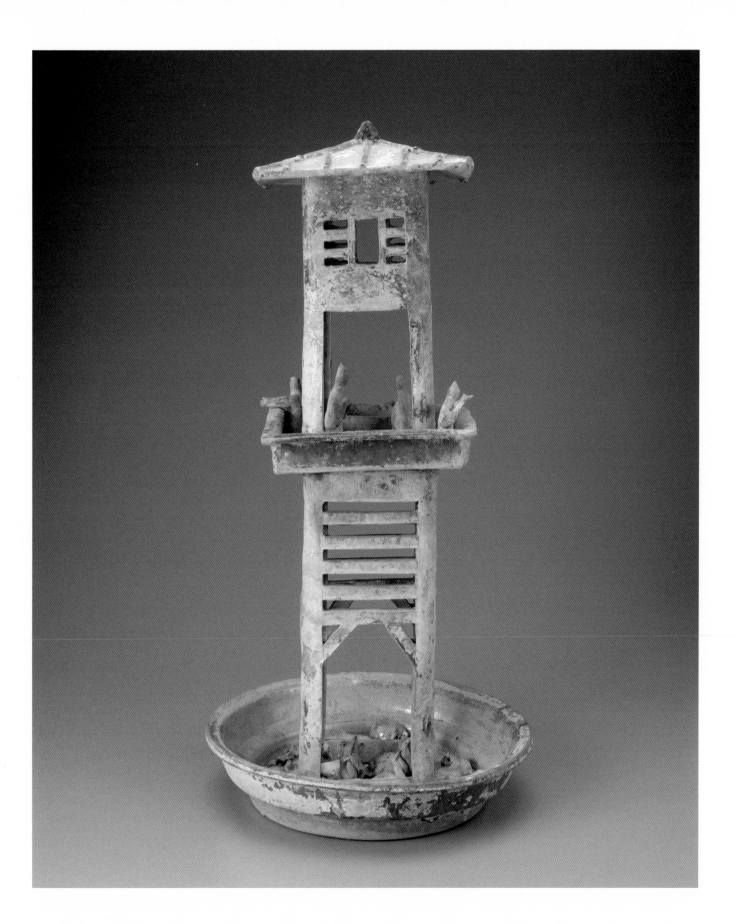

PLATE 117
Two-Story Tower with a Moat
Chinese, Eastern Han dynasty, 1st–2nd century C.E.
Earthenware with light green lead-fluxed glaze,
H. 29$^{15}/_{16}$ in. (76 cm)
The Schloss Collection, Gift of Simone Schloss

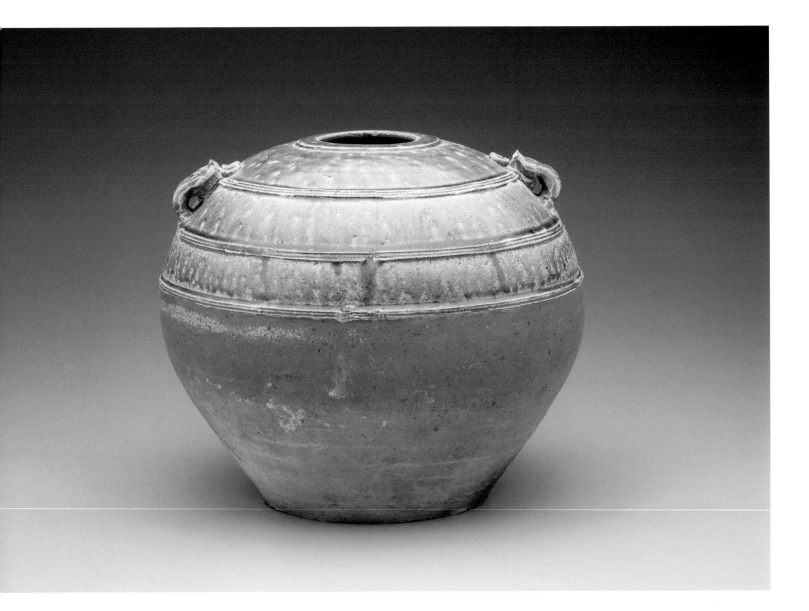

PLATE 118
Jar (Pou)
Chinese, Han dynasty, ca. 1st century B.C.E.–1st century C.E.
Stoneware with green glaze, H. 12½ in. (31.8 cm), DIAM. 14 in.
(35.6 cm)
Gift of Molly and Walter Bareiss, B.S. 1940s

PLATE 119
Funerary Vase
Chinese, Western Jin dynasty, ca. 300 C.E.
Stoneware with pale olive-green glaze, 18½ x 9 x 9 in.
(47 x 22.9 x 22.9 cm)
Gift of the Rubin-Ladd Foundation under the bequest of
Ester R. Portnow

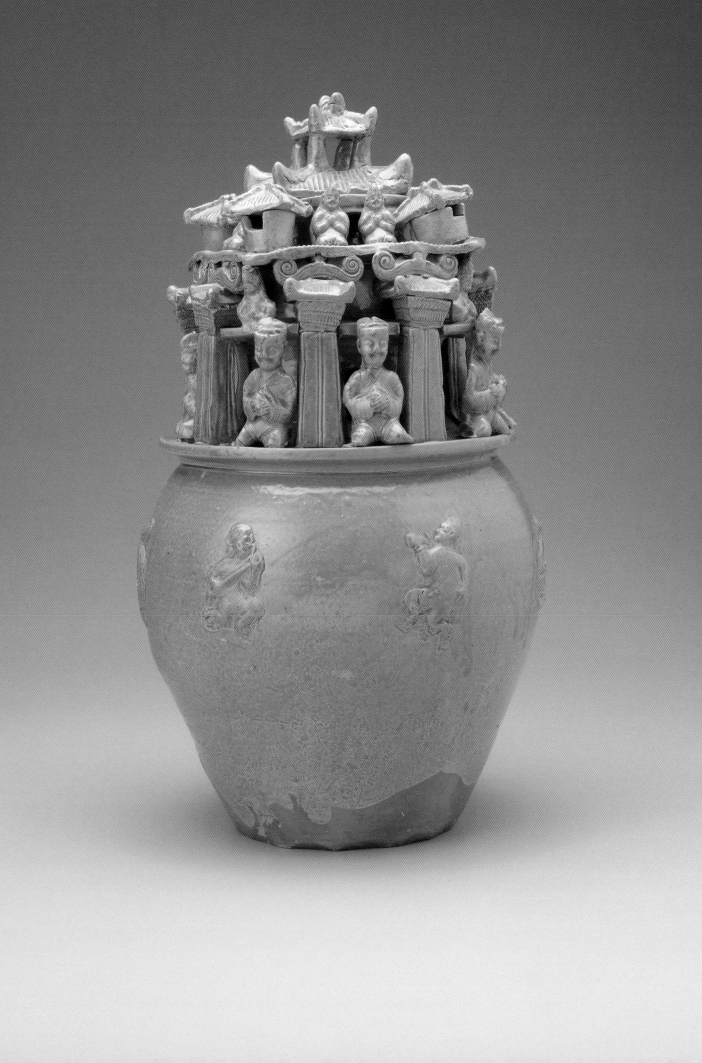

PLATE 120
Front Panel of a Funerary Couch
Chinese, Northern Dynasties, 6th century C.E.
Dark gray stone with pigment, 15⅝ x 76½ x 5 in.
(39.7 x 194.3 x 12.7 cm)
Gift of the Nathan Rubin–Ida Ladd Family Foundation
under the bequest of Ester R. Portnow

PLATE 121 (detail overleafs)
Wang Duo (Chinese, 1592–1652)
Five Tang Poems
Ming dynasty, January 12, 1642
Handscroll; ink on paper, 11¼ in. x 15 ft. 8½ in. (28.6 x 478.8 cm)
Gift of H. Christopher Luce, B.A. 1972

PLATE 124
Wu Changshuo (Chinese, 1844–1927)
Lotuses
Late Qing dynasty or early Republican period, late 19th–
early 20th century
Hanging scroll; ink and color on paper, 70¾ x 18½ in. (179.7 x 47 cm)
The Clyde and Helen Wu Collection of Chinese Painting,
Gift of Dr. Roger Wu

PLATE 125
Wu Changshuo (Chinese, 1844–1927)
Bamboos
Late Qing dynasty or early Republican period, late 19th–
early 20th century
Hanging scroll; ink on paper, 70¾ x 18½ in. (179.7 x 47 cm)
The Clyde and Helen Wu Collection of Chinese Painting,
Gift of Dr. Roger Wu

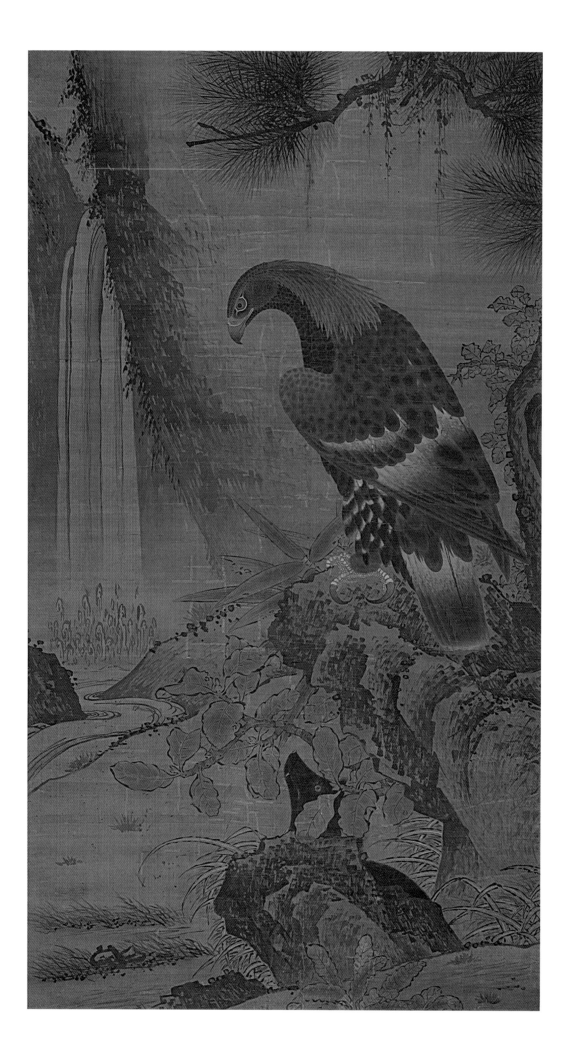

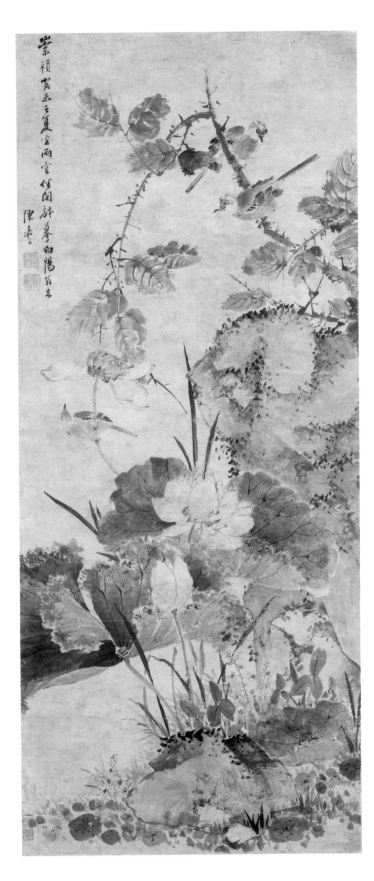

PLATE 122
Chen Jiayan (Chinese, 1599–1683)
Birds by a Lotus Pond
Ming dynasty, 1643
Hanging scroll; ink on paper, 47¼ x 20⁷⁄₁₆ in. (120 x 51.9 cm)
Gift of Nelson I. Wu in honor of the memory of Hartley Simpson
(1900–1967), historian, educator, and friend, Dean of the
Graduate School, Yale University, 1956–61

PLATE 123
Eagle in a Landscape Setting
Chinese, Ming dynasty, late 15th–early 16th century
Hanging scroll; ink and color on silk, 64¹¹⁄₁₆ x 35¹³⁄₁₆ in.
(164.3 x 91 cm)
Purchased with gifts from Ruth and Bruce B. Dayton, B.A. 1940,
The Henry Luce Foundation at the request of H. Christopher
Luce, B.A. 1972, and the Leonard C. Hanna, Jr., B.A. 1913, Fund,
in honor of Professor Richard M. Barnhart

PLATE 126
Li Huasheng (Chinese, born 1944)
Fisherman's Song at the Wu Gorge, 1979
Hanging scroll; ink and color on paper, 70¼ x 37¾ in.
(178.4 x 95.9 cm)
The Clyde and Helen Wu Collection of Chinese Painting,
Gift of Dr. Clyde Wu

PLATE 127
Wu Guanzhong (Chinese, born 1919)
A Sea of Clouds, 1988
Handscroll; ink and color on paper, 27 x 54½ in.
(68.6 x 138.4 cm)
The Clyde and Helen Wu Collection of Chinese Painting,
Gift of Dr. and Mrs. David Wu

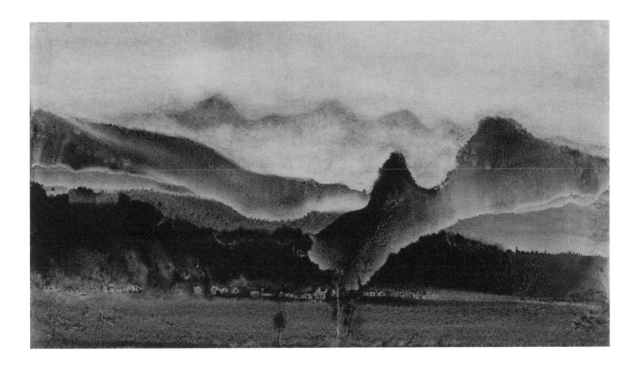

PLATE 128
Mu Xin (Chinese, born 1927)
Dawn Mood at Bohai, 1977–79
Ink and gouache on paper, 6⁹⁄₁₆ x 13 in. (16.7 x 33 cm)
Promised gift of the Rosenkranz Charitable Foundation

PLATE 129
Mu Xin (Chinese, born 1927)
Spring Brilliance at Kuaiji, 1977–79
Ink and gouache on paper, 7 x 13 in. (17.8 x 33 cm)
Promised gift of the Rosenkranz Charitable Foundation

PLATE 130
Mandala of the Sacred Name of the Kasuga Deities (Myōgō Mandara)
Japanese, Muromachi period, 15th century
Hanging scroll; ink, color, and gold on silk, 53 x 13¼ in.
(134.6 x 33.7 cm)
Purchased with a gift from Peggy and Richard M. Danziger,
LL.B. 1963

PLATE 131 (detail 142–43)
The Death of the Buddha Sakyamuni (Nehan-zu)
Japanese, Kamakura period, early to mid-14th century
Hanging scroll; ink, color, gold pigment, and cut gold on silk,
9 ft. 7⅜ in. x 69½ in. (293 x 176.5 cm)
Purchased with funds from The Japan Foundation Endowment of
the Council on East Asian Studies and the Leonard C. Hanna, Jr.,
B.A. 1913, Fund

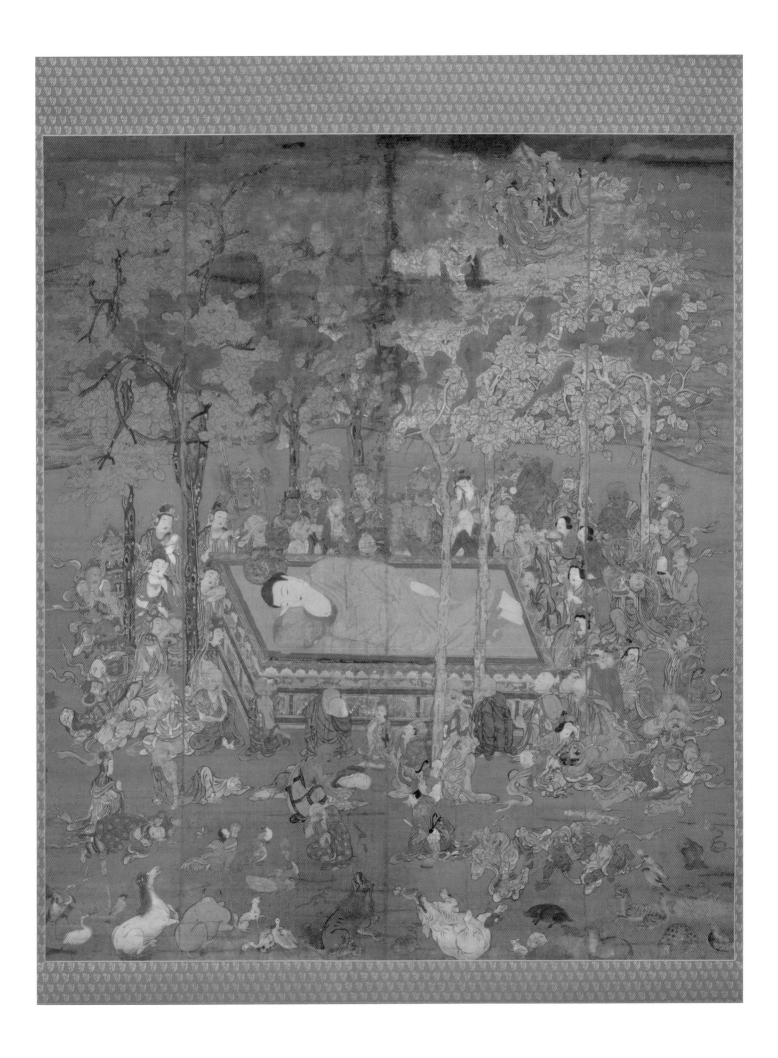

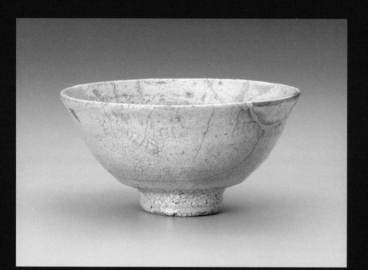

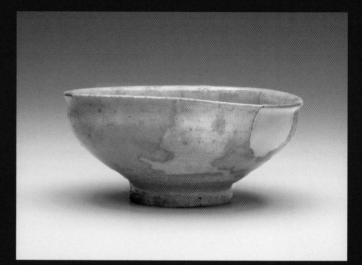

PLATE 132
Tea Bowl
Korean, Yi (Choson) dynasty, 16th century
Ido ware; stoneware with crackled glaze, 3¹⁄₁₆ x 6³⁄₁₆ in.
(7.8 x 15.7 cm)
Promised gift of Peggy and Richard M. Danziger, LL.B. 1963

PLATE 133
Tea Bowl
Korean, Yi (Choson) dynasty, second half 16th century
Kohiki or Muji Hakeme ware; stoneware with gold lacquer,
2¹⁵⁄₁₆ x 6⁵⁄₁₆ in. (7.5 x 16 cm)
Promised gift of Peggy and Richard M. Danziger, LL.B. 1963

PLATE 134
Attributed to Raku Chōjirō (Japanese, active late 16th century)
Tea Bowl, known as *Kaedegure (Twilight by the Maples)*
Momoyama period, late 16th century
Raku ware; earthenware with black glaze, 3⁹/₁₆ x 4¾ in.
(9 x 12.1 cm)
Promised gift of Peggy and Richard M. Danziger, LL.B. 1963

PLATE 135
Tea Bowl, known as *Wind in the Pines (Matsukaze)*
Japanese, Momoyama period, early 17th century
Hagi ware; stoneware with off-white glaze, 3¾ x 5⅜ in.
(9.5 x 13.7 cm)
Promised gift of Peggy and Richard M. Danziger, LL.B. 1963

PLATE 136
Tea Bowl
Korean, Yi (Choson) dynasty, first half 17th century
Irabo ware; stoneware with brown ash glaze, 3⅛ x 5⅞ in.
(7.9 x 14.9 cm)
Promised gift of Peggy and Richard M. Danziger, LL.B. 1963

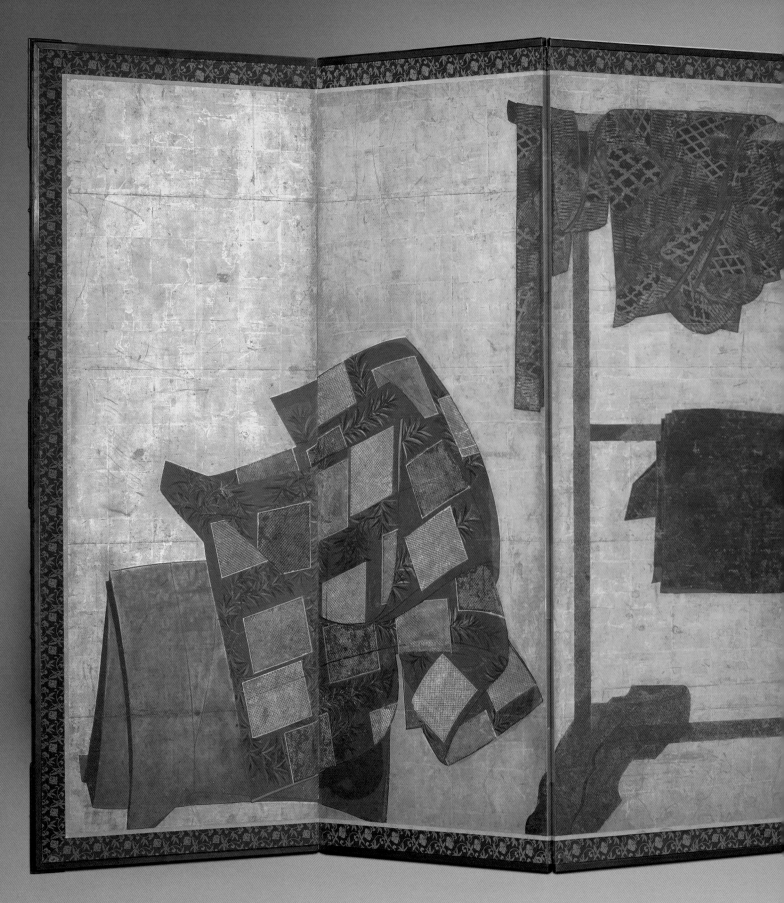

PLATE 137
Whose Sleeves? (Tagasode)
Japanese, Momoyama period, early 17th century
Six-panel folding screen; ink and color on gold leaf paper,
60¼ in. x 11 ft. 7⅜ in. (153 x 354 cm)
Promised gift of Peggy and Richard M. Danziger, LL.B. 1963

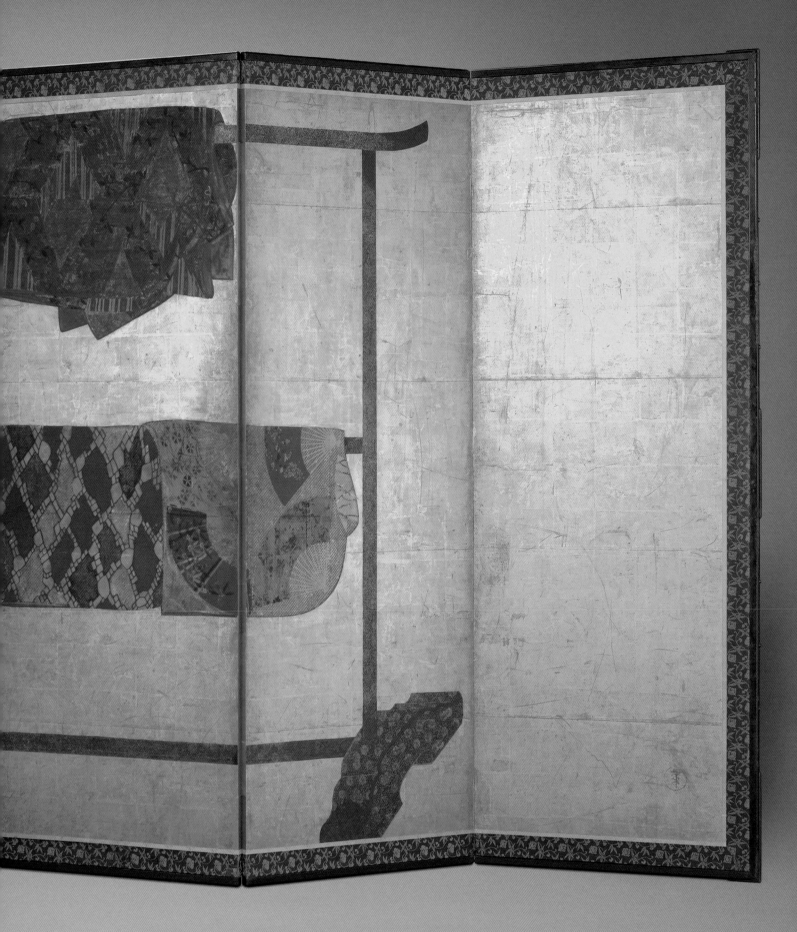

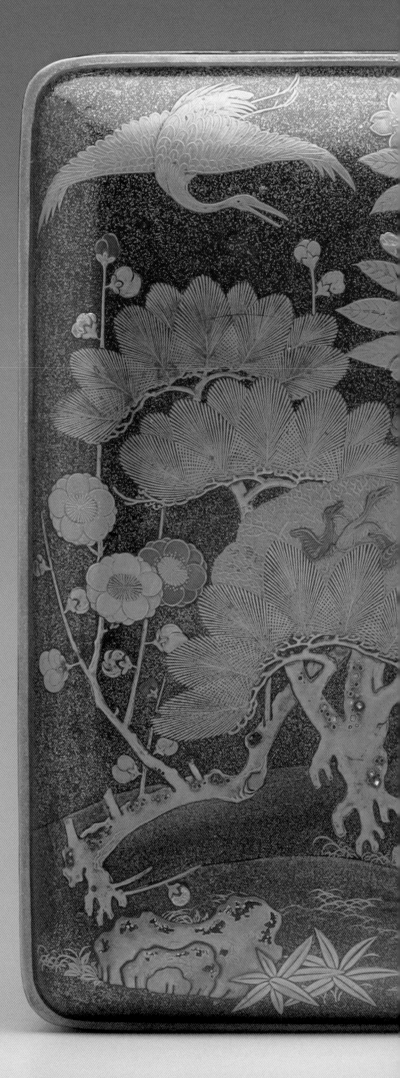

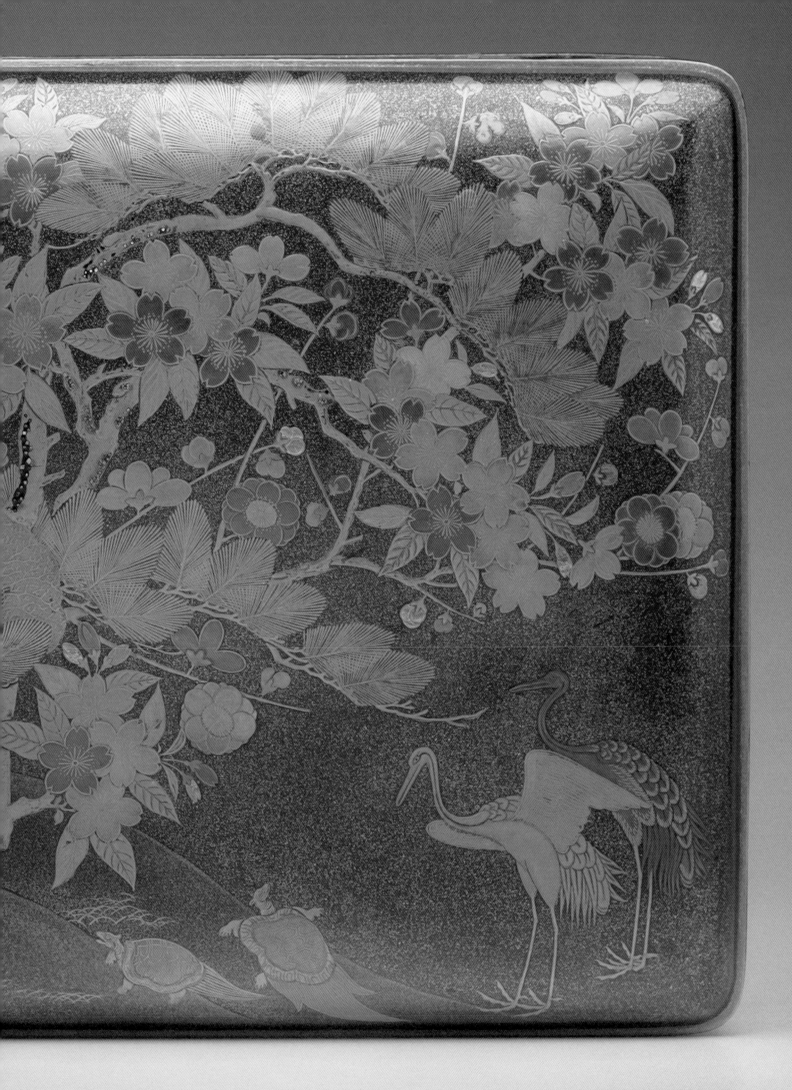

PLATE 138
Nobleman's Meal Table (Kakeban)
Japanese, Muromachi period, ca. 14th–15th century
Negoro ware; red and black lacquer on wood, $6^{9}/_{16}$ x $12^{13}/_{16}$ x
$12^{1}/_{4}$ in. (16.7 x 32.5 x 31.1 cm)
Leonard C. Hanna, Jr., B.A. 1913, Fund

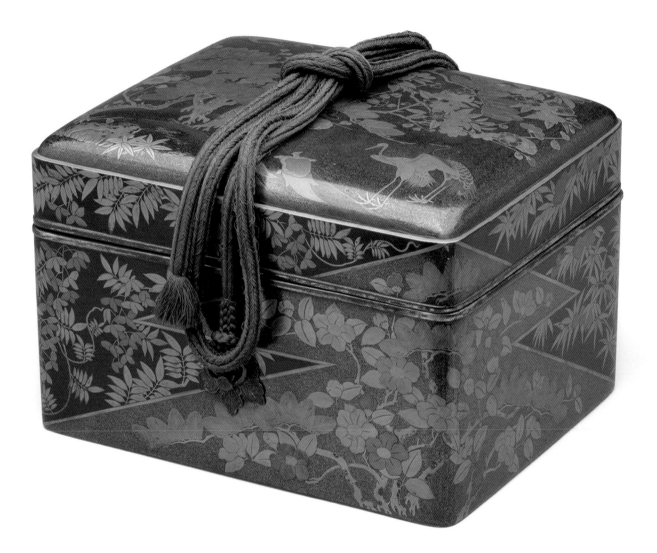

PLATE 139 (detail pages 150–51)
Trousseau Box (Tabikushige)
Japanese, Edo period, mid- to late 17th century
Black lacquer ground on wood with decoration in gold and
colored *Kōdaiji maki-e, nashiji*, gilt metal ring-fittings, and lead
rims, 8⁷⁄₁₆ x 13³⁄₁₆ x 10³⁄₈ in. (21.4 x 33.5 x 26.4 cm)
Gift of Peggy and Richard M. Danziger, LL.B. 1963

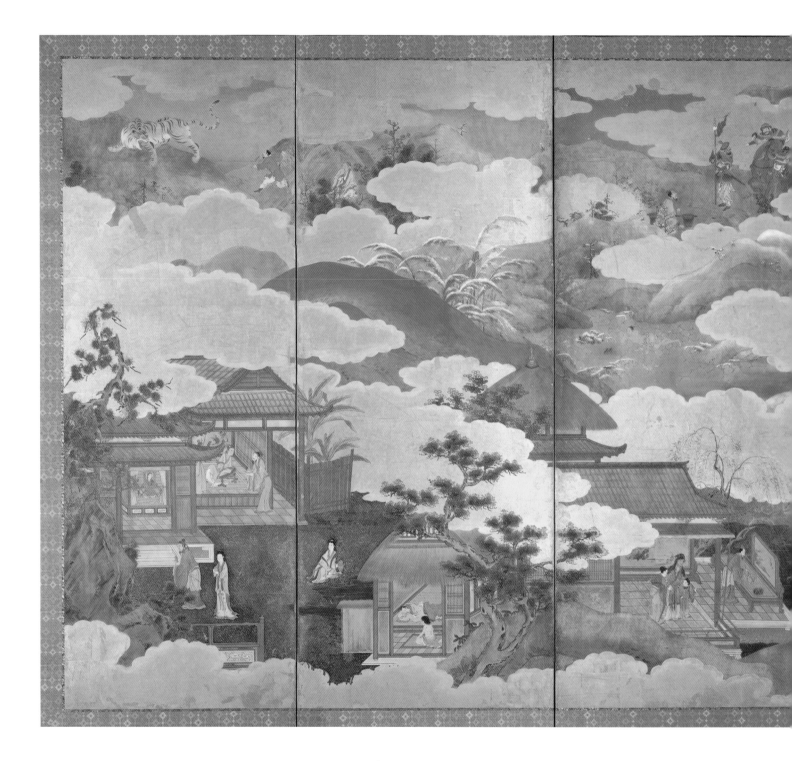

PLATE 140
Circle of Kanō Mitsunobu (Japanese, 1561/65–1602/8)
The Twenty-four Paragons of Filial Piety (*Nijūshikō*)
Edo period, ca. early 17th century
Left screen from a pair of six-panel folding screens; ink, color,
gold, silver, and gold leaf on paper, 59¹³⁄₁₆ in. x 11 ft. 11⁵⁄₁₆ in.
(152 x 364 cm)
Leonard C. Hanna, Jr., B.A. 1913, Fund

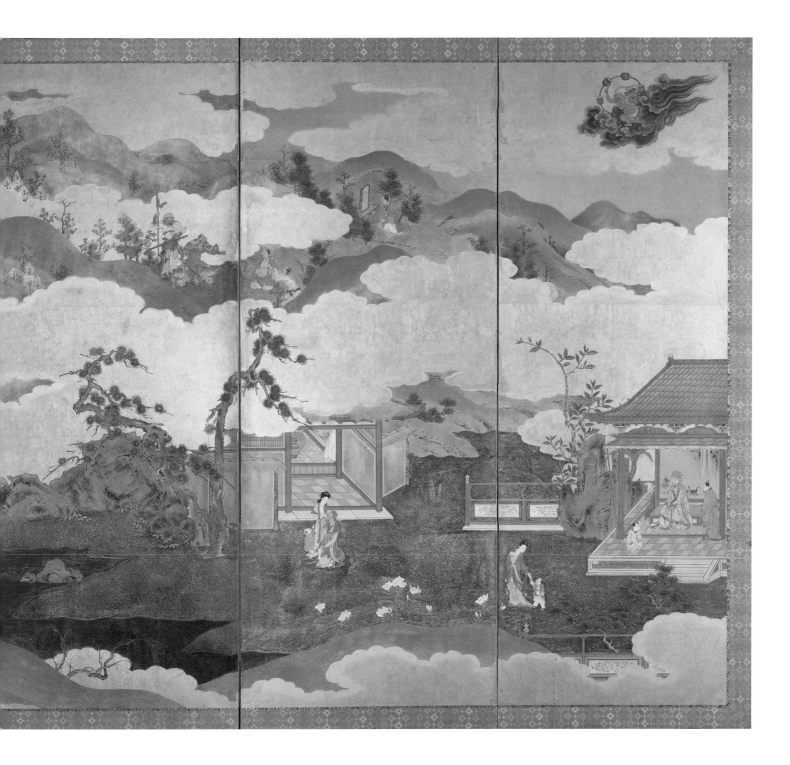

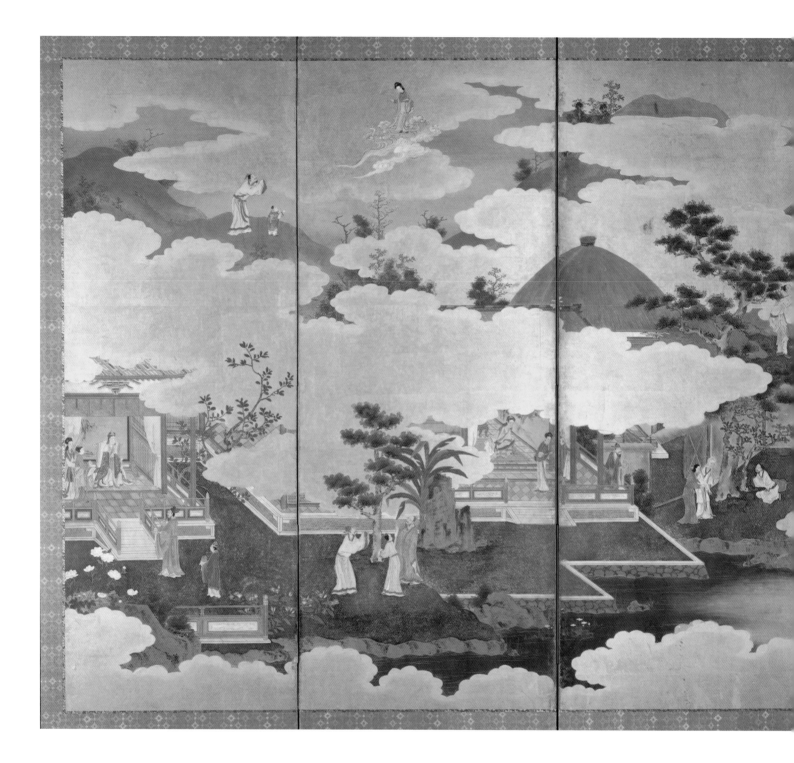

PLATE 141
Circle of Kanō Mitsunobu (Japanese, 1561/65–1602/8)
The Twenty-four Paragons of Filial Piety (*Nijūshikō*)
Edo period, ca. early 17th century
Right screen from a pair of six-panel folding screens; ink, color,
gold, silver, and gold leaf on paper, 59^{13}⁄$_{16}$ in. x 11 ft. 11^{5}⁄$_{16}$ in.
(152 x 364 cm)
Leonard C. Hanna, Jr., B.A. 1913, Fund

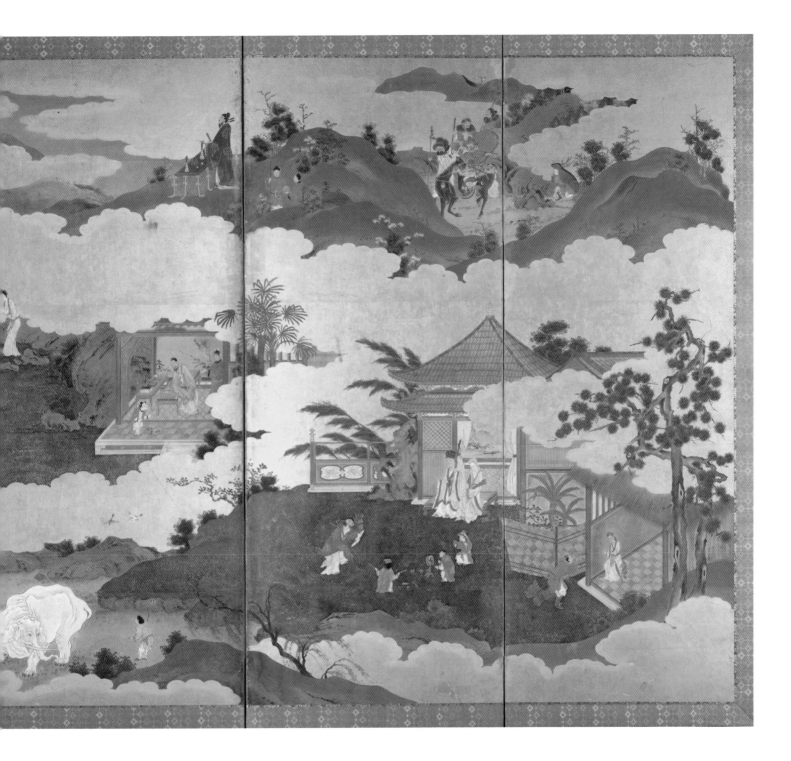

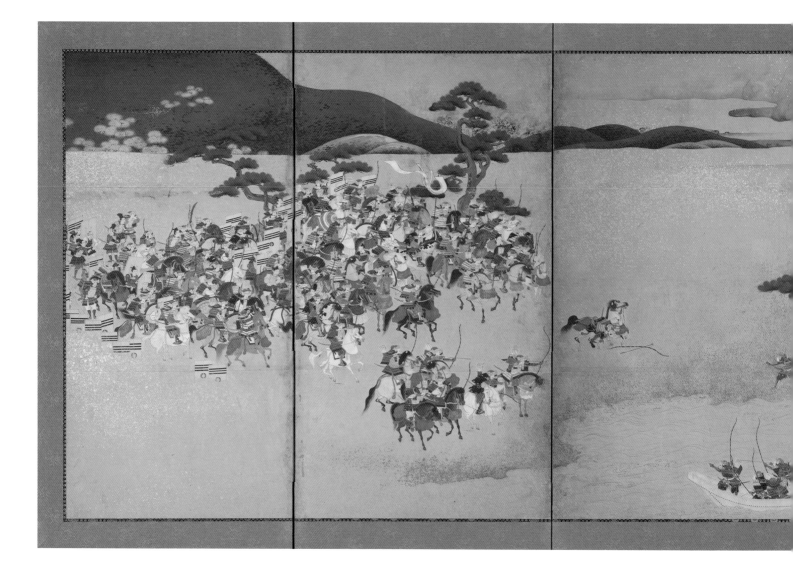

PLATE 142
Sumiyoshi School (Japanese, mid-17th–mid-19th century)
Scene from the Battle of Yashima
Edo period, ca. mid-17th century
Six-panel folding screen; ink, color, and gold leaf on paper,
37⁷⁄₁₆ in. x 9 ft. 3¼ in. (95.1 x 282.4 cm)
Leonard C. Hanna, Jr., B.A. 1913, Fund

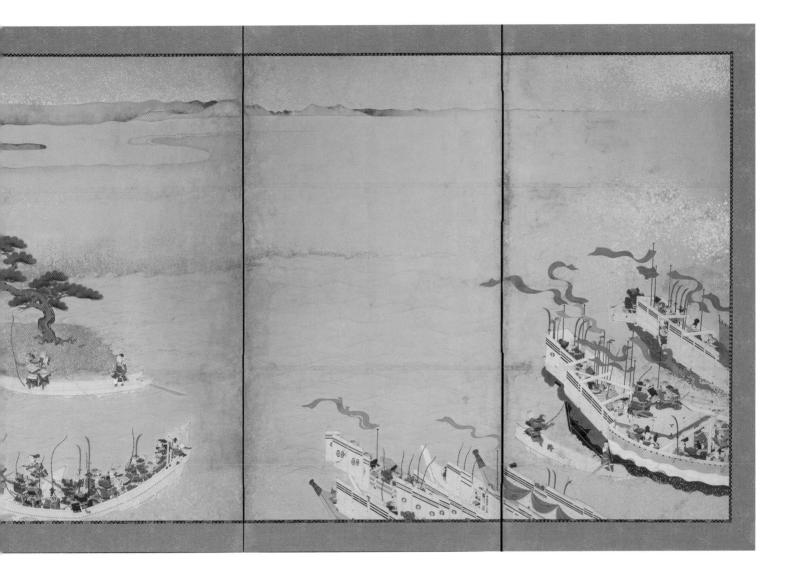

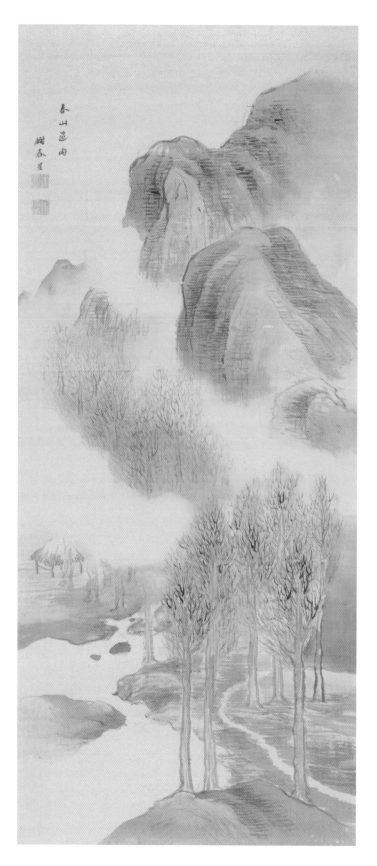

PLATE 143
Yosa Buson (Japanese, 1716–1783)
Spring Mountain, Passing Rain
Edo period, ca. 1775
Hanging scroll; ink and color on silk, 70$\frac{11}{16}$ x 23$\frac{15}{16}$ in.
(179.5 x 60.8 cm)
Purchased with funds from The Japan Foundation Endowment of
the Council on East Asian Studies and the Katharine Ordway Fund

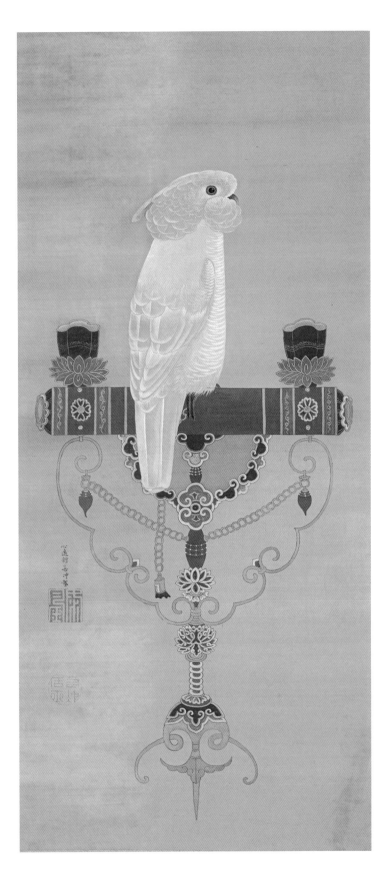

PLATE 144
Itō Jakuchū (Japanese, 1716–1800)
Cockatoo
Edo period, ca. 1755
Hanging scroll; ink and color on silk, 42½ x 19⅛ in.
(108 x 48.6 cm)
Gift of Rosemarie and Leighton R. Longhi, B.A. 1967

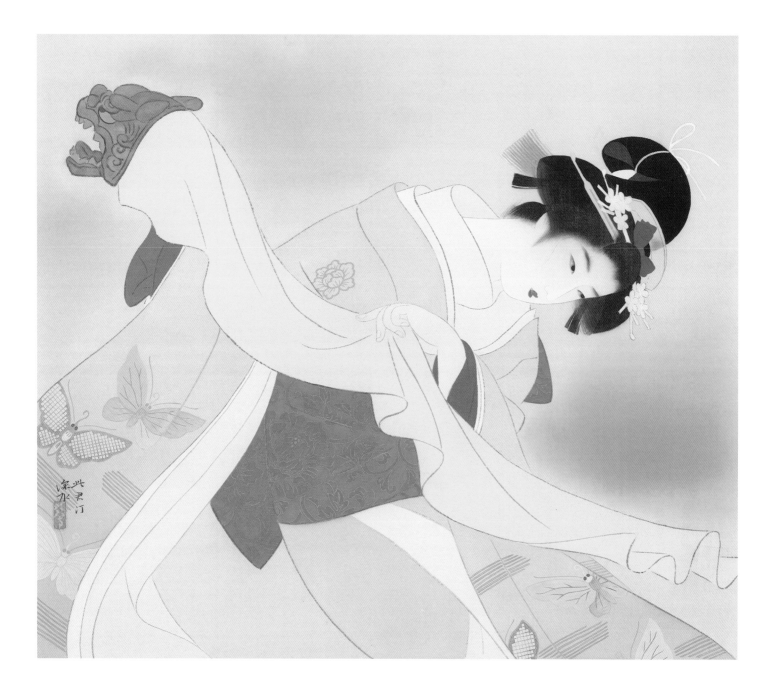

PLATE 145
Itō Shinsui (Japanese, 1898–1972)
The Lion Dance (Kagamijishi)
Shōwa period, ca. 1950
Hanging scroll; ink, color, and gold on silk, 9⁷⁄₁₆ x 22³⁄₈ in.
(24 x 56.8 cm)
The Henry Pearson, M.F.A. 1938, Collection, Gift of Dr. Lawrence
Dubin, B.S. 1955, M.D. 1958, and Regina Dubin

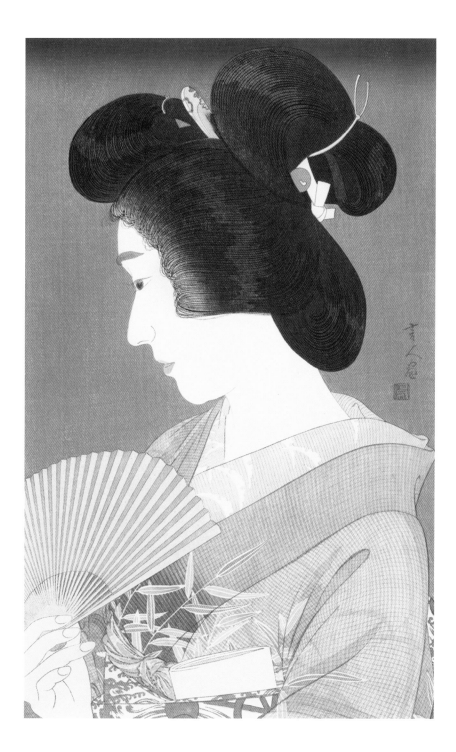

PLATE 146
Torii Kotondo (Japanese, 1900–1976)
Natsuko in Summer
Shōwa period, 1934
Shin hanga; polychrome wood-block print with mica,
16⁷⁄₁₆ x 10½ in. (41.8 x 26.7 cm)
Gift of Mr. and Mrs. Herbert Libertson

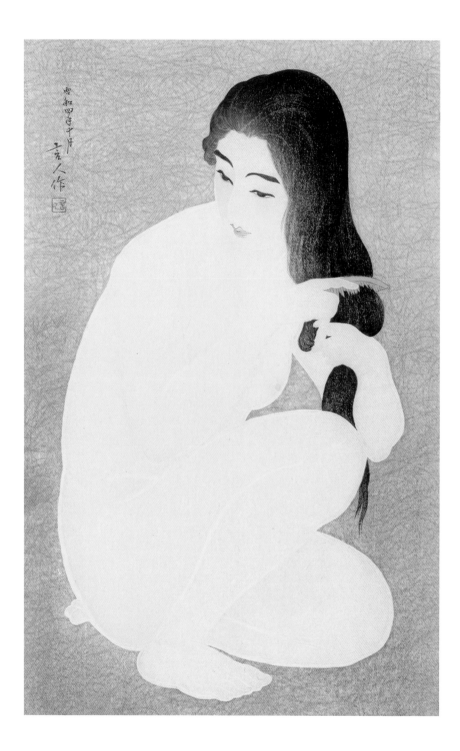

PLATE 147
Torii Kotondo (Japanese, 1900–1976)
Combing Hair (Kamisuki)
Shōwa period, 1929
Shin hanga; polychrome wood-block print, 17⅞ x 11¾ in.
(45.4 x 29.9 cm)
Purchased with a gift from Dana K. Martin, B.A. 1982

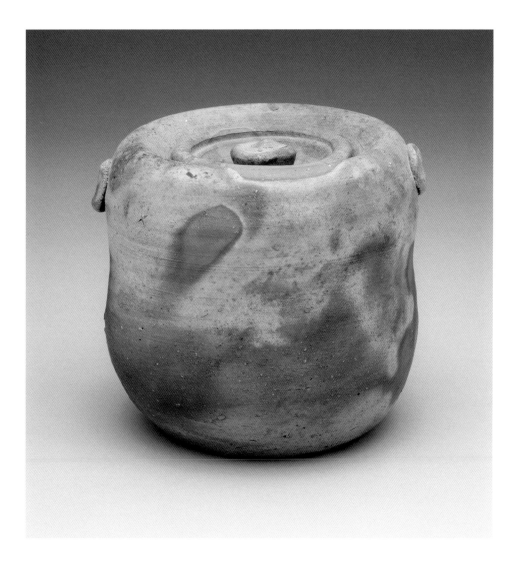

PLATE 148
Kaneshige Tōyō (Japanese, 1896–1967)
Fresh Water Jar (Mizusashi)
Shōwa period, October or November 1952
Bizen ware; unglazed stoneware with coloration produced
by wood firing, 6 x 6½ in. (15.2 x 16.5 cm)
Gift of Molly and Walter Bareiss, B.S. 1940s

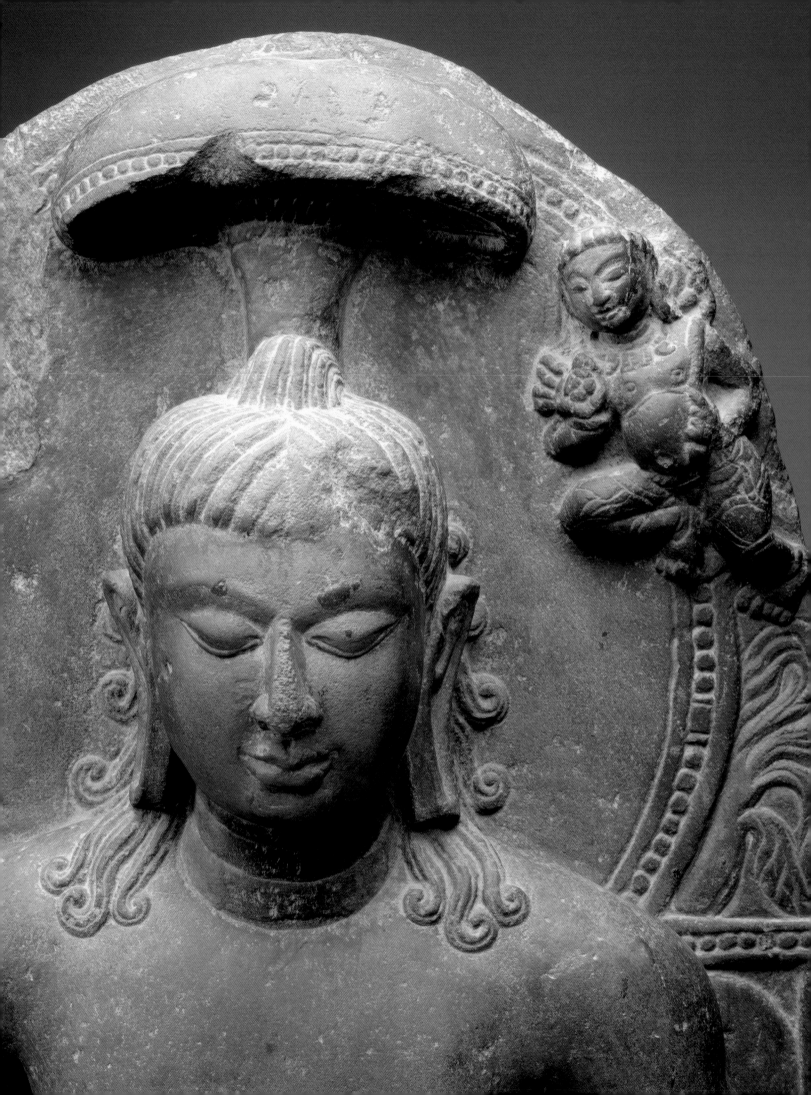

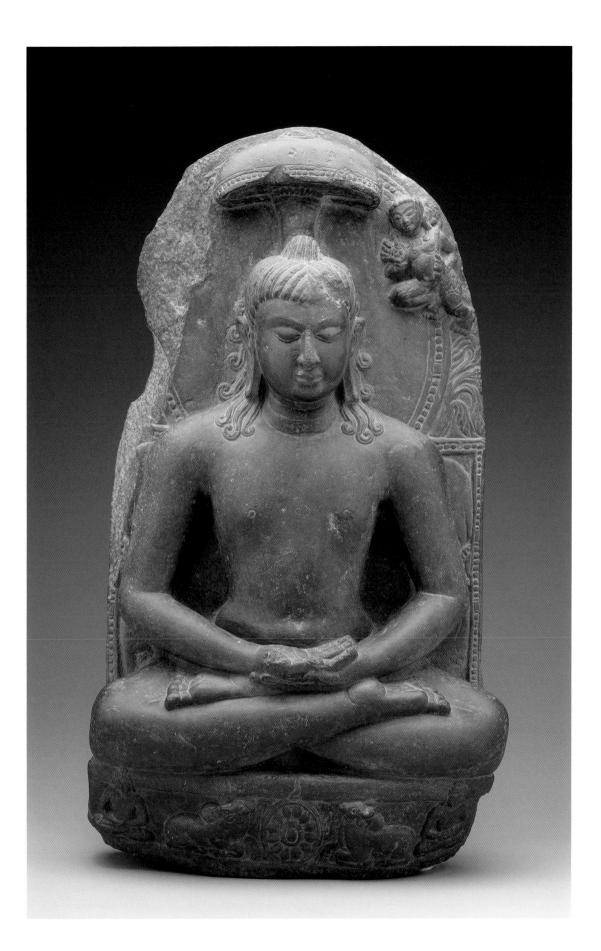

PLATE 149 (detail opposite)
Jina Rishabhanatha
Indian, east India, Gupta or Pala period, 6th–7th century C.E.
Black chlorite stone, 26 x 16 x 5 in. (66 x 40.6 x 12.7 cm)
Purchased with a gift from Steven M. Kossak, B.A. 1972

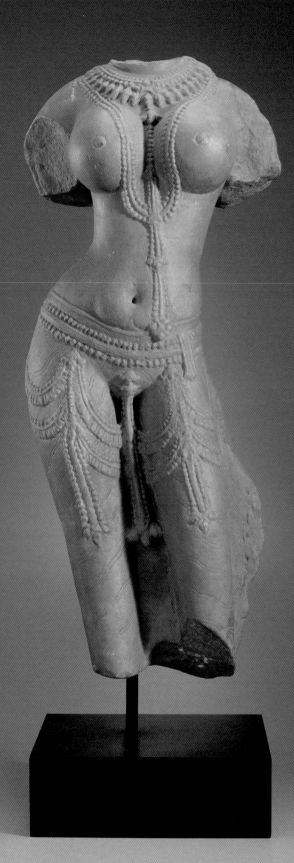

PLATE 150
Female Torso (Devi)
Indian, central India, 11th century
Beige sandstone, H. 19 in. (48.3 cm)
Gift of the Rubin-Ladd Foundation under the bequest of
Ester R. Portnow

PLATE 151
Guardian (Dvarapala)
Indian, Rajasthan, 10th century
Red sandstone, H. 25½ in. (64.8 cm)
Promised gift of Georgia and Michael H. de Havenon, B.A. 1962

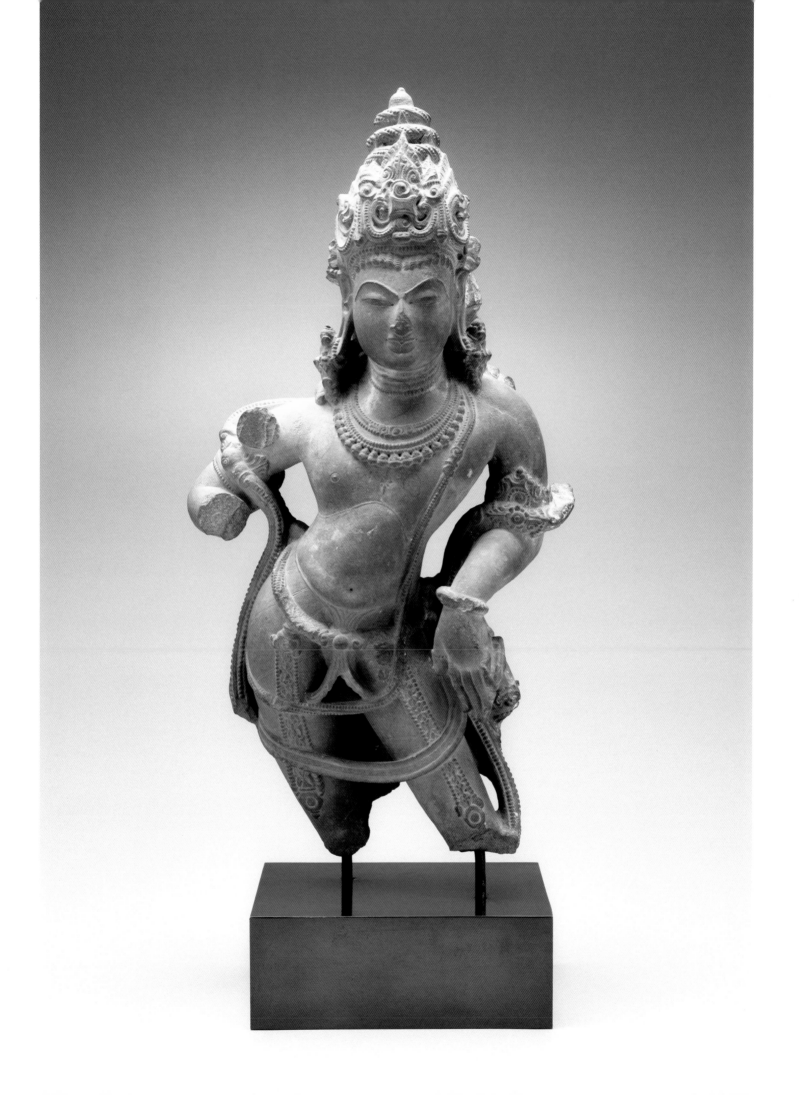

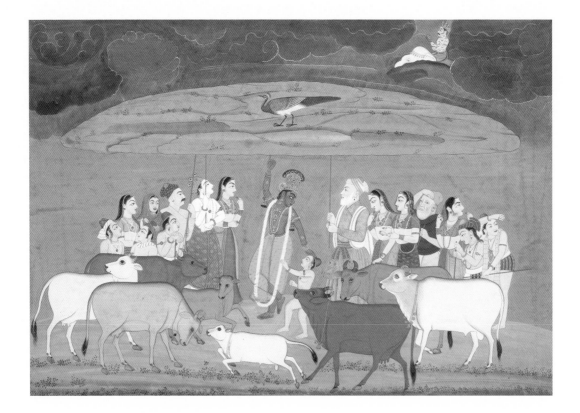

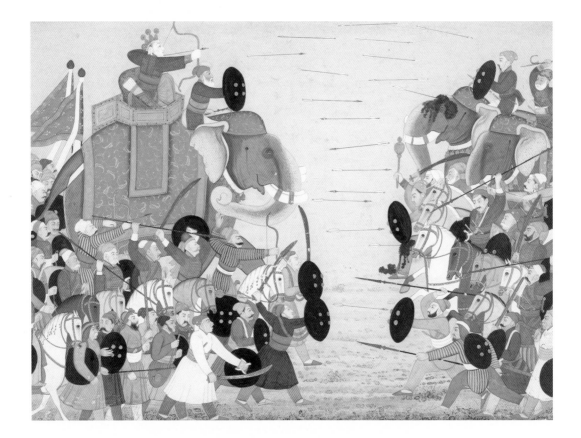

PLATE 152
Illustration from a Bhagavata Purana Series, Book 10:
Krishna Lifting Mount Govardhan
Indian, Mughal period, Basohli, ca. 1760–65
Opaque watercolor and gold on paper, 16¼ x 19¾ in. (41.2 x 50.2 cm)
The Vera M. and John D. MacDonald, B.A. 1927, Collection,
Gift of Mrs. John D. MacDonald

PLATE 153
Illustration from a Bhagavata Purana Series, Book 10:
Battle between Balarama and Jarasandha
Indian, Mughal period, Basohli, ca. 1760–65
Opaque watercolor and gold on paper, 18³⁄₁₆ x 21⁷⁄₁₆ in. (46.2 x 54.4 cm)
The Vera M. and John D. MacDonald, B.A. 1927, Collection,
Gift of Mrs. John D. MacDonald

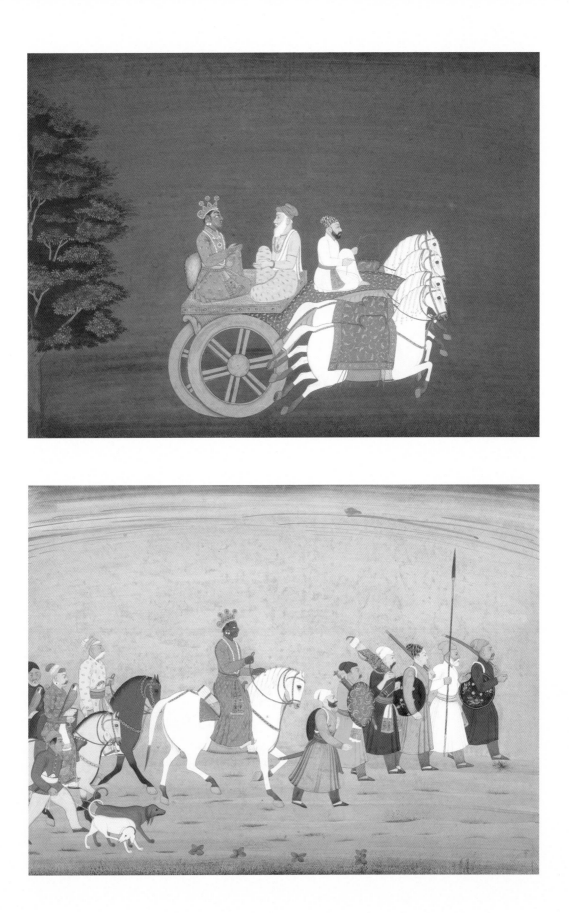

PLATE 154
Illustration from a Bhagavata Purana Series, Book 10:
Krishna and Nanda in a Chariot
Indian, Mughal period, Basohli, ca. 1760–65
Opaque watercolor and gold on paper, 18 x 21⁷⁄₁₆ in. (45.7 x 54.4 cm)
The Vera M. and John D. MacDonald, B.A. 1927, Collection,
Gift of Mrs. John D. MacDonald

PLATE 155
Illustration from a Bhagavata Purana Series, Book 10:
Krishna Rides to Kundulpur
Indian, Mughal period, Basohli, ca. 1760–65
Opaque watercolor and gold on paper, 18¼ x 21⁷⁄₁₆ in. (46.4 x 54.4 cm)
The Vera M. and John D. MacDonald, B.A. 1927, Collection,
Gift of Mrs. John D. MacDonald

PLATE 156
Trumpet
Sapi, Sierra Leone, ca. 1490–1530
Elephant ivory tusk and metal, 3½ x 20¾ in. (8.9 x 52.7 cm)
Charles B. Benenson, B.A. 1933, Collection

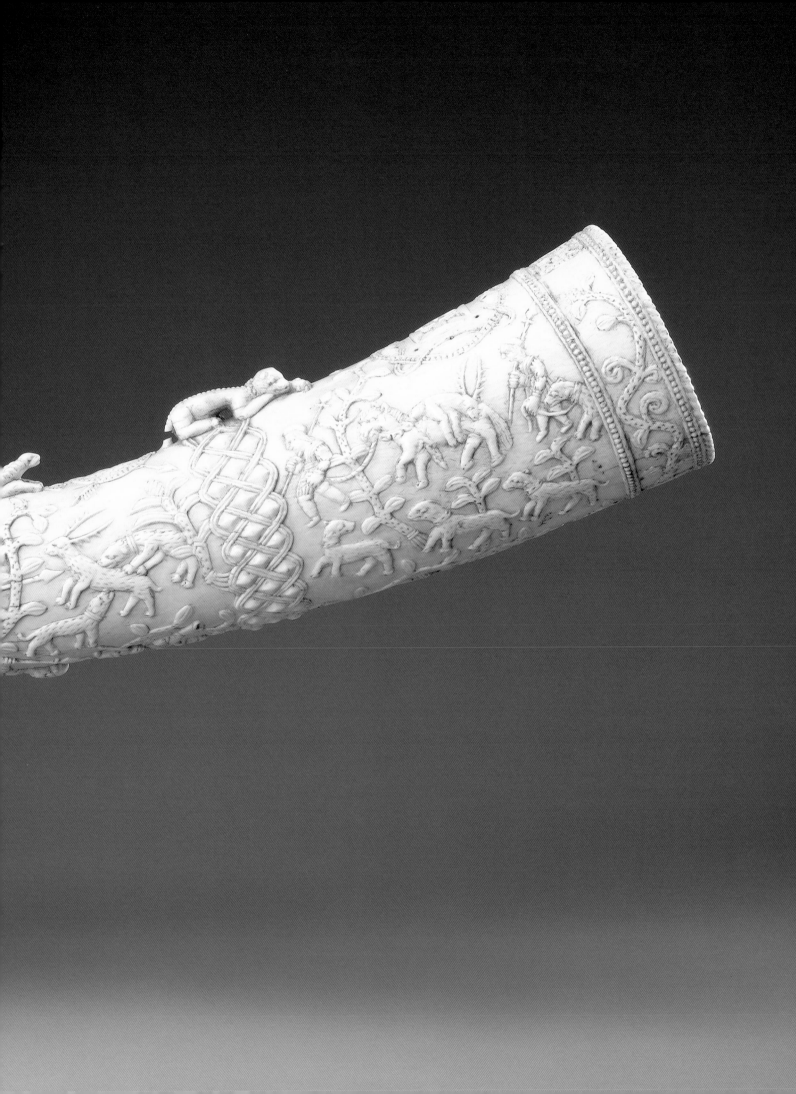

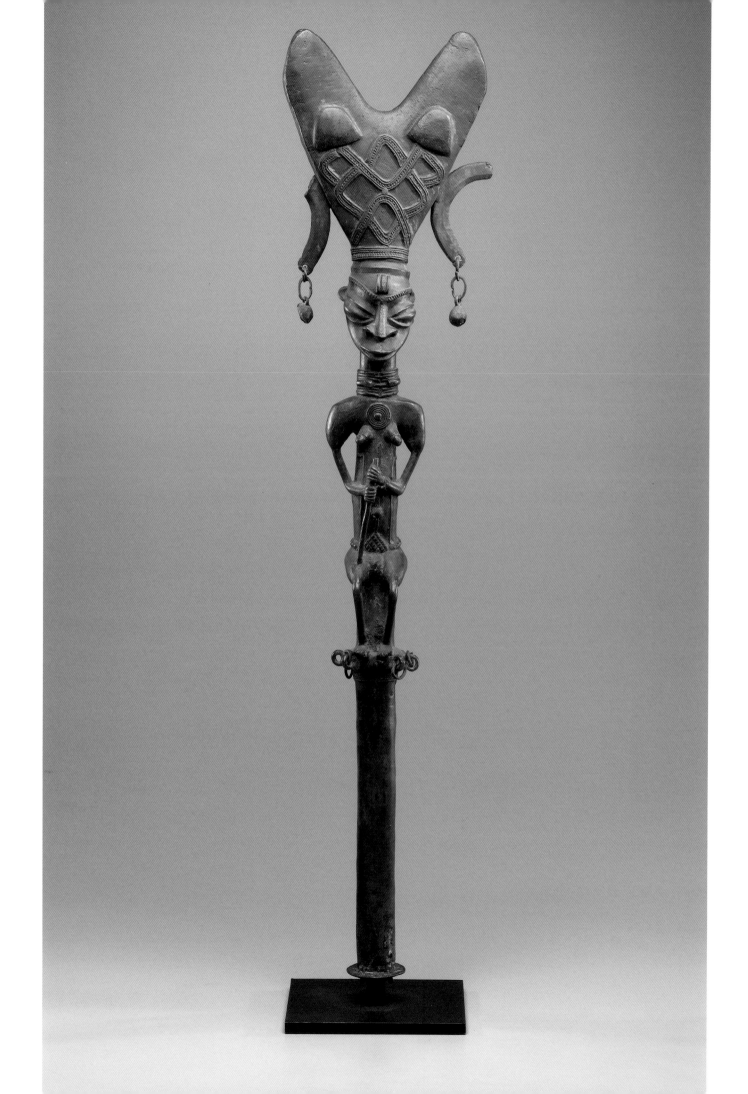

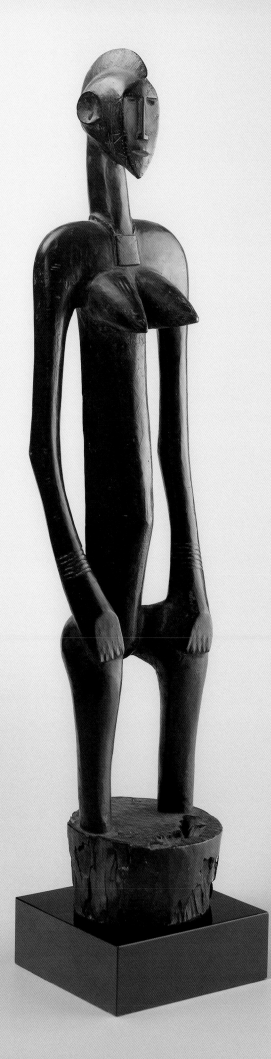

Opposite:

PLATE 157
Staff (Edan)
Yoruba, Ogboni association, Nigeria or Republic of Benin,
19th–early 20th century
Copper alloy, 26 x 6⁵⁄₁₆ x 2³⁄₁₆ in. (66 x 16 x 5.5 cm)
Charles B. Benenson, B.A. 1933, Collection

PLATE 158
Rhythm Pounder in the Form of a Female Figure (Doogele)
Senufo, Kulibele (carvers) and Celibele (users) subgroups,
Ivory Coast, Burkina Faso, or Mali, late 19th–early 20th century
Wood, 40¹⁵⁄₁₆ x 8⁷⁄₈ x 5⁷⁄₈ in. (104 x 22.5 x 14.9 cm)
Charles B. Benenson, B.A. 1933, Collection

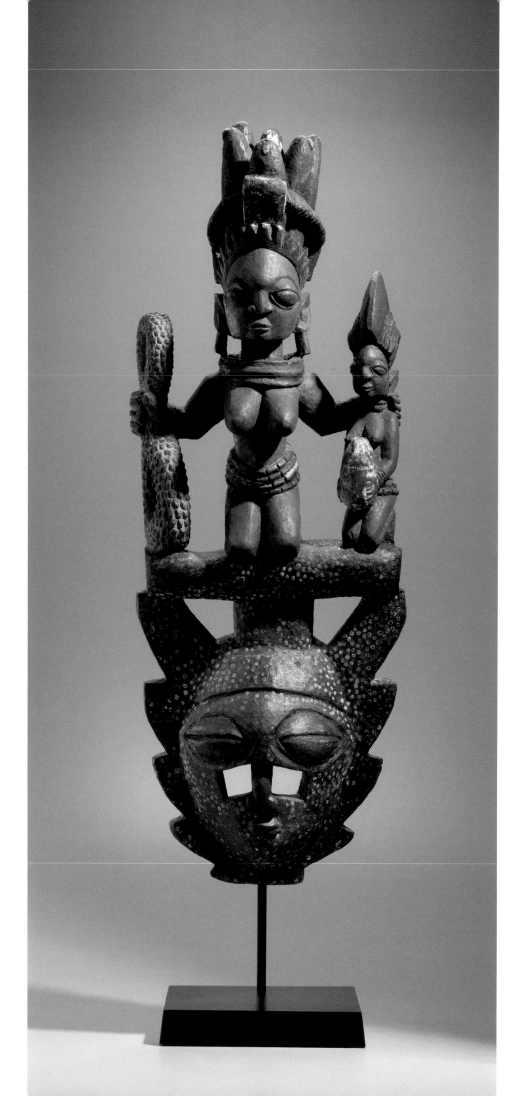

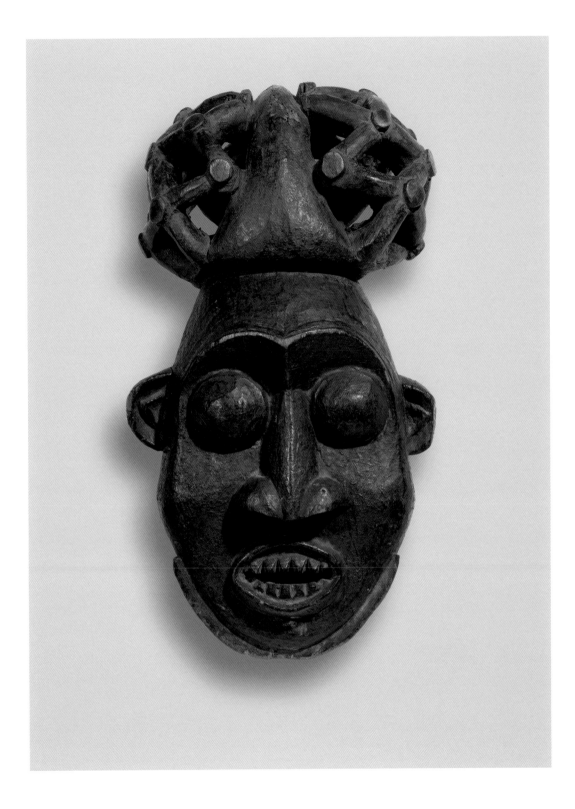

PLATE 159
Areogun of Osi-Ilorin (Yoruba, Ekiti subgroup, 1880–1954)
Mask, known as *The Owner of the Deep-Set Eyes (Oloju Foforo),*
Surmounted by a Figure of the Priestess of the Goddess Oshun
Yoruba, Ekiti subgroup, Ijeshu festival, Nigeria, early to
mid-20th century
Wood, pigment, string, and fiber, 37 x 14⅝ x 6⁵⁄₁₆ in.
(94 x 37.2 x 16 cm)
Charles B. Benenson, B.A. 1933, Collection

PLATE 160
Mask
Bamileke, Cameroon, late 19th–early 20th century
Wood and pigment, 18 x 7⅞ x 7¹⁄₁₆ in. (45.7 x 20 x 17.9 cm)
Charles B. Benenson, B.A. 1933, Collection

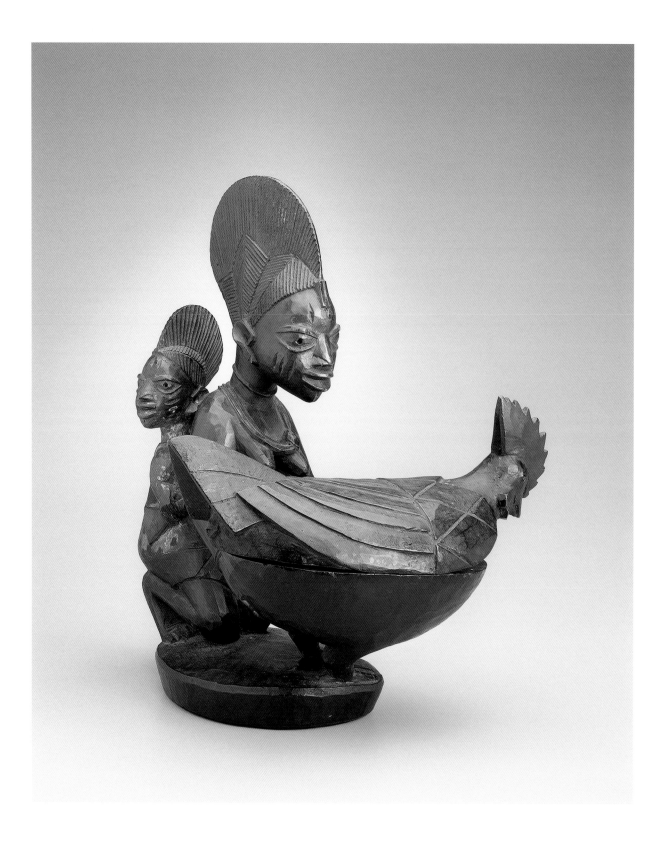

PLATE 161
Maternity Figure with a Bowl in the Form of a Rooster
Yoruba, Gelede association, Nigeria or Republic of Benin,
early 20th century
Wood and pigment, 15¾ x 10⁷⁄₁₆ x 9¼ in. (40 x 26.5 x 23.5 cm)
Charles B. Benenson, B.A. 1933, Collection

PLATE 162
Seated Female Figure with Four Children
Djenné, Mali, 12th–17th century
Terracotta, 13¾ x 8⁷⁄₁₆ x 7⁵⁄₁₆ in. (34.9 x 21.4 x 18.6 cm)
Charles B. Benenson, B.A. 1933, Collection

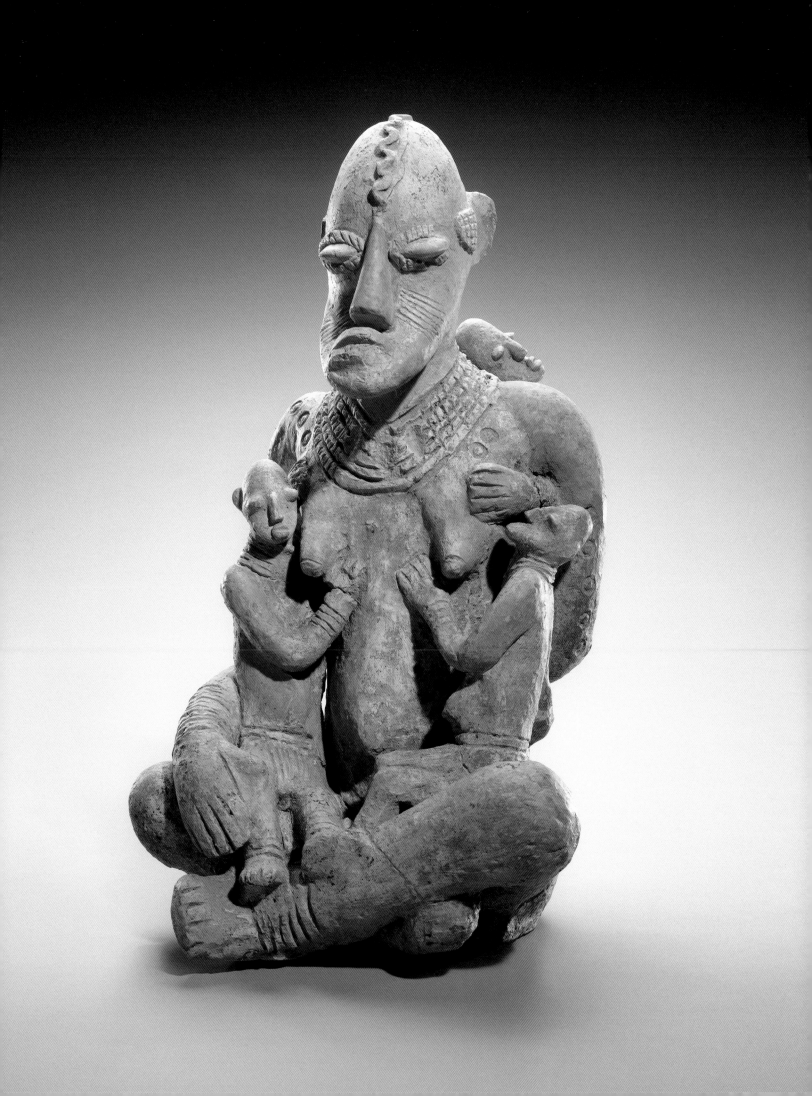

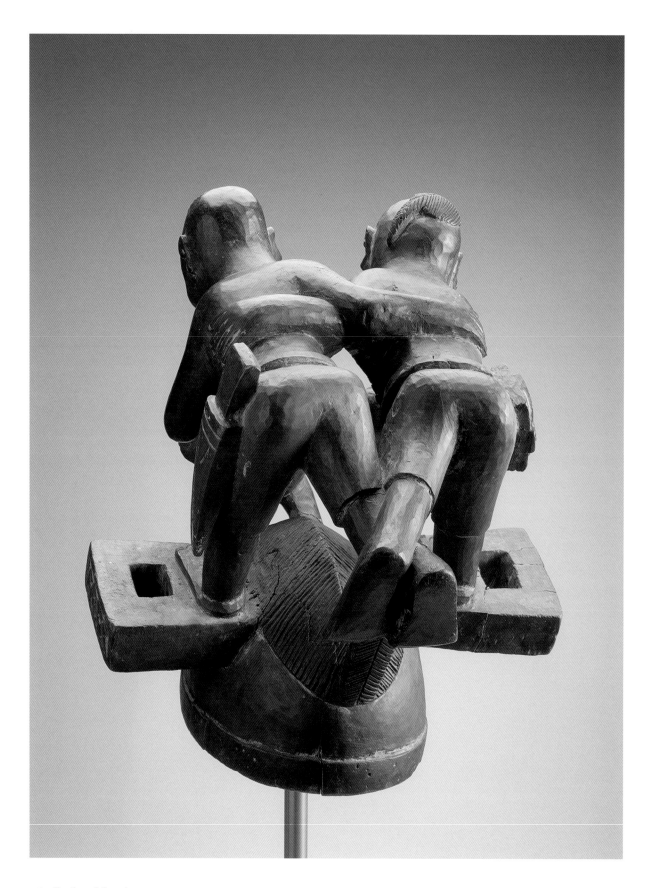

PLATE 163 (back and front)
Falola Edun, or his father, Fagbite Asamu (Yoruba, Ketu subgroup,
Republic of Benin, born 1900, father late 19th century–ca. 1970)
Helmet Mask with Two Male Figures and a Pangolin
Yoruba, Ketu subgroup, Gelede association, Idahin, Republic
of Benin, mid-20th century
Wood, pigment, and nails, 13¾ x 13¾ x 11¹³⁄₁₆ in. (34.9 x 34.9 x 28.4 cm)
Gift of Ellen and Stephen Susman, B.A. 1962

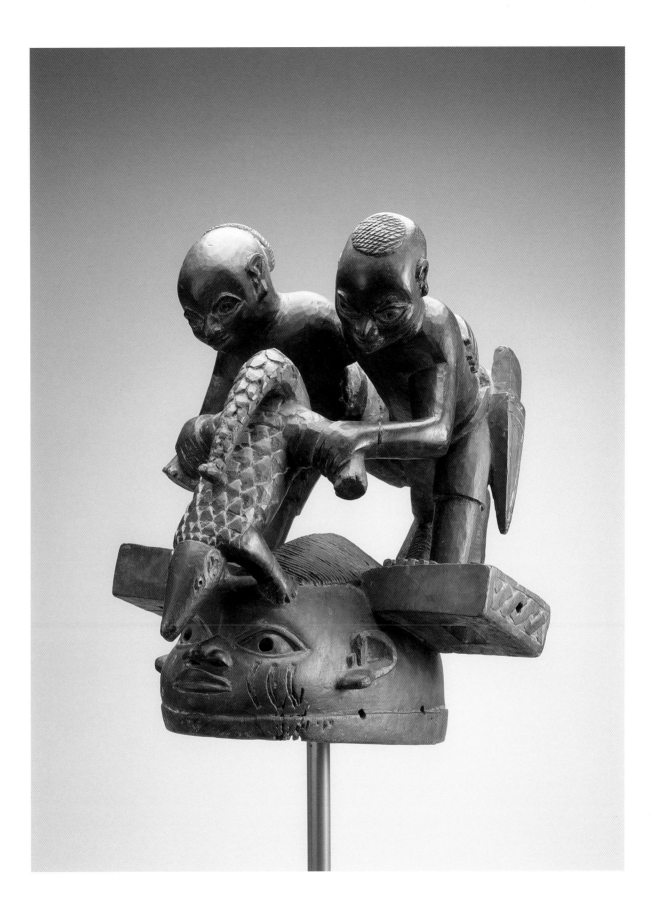

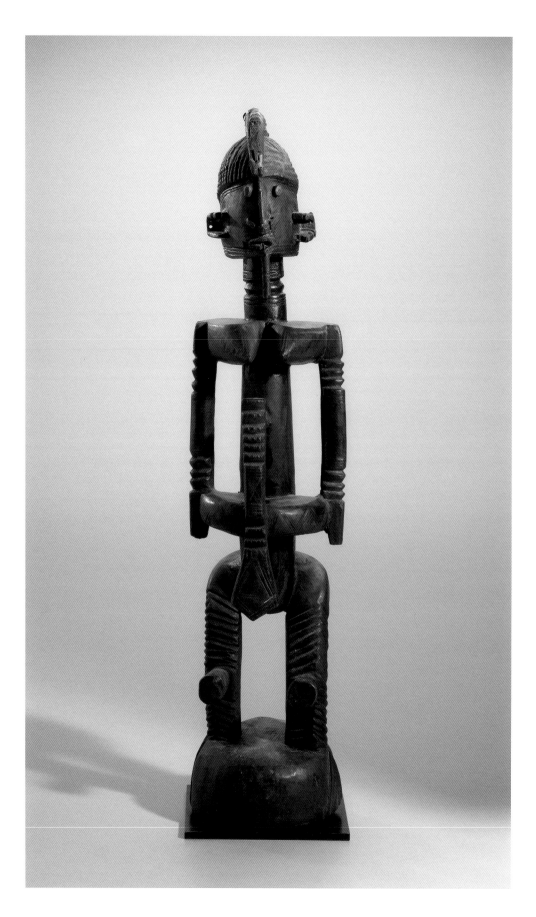

PLATE 164
Female Figure
Dogon, Mali, 19th century
Wood and brass, 26³⁄₁₆ x 6⅛ x 6⁵⁄₁₆ in. (66.5 x 15.6 x 16 cm)
Charles B. Benenson, B.A. 1933, Collection

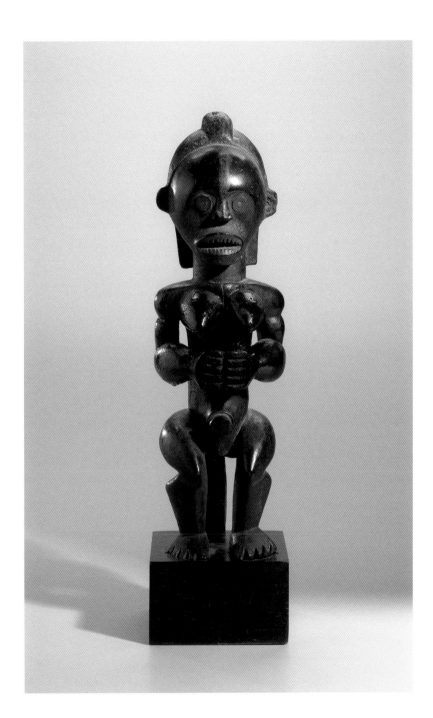

PLATE 165
Female Reliquary Figure (Bieri)
Fang, Mvai subgroup, Gabon, 19th century
Wood, brass, palm oil, and fiber, 15⅜ x 4¾ x 4¾ in.
(39.1 x 12.1 x 12.1 cm)
Charles B. Benenson, B.A. 1933, Collection

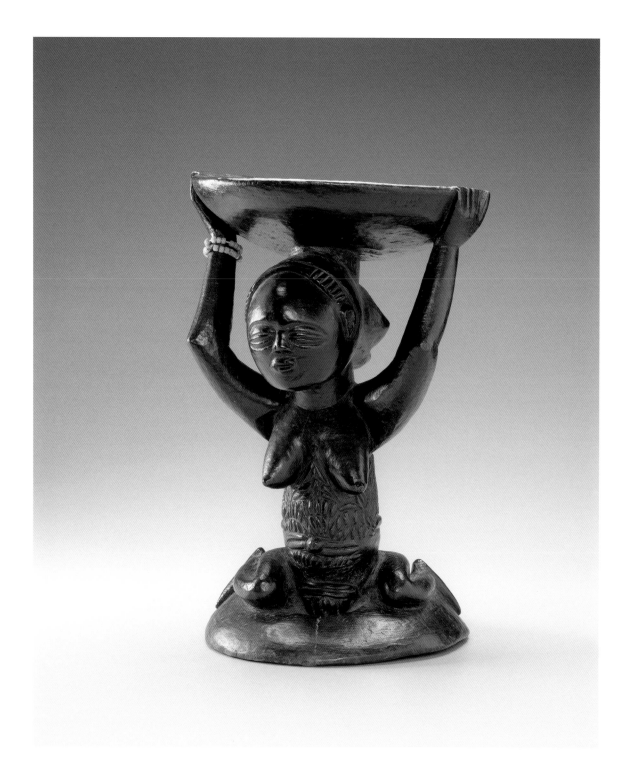

PLATE 166
Caryatid Stool
Luba, Congo (Kinshasa), late 19th century
Wood, glass beads, and string, 17⅜ x 12 x 11⁵⁄₁₆ in.
(44.1 x 30.5 x 28.7 cm)
Promised gift of Thomas Jaffe, B.A. 1971

PLATE 167
Oil Lamp (Fitula)
Sorko, Mali, Kouakourou, Kolenze village, 19th century
Iron, 56 x 20 in. (142.2 x 50.8 cm)
Gift of Labelle Prussin, PH.D. 1973

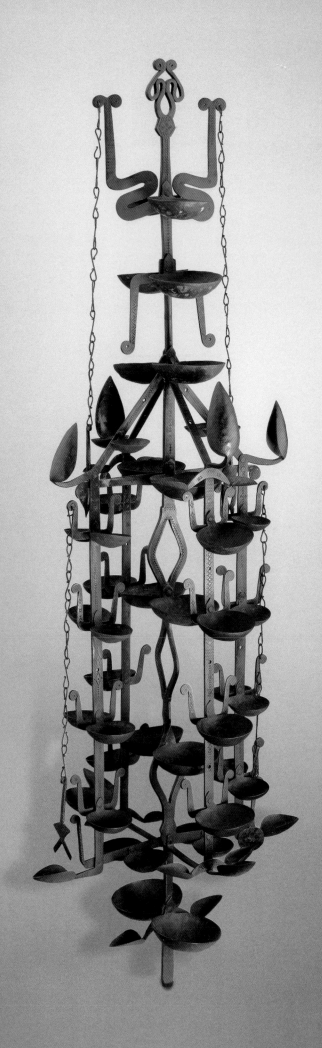

PLATE 168
Male Headdress (Chi Wara)
Bamana, Mali, late 19th–early 20th century
Wood, cowrie shells, metal, and string, 32 x 16⁹⁄₁₆ x 2¾ in.
(81.3 x 42.1 x 7 cm)
Promised gift of the Wardwell Family

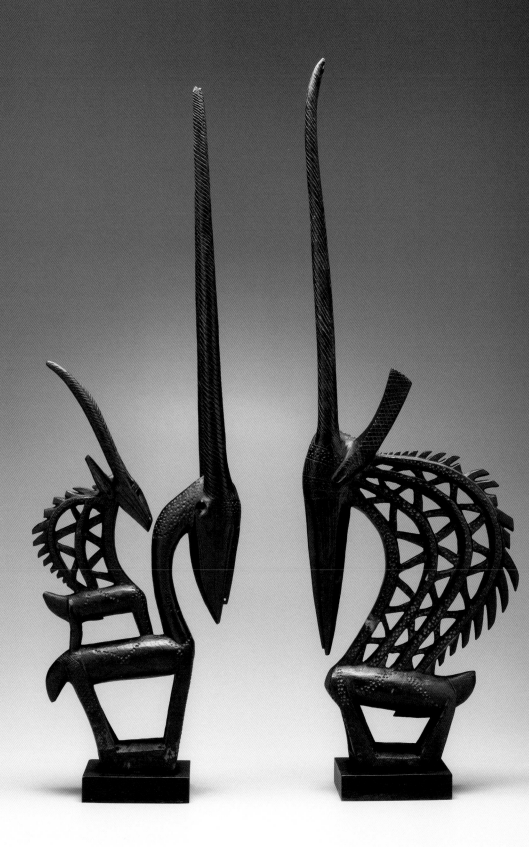

PLATE 169
Female Headdress (Chi Wara)
Bamana, Mali, late 19th–early 20th century
Wood, 37½ x 11¹³⁄₁₆ x 3⁵⁄₁₆ in. (95.3 x 30 x 8.4 cm)
Promised bequest of Erika and Thomas Leland Hughes,
B.A. 1945, LL.B. 1949

PLATE 170
Male Headdress (Chi Wara)
Bamana, Mali, late 19th–early 20th century
Wood, 38⁹⁄₁₆ x 12¹¹⁄₁₆ x 2⁹⁄₁₆ in. (97.9 x 32.2 x 6.5 cm)
Promised bequest of Erika and Thomas Leland Hughes,
B.A. 1945, LL.B. 1949

PLATE 171
Currency Blade
Lokele, Congo (Kinshasa), 18th–19th century
Iron, 59¹⁄₁₆ x 15⅝ x ⅞ in. (150 x 39.7 x 2.22 cm)
Promised gift of Dwight B. and Anna Cooper Heath

PLATE 172
Currency Blade
Mfumte, Cameroon or Nigeria, late 19th–early 20th century
Iron, 11⁹⁄₁₆ x 9³⁄₁₆ x ¹⁄₁₆ in. (29.4 x 23.3 x 0.16 cm)
Promised gift of Dwight B. and Anna Cooper Heath

PLATE 173
Currency Blade
Chamba, Nigeria, 18th–19th century
Iron, 11¹³⁄₁₆ x 6¹¹⁄₁₆ in. (30 x 17 cm)
Promised gift of Dwight B. and Anna Cooper Heath

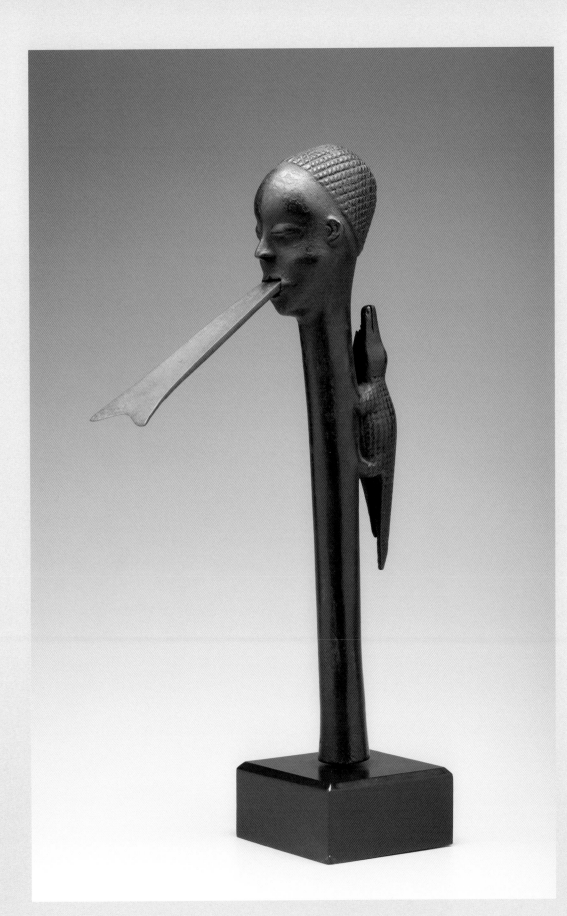

PLATE 174
Adze with a Human Head and a Crocodile
Pende, Congo (Kinshasa), late 19th–early 20th century
Wood, 15¾ x 8⁹⁄₁₆ x 2⁷⁄₁₆ in. (40 x 21.7 x 6.2 cm)
Gift of Erika and Thomas Leland Hughes, B.A. 1945, LL.B. 1949

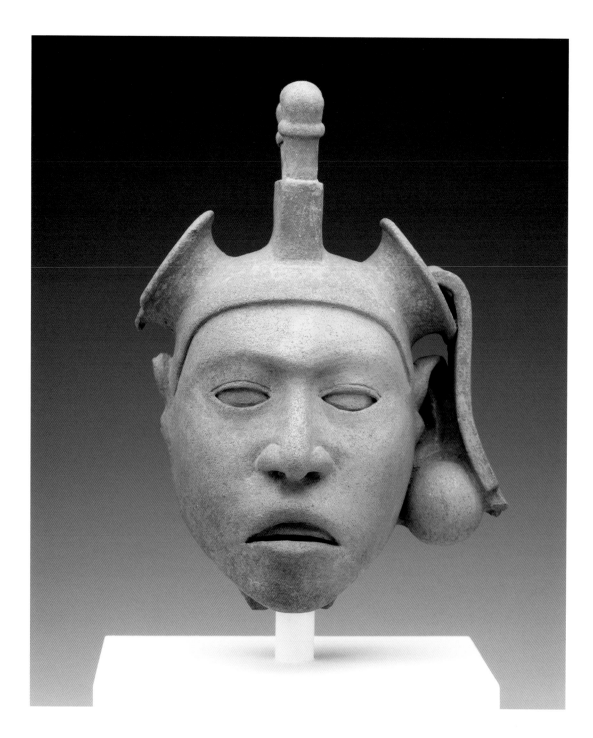

PLATE 175
Head of a Deity
Aztec, Mexico, Veracruz, ca. 1440–1521
Ceramic, 11 x 8⅜ x 6¹¹⁄₁₆ in. (27.9 x 21.3 x 17 cm)
Bequest from the Estate of Alice M. Kaplan

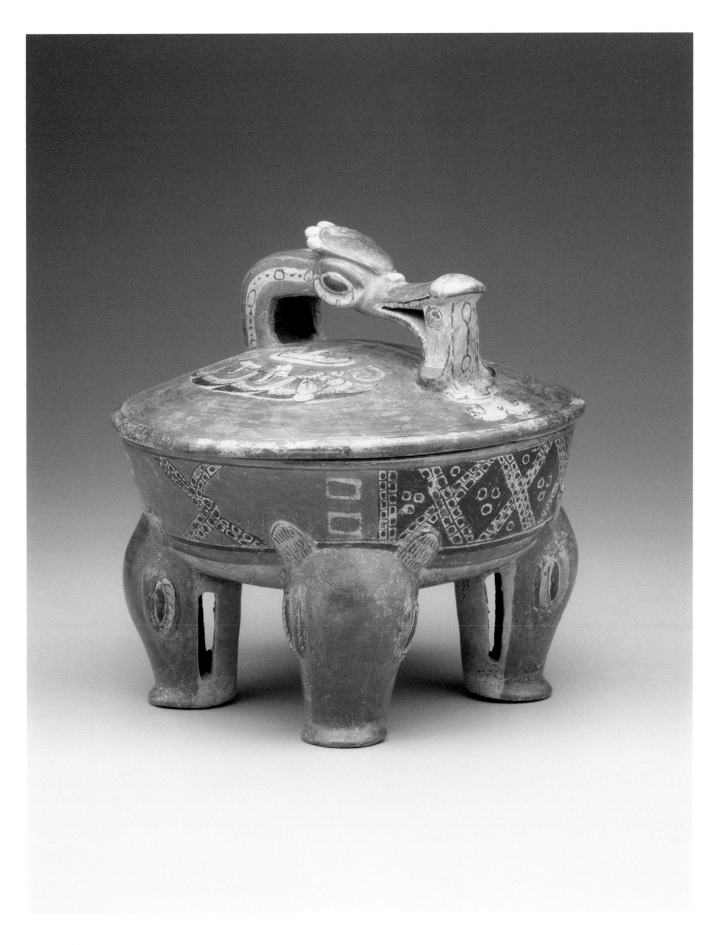

PLATE 176
Quadruped Vessel with Peccary Feet and a Lid with a Bird-and-Fish Handle
Maya, Guatemala or Mexico, A.D. 250–400
Ceramic with pigment, 10¾ x 10¾ in. (27.3 x 27.3 cm)
Gift of Peggy and Richard M. Danziger, LL.B. 1963

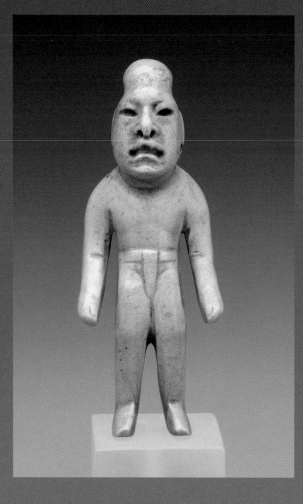

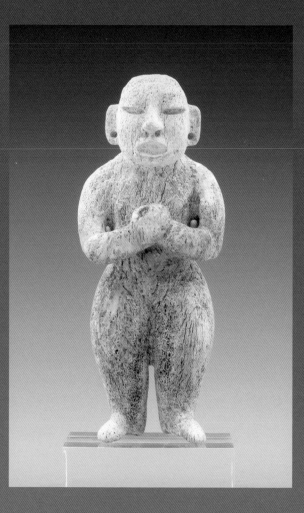

PLATE 177 (detail opposite)
Standing Male Figure
Olmec, Mexico, central or Gulf Coast, ca. 900–400 B.C.
Greenstone (probably jadeite), 3½ x 1⁷⁄₁₆ x ⁹⁄₁₆ in.
(8.9 x 3.7 x 1.43 cm)
Gift of Thomas T. Solley, B.A. 1950

PLATE 178
Standing Male Figure
Maya, coastal Belize or Mexico, ca. A.D. 200–500
Manatee bone with red pigment, 4⁷⁄₈ x 2¼ x 1⅛ in.
(12.4 x 5.7 x 2.9 cm)
Gift of Thomas T. Solley, B.A. 1950

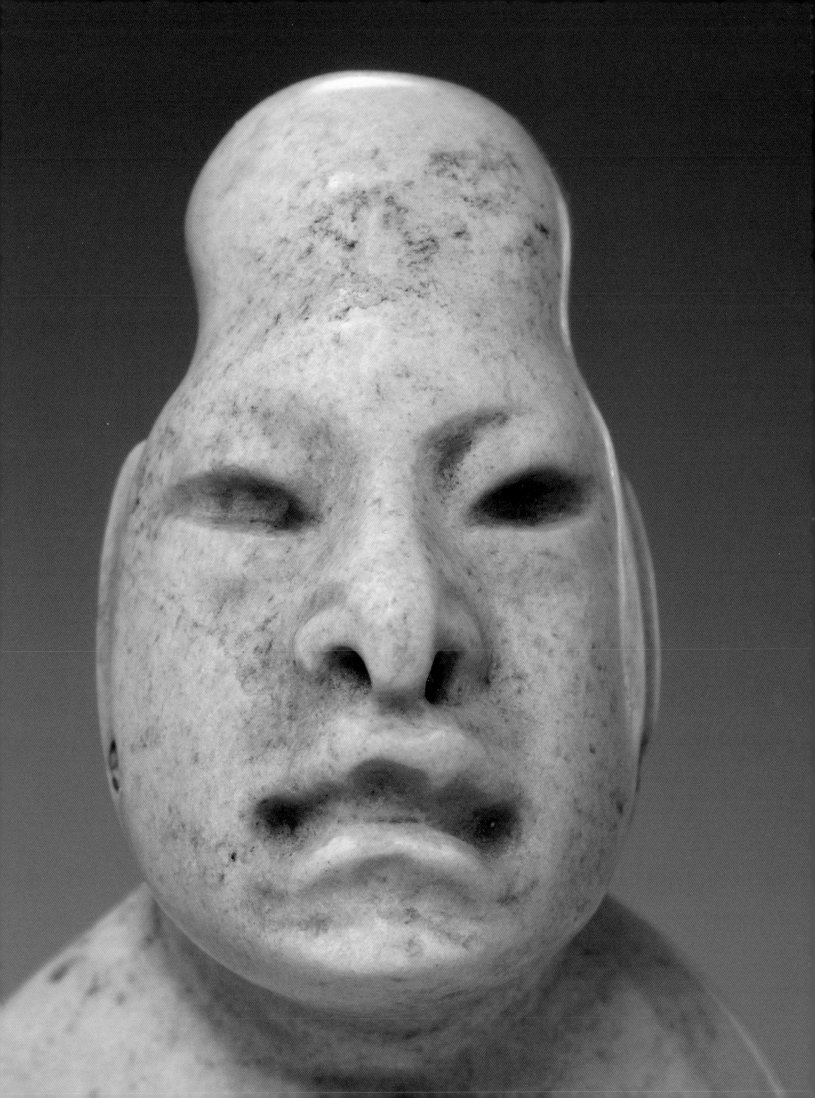

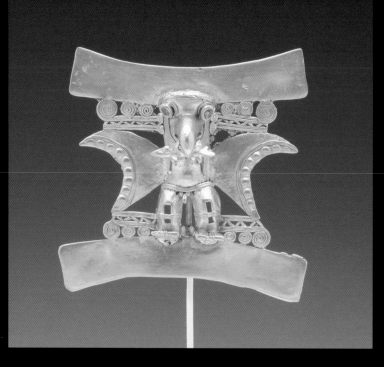

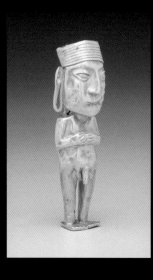

PLATE 179
Standing Male Figure
Inca, Peru, 1435–1534
Gold, 2¼ x ¹³⁄₁₆ x ⅝ in. (5.7 x 2.06 x 1.59 cm)
Gift of Thomas T. Solley, B.A. 1950

PLATE 180
Pendant with a Bird-Headed Figure
Diquís, Costa Rica, ca. A.D. 800–1500
Gold, 4 x 3¹⁵⁄₁₆ x 1³⁄₁₆ in. (10.2 x 10 x 3 cm)
The Harold A. Strickland, Jr., Collection

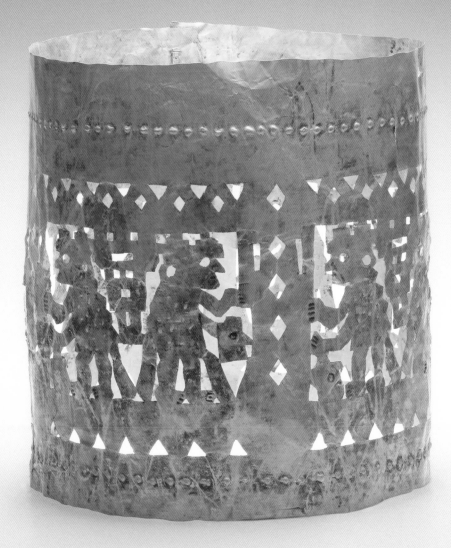

PLATE 182
Relief from the Tomb of Mentu-em-hat
Egyptian, 680–640 B.C.
Limestone with red pigment, 19½ x 29½ in. (49.5 x 74.9 cm)
Gift of William Kelly Simpson, B.A. 1947, M.A. 1948, PH.D. 1954,
in memory of his father, Hon. Kenneth F. Simpson, B.A. 1917,
and grandfather, Nathan Todd Porter, B.A. 1890

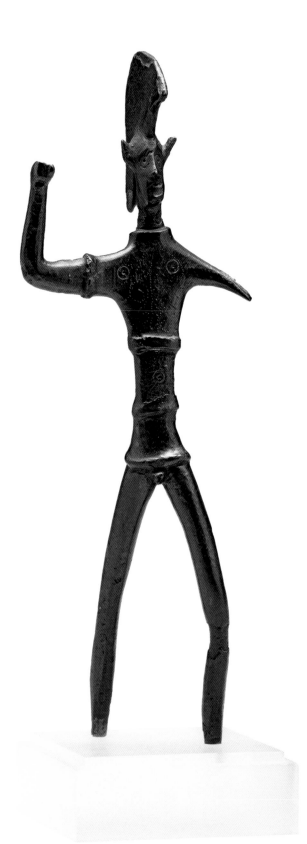

Above:

PLATE 183

The Hartog Master (Etruscan, Umbro-Sabellian,
active late 5th century B.C.)

Figure of a Warrior, late 5th century B.C.

Bronze, 7¹⁵⁄₁₆ x 2¹³⁄₁₆ x 1⅜ in. (20.2 x 7.1 x 3.5 cm)

Partial gift and promised bequest of Erika and Thomas Leland
Hughes, B.A. 1945, LL.B. 1949

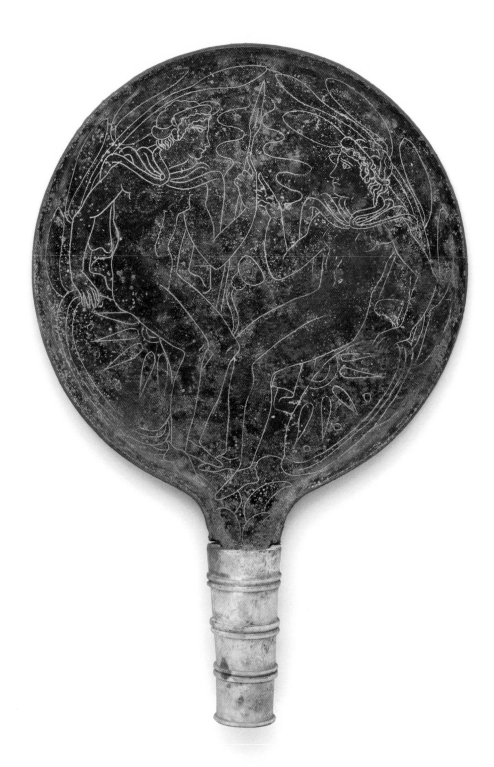

PLATE 184
Mirror
Etruscan, 4th–3rd century B.C.
Bronze with ivory or bone handle, H. 10⁷⁄₁₆ X DIAM. 6¹³⁄₁₆ in.
(26.5 x 17.3 cm)
Partial gift and promised bequest of Erika and Thomas Leland
Hughes, B.A. 1945, LL.B. 1949

PLATE 185 (detail pages 198–99)
The Spiky Garland Group (Etruscan, 3rd century B.C.)
Mirror, early 3rd century B.C.
Cast bronze with incised decoration, H. 9¹³⁄₁₆ X DIAM. 4¹³⁄₁₆ in.
(24.9 x 12.2 cm)
Gift of Molly and Walter Bareiss, B.S. 1940s

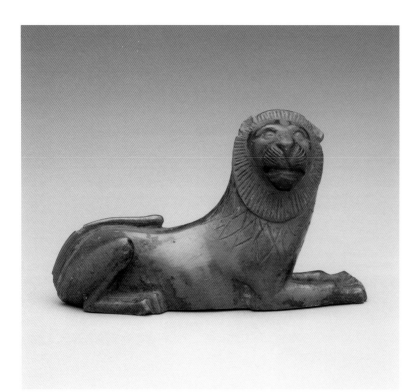

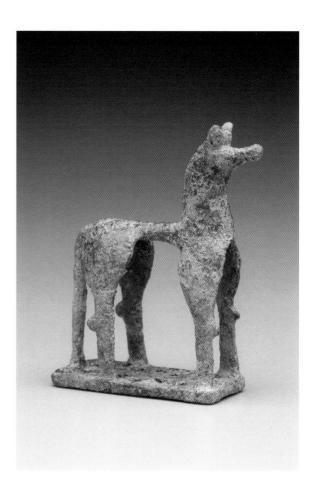

PLATE 186
Recumbent Lion
Greek, Laconian, ca. 570–530 B.C.
Bronze, 2⅛ x 1⁵⁄₁₆ x 3½ in. (5.4 x 3.3 x 8.9 cm)
Promised bequest of Jan Mayer

PLATE 187
Standing Horse
Greek, Corinthian, 8th century B.C.
Bronze, 2¹¹⁄₁₆ x 2⅛ x ¹³⁄₁₆ in. (6.9 x 5.4 x 2.1 cm)
Gift of Jan Mayer

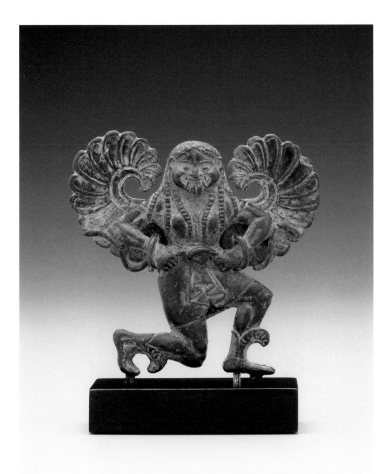

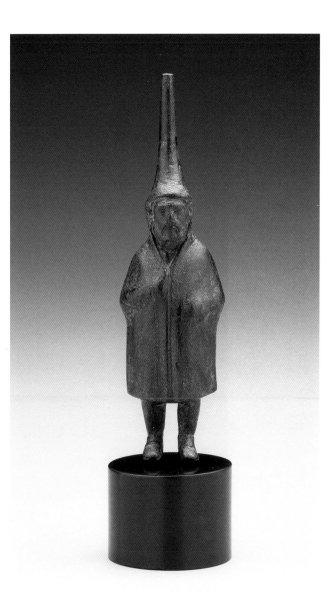

PLATE 188
Running Gorgon
Greek, ca. 540 B.C.
Bronze, 3½ x 3¹/₁₆ x ⁹/₁₆ in. (8.9 x 7.8 x 1.43 cm)
Ruth Elizabeth White Fund and gift of Cornelius C. Vermeule
in memory of Emily Townsend Vermeule

PLATE 189
Genius Cucullatus
Roman, Gallic or Germanic, 2nd century A.D.
Bronze with red copper inlay, 4¾ x 1⅜ x ⁹/₁₆ in.
(12.1 x 3.5 x 1.43 cm)
Gift of Thomas T. Solley, B.A. 1950

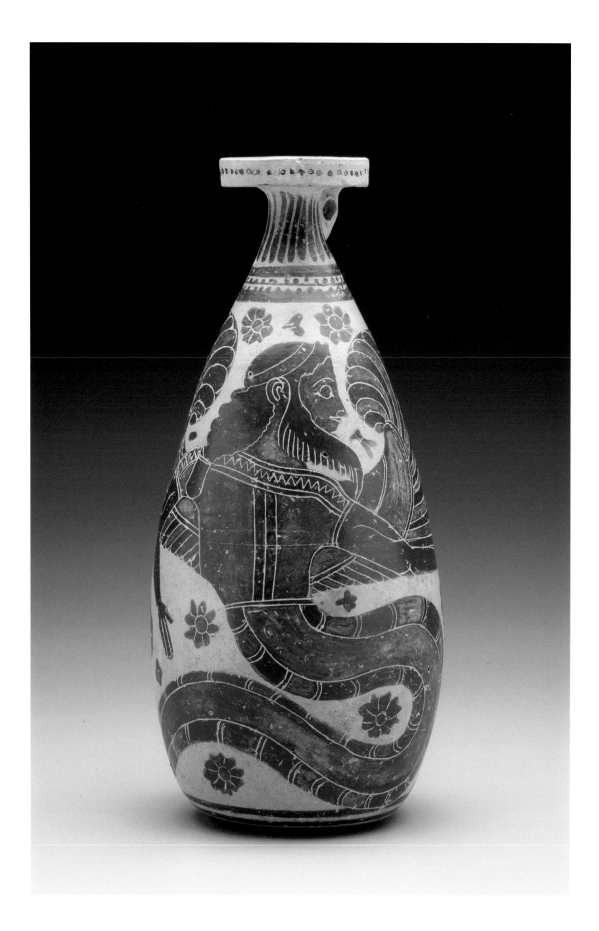

PLATE 190
The Erlenmeyer Painter (Greek, Corinthian,
active late 7th century B.C.)
Alabastron with Typhon, ca. 610–600 B.C.
Terracotta, 10¼ x 4¹¹⁄₁₆ x ¾ in. (26 x 11.9 x 1.90 cm)
The Harold A. Strickland, Jr., Collection

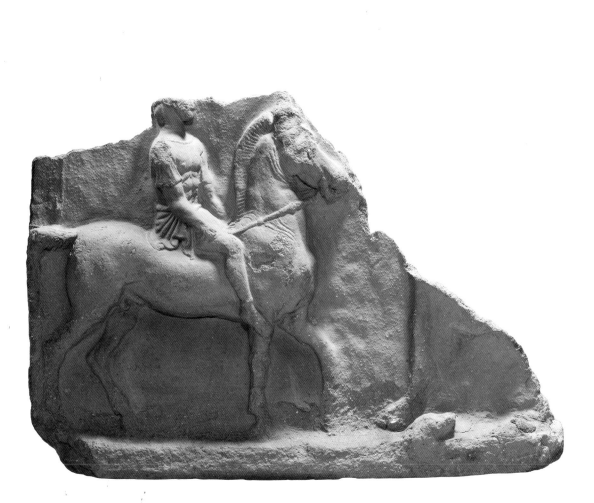

PLATE 191
Relief of a Cavalryman
Greek, 5th century B.C.
Terracotta, 11¾ x 16¾ x 2³⁄₁₆ in. (29.9 x 42.6 x 5.5 cm)
Promised bequest of Jane Davis Doggett, M.F.A. 1956

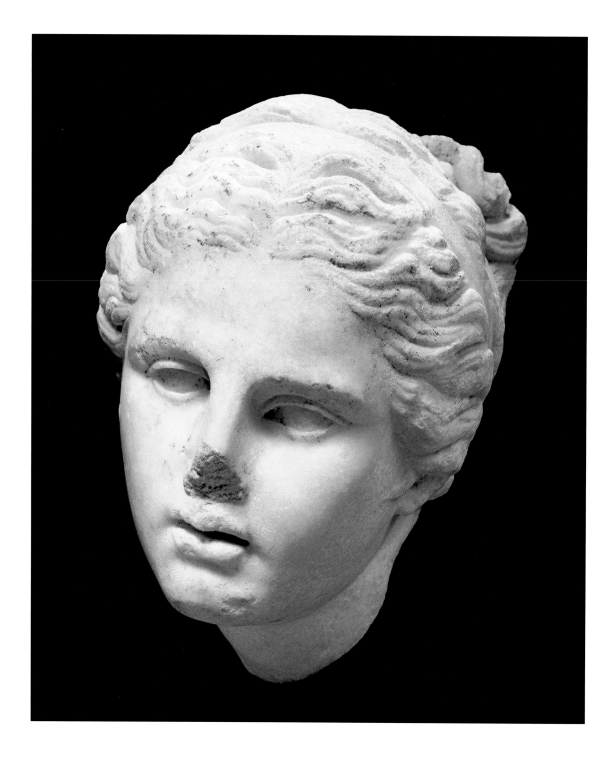

PLATE 192
Head of Aphrodite
Greek, Hellenistic, second half 2nd century B.C.
Marble, 8½ x 5¼ x 7½ in. (21.6 x 13.3 x 19.1 cm)
Promised bequest of Jan Mayer

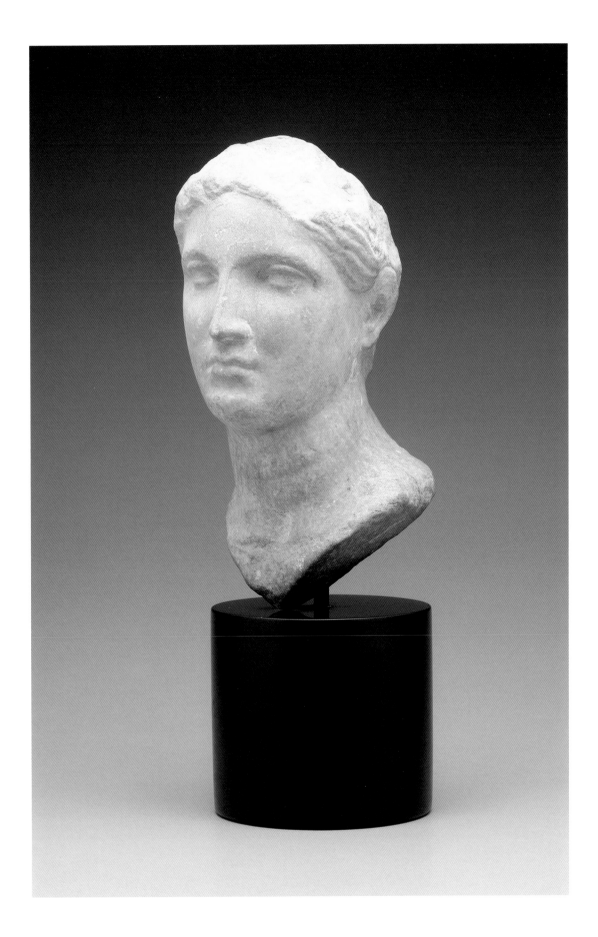

PLATE 193
Portrait of a Ptolemaic Queen, probably Arsinoe III
Egyptian or Greek, late 3rd–early 2nd century B.C.
Marble, 9¼ x 4⁵⁄₁₆ x 4¾ in. (23.5 x 11 x 12.1 cm)
The Harold A. Strickland, Jr., Collection

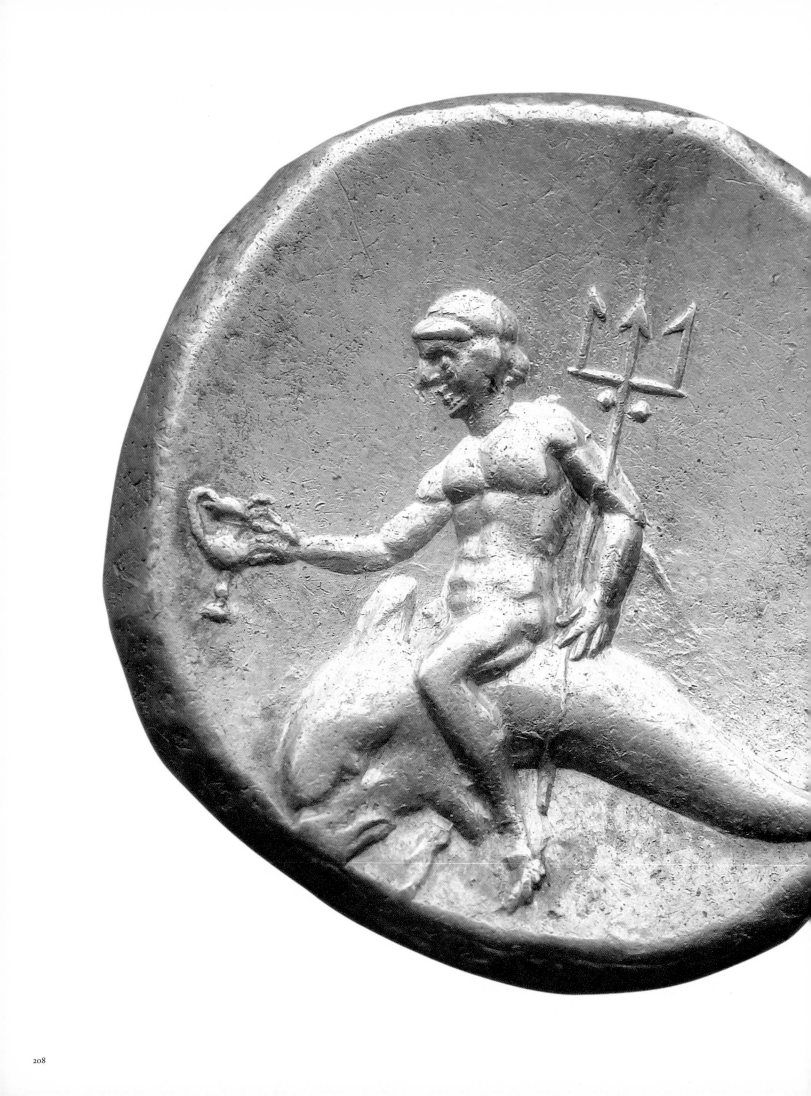

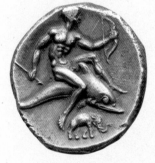
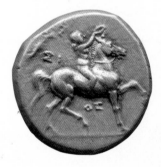
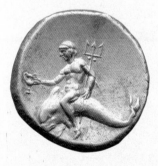

Top:
PLATE 194 (obverse and reverse)
Stater of Carthage
Carthage, 350–270 B.C.
Electrum, 7.39 gm, 6:00, 19 mm
Promised gift of Mary and James H. Ottaway, Jr., B.A. 1960

Center:
PLATE 195 (obverse and reverse)
Stater of Tarentum
Tarentum, 280–270 B.C.
Silver, 6.36 gm, 12:00, 21 mm
The Peter R. and Leonore Franke Collection; Ruth Elizabeth
White Fund

Bottom:
PLATE 196 (obverse and reverse, detail opposite)
Stater of Tarentum
Tarentum, 270–250 B.C.
Silver, 6.59 gm, 5:00, 20 mm
Promised gift of Mary and James H. Ottaway, Jr., B.A. 1960

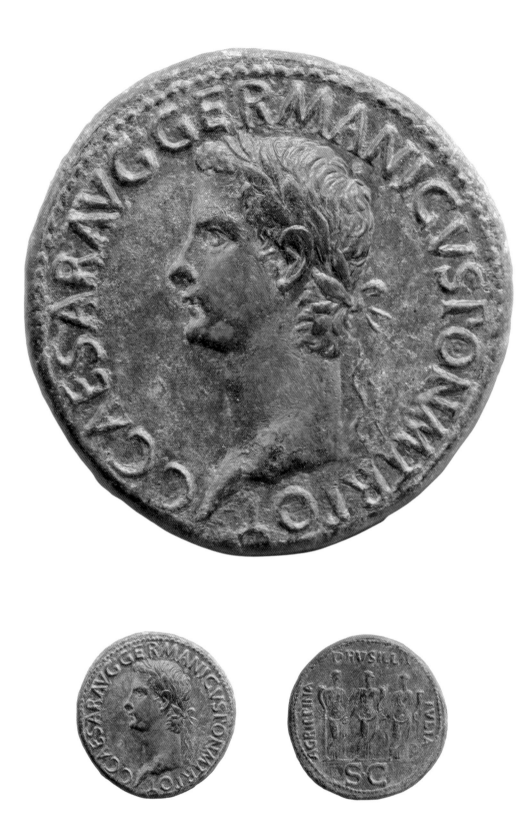

PLATE 197 (obverse and reverse, detail above)
Sestertius of Caligula
Rome, A.D. 37
Orichalcum, 28.1 gm, 6:00, 35 mm
Ruth Elizabeth White Fund

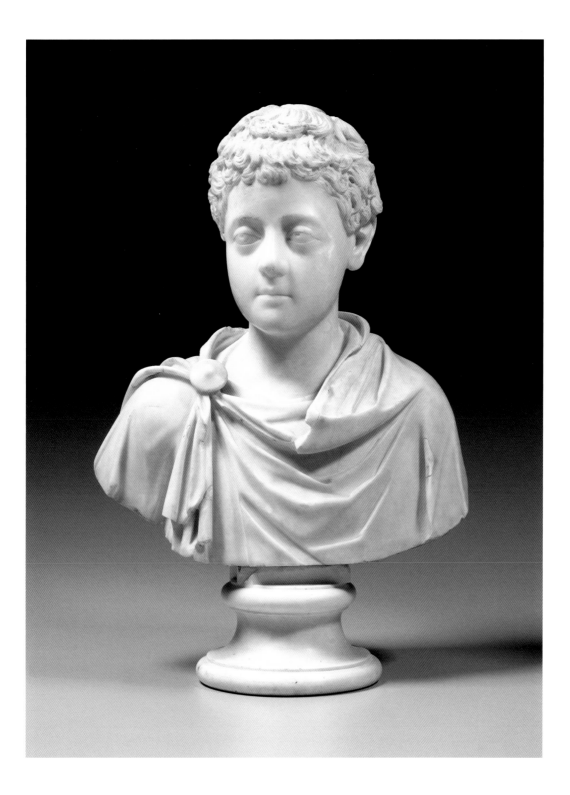

PLATE 198
Portrait of the Emperor Commodus as a Boy
Roman, A.D. 172/73
Marble, 13 x 15 x 7½ in. (33 x 38.1 x 19.1 cm)
Ruth Elizabeth White Fund

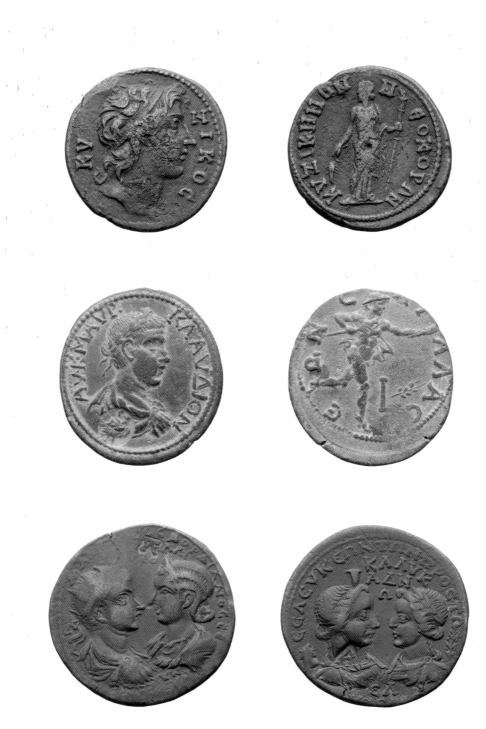

Top:

PLATE 199 (obverse and reverse)
Pseudo-Autonomous Copper Coin of Cyzicus
Cyzicus, 2nd–3rd century A.D.
Copper, 13.72 gm, 6:00, 30 mm
The Peter R. and Leonore Franke Collection; Ruth Elizabeth
White Fund

Center:

PLATE 200 (obverse and reverse)
10-Assaria of Claudius II
Sagalassus, A.D. 268–70
Bronze, 17.51 gm, 12:00, 31 mm
The Peter R. and Leonore Franke Collection; Ruth Elizabeth
White Fund

Bottom:

PLATE 201 (obverse and reverse)
Copper Coin of Gordian III and Tranquillina
Seleucia ad Calycadnum, A.D. 238–44
Copper, 21.52 gm, 6:00, 36 mm
The Peter R. and Leonore Franke Collection; Ruth Elizabeth
White Fund

PLATE 202 (details)
Column with a Capital Depicting the Adoration of the Magi
French, Saint-Martin de Savigny (Rhône), ca. 1150–60
Limestone, 54 x 19 in. (137.2 x 48.3 cm)
Gift of Ambassador and Mrs. Joseph Verner Reed, Jr., B.A. 1961

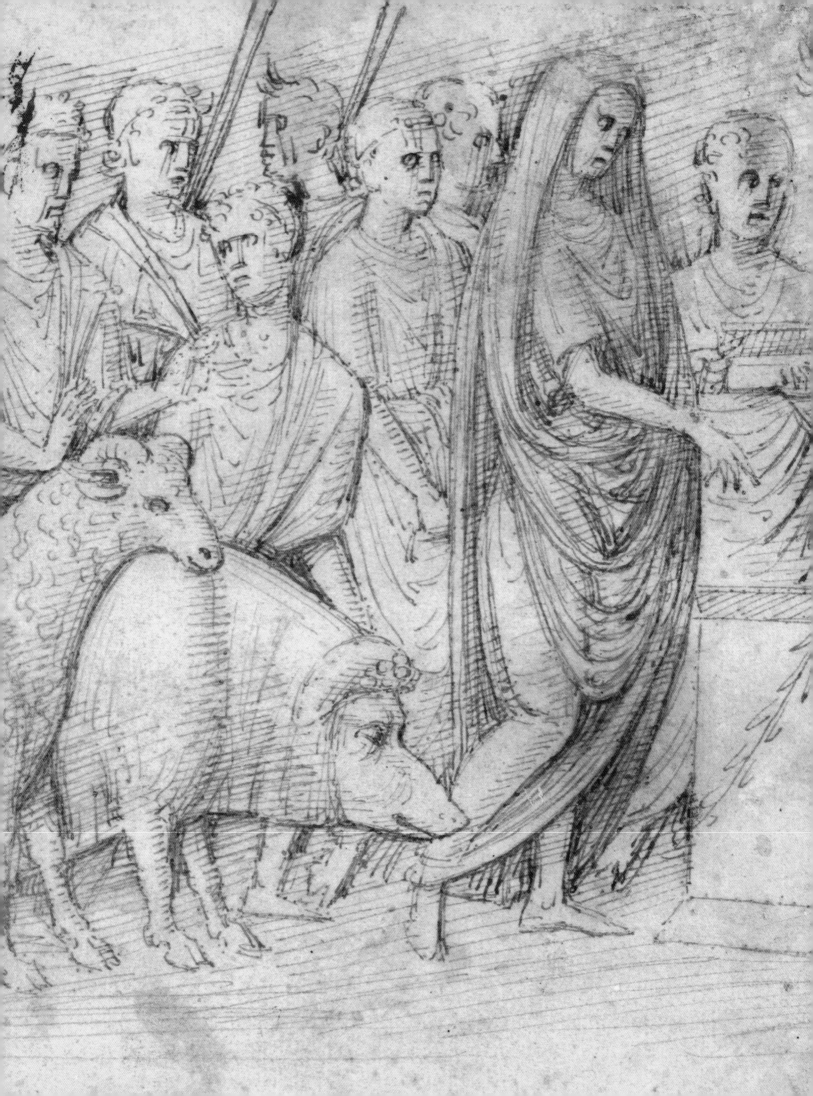

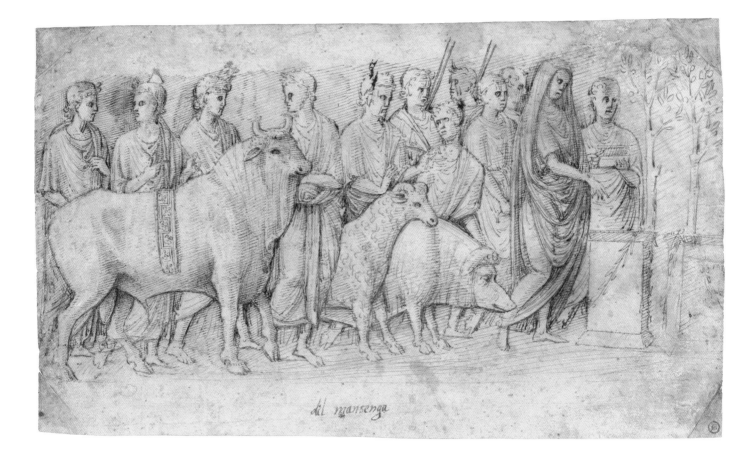

PLATE 203 (detail opposite)
Unknown artist (Italian, probably Paduan)
Study after a Roman Sacrificial Relief: The Suovetaurilia, ca. 1485
Pen and brown ink over black chalk on vellum, pricked for
transfer, 6⁹⁄₁₆ x 11¼ in. (16.7 x 28.6 cm)
Promised gift of Lionel Goldfrank III, B.A. 1965

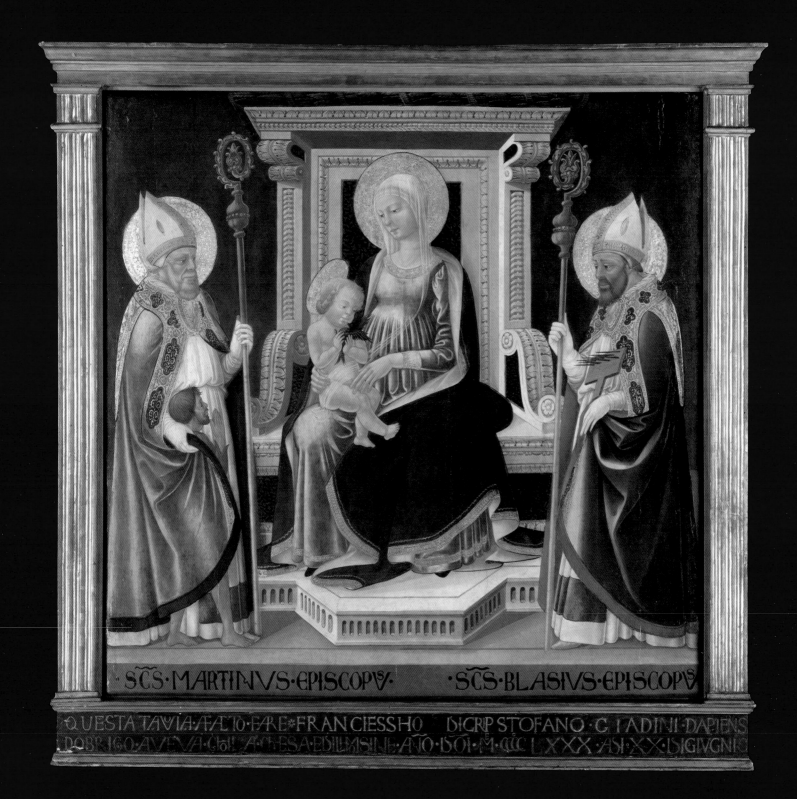

SCS · MARTINVS · EPISCOPV · · · SCS · BLASIVS · EPISCOPV

QUESTA TAVIA · AEL IO · FARE · FRANCIESSHO DICRP STOFANO · CIADINI DAPIENS
DOBRIGO · AVEVA · Ch · ACHESA EDILIMSINE · ANO 1501 · M·CCC LXXX · ASI XX · DIGIVGNI

PLATE 204
Neri di Bicci (Italian, Florence, 1418–1492)
*Virgin and Child Enthroned with Saints Martin of Tours
 and Blaise*, 1476
Tempera and gold on panel, 50 x 50 in. (127 x 127 cm)
Gift of Barbara and Robert Liberman, B.A. 1965

216

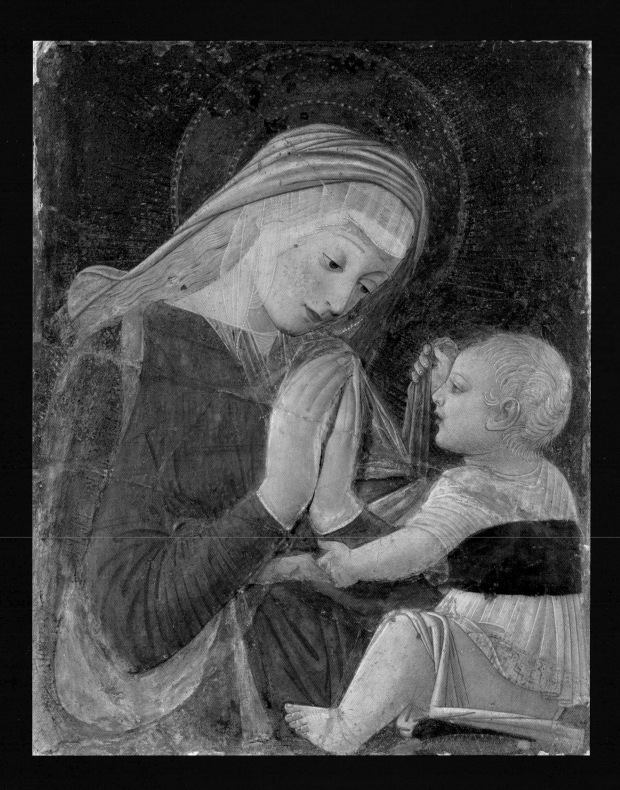

PLATE 205
Desiderio da Settignano (Italian, Florence, 1429/32–1464)
Neri di Bicci (Italian, Florence 1418–1492)
Virgin and Child, ca. 1460–65
Polychrome and gilt stucco relief, 16½ x 13¼ in. (41.9 x 33.7 cm)
Purchased with a gift from Nina Griggs

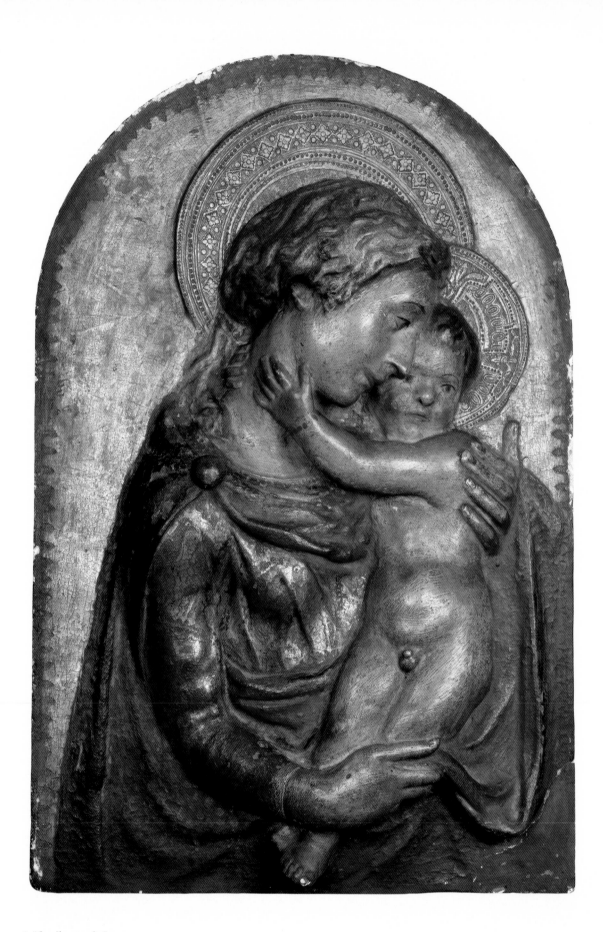

PLATE 206 (detail opposite)
Donatello (Donato di Niccolò di Betto Bardi)
(Italian, Florence, 1386/87–1466)
Matteo di Giovanni (Italian, Siena, 1430–1495/99)
Virgin and Child, 1457–59
Polychrome and gilt stucco relief, 23½ x 15 in. (59.7 x 38.1 cm)
Purchased with a gift from Nina Griggs

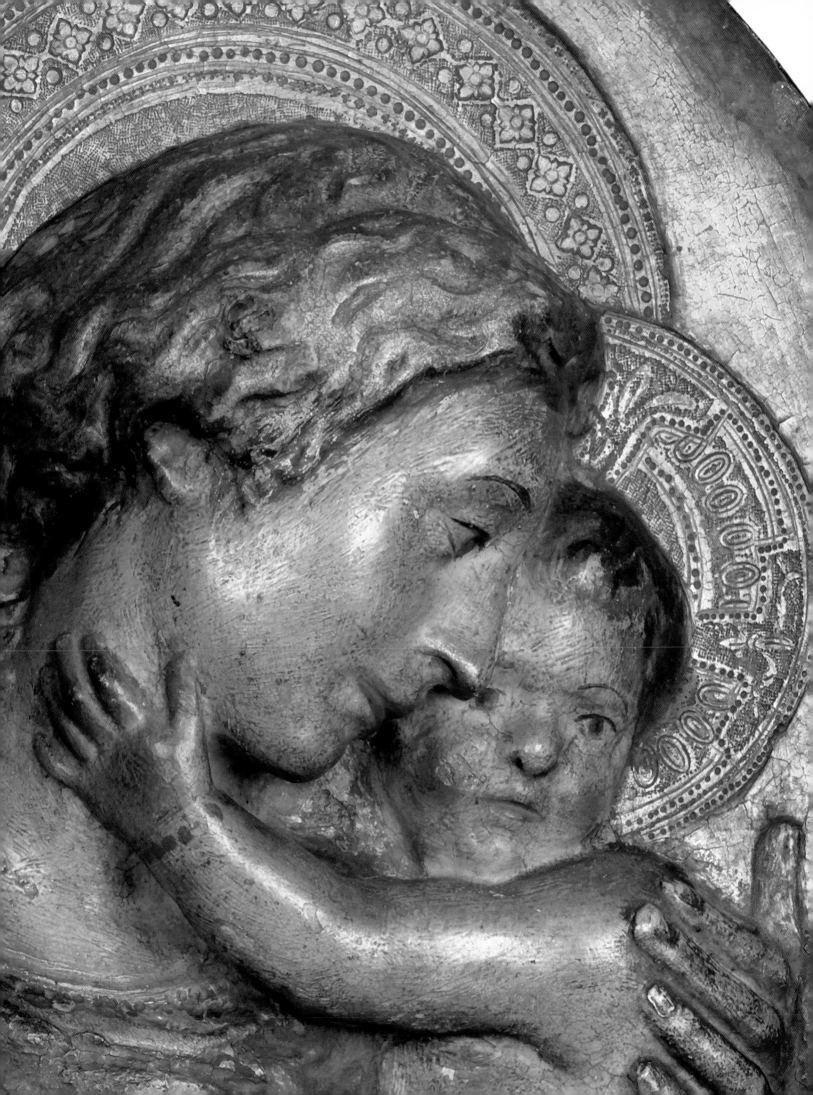

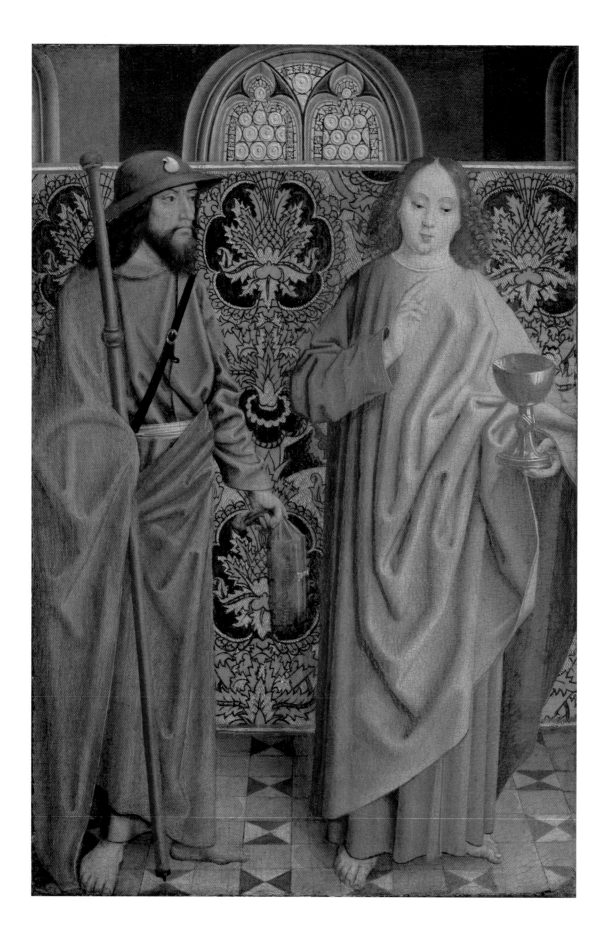

PLATE 207
The Master of the Holy Kinship (Meister der Heiligen Sippe)
(German, Cologne, active ca. 1475–1510)
Saints James the Greater and John the Evangelist, ca. 1505–7
Oil on panel, 19 x 12¹⁵⁄₁₆ in. (48.3 x 32.9 cm)

Pending partial purchase and partial gift of Robert and Virginia
Stern, parents of Adam C. Stern, B.A. 1982, in honor of all the
families in Europe who were dispossessed during the Holocaust
period 1933 to 1945

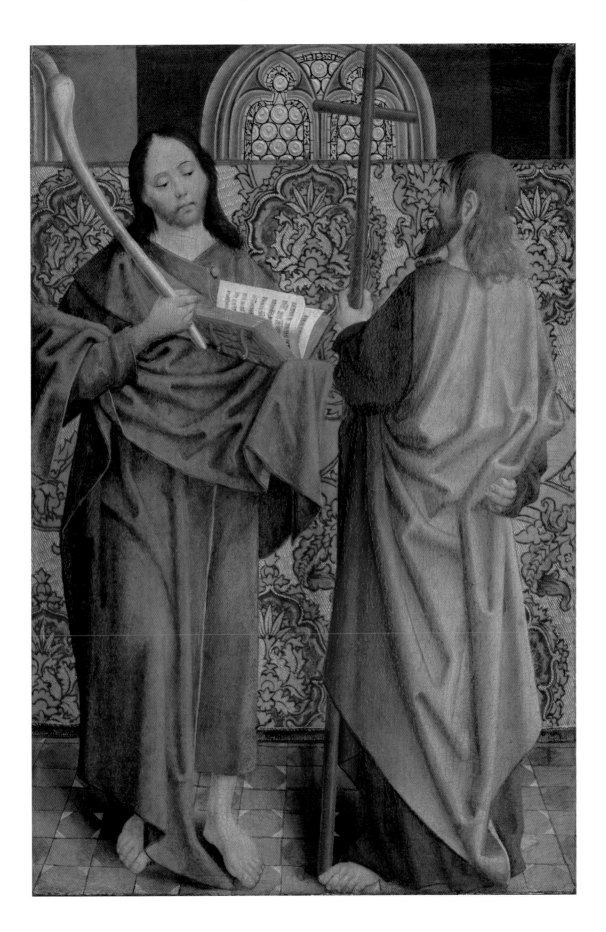

PLATE 208
The Master of the Holy Kinship (Meister der Heiligen Sippe)
(German, Cologne, active ca. 1475–1510)
Saints James the Lesser and Philip, ca. 1505–7
Oil on panel, 19 x 12¹⁵⁄₁₆ in. (48.3 x 32.9 cm)

Pending partial purchase and partial gift of Robert and Virginia
Stern, parents of Adam C. Stern, B.A. 1982, in honor of all the
families in Europe who were dispossessed during the Holocaust
period 1933 to 1945

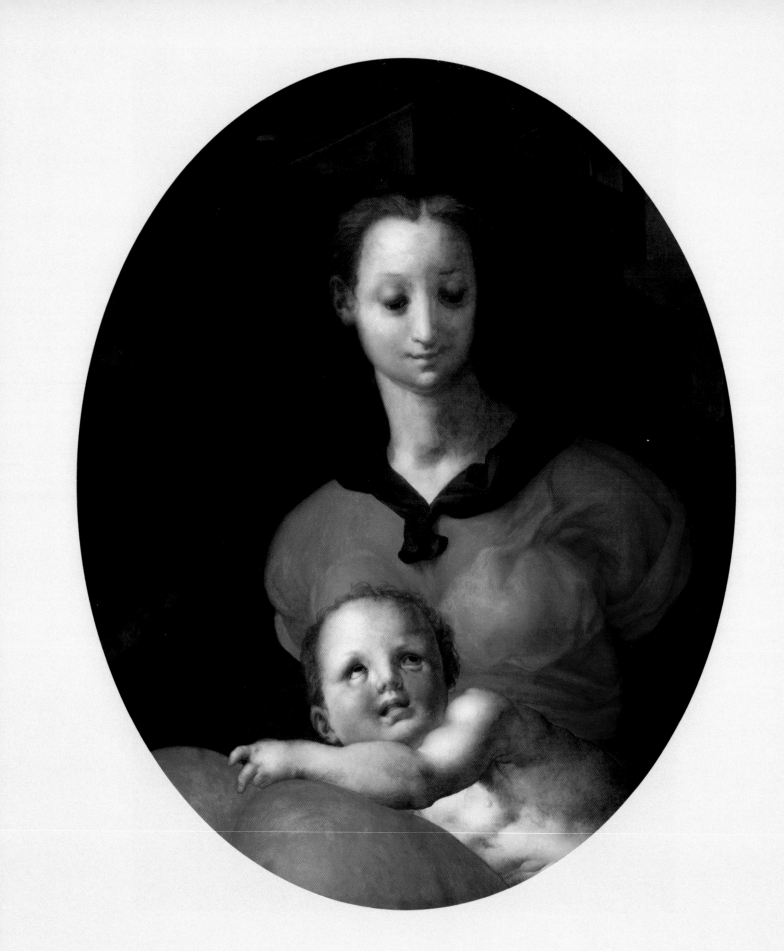

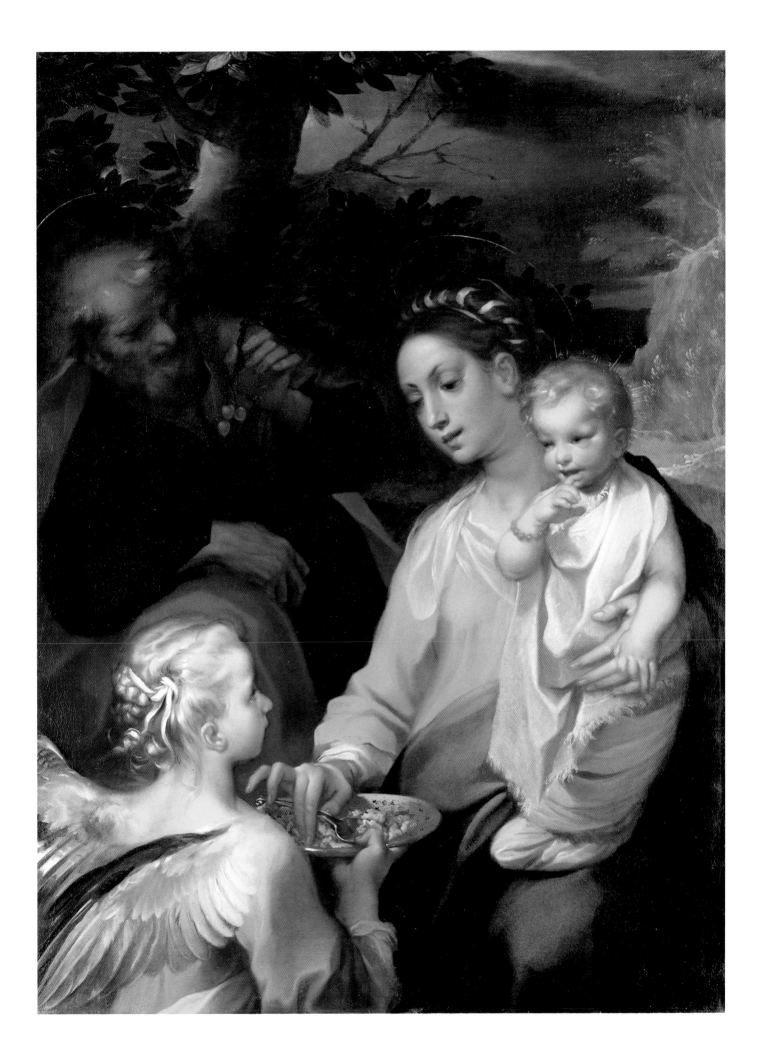

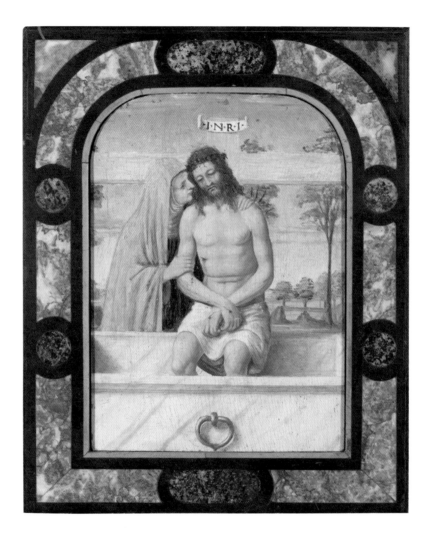

PLATE 211
Attributed to Andrea Solario (Italian, Lombardy, ca. 1465–ca. 1524)
The Entombment, ca. 1510
Oil on panel, 4⁷⁄₁₆ x 3⅜ in. (11.3 x 8.6 cm)
Gift of Edmund P. Pillsbury, B.A. 1965

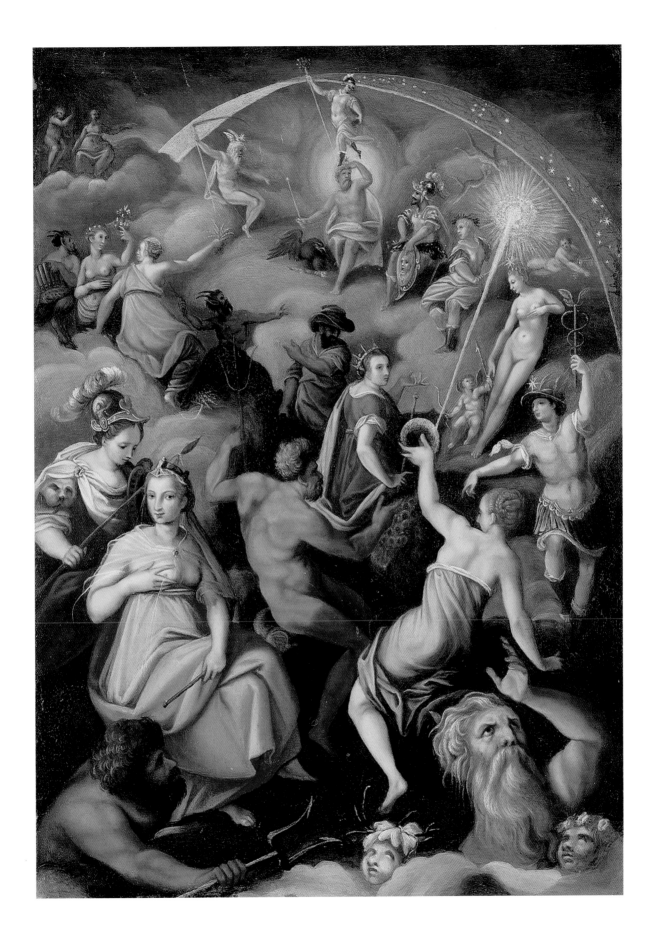

PLATE 212
Jacopo Zucchi (Italian, Florence, ca. 1540–ca. 1596)
The Assembly of the Gods, 1575–76
Oil on copper, 18¾ x 15⅝ in. (47.6 x 39.7 cm)
Gift of Edmund P. Pillsbury, B.A. 1965

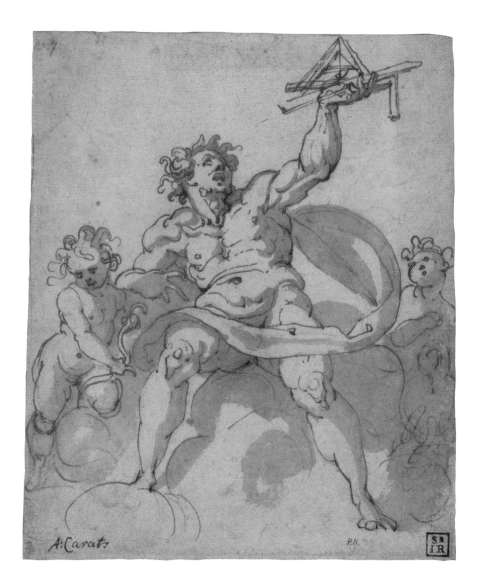

PLATE 213
Jacopo Zucchi (Italian, ca. 1540–ca. 1596)
An Allegory of Architecture: A Male Figure with Two Putti, ca. 1585
Pen, brown ink, and wash over black chalk, 7¹³⁄₁₆ x 6⁹⁄₁₆ in.
(19.8 x 16.7 cm)
Gift of Edmund P. Pillsbury, B.A. 1965

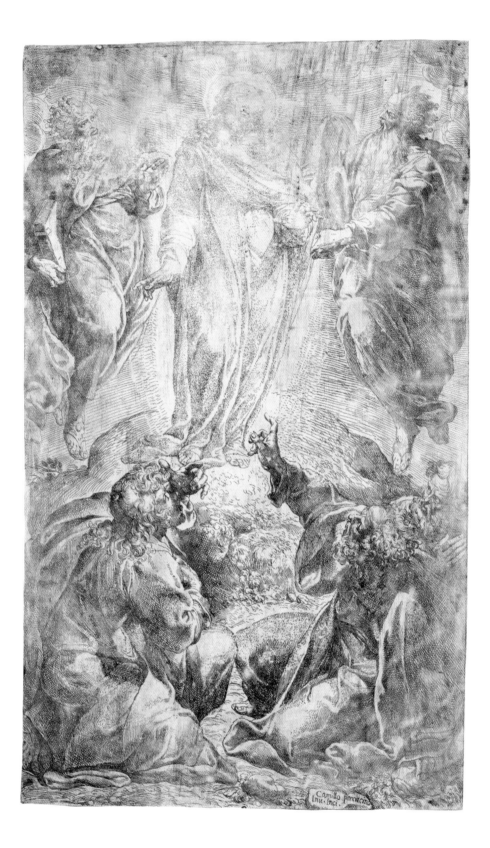

PLATE 214
Camillo Procaccini (Italian, ca. 1555–1629)
The Transfiguration, 1587–90
Etching, sheet 21⅞ x 13⅜ in. (55.6 x 34 cm)
Everett V. Meeks, B.A. 1901, Fund

Dieu declara son vueil à Ieremie,
Et luy donnant Prophetique sçauoir,
Vn pot bouillât luy fait clairemêt voir
Et d'Amandier vne verge fleurie j.

Incontinent ce bien-heureux Prophete,
Court anoncer par les estranges lieux,
De toutes gês qui croiêt aux faux Dieux
Tel qu'estoit Baal, la ruine & deffaicte.

Ieremie montre quel est le pouuoir de Dieu par l'exemple d'vn Potier, & predict la ruyne de Ierusalem. Ierem.18.19.& 20.

Par le Potier, qui faict de son argille
Dessus sa rouë vn pot bon ou cassé,
Le sainct Prophete aux Iuifs à denoncé,
Que toute chose est à Dieu tres-facile.

Il montre en fin, brisant vne bouteille,
Ierusalem estre destruicte vn iour, ij.
Dequoy Phassur indigné, sans seiour
Captif le meine, oyant telle merueille.

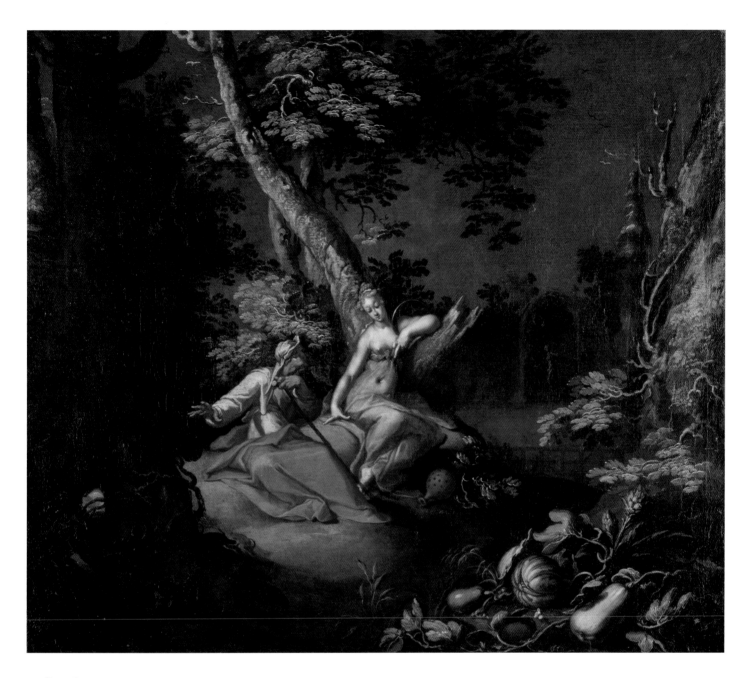

Opposite, top:
PLATE 215
Unknown artist, published by Charles le Vigoureux (French, 1547–1605)
Dieu arreste Jeremie pour Prophete, & luy faict voir un pot bouillant & une verge d'Amandier fleurie (God Calls Jeremiah to Be a Prophet and Shows Him a Boiling Pot and a Branch of a Flowering Almond Tree) (Jeremiah 1), no. 1 from *The Story of Jeremiah*, ca. 1580
Woodcut with hand coloring and stencil, from a series of six, approx. 14³⁄₁₆ x 18⅞ in. (36 x 47.9 cm)
Everett V. Meeks, B.A. 1901, Fund

Opposite, bottom:
PLATE 216
Unknown artist, published by Charles le Vigoureux (French, 1547–1605)
Jeremie montre quel est le pouvoir de Dieu par l'exemple d'un Potier, & predict la ruyne de Jerusalem (Jeremiah Shows the Power of God by the Example of a Potter, and Predicts the Ruin of Jerusalem) (Jeremiah 18–20), no. 2 from *The Story of Jeremiah*, ca. 1580
Woodcut with hand coloring and stencil, from a series of six, approx. 14³⁄₁₆ x 18⅞ in. (36 x 47.9 cm)
Everett V. Meeks, B.A. 1901, Fund

Above:
PLATE 217
Abraham Bloemaert (Dutch, 1566–1651)
Landscape with Vertumnus and Pomona, ca. 1600
Oil on canvas, mounted on board, 34 x 39 in. (86.4 x 99.1 cm)
Gift of John Walsh, B.A. 1961

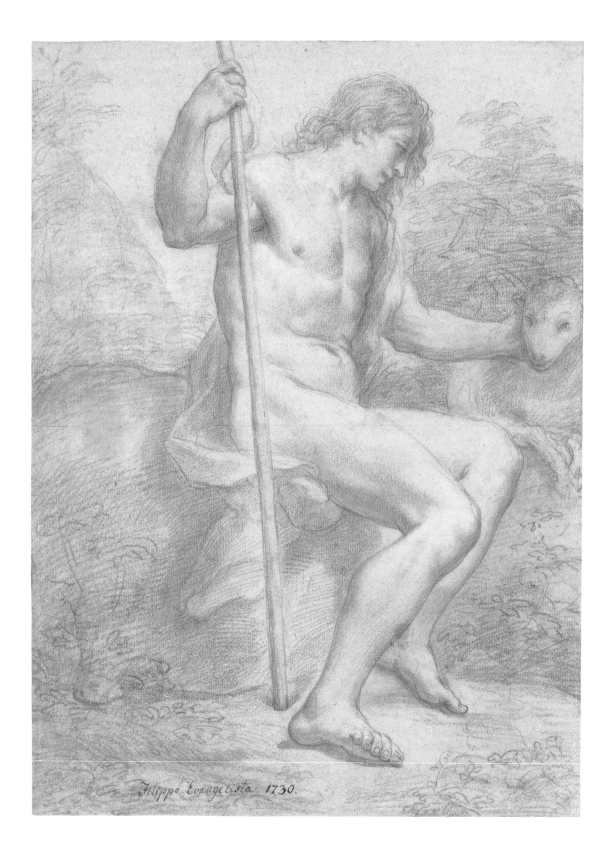

PLATE 218
Filippo Evangelisti (Italian, 1684–1761)
Saint John the Baptist, 1730
Red and white chalk, 21¾ x 16 in. (55.3 x 40.6 cm)
Gift of John Walsh, B.A. 1961, in memory of Frederick R. Mayer,
B.A. 1950

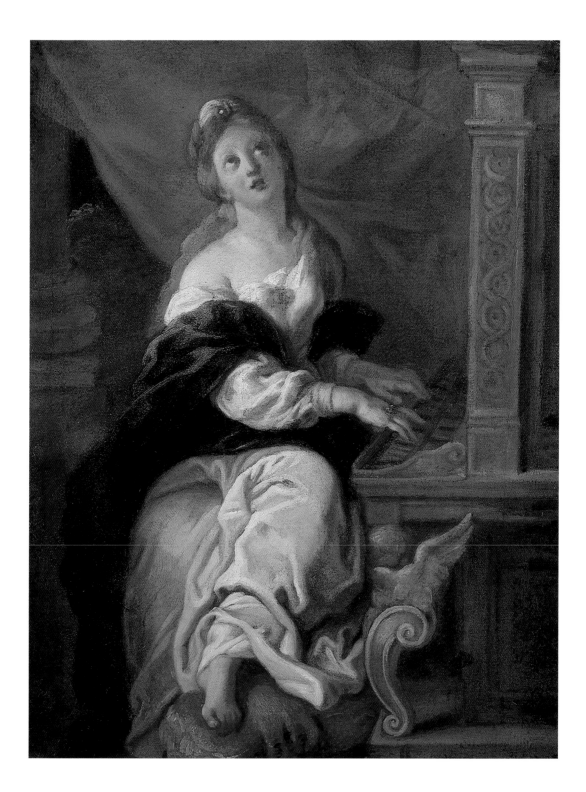

PLATE 219
Charles de La Fosse (French, 1636–1716)
Saint Cecilia, ca. 1700
Oil on paper, laid down on panel, 16¼ x 13¼ x 2 in.
(41.3 x 33.7 x 5.1 cm)
Gift of Mr. and Mrs. Edward A. Friedman, B.A. 1971,
and Mr. and Mrs. Gary D. Friedman, B.A. 1973

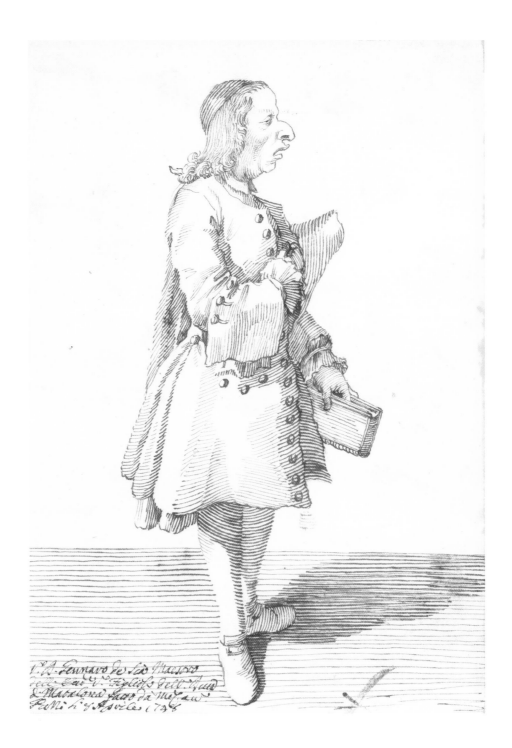

PLATE 220
Pier Leone Ghezzi (Italian, 1674–1755)
Portrait of Gennaro de Scà, April 8, 1748
Pen and brown ink, 10$\frac{15}{16}$ x 7$\frac{13}{16}$ in. (27.8 x 19.8 cm)
Purchased with a gift from Frederick Goldstein, B.A. 1955,
in honor of Suzanne Boorsch

PLATE 221
Gabriel de Saint-Aubin (French, 1724–1780)
Les deux amants (*The Two Lovers*), 1750
Etching, 4½ x 4¾ in. (11.4 x 12.1 cm)
Promised bequest of Judith L. Pillsbury and Henry A. Pillsbury,
B.A. 1958, M.A. 1960, in memory of Georges May

PLATE 222
Jacques-Louis David (French, 1748–1825)
Statue of Flora Seen from the Front, in the Palazzo Giustiniani, Rome,
ca. 1775–80
Red chalk, 9⁷⁄₁₆ x 5⁷⁄₁₆ in. (24 x 13.8 cm)
The Lawrence and Regina Dubin Family Collection, Gift of
Dr. Lawrence Dubin, B.S. 1955, M.D. 1958, and Regina Dubin

PLATE 223
Pierre-Paul Prud'hon (French, 1758–1823)
Une famille dans la désolation (*A Grief-Stricken Family*), 1821
Oil on canvas, 14¹⁵⁄₁₆ x 12¹⁄₁₆ in. (37.9 x 30.6 cm)
Purchased with the Leonard C. Hanna, Jr., B.A. 1913, Fund and a
gift in memory of James Sherman Pitkin

PLATE 224
Charles Marville (French, 1816–1879)
Rue d'Écosse, 1865–69
Albumen print, 12¾ x 10½ in. (32.4 x 26.7 cm)
Everett V. Meeks, B.A. 1901, Fund

PLATE 225
Louis-Émile Durandelle (French, 1838–1917)
Le nouvel Opéra de Paris, sculpture ornementale (*The New Paris
Opera, Ornamental Sculpture*), 1865
Albumen print, 14¾ x 11 in. (37.5 x 27.9 cm)
Everett V. Meeks, B.A. 1901, Fund

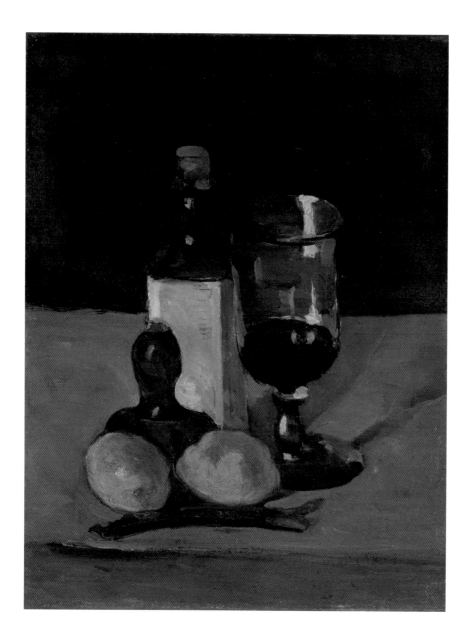

PLATE 226
Paul Cézanne (French, 1839–1906)
Bouteille, verre, et citrons (*Bottle, Glass, and Lemons*),
1867–69, possibly later
Oil on canvas, 14 x 10 in. (35.6 x 25.4 cm)
Gift from the Estate of Paul Mellon, B.A. 1929, L.H.D. Hon. 1967

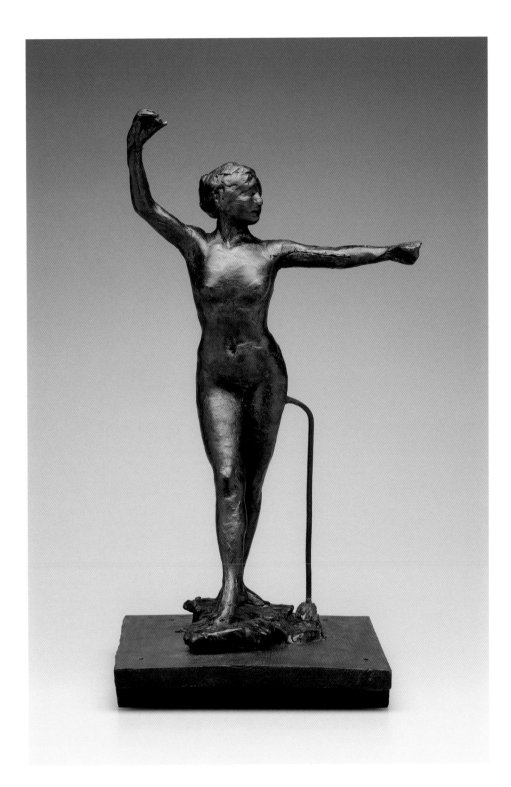

PLATE 227
Edgar Degas (French, 1834–1917)
Dancer Ready to Dance, with Right Foot Forward, 1882–95
Wax and mixed media, 22 x 13¾ x 8¼ in. (55.9 x 34.9 x 21 cm)
Gift from the Estate of Paul Mellon, B.A. 1929, L.H.D. Hon. 1967

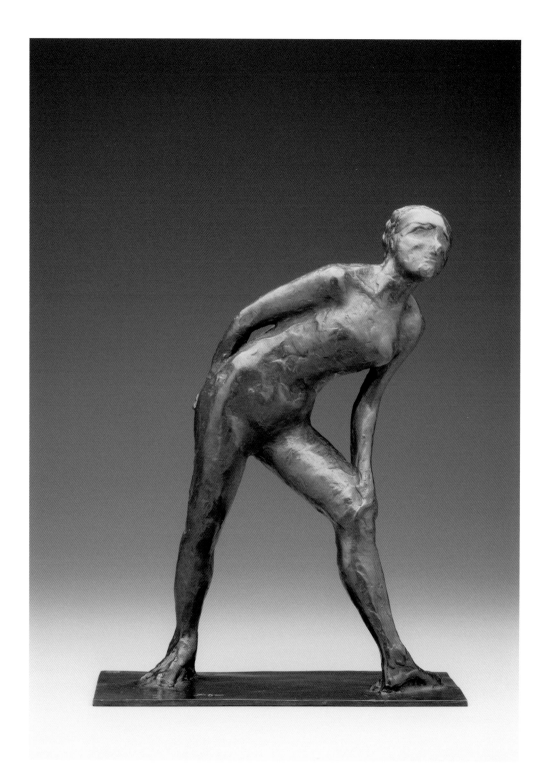

PLATE 228
Edgar Degas (French, 1834–1917)
Dancer Rubbing Her Knee (*Dancer in the Role of Harlequin*),
1920s, cast from a wax sculpture modeled ca. 1885
Bronze, 12 x 3¹¹⁄₁₆ x 6½ in. (30.5 x 9.4 x 16.5 cm)
Gift of Molly and Walter Bareiss, B.S. 1940s

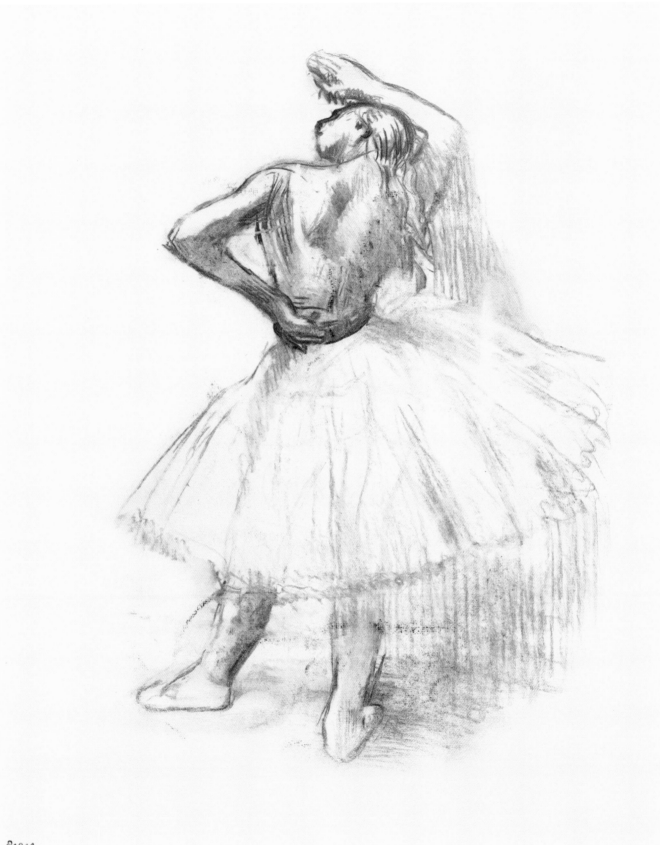

Degas

PLATE 229
Edgar Degas (French, 1834–1917)
Danseuse debout, le bras droit levé (*Standing Dancer,
Right Arm Raised*), ca. 1891
Counterproof of a drawing, 24 x 18½ in. (61 x 47 cm)
Gift of Molly and Walter Bareiss, B.S. 1940s

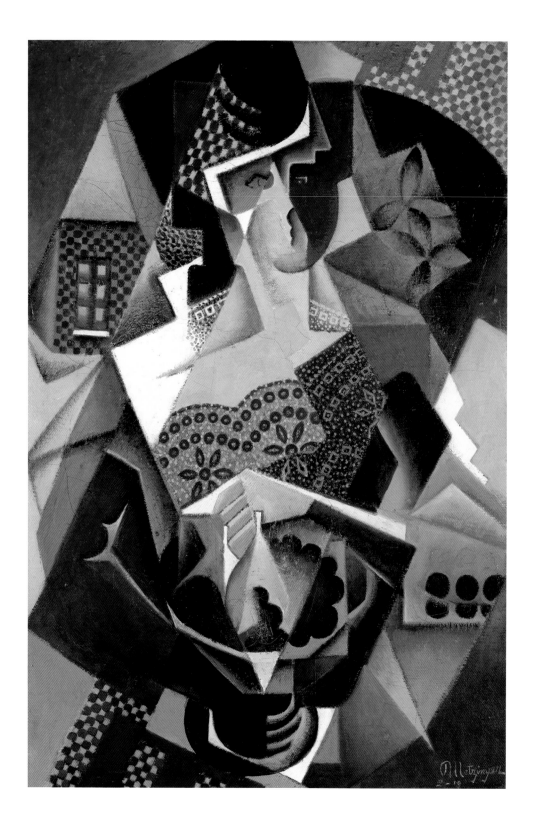

PLATE 230
Jean Metzinger (French, 1883–1956)
Femme au compotier (*Woman with a Fruit Bowl*), 1918
Oil on canvas, 31¼ x 21⅜ in. (79.4 x 54.3 cm)
Gift of Polly W. Hamilton, M.A. 1941, PH.D. 1948, in memory of
George Heard Hamilton

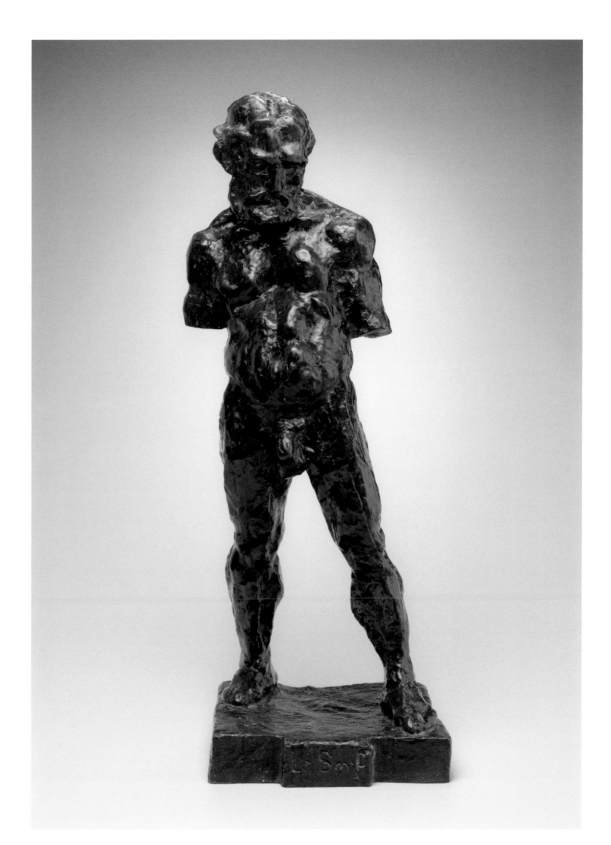

PLATE 231
Henri Matisse (French, 1869–1954)
Le serf (*The Serf*), 1901–3
Bronze, 36⅜ x 13¼ x 12⅜ in. (92.4 x 33.7 x 31.4 cm)
Charles B. Benenson, B.A. 1933, Collection, Courtesy of
Lawrence B. Benenson

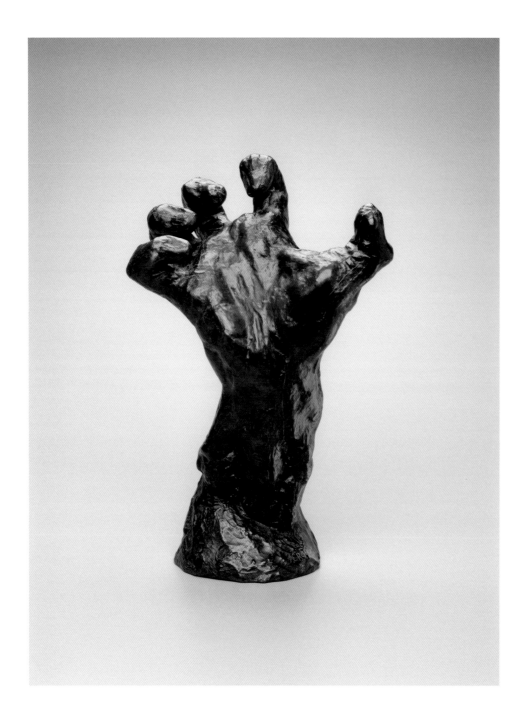

PLATE 232
Auguste Rodin (French, 1840–1917)
Le main crispé (*The Clenched Hand*), ca. 1885
Bronze, 18½ x 12½ x 6¼ in. (47 x 31.8 x 15.9 cm)
Charles B. Benenson, B.A. 1933, Collection, Courtesy of
Lawrence B. Benenson

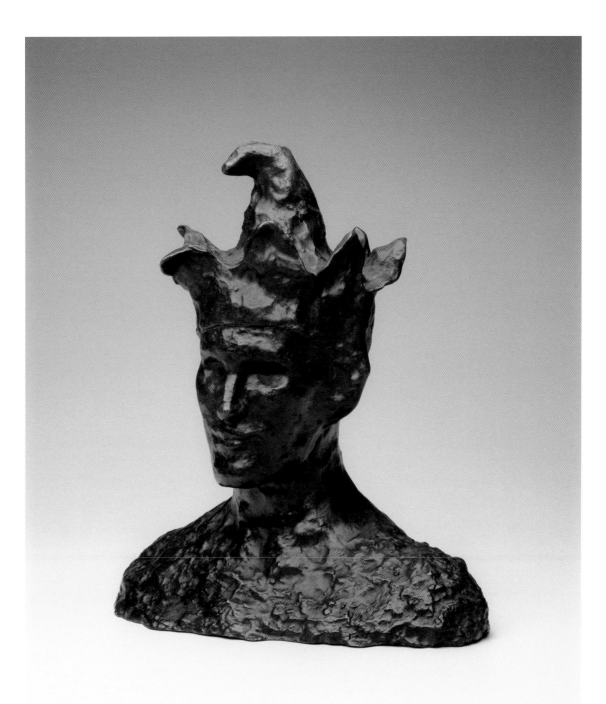

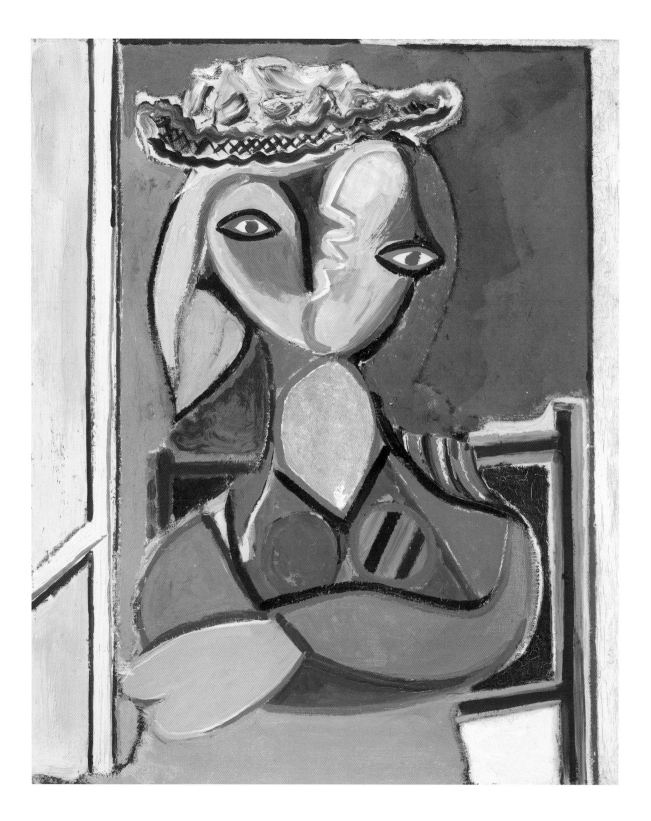

PLATE 234
Pablo Picasso (Spanish, 1881–1973)
Femme assise (Marie-Thérèse), 1936
Oil on canvas, 28¾ x 23½ in. (73 x 59.7 cm)
Charles B. Benenson, B.A. 1933, Collection

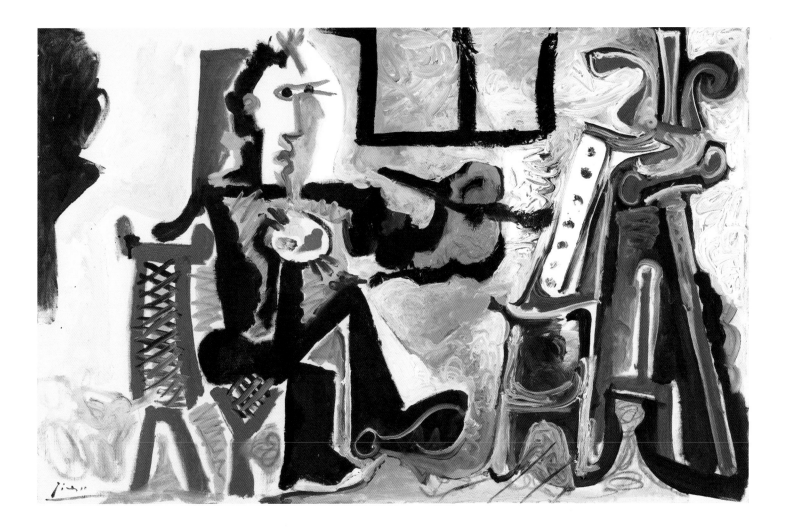

PLATE 235
Pablo Picasso (Spanish, 1881–1973)
Le peintre dans son atelier (*The Artist in His Studio*), 1963
Oil on canvas, 23 x 35½ in. (58.4 x 90.2 cm)
Charles B. Benenson, B.A. 1933, Collection

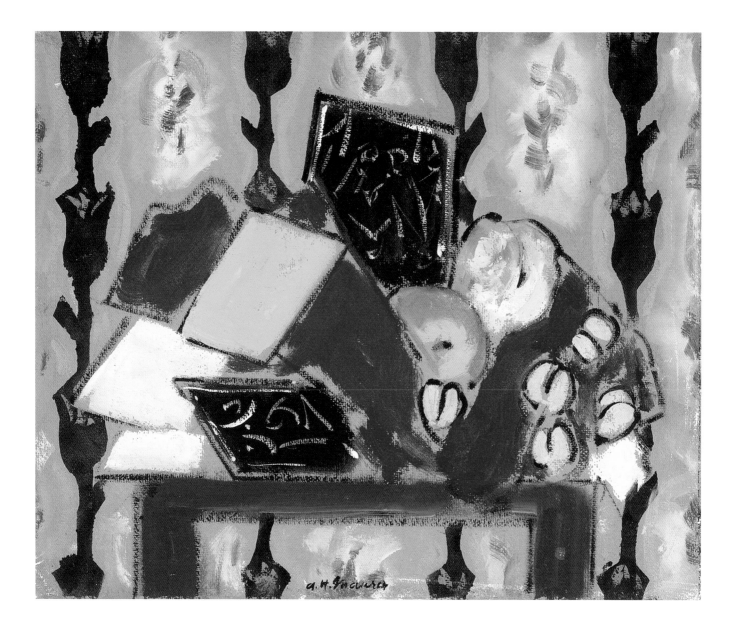

PLATE 236
Alfred Maurer (American, 1868–1932)
Apples and Nuts, 1927–28
Opaque watercolor, 17^{11}/$_{16}$ x 21^{7}/$_{16}$ in. (45 x 54.4 cm)
Gift of George Hopper Fitch, B.A. 1932, and Denise Fitch

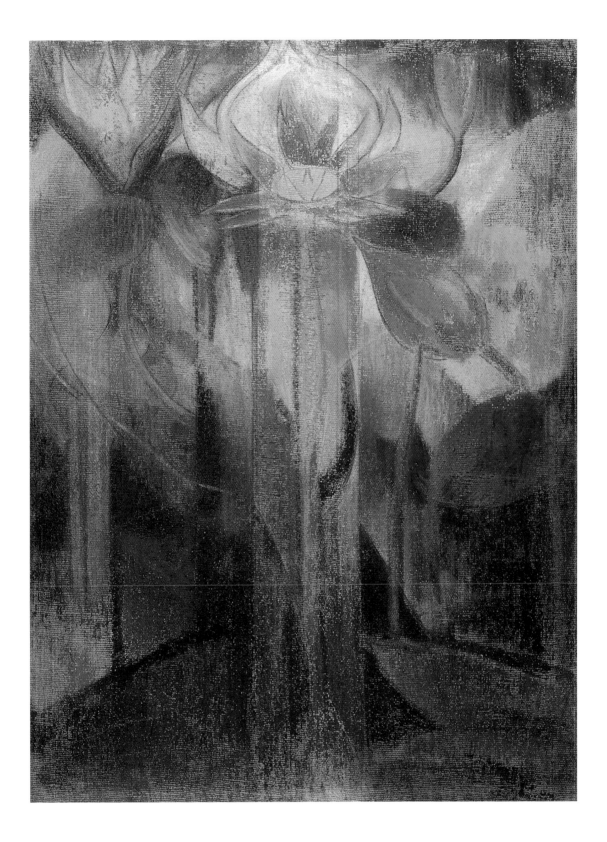

PLATE 237
Joseph Stella (American, born Italy, 1877–1946)
Jungle Foliage, ca. 1918–19
Pastel on gauze-covered paper, 25 x 18⅝ in. (63.5 x 47.3 cm)
Gift of George Hopper Fitch, B.A. 1932, and Denise Fitch

PLATE 238
Pierre Bonnard (French, 1867–1947)
Le châle jaune (*The Yellow Shawl*), ca. 1925
Oil on canvas, 50¼ x 37¾ in. (127.6 x 95.9 cm)
Gift from the Estate of Paul Mellon, B.A. 1929, L.H.D. Hon. 1967

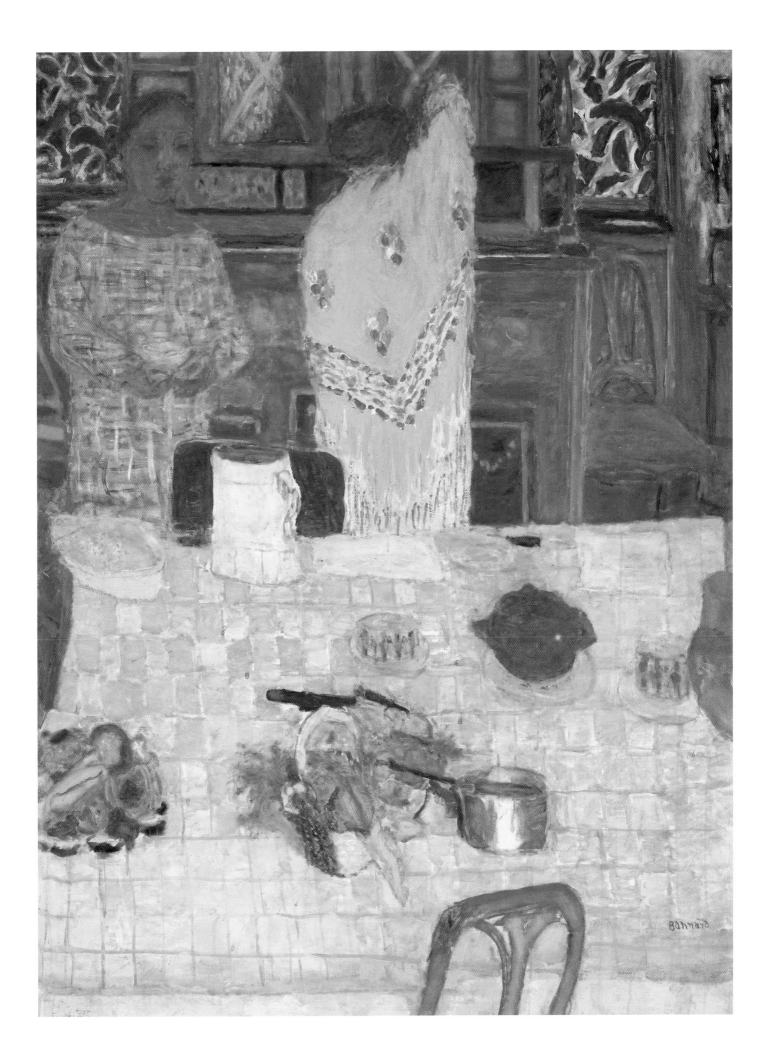

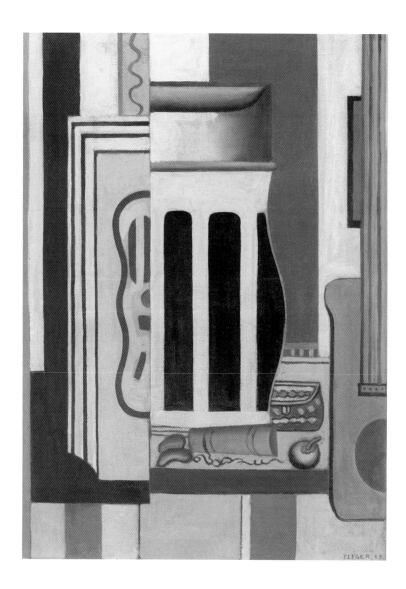

PLATE 239
Fernand Léger (French, 1881–1955)
Nature morte (*Still Life*), 1925
Oil on canvas, 25 x 17¾ in. (63.5 x 45.1 cm)
Promised gift of Thomas Jaffe, B.A. 1971

PLATE 240
Gerald Murphy (American, 1888–1964, B.A. 1912)
Bibliothèque (*Library*), 1926
Oil on canvas, 72½ x 52⅝ in. (184.2 x 133.7 cm)
Purchased with a gift from Alice Kaplan in memory of Allan S.
Kaplan, B.A. 1957, and with the Leonard C. Hanna, Jr., B.A. 1913, Fund

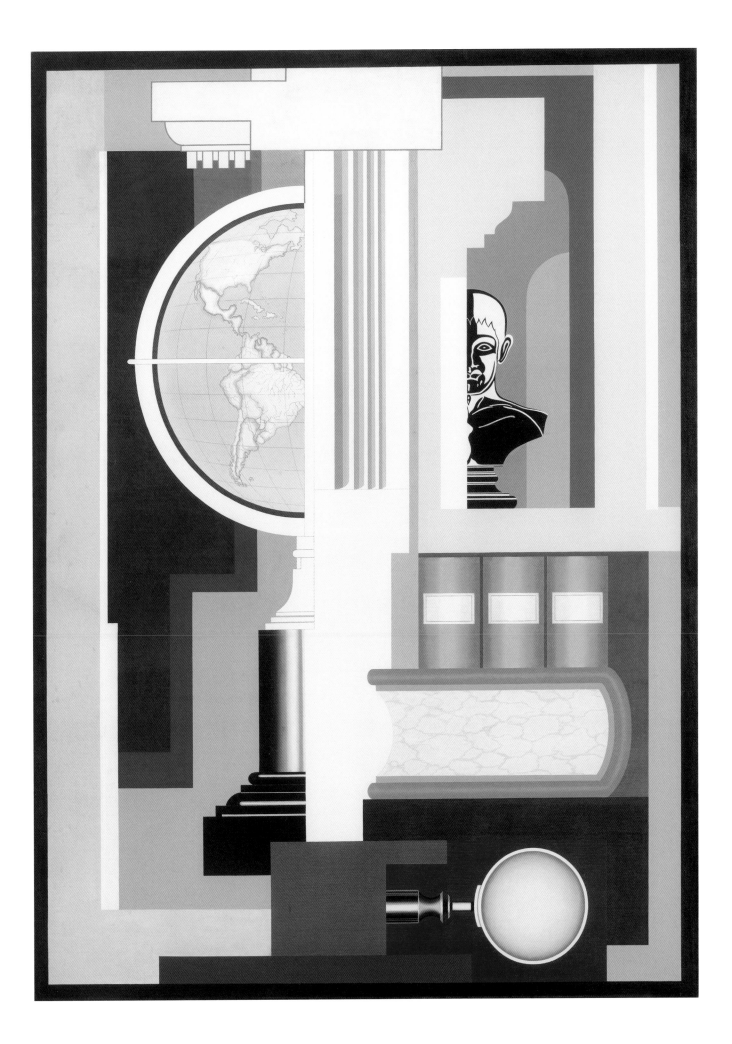

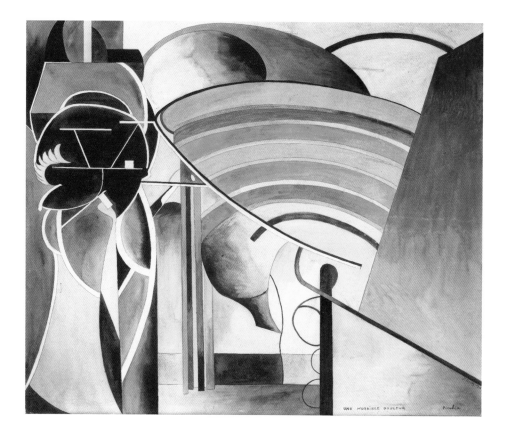

PLATE 241
Francis Picabia (French, 1879–1953)
Une horrible douleur (*A Horrible Pain*), 1914
Watercolor and ink wash, 21 x 25½ in. (53.3 x 64.8 cm)
Charles B. Benenson, B.A. 1933, Collection, Courtesy of
Lawrence B. Benenson

PLATE 242
Kurt Schwitters (German, 1887–1948)
Merzbild mit Regenbogen (*Merz Picture with Rainbow*), 1920/39
Montage and mixed media on plywood, 61⅝ x 47¾ x 10½ in.
(156.5 x 121.3 x 26.7 cm)
Charles B. Benenson, B.A. 1933, Collection

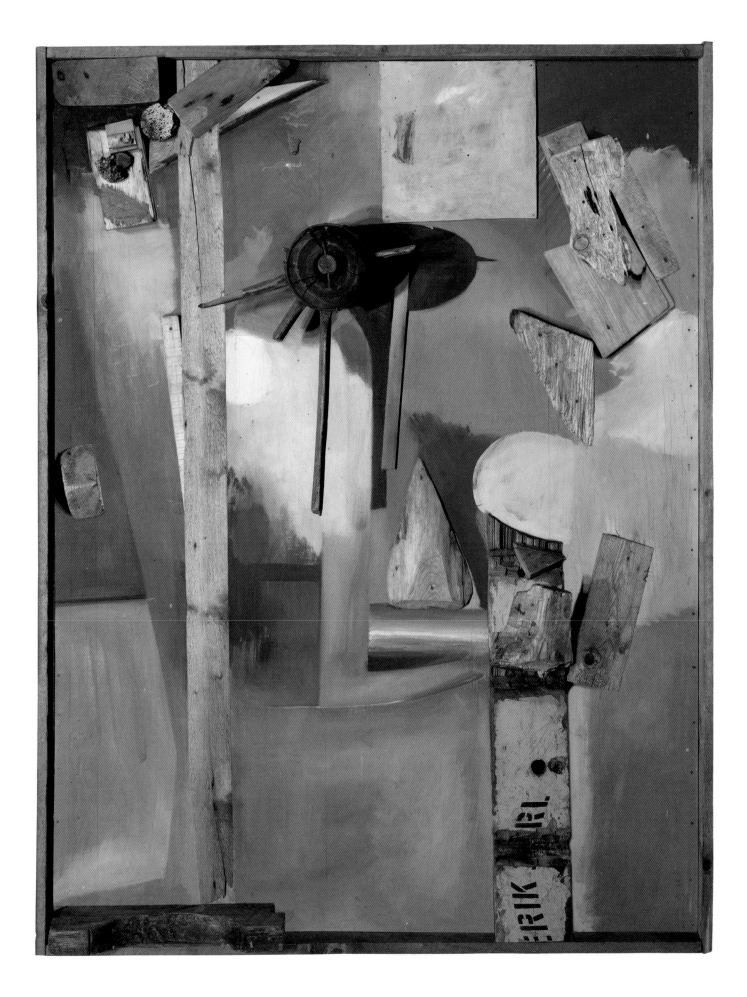

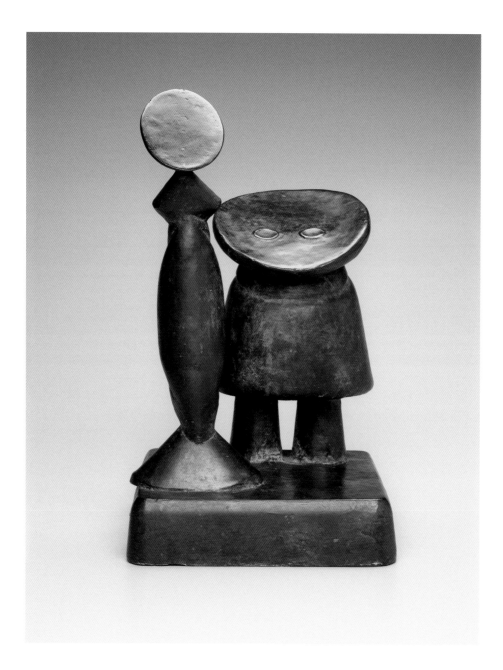

PLATE 243
Max Ernst (German, 1891–1976)
Fille et mère (*Daughter and Mother*), 1959
Bronze, 17½ x 11 x 12 in. (44.5 x 27.9 x 30.5 cm)
Charles B. Benenson, B.A. 1933, Collection, Courtesy of
Lawrence B. Benenson

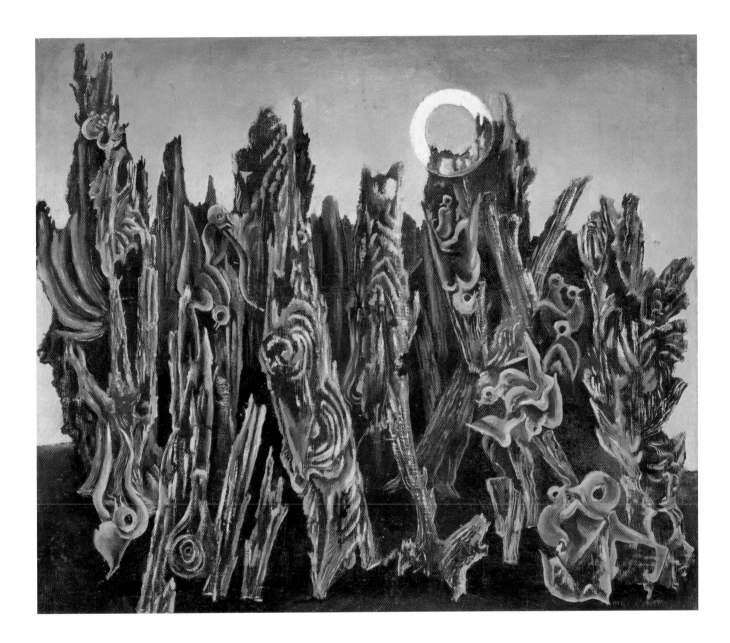

PLATE 244
Max Ernst (German, 1891–1976)
La forêt (*The Forest*), 1926
Oil on canvas, 18¼ x 15¼ in. (46.4 x 38.7 cm)
Gift of Thomas T. Solley, B.A. 1950

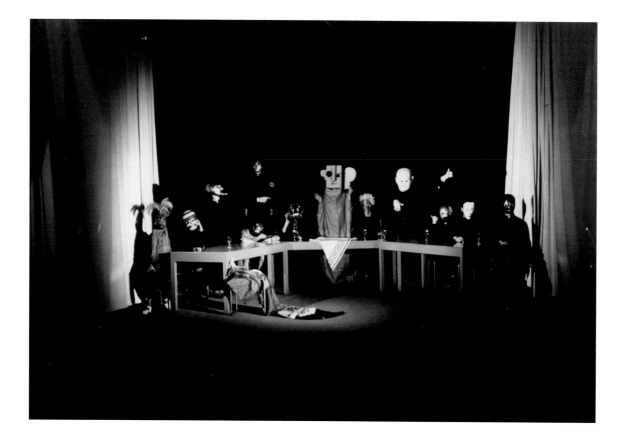

PLATE 245
T. Lux Feininger (American, born Germany, 1910)
Bauhaus Stage, ca. 1920s
Gelatin silver print, 4¼ x 6⁷⁄₁₆ in. (10.8 x 16.3 cm)
Gift of Dorothy and Eugene Prakapas, B.A. 1953,
in memory of Thomas C. Mendenhall

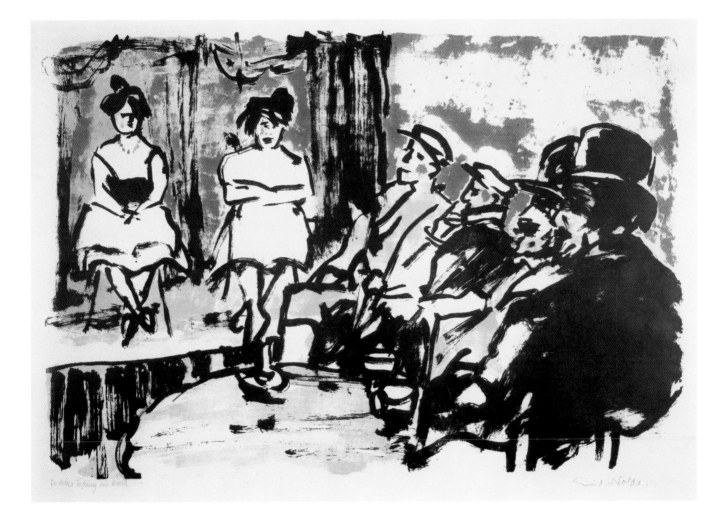

PLATE 246
Emil Nolde (German, 1876–1956)
Tingel-Tangel III, 1907/15
Lithograph from the 1915 edition, with added color,
12¹³⁄₁₆ x 18¹¹⁄₁₆ in. (32.5 x 47.5 cm)
Gift of Thomas P. Perkins III, B.A. 1957, in honor of Henry A.
Ashforth, Jr., B.A. 1952

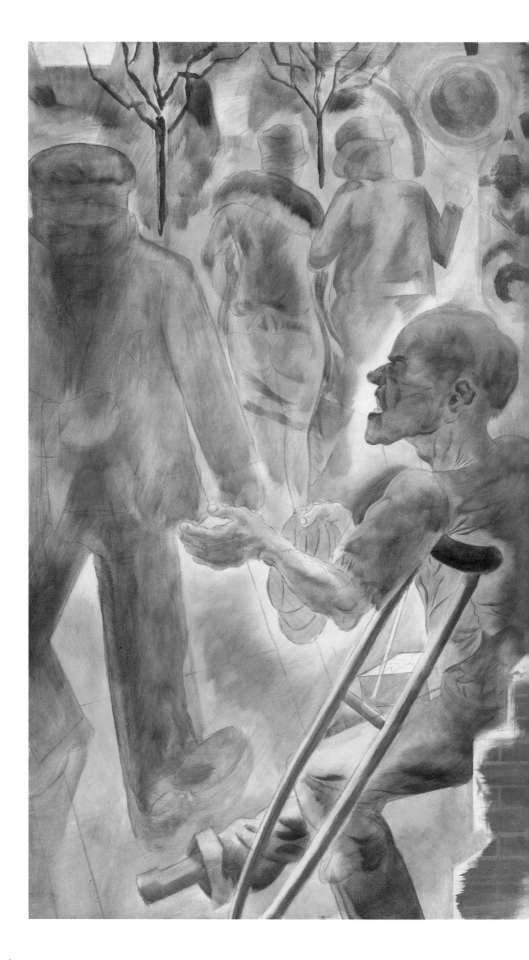

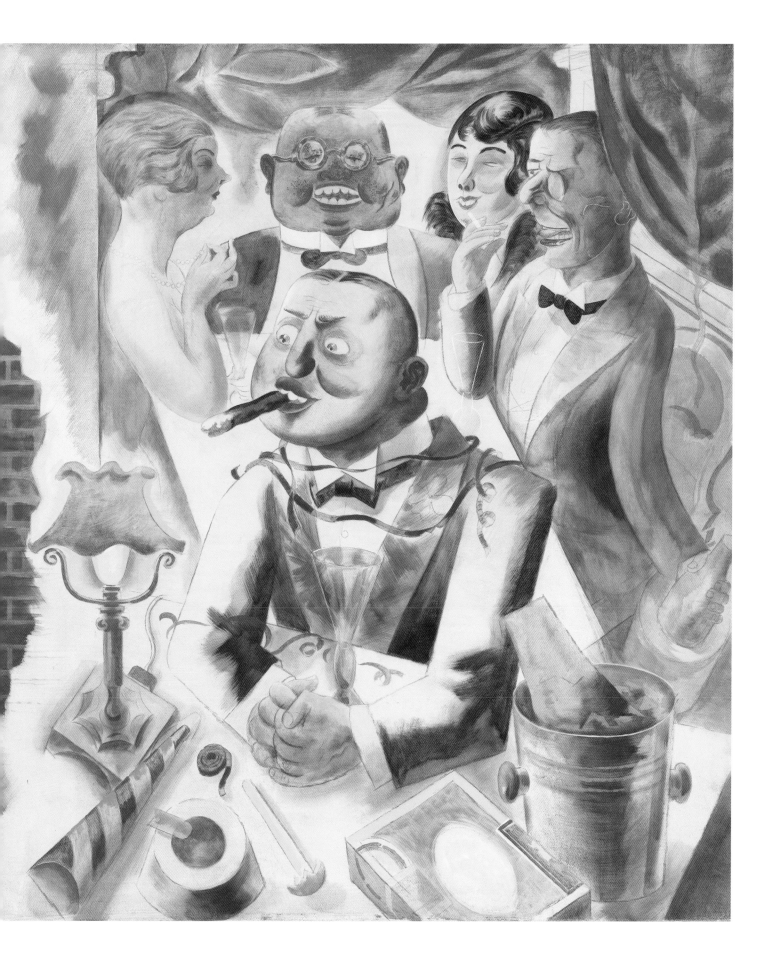

PLATE 248
Arshile Gorky (American, born Armenia, 1904–1948)
Untitled (recto), ca. 1946
Crayon, 14⅞ x 9¾ in. (37.8 x 24.8 cm)
Anonymous gift

PLATE 249
Roberto Matta (Chilean, 1911–2002)
Untitled, 1943–44
Mixed-media drawing, 15⁵⁄₁₆ x 19 in. (39 x 48.3 cm)
Gift of Thomas T. Solley, B.A. 1950

PLATE 250
Hans Hofmann (American, born Germany 1880–1966)
Untitled, 1941
Watercolor and India ink, 17 x 14 in. (43.2 x 35.6 cm)
Anonymous gift

PLATE 251
Philip Guston (American, born Canada, 1913–1980)
Untitled, 1951
Brush and black ink, 18½ x 23⅝ in. (47 x 60 cm)
Anonymous gift

PLATE 252
Philip Guston (American, born Canada, 1913–1980)
Untitled, 1962
Black ink, 26 x 39½ in. (66 x 100.3 cm)
Anonymous gift

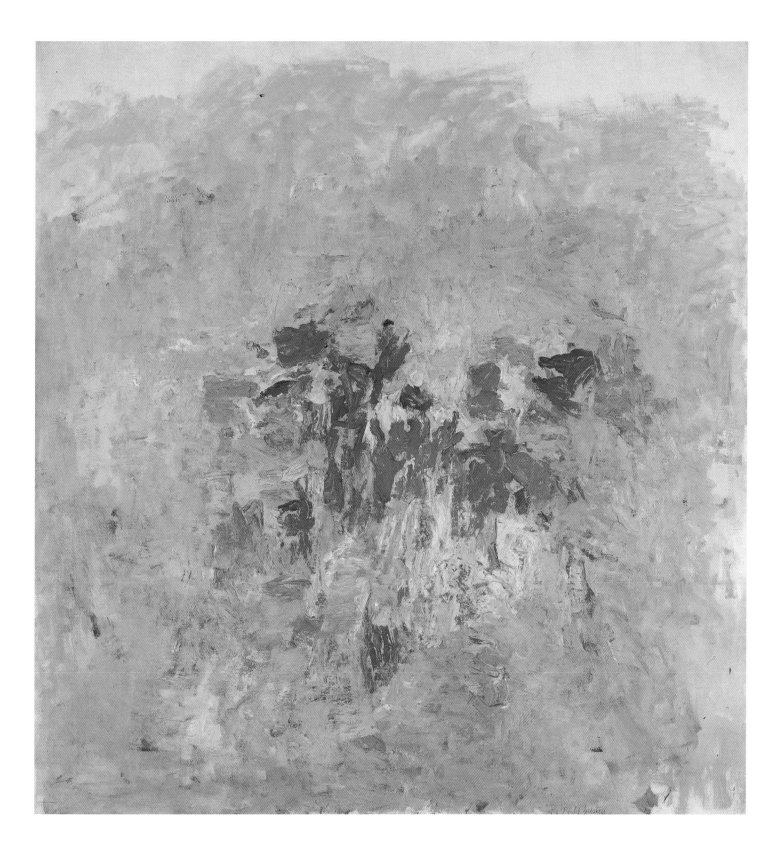

PLATE 253
Philip Guston (American, born Canada, 1913–1980)
Untitled, 1955–56
Oil on canvas, 76 x 72 in. (193 x 182.9 cm)
Promised gift of Carolyn and Gerald Grinstein, B.A. 1954

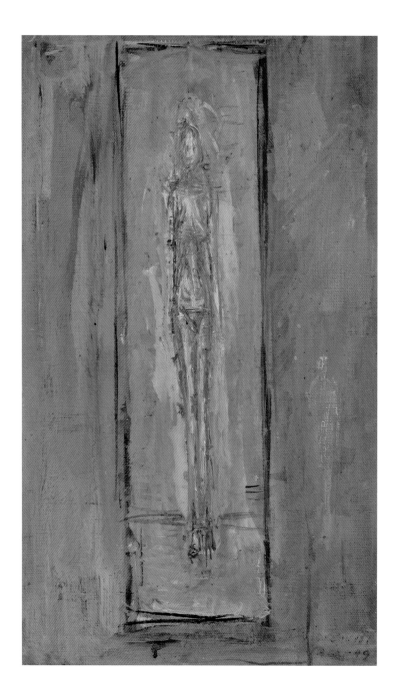

PLATE 254
Alberto Giacometti (Swiss, 1901–1966)
Standing Figure in Box, 1948–49
Oil on canvas, 10½ x 6¼ in. (26.7 x 15.9 cm)
Gift of Molly and Walter Bareiss, B.S. 1940s

PLATE 255
Alberto Giacometti (Swiss, 1901–1966)
Buste de Diego (Bust of Diego), 1957
Bronze, 24½ x 10 x 6 in. (62.2 x 25.4 x 15.2 cm)
Charles B. Benenson, B.A. 1933, Collection, Courtesy of
Bruce W. Benenson

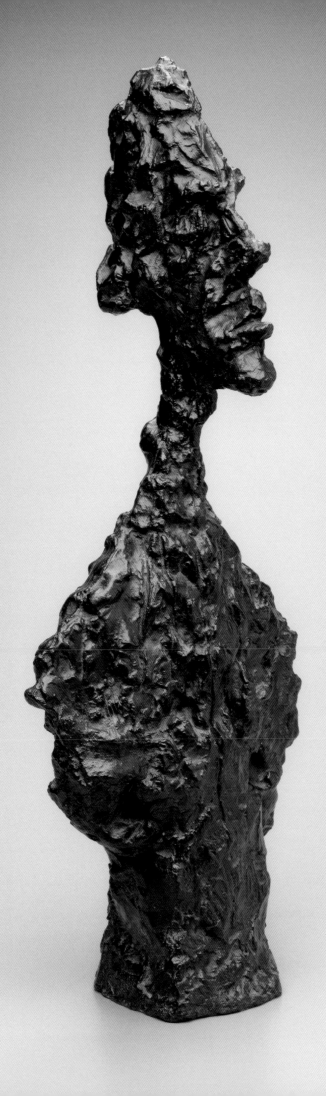

PLATE 256
Robert Frank (American, born Switzerland, 1924)
Alberto Giacometti, Paris, 1964, printed 1978
Gelatin silver print, 7¾ x 11½ in. (19.7 x 29.2 cm)
Gift of the Ethne and Clive Gray Family Collection

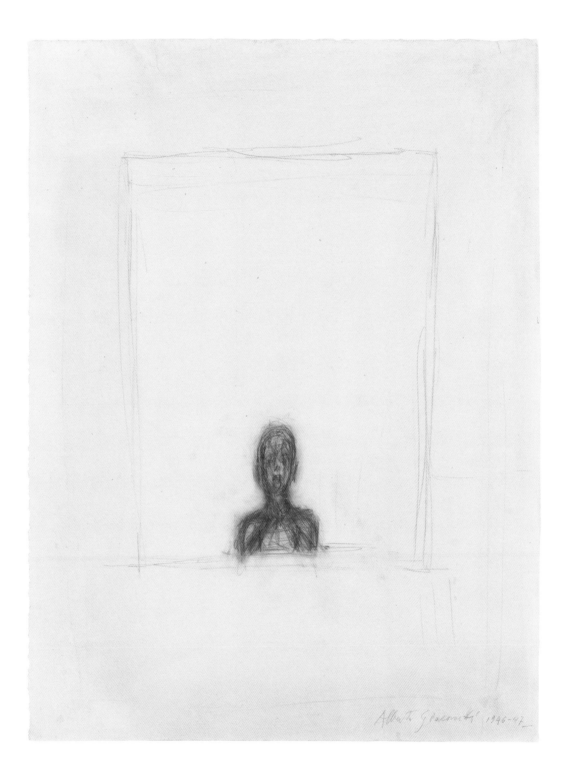

PLATE 257
Alberto Giacometti (Swiss, 1901–1966)
Untitled, 1946–47
Graphite, 23¼ x 17⅞ in. (59.1 x 45.4 cm)
Gift of Molly and Walter Bareiss, B.S. 1940S

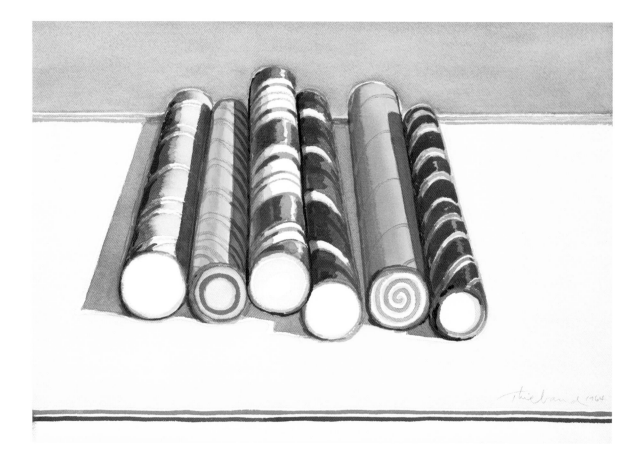

PLATE 258
Wayne Thiebaud (American, born 1920)
Candy Sticks, 1964
Watercolor and graphite, 11¼ x 15 in. (28.6 x 38.1 cm)
Bequest of Susan Morse Hilles

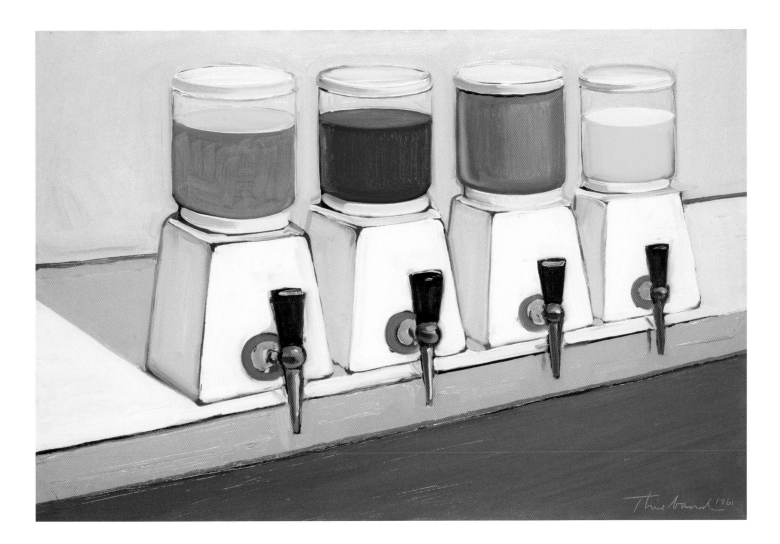

PLATE 259
Wayne Thiebaud (American, born 1920)
Drink Syrups, 1961
Oil on canvas, 24⅛ x 36 in. (61.3 x 91.4 cm)
The Twigg-Smith Collection, Gift of Thurston Twigg-Smith,
B.E. 1942

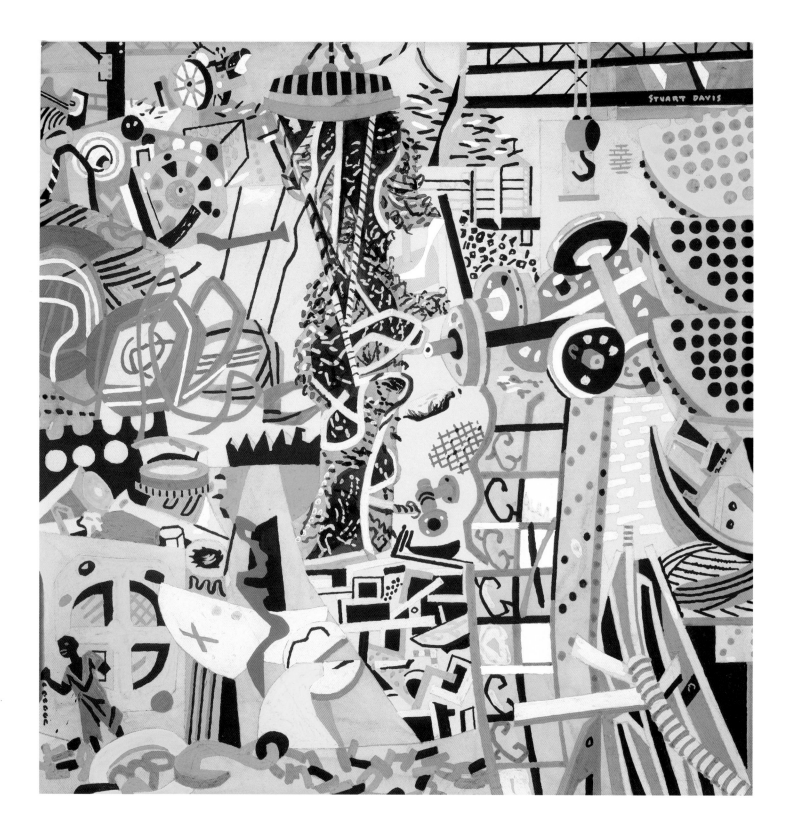

PLATE 260
Stuart Davis (American, 1894–1964)
Ana, 1942
Gouache, 16½ x 16½ in. (41.9 x 41.9 cm)
Promised gift of Mary Jo and Ted Shen, B.A. 1966, M.A. Hon. 2001

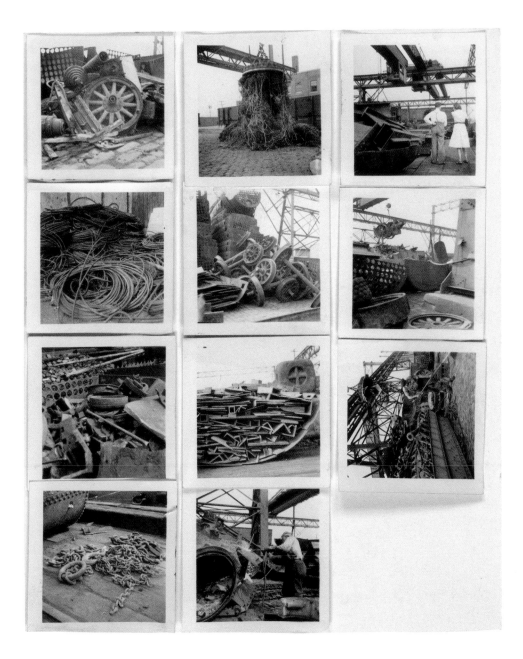

PLATE 262
Stuart Davis (American, 1894–1964)
Eleven study photographs for *Ana*, 1942
Gelatin silver prints, each 2⅛ x 2½ in. (5.4 x 6.4 cm)
Gift of Mr. and Mrs. Gifford Phillips, Class of 1942, by exchange

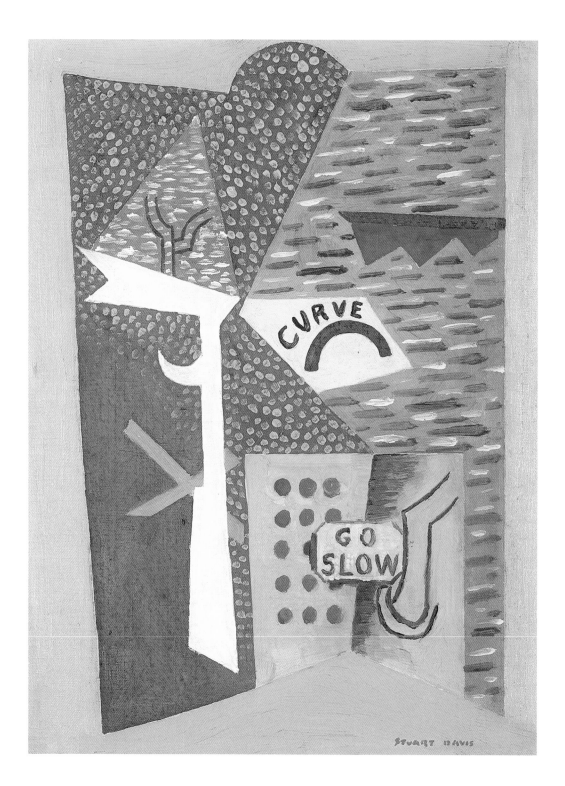

PLATE 263
Stuart Davis (American, 1894–1964)
Curve Go Slow, 1922
Oil on artist's board, 15¼ x 11½ in. (38.7 x 29.2 cm)
Gift of Mr. and Mrs. Gifford Phillips, Class of 1942, by exchange

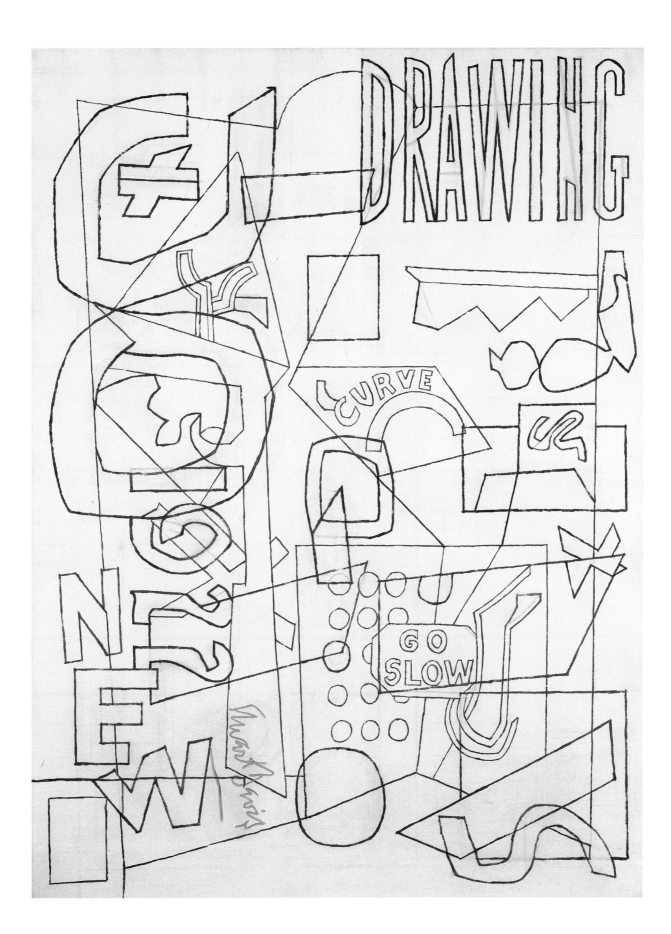

PLATE 264 (detail overleaf)
Stuart Davis (American, 1894–1964)
Combination Concrete #2 (Black and White Version), 1956
Casein on canvas, 60 x 45 in. (152.4 x 114.3 cm)
Gift of Mr. and Mrs. Gifford Phillips, Class of 1942, by exchange

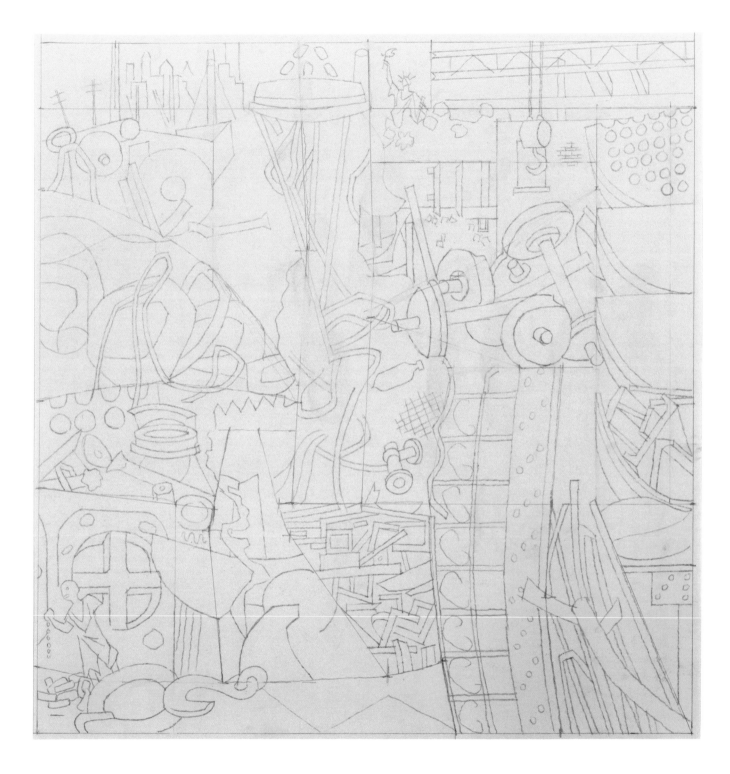

PLATE 261
Stuart Davis (American, 1894–1964)
Study for *Ana*, 1942
Graphite, 16 x 16½ in. (40.6 x 41.9 cm)
Gift of Mr. and Mrs. Gifford Phillips, Class of 1942, by exchange

PLATE 266
Stuart Davis (American, 1894–1964)
Study for Composition Concrete, ca. 1957
Gouache and traces of graphite, 8⅞ x 4⅝ in. (22.5 x 11.8 cm)
Gift of Mr. and Mrs. Gifford Phillips, Class of 1942, by exchange

PLATE 265
Stuart Davis (American, 1894–1964)
Combination Concrete #2, 1956–58
Oil on canvas, 71 x 53 in. (180.3 x 134.6 cm)
Charles B. Benenson, B.A. 1933, Collection

PLATE 267
Stuart Davis (American, 1894–1964)
Punch-Card Flutter #3 (Black and White Version), ca. 1963
Casein on canvas, 24 x 36 in. (61 x 91.4 cm)
Promised gift of Mr. and Mrs. Henry A. Ashforth, Jr., B.A. 1952

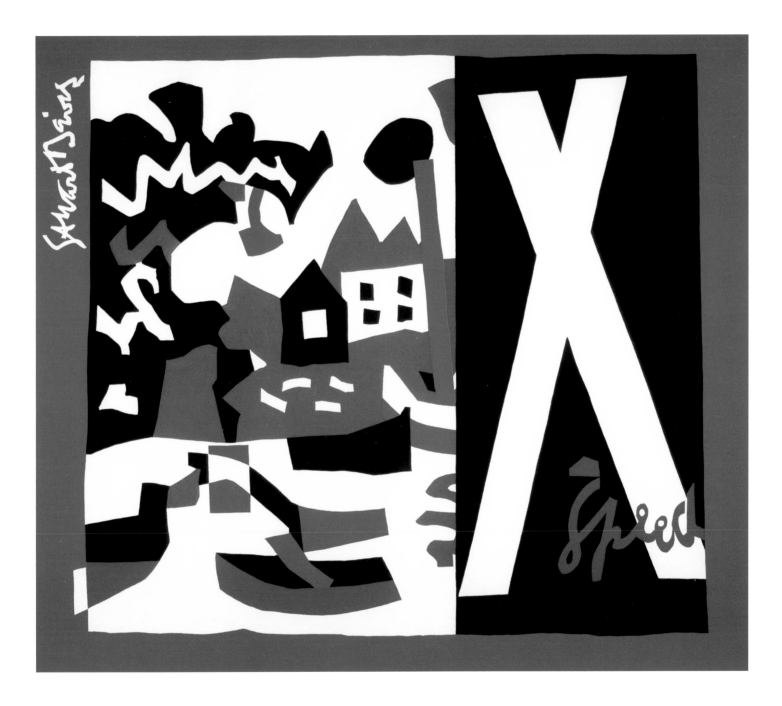

PLATE 268
Stuart Davis (American, 1894–1964)
Lesson One, 1956
Oil on canvas, 52 x 60⅛ in. (132.1 x 152.7 cm)
Charles B. Benenson, B.A. 1933, Collection

PLATE 269
David Smith (American, 1906–1965)
Untitled (recto), 1954
Black ink, 10⅛ x 7¾ in. (25.7 x 19.7 cm)
Promised gift of Evelyn H. and Robert W. Doran, B.A. 1955

PLATE 270
David Smith (American, 1906–1965)
Isabella, 1956
Stainless steel, 36 x 8 in. (91.4 x 20.3 cm)
Promised gift of Mr. and Mrs. Henry A. Ashforth, Jr., B.A. 1952

PLATE 273
Martin Puryear (American, born 1941, M.F.A. 1971, D.F.A. Hon. 1994)
Untitled, 1982
Maple sapling, pear wood, and yellow cedar, 59 x 66 x 5 in.
(149.9 x 167.6 x 12.7 cm)
Promised gift of the Neisser Family, Judith Neisser, David Neisser,
Kate Neisser, and Stephen Burns, in memory of Edward Neisser,
B.A. 1952

Exhibited in *Martin Puryear*, Museum of Modern Art, New York,
November 4, 2007–January 14, 2008

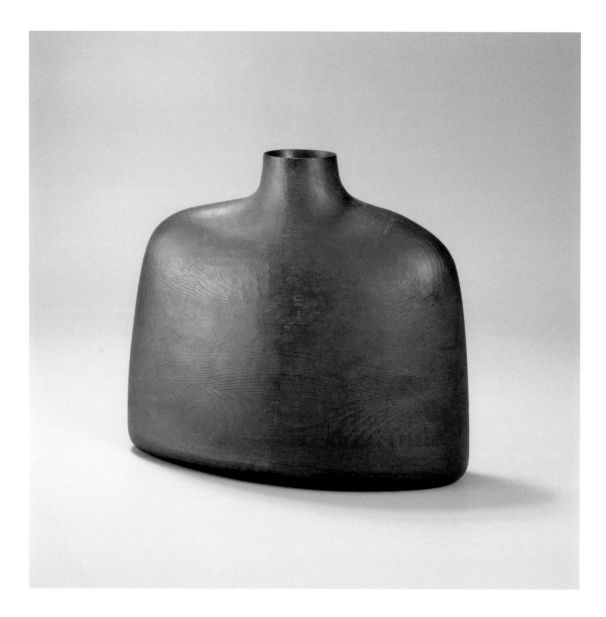

PLATE 274
Martin Puryear (American, born 1941, M.F.A. 1971, D.F.A. Hon. 1994)
Untitled, 1994
Edition 1/2, with one artist's proof
Bronze, 15 x 16 x 5½ in. (38.1 x 40.6 x 14 cm)
Promised gift of Evelyn H. and Robert W. Doran, B.A. 1955

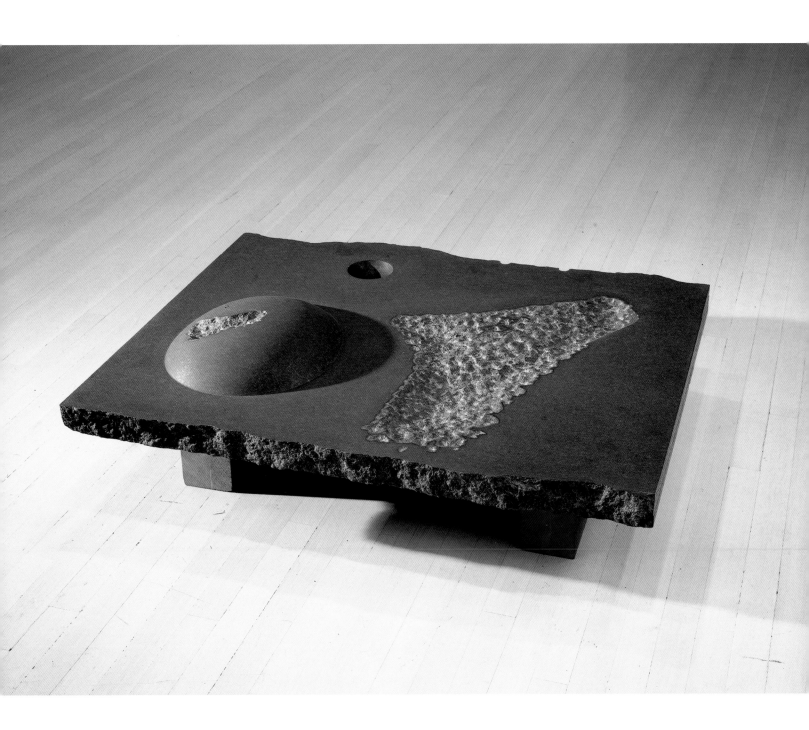

PLATE 275
Isamu Noguchi (American, 1904–1988)
Galaxy Calligraphy, 1983–84
Black Swedish granite and wood, 15½ x 40½ x 32 in.
(39.4 x 102.9 x 81.3 cm)
Promised gift of the Shamos Family

PLATE 276
Agnes Martin (American, 1912–2004)
Valentine, 1962
Oil on canvas, 16 x 16 in. (40.6 x 40.6 cm)
Richard Brown Baker, B.A. 1935, Collection

PLATE 277
Sylvia Plimack Mangold (American, born 1938, B.F.A. 1961)
Untitled (Taping Three Edges, so as to Paint the Tape of Those Edges . . .), 1977
Acrylic and graphite, 20 x 30 in. (50.8 x 76.2 cm)
Gift of Sylvia Plimack Mangold, B.F.A. 1961, in honor of Richard S. Field

PLATE 278
Sylvia Plimack Mangold (American, born 1938, B.F.A. 1961)
Untitled (Tape Down Dimensions, Paint Internal Color, Paint Tapes which Mark Out Picture to Paint . . .), 1977
Acrylic and graphite, 20 x 30 in. (50.8 x 76.2 cm)
Gift of Sylvia Plimack Mangold, B.F.A. 1961, in honor of Richard S. Field

PLATE 279
Joel Shapiro (American, born 1941)
Untitled, 1977
Charcoal, 38 x 49⅞ in. (96.5 x 126.7 cm)
Gift of Peggy and Richard M. Danziger, LL.B. 1963, in honor of
Richard S. Field

PLATE 280
Robert Mangold (American, born 1937, B.F.A. 1961, M.F.A. 1963)
Six Working Drawings for the WXV Models of 1968, ca. 1968
Graphite on yellow paper, each 13⅞ x 8½ in. (35.2 x 21.6 cm)
Gift of Robert Mangold, B.F.A. 1961, M.F.A. 1963, in honor of
Richard S. Field

PLATE 281
Sol LeWitt (American, 1928–2007)
Wall Drawing #11 (detail), 1969
Graphite, dimensions variable
Gift of Anna Marie and Robert F. Shapiro, B.A. 1956

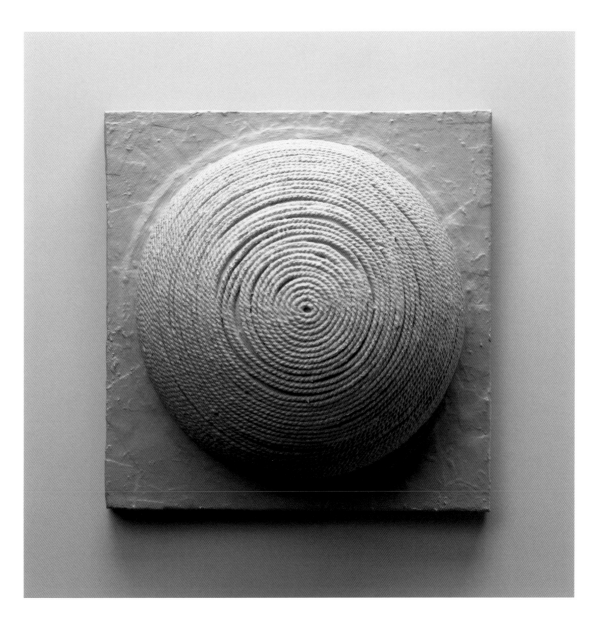

PLATE 282
Eva Hesse (American, 1936–1970, B.F.A. 1959)
Untitled, 1966
Acrylic paint, cord, papier-mâché, and wood, 7½ x 7½ x 4 in.
(19.1 x 19.1 x 10.2 cm)
The LeWitt Collection, Chester, Conn.

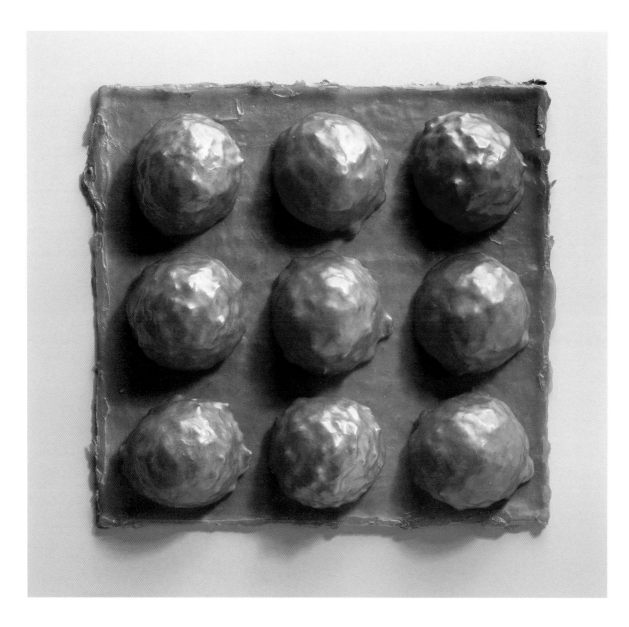

PLATE 283
Eva Hesse (American, 1936–1970, B.F.A. 1959)
Study for *Schema*, 1967
Latex, 2½ x 9½ x 9½ in. (6.4 x 24.1 x 24.1 cm)
The LeWitt Collection, Chester, Conn.

PLATE 284
Eva Hesse (American, 1936–1970, B.F.A. 1959)
Untitled, 1967–68
Mixed media, 14⅝ x 10¼ x 10¼ in. (37.2 x 26 x 26 cm)
The LeWitt Collection, Chester, Conn.

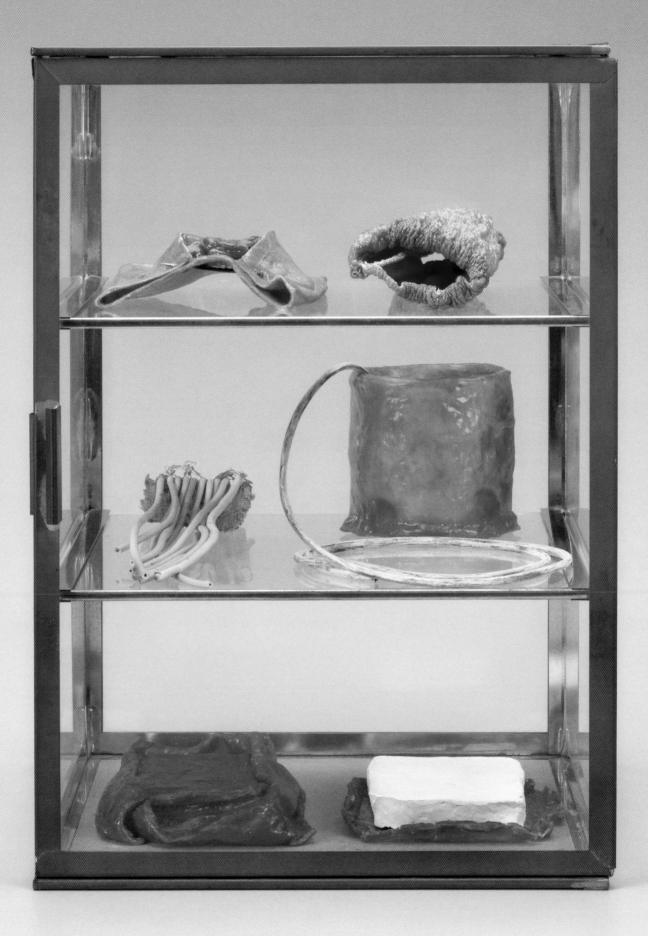

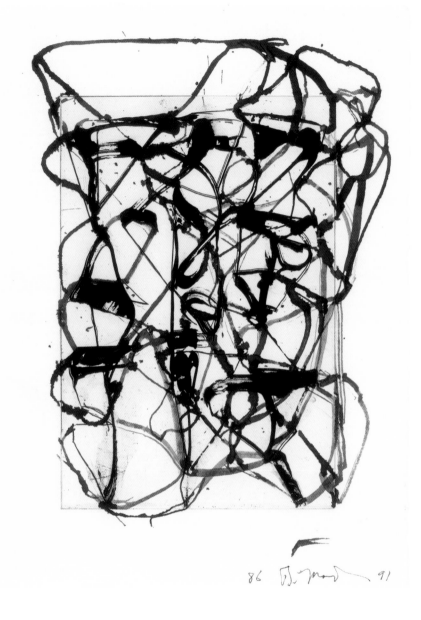

PLATE 285
Brice Marden (American, born 1938, M.F.A. 1963)
Tu Fu Dog I, 1986/1991
Black ink over embossed platemark, 9⅜ x 7 in. (23.9 x 17.8 cm)
Richard Brown Baker, B.A. 1935, Collection

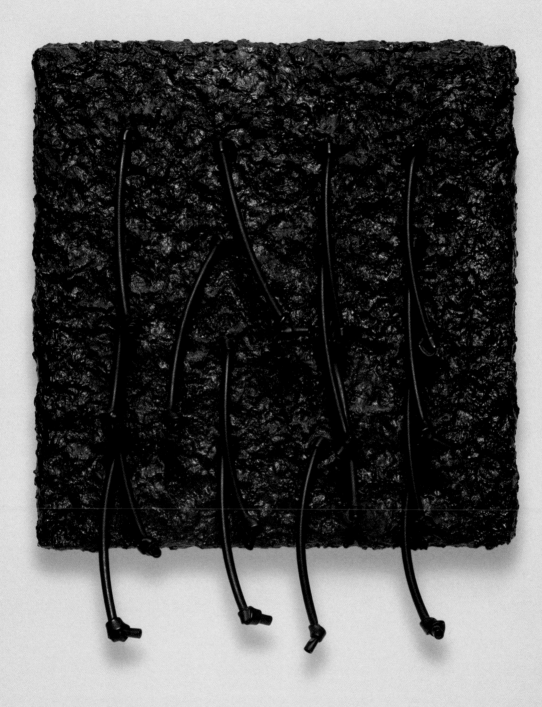

PLATE 286
Eva Hesse (American, 1936–1970, B.F.A. 1959)
Untitled, 1967
Acrylic, wood shavings, and glue on Masonite with rubber
tubing, 12 x 10 x 2½ in. (30.5 x 25.4 x 6.4 cm)
Gift of Robert Mangold, B.F.A. 1961, M.F.A. 1963, and Sylvia
Plimack Mangold, B.F.A. 1961, in memory of Eva Hesse, B.F.A.
1959, and in honor of Helen A. Cooper

PLATE 287
Josef Albers (American, born Germany, 1888–1976)
Study for *Skyscrapers A*, ca. 1929
Graphite on graph paper, 16¼ x 16¼ in. (41.3 x 41.3 cm)
Promised gift of James H. Clark, Jr., B.A. 1958

PLATE 288
Sol LeWitt (American, 1928–2007)
Four Colors in Four Directions, 1971
Colored ink, 13⅞ x 14 in. (35.2 x 35.6 cm)
Janet and Simeon Braguin Fund

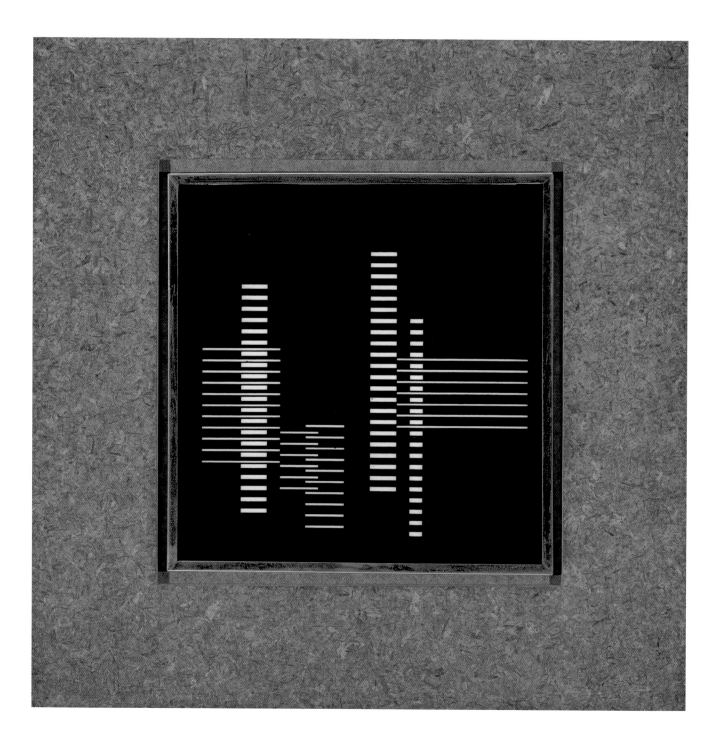

PLATE 289
Josef Albers (American, born Germany, 1888–1976)
Skyscrapers A, ca. 1929
Sandblasted opaque flashed glass, 13¾ x 13¾ in. (34.9 x 34.9 cm)
Promised gift of James H. Clark, Jr., B.A. 1958

PLATE 290
Mel Bochner (American, born 1940)
12 Photographs and 4 Diagrams (N+1 Center Sets),
1966–67, printed 1999
Sixteen gelatin silver prints, each sheet 19 x 19 in.
(48.3 x 48.3 cm)
Janet and Simeon Braguin Fund

PLATE 291
Sol LeWitt (American, 1928–2007)
Wall Drawing #614, 1989
Acrylic, dimensions variable
Gift of the artist

305

PLATE 292
Henri Matisse (French, 1869–1954)
La danse (*The Dance*), 1935–36
Color aquatint, 9⁵/₁₆ x 29⅛ in. (23.7 x 74 cm)
Gift of Thurston Twigg-Smith, B.E. 1942, and Sharon Twigg-Smith

PLATE 293
Julio González (Spanish, 1876–1942)
La petite faucille (*Small Sickle* [*Figure of a Woman*]), ca. 1937
Forged bronze, 11¾ x 4½ x 3⅛ in. (29.9 x 11.4 x 7.9 cm)
Bequest of Susan Morse Hilles

PLATE 294
Frank Stella (American, born 1936)
Pergusa Three, 1982
Ten-color relief-printed etching and woodcut on handmade
paper, 66⅜ x 51½ in. (168.6 x 130.8 cm)
Gift of Sharon and Thurston Twigg-Smith, B.E. 1942

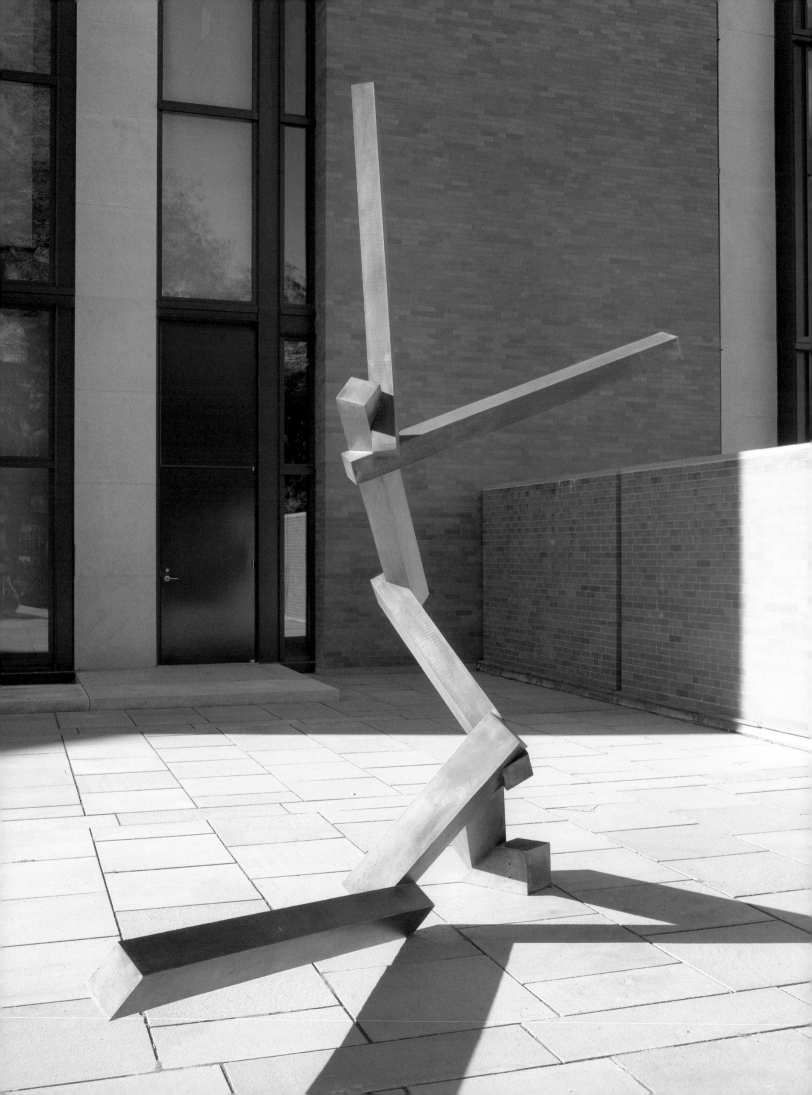

PLATE 295
Joel Shapiro (American, born 1941)
Untitled, 2000
Bronze, 10 ft. 3 in. x 8 ft. 8 in. x 49 in. (312.4 x 264.2 x 124.5 cm)
Gift of the artist in honor of Anna Marie and Robert Shapiro,
B.A. 1956

PLATE 296
Edward Ruscha (American, born 1937)
Cut Lip, 1968
Oil on canvas, 20 x 24 in. (50.8 x 61 cm)
Richard Brown Baker, B.A. 1935, Collection

SOLVING EACH PROBLEM AS IT ARISES

IT CAN BE SUBJECT MATTER OF
A RELIGIOUS NATURE, A SCENE
IN A FOREIGN COUNTRY. WHAT-
EVER THE SUBJECT, THE PROFES-
SIONAL ARTIST MAKES EXHAUSTIVE
STUDIES OF IT. WHEN HE FEELS
THAT HE HAS INTERPRETED THE SUB-
JECT TO THE EXTENT OF HIS CAPABILI-
TIES HE MAY HAVE A ONE-MAN EXHIBITION
WHOSE THEME IS THE SOLUTION OF
THE PROBLEM. IT IS SURPRISING HOW
FEW PEOPLE WHO VIEW THE PAINTINGS
REALIZE THIS.

PLATE 297
John Baldessari (American, born 1931)
Solving Each Problem as It Arises, 1966–68
Acrylic on canvas, 67¾ x 56½ in. (172.1 x 143.5 cm)
Janet and Simeon Braguin Fund

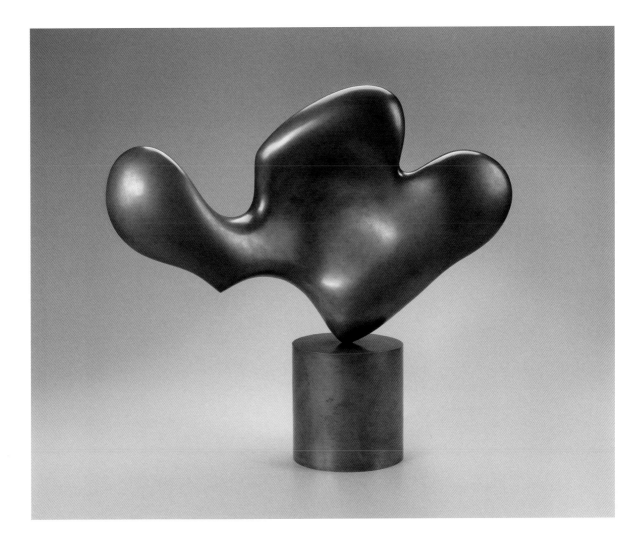

PLATE 298
Jean Arp (French, 1886–1966)
Resting Leaf, 1959
Bronze, 23 x 24 x 7 in. (58.4 x 61 x 17.8 cm)
Charles B. Benenson, B.A. 1933, Collection

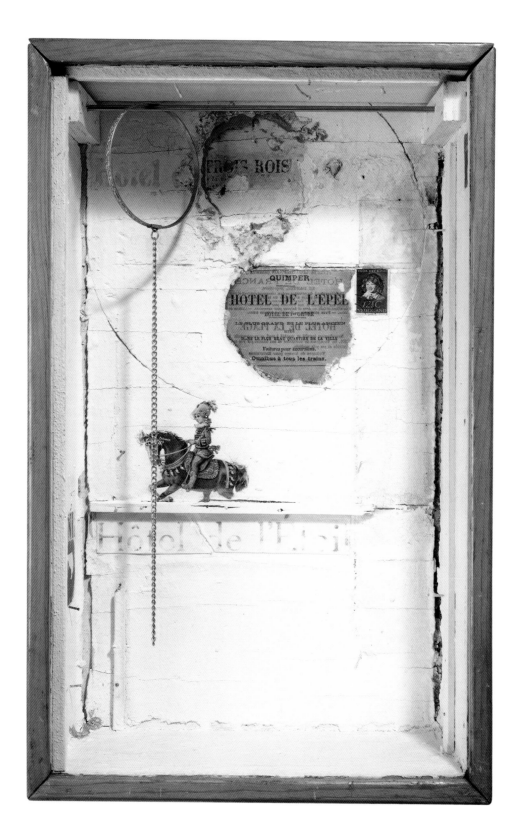

PLATE 299
Joseph Cornell (American, 1903–1972)
Untitled (*Grand Hôtel de l'Étoile*), ca. 1950
Mixed media, 15⅜ x 9⁷⁄₁₆ x 3⅞ in. (39.1 x 24 x 9.8 cm)
Promised bequest of Samuel F. Pryor IV, B.A. 1977

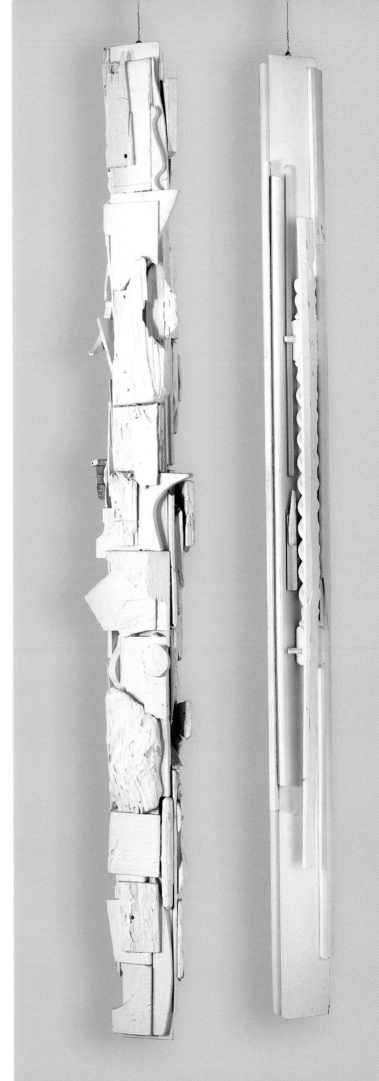

PLATE 300
Louise Nevelson (American, 1899–1988)
Hanging Columns, from *Dawn's Wedding Feast*, 1959
Painted wood, 72 x 4½ x 4½ in. (182.9 x 11.4 x 11.4 cm) and
72 x 5 x 5 in. (182.9 x 12.7 x 12.7 cm)
Promised gift of Reid White, B.A. 1957, and Laird Trowbridge
White (formerly of the collection of Dorothy C. Miller)

Exhibited in *The Sculpture of Louise Nevelson: Constructing a
Legend*, The Jewish Museum, New York, May 5, 2007–
September 18, 2007; de Young Museum, Fine Arts Museum of
San Francisco, October 27, 2007–January 13, 2008

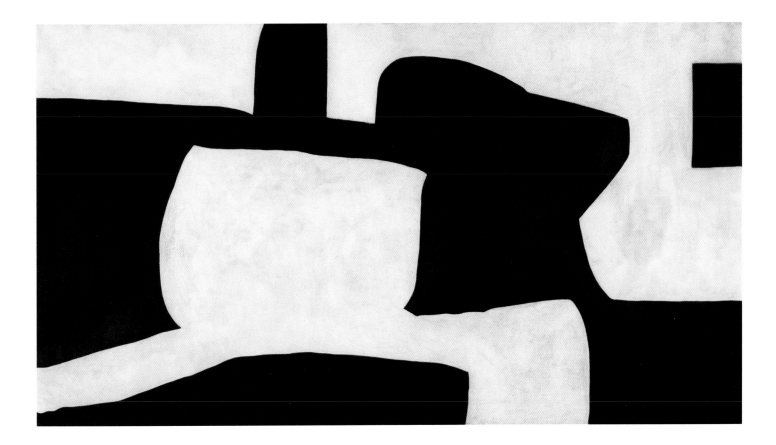

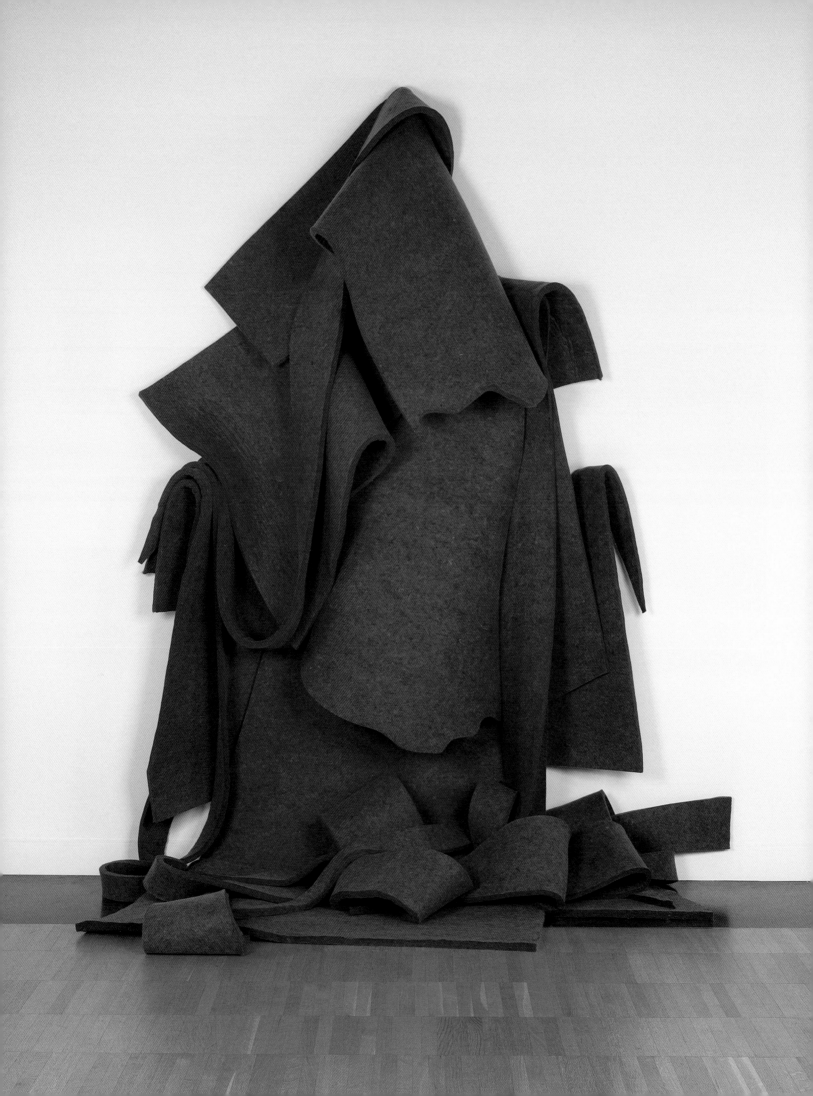

PLATE 303
Robert Morris (American, born 1931)
Untitled (Version 1 in 19 Parts), 1968/2002
Felt, 8 ft. 7 in. x 85 in. x 44 in. (261.6 x 215.9 x 111.8 cm)
Janet and Simeon Braguin Fund

PLATE 304
Edward Ruscha (American, born 1937)
Level, 2003
Acrylic on canvas, 64 x 72 in. (162.6 x 182.9 cm)
Gift of Laila Twigg-Smith, by exchange

PLATE 305
William T. Wiley (American, born 1937)
Mona Lisa Wipe Out or "Three Wishes," 1967
Paper, wire, canvas, and tape, 24 x 17⅛ in. (61 x 43.5 cm)
Janet and Simeon Braguin Fund

PLATE 306
H. C. Westermann (American, 1922–1981)
Imitation Knotty Pine, 1966
Clear pine, brass, and inlaid knotty pine, 21 x 20¾ x 13 in.
(53.3 x 52.7 x 33 cm)
Gift of Sharon and Thurston Twigg-Smith, B.E. 1942

PLATE 307
Richard Artschwager (American, born 1923)
Portrait II, 1963
Formica on wood, 68 x 26 x 13 in. (172.7 x 66 x 33 cm)
Promised gift of Anna Marie and Robert F. Shapiro, B.A. 1956

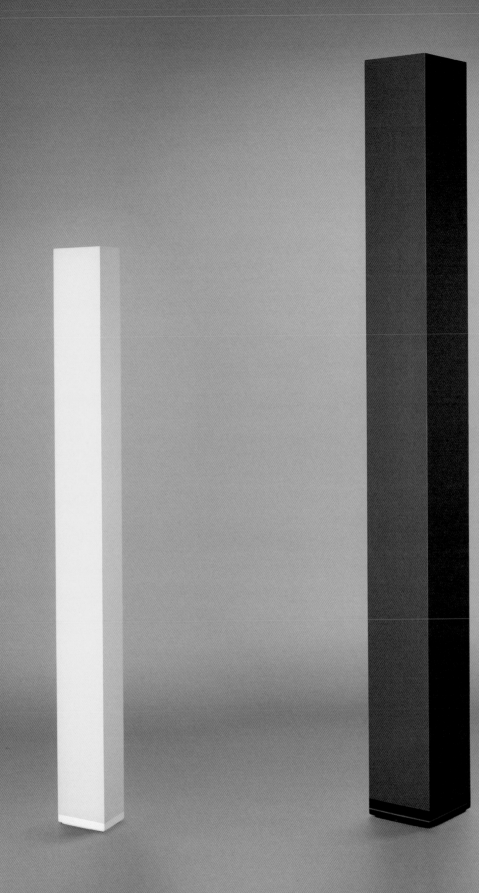

PLATE 308
Anne Truitt (American, 1921–2004)
April, 1996
Acrylic on wood, 60¼ x 5½ x 4 in. (153 x 14 x 10.2 cm)
Gift of Celia Faulkner Crawford

PLATE 309
Anne Truitt (American, 1921–2004)
Amur, 1983
Acrylic on wood, 81⅛ x 8 x 8 in. (206.1 x 20.3 x 20.3 cm)
Gift of Celia Faulkner Crawford

323

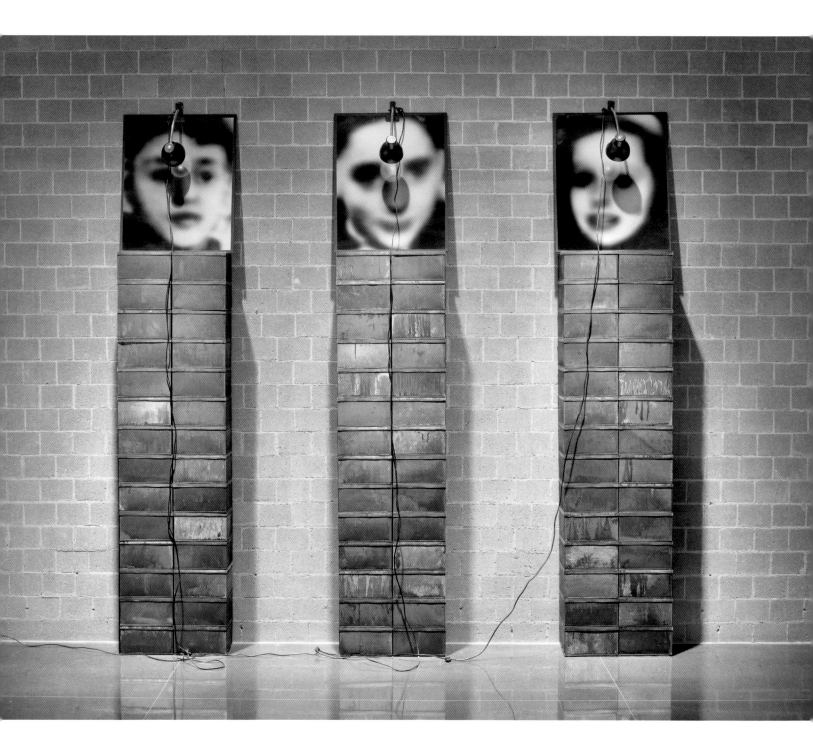

PLATE 310
Christian Boltanski (French, born 1944)
La fête de Pourim, 1988
Tin boxes, photographs, lamps, and electric wire,
92½ x 19¹¹⁄₁₆ x 9¹⁄₁₆ in. (235 x 50 x 23 cm)
Gift of Anna Marie and Robert F. Shapiro, B.A. 1956

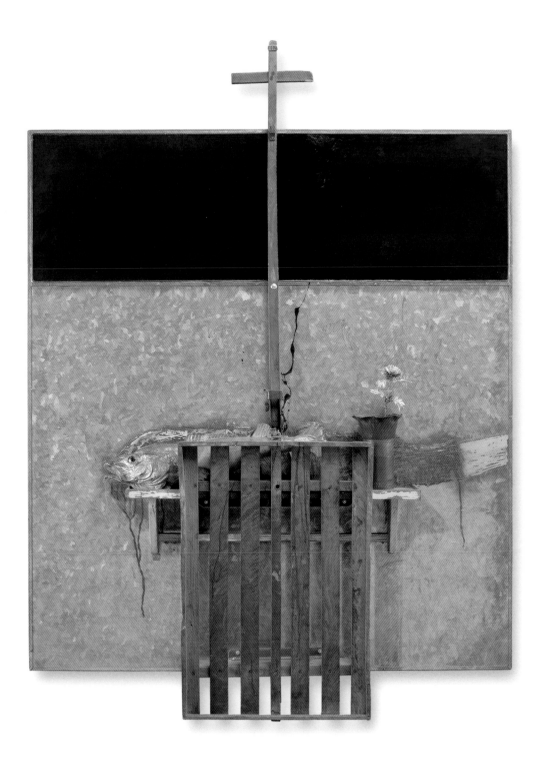

PLATE 311
Edward Kienholz (American, 1927–1994)
Nancy Reddin (American, born 1943)
The Silver Fish and the Multitudes Have Lunch and Other Myths, 1981
Mixed media, 68 x 51¼ x 6¾ in. (172.7 x 130.2 x 17.2 cm)
The Twigg-Smith Collection; Gift of Thurston Twigg-Smith,
B.E. 1942

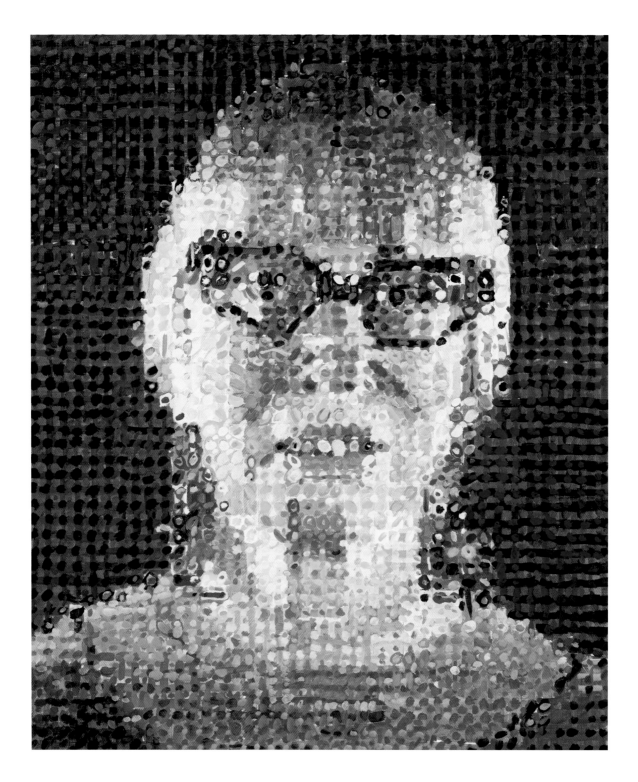

PLATE 312 (detail opposite)
Chuck Close (American, born 1940, B.F.A. 1963, M.F.A. 1964,
D.F.A. Hon. 1996)
Janet, 1989
Oil on canvas, 36 x 30 in. (91.4 x 76.2 cm)
Promised bequest of Jon and Mary Shirley

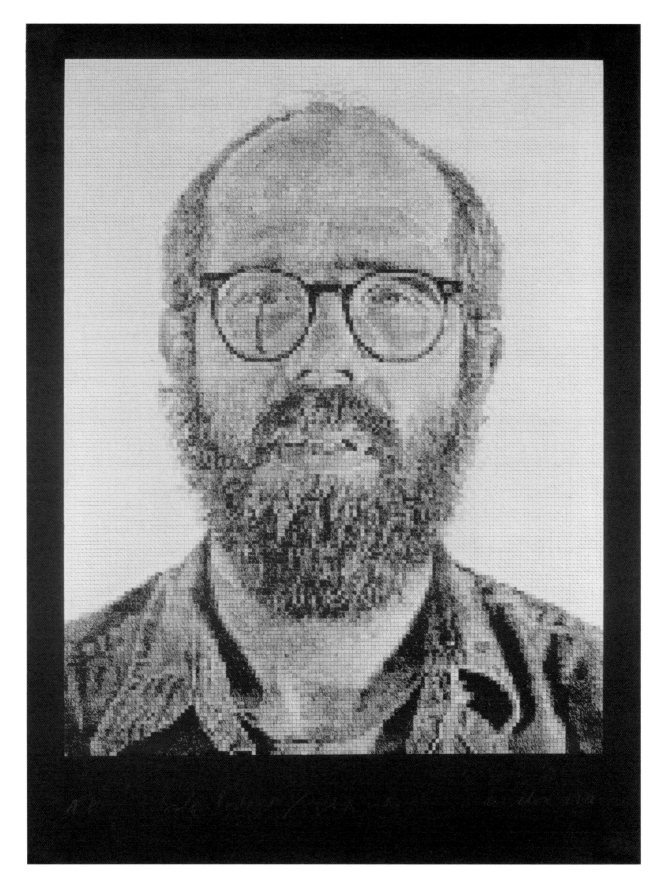

PLATE 313
Chuck Close (American, born 1940, B.F.A. 1963, M.F.A. 1964,
D.F.A. Hon. 1996)
Self-Portrait/White Ink, 1978
Etching in white ink on black wove paper, surface-rolled,
44½ x 35½ in. (113 x 90.2 cm)
Gift of Mr. and Mrs. Harrison H. Augur, B.A. 1964, in honor of
Richard S. Field

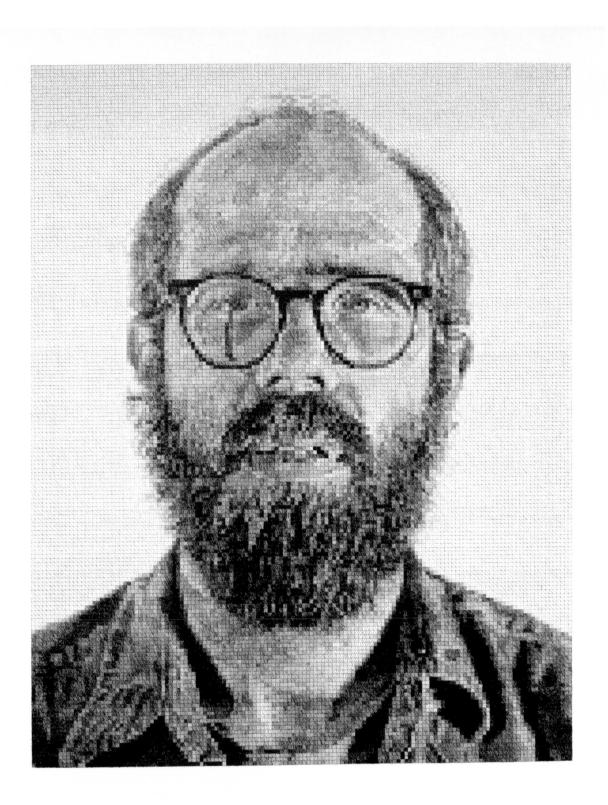

PLATE 314
Chuck Close (American, born 1940, B.F.A. 1963, M.F.A. 1964,
D.F.A. Hon. 1996)
Self-Portrait/Black Ink, 1977
Etching in black ink on white wove paper, 44½ x 35½ in.
(113 x 90.2 cm)
Gift of Mr. and Mrs. Harrison H. Augur, B.A. 1964, in honor of
Helen A. Cooper

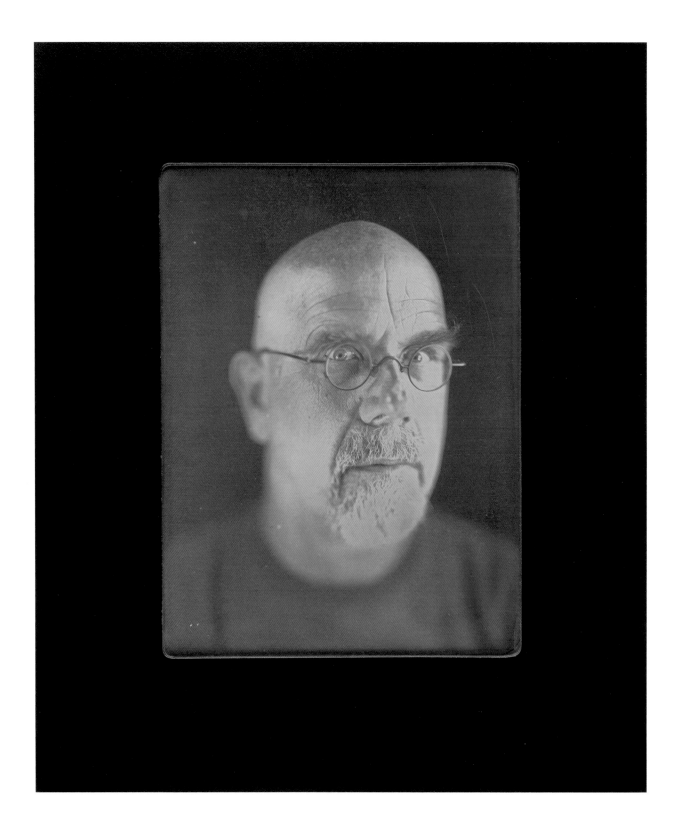

PLATE 315
Chuck Close (American, born 1940, B.F.A. 1963, M.F.A. 1964,
D.F.A. Hon. 1996)
Self-Portrait, 2000
Daguerreotype, 8½ x 6½ in. (21.6 x 16.5 cm)
Gift of Leslie and Chuck Close, B.F.A. 1963, M.F.A. 1964,
D.F.A. Hon. 1996

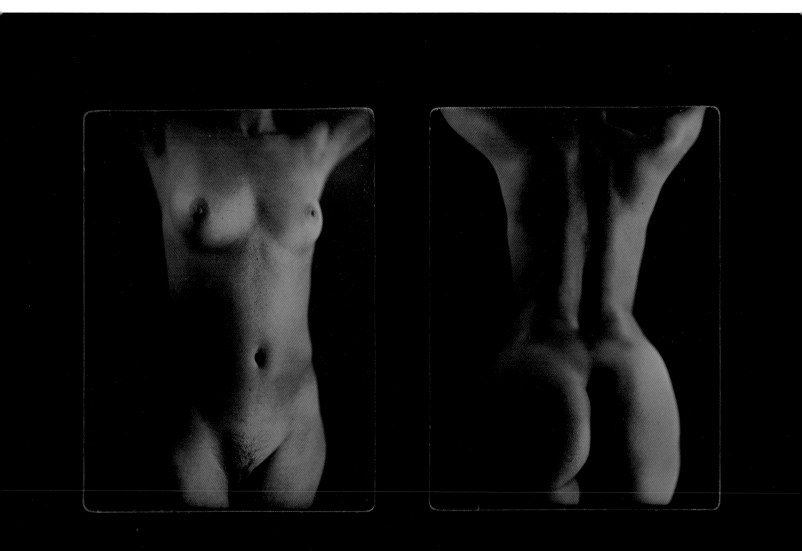

PLATE 316
Chuck Close (American, born 1940, B.F.A. 1963, M.F.A. 1964,
D.F.A. Hon. 1996)
Untitled Torso (K. W.), 2000
Daguerreotype diptych, each plate 8 x 6⅛ in. (20.3 x 15.6 cm)
Purchased with a gift from Peggy and Richard M. Danziger,
LL.B. 1963, and the Annual Fund

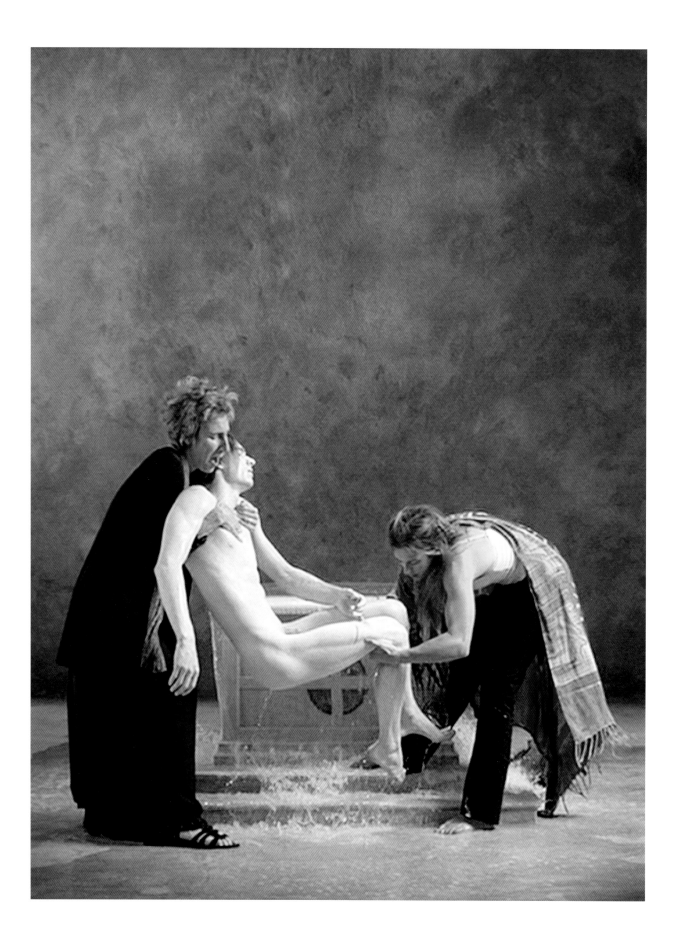

PLATE 317
Bill Viola (American, born 1951)
Study for Emergence, 2002
Color video on freestanding vertical LCD flat panel,
14¼ x 11½ x 1⅞ in. (36.2 x 29.2 x 4.8 cm)
Gift of John Walsh, B.A. 1961

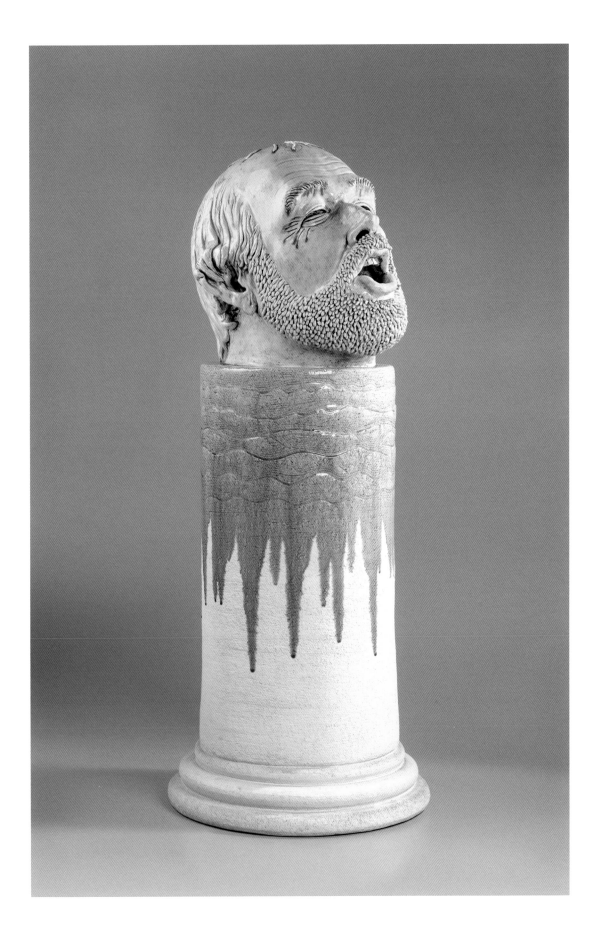

PLATE 318
Robert Arneson (American, 1930–1992)
Last Gasp
Benicia, California, 1980
Glazed ceramic, 52 x 17 x 19½ in. (132.1 x 43.2 x 49.5 cm)
Richard Brown Baker, B.A. 1935, Collection

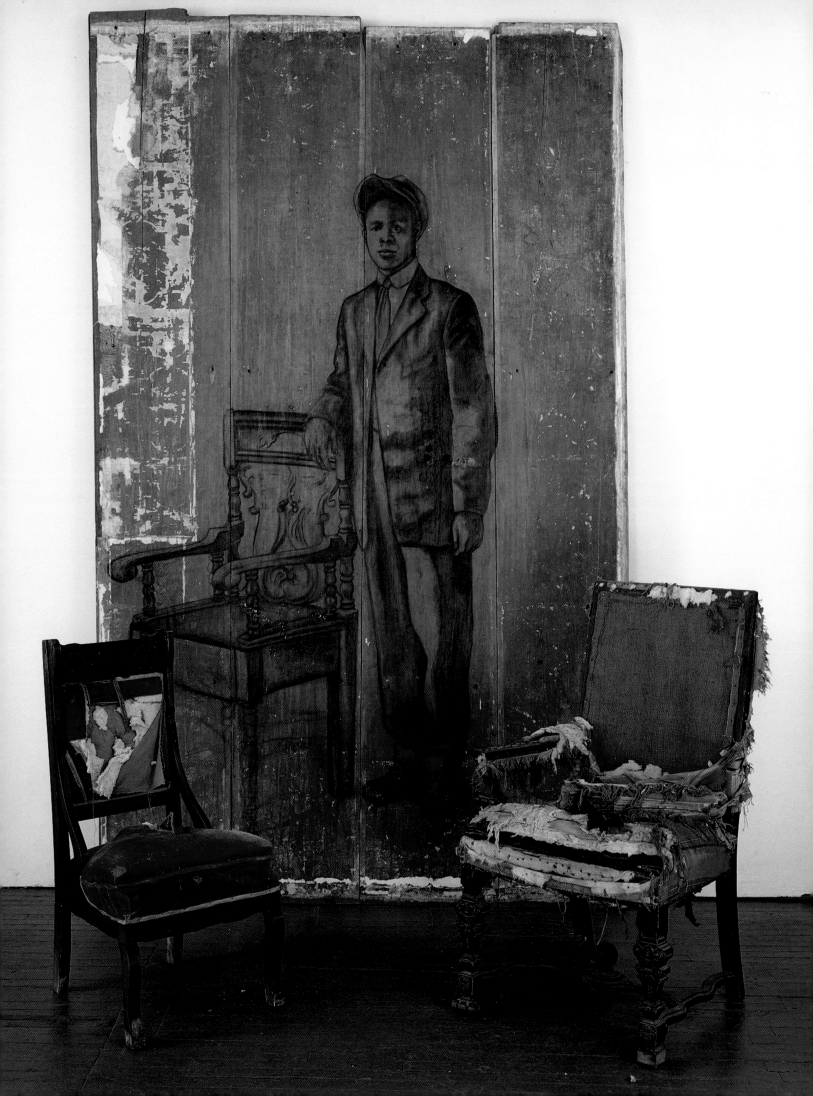

PLATE 319
Whitfield Lovell (American, born 1959)
Ode, 1999
Mixed media on wood and chairs, 9 ft. 9 in. x 72 in. x 59 in.
(297.2 x 182.9 x 149.9 cm)
Katharine Ordway Fund

PLATE 320
David Salle (American, born 1952)
Nearby a Finch Was Covering Itself with Pale Dust, 1980
Acrylic and graphite on canvas, 84 x 60 in. (213.4 x 152.4 cm)
Gift of Mr. and Mrs. Gilbert H. Kinney, B.A. 1953, M.A. 1954

PLATE 321
Jean-Michel Basquiat (American, 1960–1988)
The Ankle, 1982
Oil stick, paper Xerox collage, and acrylic, 60 in. x 10 ft.
(152.4 x 304.8 cm)
Charles B. Benenson, B.A. 1933, Collection

ODE A L'OUBLI

ODE
A
L'OUBLI

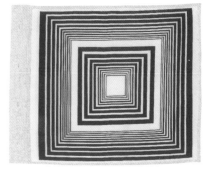

I had a flashback
of something
that never existed

The
return
of
the
repressed

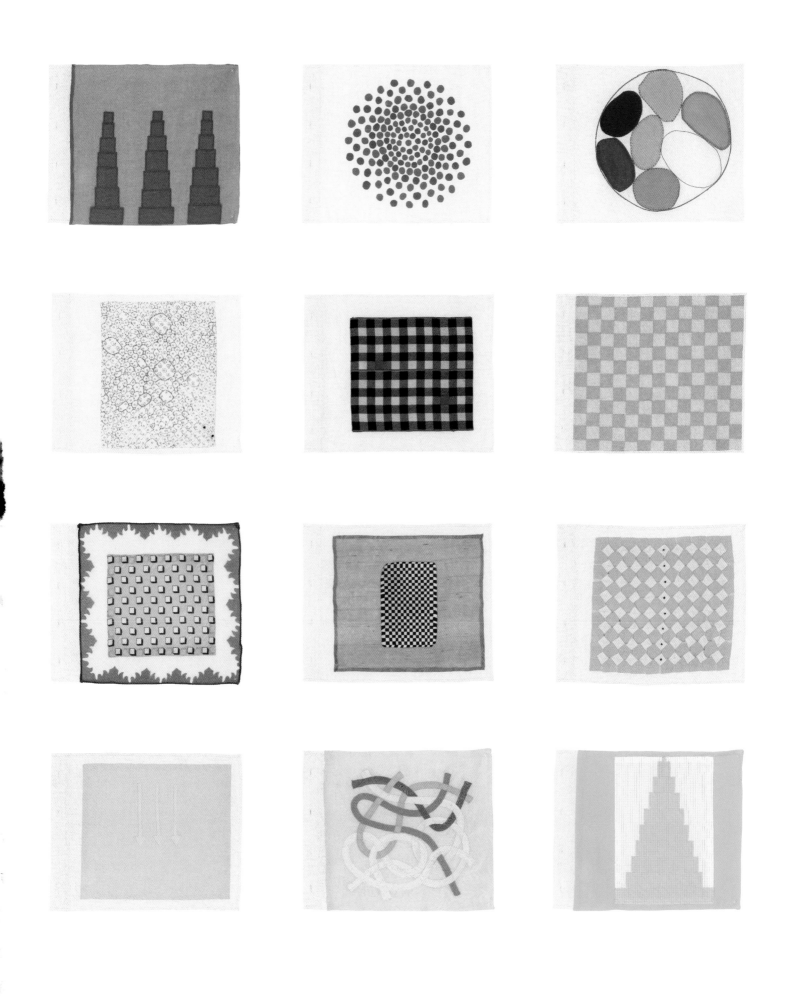

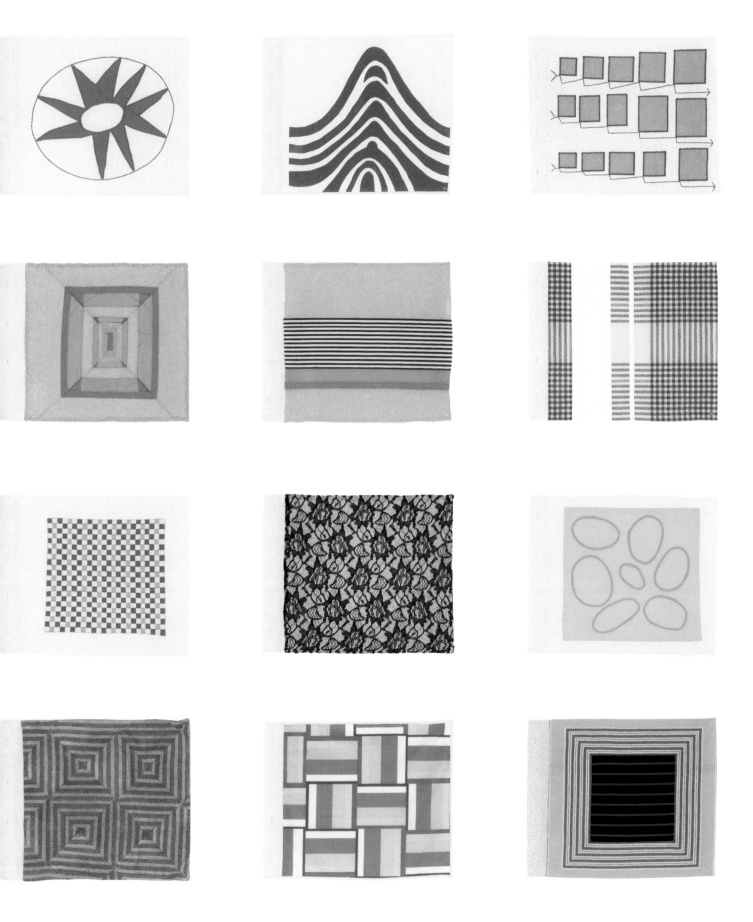

PLATE 322 (detail overleaf)
Louise Bourgeois (American, born France, 1911, D.F.A. Hon. 1977)
Ode à l'oubli (*Ode to Forgetfulness*), 2004
Edition 24/25, with 7 additional artist's proofs

Hand-sewn cloth book printed with lithographic ink, containing
thirty-six pages, each page 10⅝ x 13⅜ in. (27 x 34 cm)
Gift of Francis H. Williams in honor of Jennifer R. Gross

PLATE 323
Helen Frankenthaler (American, born 1928, D.F.A. Hon. 1981)
Tales of Genji III, 1998
Fifty-three-color woodcut from eighteen woodblocks (seventeen
maple, one mahogany) and two stencils on gray TGL handmade
paper, irreg. 46½ x 42 in. (118.1 x 106.7 cm)
Gift of the artist

PLATE 324
Roni Horn (American, born 1955, M.F.A. 1978)
Untitled *(Gun)*, 1994
Edition 2/3
Aluminum and plastic, 10 ft. 10 in. x 5 in. x 5 in.
(330.4 x 12.7 x 12.7 cm)
Janet and Simeon Braguin Fund

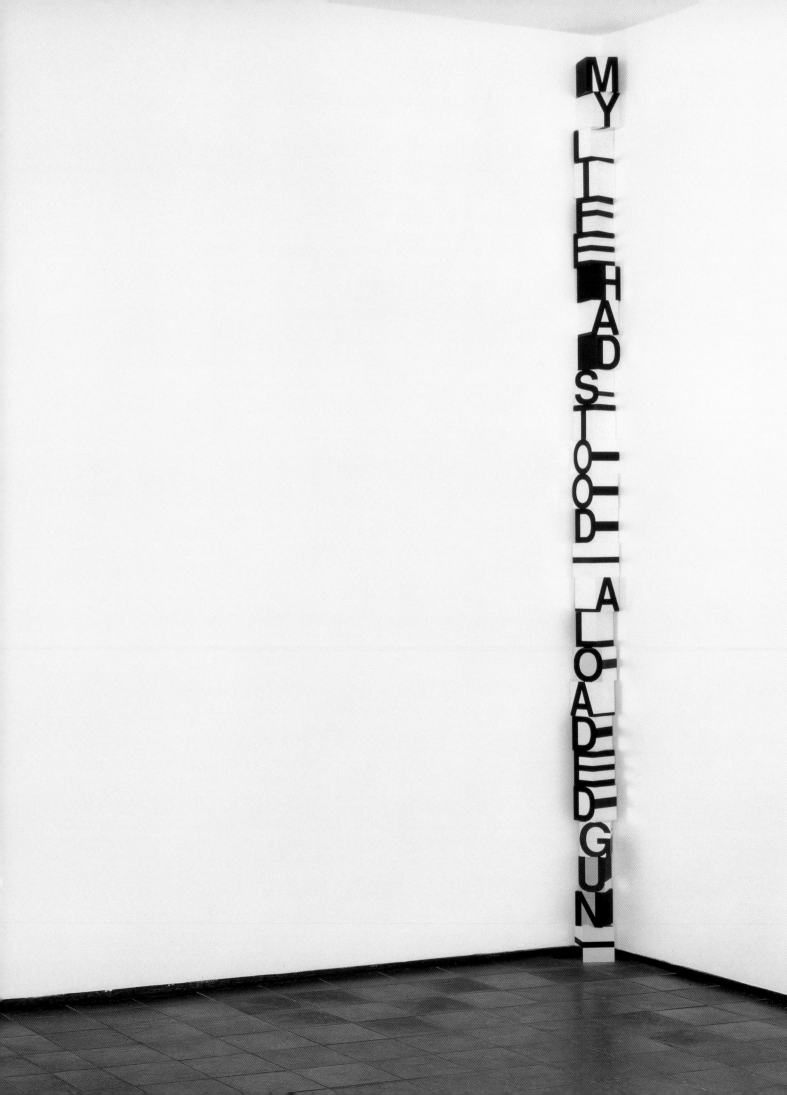

PLATE 325
Robert Ryman (American, born 1930)
Resident, 2002
Oil on canvas, 34 x 34 in. (86.4 x 86.4 cm)
Promised gift of Richard Serra, B.F.A. 1962, M.F.A. 1964

PLATE 326
Richard Serra (American, born 1939, B.F.A 1962, M.F.A. 1964)
Sinker, 1992−93
Oil stick, 70 x 70 in. (177.8 x 177.8 cm)
Gift of Sally and Wynn Kramarsky

CONTRIBUTORS TO THE CATALOGUE

Richard M. Barnhart RMB

Suzanne Boorsch SB

Walter Cahn WC

Dennis A. Carr DAC

Joshua Chuang JC

Helen A. Cooper HAC

Elizabeth C. DeRose ECD

Erin E. Eisenbarth EEE

Susan Greenberg Fisher SGF

Robin Jaffee Frank RJF

Pamela Franks PF

John Stuart Gordon JSG

Jennifer Gross JG

Richard A. Grossmann RAG

Elisabeth Hodermarsky EH

Nathaniel Jones NJ

Edward Kamens EK

Patricia E. Kane PEK

Laurence B. Kanter LBK

Frederick John Lamp FJL

Amy Kurtz Lansing AKL

Benjamin Lima BL

Russell Lord RL

Colleen Manassa CM

John J. Marciari JJM

Susan B. Matheson SBM

Matthew M. McCarty MMM

William E. Metcalf WEM

Mary E. Miller MEM

Sadako Ohki SO

Megan E. O'Neil MEO

Christine Paglia CP

Jock Reynolds JR

Matthew H. Robb MHR

Ingrid Schaffner IS

David Ake Sensabaugh DAS

Robert Slifkin RS

Takeshi Watanabe TW

Entries on
Selected Works

PLATE 1

John Brewster, Jr.
(American, 1766–1854)

Comfort Starr Mygatt and Lucy Mygatt, 1799
Oil on canvas, 54 x 39½ in. (137.2 x 100.3 cm)
Promised gift of Jane and Gerald Katcher, LL.B. 1950

Itinerant New England portraitist John Brewster, Jr.'s, paintings of children convey the poignant desire of parents to capture their sons' and daughters' likenesses in an era when family members often died young. Nowhere is that hopeful bond of affection more endearingly expressed than in this portrait of a serenely solemn five-year-old girl, Lucy Mygatt, reaching for her father, Comfort's, hand, casually draped over the back of a Windsor chair. By stripping the setting of inessential detail and placing father and daughter against a blank gray wall, the artist focuses our attention on their direct gazes just as their hands meet, so that the viewer experiences a moment of intense communion with the sitters. For Brewster, who was deaf, eye contact and gesture were vital means of communication; here, he translated his sensitivity to the nuances of gaze and touch into the language of paint with quiet eloquence.

Born in Hampton, Connecticut, Brewster descended from one of New England's oldest Puritan families. Through his social connections and unique vision, he established himself as a leading portraitist for the region's elite merchant class. Comfort Starr Mygatt was a prominent merchant, silversmith, and watchmaker in Danbury, Connecticut, whose account book reveals that in exchange for goods from Mygatt's store, Brewster painted four portraits of family members, including a companion portrait of Comfort's wife, Lucy, and their son George (Palmer Museum of Art, University Park, Pa.). In 1807, the family emigrated to Canfield, Ohio, by covered wagon. There, the younger Lucy, the sixth of the Mygatts' eight children, married Asahel Adams in 1814; they, too, had eight children. This painting descended in their family until 1987, a testament to its role in perpetuating familial devotion through time.

RJF

See Paul S. D'Ambrosio, "Two Masterworks by John Brewster, Jr.," in *Expressions of Innocence and Eloquence: Selections from the Jane Katcher Collection of Americana*, ed. Jane Katcher, David A. Schorsch, and Ruth Wolfe (New Haven and Seattle: Yale University Press and Marquand Books, 2006), 57–65 and 325–26, cat. no. 31.

PLATE 4

John Seymour and Son
(American, 1794–1804)

Tambour Desk
Boston, Massachusetts, ca. 1800
Mahogany, light and dark wood inlays, and white pine, 41 x 36¼ x 19½ in. (104.1 x 92.1 x 49.5 cm)
Promised anonymous bequest

Ladies' tambour desks were popularized in America by English immigrant cabinetmakers John Seymour (1738–1818) and his son Thomas (1771–1849). Seeking new economic opportunities, the Seymours arrived in Maine in 1784, eventually moving to Boston in 1793. Their English-inspired craftsmanship and design sensibility found a ready market in post-Revolutionary Boston, which had long held a preference for British styles. The pair owned a copy of Thomas Sheraton's *The Cabinet-Maker and Upholsterer's Drawing Book* (1791) and were obviously influenced by Sheraton's designs, particularly his use of the principles of classical architecture. Their furniture constantly pushes the boundaries of the often conventional Boston styles of the period, and the pair's designs influenced an entire generation of Boston craftsmen. Father and son worked together until 1804, when John appears to have retired from active craftsmanship and Thomas opened his ambitious Boston Furniture Warehouse, which at its zenith offered cabinetmaking and chairmaking, sold looking glasses, retailed used furniture, and even sold carriages.

The Federal period saw the development of distinctly gendered furniture forms. As women's education became more intensive and widespread, diminutive desks sized to female forms and tasks developed. With tambours, or sliding doors made of thin slats glued to canvas, which open to reveal a variety of storage compartments for paperwork and writing paraphernalia and a foldout writing surface, the mahogany desk conceals its practical functions behind an elegant architectural facade of columns and cornices. It features several hallmarks of the Seymours' style, including inlaid swags on the desk doors, bellflower inlay along the legs, inlaid stringing along the case's edges, decorative knee brackets, and molded therm feet. The Seymours and other Boston craftsmen offered numerous variations on this form, selling it in one-, two-, and three-drawer versions with a variety of available finishing details; this version would have been among the most elaborate and expensive offered.

EEE

Robert D. Mussey, Jr., *The Furniture Masterworks of John and Thomas Seymour*, Peabody Essex Museum Collections Series (Salem, Mass.: Peabody Essex Museum, 2002), 81–84 and cat. nos. 3–4.

PLATE 5

Goddess of Liberty Weathervane
Manufactured by J. L. Mott Ironworks (1828–1903)
New York, New York, 1880–1900
Copper, zinc, gilding, and painted decoration, 38 x 52 in. (96.5 x 132.1 cm)
Promised gift of Jane and Gerald Katcher, LL.B. 1950

Although weathervanes serve a practical purpose—indicating which way the wind is blowing—people capitalized on their decorative potential to create a variety of sculptural pieces in whimsical and unusual forms. Weathervanes' shapes often display symbols of qualities that were important to their owners and their communities. This weathervane depicts the Goddess of Liberty, a figure that had been popular in American decorative arts since soon after the Revolution. Standing atop a large arrow and wearing flowing Grecian-style robes and a Phrygian or liberty cap (modeled on those worn by freed slaves in ancient Rome and later by French revolutionaries), the young and vital figure of Liberty was the perfect personification of the new nation's hopes and dreams. Her outstretched hand serves to indicate the wind's direction but also points inexorably forward as she urges the nation onward. She

holds the American flag in her other hand, firmly staking the nation's claim on the lands that the weathervane looked over from above. Though the figure of Liberty can be found on goods produced throughout the nineteenth century, it enjoyed a new popularity in the post–Civil War years, especially after 1886, when the French gifted America with Frederic Auguste Bartholdi's colossal sculpture, *Liberty Enlightening the World*—the Statue of Liberty. This weathervane is attributed to New York City's J. L. Mott Ironworks, based on an 1892 edition of the plumbing fixture firm's catalogue that features a variant of this design with similar treatment of the head and hands.

EEE

Jane Katcher, David A. Schorsch, and Ruth Wolfe, eds., *Expressions of Innocence and Eloquence: Selections from the Jane Katcher Collection of Americana* (New Haven and Seattle: Yale University Press and Marquand Books, 2006), 382–83, cat. no. 153.

PLATE 6

Sarah Burke Pool

(American, 1824–unknown)

Mary J. Pool

(American, 1826–unknown)

Design attributed to Mary Heidentroder Simon

(American, born Germany, active 1844)

Album Quilt

Baltimore, Maryland, 1845–55
Appliquéd cotton fabrics with ink details, 8 ft. 10 in. x 8 ft. 11 in.
(269.2 x 271.8 cm)
Promised gift of Jane and Gerald Katcher, LL.B. 1950

Filled with allusions to American political culture of the mid-nineteenth century, this Baltimore album quilt is an unusual and elaborate example of the form. Album quilts were so named because the individual squares that made up each quilt were often made and signed by its owner's friends and relatives. Often associated with marriages and other significant life events, each panel of the quilt served as a reminder of its maker in much the same way that the decorated pages of an autograph book or a friendship album did. These books, popular pastimes among young women of the era, and their quilted equivalents served as visual reminders of the ties of friendship and family that bound women together.

This quilt is signed by two women, Sarah and Mary J. Pool, who lived in Baltimore during the early 1850s and were likely sisters-in-law. It appears to be based on a design by Mary Simon, a German immigrant to Baltimore who may have sold quilt designs or even album square "kits" to aspiring local quilters. While it contains the elaborate floral designs characteristic of Baltimore album quilts, the Pool quilt is most notable for its elaborate appliquéd structures relating to the Baltimore area. A log cabin with an American flag and a barrel of hard cider by the door refers to William Henry Harrison's 1840 presidential campaign, which was launched in Baltimore and whose slogan was "Log Cabin and Hard Cider." Baltimore's Battle Monument, which honors those who fell defending the city in the War of 1812, is also pictured, as is a steam locomotive, which may refer to the Baltimore and Ohio Railroad, which became the first passenger railroad line in 1830. The other

Neoclassical-style buildings have not been identified but may also refer to prominent structures in the city. Other squares are filled with intricate designs of flowers and patriotic symbols.

EEE

Jane Katcher, David A. Schorsch, and Ruth Wolfe, eds., *Expressions of Innocence and Eloquence: Selections from the Jane Katcher Collection of Americana* (New Haven and Seattle: Yale University Press and Marquand Books, 2006), 307–8, cat. no. 5.

PLATE 7

Side Chair

Probably New York, New York, ca. 1835–50
Mahogany, mahogany veneer, and pine, 37¼ x 17¾ x 17½ in.
(94.6 x 45.1 x 44.5 cm)
Promised gift of Jay E. Cantor

The Gothic Revival had its beginnings in nineteenth-century England, where everyday proximity to medieval art and architecture meant that the historical past was never far from hand. The style soon spread to the United States, finding expression in both architecture and the decorative arts. Its historical ties appealed to an era interested in romanticism, and its bold and dramatic shapes were reminiscent of a distant, and therefore exotic and mysterious, past. Offering a direct contrast to the restraints of Classical architecture, the Gothic Revival style gave architects and designers a chance to experience great creative freedom. The Gothic Revival made no attempt to reproduce actual medieval furniture or architecture, which was regarded as uncomfortable, impractical, and unsanitary by nineteenth-century standards. Instead, Gothic motifs were applied to modern forms that owed more to imagination than to historical evidence.

This mahogany chair represents a transitional moment in American decorative arts between the Empire, or late Neoclassical, style and the Gothic Revival. The chair's frame is a Neoclassical form known as a gondola chair (with a bowed front and sweepingly curved legs) overlaid with a variety of Gothic ornamentation. The pointed arches and quatrefoil openwork and finial are hallmarks of the Gothic style, designed to evoke the majestic architecture of Europe's great medieval castles and cathedrals. Probably made in New York, which had by the middle decades of the nineteenth century become a major center of American furniture manufacture and design, the chair would have been at home in any stylish room of the period.

EEE

Katherine S. Howe and David B. Warren, *The Gothic Revival Style in America, 1830–1870*, exh. cat. (Houston: The Museum of Fine Arts, Houston, 1976).

PLATE 9

Thomas Eakins

(American, 1844–1916)

Trotting Horses: Fairman Rogers's Four-in-Hand, 1879

Wax, 12 x 10¼ in. (30.5 x 26 cm)
Gift of the Estate of Paul Mellon, B.A. 1929, L.H.D. Hon. 1967

Although Thomas Eakins produced only ten finished works of sculpture during his career, all of them in relief, the artist created

Figure 1. Thomas Eakins, *A May Morning in the Park (The Fairman Rogers Four-in-Hand)*, 1879–80. Oil on canvas, 23¾ x 36 in. (60.3 x 91.4 cm). Philadelphia Museum of Art, Gift of William Alexander Dick, 1930

ambitious paintings. Eakins created these wax studies in an effort to solve the technical and anatomical challenges of portraying four trotting horses for *A May Morning in the Park* (fig. 1), his most ambitious painting to date. Commissioned by Fairman Rogers, a wealthy engineer and avid amateur coachman who was interested in the motion of horses, as a portrait of his new coach-and-four, the scene combined the two central themes of Eakins's early work: the realistic depiction of bodies in motion and the portrayal of new modes of middle-class outdoor leisure. Like Rogers, Eakins was an amateur photographer and was fascinated by the series of stop-action photographs of horses trotting recently produced by Eadweard Muybridge. This new technology solved one of the most persistent mysteries of visual representation: the exact and truthful depiction of a trotting or galloping horse. By basing his wax models on the static frozen instances documented in Muybridge's photographs, Eakins was able to render in three dimensions the position of each horse's legs and hooves, thus allowing the rhythmic tangle caused by their incorporated motion to be represented with greater accuracy in the finished painting.

RS

For an excellent discussion of the creation of the painting and its various studies, as well as of Eakins's working method, see Kathleen A. Foster, *Thomas Eakins Rediscovered* (New Haven: Yale University Press, 1997).

PLATE 18

Pier Table

New York, New York, 1810–30
Black marble, rosewood, brass, yellow poplar, pine, and glass, 37 x 42 x 18 in. (94 x 106.7 x 45.7 cm)
Gift of Mr. and Mrs. George M. Kaufman

Pier tables, and their associated looking glasses, were a key component of well-appointed parlors during the first decades of the nineteenth century. Used for the display of luxury objects, they were also objects themselves—the polished rosewood, gilt-brass mounts, and mirrored back would have glimmered in flickering gas or candlelight. This pier table is a particularly fine example: its sumptuous materials and cultured references exemplify the international trade and sophistication of America's leading port city.

Pier tables of this form—planar surfaces with two freestanding columns supporting a rectangular top—proliferated in New York, yet the lavish use of expensive marble and brass inlay instead of gold stenciling indicates high-caliber craftsmanship. The richly veined, black marble of the slab top, front columns, and rear pilasters was probably imported from France or Italy. The rosewood veneer originated in Brazil. The columns' gilt-brass capitals and bases, as well as the intricately pierced fretwork band, are closely related to examples manufactured in Birmingham, England. The figurative and foliate mounts are each marked "GA" on the reverse, which Donald Fennimore associates with a foundry in Germany, possibly Iserlohn.[1] Such variety of costly, imported materials attests to New York's thriving economy and makes this pier table a thoroughly international object.

With columns, lion's paw feet, and carved acanthus leaves, this pier table brought elements of the classical world into the domestic sphere. By the 1830s, the fashion for archaeologically fastidious Neoclassicism became more eclectic, as evidenced here by the two figural, cast-brass mounts: above the columns are figures of Robinson Crusoe and his man Friday, taken from Daniel Defoe's heroic tale, first published in 1718. Such narrative mounts spoke to the erudition of the table's patron and would have delighted guests educated enough to recognize the literary characters.

JSG

1. Donald Fennimore, *Metalwork in Early America: Copper and Its Alloys from the Winterthur Collection* (Winterthur, Del.: Henry Francis DuPont Winterthur Museum, 1996), 424–25.

PLATE 19

Looking Glass

England, 1825–40
Gilded pine and glass, 51 x 36 in. (129.5 x 91.4 cm)
Gift of Jean M. Buist, D.V.M.

Circular looking glasses like this English example, which descended in the Judge Richard Morris family of New Jersey, were common ornaments in the dining rooms and parlors of well-to-do American homes in the first half of the nineteenth century. Displayed over a sideboard, pier table, or mantel, their gilded surfaces and silvered glass made rooms brighter by multiplying available light from candles or lamps. The ornaments placed near looking glasses were often strategically arranged to highlight a family's valuables or art objects, such as silver plate, within the glass's shining surface.[1] Topped with a large eagle perched on a molded outcropping of rocks, the looking glass shows the ways that American symbols were incorporated into the elaborate and massively solid designs of Empire-style furniture.

Expensive, fragile, and difficult to keep clean, looking glasses were nonetheless an important part of American decor since the colonial period. The fragile nature of their glasses and frames means that few survive today. Not only does this monumental glass still survive, it retains its original surface, with no overgilding. Even after domestically made looking glasses became available in the nineteenth century, many Americans continued to import them from Europe, both because imported goods were seen as

more stylish and because large, specialized European workshops could undersell American makers owing to their large-scale production. With its large size, impressive façade, and English pedigree, this looking glass made an unmistakable statement about the wealth and prestige of its owners.

EEE

1. Elizabeth Donaghy Garrett, "Looking Glasses in America, 1700–1850," in David L. Barquist, *American Tables and Looking Glasses in the Mabel Brady Garvan and Other Collections at Yale University* (New Haven: Yale University Art Gallery, 1992), 28.

PLATE 21

Vase

Decorated by M. B. G. (19th century)
Manufactured by Faience Manufacturing Company (1881–92)
Greenpoint, Brooklyn, New York, ca. 1891, decorated June 1891
Soft-paste porcelain with painted decoration and gilding, H. 18 x
DIAM. (waist) 8¼ x DIAM. (foot) 5³⁄₁₆ in. (45.7 x 21 x 13.2 cm)
Gift of Nancy Stiner

The Faience Manufacturing Company created some of the most inventive and fashionable ceramics of America's Gilded Age during its eleven years of operation. The firm's art director, Edward Lycett, an English china painter who emigrated to New York in 1861, incorporated lavish decoration, textured surfaces, and novel forms, which successfully competed with European imports from Royal Worcester and Sèvres.

The semicircular cover topped by a finial, the long neck with a ribbed collar, and the broad shoulders give this vase a Moorish appearance. The decoration, on the other hand, is inspired by Japanese prints and porcelains, featuring lush roses painted in semimatte glaze against a white background. The open roses naturalistically cascade around the body of the vase, with stems and leaves extending into the upper register and down onto the foot. This blend of references reflects the era's broad interest in non-Western aesthetics, informed by the exotic displays staged at the various international exhibitions and promoted in popular women's magazines.

By the time this vase was painted in 1891, the fortunes of the Faience Manufacturing Company were in decline. The company ceased producing new ceramics in 1890 and shortly thereafter put the molds and factory up for sale.[1] The underside of this vase bears the pattern mark "1129" but not the company's standard cipher. In addition, the decoration lacks the ornate gilding and applied texture evident on earlier pieces, suggesting this may be one of the excess blanks that the Faience Manufacturing Company sold for others to embellish. During the late nineteenth century, china painting grew in popularity as a socially acceptable vocation for women and as a pastime for members of the leisure class. Painted on the underside of this vase are the initials and date: "M. B. G. June 1891," most likely the signature of a gifted amateur china painter.

JSG

1. Barbara Veith, "Edward Lycett and the Faience Manufacturing Company," *Antiques* (July 2001): 84–91.

PLATE 22

Center Table

Probably New York, New York, ca. 1885
Satinwood and maple with an onyx or alabaster top, 29⁵⁄₁₆ x 42⁵⁄₁₆ x
30¹⁄₁₆ in. (74.5 x 107.4 x 76.4 cm)
Promised gift of Stewart G. Rosenblum, J.D. 1974, M.A. 1974,
M.PHIL. 1976, in memory of his parents, Elmer M. and Harriet G.
Rosenblum

This ornamental table belongs to a suite of parlor furniture comprised of a settee, two armchairs, two side chairs, and a slipper chair. All of the pieces are in the Louis XIV revival style and are characterized by honey-colored satinwood with delicate scroll leaf and floral carving, trails of bellflowers, and gadrooned moldings. On the table in particular, the dramatic contrasting colors of the marble top, the gadrooned molding surrounding it, the elaborately carved rails, and the tapered rectangular legs terminated by Ionic capitals and reinforced by richly carved stretchers evoke the sumptuous style created in the court of France's most illustrious ruler. This return to historical reference and high degree of luxe appealed to wealthy American industrialists after the planarity and rectangularity of furniture inspired by the British design-reform movement and Japanese decorative arts of the late 1870s to the mid-1880s.

The table and other pieces in the suite give evidence of having been made in a custom cabinetshop. The minute and scrupulous details of the floral carving indicate that it was executed by hand. The use of satinwood, an expensive imported tropical hardwood, points to high-end production and can be found, for instance, on furniture made in the 1880s by Herter Brothers, a leading decorating firm in New York City. Blocks supporting the joints of the legs and table frame are numbered in graphite, as is often found in cabinetwork of the preindustrial era. The rails of the settee, arm, and side chairs are stamped with sequential four-digit numbers, and all of the pieces are supported on hard rubber casters manufactured by the Queens, New York, firm India Hard Rubber Comb Company in the manner of documented Herter Brothers pieces. Conforming as it does in a number of ways to furniture made by Herter Brothers, the suite may well have been made by that firm.

PEK

Katherine S. Howe et al., *Herter Brothers: Furniture and Interiors for a Gilded Age* (New York: Harry N. Abrams, in association with the Museum of Fine Arts, Houston, 1994).

PLATE 24

John F. Francis

(American, 1808–1886)

Dessert Still Life, 1855

Oil on canvas, 20 x 24 in. (50.8 x 61 cm)
Partial and promised gift of Mr. and Mrs. Andrew J. Goodman,
B.S. 1968

The depiction of a simple dessert arrangement was among John F. Francis's favorite themes. A native of Philadelphia, Francis was understandably influenced by the city's most celebrated still-life painter, Raphaelle Peale, whose technical perfection in severe

arrangements of fruit, cakes, and other objects dominated the genre for many years. In *Dessert Still Life*, Francis places a large porcelain bowl filled with ripe strawberries as the central motif. The intense red hue of the berries is reflected upon almost every lustrous surface set on the table: the gilded trim of the tall pastry tray holding the haphazardly arranged cakes, the spout of the glass milk jug, the silver sugar bowl, the bowl of the spoon set in the center of the composition. This play of reflections unites all of the disparate and irregularly assembled objects upon the table, creating a harmonious and spatially complex composition. Just as the mirrorlike reflections play across the various surfaces of the objects, Francis's nearly invisible technique seems to transform material objects into the two-dimensional realm of the canvas through an almost magical act of duplication.

RS

PLATE 25

Robert Spear Dunning

(American, 1829–1905)

Still Life with Honeycomb, ca. 1880

Oil on canvas, 13 x 17 in. (33 x 43.2 cm)
Promised bequest of Andrew J. Goodman, B.S. 1968

Robert Spear Dunning's meticulous rendering of a casual display of fruit is at once a paean to the bounties of the American harvest and a showcase for his technical mastery of still life. Within the pyramidal composition, he creates a rhythmic pattern of circular forms uniting a sole apple in the left background with a group of four peaches on the opposite end of the arrangement through wavelike bunches of white and red grapes, their leaves from the vine vaguely visible in the painting's shadowy background. A handful of cherries, whose hard surfaces subtly contrast with the translucence of the grapes, lie in the foreground; one cherry droops over the edge of the tabletop, teasing the viewer to reach out and pluck it. Dunning gives special attention to the wood table, capturing the hazy reflections on its highly polished surface and illusionistically rendering the carved molding whose flat, sculptural facade, parallel to the picture plane, creates a striking opposition to the depicted depth of the arrangement and the carefully modeled forms of the fruit.

Most notable among the items on display is the wedge of honeycomb, which was a signature motif for the artist. Set upon a delicate serving tray whose silver base echoes the shallow glass goblet in the background, the glistening cells of the sweet delicacy give the artist an opportunity to exhibit his skill at depicting texture and the play of light upon gleaming surfaces. As the central focus within the highly organized arrangement, the honeycomb, with its geometrically ordered internal constitution, reiterates the painting's prevailing theme of domestic tranquility, hospitality, and natural abundance.

RS

Dunning was among a group of artists in his native Fall River, Massachusetts, who formed a regional school of still-life painters. For a brief survey of his career, see William Gerdts and Russell Burke, *American Still Life Painting* (New York: Praeger, 1971), 169–80.

PLATE 26

Martin Johnson Heade

(American, 1819–1904)

Two Hummingbirds with Their Young, ca. 1865

Oil on canvas, 13 x 11 in. (33 x 27.9 cm)
Promised bequest of Jerald Dillon Fessenden, B.A. 1960

Hoping to create a book that would rival Audubon's *The Birds of America*, Martin Johnson Heade traveled to Brazil in 1864 to sketch hummingbirds for a proposed magnum opus that would feature color lithographs based on his finished oil paintings and include an introductory text by the artist. Best known for his serene landscapes of New England salt marshes in which he explored the atmospheric effects of sunlight at various times of the day and under different meteorological conditions, Heade applied the same attention to detail and the environment in his series of hummingbird pictures. Although the projected book, which was to be titled *The Gems of Brazil*, was never published because of lack of financial sponsors as well as the artist's own dissatisfaction with the printed versions of his paintings, the twenty canvases Heade produced are assured statements of artistic purpose.

This painting depicts the male and female (the latter distinguished by the white tips at the end of her tail) Sappho Comet (*Cometes sparganurus*). With their intensely colorful feathers of iridescent reds and greens, the diminutive birds, presented to the viewer at very close range, stand out from the hazy sky and distant mountains behind them, while their extraordinary forked tails, which visually echo the branches of the tree they perch upon, subtly underscore ecological harmony. Although this species is native to Peru and Bolivia rather than Brazil, Heade chose to include it in his *Gems*, suggesting that the artist was more interested in artistic beauty and variety than regional specificity and scientific taxonomy. Heade presents the birds in a geographically accurate environment, giving special attention to each species' distinctive nests and, here, including their young. Forming an arch over their young and surrounded by the verdant tropical wilderness, the Sappho Comet couple invokes the harmony of the natural order and the eternal cycle of life. With their jewel-like feathers that change color with every movement and variation in light, hummingbirds served as a microcosmic example of the same ever-changing cosmos Heade explored in his landscapes. His images of these exquisite birds further reiterated the artist's commitment to the immediate individual perception of natural phenomenon.[1]

Like his friend and occasional studio associate Frederic Edwin Church, Heade chose to depict South American scenery during the Civil War. Such a subject appealed to both Northern and Southern collectors, thus guaranteeing the broadest possible audience for his works. Paintings like *Two Hummingbirds with Their Young* also express the desire to find examples of unencumbered beauty during the darkest moments of history.

RS

1. For a good summary of Heade's South American travels, as well as the history of hummingbird books, see Theodore Stebbins, *Martin Johnson Heade*, exh. cat. (Boston: Museum of Fine Arts, 1999).

PLATE 27

Thomas Eakins

(American, 1844–1916)

John Biglin in a Single Scull, 1873

Watercolor, 16⅞ x 23¹⁵⁄₁₆ in. (42.9 x 60.8 cm)

Gift of Paul Mellon, B.A. 1929, L.H.D. Hon. 1967, in honor of Jules D. Prown, the first Director of the Yale Center for British Art

Thomas Eakins's rowing pictures are among the most recognized images in American art. Created between 1871 and 1874, when rowing's popularity in America was at its height as a sporting and social event, they represent the most ambitious project of his early career.[1] A landmark in the history of American realism, they would become the first sustained treatment of sculling to appear in fine art.

The Philadelphia-born Eakins brought to the theme both his personal experiences as an avid amateur rower and a scientific understanding of the muscles utilized in the physical effort. The celebrated oarsman John Biglin was his most frequent subject. As an artistic subject, the seminude, muscular rower allowed Eakins to demonstrate his skills as a figure painter. Seen against the New Jersey shoreline of the Delaware River, Biglin is portrayed in a classic posture as he approaches the moment of the catch, with the boat running under him and his blade on the feather. He has the concentrated gaze of an oarsman in competition. From Biglin's facial features to the slight wearing away of the wooden thole pin that acts as a fulcrum for the oar, Eakins rendered every element with meticulous attention to detail. In the distance, an eight-oared shell follows the race down the course, the crew's red shirt a refrain of Biglin's red headscarf.

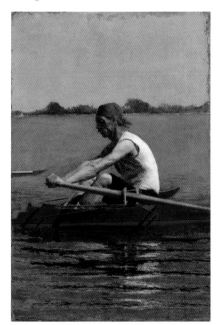

Figure 1. Thomas Eakins, *John Biglin in a Single Skull*, 1874. Oil on canvas, 24⅜ x 16 in. (61.9 x 40.6 cm). Yale University Art Gallery, Whitney Collections of Sporting Art, given in memory of Harry Payne Whitney, B.A. 1894, and Payne Whitney, B.A. 1898, by Francis P. Garvan, B.A. 1897, M.A. Hon. 1922

The famous Eakins oil painting of the same subject (fig. 1), also in the Gallery's collection, was originally begun as a study for this watercolor; later, Eakins completed the oil to stand as a fin-

ished work. The unusual procedure of making an oil study for a watercolor expresses perfectly Eakins's meticulous preparation and premeditated approach.

HAC

1. See Helen A. Cooper, *Thomas Eakins: The Rowing Pictures* (New Haven: Yale University Art Gallery, 1996).

PLATE 28

Winslow Homer

(American, 1836–1910)

At Anchor, 1885

Watercolor and graphite, 14 x 20 in. (35.6 x 50.8 cm)

Promised anonymous bequest

In 1884, *Century* magazine commissioned Winslow Homer to illustrate an article it was planning on the newly popular winter resort of Nassau. It would be the New Englander's first visit to the tropics. Departing New York City on a December day, the artist arrived to find a flourishing town of dazzling white and pastel-colored houses, pink beaches, open bazaars, lush vegetation, unsullied blue waters, and a colorfully costumed local population. The impact had an immediate—and lasting—effect on his watercolor style. In the more than thirty watercolors he produced during his two-month stay, he found a freedom of expression that had nowhere appeared in his work before. The Bahamas sheets are painted with free and gestural strokes in transparent washes often of brilliant colors, leaving large areas of white paper exposed. Their style was undoubtedly affected by the conditions of their creation: painted outdoors, and quickly, before the watery pigment could dry under the hot sun. With fewer spongings, scrapings, and lift-outs—characteristics of the more highly finished watercolors of his stay in England three years earlier—they have a direct, seemingly unpremeditated execution.

The daily life of Nassau presented rich material for the artist. In *At Anchor*, Homer captures a scene he would have seen from the wharf—a crowded market boat of the kind that moved to and from the islands, serving the Bahamians. The boat is alive with activity: amid barrels and rolled-up bundles, white sheep, brown roosters, and other livestock share the deck with busy, straw-hatted black men and other figures, while two men in a small rowboat alongside the larger vessel appear engaged in a transaction. Over loose and lively graphite outlines to suggest the bustling activity, Homer exploits the accidental effects of the transparent washes, adding pools of more saturated color, such as the red hat and red shirt on two of the figures and blue shirts on others, to create a sense of movement and fluidity. Dividing the sheet in half, he almost completely obscures the sky with pale gray and white clouds, while calling forth the wide sea through shimmering blues flooded here and there with greens and turquoise. Homer's use of the untouched white paper is masterful—the white of the boat, the shirts of some of the figures, and the light of a tropical morning reflecting off the glittering sea. At the same time, he uses subtle scraping for the masts and rigging to give sparkle and texture to the sheet.

HAC

For a discussion of Homer's watercolor career, see Helen A. Cooper, *Winslow Homer Watercolors* (Washington, D.C.: National Gallery of Art, 1986).

PLATE 29

Sanford Robinson Gifford

(American, 1823–1880)

A Twilight in the Catskills, 1861

Oil on canvas, 27 x 54 in. (68.6 x 137.2 cm)
Promised anonymous gift

This landscape made Sanford Robinson Gifford's reputation.
Praised by a critic who saw *A Twilight in the Catskills* in the artist's
studio in 1860 as "one of the most original and admirable delin-
eations of our scenery yet produced," it was further acclaimed as
the "largest and most important landscape in the Exhibition" and
"the great picture of the season" when it was shown at the National
Academy of Design in 1861. But the painting's public presence was
relatively short-lived: soon after Sanford Robinson Gifford's death
in 1880, its whereabouts became unknown to scholars for more
than a hundred years, until 1998, when a private collector brought
it to the Williamstown Conservation Center, where it was identi-
fied as the long-lost work.

Gifford adopted an elongated horizontal format to create a
panoramic view of his favorite Catskills site, Kauterskill Clove, seen
from a high vantage toward a distant mountain range at sunset.
Dead trees stand mute in the foreground, their stark, leafless silhou-
ettes the result of some natural disaster, framing a scene of burning
color. Dividing the composition into broad bands, Gifford laid in
strokes of fiery crimsons, purples, and orange, under clouds of
opalescent gold, to capture forever the fleeting instant of spectacular
light that flashes a moment and then is gone. "The brilliance of this
picture almost fills the room," exclaimed one reviewer. "[Gifford's]
imagination seems more profound, his sentiment more enlarged,"
observed another.

Although Gifford would depict Kauterskill Clove many times
in his career, the expressive intensity of this rendering is unique. *A
Twilight in the Catskills* was painted on the eve of the outbreak of
the Civil War. In late 1860, the nation was facing its most serious
crisis; within months, the country would be torn apart, both politi-
cally and emotionally. The painting's charged palette, dead trees,
rocky and dangerous ledge, and the treacherous drop of the water-
fall into the valley below not only reflect Gifford's intensely per-
sonal response to a beloved American place but seem to mirror the
mood of the nation.

HAC

The most complete discussion of the painting is by Adam Greenhalgh, "'Darkness
Visible': *A Twilight in the Catskills* by Sanford Robinson Gifford," in *American Art
Journal* 22 (2001): 45–75. The information and the quotations in this entry are taken
from there.

PLATE 30

John Trumbull

(American, 1756–1843)

Study for *The Death of General Warren at the Battle
of Bunker's Hill, June 17, 1775*, 1785–86

Pen and brown ink with gray and brown ink washes, squared for
transfer in graphite, 5½ x 8⅛ in. (14 x 20.6 cm)
Purchased with a gift from Robert L. McNeil, Jr., B.S. 1936s, and
the John Hill Morgan, B.A. 1893, LL.B. 1896, M.A. Hon. 1929, Fund

On seeing *The Battle of Bunker's Hill* (fig. 1)[1] on an easel in
Benjamin West's studio in March 1786, Abigail Adams wrote to her
sister: "I can only say that in looking at it my whole frame con-
tracted, my blood shivered, and I felt a faintness at my heart.
Trumbull is the first painter who has undertaken to immortalize by
his pencil those great actions that gave birth to our nation. . . . He
teaches mankind that it is not rank nor titles, but character alone,
which interests posterity."

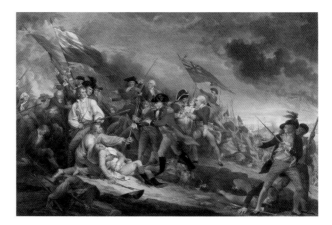

Figure 1. John Trumbull, *The Battle of Bunker's Hill*, 1786. Oil on canvas, 25⅝ x 37⅝
in. (65.1 x 95.6 cm). Yale University Art Gallery, Trumbull Collection

John Trumbull began his series of scenes of the American
Revolution with *Bunker's Hill*. On June 17, 1775, as an adjutant of
the First Regiment of Connecticut under General Joseph Spencer,
the artist had witnessed the conflict through field glasses from his
vantage in Roxbury. He represents the moment when the thirty-
four-year-old American general Joseph Warren is mortally
wounded by a musket ball just as the British successfully press
beyond the American fortifications. Rather than paint a scene in
which American forces proved triumphant, Trumbull focused
instead on the noble behavior of the participants, on the bond of
chivalry and gentlemanly conduct among military officers that
transcends national boundaries. In a magnanimous act, the British
major John Small is shown attempting to save Warren from being
bayoneted by a grenadier avenging the death of his fallen officer.

Squared for transfer to the canvas, this is the only known
sketch for *Bunker's Hill* to reflect the crucial elements of the paint-
ing. With confident and descriptive penwork that is full of energy
and telling details, and a deft use of washes, Trumbull defined the
central drama of the scene and the figures' relationship to one
another. The diagonals of banners and smoke, and the alternating
areas of light and shadow, further heighten the immediacy and
impact of the death scene.

HAC

1. Trumbull follows the British usage "Bunker's Hill." For a full discussion of the
painting, see Helen A. Cooper, *John Trumbull: The Hand and Spirit of a Painter* (New
Haven: Yale University Art Gallery, 1982).

PLATE 31

Sanford Robinson Gifford

(American, 1823–1880)

Study for Camp of the Seventh Regiment, near Frederick, Maryland, in July 1863, 1863

Oil on canvas, 9½ x 15½ in. (24.1 x 39.4 cm)
Promised bequest of Joseph G. Fogg III, B.A. 1968

Although best known for his placid and idyllic landscapes of the Catskill Mountains, Sanford Robinson Gifford created four paintings based on his personal experiences as a soldier during the Civil War. This small canvas served as a study for one such painting (Seventh Regiment Fund, New York). Gifford's Civil War paintings were a by-product of his military duty as a member of the Seventh Regiment of New York, a situation notably different from that of the artist most often associated with the war, Winslow Homer, who was commissioned by *Harper's Weekly*. Because of Gifford's intimate involvement with the war, his paintings reveal an attention to historical accuracy unique among artistic portrayals of the subject.

This painting depicts the camp of the artist's regiment days after the bloody but decisive Union victory at Gettysburg. Like Homer, Gifford presents the prosaic moments of soldiering rather than the violence and gallantry usually associated with representations of warfare. Here, he portrays a panoramic view of the camp, highlighting the action and expansiveness of the regiment rather than the individual experiences of the troops. Soldiers set their clothing and equipment out to dry; others relax and converse, write letters, cook by fires, and—at the banks of the river marked by a row of trees—wash their laundry. Beyond the camp, at the foot of the mountains, supply and artillery trains and various regiments of the Army of the Potomac can be discerned as a series of white and brown dots as they follow the Confederate forces retreating south.

RS

For a good summary of Gifford's military as well as artistic career, see Ila Weiss, *Poetic Landscape: The Art and Experience of Sanford Robinson Gifford* (Newark: University of Delaware Press, 1987).

PLATE 32

Winslow Homer

(American, 1836–1910)

The Sutler's Tent, 1863

Oil on canvas, 16½ x 12 in. (41.9 x 30.5 cm)
Promised bequest of Joseph G. Fogg III, B.A. 1968

During the first years of the Civil War, Winslow Homer accompanied New York's Sixty-first Infantry Regiment as an artist correspondent for *Harper's Weekly*, sketching scenes of military life during the army's campaign in Virginia. In 1863 he began a series of oil paintings based on his sketches and published wood engravings, which rapidly earned him a national reputation for his realistic depictions of camp life. Eschewing the tradition of heroic battle scenes, Homer instead presented the everyday life of individual soldiers, their camaraderie, and their boredom. As a result of this unconventional emphasis, the artist forged a new model of contem-

porary history painting, influenced by journalistic immediacy and the emerging technology of photography, which sought to portray a more democratic, if less chivalrous, view of modern warfare.

Typical of Homer's Civil War imagery, *The Sutler's Tent* depicts a moment in the life of an ordinary soldier. While the war is faintly suggested by the long row of tethered horses and scattered tents in the background, Homer focuses on two soldiers relaxing under the shade of a makeshift canopy of pine boughs next to the tent of one of the many itinerant merchants, or sutlers, who traveled with Union regiments. Sutlers supplemented the meager official rations of the soldiers, offering such amenities as tobacco, clothing, a variety of food, and (despite being generally prohibited) liquor. Although sutlers were regularly berated in the popular press and in many soldiers' letters for the high prices and low quality of their wares, they were nonetheless accepted as a necessary adjunct to the regiment and eagerly patronized on payday at the camp.

RS

For a discussion of Homer's Civil War–era art, see Marc Simpson, *Winslow Homer: Paintings from the Civil War*, exh. cat. (San Francisco: Fine Arts Museum of San Francisco, 1988).

Richard M. Benson

(American, born 1943)

PLATE 33

Untitled, from Lay This Laurel, 1972

Platinum-palladium print, 12⅝ x 9⅞ in. (32.1 x 25.1 cm)
Purchased with discretionary funds from Yale University President Richard C. Levin in honor of Richard Benson, Dean of the Yale University School of Art

PLATE 35

Untitled, from Lay This Laurel, 1972

Platinum-palladium print, 10⅛ x 12½ in. (25.7 x 31.8 cm)
Purchased with discretionary funds from Yale University President Richard C. Levin in honor of Richard Benson, Dean of the Yale University School of Art

Figure 1. Richard Benson, Untitled, from *Lay This Laurel*, 1972. Platinum-palladium print, 8¹⁵⁄₁₆ x 11⅜ in. (22.7 x 28.9 cm). Yale University Art Gallery, purchased with discretionary funds from Yale University President Richard C. Levin in honor of Richard Benson, Dean of the Yale University School of Art

When Richard Benson photographed the Shaw Memorial by Augustus Saint-Gaudens in 1972 (pls. 33, 35, and fig. 1), he called attention to both a monument and a part of Civil War history that had been largely forgotten. Situated on Boston Common, the memorial honors the first regiment of African American soldiers in U.S. history and their leader, Colonel Robert Gould Shaw. Saint-Gaudens completed the Shaw Memorial in 1897, and seventy-five years later, Benson's photographs reveal white oxidation veiling the figures and Shaw's broken blade, underscoring years of neglect.

The impetus for Benson's photographs was the creation of the book *Lay This Laurel: An Album on the Saint-Gaudens Memorial on Boston Common*, in which they accompany an essay by Lincoln Kirstein. Kirstein discusses the men honored by the monument and its changing audience, while Benson's photographs survey its situation, composition, and details. His unusual choice of platinum-palladium prints reflects Benson's interest in how photographic processes impact our perception, and the extremely fine detail and warm tone of these photographs perfectly suit their subject.

The memorial shows Shaw and the regiment in procession, and it is located where the living men marched on their way to battle in 1863, garnering the attention of nearly twenty thousand spectators. Two months later, Shaw and the majority of the regiment were killed in the bloody assault of Fort Wagner, South Carolina, and their bodies desecrated. After the war a committee formed in Boston to plan a memorial, commissioning Saint-Gaudens in 1884. The innovative composition that he completed in 1897 combines a classical frieze with an equestrian portrait, visually asserting the equal import of leader and troops. Individualized depictions of the soldiers provide intimations of the human lives behind the historical events. The soldiers' names were recorded for the first time in *Lay This Laurel* and were inscribed on the reverse of the monument by John Benson (a stone carver and the photographer's brother) and Brook Roberts in 1982. Benson's photographs not only document a moment in the life of the memorial but also play a role in its future.

CP

Richard Benson and Lincoln Kirstein, *Lay This Laurel: An Album on the Saint-Gaudens Memorial on Boston Common Honoring Black and White Men Together Who Served the Union Cause with Robert Gould Shaw and Died with Him July 18, 1863* (New York: Eakins Press, 1973).

PLATE 34

Edward Lamson Henry
(American, 1841–1919)

Memories, 1873

Oil on canvas, 12 x 11 in. (30.5 x 27.9 cm)
Partial and promised gift of Mr. and Mrs. Andrew J. Goodman, B.S. 1968

Following the Civil War, Americans turned to the past in a search to define themselves. In an increasingly disparate society transformed by industrialization, urbanization, and immigration, the past offered a rare opportunity to establish common ground. The 1876 Centennial Exposition in Philadelphia culminated public efforts to enshrine the country's collective history. At the same time, a desire to preserve the past as a territory for private reflection rather

than public commemoration emerged. In the jewel-like *Memories*, Edward Lamson Henry nurtured Americans' appetite for personal nostalgia through his mesmerizing portrayal of a woman lost in thought.

The sitter contemplates a daguerreotype—her touchstone for reflection upon the past. While Henry's juxtaposition of gold and red draws attention to the daguerreotype's mirrored surface and velvet-lined case, he angles the photograph away, reinforcing the personal dimension of memory. The window, like the daguerreotype a rectangle trimmed with red, provides the vista the cased photograph denies. Framed by vines that echo the woman's curls, the landscape seems to be an extension of her imagination; the window, a portal to her mind. Absorbed in the memories generated by the daguerreotype, the sitter occupies a world of her own creation, independent from that outside.

Engrossed, the woman appears insulated from the mild disarray around her. Packing or unpacking her open trunk, she is caught in a transitional moment. Clashing patterns in the room's furnishings add to the sense of physical and psychological disorder. The cuff and sleeve of a purple garment spilling from a drawer adjacent to the sitter's head echo the shape of her topknot, suggesting the upheaval of her thoughts. Only the antiques and the woman's connection to the daguerreotype anchor her. Visible only to her, the photograph becomes an opening to a realm that she explores alone, letting history's burdens in the present, like her sleeping dog, lie.

AKL

Amy Kurtz Lansing, *Historical Fictions: Edward Lamson Henry's Paintings of Past and Present*, exh. cat. (New Haven: Yale University Art Gallery, 2005).

PLATE 38

Larry Burrows
(British, 1926–1971)

In Prayer, Operation Prairie, near Dong Ha, Vietnam, 1966, printed 2005

Dye transfer print, 11¾ x 17^{15}/$_{16}$ in. (29.9 x 45.6 cm)
Purchased with The George A., Class of 1954, and Nancy P. Shutt Acquisition Fund and the Heinz Family Fund

The Vietnam War was the most comprehensively photographed war of the twentieth century, and among his intrepid colleagues, Larry Burrows distinguished himself as its definitive chronicler. Under the auspices of *Life* magazine, the British-born photojournalist was first dispatched to Vietnam in 1962 to cover the American military's early presence in the region. Compelled by what he saw, Burrows would return repeatedly over the next nine years to bear witness to the conflict's profound toll on humanity at large. Though he would not survive to see the war's end, his arresting images—many of them reproduced in vivid color on *Life*'s pages—had already left an indelible mark on the American consciousness by revealing a reality that contrasted sharply with official accounts of the war's progress.

Possessing a special feel for the heat of battle, Burrows was equally adept at expressing the portent of stiller moments like the one depicted here. Huddled in their sweat-encrusted fatigues, the men of the Second Battalion, Fifth Marines—who as a unit were

especially tight-knit for having trained and served together before arriving in Vietnam – gird themselves for what would be one of the war's most treacherous operations.[1] With steely resolve as well as trepidation, the exhausted men bow their heads and join their hands with a disarming poignancy rarely seen in photographic images of war. Anchoring the scene is Burrows's own quiet poise, which elevates the picture beyond its specificity, making it a timeless elegy to the sacrifices war demands.

JC

1. Thanks to Russell Burrows, the photographer's son, for sharing his research on this subject.

PLATE 46

Mourning Embroidery

Susanna Rowson's Academy (1797–1822),
Boston, Massachusetts, ca. 1799
Silk thread, silk, watercolor, and paper, 24¾ x 19½ in.
(62.9 x 49.5 cm)
Gift of Elizabeth Ames, B.A. 1979, in loving memory of Margaret A. Ames

Susanna Rowson's Academy was one of the best-known female academies in Boston during the Federal period (see entry for *Rowson and Haswell's Academy Medal*, p. 360) and was famous for the fine needlework produced by its students. In newspaper advertisements for her academy, Rowson listed the many accomplishments girls could expect to learn under her tutelage: "Tuition in Reading, Writing, Arithmetic, English Grammar, Geography, use of the Globes and useful Needlework, . . . Embroidery in its various branches, . . . Painting and Drawing flowers, figures, or landscape," along with piano lessons and dancing.[1]

Needlework played a key role in the education of genteel women, serving as a symbol of their refinement. While young women from all socioeconomic levels learned basic sewing techniques, education in fancy needlework was reserved for young women in the middle and upper classes. Although this elaborate mourning picture no doubt memorialized a deceased member of the maker's family, such pictures could also be quite stylish, especially after George Washington's death in 1799, when a national outpouring of grief led to a flood of mourning pictures and embroideries created in his honor. Young women often adapted these designs, personalizing them with the names and dates of family members. This scene was probably derived from an as-yet-unidentified print, since several other similar embroideries exist. The central motif of the piece – a weeping figure in flowing Neoclassical garb draped over a sarcophagus that stands in front a willow tree – is a typical element found in mourning pieces of the period, although this one is unusual because the figure stands in front of the name embroidered on the monument, partially obscuring it from view and rendering the honored of this piece anonymous. The evergreen trees in the background are a distinctive feature of mourning pieces from Rowson's school.

EEE

1. Advertisement, *Columbian Centinal*, Boston (April 21, 1802). Reprinted in Betty Ring, *Girlhood Embroidery: American Samplers and Pictorial Needlework, 1650–1850* (New York: Alfred A. Knopf, 1993), vol. 1, 88–93 and endpapers.

Elkanah Tisdale
(American, 1768–1835)

PLATE 49

William Brown (1779–1805), between 1800 and 1805

Watercolor on ivory, 2¹³⁄₁₆ x 2¼ in. (7.1 x 5.7 cm); on reverse, cut gold initials "W B" over woven hair
Promised bequest of Davida Tenenbaum Deutsch and Alvin Deutsch, LL.B. 1958, in honor of Robin Jaffee Frank, PH.D. 1994

PLATE 50

Ann Brown (Mrs. John Vernet) (1780–1859), between 1798 and 1802

Watercolor on ivory, 2¾ x 2¼ in. (7 x 5.7 cm); on reverse, two locks of hair with gold wire and seed pearls
Promised bequest of Davida Tenenbaum Deutsch and Alvin Deutsch, LL.B. 1958, in honor of Robin Jaffee Frank, PH.D. 1994

The stories behind portrait and mourning miniatures often tell tales of love and loss. Following a tradition established in Europe, primarily England, most American miniatures were painted in watercolor on ivory, then either set to be worn as jewelry or framed to be viewed privately. In an era of high mortality rates for children (see pls. 47–48), families frequently commissioned miniatures to celebrate the emergence of sons and daughters into adulthood. Among Elkanah Tisdale's most sensitive miniatures are the sibling portraits of William and Ann Brown (pls. 49–50). Their father, Jesse Brown, was the proprietor of a famous Norwich, Connecticut, inn and tavern patronized largely by West Indies merchants. Tisdale, who worked in Connecticut and New York, may have known the Browns personally; they shared a mutual friendship with the patriot-painter (and Yale University Art Gallery founder) John Trumbull, who, like Tisdale, came from Lebanon, Connecticut. Trumbull painted two easel portraits of William (now at the Art Institute of Chicago and the Addison Gallery of American Art, Andover, Mass.) seated at a desk laden with ledgers proclaiming his mercantile profession. In Tisdale's miniature, William's hair, worn *en queue*, is fashionably powdered, turning it gray, but on the locket's reverse his youth reveals itself in his rich, brown locks preserved beneath cut-gold initials.

Perhaps his parents commissioned the portraits to soothe their anxiety as their son embarked on his career. Danger lurked on the high seas from storms, from belligerent nations striking at neutral cargo vessels, and from French privateers who seized sixty to seventy American ships during the year 1804. Norwich lost eleven men from marine pursuits in a single year, 1805. On December 4, the local paper announced the death of twenty-six-year-old William Brown at Martinique. A month later, Tisdale's brother also died there, so the artist understood only too well why the Brown family cherished the keepsake he created, for even miniatures that were not painted posthumously often played a role in mourning. Since William Brown never married, Trumbull's easel portraits of him and Tisdale's miniature descended in Ann Brown's family.

Tisdale's portrait of Ann as a young lady captures her finely chiseled beauty and air of refinement. On the locket's reverse,

Figure 1. John Trumbull, *The Vernet Family*, 1806. Oil on canvas, 40 x 50⅛ in. (101.6 x 127.3 cm). Yale University Art Gallery, Gift of the Associates in Fine Arts

plumes of hair decorated with seed pearls and gold wire lend a romantic aura, seemingly set to music by the lute gently strummed by the sitter. Within the confines of the home, a genteel woman's ability to make music fostered harmonious domestic relationships. Affluent parents recorded their daughters' qualifications for marriage in easel portraits, hung for visitors to see in the parlor, depicting the eligible young ladies doing fancy needlework, drawing, reading, or playing a musical instrument. This miniature offers the same conceit in an intimate form, perhaps meant only for the eyes of a specific courting gentleman. On December 15, 1802, Ann Brown married John Vernet, a successful trader who came to Norwich from Saint-Pierre, Martinique. About 1805, Trumbull portrayed the couple and their two children on the porch of their luxurious home with the Thames River providing the backdrop (fig. 1). The Vernets eventually had five children, one of whom they named William, after Ann's deceased brother.

RJF

To place Tisdale's *Ann Brown* in context, see Davida Tenenbaum Deutsch, "The Polite Lady: Portraits of American Schoolgirls and Their Accomplishments," *Antiques* 135 (March 1989): 743–53.

PLATE 51
John Ramage
(British, born Ireland, ca. 1748–1802, active in America, 1775–94)

Elbridge Gerry (1744–1814), ca. 1785
Watercolor on ivory, 2 x 1½ in. (5.1 x 3.8 cm)
Promised bequest of Davida Tenenbaum Deutsch and Alvin Deutsch, LL.B. 1958, in honor of Robin Jaffee Frank, PH.D. 1994

The most acclaimed early miniaturist in America was the Irish-born John Ramage. Although he remained loyal to the British Crown, as the foremost miniaturist in New York he painted many leaders of the new republic, including Elbridge Gerry. From 1776 until 1785, the Harvard-educated Gerry served in the Continental Congress, where he signed the Declaration of Independence and the Articles of Confederation. On January 12, 1786, the forty-one-year-old statesman married twenty-three-year-old Ann Thompson. As a token of his love, he undoubtedly offered her this likeness, set

to be worn as a bracelet. The couple, who eventually had nine children, sat for Ramage at least twice. Miniatures would have eased many periods of separation, for Gerry spent much time away from home, serving as diplomat to France, governor of Massachusetts, and vice president of the United States under James Madison. When he died suddenly in office, his biographer relates that he drew "from his bosom a miniature [of his wife], which was always suspended round his neck when the original was absent."

PLATE 53
Edward Greene Malbone
(American, 1777–1807)

Mary Hooper (Mrs. Alexander Schaw, Mrs. James Fleming) (1779/80–1831), probably 1802
Watercolor on ivory, 2¹¹⁄₁₆ x 2¼ in. (6.8 x 5.7 cm)
Gift of Davida Tenenbaum Deutsch and Alvin Deutsch, LL.B. 1958, in honor of Kathleen Luhrs

The romantic sensibilities prevalent at the turn of the eighteenth-century make themselves felt in Elkanah Tisdale's *Ann Brown* (pl. 50). The American miniaturist whose luminous likenesses embody that cultural mood is Edward Greene Malbone. In 1801 he traveled to London, where, in the work of the leading British miniaturists, he found affirmation of his already evident stylistic move away from the small, opaque miniatures of the colonial period (see pl. 51) toward the larger, airier miniatures of the Federal era. Reinvigorated, Malbone returned to Charleston and began his most prolific period. That is when he created this portrait of Mary Hooper, the daughter of merchant George Hooper and a native of Wilmington, North Carolina. The ivory's lucent surface, emerging through veils of fine lines and pale washes, sets aglow the diaphanous Neoclassical dress and delicate skin of the sitter, who engages the viewer with a relaxed immediacy. Her serene expression suggests that Malbone captured her likeness before her first husband, Alexander Schaw, about whom little is known, died in 1802, leaving her with a young daughter. In 1806, the widow married Irish-born merchant James Fleming, and the couple had a son, who died young, and three daughters. Contemporary reports reveal that Fleming died suddenly in 1811 when, having only "a few moments previous" left the family's dining table, he was "thrown against the corner of the brick market house in town by an unruly horse."

RJF

PLATE 55
Sarah Goodridge
(American, 1788–1853)

Anna Powell Mason Perkins (Mrs. Henry Bromfield Rogers) (1805–1880), between 1821 and 1824
Watercolor on ivory, 3¹⁄₁₆ x 2½ in. (7.8 x 6.4 cm)
Gift of Davida Tenenbaum Deutsch and Alvin Deutsch, LL.B. 1958, in honor of Kathleen Luhrs

Eliza Goodridge
(American, 1798–1882)

PLATE 56

Julia Porter Dwight (1830–1869), ca. 1832
Watercolor on ivory, 2¹¹⁄₁₆ x 2¼ in. (6.8 x 5.7 cm)
Gift of Leonard F. Hill, B.A. 1969

PLATE 57

Elizabeth Russell Fiske (ca. 1799–1833), ca. 1832
Watercolor on ivory, 3⁹⁄₁₆ x 2¹¹⁄₁₆ in. (9 x 6.8 cm)
Gift of Leonard F. Hill, B.A. 1969

By the 1820s in America, competition with large-scale painting led to greater diversity of housing formats; many portrait miniatures were still set in jewelry to be worn, but others were mounted in larger, rectangular frames to be hung at home in a parlor or cabinet. Among the first women to paint miniatures professionally, Sarah Goodridge trained her younger sister Eliza in the painstaking art, and both sisters often used a rectangular format. At the outset of her career, Sarah Goodridge received "useful lessons" from an unnamed miniaturist who, her sister recalled, "came from Hartford"—perhaps Elkanah Tisdale—as well as from the famous oil painter Gilbert Stuart. By 1820, she established a studio in Boston. She probably painted *Anna Powell Mason Perkins* (pl. 55) only a couple of years after she opened her doors. A member of Boston's social elite, the sitter was the daughter of merchant Thomas Perkins, formerly Commissioner of Loans for the state, and his second wife, Anna Dummer Powell. An inscription in a later nineteenth-century hand gives Anna's age as sixteen, although she could be slightly older. Her intent gaze, slight yet knowing smile, and upswept locks fastened with a high comb convey her new status, poised on the brink of womanhood. The hairstyle and the cut of her dress date the portrait to about 1821 to 1824, making it a remarkably polished early miniature by Goodridge.

In 1822, Anna's future husband, Henry Bromfield Rogers, graduated from Harvard. If they already shared a friendship, the miniature may have been commissioned as a graduation gift; however, the couple did not marry until 1831 or 1832, at which time her father built a house for them on Beacon Hill. Henry Rogers became a lawyer, a trustee of the Massachusetts Institute of Technology, and a benefactor of Harvard College. The couple's daughter, Annette Perkins Rogers, grew up to become a member of Boston's coterie of women artists—a career paved by predecessors like Sarah and Eliza Goodridge.

The first miniatures by Eliza Goodridge to enter Yale's collection depict Julia Porter Dwight (pl. 56), who was the great-niece of Yale president Timothy Dwight, and her aunt Elizabeth Russell Fiske (pl. 57). They exhibit the artist's paler, softer technique, in contrast to her sister Sarah's use of deeper colors and crisper modeling. Elizabeth Fiske lived in New Braintree, Massachusetts, where her father, the Reverend John Fiske, was a pastor and one of the founders of Amherst College. Her sister Mary Warren Fiske married William Richard Dwight, a New York banker and proprietor of the *New York Daily Advertiser*. Their second child, Julia, grew up

in Brooklyn, New York. Boston-based Eliza Goodridge, who also painted Julia's mother and Elizabeth Russell Fiske's parents, may have made these portraits during a family visit by the Dwights to the Fiskes.

Family correspondence describes just such a close-knit gathering: "I wish you could see our parlour, in which I am writing, and you could hardly wonder at the appearance. My mother, aunt, cousin, brother, sister, and little niece [Julia] are all talking, singing and laughing." The cousins were "very much devoted" to cats and lavished "a vast deal of affection on them." Goodridge captures Julia as she momentarily looks up while patiently allowing her lively kitten to paw at the blue ribbon she holds in both hands. This endearing depiction simultaneously forecasts Julia's expected maternal role in adult life and accentuates the vulnerability that separates both toddler and kitten from that world.

Perhaps it was an awareness of that vulnerability, brought about by the recent death of Julia's older sister—her aunt's namesake, Elizabeth—that led the family to want to preserve the living likenesses of those they loved in these miniatures. Aunt Elizabeth, unmarried and childless, may have been ill at the time she sat for her portrait, for she died the following year, on August 9. Only six days later, Mary Dwight bravely named another daughter Elizabeth Fiske Dwight after both her sister and first child. The Fiske-Dwight family celebrated the endurance of family ties through these miniatures, and through the naming of their children.

RJF

PLATE 58

Edward Samuel Dodge
(American, 1816–1857)

Harriet E. Hulse (Mrs. William J. Felthousen) (1840–1921), 1842
Watercolor on ivory, 2¼ x 1¾ in. (5.7 x 4.5 cm)
Gift of Davida Tenenbaum Deutsch and Alvin Deutsch, LL.B. 1958, in honor of Kathleen Luhrs

John Wood Dodge
(American, 1807–1893)

PLATE 59

Mrs. Ezra Nye (Nancy Freeman Fessenden) (1799–1874), 1837
Watercolor on ivory, 3¼ x 2⅞ in. (8.3 x 7.3 cm)
Promised gift of Leonard F. Hill, B.A. 1969

PLATE 60

Self-Portrait, 1848
Watercolor on ivory, 1⅝ x 1¼ in. (4.1 x 3.2 cm); on reverse, "To / Juliette" below compartment containing brown hair plaid
John Hill Morgan, B.A. 1893, LL.B. 1896, M.A. Hon. 1929, Fund

Just as Sarah Goodridge instructed her younger sister Eliza in the art of miniature painting (see pls. 55–57), the self-taught John Wood Dodge likely trained his younger brother Edward Samuel, who was

exhibiting miniatures at the National Academy of Design in New York City by 1836. The following year he moved to Poughkeepsie, New York, where he remained until 1842, when he painted this portrait of Harriet E. Hulse, the daughter of watchcase maker Charles A. Hulse and his wife, Sarah, who lived in nearby Hamptonburgh (pl. 58). The first work by the younger Dodge to enter Yale's collection, this likeness embodies the nineteenth-century association of children with piety and innocence. Against a pastel sunset, a cherubic blond toddler dressed in black looks upward, as if at the loving adults who commissioned this miniature, or perhaps toward heaven. That attitude sadly fits the probable story, for such young children were only dressed in black when in mourning to honor a close relative. The off-the-shoulder neckline and short sleeves were fashionable for what was called full dress. Children participated in the social rituals performed to express grief; wearing clothing designed especially for mourning linked the remaining family together and set them apart from others. Like the Fiske-Dwight miniatures, this portrait of a mourning child suggests that families were often moved by the death of relatives to commission miniatures of surviving loved ones.

Edward Samuel Dodge's older brother John Wood Dodge, who had taught himself to draw in part by sketching casts in the collection at the National Academy, was elected an associate there in 1832. Five years later, on November 25, 1837, he recorded a portrait of "Mrs. Capt. E. Nye" in his account book. In his likeness (pl. 59), Dodge combines a subtle transcription of surface texture — most evident in the sheer chemisette culminating in lace trim — with penetrating psychological insight. Painted a year after her husband, Captain Ezra Nye (1798–1866), set a speed record for transatlantic crossings, this portable portrait probably traveled with him aboard the Liverpool packet *Independence*. His reputation as a "first-rate captain of a first-rate ship" earned him the nickname "Independence Nye," and his bravery rescuing the crew and passengers of the British vessel *Jessie Stephens* during a mid-Atlantic storm led Queen Victoria to present him with a gold chronometer in gratitude. But his wealth and fame did not compensate his wife, Nancy, for the constant worry and loneliness, revealed by her sad gaze in Dodge's portrait. She confessed to her sister: "I have learned to keep my anxious feelings to myself and hide an aching heart under a cheerful face. . . . I say to you, Lucy, if I had my life to live over again and my choice between the bare necessities of existence and such anxious homes and bitter partings, I would be content with one meal a day."

Mrs. Ezra Nye exemplifies Dodge's achievement as a leading miniaturist in New York. Nonetheless, ill health compelled the prosperous artist to move to the South about 1840. He settled in Crossville, Tennessee, where he and his wife, Mary, raised eight children (five of whom lived to adulthood) and established a huge apple orchard. From there, he traveled extensively throughout Tennessee, Kentucky, Alabama, Mississippi, and Louisiana. His sophisticated style attracted prominent clients, among them Andrew Jackson and Henry Clay.

But no client was more important to him than the one who cherished this self-portrait (pl. 60). Dodge's account book, which documents more than eleven hundred miniatures, reveals that he

was in New Orleans on March 8, 1848, when he recorded: "My own. Small for Juliet [*sic*]." The portrait is set in a Rococo Revival brooch that appears to be an example of handworked jewelry, enhancing the miniature's uniqueness. On the brooch's reverse, below a compartment containing locks of hair, is the engraved dedication, "To / Juliette." Thus, the absent father painted this token of affection for his five-year-old daughter as a surrogate for himself during his long absences in search of commissions. It descended in the family of Juliette Lavinia Dodge (Mrs. Charles H. Smith) through four generations, enriching our understanding of the miniature's role in perpetuating familial affection through time.

Despite being remarkably tiny to suit the size of its young recipient, Dodge's finely stippled *Self-Portrait* includes the exacting detail valued by a generation enamored with a new invention, photography. Unlike the silvery daguerreotypes of the period, the portrait exhibits the rich coloring characteristic of oil painting. Dodge depicted himself seated in a red upholstered chair, wearing a black coat, black satin waistcoat, white shirt with pearl buttons, black and red striped tie, and a gold watch chain — emblematic of every traveling parent's promise to return home soon. The artist gazes at his intended viewer with tenderness. By borrowing elements from both photography and oil painting, Dodge updated the tradition of miniature painting without diminishing its power as the most intimate of keepsakes.

RJF

Research for this and the above texts on miniatures is based on primary sources documented in the American arts office files, Yale University Art Gallery, and on secondary sources, many of which are listed in Robin Jaffee Frank, *Love and Loss: American Portrait and Mourning Miniatures* (New Haven: Yale University Art Gallery, 2000). See also *Love and Loss* for a discussion of some miniatures, including those illustrated in the plate section but not discussed here, in the substantial Deutsch gift and promised bequest.

PLATE 61

City Medal for Females

Boston, Massachusetts, 1839
Silver, 16.25 gm, 12:00, 44 mm
Promised bequest of Davida Tenenbaum Deutsch and Alvin Deutsch, LL.B. 1958, in honor of Robin Jaffee Frank, PH.D. 1994

PLATE 62

Rowson and Haswell's Academy Medal

Boston, Massachusetts, 1806
Silver, 5.3 gm, 12:00, 37 mm
Promised bequest of Davida Tenenbaum Deutsch and Alvin Deutsch, LL.B. 1958, in honor of Robin Jaffee Frank, PH.D. 1994

Rewards of merit have long been used by teachers to encourage and to commemorate academic achievements. The majority of rewards of merit are paper, either printed or handcrafted, and embellished with calligraphy, a pictorial scene, and a dedicatory verse. Medallic rewards of merit are less common, as they involve a more sophisticated means of production and are often fashioned from precious metals. These two silver medals are especially noteworthy for their link to early female education in the United States.

In 1806, the Rowson and Haswell Academy awarded this

engraved silver medal (pl. 62) to the school's best arithmetician. With its lozenge shape and bright-cut border, it is a precious memento that exhibits the clean geometry and shimmering decoration of Federal-era silver. The Rowson and Haswell Academy was named after its founder, Susanna Haswell Rowson. Born in England, Susanna Haswell and her husband, William Rowson, emigrated to Philadelphia in 1793, where she worked as a writer and actress. Upon retiring from the stage in 1797, the couple moved to Boston, where Rowson opened a girl's academy, which first appears in the 1807 *Boston Directory* on Washington Street, near Roxbury. In a time when most female academies focused on teaching domestic economy, Rowson created her own primers that addressed science, geography, and history. This medal was awarded to the best arithmetician and is indicative of Rowson's progressive view of female education; mathematics was traditionally taught only to males.

When Benjamin Franklin died in 1790, he left a bequest to the city of Boston of one hundred pounds sterling, the interest of which would be used to award medals to the city's most academically gifted youths. Because Franklin finalized his will before females were admitted into public schools, his executors assumed he intended a male-only medal. In recognition of the gender disparity, the Boston School Committee founded the City Medal in 1821, which awarded a comparable prize to females. The medals were presented at an annual school festival held in Boston's Faneuil Hall and would have hung from the recipient's neck by a ribbon, blue for the Franklin Medals and white for the City Medals. This hexagonal silver medal (pl. 61) was awarded to a Clarissa A. Baker in 1839 for superior scholarship. Although numerous Bakers lived in Boston at this time, nothing more is known about her. The medal was struck from a die with spaces left for an engraver to add the recipient's name and the year. City Medals were awarded annually until 1866 and changed form a few times. Early medals were hexagonal, and the intricate ornamental band on the reverse of this example first appears on medals dated 1837.

These two medals evince Boston's dedication to female education, in both its public and private schools. Boston's tradition of school medals became a model for similar academic traditions in other American cities. For the recipients, these medals not only motivated scholastic achievement but also became cherished objects.

JSG

John M. Sallay, "The Boston School Medals," *The Numismatist* (April 1978): 677–706.

PLATE 63

Grover Cleveland and Thomas A. Hendricks Bandanna

Manufactured by S. H. Greene and Sons (1865–1926)

Warwick, Rhode Island, 1884

Printed cotton, 20 x 20 in. (50.8 x 50.8 cm)

Gift of John R. Monsky, B.A. 1981, and Jennifer Weis Monsky, B.A. 1981

Displayed in gentlemen's pockets or waved during rallies, bandannas played a visible role in American political campaigns during the second half of the nineteenth century. These two bandannas are from the "Washington" and "Martha Washington" lines of political textiles produced by S. H. Greene and Sons, one of the foremost textile manufacturers in Rhode Island. S. H. Greene and Sons celebrated both Republican and Democratic candidates in a variety of red, white, and black bandannas that featured patriotic images surrounding portraits of the candidates reproduced from popular sources. As emblems of political choice and as part of a lucrative market for textile manufacturers, these bandannas blended democracy with consumerism. Within the wide range of nineteenth-century political textiles, those produced by S. H. Greene and Sons are noteworthy for their saturated colors and particularly fine detail.

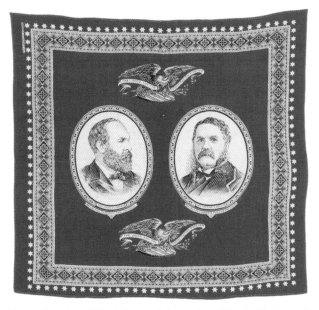

Figure 1. *James A. Garfield and Chester A. Arthur Bandanna.* Warwick, Rhode Island, 1880. Manufactured by S. H. Greene and Sons (1865–1926). Printed cotton, 20 x 20 in. (50.8 x 50.8 cm). Yale University Art Gallery, Gift of John R. Monsky, B.A. 1981, and Jennifer Weis Monsky, B.A. 1981

For the 1880 presidential campaign, S. H. Greene and Sons issued a bandanna featuring portraits of the Republican candidates James A. Garfield and Chester A. Arthur (fig. 1). Garfield's image is based upon a photograph taken by the Pach Brothers of New York, which was engraved by Henry Bryan Hall, Jr., for the publishing house D. Appleton and Company. Arthur's image derives from a photograph taken by the popular portrait photographer Napoleon Sarony and engraved by John Charles Butte. The prestige of Arthur's earlier political appointment as Collector of the Port of New York would have made him an ideal sitter for Sarony, who won acclaim for his portraits of Oscar Wilde and Sarah Bernhardt. Set against a brilliant red field, the white-ground portrait ovals are framed by two American eagles with outspread wings, under which unfurl banners reading: "The Union and the Constitution Forever." A band containing lozenges and quatrefoils and a line of white stars forms the edge of the bandanna. This composition was clearly part of S. H. Greene and Sons' general stock as they reissued it on at least one other occasion: the 1892 campaign of Benjamin Harrison and Whitelaw Reid.

In 1884, S. H. Greene and Sons supplied a bandanna for the presidential campaign of Grover Cleveland and Thomas A. Hendricks (pl. 63). Running against Republican candidates James G. Blaine and John A. Logan, Cleveland secured victory by uniting

Democrats and reform Republicans, called "Mugwumps," to become the first Democratic president after the Civil War. Cleveland's image is based upon an engraving by the Atlantic Publishing and Engraving Company; Hendricks's image is from an unknown source. Hendricks died in office in 1885, leaving the vice presidency vacant for the duration of Cleveland's first term. When Cleveland unsuccessfully ran for reelection in 1888, S. H. Greene and Sons reissued this bandanna with the face of his new running mate, Allen Thurman, in place of the portrait of Hendricks.

The Cleveland-Hendricks bandanna was part of S. H. Greene and Sons' "Martha Washington" line, presumably directed toward a female audience. Although women could not yet vote in federal elections, they still attended political functions and would have eagerly purchased or been given such textiles. This vividly patterned bandanna features portraits of Cleveland and Hendricks surrounded by stars, billowing flags, and intricately rendered American eagles. The central quatrefoil has a Greek meander border contained within a white-ground reserve with an ogival border edged by lambrequins. This accumulation of curves and patterns reflects the late nineteenth-century taste for exotic references, as does the color.

Both bandannas are examples of "Turkey red" printed cottons—named after the vibrant textiles imported into Europe from the Middle East. Turkey red is not a dye but an extended dyeing process that includes boiling fabric in a series of madder, blood, dung, and soda ash baths. Synthetic alternatives to Turkey red were first introduced to the American market in 1878 by the Clyde Print Works, a subsidiary of S. H. Greene and Sons, but the chemical color proved unstable. The striking color of these bandannas suggests they were made using the natural dyeing process. As beguiling today as when they were made, these bandannas encapsulate America's continued fascination with fashion, technology, and politics.

JSG

Herbert Ridgeway Collins, *Threads of History: Americana Recorded on Cloth, 1775 to the Present* (Washington, D.C.: Smithsonian Institution Press, 1979).

PLATE 65

Walker Evans

(American, 1903–1975)

Main Street, Saratoga Springs, New York, 1931, printed 1971

Gelatin silver print, 8 1/16 x 6 5/16 in. (20.5 x 16 cm)
Purchased with a gift from Alexander K. McLanahan, B.A. 1949, in honor of his wife, Mary Ann C. McLanahan

"Suddenly there is a difference," wrote Walker Evans in 1931, "between a quaint evocation of the past and an open window looking straight down a stack of decades."[1] Evans was referring to the emergence of a new group of photographers who had harnessed the camera's natural inclination for straightforward description to make the important lyric documents of their time, but he may also have had in mind his own *Main Street, Saratoga Springs, New York*, likely taken earlier that year from an upper-floor window of Saratoga Springs's Grand Union Hotel.

Perhaps more than any other picture that appeared in his

landmark book *American Photographs,* Evans's *Main Street* takes on the quality of metaphor, capturing the zeitgeist of Depression-era America. Rather than train his lens on any particular tree, figure, or building, Evans instead seems to have photographed time itself. The slick, angled roofs of parked cars resemble the weathered cobblestones in prior pictures made by the Parisian photographer Eugène Atget, and the city's Dutch elms recess majestically into space, with their bare, gesturing branches conspiring with the rain-swept surfaces and misty autumn air to turn Broadway into an eternal canal. The grandeur of Saratoga Springs, which for decades had attracted the elite with its famous spas and horse races before its elegant decline, is submerged in a baronial melancholy that permeates the entire scene.

JC

1. Walker Evans, "The Reappearance of Photography," *Hound and Horn* 5, no. 1 (October–December 1931): 126.

PLATE 67

Charles Sheeler

(American, 1883–1965)

California Industrial, 1957

Oil on canvas, 25 x 33 in. (63.5 x 83.8 cm)
Gift of Mr. and Mrs. S. Roger Horchow, B.A. 1950

Charles Sheeler used multiple-exposure photography to create *California Industrial*. The cinematic effect, with building facades dissolving and coalescing, and the superimposition of a mountain on the scene, evokes what he called in his notebook "the realm of the unconscious": "When we look at any object in Nature we inevitably carry over a memory of the object we have just previously seen. . . . I have endeavored to combine the memory and the present in a given painting." Sheeler arrived at this image through

Figure 1. Charles Sheeler, *Contact Sheet*, California, 1956. Gelatin silver print, 10 x 8 in. (25.4 x 20.3 cm). The Lane Collection, Museum of Fine Arts, Boston

a radically innovative process. Photographic contact sheets from his trip in 1956 to San Francisco and Yosemite contain views of industrial architecture and mountains (fig. 1). He sandwiched together negatives, then projected this composite design to transfer it to paper, creating a drawing stripped of inessential detail (Collection of James and Barbara Palmer). One extant photograph reveals that the tower on the left in the painting is, in fact, a smokestack that rises above a flared vertical structure, scaffolding, an arch, and an elevated connector leading to a building (fig. 2).

Figure 2. Charles Sheeler, *Industrial Site*, 1956. Gelatin silver print, 10 x 8 in. (25.4 x 20.3 cm). The Lane Collection, Museum of Fine Arts, Boston

But in the photograph, the smokestack spews smoke; in the painting, its top is cut off, and the dark, solid tower is mirrored by a shaft of translucent light—transforming a gritty reality into an eerie dreamscape. The building appears on the left in the photograph, on the right in the painting—a reversal reflecting Sheeler's method of working from negatives. He attached the drawing derived from those negatives to the back of a Plexiglas sheet. He painted the front with tempera, which could be easily removed, to experiment with colors (Minneapolis Institute of Arts) before re-creating the composition in oil on canvas. The luminosity of the negatives and the Plexiglas is echoed in the painting's shifting harmonies of opalescent lavenders and blues, far removed from the colors of the actual industrial site or Yosemite landscape. Sheeler's layering of Western images evokes the passage of time—not only his remembered experience and current moment, but also a nation's wilderness past and industrial present.

RJF

I thank Karen E. Haas and Carol Troyen, Museum of Fine Arts, Boston, for sharing their insights in 2003 in preparation for my Art and Learning session, "Transforming Vision: Photography into Painting," which is the basis for this entry.

PLATE 68

Ralston Crawford

(American, born Canada, 1906–1978)

From the Bridge, 1942

Oil on canvas, 27⅞ x 39¾ in. (70.8 x 101 cm)
Purchased with the Iola S. Haverstick Fund for American Art and the Katharine Ordway Fund

Ralston Crawford's *From the Bridge* hovers at the edge of abstraction. Using flat planes with crisp outlines, the artist looks through the black girders of a bridge at brown land, a red factory with a smokestack, a stark white wall, and rectangular strips of sky. His stated goal in painting was the "selection, elimination, simplification and distortion for the purpose of conveying emotional and intellectual reactions to the thing seen." In his Precisionist canvases of the 1930s, he discovered poetry in mundane scenes of coal elevators, electrical lines, water tanks, ships, and highways. Created in 1942, *From the Bridge* eradicates the remnants of sculptural modeling and perspective found in his earlier paintings. This kind of architectonic vision of America's industrial landscape, devoid of human presence, is explored to different effect by Crawford's contemporary Charles Sheeler in *California Industrial* (pl. 67). In its inspired manipulation of flattened space, hard-edged line, and clean color, Crawford's painting also relates to works by his friend Stuart Davis (see pls. 260–68). Like Davis, he tended toward abstraction while believing that artists must begin with contemporary reality as their subject.

Crawford came of age with the Abstract Expressionists, but he never embraced their emotive Action Painting. Nonetheless, his paintings do not exclude feeling: "They are complete when they express a synthesis of my emotions and ideas." In *From the Bridge*, he evokes the sensation of glancing out the window while traveling in a car over a steel bridge, a quintessentially modern experience distilled to its essential forms and frozen in time. Bridges, technical feats and gateways across space, connote real and mythic journeys. A paragon of order based on everyday life, *From the Bridge* suggests the presence of larger forces. The painting is a masterly arrangement of geometric shapes as well as an affirmative statement about America's industrial and engineering power as the nation emerged from the Depression and entered World War II, in which Crawford served. In 1942, critics saw his paintings as embodying a "faith in the final unity of man's genius with the machine" and a "message of optimism . . . [that] makes his art stand out in the era like pillars of fortitude in a morbidly crumbling world." The destruction Crawford witnessed eventually would shatter the serene harmony achieved in *From the Bridge*.

RJF

Quotations from Barbara Haskell, *Ralston Crawford*, exh. cat. (New York: Whitney Museum of American Art, 1985), 56; "Statements by the Artist," in Edward H. Dwight, *Ralston Crawford*, exh. cat. (Milwaukee: Milwaukee Art Center, 1958), 12.

PLATE 70

Robert Frank

(American, born Switzerland, 1924)

Hoover Dam, Nevada, 1955, printed later

Gelatin silver print, 14⅞ x 10⅟₁₆ in. (37.8 x 25.5 cm)
Purchased with a gift from George C. Hutchinson, B.A. 1957

In the winter of 1955, while driving across the country to make photographs for a self-assigned, Guggenheim-sponsored project, Robert Frank made this image of a postcard display at a rest stop just outside Hoover Dam in Nevada. Although Frank chose not to include *Hoover Dam* in his seminal 1958–59 book, *The Americans*, he resurrected it in his 1972 volume, *The Lines of My Hand*, which announced his return to still imagery after more than a decade of experimentation with filmmaking. The form of *Hoover Dam* presages the photographer's later practice of combining multiple images to form a single narrative picture.

Hoover Dam's central subject, a found arrangement of three postcards, presents viewers with a visual parable for our time. The story begins with a majestic vista of the Grand Canyon, an expansive natural world that in the second image seems to recede into the background to make way for a marvel of human endeavor—the dam itself—with a rather diminutive American flag hoisted in the center. In the final image, an ominous plume rises dramatically from a nuclear test performed just a few years earlier, less than a hundred miles away. The camera's slightly oblique vantage point, as well as the promotional broadside and gleaming automobile seen at the display's peripheries, at once disarms the threat of impending doom and discloses the ingredients of the picture's making.

Figure 1. *Grand Canyon National Park, Arizona*, ca. 1950s. Published by Fred Harvey Hotels–Shops–Restaurants. Photolithographic postcard, 3⅜ x 5½ in. (8.6 x 13.9 cm). Yale University Art Gallery, Gift of Joshua Chuang, M.B.A. 2005

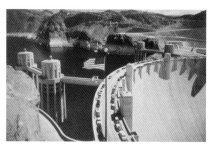

Figure 2. *Highway 66 North, between Kingman, Arizona, and Las Vegas, Nevada, Crosses World-Famous Hoover Dam, World's Highest—727 Feet*, ca. 1950s. Published by Mike Roberts Color Production. Photolithographic postcard, 3⁷⁄₁₆ x 5⁷⁄₁₆ in. (8.7 x 13.8 cm). Yale University Art Gallery, Gift of Joshua Chuang, M.B.A. 2005

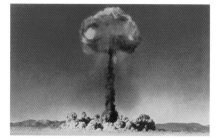

Figure 3. *Atomic Explosion, Frenchman's Flat, or Yucca Flat, Nevada*, ca. 1950s. Published by Mike Roberts Color Production. Photolithographic postcard, 3⁷⁄₁₆ x 5⁷⁄₁₆ in. (8.8 x 13.8 cm). Yale University Art Gallery, Gift of Joshua Chuang, M.B.A. 2005

Frank's remarkable ability to transform an otherwise banal scene into an inexorable totem of enduring meaning is made all the more apparent when his print is seen in relation to the very postcards he photographed, examples of which can also be found in the Gallery's collection (figs. 1–3). With their saturated hues, these cards are souvenirs of the emphatic, unquestioning patriotism that characterized mainstream America in the 1950s—something that Frank sought to confront in the lean terms of black and white, which he once referred to as "the colors of photography."[1] Yale's print is made especially poignant by Frank's postcardlike inscription to his son Pablo, who accompanied him on the trip.

JC

For a full discussion of this photograph, see Sarah Greenough, "Fragments that Make a Whole: Meaning in Photographic Sequences," in *Robert Frank: Moving Out*, Sarah Greenough and Philip Brookman (Washington, D.C.: National Gallery of Art, 1994).

1. Robert Frank, quoted in Edna Bennett, "Black and White Are the Colors of Robert Frank," *Aperture* 9, no. 1 (1961): 22.

PLATE 71

Garry Winogrand

(American, 1928–1984)

Dealey Plaza, Dallas, 1964

Gelatin silver print, 9⅛ x 13½ in. (23.2 x 34.3 cm)
Purchased with a gift from George C. Hutchinson, B.A. 1957

Of the major photographic oeuvres to emerge during the second half of the twentieth century, that of Garry Winogrand remains among the most complex, ambitious, and misunderstood. Part of the challenge of comprehending Winogrand's hyperkinetic images lies in the sheer volume of his output (more than one million negatives and thirty thousand prints) and his reluctance to organize his work according to easily digested themes or narratives, but part can also be attributed to the photographer's willful determination to embed difficulty in the very structure of his pictures.

Winogrand's oft-quoted dictum, "I photograph to see what something will look like photographed," suggests that he was concerned more with the form of his work than with its social import, but pictures such as *Dealey Plaza, Dallas*, in which form and content coalesce to testify about the social world with piercing eloquence, query this notion. In *Dealey Plaza*, we are thrust into a ring of figures who with their leisurely attire, cameras, and postcards seem to be on a sightseeing expedition. A further investigation of the scene reveals it to be that of John F. Kennedy's assassination, with the infamous grassy knoll looming in the background. The figures appear disoriented, their wary unsettledness perhaps symbolic of the nation's greater anxiety, or—with the collapse of Winogrand's marriage earlier that year—of the photographer's own fragmentary state.

In addition to its social commentary, *Dealey Plaza* is also assuredly a statement about photography itself. Every eye—including Winogrand's own—views the world through a lens, and here the Texas School Book Depository building in which Lee Harvey Oswald once worked has been reduced and replaced by photographic surrogates. Rather than having captured a decisively

dramatic instant in time, Winogrand instead has deconstructed an otherwise inconsequential moment in history to show us what photography can do.

JC

Robert Adams
(American, born 1937)

PLATE 72

Newly Completed Tract House, Colorado Springs, Colorado, from The New West, 1968

Gelatin silver print, 5 11/$_{16}$ x 6 in. (14.4 x 15.2 cm)
Purchased with a gift from Saundra B. Lane, a grant from the Trellis Fund, and the Janet and Simeon Braguin Fund

PLATE 73

Colorado Springs, Colorado, from The New West, 1968

Gelatin silver print, 5 15/$_{16}$ x 5 15/$_{16}$ in. (15.1 x 15.1 cm)
Purchased with a gift from Saundra B. Lane, a grant from the Trellis Fund, and the Janet and Simeon Braguin Fund

PLATE 74

Out a Front Window, Longmont, Colorado, from The New West, 1968–71

Gelatin silver print, 5 15/$_{16}$ x 5 15/$_{16}$ in. (15.1 x 15.1 cm)
Purchased with a gift from Saundra B. Lane, a grant from the Trellis Fund, and the Janet and Simeon Braguin Fund

PLATE 75

The Center of Denver, Ten Miles Distant, from The New West, 1968–71

Gelatin silver print, 5¾ x 5 15/$_{16}$ in. (14.6 x 15.1 cm)
Purchased with a gift from Saundra B. Lane, a grant from the Trellis Fund, and the Janet and Simeon Braguin Fund

Lewis Baltz
(American, born 1945)

PLATE 76

Pacific Grove, from Public Places, 1969

Gelatin silver print, 5 x 7¾ in. (12.7 x 19.7 cm)
Gift of Arthur Fleischer, B.A. 1953, LL.B. 1958

PLATE 77

Interior, 33, from Park City, 1978–79

Gelatin silver print, 9½ x 6½ in. (24.1 x 16.5 cm)
Purchased with a gift from Frank H. Goodyear, Jr., B.A. 1966, and with the Janet and Simeon Braguin Fund

PLATE 78

Interior, 34, from Park City, 1978–79

Gelatin silver print, 9½ x 6¼ in. (24.1 x 15.9 cm)
Purchased with a gift from Frank H. Goodyear, Jr., B.A. 1966, and with the Janet and Simeon Braguin Fund

Although their aesthetics were developed independently of each other, the modestly scaled black-and-white photographs of Robert Adams and Lewis Baltz from the late 1960s and 1970s share several essential qualities: exacting description, an unflinching commitment to unexceptional places, and a subject—the featureless residential and commercial developments that were blanketing the American West with alarming speed. Given prominence in the George Eastman House's influential 1975 exhibition New Topographics, these works of Adams and Baltz proffered a photographic approach that was as urgent and unadorned as the places they depicted, and far from the highly figurative and increasingly antiquated notions of landscape held by their forebears.

While teaching English literature at Colorado College, Robert Adams was first led to photograph out of a desire to document the state's native architecture. The views he made between 1965 and 1974 provided material for his many subsequent books about the area, including The New West (1974). In describing man's incursion on the regal landscape of the Colorado Front Range, The New West shocked viewers with its quiet austerity. Rather than indulge in easy rebuke, Adams's photographs (pls. 72–75) offer distance, perspective, and light. Hastily conceived buildings (and the constricted spaces they create) seem alien but consequential, an effect heightened by the photographer's unorthodox use of a square frame to contain a landscape that otherwise lends itself to panorama. Even the most incongruous of scenes possesses a splendor that expresses Adams's belief that "all land, no matter what has happened to it, has over it a grace, an absolutely persistent beauty."[1] At once enthralled by the natural world, deeply concerned about our stewardship of it, and sympathetic to those who must find a way to live within it, Adams has, with these pictures, created a spare and enduring epic that ranges far beyond its locale.

More coolly conceptual in nature, the work of California-born, art school–trained Lewis Baltz has been as much informed by land art and minimalism as any photographic precursor. In the late 1960s, Baltz began to adopt the clinical style of a surveyor, reducing often graceless exteriors to the unintentional yet mesmerizing designs and patterns that are the afterthoughts of mass architecture (pl. 76). It was these pictures that helped demonstrate once and for all that photography could hold its own as a medium for rigorous conceptual practice. Unlike Adams's, Baltz's photographs of this period feature built environments assiduously devoid of man, emotion, and history—form is their principle concern. Like Adams's pictures, however, they manage to negotiate an abiding paradoxical tension. Firmly rooted in the world, the unfinished interiors of Baltz's later series Park City (pls. 77–78) achieve a sublimity that does not deny their bleakness. It is by way of the photographer's meticulous scrutiny that these otherwise ignoble scenes are transformed, redeemed by their own strange and brilliant radiance.

JC

1. Robert Adams, The New West, 2d ed. (Cologne: König, 2000), xiv.

Tod Papageorge

(American, born 1940, M.A. Hon. 1979)

PLATE 81

Opening Day, Yankee Stadium, from *American Sports, 1970*, 1970, printed 2006

Gelatin silver print, 8⅜ x 12⅝ in. (21.3 x 32 cm)
Janet and Simeon Braguin Fund

PLATE 82

From the Mets Dugout, Shea Stadium, from *American Sports, 1970*, 1970, printed 2006

Gelatin silver print, 8¼ x 12⅝ in. (21 x 32 cm)
Janet and Simeon Braguin Fund

In 1970, armed with a Leica camera and Guggenheim grant like Robert Frank and Garry Winogrand before him, Tod Papageorge embarked on a project to photograph professional sporting events across America.[1] The photographer's original intent was to mine the poetics of athletic endeavor; the tragic shootings at Kent State that spring, however, led him to alter his approach. While he retained his nominal subject, Papageorge opted to use it instead as a metaphor with which to address the roiling social tensions over the war in Vietnam.

Often depicting spectacles beyond the sidelines, his resulting series of pictures (which remained unassembled and virtually unknown until recently) presents an oblique yet penetrating portrayal of a society descending into chaos. Each composition seems taut with anxiety and delirium, afflicted by some vague menace. In *Opening Day*, the rational order suggested by the outfield scoreboard is blithely disregarded by the restless, unchaperoned youths who prowl the cheap seats. Similarly powerless is the dilapidated billboard above that at once urges its viewers to "Follow the Yankees" and "Chry." In *From the Mets Dugout*, an overhang serves as a ballast from which a uniformed player steadies himself; behind him, the massive arc of Shea Stadium's crowded upper decks hangs at a precipitous pitch. The small silhouette of a plane overhead compounds the scene's unease. In Papageorge's turbulent magnum opus, even our national pastime is incapable of distracting us from the discontents of war.

JC

1. See pls. 70–71, respectively, for examples of work from Frank's and Winogrand's Guggenheim-sponsored projects.

PLATE 83

Ralph Eugene Meatyard

(American, 1925–1972)

Untitled, 1960

Gelatin silver print, 7½ x 7⅜ in. (19.1 x 18.7 cm)
The Ralph Eugene Meatyard Collection, Gift of Allan Chasanoff, B.A. 1961

Ralph Eugene Meatyard was an optician who made photographs first as a dedicated amateur. In the 1950s, he was a student of Van Deren Coke, through whom he met Aaron Siskind and Minor

White—giants of photography. While his photography is certainly indebted to these masters in its striking formal qualities, Meatyard also explored narrative, almost folkloric sensibilities in his pictures.

Meatyard began photographing his friends and family members posing in masks or landscapes and architecture in the 1960s. In these scenes, his acquaintances become puppets, acting out various vignettes, human comedies that are often at once humorous and dark. In the Gallery's print, two boys form shadowy silhouettes in a doorway, while a third sits just inside, seemingly unaware of their looming presence. If not for the faintly visible smile on one of the boys' faces, or the youthful symbol of the ringed socks, one might assume that something sinister is at play. As an optician aware of the exactitude of vision and the possibilities of the camera lens, Meatyard is careful to reveal just the right amount of detail to imbue this scene with a sense of mystery.

Though he signed many of his prints "Gene Meatyard," he is now most commonly referred to by his full name, Ralph Eugene Meatyard, a name that produces a curious set of initials for an optician, since they are also an acronym for rapid eye movement, the name given to the state of sleep during which dreams occur. This is, of course, coincidental, but the pictures do operate in a dreamlike, or nightmarish, world. Meatyard himself claimed to create "uncanny pictures—that is, not surreal, but which give the feeling of being not quite of this world."[1] As such they belong, like romantic stories, also to the world of legend.

RL

1. From a lecture to a Louisville Photographic Society, May 17, 1959, quoted in Guy Davenport, *Ralph Eugene Meatyard* (New York: Steidl, 2004), 34.

PLATE 87

Lewis W. Hine

(American, 1874–1940)

Cotton Pickers, Denison, Texas, 1913

Gelatin silver print, 4¼ x 6¼ in. (10.8 x 15.9 cm)
Gift of Pamela Lord

In the autumn of 1913, Lewis Hine photographed six child laborers in a cotton field in Denison, Texas. The group of three boys and three girls look out from the photograph with expressions that range from a hesitant smile to sentiments of mistrust and discontent. The children's tattered clothes and bare feet, and the vast field remaining to be picked, point to the hardships that they face. They hold unwieldy sacks of cotton, contorting their bodies to counterbalance the weight of these burdens. Hine's composition leads our eyes from the largest child to the smallest and back into the expansive fields beyond, emphasizing the smallness of the children and the magnitude of their task.

The empathy that *Cotton Pickers, Denison, Texas* may elicit is the result of Hine's efforts as both a photographer and a social activist. The photograph is one of many from a 1913 trip in which Hine set out to document the textile industry in the southeastern United States for the National Child Labor Committee. He often bolstered the aesthetic power of his images with data about the subjects, jotting notes on the photographs. On the reverse of *Cotton Pickers, Denison, Texas*, Hine recorded the following: "Cotton

Pickers, ages 5, 6, 7, 9, and two a little older." We may assume that in addition to photographing the children at their eye level, Hine conversed with them to acquire such information. At a time when childhood was only beginning to be valued as a time of innocence, Hine combined his aesthetic and ethical sensibilities to encourage social change throughout the strata of American society.

CP

Alan Trachtenberg, "Camera Work/Social Work," in *Reading American Photographs, Images as History: Mathew Brady to Walker Evans* (Toronto: Collins, 1989), 164–230.

PLATE 88

Helen Levitt
(American, born 1918)

New York, ca. 1940, printed later
Gelatin silver print, 10¼ x 6⅞ in. (26 x 17.5 cm)
Gift of Richard and Elizabeth Devereaux, B.A. 1981

Caught in a moment of exuberance, the partially clothed and water-soaked children play at a gushing fire hydrant, cooled by the free-flowing water on a hot summer afternoon. While Helen Levitt is often noted for sharing with documentary photography an "attitude of invisible selflessness"—she photographs with an inconspicuous yet rapid-fire 35 mm Leica camera fixed with a right-angle viewfinder—*New York* stands apart in the role of the viewer being both observer and participant.

Levitt achieves this duality through spatial arrangement and the camera's ability to fix a spontaneous moment in time. The three boys at the hydrant (the only section of the photograph that is in focus) are the central image; however, the foreground and background are essential to Levitt's vision of recording people in relation to their surroundings. By closely cropping the figures of the two boys in the foreground, Levitt places the viewer on the same plane (or level), and we jointly observe the active scene in the middle ground. The angled blast of water directed toward the camera further heightens this vicarious experience.

Typical of Levitt's photographs of children, their fantasy world contrasts with the stark realism of the adult world. Behind the hydrant some children shelter their bodies from the rain with newspapers, while others run directly into the oncoming water. In the far background adults idly sit or stand, oblivious to the children's mischief and seemingly unaffected by the joy and infinite imaginative possibilities offered by the exploding hydrant.

ECD

Sandra S. Phillips and Maria Morris Hambourg, *Helen Levitt* (San Francisco: San Francisco Museum of Modern Art, 1991).

PLATE 89

Eugène Atget
(French, 1857–1927)

Capucines (Nasturtiums), 1921–22
Albumen print, 8⅝ x 6⅝ in. (22 x 16.8 cm)
Everett V. Meeks, B.A. 1901, Fund

PLATE 90

Lois Conner
(American, born 1951, M.F.A. 1981)

Mirrors, Paris, France, 1979
Platinum-palladium print, 9⅝ x 7⅝ in. (24.5 x 19.4 cm)
Gift of the artist in honor of Richard Benson

Eugène Atget is a tricky figure. As a commercial photographer during the height of that field's expansion in the late nineteenth century, he was no different, in practice, from many other such photographers. By his own admission, his prints were mere "documents" that he sold to painters, sculptors, architects, designers, and craftsmen in order to make a living. Armed with a standard box camera and glass negatives, Atget made pictures with less regard for technical perfection than some, and his printing process was certainly less technically adventurous than the complicated ones employed by the Pictorialist photographers of the era. By comparison, Atget would seem a rather ordinary figure. The way he went about his practice, however, is extraordinary: over almost four decades Atget produced some ten thousand photographs of doors, windows, streets, stairs, churches, courtyards, parks, and people. His pictures add up to an encyclopedia of the bits and pieces of French life and culture around the turn of the century.

The print in the Gallery's collection (pl. 89) presents one of the more unusual bits in Atget's catalogue. Made later in his career, about 1921–22, it is at once a useful description of the flowering plant and a study in shape and texture: the biomorphic nasturtiums mingle with the rigid and regular slats in the latticework. One can imagine a painter making good use of it as a model for its impressionistic play of light on the upturned surfaces of the leaves.

Atget's massive body of work reveals the inherent democracy in photography: his dead-on, unmanipulated approach offers each of his subjects an equal opportunity at greatness, be it a picturesque park or a door knocker. While each of his pictures individually provides a description of a particular subject, each also captures something ephemeral, invoking a palpable sense of nostalgia. Perhaps he was a simple commercial photographer, but his massive body of work carries with it a comprehensive description of a fleeting moment from the past.

Such an uninhibited practice of looking and capturing is, in fact, a purely photographic approach. Sketches are quick, photographs even quicker, and with photography scenes of beauty or intrigue are limited only by the imagination and insight of the photographer. Lois Conner shares Atget's attentive, photographic gaze, and her *Mirrors, Paris, France* (pl. 90) reveals this affinity. At first, it is as much a delightful jumble of circles and lines as Atget's nasturtiums, but on closer inspection, bits and pieces of Paris emerge: the jostled assembly of mirrors in a street-front window,

the reflection of spindly branches from a sidewalk allée of trees, and in the mirror at lower center, a poetic, inverted image of a distinctive Parisian rooftop capped by three slight chimneys. This roof makes a second, enlarged appearance as the shadowy form of the opposing building in the window reflection. On the ground glass of Conner's eight- by ten-inch camera, the detail of the roof was right-side up while the rest of the scene was inverted. In Conner's print, orientation, abstraction, reflection, and refraction combine to form a photograph *about* photography and the attributes of light and vision. Conner's masterful platinum printing also explicitly emphasizes the richness and breadth of light and tone in the picture, from the ivory whites of the overhead lights to the smoky form of the opposing building. Atget's picture-making process was purely about his subjects; it was both descriptive and celebratory, but Lois Conner celebrates the medium itself, combining technical mastery with a discerning eye. Atget opened the door for twentieth-century photography, and Conner has not forgotten its roots.

RL

PLATE 94

Mary Cassatt

(American, 1844–1926)

The Lamp, 1890–91

Drypoint, soft-ground etching, and aquatint, from two plates, 12⅝ x 9⅞ in. (32.1 x 25.1 cm)

Gift of Jan and Warren Adelson, Mr. and Mrs. N. Lee Griggs, Jr., B.A. 1951, Anthony M. Schulte, B.A. 1951, John Mark Rudkin, B.A. 1951, and purchased with the Everett V. Meeks, B.A. 1901, and the Walter H. and Margaret Dwyer Clemens, B.A. 1951, Funds

In 1890–91, inspired by an exhibition in Paris in 1890 of Japanese woodcuts—then new to the West and a revelation—Mary Cassatt made a group of ten color etchings, which immediately established her fame as a printmaker and remain her greatest contribution to the medium. *The Lamp* is one of these images. The catalogue raisonné of Cassatt's color prints lists four states, but this impression is of a state unknown until shortly before it was acquired by the Gallery, between the first and what had been thought to be the second. It may be the only extant impression of this state. It is printed from two plates, in black and colors in a close tonal range of russet-brown, violet-brown, and pink; all of the colors except the pink appear to have been printed together from the first plate.

The print is amazingly lively and fresh. The woman looks as though she is about to speak, and her brown eye, even seen as it is just from the corner, at an oblique angle, seems to focus intelligently and thoughtfully on something across the room. A lighter area in her hair makes it seem to shine. The subtle and only partial coloration of the print—parts of the paper are left with no color at all—manifests that it is a work in progress.

Six drawings used in the process of making the series of ten etchings are known: three in the National Gallery of Art, Washington, D.C., two at the Metropolitan Museum of Art, New York, and one—the drawing for *The Lamp*—at Yale (fig. 1). When the drawing is examined, it becomes evident that Cassatt folded it

Figure 1. Mary Cassatt, *The Lamp,* ca. 1890. Black chalk and graphite, 14¼ x 10 in. (36.2 x 25.4 cm). Yale University Art Gallery, Bequest of Edith Malvina K. Wetmore

over the etching plate, image outward, and then transferred the lines to the plate by tracing over them with a blunt tool. This method was also used for the other known drawings for the series.

SB

Nancy Mowll Mathews and Barbara Stern Shapiro, *Mary Cassatt, the Color Prints* (New York and Williamstown, Mass.: Harry N. Abrams in association with Williams College Museum of Art, 1989), cat. no. 6.

PLATE 95

Walt Kuhn

(American, 1877–1949)

Chorus Captain, 1935

Oil on canvas, 40 x 30 in. (101.6 x 76.2 cm)
Katharine Ordway Fund

In *Chorus Captain,* Walt Kuhn's portrayal of a weary yet dignified showgirl, masked with makeup and crowned with voluminous ostrich plumage, offers psychological insight into the backstage life of the performer. The artist's fascination with theater began when, as a boy, he delivered rental costumes to New York acting troupes. Later, he produced costume balls, designed costumes and sets, and staged ballets for vaudeville and musical revues, gaining a wide acquaintance among performers. An icon of the underpaid, overworked entertainer caught off guard, the introverted face at the center of this composition rivets our attention. The model may be an individual Kuhn knew personally, but she is also a metaphor for the human condition. While many of his sitters were actors who presented themselves in their own costumes, makeup, and poses, others were transformed by Kuhn, who auditioned models during "cattle calls," applied makeup, reused props like the plumed tiara, and either offered costumes from his extensive collection or designed new ones, sewn by his wife. In *Chorus Captain,* he used direct paint application, a frontal viewpoint, and flattened forms on a dark background to bring his subject forward, impressing the viewer with her magnetic appeal. Her slumped shoulders and

scanty attire — particularly the strip of green cloth that covers her lap and looks as if it could be pulled away — reveal her weariness and vulnerability. The acid palette of pink, green, yellow, and red reflects the brash costumes, colors, and lights of the entertainment world. The tension between the sitter's private mood and her public role lends the portrait its evocative quality.

RJF

On Kuhn, see Bennard B. Perlman, with foreword by John W. Payson, *Walt Kuhn, 1877–1949*, exh. cat. (New York: Midtown Galleries, 1989).

PLATE 96

Everett Shinn

(American, 1876–1953)

The Orchestra Pit, Old Proctor's Fifth Avenue Theatre, 1906

Oil on canvas, 17⁷⁄₁₆ x 19½ in. (44.3 x 49.5 cm)
Bequest of Arthur G. Altschul, B.A. 1943

Among the first American artists to choose the theater as a signature theme, the versatile Everett Shinn wrote more than thirty-five plays, worked as a theatrical producer and actor, and later was a set designer and art director in the burgeoning motion-picture industry. About the time he painted *The Orchestra Pit*, Shinn was commissioned by impresario David Belasco to create murals for his Broadway theater. Belasco's experiments with electric lighting are reflected in Shinn's painting of musicians darkly silhouetted against a stage bathed in an aquamarine glow. The curtained barrier between the orchestra pit and the audience marks Shinn's role as spectator rather than participant, although his proximity to the stage underscores his familiarity with the performers. A female dancer bends down to provocatively engage the foreground musician, or the handsome artist — a legendary womanizer — apparently seated in the first row.

The setting for *The Orchestra Pit* is the incongruously named Proctor's Fifth Avenue Theatre, located at Broadway and Twenty-eighth Street. When the "King of Vaudeville," Frederick F. Proctor, acquired the traditional theater in 1900, the *New York Herald* announced its conversion into a "house with high class 'continuous' vaudeville," offering a variety format — skits, female impersonators, slapstick comedians, circus acts, dancers, and singers. Shinn painted *The Orchestra Pit* during a pivotal year. In 1906 Proctor celebrated his twenty-fifth anniversary in theatrical management with leading attractions that drew overflowing audiences. While most houses in the Proctor circuit of seven theaters still offered a vaudeville program, by 1906 the Fifth Avenue Theatre instead devoted itself to dramatic productions. Therefore, the three women musicians and dancers depicted on stage in *The Orchestra Pit* probably performed during the "Extraordinary All-Star Jubilee Concert" that culminated "The Wondrous Anniversary Schedule" presented at Proctor's Fifth Avenue from April 9–15, 1906.

RJF

On Shinn's theater subjects, see Patricia McDonnell et al., *On the Edge of Your Seat: Popular Theater and Film in Early Twentieth-Century American Art,* exh. cat. (New Haven: Yale University Press, in association with Frederick R. Weisman Art Museum, University of Minnesota, 2002). On Proctor, see William Moulton Marston and John Henry Feller, *F. F. Proctor: Vaudeville Pioneer* (New York: Richard R. Smith, 1943).

PLATE 97

Mary Cassatt

(American, 1844–1926)

Boy with Golden Curls (Portrait of Harris Whittemore, Jr., B.A. 1918), 1898

Pastel on paper, mounted on canvas, 21½ x 19½ in. (54.6 x 49.5 cm)
Gift of Robert N. Whittemore, B.S. 1943

The American artist Mary Cassatt spent most of her adult life in Paris, but she returned to the United States often to visit her parents and, after their deaths, her brother, living in Philadelphia. Cassatt had met Harris and Justine Whittemore during their honeymoon in Paris in 1893, and in the summer of 1898 she visited the couple and their family in Naugatuck, Connecticut. It was there that she created this vivid likeness of four-year-old Harris Whittemore, Jr. She made two other portraits during the same visit, one of Harris's paternal grandmother and one of his mother holding his baby sister, Helen.

The artist had only her pastels with her during this trip, and in fact by this date she worked in pastel much more than in oil. Pastels, manufactured in sticks like crayons, were portable and immediately usable, and thus they lent themselves to spontaneous work; they have the wide range of color of oil paints but not the drawback of slow drying or the need for oils, turpentine, brushes, or rags.

The boy, dressed in a blue sailor suit with a broad white collar, sits pensively in an armchair, his right calf resting on his left knee, and his right hand, with fingers slightly spread, on his right knee, while his left hand holds the arm of the chair. He looks off pensively, even solemnly, into the distance. His hair is cut in short bangs over his forehead, while the rest falls in shoulder-length curls; at the time, it was customary not to cut boys' hair until they reached about the age of six.

Robert Whittemore, the donor of this portrait of his father, also provided, for the Yale University Art Gallery's files, a poem that Harris Whittemore had written — just when is uncertain — thinking back to his sessions with Cassatt.

> *For half of every day*
> *It seemed he sat*
> *Having his picture drawn by M. Cassatt*
> *All he wanted was a chance to play*
> *He looked so glum & had no fun*
> *So when the portrait was all done*
> *He pointed: "There's the door,"*
> *Said little Harris Whittemore.*

SB

Adelyn Dohme Breeskin, *Mary Cassatt, A Catalogue Raisonné of the Oils, Pastels, Watercolors, and Drawings* (Washington, D.C.: Smithsonian Institution Press, 1970), cat. no. 299.

PLATE 98

George Bellows

(American, 1882–1925)

Lady Jean, 1924

Graphite, 20¹³⁄₁₆ x 10¹¹⁄₁₆ in. (52.8 x 27.2 cm)

Gift of Mr. and Mrs. Warren Adelson

This beautiful drawing of George Bellows's younger daughter, Jean, is a study for his painting *Lady Jean* (fig. 1) in the Gallery's collection. Created during the family's summer stay in Woodstock, New York, it shows a determined-looking nine-year-old girl wearing an adult dress of the 1880s that had been handed down in the family, and an improvised lace hat made by her mother. The hutch in the background had been built by the artist. Later in life, Jean Bellows recalled that it was very hot in July when she posed for the portrait and that her father paid her a dollar each day to do so. "My father was being tongue-in-cheek when he named it 'Lady Jean' because I was no lady at the time. I was an impossible child—very stubborn, always having fights with my father about something."[1]

Figure 1. George Bellows, *Lady Jean*, 1924. Oil on canvas, 72 x 36 in. (182.9 x 91.4 cm). Yale University Art Gallery, Bequest of Stephen Carlton Clark, B.A. 1903

The drawing reveals the intricate geometrical structure that lies beneath the surface of the realist painting. The scheme is based on a compositional system called Dynamic Symmetry that Bellows began to use in 1918. Conceived in 1917 by the Canadian art theorist Jay Hambidge, who derived it from a complicated theory of design used in ancient architecture and painting, it attracted many American architects and artists who were drawn to its structural concept of interlocking geometric angles and planes; for some, it was a means of addressing the new formal challenges presented by European Cubism, which many artists had encountered for the first time at the Armory Show in 1913. Dynamic Symmetry essentially proposed a compositional structure that divides rectangles into regular parts that bear some proportionate relationship to each

other and the whole, with further divisions, subdivisions, and diagonals of the various squares and rectangles.

HAC

1. Oral interview, 2001, typescript Yale University Art Gallery. For a full discussion of Bellows's career, see Michael Quick, Jane Myers, Marianne Doezema, and Franklin Kelly, *The Paintings of George Bellows* (New York: Harry N. Abrams, 1992).

PLATE 100

John Marshall

(American, born 1936)

Yale Bowl

Edmonds, Washington, 2001

Silver, *mokume gane* (.925 silver and copper), and acrylic, 26⅛ x 28½ x 15⅜ in. (66.4 x 72.4 x 39.1 cm)

Purchased with gifts from Lisa Koenigsberg, M.A. 1981, M.PHIL. 1984, PH.D. 1987, and David Becker, B.A. 1979, and Archer B. Huntington, M.A. 1897, in memory of his mother, Arabella D. Huntington (by exchange), and with the Janet and Simeon Braguin Fund

John Marshall is internationally renowned for his virtuoso work in silver. He is both a sculptor and a silversmith who originates boldly conceived and masterfully executed works on a large scale. His ability to work on a large scale is grounded in the tradition in which he was trained—the silversmithing revival that took place in the United States after World War II. Marshall's teacher, Frederick Miller, was renowned for raising free-form vessels by the stretching method. This method is ideal for making irregular shapes and for giving vessel edges extra thickness. Marshall mastered this technique early in his career, and over time he has drawn and built upon it to make original and dramatic forms.

This bowl, which was commissioned by the Gallery to celebrate Yale's tercentennial, combines Marshall's penchant for large and exuberant forms with two additional signatures of his work—the use of acrylic and the *mokume-gane* technique. An integral part of Marshall's work since the late 1970s, the opaque and luminous surfaces of colorless acrylic are foils to the reflective quality of the metal, seen here in the slab mediating the transition from the bowl to its pedestal supports. The traditional Japanese metalworking technique *mokume gane*, where layers of different metals are laminated and forged to create a wood-grain effect, has been evident in Marshall's silver since the 1990s and appears in this work on the pedestals. The ingots used for these pedestals were approximately three inches thick and composed of eighteen sheets of eighteen-gauge copper interleaved with a corresponding number of sheets of eighteen-gauge sterling silver. Metal processed in this way lacks the lustrous reflective surfaces that Marshall attains through embossing and chasing, but it exhibits the rich texture that characterizes so much of Marshall's work. Here, the pedestals have an earthy tone compared with the dramatic, light-catching vessel that they support.

PEK

John Marshall, Metalsmith: Selected Work from 1991–1997, exh. cat. (Seattle: Henry Art Gallery, 1998).

PLATE 102

Ronald Hayes Pearson

(American, 1924–1996)

Pendant

Rochester, New York, ca. 1955
Sterling silver and plique-à-jour enamel, 3 x 1 in. (7.6 x 2.5 cm)
Promised gift of Jane and Arthur Mason

Ronald Hayes Pearson, a leading metalsmith in the craft revival following World War II, had his roots in the Arts and Crafts movement. His father, Ralph M. Pearson, a printmaker who inaugurated the art program at the New School for Social Research in New York City, took his family to spend summers at Elverhoj, a crafts colony at Milton-on-Hudson near Poughkeepsie, New York, and later to design workshops he ran in Gloucester, Massachusetts. Following service in the merchant marines during World War II, in 1947 Ronald Pearson enrolled in the School for American Craftsmen (SAC), which was then in Alfred, New York. Recognition of his skills came early in his career, with the first prize for silversmithing at the *Third Annual Decorative Arts and Ceramics Exhibition* of the Wichita Art Association in 1948. Pearson left the school after only one year and began to produce work in a shop he set up in a converted chicken coop. In 1953, after the SAC moved to Rochester and became part of the Rochester Institute of Technology, the Scandinavian-trained metalsmith Jack Prip, the woodworker Tage Frid, and the ceramist Frans Wildenhain founded a retail outlet called Shop One, which they asked Pearson to manage. Prip eventually went into a full-time partnership with Pearson.

Pearson made this silver and enamel pendant about 1956 during the Prip-Pearson partnership. The pendant employs plique-à-jour enamel, which Pearson taught himself through trial and error. The enamel was a staple of the Scandinavian jewelry then being retailed in the United States. The pendant's biomorphic forms are rooted in the paintings of Joan Miró, the sculpture of Henry Moore, and the design concepts of Alvar Aalto. The design of the pendant speaks to the vibrant craft world of the 1950s in which young craftspeople responded to currents in the contemporary art world. From these beginnings, Pearson went on to a long and successful career as an independent jeweler and metalsmith.

PEK

W. Scott Braznell, "The Early Career of Ronald Hayes Pearson and the Post-World War II Revival of American Silversmithing and Jewelrymaking," *Winterthur Portfolio* 34 (Winter 1999): 185–213.

PLATE 105

Jake Cress

(American, born 1945)

"Oops" Chair

Fincastle, Virginia, 1991
Cherry and paint, 37¼ x 30 x 23¼ in. (94.6 x 76.2 x 59.1 cm)
Promised gift of Lulu C. and Anthony W. Wang, B.A. 1965

In 1991, Virginia cabinetmaker Jake Cress created his first *"Oops" Chair*. Exhibiting a sly wit, *"Oops"* questions the traditions of craftsmanship and the conventions of American antiques. Cress

intended *"Oops"* to be a unique piece of sculptural furniture, but the initial design proved so successful that he expanded the project into a series of ten chairs; the Gallery's chair is the original model.

"Oops" has a molded crest rail and splat of interlaced scrolls similar to eighteenth-century chairs from Pennsylvania and Connecticut; the cabriole legs terminate in ball-and-claw feet. In overall form, *"Oops"* is a seemingly faithful reproduction of an American Rococo chair, yet Cress manipulates design elements in a comically insightful manner. Carved eyes peer out from the chair in a literal interpretation of the trade term "owl eye splat." The added eyes transform the surrounding strapwork into an abstracted face that looks downward in consternation as the front leg strains to reclaim a ball that has rolled just out of reach. Cress's insouciant treatment of the leg dislodges the motif from its normal context: the ball-and-claw foot is no longer a mere marker of high-style craftsmanship and regional difference but is now an animated, confrontational detail.

The success of the *"Oops" Chair* lies in its subversion of shared cultural beliefs. One expects a chair to assist in the act of sitting, yet *"Oops"* has only three functional legs and no seat. Cress views the antiques trade as stereotypically stuffy and serious and so creates self-consciously "funny furniture." Even the distinction between sculpture and decorative art becomes blurred. With *"Oops,"* Cress lightheartedly questions the implied meanings of anthropomorphizing terminology, the conventions of connoisseurship, and the very idea of whether a chair can be a work of art.

JSG

PLATE 107

Tomb Guardian Creature (Zhenmushou)

Chinese, Tang dynasty, ca. 740 C.E.
Earthenware with traces of pigment, H. 23 in. (58.4 cm)
Purchased with a gift from Ruth and Bruce B. Dayton, B.A. 1940

The protective power of this tomb guardian creature is directly engaged as it stands astride a recumbent boar whose mouth opens wide in agony. The fierce energy of the guardian is conveyed through the posture: the right arm is raised as if about to strike; the left leg is thrust forward, the muscles tensed; and the chest bulges forward. The appearance of the lionlike face further supports the ferocity of the guardian: the eyes are bulging, the eyebrows erect, the nostrils flaring, and the square mouth open wide exposing fangs. Two curling horns rise above the eyebrows, and a single flame emerges from the back of the head. Flames rising from the shoulders and a snake throttled in the claws of the left paw complete the ferocious image.

Such lionlike guardians were usually paired with human-faced creatures and were generally placed just outside the tomb chamber on either side of the passageway facing the entry. They began to appear as pairs in tombs in north China during the late fifth and early sixth centuries. The earlier figures were usually seated with their front legs resting on the ground. Over time, the pair of guardian creatures came to be grouped with two guardian warriors and sometimes with two civil officials. By the late seventh century, the guardian warriors were replaced by Spirit Kings or

Heavenly Kings of the Buddhist tradition. These kings, standing fully erect, surmounted other creatures, which may well be the origin of the boar in this image. The fierce energy of this guardian also probably derives from Buddhism. Esoteric Buddhism spread rapidly during the seventh and eighth centuries with major interpreters arriving in the capital city of Chang'an in the early eighth century. The ferocity of this guardian may well reflect the spread of those beliefs on the popular level.

DAS

PLATE 108

Zither (Se)

Chinese, Eastern Zhou dynasty, Warring States period, 5th–3rd century B.C.E.
Lacquered wood, 4⅜ x 12⅞ x 26⅝ in. (11.1 x 32.7 x 67.6 cm)
Gift of Audrey Lam Buchner, B.A. 1994

PLATE 109

Wine Vessel (Zhi)

Chinese, Eastern Zhou dynasty, Warring States period, 4th–3rd century B.C.E.
Lacquered wood, H. 8⁷⁄₁₆ in. (21.4 cm)
Gift of Audrey Lam Buchner, B.A. 1994

PLATE 110

Wine Vessel (Zhi)

Chinese, Western Han dynasty, 2nd–1st century B.C.E.
Lacquered wood and bronze, H. 7½ in. (19.1 cm)
Gift of Audrey Lam Buchner, B.A. 1994

PLATE 111

Cylindrical Box with Cover

Chinese, Warring States period or Qin dynasty, 3rd century B.C.E.
Lacquered wood and bronze, DIAM. 13¾ in. (34.9 cm)
Gift of Audrey Lam Buchner, B.A. 1994

Chinese craftsmen began to use lacquer—a natural substance extracted from a tree indigenous to East Asia, *Rhus verniciflua*—during the Neolithic period, but perhaps the most important period in the evolution of the craft came during the second half of the first millennium B.C.E. During the Warring States period (475–221 B.C.E.), the kingdoms of Chu and Qin developed independent traditions of lacquerware, traditions that were inherited by the Han dynasty (206 B.C.E.–220 C.E.) after the unification of China by Qin in 221 B.C.E. Craftsmen took advantage of the imperviousness of lacquer to liquids, of its durability and protective qualities, as well as of the decorative potentials of its glossy surface. Lacquer was used for a wide variety of objects ranging from eating utensils and musical instruments to weapons and funerary items, such as coffins and tomb sculpture. In most cases, lacquer was applied to a wood base. The colors were black from carbon and red from cinnabar. During the fifth and fourth centuries B.C.E. improvements in wood carving and joinery techniques led to the manufacture of highly refined objects. The invention of the lathe made it possible to create thin-walled, round containers, and a technique favored by Qin craftsmen of curving thinly sliced pieces of wood allowed for the creation of delicate cylindrical shapes. The vessels of curved wood were often set in bronze fittings. The palette of colors was extended to include yellow and brown; other colorants, which were added not to the lacquer itself but rather to oil before being painted on the surface of the lacquerware, further extended the range of colors. The decorators developed a rich vocabulary of fluid designs that took cues from other media such as textiles and in turn had an impact on bronze decor.

DAS

PLATE 112

Money Tree (Qian Shu)

Chinese, Eastern Han dynasty, ca. 2nd century C.E.
Bronze and earthenware, H. 55¼ in. (140.3 cm), DIAM. 23½ in. (59.7 cm)
Gift of the Nathan Rubin–Ida Ladd Family Foundation under the Bequest of Ester R. Portnow

One of the most intriguing objects found in Eastern Han dynasty (25–220 C.E.) tombs of southwest China is known in modern literature as a "money tree" (*qian shu*) or "money shaking tree" (*yao qian shu*), named for the coins that appear among the branches. In Han times, the trees may have been called "coin pillars" (*zhuzhu*), although there are no clear textual references to such objects. Images of the Queen Mother of the West (*Xiwangmu*), whose cult was widespread in Sichuan during the Eastern Han, frequently appear along with the coins, thus associating the trees with beliefs in immortality. The presence of the coins suggests eternal wealth for the occupant of the tomb.

The base of this money tree is of earthenware, and the trunk segments and branches are of thinly cast bronze with traces of gilding. The base resembling a mountain, probably Mount Kunlun, where the Queen Mother of the West resided, was made in a two-part mold and glazed. It is surmounted by a figure riding a winged ram, the figure appearing to hold the support for the trunk in his arms. Rams appear frequently in Han funerary art; the character for *ram* had the same pronunciation as the character for *auspiciousness* and thus carried that meaning. The trunk rises in five sections with an ascending dragon on each side. At the join of each section of the trunk, there are four sockets to receive the tangs of branches projecting in the four directions. As assembled at present, the four upper tiers of branches all appear to have been cast in the same mold. In complete form, each branch has seven coins and small figures encircled by a scrolling stem. The lowest-level branches are longer with more coins; there are at present monkeys suspended from each branch. The tree is surmounted by two birds facing each other, each with spread wings and peacocklike tail feathers. There are coins on the heads of both birds, and a scene with dancing figures and a single surviving mounted hunter with drawn bow is being enacted. The birds, like the ram, had auspicious meaning. The tree may have functioned as an axis mundi.

DAS

PLATE 120

Front Panel of a Funerary Couch

Chinese, Northern Dynasties, 6th century C.E.
Dark gray stone with pigment, 15⅝ x 76½ x 5 in. (39.7 x 194.3 x 12.7 cm)
Gift of the Nathan Rubin–Ida Ladd Family Foundation under the bequest of Ester R. Portnow

Stone funerary beds begin to be encountered in excavated tombs dating to the late fifth century C.E. At first, the beds appear to have been simply rectangular platforms with a decorated, three-legged base on one long side, but by the early sixth century they take the shape of a domestic couch with stone units simulating the panels of a three-sided screen enclosing the couch platform. The corpse may have been laid out on the couch or placed in a coffin on the surface, or the couch may have been empty, functioning to receive the soul of the deceased on its periodic visits to the tomb.

Figure 1. Detail of plate 120

This horizontal stone is the front base of such a couch. It is supported by three quadrangular legs, positioned at the two edges and the center. Across the top is a band of bisegmented lotus leaves in rounded relief, while framing the bottom edge, executed in low relief, is a scalloped border resembling waves. The main band of decoration is composed of nine rectangular low-relief images of beasts and "thunder monsters." Each creature fills the available space and conveys explosive energy: their arms are raised, their mouths are open, and flamelike wings sprout from their shoulders. The three legs are executed in high relief. On the two outer supports are seated figures of guardian beasts shown in a rocky landscape with a cub. In the center is the head of a fantastic beast with bulging eyes and curly mane (fig. 1). Rather than showing the head *en face,* the carver has turned it slightly, exemplifying its power. The carving of the nine mythical beasts is particularly close to similar creatures appearing on the epitaph cover of Lady Yuan dated to 522 C.E., thus suggesting a date in the late Northern Wei (386–535 C.E.) for the couch front.

DAS

PLATE 121

Wang Duo

(Chinese, 1592–1652)

Five Tang Poems

Ming dynasty, January 12, 1642
Handscroll, ink on paper, 11¼ in. x 15 ft. 8½ in. (28.6 x 478.8 cm)
Gift of H. Christopher Luce, B.A. 1972

Wang Duo was one of the most innovative of seventeenth-century Chinese calligraphers. He began his study at an early age by copying Wang Xizhi and his son Wang Xianzhi, the two orthodox masters of the classical tradition. Over a lifetime of daily copying and concentrated study, Wang Duo was able to internalize his models and completely transform them. In addition to the two Wangs, he looked to the Tang dynasty (618–907 C.E.) masters of wild cursive script (*kuangcao*) for inspiration. Later in life, his artistic language gained in boldness. His transformations of the past are clearly apparent in *Five Tang Poems.*

In *Five Tang Poems,* Wang Duo has written out each poem in continuous sequence on several sheets of paper mounted together as a handscroll. In each column, there are an irregular number of characters, and the characters vary in size and in ink tonality. Some strokes are thick and some thin. While overall there is a ribbonlike fluidity to the movement of the brush, at some points there are sharper, more angular turns. In the context of early seventeenth-century calligraphy derived from Wang Xizhi and Wang Xianzhi, these characteristics make Wang Duo's writing appear unusual or strange. This quality of unusualness or strangeness (*qi*) was something that Wang wrote about and was much prized by him and his contemporaries. In Wang Duo's case, he saw the strange as something that was present in the calligraphy of the orthodox masters but needed to be brought out. Another aspect of his writing is his use of one-stroke script, in which a sequence of characters is written without lifting up the brush. In addition, he seems to be consciously exploring the use of dry brush: after loading the brush, he continues to write until the brush is dry. This creates another kind of rhythm throughout the scroll.

DAS

PLATE 122

Chen Jiayan

(Chinese, 1599–1683)

Birds by a Lotus Pond

Ming dynasty, 1643
Hanging scroll; ink on paper, 47¼ x 20⁷⁄₁₆ in. (120 x 51.9 cm)
Gift of Nelson I. Wu in honor of the memory of Hartley Simpson (1900–1967), historian, educator, and friend, Dean of the Graduate School, Yale University, 1956–61

In the summer of 1643, Chen Jiayan painted this hanging scroll depicting birds by a lotus pond. He wrote in his inscription that he was inspired by Chen Shun, one of the most important Suzhou painters of bird-and-flower subject matter from the first half of the sixteenth century. Chen Jiayan executed his picture solely in ink, arranging three birds perched above the lotus pond with a rock at

right. The lotus leaves rise above the pond with blossoms fully open. Only the decay at the edges of the leaves hints that the summer season is well advanced.

Chen Jiayan rarely inscribed poems on his pictures that could reveal further layers of meaning, and he usually dated his paintings with only a cyclical date, sometimes adding his age. Because his images were so close in style to that of Chen Shun, he was assumed to be a late sixteenth-century painter from Suzhou working in the style of Chen Shun. This painting is unusual, however, because he dated it precisely using both a reign date, Chongzhen, and a cyclical date, *kuiwei*. This exact date was one of the crucial clues that led Richard Barnhart to date Chen Jiayan to the seventeenth century. Barnhart was able to establish the painter's birth date as 1599 and his approximate death date as 1683. Further, Barnhart found that Chen was not a native of Suzhou but rather came from the Chongming islands in the Yangzi River delta. Chen can now be understood as a painter who lived half his life under the Ming and half his life under the Qing. After the Manchu conquest, he appears to have considered himself an *yimin,* or leftover subject, of the Ming. He taught in his home village and may well have earned a living from his painting.

DAS

Richard Barnhart, "On Dating the Paintings of Ch'en Chia-yen," *Yale University Art Gallery Bulletin* 40, no. 1 (Spring 1987): 47–57.

PLATE 123

Eagle in a Landscape Setting

Chinese, Ming dynasty, late 15th–early 16th century
Hanging scroll; ink and color on silk, 64¹¹⁄₁₆ in. x 35¹³⁄₁₆ in. (164.3 x 91 cm)
Purchased with gifts from Ruth and Bruce B. Dayton, B.A. 1940, The Henry Luce Foundation at the request of H. Christopher Luce, B.A. 1972, and the Leonard C. Hanna, Jr., B.A. 1913, Fund, in honor of Professor Richard M. Barnhart

The fifteenth century was a great age for bird-and-flower painting in China. The Ming court sought to reinvigorate Song dynasty (960–1279) traditions of court painting through direct sponsorship of painters in the capital cities of Nanjing and Beijing. These court painters created large pictures that revived old subjects and endowed them with new meanings. This painting of an eagle in a landscape setting is one such picture.

Eagles and hawks were often depicted as birds of prey swooping out of the sky; they were admired for their strength and swiftness of action. They were seen as both martial and courageous, as a guard against sly foxes or tricky rabbits, and in this capacity they were likened to righteous censors whose duty it was to maintain disciplinary surveillance over corrupt officials. At the end of the fifteenth century, the great court painter of birds and flowers Lü Ji was commended by the emperor for using his images to offer admonitions. From contemporary sources it is clear that the admonitions were conveyed through rebuses. In this painting, the eagle (*ying*) is tall, perched with its head slightly cocked in the direction of the mountain torrent (*jian*). Among the leaves in the foreground is a dark-skinned, fanged animal, also attentive. The animal is a

bear (*xiong*). As a compound, *yingxiong* means "hero," or by implication, "the ruler." Another character, *jian*, means "admonitions." The action of listening (*ting*) completes the rebus, *yingxiong ting jian*, "the hero/ruler listens to admonitions." The painting is in the style of Lü Ji and is the only known example of this rebus. Its message reflects the struggles between the scholar officials of the outer court and the eunuchs of the inner court that marked the politics of late fifteenth-century Ming China.

DAS

Mu Xin
(Chinese, born 1927)

PLATE 128

Dawn Mood at Bohai, 1977–79

Ink and gouache on paper, 6⁹⁄₁₆ x 13 in. (16.7 x 33 cm)
Promised gift of the Rosenkranz Charitable Foundation

PLATE 129

Spring Brilliance at Kuaiji, 1977–79

Ink and gouache on paper, 7 x 13 in. (17.8 x 33 cm)
Promised gift of the Rosenkranz Charitable Foundation

These four paintings (pls. 128–29 and figs. 1–2) were made by Mu Xin in the period 1977–79, while he was under house arrest in the aftermath of the destructive Cultural Revolution that occurred in China between 1966 and 1976. The artist conceived a suite of fifty paintings on the occasion of his own fiftieth birthday; thirty-five paintings constitute the present set, which was promised to the Yale University Art Gallery in 2003 by the Rosenkranz Charitable Foundation.

Painted on watercolor paper in ink and gouache, these evocative landscapes usually began with the practice of transfer painting or decalcomania, a technique used by such Surrealist artists as Max Ernst that involves brushing gouache or ink or other pigments onto a paper surface, then pressing a second sheet of paper onto it. When pulled apart, both papers are marked with abstract, unpredictable, and highly suggestive forms that can then be modified and elaborated into such images as seen in these works. Mu Xin refers to this initial stage as "controlled coincidence," and it can be

Figure 1. Mu Xin, *Slumbering Stones at a Quiet Pond,* 1977–79. Ink and gouache on paper, 7⅜ x 12¾ in. (18.7 x 32.4 cm). Yale University Art Gallery, Promised gift of the Rosenkranz Charitable Foundation

Figure 2. Mu Xin, *Autumn Colors at Jinling*, 1977–79. Ink and gouache on paper, 12⅞ x 7⅞ in. (32.7 x 20 cm). Yale University Art Gallery, Promised gift of the Rosenkranz Charitable Foundation

related to techniques of accidental pictorial inspiration going back a thousand years to the classical Song landscape masters who plastered dirt on a wall to evoke natural imagery. Proceeding from accident to images, the artist fashioned a suite of landscape evocations of the real and imaginary worlds of his mind, a mind that associates freely across the music, literature, poetry, and painting of the world and evokes artists from Leonardo da Vinci to Lin Fengmian. Mu Xin's paintings have aroused a great variety of interpretations, all of which are challenged by the quotation from Gustave Flaubert that he likes to cite: "Reveal art; conceal the artist." In the long run of history, Mu Xin will take his place among the small group of Chinese writers and artists in the twentieth and twenty-first centuries who devoted their lives to joining the humanistic traditions of China to those of Europe and the world.

RMB

The Art of Mu Xin: Landscape Paintings and Prison Notes (New Haven and Chicago: Yale University Art Gallery and David and Alfred Smart Museum of Art, 2001).

PLATE 130

Mandala of the Sacred Name of the Kasuga Deities (Myōgō Mandara)

Japanese, Muromachi period, 15th century
Hanging scroll; ink, color, and gold on silk, 53 x 13¼ in. (134.6 x 33.7 cm)
Purchased with a gift from Peggy and Richard M. Danziger, LL.B. 1963

This hanging scroll, *Mandala of the Sacred Name of the Kasuga Deities (Myōgō Mandara)*, is the first Shinto-related art to come to the Yale University Art Gallery's Asian collection. In the strictest sense, a mandala, a concept of Buddhist origin, was a systematic diagram of sacred space noting the position of each deity in the universe. By the medieval period in Japan, however, the word *mandala* had become a generic term that included any depiction of a Japanese sacred site, such as the Kasuga Shrine, the tutelary shrine of the historical Fujiwara family.

This particular mandala is unusual; it is an example of a name scroll in which the name of the deity is written out in large characters that function as the image of the deity itself. Seven Chinese characters, written in gold, form a central column atop a lotus dais and crowned with a bejeweled canopy. The writing appears to take on the physical presence of the image of a deity. It reads "Namu Kasuga Dai Myōjin" (In homage to the great and radiant deities of the Kasuga Shrine). The way the large characters were written out in the center follows a Pure Land Buddhist tradition established in the thirteenth century. At the top of the painting, the characters are set against Mount Kasuga, which looms over Mount Mikasa. The five tutelary Shinto deities of the Fujiwara family, shown in their Buddhist manifestations, are placed against the mountains.

Over the centuries, the religions of Shinto and Buddhism adapted to each other, often coexisting at the same site. This beautifully subdued *Mandala of the Sacred Name of the Kasuga Deities* provides a path to understand the sophisticated eclecticism of Japanese religious art during the medieval period. A scroll of this type was often placed in an alcove for ritual worship.

SO

PLATE 132

Tea Bowl

Korean, Yi (Choson) dynasty, 16th century
Ido ware; stoneware with crackled glaze, 3¹/₁₆ x 6³/₁₆ in. (7.8 x 15.7 cm)
Promised gift of Peggy and Richard M. Danziger, LL.B. 1963

PLATE 133

Tea Bowl

Korean, Yi (Choson) dynasty, second half 16th century
Kohiki or Muji Hakeme ware; stoneware with gold lacquer, 2¹⁵/₁₆ x 6⁵/₁₆ in. (7.5 x 16 cm)
Promised gift of Peggy and Richard M. Danziger, LL.B. 1963

PLATE 134

Attributed to Raku Chōjirō
(Japanese, active late 16th century)

Tea Bowl, known as Kaedegure (Twilight by the Maples)

Momoyama period, late 16th century
Raku ware; earthenware with black glaze, 3⁹/₁₆ x 4¾ in. (9 x 12.1 cm)
Promised gift of Peggy and Richard M. Danziger, LL.B. 1963

PLATE 135

Tea Bowl, known as Wind in the Pines (Matsukaze)

Japanese, Momoyama period, early 17th century
Hagi ware; stoneware with off-white glaze, 3¾ x 5⅜ in. (9.5 x 13.7 cm)
Promised gift of Peggy and Richard M. Danziger, LL.B. 1963

PLATE 136

Tea Bowl

Korean, Yi (Choson) dynasty, first half 17th century
Irabo ware; stoneware with brown ash glaze, 3⅛ x 5⅞ in.
(7.9 x 14.9 cm)
Promised gift of Peggy and Richard M. Danziger, LL.B. 1963

Peggy and Richard Danziger have assembled one of the best collections of tea utensils outside of Japan. Their exhaustive collection not only shows the full range of art related to tea—functionally, geographically, and chronologically—but it also features an eclecticism rarely found in compilations related to *chanoyu* (literally "hot water for tea," Japanese tea culture). Their taste is not confined to fixed notions of artistic movements or territorial borders. As true tea practitioners, their idea of collecting never falls into complacency, but their discriminating eye challenges the stereotypical notions of what tea art should be. The anticipated gift of these five bowls and the *Whose Sleeves?* (*Tagasode*) screen (pl. 137) has already changed the landscape of the Gallery's Asian collection and its teaching capacity.

Unassuming though they may seem, these five bowls illustrate a defining era in the history of *chanoyu*. What makes these utensils special, so venerated as to be on view here today, was largely the effect of sixteenth-century Sen no Rikyū, who epitomized the period in which the Japanese population came to see beauty in ways radically different from before. Indeed, Korean potters originally made two of these bowls not for tea but for ordinary meals. While tea connoisseurs prior to Rikyū esteemed Korean wares, Rikyū did more than anyone else to alter the way people viewed them. Earlier, tea emphasized extravagant utensils and settings. Rikyū advocated instead *wabicha*, grounded in simplicity, sparseness, and understatement.

A sixteenth-century tea practitioner underlines the radical turn of Rikyū's aesthetic by noting how the master "made mountains into valleys, west into east, and freely broke all rules of *chanoyu*."[1] Rikyū's views did not, however, arise from nowhere. Rikyū's teachers set an invaluable precedent. Yet his tea arose at an opportune time, when his aesthetic could take root, when it matched the political turbulence that allowed a peasant to conquer Japan, as in the case of Rikyū's patron, Toyotomi Hideyoshi. By the time the Tokugawa family established their regime in the early seventeenth century, the innovations of Rikyū's time had left an indelible mark. Traces of his words, the utensils he possessed, and his persona—these have continued to be a source of not only inspiration but also debate over the nature of the Japanese aesthetic.

Imported during the first half of the sixteenth century from kilns in southeastern Korea (Gyeongsangnamdo), the Ido tea bowl (pl. 132) exemplifies the best of the Korean bowls cherished by *wabicha* connoisseurs. The term "Ido tea bowl" appears in a record of a tea gathering in 1578, by which time they had permeated Japanese tea circles. Since potters made these bowls for rice, they are often amply proportioned, and a solid base grounds the bowl's open mouth. Upon taking the bowl into one's hands, however, we can see why *chanoyu* masters found it to be so appropriate for tea, even warranting repair with a piece of another bowl to mend its

rim. The clay is not too heavy, imparting a comfortable weight and density that allows the warmth to dissipate slowly. The rim is soft to the lips. The bowl looks and feels inviting with its generosity, a trait that fits Rikyū's philosophy of equality among tea drinkers, irrespective of their social status. Rikyū's juxtaposition of the ordinary and the extraordinary can even be found in the images suggested by the name of the ware itself. "Ido" literally means a "well," a gathering place for commoners. At the same time, it evokes the depth of a well into infinity—the bowl's rim echoes the well curb, the tea, the spring below.

The Kohiki or Muji Hakeme bowl (pl. 133) was imported into Japan during the latter half of the sixteenth century. The dual classification might be explained by acknowledging that owners applied some of this nomenclature anachronistically. This bowl in fact looks closer to the Muji Hakeme type, which has a brushed slip without any brush marks. But like some other Kohiki wares, known for their "powdery" look, this bowl began its life with a more mundane purpose. In fact, many of the Korean bowls adopted by the Japanese for use in tea had originally been made for daily use. As one can see with this bowl, the section of the rim repaired in gold lacquer had once been the location for the spout of a pourer. Though market forces might have led to these conversions, Rikyū's conception of *wabicha* purposefully invited the everyday into the timeless setting of tea. Besides the section near the foot, there are a few unglazed areas on the body that display firing marks. Such "imperfections" are highly admired, rather than shunned, in *wabicha*.

The black Raku tea bowl, named *Kaedegure* (*Twilight by the Maples*) (pl. 134), conveys a subdued tone typical for early Raku bowls attributed to Chōjirō. What looks like a dusted pattern in muffled gold evokes the scene of autumnal maples at dusk. This particular bowl, *Twilight*, has an unusual shape resembling a pouch used to hold gold dust (*sakinbukuro*). The flared mouth echoes another of Chōjirō's bowls, *Dōjōji*, from about 1586, but the ultimate source for this form may have been the Komogai type of Korean bowls, especially when one considers Chōjirō's continental origins.

Held to be the founding father of the Raku family of potters, Chōjirō was a son of a roof-tile maker originally from China. Chōjirō is believed to have made his pioneering Raku bowls in collaboration with Sen no Rikyū, but their exact relationship is uncertain.[2] However, Rikyū's advocacy of the new style of *wabicha* no doubt profoundly influenced the Raku workshop. The visual link to Korean forms suggests how Rikyū's aesthetics led to the development of such Japanese wares made expressly for tea in accordance with *wabi* taste.

Old Hagi bowls, including the tea bowl known as *Wind in the Pines (Matsukaze)* (pl. 135), were made in the early seventeenth century. Hagi ware was founded in 1604 by the Korean potters Li Sukkwang and his brother Li Kyong, who were brought to Japan at the time of Hideyoshi's invasion of Korea in the 1590s. In fact, Hideyoshi's invasion decimated kilns in Korea, owing partly to the loss of skilled artisans. While Korean kilns ceased to make wares such as the Muji Hakeme, Hagi instead became a center for an analogous tradition. Still, the Japanese bowls do not merely reproduce their foreign antecedents. Despite the Japanese use of similar

techniques and materials, their bowls are subtly different from the Korean prototypes as the overlap of the white glaze over the porous red clay radiates a gentle luster. Instead of the natural roughness of the converted bowls, *Wind in the Pines* points in the direction of *kirei sabi*, a seventeenth-century aesthetic variation of Rikyū's teachings. Espoused especially by the warrior class, at peace and in search of a new identity, *kirei sabi* revived the courtly elegance and connoisseurship of earlier ages.

Finally, the Irabo tea bowl from the first half of the seventeenth century (pl. 136) also demonstrates the evolvement of Rikyū's tea. Potters in the area of contemporary Yangsan County in Korea made this type of bowl for export to Japan. The strange name, Irabo, is believed to have come from the words used to describe the uneven surface (*ibo ibo*) that may, in some, provoke a feeling of irritability (*ira ira*). The rough, brick-colored clay mixed with sand reminds us of the Japanese Shigaraki ware, also beloved by tea connoisseurs. Whereas earlier Korean imports centered on bowls like the Ido that coincidentally fulfilled the needs of *wabicha*, the Irabo belongs to a later time when Korean production responded to Japanese tastes. Rikyū's "radical" views had, by this time, entered the mainstream, so much so that domestic wares alone could not satisfy the market. Because of its powerful character, however, this bowl does not feel affected. When held, the bowl conveys a weightiness appropriate to its austere, textured surface. The potter has carved out the distinctive foot with a nail, making a forceful swirl.

All five bowls demonstrate the different aspects of *wabi* taste — the love of the rustic, as well as the elegant, the provocative, as well as the subtle, or the well-worn, as well as the novel. This new aesthetic emerged from a time of political turmoil, one which in fact spurred creativity among various artists, some of whom came to Japan bearing advanced foreign technology. Just as these ideas from across the seas contested the preexisting artistic structures of sixteenth-century Japan, the *wabi* aesthetic still challenges us to expand our notions of beauty, based not only in visual terms but also in utility.

SO & TW

Many thanks go to Richard Danziger, whose knowledge of the topic helped shape this entry.

1. *Yamanoue no Sōji ki*, quoted in Dennis Hirota, *Wind in the Pines: Classic Writings of the Way of Tea as a Buddhist Path* (Fremont, Calif.: Asian Humanities Press, 1995), 94.

2. Morgan Pitelka, *Handmade Culture: Raku Potters, Patrons, and Tea Practitioners in Japan* (Honolulu, Hawaii: University of Hawaii Press, 2005), 17–30.

PLATE 137

Whose Sleeves? (Tagasode)

Japanese, Momoyama period, early 17th century
Six-panel folding screen; ink and color on gold leaf paper, 60¼ in. x 11 ft. 7⅜ in. (153 x 354 cm)
Promised gift of Peggy and Richard M. Danziger, LL.B. 1963

"Whose sleeves are these?" the *Whose Sleeves? (Tagasode)* screens make us wonder. Depicting kimonos of various patterns draped over sumptuous, lacquered stands, these screens do not feature the people who presumably wore the colorful robes. They tempt us, rather, to imagine what is happening in private quarters, beyond

our view. Painters produced most of these screens in the early to mid-seventeenth century, after long warfare, and shortly before Tokugawa Ieyasu consolidated his authority over the country. During this time, all art forms expressed tremendous freedom and vitality, qualities also evident in the practice of tea, as discussed in the previous entry.

The term *tagasode* first appeared in a tenth-century courtly *waka* poem expressing longing for a loved one, but such vocabulary came to be used in more plebian contexts as a newly invigorated merchant culture emerged. This painting concentrates on displaying the kimonos with their engaging designs. These include geometric patterns with ivy, as well as fans decorated with dianthus and bamboo. Lush willow leaves and square poetry cards cover a folded red kimono on the left. Some of these designs look similar to the stamped images made by Tawaraya Sōtatsu and used on a handscroll dated to 1628.[1] The distinctive tie-dyed technique called *hitta shibori* that was popular in the early seventeenth century decorates the kimono hanging on the second rack. The freer brushwork on the Yale screen predates the advanced stylization developed by Ogata Kōrin. An *Inen* seal from Sōtatsu's atelier, affixed on the first right panel of the screen, is unusual, but visual analysis confirms its origins in Sōtatsu's workshop.

SO

1. *The Art of Rimpa from the Idemitsu Collection* (Tokyo: Idemitsu Museum of Art, 1993), pl. 13, "Poems from the *Kokin Wakashū* over a Floral Design."

PLATE 138

Nobleman's Meal Table (Kakeban)

Japanese, Muromachi period, ca. 14th–15th century
Negoro ware; red and black lacquer on wood, 6⁹⁄₁₆ x 12¹³⁄₁₆ x 12¼ in. (16.7 x 32.5 x 31.1 cm)
Leonard C. Hanna, Jr., B.A. 1913, Fund

This low, lacquered tray table is one of the rarest types of Negoro lacquer pieces, seldom seen outside of Japan. It was used to serve meals to noblemen who would be seated on a tatami mat to partake of food. Lightweight and yet very sturdy, its four legs are reinforced at the bottom with flat, rectangular pieces of wood to allow it to glide easily on the mat. The so-called Negoro ware was originally created by the monks of the Negoroji temple in Wakayama at the end of the thirteenth century for their daily use. The functionality of this piece is pronounced even as the gently curving legs and scalloped edges of the tray give it a graceful appearance.

As the red lacquer surface wears away with use, the black lacquer underneath is revealed; such rustic visual effects are subtle and arresting, and they began being prized by the tea connoisseurs in the sixteenth century and later. The *Nobleman's Meal Table (Kakeban)* is a counterpoint to the lustrous and lavishly decorated *Kōdaiji maki-e Trousseau Box (Tabikushige)* (pl. 139) of the seventeenth century, and together they allow us to discuss the history of Japanese lacquer. Furthermore, Negoro wares may have been inspired by the Chinese monochrome lacquer wares of the Song (960–1279) and Yuan (1279–1368) dynasties that were brought to Japan during the Kamakura period (1185–1333), extending the scope of discussion beyond the confines of Japan.

SO

PLATE 139

Trousseau Box (Tabikushige)

Japanese, Edo period, mid- to late 17th century
Black lacquer ground on wood with decoration in gold and colored
Kōdaiji maki-e, nashiji, gilt metal ring-fittings, and lead rims, 8$\frac{7}{16}$ x
13$\frac{3}{16}$ x 10$\frac{3}{8}$ in. (21.4 x 33.5 x 26.4 cm)
Gift of Peggy and Richard M. Danziger, LL.B. 1963

This luxurious lacquer box, with its substantial size and depth, tied with a pair of thick purple silk cords, invites us to contemplate for whom it was made and for what occasion. The *tabikushige*, literally meaning "travel comb boxes," were made sturdy for long journeys, perhaps for a young woman making a trip to be married to a prince or a feudal lord far away. The design on top of the box (see pp. 150–51) is of plants representing different seasons, along with such auspicious symbols as cranes, turtles, and pines—symbols of fidelity, longevity, and everlasting freshness. The sides of the box each consist of two contrasting fields of black and "pear skin" (*nashiji*) lacquer, divided by a diagonal gold zigzag that resembles a bolt of lightning. The four sides are decorated with floral designs of pine and camellia, wisteria, peony, and snow-covered bamboo.

In order to meet a great demand, *Kōdaiji* lacquer was produced in large quantities in a workshop setting, using simple techniques and designs, and employing a fast lacquering technique called "flat sprinkled picture" (*hira maki-e*). The *maki-e* technique itself is very time-consuming; each layer of lacquer has to be completely dry before adding another layer, and some lacquer works have hundreds of layers. The name *Kōdaiji* derives from the style of *maki-e* observed in the decoration of the Kōdaiji temple, which was established in 1605 by the widow of Toyotomi Hideyoshi, the second of the three warlords of the late sixteenth and early seventeenth centuries, who unified the country after long warfare. This box has a more complex design and technique than works made in the early seventeenth century, which indicates that it was made at a slightly later date. It is believed that *Kōdaiji* lacquer works have spontaneity because the artists did not have time to make underdrawings. A lively "touch" can be observed, for example, in the dancing wisteria vines.

SO

Circle of Kanō Mitsunobu

(Japanese, 1561/65–1602/8)

The Twenty-four Paragons of Filial Piety (Nijūshikō)

Edo period, ca. early 17th century
Pair of six-panel folding screens; ink, color, gold, silver, and gold
leaf on paper, each 59$\frac{13}{16}$ in. x 11 ft. 11$\frac{5}{16}$ in. (152 x 364 cm)
Leonard C. Hanna, Jr., B.A. 1913, Fund

This dazzling, colorful pair of large screens covered with gold leaf was acquired as part of the Japan-Initiative of 2002, which was endorsed by the members of the executive boards of the Yale University Art Gallery and Yale University's Council on East Asian Studies.

The screens depict the collection of twenty-four episodes of filial piety, stories first compiled in China during the Yuan dynasty (1271–1368). The stories entered Japan during medieval times, but they attracted renewed attention during the seventeenth century, when the Tokugawa Shogunate adopted Neo-Confucian ideology to buttress their political legitimacy. This particular pair of screens is unusual in that all twenty-four episodes are depicted. Most of the surviving screens of this theme illustrate only selected stories from the collection.

Certainly, in today's individualistic society, one cares little, or even is repulsed, to see a daughter-in-law nourish her aged and toothless mother-in-law with her breast milk. Or one may deride the son offering his naked body to the mosquitoes so that his father can sleep. Visually amusing is the story of the white elephant that helps plow the field for a filial man, or the story about the group of bandits, impressed by an elder brother who tries to sacrifice himself for his younger brother. Rather than arranging the stories in chronological order, the painter has clustered episodes together according to their settings: snowy landscapes, interiors of buildings, or among celestial beings. He has also used golden clouds to differentiate time and space, a conventional technique.

Though devoid of a signature, visually the painting appears to belong to the circle of Kanō Mitsunobu, a son of the famous Eitoku. The elongated figures in these screens look more exaggerated than those by Mitsunobu, but the general painting style of figures, architecture, and trees seems close. From the fifteenth century, the Kanō school established an official painting bureau to serve the rising warrior, and their hereditary school handled large commissions like these screens to meet the interior decorative needs of their patrons.

Although today we may not readily accept the morals the paintings present, they hold our attention with their startling literary content as well as their visual variety, which can be seen, for instance, in the architectural elements, the clothing of various people, and the natural landscape in all seasons. For example, in just illustrating a roof, the painter has given us one both thatched and tiled, covered with both plain and Chinese-style tiles.

SO

PLATE 142

Sumiyoshi School

(Japanese, mid-17th–mid-19th century)

Scene from the Battle of Yashima

Edo period, ca. mid-17th century
Six-panel folding screen; ink, color, and gold leaf on paper,
37$\frac{7}{16}$ in. x 9 ft. 3$\frac{1}{4}$ in. (95.1 x 282.4 cm)
Leonard C. Hanna, Jr., B.A. 1913, Fund

The Tales of the Heike (*Heike monogatari*) is a narrative of events that led to and culminated in cataclysmic warfare waged across Japan in the last decades of the twelfth century. Oral performance scripts (libretti chanted to accompaniment of the *biwa*, a stringed instrument resembling a lute) and written accounts (some composed by scribes in Buddhist monasteries) began to circulate as soon as the conflict subsided, producing multiple families of texts:

there is no single *Tales of the Heike*, but the Kakuichi-bon assembled in the mid-fourteenth century is the best-known version. Live performance of *Heike* episodes was popular in early modern Japan (1600–1868), and a few musicians keep the tradition of *Heike biwa* alive in Japan today, while the textual *Tales of the Heike* numbers among the most widely read and memorable of the Japanese literary classics.

Throughout its history, the *Heike* also inspired representations in illustrated books, prints, and particularly in the format of screen painting, a genre that also saw its greatest florescence in the seventeenth and eighteenth centuries. Many screen paintings based on literary classics, such as the Gallery's *Tale of Genji* screens, depict noncontiguous selected episodes in a single visual space, but the *Scene from the Battle of Yashima* screen (probably one-half of what was originally a pair) focuses on just one dramatic moment: the Heike warriors and members of the court, including the child emperor, have been forced from their temporary palace at Yashima on the northeast coast of Shikoku and have taken to their ships (at right); fighting breaks out on- and offshore, and a valiant foe, Tsuginobu, is struck from his horse by a skilled Taira marksman (on boat at center) while Tsuginobu's commander Minamoto no Yoshitsune (on his black steed) and others look on (at left).

EK

PLATE 143

Yosa Buson

(Japanese, 1716–1783)

Spring Mountain, Passing Rain

Edo period, ca. 1775
Hanging scroll; ink and color on silk, 70¹¹⁄₁₆ x 23¹⁵⁄₁₆ in.
(179.5 x 60.8 cm)
Purchased with funds from The Japan Foundation Endowment of the Council on East Asian Studies and the Katharine Ordway Fund

PLATE 144

Itō Jakuchū

(Japanese, 1716–1800)

Cockatoo

Edo period, ca. 1755
Hanging scroll; ink and color on silk, 42½ x 19⅛ in.
(108 x 48.6 cm)
Gift of Rosemarie and Leighton R. Longhi, B.A. 1967

A group of twenty-four Japanese paintings assembled over the past few decades by Leighton Longhi of New York, ranging from a fourteenth-century Buddhist painting to a twentieth-century *nihonga* (Japanese-style painting), entered the Department of Asian Art by combined gift and purchase in 2006. This group has enriched the Gallery's collection tremendously—not only by the sheer number of paintings but also by filling in vital areas that were hitherto unrepresented at the Gallery: landscape paintings by two great literati masters—Taiga and Buson, the latter seen here (pl. 143); works by Individualists like Jakuchū and Shōhaku; a Zen painting by Hakuin; and a pair of ink-painted handscrolls by Kanō masters, including the great Tan'yū.

Itō Jakuchū's *Cockatoo* (pl. 144) is significant both as a work of excellent quality and for the scope it has brought to the Gallery's collection. The sheen on the feathers of the cockatoo as well as the physicality of the bird are delineated solely by a meticulous line drawing using white *gofun* pigment. The bird's body contrasts with the flat depiction of the colorful Chinese bird stand. The eighteenth century was a time of peace and prosperity in Japan when the merchant class rose to establish their power and identity through art. Artists like Jakuchū, the son of a wealthy wholesale greengrocer, could establish his own style independently, without belonging to any schools. This colorful and meticulous painting technique is in stark contrast with his *Lotus*, another of his works that entered the Gallery's collection at the same time, which is executed in a broad, spontaneous ink wash. There is a sense of devotional spirituality in *Cockatoo*—the colorful bird stand decorated with traditional Chinese motifs such as clouds, lotus petals, and floral scrolls brings to mind religious decor, leading us to view the cockatoo as a Buddhist deity seated on a Chinese-style altar.

SO

Money L. Hickman and Yasuhiro Satō, *The Painting of Jakuchū* (New York: The Asia Society, 1989), 90–91, pl. 4.

PLATE 145

Itō Shinsui

(Japanese, 1898–1972)

The Lion Dance (Kagamijishi)

Shōwa period, ca. 1950
Hanging scroll; ink, color, and gold on silk, 9⁷⁄₁₆ x 22⅜ in.
(24 x 56.8 cm)
The Henry Pearson, M.F.A. 1938, Collection, Gift of Dr. Lawrence Dubin, B.S. 1955, M.D. 1958, and Regina Dubin

Torii Kotondo

(Japanese, 1900–1976)

PLATE 146

Natsuko in Summer

Shōwa period, 1934
Shin hanga; polychrome wood-block print with mica,
16⁷⁄₁₆ x 10½ in. (41.8 x 26.7 cm)
Gift of Mr. and Mrs. Herbert Libertson

PLATE 147

Combing Hair (Kamisuki)

Shōwa period, 1929
Shin hanga; polychrome wood-block print, 17⅞ x 11¾ in.
(45.4 x 29.9 cm)
Purchased with a gift from Dana K. Martin, B.A. 1982

The Yale University Art Gallery's collection of modern Japanese paintings began in 2000, with the donation of the Henry Pearson Collection of *nihonga* by Lawrence and Regina Dubin. The Gallery's print collection, however, is much older, and far more extensive. But over the past decade, the gifts of both modern and

historical Japanese prints from Herbert and Roni Libertson and the recent support of a younger donor, Dana K. Martin, have enriched the collection of modern Japanese prints and paintings. Three excellent works, donated by the three above-mentioned collectors, show an exciting new direction in the Gallery's Japanese art holdings.

After the Meiji Restoration of 1868, Japan was officially open to the West for the first time in more than 250 years. Japan embraced the influx of modern Western ideas, systems of government, and technology, as well as Western clothing, hairstyles, and cuisine with such gusto and speed during the Meiji (1868–1912) and Taishō (1912–26) periods that only its defeat in World War II in 1945 gave it pause. The artists Itō Shinsui and Torii Kotondo both lived through this turbulent time.

Shinsui and Kotondo represent a conservative counterpart to those in favor of a radical modernization of Japanese art. Although Shinsui took inspiration from the ukiyo-e tradition of the so-called *bijinga,* or paintings of beauties, he discarded many of its clichés, such as willowy hips, sloped shoulders, and emotionless facial features and adopted Western painting practices that drew from life. Outwardly, his women wear kimonos and traditional hairstyles, and a majority of them appear to be geishas, women better defined as keepers of traditional art—dance, music, fashion, and customs— rather than as physical entertainers. And by revealing their inner qualities, like gentleness, harmony, and subtlety, Shinsui reinvented the ideal of traditional Japanese beauty.

Except for the sense of movement, *The Lion Dance (Kagamijishi)* (pl. 145) is a typical example of a *bijinga* painting. A woman dances with a lion-headed puppet held in her right hand. Her pitch-black hair is arranged in the traditional Shimada style, and she is wearing a light grayish purple kimono with a design of butterflies and mist. Her upper body leans to the right and the puppet leans to the left, and together they crisscross the center of the painting. The meticulously drawn hair, butterfly wings in a tie-dyed pattern on the sleeves of the kimono, and see-through tortoiseshell (*bekkō*) comb and other hair ornaments (*kanzashi*) evoke a superrealistic mood.

Judging from some prints dated to 1950, which were based on this painting, *The Lion Dance* was most likely executed at Shinsui's new studio in Kamakura, which was built after World War II. After studying under Kaburagi Kiyokata, the pioneer of modern prints of beauties, Shinsui began his career in 1916, producing his first color prints in collaboration with Watanabe Shōzaburō, a leading publisher promoting modern prints called *shin hanga.* After the war, Shinsui devoted himself to painting rather than prints, and this painting is from that later period. The intensity of the painting in its execution and composition reveals his new determination to cultivate and promote *nihonga* painting, which often favors traditional themes but always adheres to the use of *washi* paper, ink, and mineral pigments.

Torii Kotondo was installed as the eighteenth head of the Torii school of ukiyo-e prints in 1929. *Combing Hair (Kamisuki)* (pl. 147) is one of the first prints he produced in that year. This print was once owned by Oliver Statler, a well-known modern scholar of Asia. Although erotic prints (*shunga*) were abundant and widely admired during the Edo period (1615–1868), in early twentieth-

century Japan, the depiction of women in the nude was almost limited to bathing scenes. This mildly erotic painting shows a bathing woman combing her wet hair; her left breast declares her nakedness. Her long black hair, flushed cheeks, and naked body all appear to emit a steamy fragrance that pervades the print surface. This emphasis on the figure was partly accomplished by a technique called *gauffrage,* or blind printing, in which the back of the paper was tapped along the body contour with a wet paper so that the body section seemed embossed from the front.

Natsuko in Summer by Kotondo (pl. 146) is a profile of the geisha Natsuko wearing a see-through summer kimono. Her under-kimono is of a faint pinkish wisteria color close to the Western color lavender. Its subdued tone emphasizes the fair facial complexion, the lamp-black hair, and the colorful design of bamboo leaves in multiple hues of green, red, pink, and gray that decorates her bosom. In her right hand, Natsuko daintily holds an opened folding fan; a bundle of white *washi* paper is tucked into her obi sash. *Washi* paper can be used as a napkin to hold sweets at tea gatherings or as a sheet of notepaper at poetry gatherings. She is an ideal image of the traditional Japanese woman in the summer mode. Hardly any of the women depicted by Shinsui or Kotondo wear such signs of modernity as watches or rings. Natsuko is the Japanese counterpart of a Victorian woman with her parasol and handkerchief.

so

Essays by Kendal H. Brown and Sharon A. Minichiello, *Taishō Chic: Japanese Modernity, Nostalgia, and Deco* (Honolulu, Hawaii: Honolulu Academy of Arts, 2001).

Itō Shinsui: Zen mokuhan ga [All the Woodblock Prints of Shinsui Itō], ed. Minoru Kōno, Masahito Iino, and Kanzō Hirasawa (Machida: Executive Committee for the exhibition "All the Woodblock Prints of Shinsui ITO," 1992).

Kendal H. Brown and Hollis Goodall-Cristante, *Shin-Hanga: New Prints in Modern Japan* (Los Angeles: Museum Associates, Los Angeles County Museum of Art, 1996).

PLATE 148
Kaneshige Tōyō
(Japanese, 1896–1967)

Fresh Water Jar (Mizusashi)
Shōwa period, October or November 1952
Bizen ware; unglazed stoneware with coloration produced by wood firing, 6 x 6½ in. (15.2 x 16.5 cm)
Gift of Molly and Walter Bareiss, B.S. 1940s

The Yale University Art Gallery's collection of contemporary Japanese ceramics began with the collaboration between Walter Bareiss, a longtime member of the Gallery's Governing Board, and the former Gallery director Mimi Gardner Gates, during the 1970s and the 1980s.

One of the most recent gifts from Walter Bareiss was this *Fresh Water Jar (Mizusashi)* by Kaneshige Tōyō, perhaps the most important twentieth-century reinventor of the classical Bizen kiln structure and firing technique. He was honored as a "Living National Treasure" by the Japanese government in 1956. In October and November of 1952, Tōyō built and fired a Bizen-style kiln in Kita Kamakura, southwest of Tokyo, for Kitaōji Rosanjin, a brilliantly eclectic ceramic artist, who, however, was unable to

replicate the effects that Tōyō coaxed from the kiln. This *Fresh Water Jar* is a product of that firing. Also participating on this occasion was Isamu Noguchi, a modern American sculptor who wanted to gain technical facility with clay as a medium for his art. He came to possess this *Fresh Water Jar* perhaps as a present in return from Tōyō, who received one of Noguchi's sculptures as a gift in August 1952.

The silhouette of this jar reveals a slightly constricted middle section, two small applied ears, and a sunken mouth. The soft, gray body bears cloudlike brownish fire marks in the lower section, and a deep orange cometlike fire mark near the shoulder—both results of the piece's contact with heated air and wood ash in the kiln. There might have been some manipulation on Tōyō's part— the red "comet" may have resulted from a small ball of clay that he applied to that spot, forcing the flame and smoke to go around it, leaving the red "shadow" untouched by the wood ash. The surface is smooth to the touch, perhaps indicating some sanding after the firing. It is also lightweight, an advantage for the host who carries the jar full of water to the tearoom.

Bizen ware is famous for its natural ash glaze. Since no glaze is initially applied to the ceramic body, potters must look to the quality of the clay and their wood-firing technique for artistic success. Tōyō was famous for his complete mastery of wood firings. Because of their strict adherence to simplicity without decoration, and because of the subtle range of understated colors produced by the firing, tea connoisseurs hold Bizen utensils in high esteem.

SO

Many thanks to Louise Cort, who corrected and made suggestions to this entry.

Louise Allison Cort and Bert Winther-Tamaki, *Isamu Noguchi and Modern Japanese Ceramics: A Close Embrace of the Earth* (Washington, D.C.: Smithsonian Institution, 2003), 136, fig. 3.21.

PLATE 158

Rhythm Pounder in the Form of a Female Figure (Doogele)

Senufo, Kulibele (carvers) and Celibele (users) subgroups, Ivory Coast, Burkina Faso, or Mali, late 19th–early 20th century
Wood, 40^{15}⁄$_{16}$ x 8⅞ x 5⅞ in. (104 x 22.5 x 14.9 cm)
Charles B. Benenson, B.A. 1933, Collection

Rhythm pounders were used during the burial of an important elder and member of the powerful Poro, a ceremonial association among the Senufo. The figures were pounded on the ground while they were held usually at the arms, or at the neck or shoulders. They were made by carvers from a subgroup of the Senufo, an artisan group called the Kulibele, but they were mainly produced for another small artisan group, the Celibele, who make their living as rope makers and tanners. Both the Kulibele and the Celibele live in distinct quarters within the ordinary Senufo farming villages. They have recently converted to Islam, so these items of indigenous religion have become rare. The non-Celibele Senufo farmers who attend the funeral rites call these figures *Poro piibele,* the "children of Poro," while the rope makers themselves speak privately of *doogele,* which means "pestle."

Till Förster has described a burial in which two rhythm pounders were used. Celibele masked dancers called Korogo

performed around the corpse, now wrapped in Senufo narrow-strip cloth and appearing only as a bundle. The men laid the rhythm pounders on either side of the bundle and allowed the masked dancers to continue performing around and over the corpse. When it was time to inter the deceased, Poro members carried the bundle on their shoulders to the graveyard at the western end of town, while the elders preceded them, pounding the wood figures on the ground, as if to clear a pathway. When the bundle was set down in the forest, the two rhythm pounders were placed on top of the bundle, and the corpse was carried strapped to a palanquin to be buried in the forest. Before the interment, the two pounders were secretly brought back to the grove where they were kept.

FJL

Till Förster, "Smoothing the Way of the Dead: A Senufo Rhythm Pounder," *Yale University Art Gallery Bulletin* (2005): 55–67.

PLATE 163

Falola Edun, or his father, Fagbite Asamu

(Yoruba, Ketu subgroup, Republic of Benin, born 1900, father late 19th century–ca. 1970)

Helmet Mask with Two Male Figures and a Pangolin

Yoruba, Ketu subgroup, Gelede association, Idahin, Republic of Benin, mid-20th century
Wood, pigment, and nails, 13¾ x 13¾ x 11³⁄₁₆ in. (34.9 x 34.9 x 28.4 cm)
Gift of Ellen and Stephen Susman, B.A. 1962

Gelede masks are made in identical pairs and danced by men during a celebration honoring elder women and ancestors, fostering social cohesion and harmony, and providing entertainment. The "mothers" are believed to have both positive and negative power. Here, the large face depicts a serene mother.

The superstructure here depicts two men struggling with a pangolin. The men, with their arms around each other, hold the rear legs of the pangolin, while the figure on the left crosses his leg over the leg of the figure on the right. This mask honors the social contributions of hunters but also refers metaphysically to the Yoruba deity Ogun, the patron of hunters, concerned with aggression, protection, and cooperation. The pangolin, about to escape, reminds the hunters that the battle is not won until the capture is complete and also that even the vanquished is to be respected.

This particular example of the Gelede mask is by the hand of the noted Ketu sculptor Falola Edun, or his father, Fagbite Asamu, of Idahin, Republic of Benin, who were among the most prolific carvers of Gelede masks. Other examples are found in the Baltimore Museum of Art (depicting two wrestlers); the National Museum of African Art at the Smithsonian Institution, Washington, D.C. (depicting two hunters setting a trap); the Museum für Völkerkunde, Berlin (showing two men supporting two acrobats); and the Nigerian Museum, Lagos (depicting two men scraping calabashes to make bowls). One mask in a private collection in Chicago is probably the pair to the Gallery's mask, carved almost identically.

This mask is extraordinary in several ways. It is not "anonymous" but can be clearly identified as the work of a well-known

African atelier. We know of possibly thirteen other Gelede masks by the same carvers (father or son). The existence of its twin makes it extremely rare.

FJL

Babatunde Lawal, "The World Is Fragile . . . Life Should Not Be Lived with Force: A Yoruba Headdress (*Igi Gèlèdé Oníjàkadì*)," in *See the Music, Hear the Dance: Rethinking African Art at The Baltimore Museum of Art*, ed. Frederick John Lamp (Munich: Prestel Verlag, 2004).

PLATE 166

Caryatid Stool

Luba, Congo (Kinshasa), late 19th century

Wood, glass beads, and string, 17⅜ x 12 x 11⁵⁄₁₆ in. (44.1 x 30.5 x 28.7 cm)

Promised gift of Thomas Jaffe, B.A. 1971

Ceremonial figurative stools were important prestige items used all over Africa until the colonial period and well beyond, and they continue to be used in many parts of Africa today. Chiefs, kings, and politically powerful persons sat on decorated stools on special occasions, while their court and other subjects sat on the ground. For the most part, the objects were displayed at public ceremonies to enhance the awesome presence of the owner.

The Luba, especially, had a long history of powerful kings and chiefs who were able to commission fine works of art from professional carvers. Consequently, Luba art is noted for a peak of refinement in the history of art from Africa, reflecting discriminating tastes and a court aesthetic that was highly standardized. The image of a seated woman with upraised arms bearing the seat of the stool is seen frequently in Luba court art and is reflected also in small wood headrests used to support the head when the owner has had an elaborate coiffure constructed.

Such a coiffure is borne by the female figure here, indicating that she is a royal woman with the luxury of time-consuming hairdressing. Her status is also indicated by elaborate cicatrization patterns throughout her torso, designed and executed by a professional artist to enhance the woman's beauty.

This particular stool comes from the former Dehondt collection of Brussels, Belgium, and was illustrated in the first major publication on the arts of the former Belgian Congo in 1959 by the distinguished Belgian professor of art history at the University of Ghent and director of the Musée Royal de l'Afrique Centrale, Tervuren, the late Frans Olbrechts.

FJL

Frans M. Olbrechts, *Les arts plastiques du Congo Belge* (Brussels: Editions Erasme, S. A., 1959), pl. 167.

PLATE 167

Oil Lamp (Fitula)

Sorko, Mali, Kouakourou, Kolenze village, 19th century

Iron, 56 x 20 in. (142.2 x 50.8 cm)

Gift of Labelle Prussin, PH.D. 1973

The Bamana and Sorko peoples of Mali use iron lamps consisting of small cups to be filled with oil and lit with a cotton thread wick. Elaborate lamps are used at weddings, royal ceremonies, initia-

tions, sports events, and other rituals. The cup is likened to the human mouth as the wick is to the tongue, and the heat to breath, vitality, and human spirituality. At the funeral of an elder, the family chants, "My lamp has gone out." Another lamp almost identical to this one, called a *fini nanchori*, was photographed in 1964 in the courtyard of the blacksmith Souri Tenentao in Kolenze.

In elevation, the form of the lamp resembles the Hebraic "Tree of Life" or "Tree of Light," which spread throughout North Africa in conjunction with the sacred graphic system called kabbalah. The decorative volutes of the lamp, with spiraling tips, recall the common schematic reference to ram's horns, specifically the ram that is traditionally slaughtered for the Feast of Abraham, Tabaski, whose Berber etymology can be traced back to Hebrew.

In the plan and in the elevation of the forty-six cups, there is a sacred numerology of threes, fours, sevens, tens, fourteens, and twenty-twos, all ritually significant numbers. The scholar and collector of this lamp, Labelle Prussin, has offered considerable cultural evidence of Judaica in West Africa, especially in the realm of blacksmithing and the working of precious metals. The number twenty-two is ubiquitous in West African mythologies and in the genealogies of itinerant Jewish blacksmiths, but it is not common in traditional Muslim numerology. The oil containers of the fitula are arranged on the various stems in twin clusters of three, four, and seven, but the sum of their combinations—ten, fourteen, and twenty-two, the sacred letters-*cum*-numbers of the Hebrew alphabet—particularly recall the kabbalistic tradition.

FJL

Labelle Prussin, "David in West Africa: 'No More Forever'?" *Yale University Art Gallery Bulletin* (2005): 89–109.

PLATE 168

Male Headdress (Chi Wara)

Bamana, Mali, late 19th–early 20th century

Wood, cowrie shells, metal, and string, 32 x 16⁹⁄₁₆ x 2¾ in. (81.3 x 42.1 x 7 cm)

Promised gift of the Wardwell Family

PLATE 169

Female Headdress (Chi Wara)

Bamana, Mali, late 19th–early 20th century

Wood, 37½ x 11¹³⁄₁₆ x 3¹⁵⁄₁₆ in. (95.3 x 30 x 8.4 cm)

Promised bequest of Erika and Thomas Leland Hughes, B.A. 1945, LL.B. 1949

PLATE 170

Male Headdress (Chi Wara)

Bamana, Mali, late 19th–early 20th century

Wood, 38⁹⁄₁₆ x 12¹¹⁄₁₆ x 2⁹⁄₁₆ in. (97.9 x 32.2 x 6.5 cm)

Promised bequest of Erika and Thomas Leland Hughes, B.A. 1945, LL.B. 1949

Chi Wara (the Farming Beast) commemorates an ancient deity who taught the Bamana ancestors to farm. The form is a combination of two animals. Above is the head of an antelope, which leaps through the air and is associated with the sun. Below is the body of

an anteater, associated with the earth. The headdresses are danced in male and female pairs in agricultural ritual that promotes sexual union, reproduction, and unity in the cosmos. The dancers are male champion cultivators, who have earned the right to wear the headdresses, and through the performance they celebrate this responsibility and arduous work.

These three examples of the Chi Wara headdress are from the Segou region, a northeastern division of the Bamana. There are three other main styles of the Chi Wara, including a horizontal style of the northwest, a much simpler version of the vertical Segou style in the southeast, and a very abstract vertical style found in the south with a clear representation of the anteater, as well as a great many other individual styles. The costume is completed, in the case of the Segou headdresses, with a black-dyed Baobab-fiber covering the head and body of the dancer. Each dancer often carries a cane in each hand on which he supports himself as if they were the front legs of the antelope. In the Segou style, the male counterpart has a long, narrow, pointed head with a soaring pair of antelope horns reaching skyward. The neck is a flat arc pierced with zigzag designs and a jagged edge on the back suggesting a lion's mane. The body structure is minimal, with a projecting tail and often a prominent penis. The female counterpart lacks the mane, with a simple arching neck, and she bears a smaller figure, usually male, on her back.

FJL

Jean-Paul Colleyn, ed., *Bamana: The Art of Existence in Mali* (New York: Museum for African Art, 2001).

PLATE 171

Currency Blade

Lokele, Congo (Kinshasa), 18th–19th century
Iron, 59$\frac{1}{16}$ x 15$\frac{5}{8}$ x $\frac{7}{8}$ in. (150 x 39.7 x 2.22 cm)
Promised gift of Dwight B. and Anna Cooper Heath

PLATE 172

Currency Blade

Mfumte, Cameroon or Nigeria, late 19th–early 20th century
Iron, 11$\frac{9}{16}$ x 9$\frac{3}{16}$ x $\frac{1}{16}$ in. (29.4 x 23.3 x 0.16 cm)
Promised gift of Dwight B. and Anna Cooper Heath

PLATE 173

Currency Blade

Chamba, Nigeria, 18th–19th century
Iron, 11$\frac{13}{16}$ x 6$\frac{11}{16}$ in. (30 x 17 cm)
Promised gift of Dwight B. and Anna Cooper Heath

Iron currency pieces were used from antiquity through the early twentieth century in exchange, in particular contexts, but not functioning generally as money. The principal context was the negotiation of marriage between families, where the iron piece served as an offering from the family of the groom to the family of the bride to secure their approval and continued throughout the life of a married couple. These offerings also included food, animals, household goods, clothing, jewelry, and tools.

Unlike coins, the African iron currency would vary in value according to size as well as aesthetic and technical excellence, as a work of art. Each culture throughout Africa had its own distinctive designs, which apparently were not used in external exchange. African iron currency was largely banned by the European colonial powers in the twentieth century.

The decorative iron forms bore a social meaning, serving in the public display. Sometimes, among the Kwele people, for example, just a few were given by the fiancé to the bride's family on his first visit, indicating his preference of exchange, termed "a mark made on a forest that is to be cleared." At some time after the marriage, the new wife would travel back to her own family of birth holding a currency blade in each hand to proclaim her new status as a bride to everyone along the route. Among some groups in Central Africa, a large collection of currency pieces would be displayed at the formal marriage ceremonies, stuck into the ground and standing vertically. Metal regalia were often conserved in mud, eroding the surface of the iron, or packaged and stored privately above the hearth. As treasured family collections they actively documented contracts of marriage and social alignment.

FJL

Barbara Blackmun and Jacques Hautelet, *Blades of Beauty and Death* (San Diego: Mesa College Art Gallery, 1990), 38, pl. 15.

PLATE 175

Head of a Deity

Aztec, Mexico, Veracruz, ca. 1440–1521
Ceramic, 11 x 8$\frac{3}{8}$ x 6$\frac{11}{16}$ in. (27.9 x 21.3 x 17 cm)
Bequest from the Estate of Alice M. Kaplan

Aztec sources describe the ideal human to be "like something smoothed, like a tomato, or like a pebble, as if hewn of wood." Life-sized, this ceramic head embodies this perfection of young male beauty. Underlying the artist's final work is also anatomical understanding of cheekbones, brow, and jaw; the clay conveys the height of youth at the moment of youth's potential loss, whether in battle, in sacrifice, or to time.

Once part of a full-sized representation, this figure wears five (of which only three survive intact) vertical stalks along the central axis of his headdress. This distinctive feature identifies this young man as the embodiment of a god known as Xochipilli, "Young Flower Prince," or Macuilxochitl, "Five Flower." The god of music, art, dance, and games, he represented ideal young male behavior. But this same god personified the darker side of pleasure, punishing those who overindulged in drink, sex, drugs, or gambling and smiting them with disfiguring venereal diseases.

Archaeologists have excavated large ceramic figures of similar facture at the Aztec ceremonial precinct. Within the same precinct, archaeologists have also uncovered stone representations of Xochipilli, accompanied by musical instruments and stones worked into the form of the Aztec glyph "tetl," or stone, the symbols of pleasure and punishment in a single offering.

Although lacking specific provenance, this Xochipilli head may have come from Tres Zapotes, Veracruz, a site known for sculptures made about 500 B.C.–A.D. 100. A tradition of forming large, hollow ceramic sculptures developed early in Veracruz, certainly no later than the first millennium B.C., during the height of

Olmec culture there. Aztec trade and tribute routes to the region after A.D. 1455 brought both Veracruz goods and artisans into the capital; emulation of imperial models also transformed local material culture with Aztec ideology. The Yale Xochipilli head thus belongs to a tradition established between the Aztec capital and the coast.

MEM

Felipe Solis, *The Aztec Empire,* exh. cat. (New York: Solomon R. Guggenheim Museum, 2004).

PLATE 176

Quadruped Vessel with Peccary Feet and a Lid with a Bird-and-Fish Handle

Maya, Guatemala or Mexico, A.D. 250–400
Ceramic with pigment, 10¾ x 10¾ in. (27.3 x 27.3 cm)
Gift of Peggy and Richard M. Danziger, LL.B. 1963

At the time of a royal death during the fourth century A.D., attendants filled this vessel with foodstuffs and placed it in a tomb to accompany a lord or lady. The contents provided literal sustenance, but the vessel itself encapsulated the ancient Maya cosmos, as if to map the journey after death.

The journey of the afterlife begins with travel through water. Here, against a dramatic red background, a crested cormorant is described on the vessel lid, the neck and head curving to form a three-dimensional handle. This water bird secures a fish in its open beak: the fish is painted in two dimensions on the lid's surface and then takes three-dimensional form. The bird swims on the water's surface, its wings resting atop the vessel. The knotted cords of the bowl's exterior suggest the hide of a crocodilian like the great black caiman of Central America, the rounded zoomorph usually understood to form the surface of the earth. The four supports are all configured as snouts of peccary pigs, with their ears appliquéd to the base of the bowl. The peccaries support the surface of the earth, thus taking the observer down into the depths of the underworld.

The Maya potter formed this two-part vessel by coiling strips of clay; the potter then smoothed the four supports before joining them to the bowl. Each support requires firing holes, in order that the clay not explode when fired; cleverly, here they have been cut into the legs so that the slits appear to be the mouths of the peccaries. Once the pot was formed and leather hard, the painter worked with colored clay slips: hematite, or iron ore, created the brilliant red; ochers made yellow; carbon, of course, was added to slip to make black. A faded gray on the bird's wings may once have been an iridescent green, formed by adding copper to slip. The painter has drawn delicate eyelashes on the peccary.

MEM

Peter Schmidt, Mercedes de la Garza, and Enrique Nalda, eds., *Maya* (New York: Rizzoli, 1998).

PLATE 177

Standing Male Figure

Olmec, Mexico, central or Gulf Coast, ca. 900–400 B.C.
Greenstone (probably jadeite), 3½ x 1⁷⁄₁₆ x ⁹⁄₁₆ in. (8.9 x 3.7 x 1.43 cm)
Gift of Thomas T. Solley, B.A. 1950

Small greenstone standing figures constitute a distinct category of Olmec sculpture, but their function and meaning are not fully understood. Most of the known examples do not come from controlled excavations, making interpretation more difficult. The slightly bent knees and swayback shoulders have suggested to Carolyn Tate that the figures represent persons entering a meditative trance. This explanation is in keeping with the argument that Olmec religion was shamanic at its core.

Olmec lapidaries, working without metal tools, carved these figures using only jade and greenstone drills. The standing figures rarely, if ever, show the attention to physical detail and portraiture seen on the well-known colossal heads. Artists incised simple lines to schematically indicate hands and feet. Often, a triangular incision at the waist defines a loincloth or penis sheath. The figures emphasize an elongated, tapered head that may be a precursor to the sloping Mayan forehead of later centuries.

This figure is remarkable for its high polish and small size. The precise vertical planes of the front and rear give the impression that the figure was carved from a slice of a large jade cobble. The carver then drilled away the areas between the legs and arms, then laboriously sawed and chipped away at the interstices. A variety of smaller drills would have been used to finish off the details of the face and nose. Some drills must have been incredibly small—the holes for septum and ear piercings are difficult to see. On this figure, details are slightly but consistently higher on the left-hand side, perhaps indicating a right-handed artist.

The best-known standing figures come from tombs and offerings at the Gulf Coast site of La Venta and are generally dated to 900–600 B.C. One such group, Offering No. 4, consists of sixteen similar figures carved in a variety of stones arranged in front of four celts. The offering was placed in a hole dug in one of the site's ceremonial plazas, directly in front of mound containing the tombs of the La Venta elite. Offering No. 4 was buried and later reexcavated, indicating that knowledge of its precise location was preserved for a century. The seeming specificity creates a sense of narrative tableau, its historical details now rendered inscrutable.

Greenstone and jade were not locally available on the Gulf Coast. Instead, the rulers of La Venta developed extensive trade routes to areas in Guerrero and Guatemala and imported massive quantities of greenstone and jade. Artisans then processed these raw materials into a range of jewelry and other ritual items, which were then traded anew. These networks of acquisition, manufacture, and redistribution allowed the elites of the Gulf Coast to propagate and share their images and justifications of religious and political power. Yet standing figures have never been found in large quantities outside the Gulf Coast, indicating that they held special importance for residents of the Olmec heartland.

MHR

Elizabeth P. Benson and Beatriz de la Fuente, eds., *Olmec Art of Ancient Mexico* (Washington, D.C.: National Gallery of Art, 1996).

Carolyn E. Tate, "Shaman's Stance: Integration of Body, Spirit and Cosmos in Olmec Sculpture," in *Eighth Palenque Round Table, 1993,* ed. Martha J. Macri and Jan McHargue (San Francisco: Pre-Columbian Art Research Institute, 1996).

PLATE 178

Standing Male Figure

Maya, coastal Belize or Mexico, ca. A.D. 200–500
Manatee bone with red pigment, 4⅞ x 2¼ x 1⅛ in.
(12.4 x 5.7 x 2.9 cm)
Gift of Thomas T. Solley, B.A. 1950

This Maya figurine, carved from the dense rib bone of a Caribbean manatee, is an example of outstanding skill in bone carving and three-dimensional sculpting of the human form. Rounded buttocks and large thighs make up most of the standing male's body mass, contrasting with more delicate carving above the waist. The placement of hands resting upon the chest, at the heart of the body along the vertical axis of symmetry, creates stability and repose in the corporeal form, although the face's open mouth enlivens the figure. On this face are delicately articulated facial features that recall Olmec figurines and masks of centuries earlier, a gesture to the past.

Archaeologists have excavated manatee-bone figurines in coastal Belize, including one from an Altun Ha burial (ca. A.D. 500) whose dimensions, proportions, corporeal curves, and mask-like face are strikingly similar to the Yale figurine.[1] Excavations in a trash dump (ca. A.D. 400–700) on Moho Cay revealed another figurine, musical instruments, and miniature canoes of manatee bone, both finished and unfinished.[2] Such contexts allow us to hypothesize that this figurine came from a coastal Maya site in Belize or Mexico's Yucatán Peninsula.

Residue of the material's original form remains in the figurine, for the nature of manatee rib-bone is identifiable by sight and touch, and the symbolism of its biological origin may have been meaningful to its producers and consumers. The manatee is accustomed to water navigation, and if buried in a Maya tomb, this figurine accompanied the deceased on the journey through the watery underworld. Moreover, because manatees travel in both fresh and salt water, ancient coastal Maya may have considered manatees transitional animals, comparable to birds that travel through water and sky or caimans that traverse water and land. Such transitional animals were favored in ancient Maya art and burials, and their ability to transcend diverse environments allowed them to aid humans in journeys of transition.

MEO

1. David M. Pendergast, *Excavations at Altun Ha, Belize, 1964–1970* (Toronto: Royal Ontario Museum, 1979), vol. 1, 48–53.

2. Heather I. McKillop, "Prehistoric Exploitation of the Manatee in the Maya and Circum-Caribbean Areas," *World Archaeology* 16, no. 3 (February 1985): 342–45.

PLATE 179

Standing Male Figure

Inca, Peru, 1435–1534
Gold, 2¼ x ¹³⁄₁₆ x ⅝ in. (5.7 x 2.06 x 1.59 cm)
Gift of Thomas T. Solley, B.A. 1950

Made by accomplished metalsmiths of the Inca Empire, this hollow gold figurine of a standing male is noteworthy as a representation of a three-dimensional human form, rare in Inca art except in

figurines. Like others of its kind, this object is made primarily of hammered sheet gold, and the soldering seams are skillfully hidden. Analogous figurines are hollow (made of hammered metal) or solid (cast metal) and are made of gold, silver, bronze, or another alloy. Common features are large heads with prominent, seed-shaped eyes, large noses, slit mouths, rounded torsos, visible male or female genitalia, tubular legs, and flat, wedge-shaped feet. In some instances, the males have a small protrusion in the cheek, meant to signify a wad of coca leaves in the mouth.

The only ornamentation this male wears is his close-fitting, horizontally striated cap, which was made separately and attached to the head. Otherwise, the body is nude. Most likely he once was dressed in metal ornaments and layers of perishable clothing, including shawl pins, feathers, and miniature tunics. In fact, his long, droopy earlobes, formed of filigreed gold, show the effect of wearing large, heavy ear spools and would have allowed for the attachment of miniature ear spools.

Dedication of this figurine probably had a religious significance. Excavated examples have been found with mummies of sacrificed children and adolescents in high-altitude mountain shrines in the southernmost parts of the Inca Empire, in Peru and Chile. When preservation is favorable, these figurines are dressed in textiles and decorated with feathers and metal ornaments; at times, these figurines have their own miniature grave goods. Such dedications likely related to offerings of the *capac hucha* child sacrifice ritual known from ethnohistorical literature.[1] Moreover, other excavated examples appear in contexts that, although non-mortuary, are clearly offertory.

MEO

1. Rebecca Stone-Miller, *Art of the Andes: From Chavín to Inca* (London: Thames and Hudson, 1995), 214.

Richard L. Burger and Lucy C. Salazar, *Machu Picchu: Unveiling the Mystery of the Incas*, exh. cat. (New Haven: Yale University Press, 2004), 199, cat. no. 167.

PLATE 180

Pendant with a Bird-Headed Figure

Diquís, Costa Rica, ca. A.D. 800–1500
Gold, 4 x 3¹⁵⁄₁₆ x 1³⁄₁₆ in. (10.2 x 10 x 3 cm)
The Harold A. Strickland, Jr., Collection

The Diquís delta region of Costa Rica was a prominent metal-producing area in the Intermediate Area, a cultural zone incorporating parts of modern-day Honduras, Costa Rica, Panama, and the gold-working regions of Colombia. By A.D. 700, gold began to replace jade and greenstone as the primary medium symbolizing elite power in Costa Rica. Often the gold of this area is *tumbaga*, an alloy with a fairly high copper content. The copper accounts for the reddish hue often visible on these figures. To purify the metal to a bright yellow, goldsmiths used a technique known as depletion gilding, where organic acids were used to remove the copper.

This figure, from the Diquís region, exemplifies the mixture of techniques and iconography used from about A.D. 800 to 1500. The central figure combines a human body with a bird's head and wings. The bird-human combination, flanked by lunette wings with slightly raised circular borders; the spirals emanating from

the figure's head and feet; the broad flanges at top and bottom—all are hallmarks of Diquís goldwork. The figure was made using a variety of techniques, primarily lost wax for the body and false-filigree for the spirals beside the head and feet. Minor casting flaws can be seen left of the figure's head. A crossbar on the rear indicates the figure was worn as a pendant, but it shows little sign of wear. Struts in the corners support connections between the flanges and wings.

The amalgamation of human and avian indicates a shamanic cosmovision where the human ruler held sway over the three regions of sky, earth, and water. The raptorial bird rules over the domain of water, indicated by the fish held in the beak. The spirals, generally understood as abbreviated renditions of crocodiles, underscore the bird's ability to move through the three realms.

MHR

Colin McEwan, ed. *Precolumbian Gold: Technology, Style, and Iconography* (Chicago: Fitzroy Dearborn, 2000).

Mark Miller Graham, "Creation Imagery in the Goldwork of Costa Rica, Panama, and Colombia," in *Gold and Power in Ancient Costa Rica, Panama, and Colombia*, ed. Jeffrey Quilter and John W. Hoopes (Washington, D.C.: Dumbarton Oaks Research Library and Collections, 2003), 279–300.

PLATE 181

Perforated Crown with Human Figures

Lambayeque, Peru, A.D. 900–1100
Gold, 7⅝ x 6¾ in. (19.4 x 17.2 cm)
Promised gift of Thomas Jaffe, B.A. 1971

Gold crowns are recorded in large deposits of gold and silver personal ornaments found in archaeological excavations of royal burials from ancient Peru. The multitude of different crowns found in single elite sites indicates the range of precious head ornaments, some interwoven with costly textiles or ornamented with featherwork, used by high-status individuals for religious and secular ceremonies. The style of this finely wrought gold crown decorated with repoussé banding is similar to objects excavated from Lambayeque royal tombs at Batán Grande near the La Leche River valley on the North Coast.[1]

The crown has eight profile figures arrayed within the center register. Framed by geometric cutouts, the standing figures hold decapitated trophy heads and raised weapons, probably clubs. The taking of prisoners and the sacrificing of human captives were principal objectives of warfare among most cultures of early Peru. Ritual decapitation appears in art of the Moche, Lambayeque, and Chimú cultures of the North Coast, often associated with representations of supernatural beings or possibly human impersonators of divinities. The figures in this crown may in fact be warriors, whose costume as an indicator of their worldly status is carefully depicted by textured cloth tunics, stepped headdresses, and ear spools. The remarkable thinness and fragility of the gold crown implies a ritual use as a ceremonial object, imbuing its wearer with powerful memories of past conquests. An inner frame of organic materials, such as basketry or cloth, may have originally supported the thin cylinder of hammered sheet gold.

Gold deposits were present in the coastal river valleys of northern Peru, where a remarkable artistic tradition of hammering

and casting metalwork flourished from at least 1200 B.C. The Spanish reported upon their arrival in the sixteenth century that among the Inca gold had associations with the sun and fertility. Like offerings of human and animal sacrifices, gold may have been linked to ritual practices seeking to ensure the continued fecundity of the land and agricultural cycles on which early communities depended.

DAC

1. Izumi Shimada, *Cultura Sicán: Dios, riqueza, y poder en la Costa Norte del Peru* (Lima: Fundación del Banco Continental para el Fomento de la Educación y la Cultura, Edubanco, 1995).

PLATE 182

Relief from the Tomb of Mentu-em-hat

Egyptian, 680–640 B.C.
Limestone with red pigment, 19½ x 29½ in. (49.5 x 74.9 cm)
Gift of William Kelly Simpson, B.A. 1947, M.A. 1948, PH.D. 1954, in memory of his father, Hon. Kenneth F. Simpson, B.A. 1917, and grandfather, Nathan Todd Porter, B.A. 1890

Carved in raised relief and preserving traces of original paint, this limestone fragment from the tomb of Mentu-em-hat depicts five offering bearers. The pairs of figures, each carrying different types of staves, shoulder rectangular chests, atop which appear necklaces, stone vessels, a chair, a kilt, and statues of divine falcons. According to Egyptian artistic convention, these items represent the contents of the chests. In a fragmentary register below the figures appear the tops of two festival booths, decorated with flowers and containing wine jars and foodstuffs. The offering bearers and booths immortalize the burial rites for the tomb owner, Mentu-em-hat, themselves reminiscent of Egyptian New Year festivities.

The fourth priest of Amun and de facto ruler of the important city of Thebes during the latter part of the seventh century B.C., Mentu-em-hat commissioned one of the largest tomb complexes on the West Bank of Thebes (Theban Tomb 34). The serene beauty of the carvings within Mentu-em-hat's eternal resting place belie the political turmoil of his time; Mentu-em-hat began his career during the Twenty-fifth Dynasty, a line of Nubian kings, weathered an Assyrian invasion, and maintained his position when the Twenty-sixth Dynasty, from the Delta city of Sais, expelled the Assyrians. The Twenty-sixth Dynasty—and to a lesser extent the Twenty-fifth—are renowned for their archaistic tendencies, well in evidence in the Mentu-em-hat offering bearers. The positions of the central two men, the rectangular chest, and the objects it contains were copied from a painting in the New Kingdom Theban tomb of Rekhmire (ca. 1370 B.C.). However, the male body proportions, the leg and arm musculature, and the style of the kilts are modeled on Egyptian art of the Old Kingdom (ca. 2500 B.C.). Rather than slavishly copying an earlier work of art, the Mentu-em-hat relief embraces eclecticism, infusing the scene with a unique combination of earlier iconography and artistic styles.

CM

Peter der Manuelian, "Two Fragments of Relief and a New Model for the Tomb of Montuemhet at Thebes," *Journal of Egyptian Archaeology* 71 (1985): 98–121.

PLATE 183

The Hartog Master

(Etruscan, Umbro-Sabellian, active late 5th century B.C.)

Figure of a Warrior, late 5th century B.C.

Bronze, $7^{15}/_{16}$ x $2^{13}/_{16}$ x $1^{3}/_{8}$ in. (20.2 x 7.1 x 3.5 cm)
Partial gift and promised bequest of Erika and Thomas Leland
Hughes, B.A. 1945, LL.B. 1949

Among the earliest skilled bronze workers in Italy are those of
Etruria and the Po River valley during the Villanovan period of the
Iron Age. Their artistic tradition spread northward to Umbria and
continued through the Archaic period. Among the most striking of
the bronze figures created by Umbrian craftsmen are the tall
bronze warriors of the fifth century B.C. An exceptionally cohesive
group of votive bronzes, these figures develop from Archaic
Etruscan warriors but transform the more naturalistic Etruscan
style into the streamlined essence of a martial figure in motion.

Striding forward with the vigor typical of Umbrian warriors,
this tall, slim fighter once held a shield on his left arm and a
thrusting spear in his raised right hand. Aggressive and intimidat-
ing from the front, in profile the thinness of the figure emphasizes
the tension of its forward movement, described by some as almost
prancing. This warrior wears body armor in the form of a short-
sleeved cuirass made of metal or leather and decorated with incised
circles and punched spiral and lozenge designs. Underneath it is a
short tunic. The cuirass, ending at the waist, would have been
trimmed below with two rows of leather tabs, here evoked by a wide
horizontal band. A second horizontal band above the waist should
define a belt, based on other warrior figures, but here it is higher
than usual. As is typical, the warrior wears an Attic helmet with its
cheekpieces folded up. A dramatic high crest tops the helmet and
complements the prominent profile of the face.

Several regional schools within Umbria produced such bronze
warriors. The distinctive style of this figure has allowed scholars to
attribute others to the same maker, who has been named the
Hartog Master after the owner of the bronze in the 1960s.

SBM

Quentin Maule, "Regional Styles: The Valley of the Esino," *Studi Etruschi* 59 (1994):
89–90, no. 1, pl. 15, and p. 98: the name piece of the Hartog Master.

PLATE 184

Mirror

Etruscan, 4th–3rd century B.C.
Bronze with ivory or bone handle, H. $10^{7}/_{16}$ x DIAM. $6^{13}/_{16}$ in.
(26.5 x 17.3 cm)
Partial gift and promised bequest of Erika and Thomas Leland
Hughes, B.A. 1945, LL.B. 1949

Bronze mirrors, of which around three thousand survive, are
among the most numerous examples of Etruscan material culture
that survive to the present day. These mirrors are now assembled
and exhibited in museum collections, but it is important to
remember that they were functional items, and that the face that is
displayed is the back of the object. Mirrors such as this were ini-
tially cast in a mold, then hammered and cut into shape, and
finally polished on one side and decorated with an engraving on
the other. This mirror features a bronze tang that slots into a
handle of bone or ivory decorated with simple horizontal bands.

The incised reverse of the object depicts two women who face
each other while reclining on shields decorated with starbursts. Both
figures are nude except for caps (*piloi*) and cloaks (*chlamydes*). The
woman on the left holds a spear, and a flower stands in the middle.
An ivy wreath surrounds the figures and defines the pictorial field
in which they exist, though parts of the figures transgress the bor-
der provided by the wreath.

According to Professor Richard DePuma (personal communi-
cation), the mirror may be related stylistically to several mirrors
produced around Orvieto. Iconographically, however, it is unusual.
Etruscan mirrors often display scenes from Greek mythology, and
the attributes of the two figures are consistent with Etruscan depic-
tions of the twin Greek heroes, the Dioskouroi (*Tinas Cliniar* in
Etruscan). The Dioskouroi, who are among the most popular sub-
ject matter on Etruscan mirrors, are men, however, not women,
and the Yale mirror thus appears to be anomalous. In the absence
of an inscription it is unfortunately impossible to securely identify
either figure.

NJ

Nancy de Grummond, ed., *A Guide to Etruscan Mirrors* (Tallahassee, Fla.:
Archaeological News, 1982).

PLATE 186

Recumbent Lion

Greek, Laconian, ca. 570–530 B.C.
Bronze, $2^{1}/_{8}$ x $1^{5}/_{16}$ x $3^{1}/_{2}$ in. (5.4 x 3.3 x 8.9 cm)
Promised bequest of Jan Mayer

Divided into a patchwork of city-states, Greece during the Archaic
period (ca. 575–480 B.C.) was home to diverse regional artistic
schools. Different areas became known for the quality of various
crafts; while the painted pottery of Athens was exported across the
Mediterranean, the metalwork of Corinth and Laconia was consid-
ered to be some of the finest.

From the eighth century B.C., Laconian craftsmen were
among the most famous bronze workers. Their vessels, mirrors,
and implements were exported across Greece, and even beyond;
Laconian bronze tripods and kraters (vessels used for mixing wine
and water) were entombed with the Celtic kings of central Europe.
About 530 B.C., however, the trade in Laconian bronzes and the
production of metal vessels dropped off dramatically. The cause of
this decline is unclear but may be connected to the outbreak of the
war with the eastern Greek isle of Samos, whose merchants and
sailors were responsible for shipping Laconian goods.

This small bronze lion represents the height of the Laconian
bronze industry. Because the different regions of Greece had such
different artistic styles, the details of workmanship suggest the
Laconian origin of the piece and offer a date of about 570–530 B.C.
The beast lies recumbent, its forelegs stretched out in front of it,
its head turned to the right. The tail is stretched up along the
feline's spine. The lion's mane falls down the back of its neck in a
series of flowing waves, incised into the surface of the bronze.

Under the lion's chin, the mane becomes a series of diagonal, geometric lozenges. The front of the mane is sculpted as a raised collar that creates a ring perpendicular to the neck, with incised lines radiating outward from the face. A nose, whiskers, and a down-turned mouth are indicated on the large, square snout of the beast.

The underside of the lion indicates its use in antiquity. The bottom of the bronze is left open, exposing the hollow interior of the piece. The edges around this display remnants of a silver-colored metal, probably used to solder the lion to another metal surface. The beast most likely originally sat on the edge of a bronze cauldron or tripod ring; such highly ornamented Laconian vessels were among the most prized treasures of barbarian kings and must have been equally valuable within Greece itself.

Unlike the aggressively fearsome beasts that had decorated earlier metal vessels, the lion is depicted as reclining docilely. Like these earlier monsters, the lion probably served an apotropaic function, with its head turned outward from the vessel to stare at the viewer. Yet the tameness of the beast suggests the growing confidence of the Greeks in their ability to domesticate nature and its creatures. This, in turn, hints at the beginning of the philosophy that would come to be a hallmark of the Classical age: no longer was the outside world to be greatly feared, but instead to be overcome and civilized by the Greeks.

MMM

PLATE 188

Running Gorgon

Greek, ca. 540 B.C.
Bronze, 3½ x 3¹⁄₁₆ x ⁹⁄₁₆ in. (8.9 x 7.8 x 1.43 cm)
Ruth Elizabeth White Fund and gift of Cornelius C. Vermeule in memory of Emily Townsend Vermeule

Gazing upon the face of a Gorgon will turn the viewer to stone. Characteristically frontal, wide, and masklike, this Gorgon's face petrifies with its long fearsome fangs, open howling mouth, and ugly distended tongue. The Gorgon has power over even the snakes twining around her arms, tying them in a knot as a belt. Her long, corkscrew curls and the zigzag central folds of her short tunic (*chiton*) exemplify the Archaic style in Greek art. The outstretched wings emerge behind the frontal upper body, while the lower body, bent legs, and boots are shown in profile, the winged boots adding speed to the power of the churning muscular legs. The pose signifies "running" in Archaic Greek art, and the running Gorgon remains one of the most evocative images of the Archaic period.

The figure was once attached to a bronze vessel, either below the handle of a large volute krater or as one of several fixed to the rim of a *dinos*, both vessels used for mixing and serving wine. In this context, as in many others, the Gorgon served an apotropaic role, warding off evil and protecting the user. Best known from the story of Perseus and Medusa, the Gorgons were the three daughters of a sea god (Phorkys) and a sea monster (Keto). Separated from their original mythological context, running figures and disembodied heads of gorgons not only adorned vessels, saving the potential drunkard from his queasy fate, but protected the

entrances and roofs of buildings and the gateways and perimeters of cities and sanctuaries throughout the Greek world.

SBM

S. B. Matheson, in J. Michael Padgett, ed., *The Centaur's Smile: The Human Animal in Early Greek Art*, exh. cat. (Princeton: Princeton University Art Museum, 2003), 312–15.

PLATE 189

Genius Cucullatus

Roman, Gallic or Germanic, 2nd century A.D.
Bronze with red copper inlay, 4¾ x 1⅜ x ⁹⁄₁₆ in. (12.1 x 3.5 x 1.43 cm)
Gift of Thomas T. Solley, B.A. 1950

At its height, the Roman Empire stretched from Britain to the Middle East, from Germany to Africa. Many peoples and cultures were contained within the broad political boundaries of the empire, all with their own backgrounds and customs. Yet their traditions were never left wholly untouched by the influence of the Romans, as this bronze figure of a male deity demonstrates.

The bearded man is wrapped in a voluminous cloak, which obscures his body; only two small ridges, to indicate his arms folded beneath its surface, add texture to the garment. The mantle is drawn up in a hood, which terminates in a tall, vertical pin atop the figure's head. Strips of red copper are inlaid into the surface of the bronze to indicate a pattern on the garment; they run from the bottom of the cloak, up over his shoulders, and around to the front of his hood. On his feet, the man wears a pair of short boots.

His dress and beard suggest that the figure can be identified as a *genius cucullatus*—a cloaked spirit. He was a minor god worshipped by the Celtic inhabitants of the northwestern Roman provinces, in parts of what are now modern France, Germany, and Britain. His cult is attested by a few carved reliefs and by a series of small bronzes similar to this one.

Yet while the subject of this bronze is local, its workmanship and style are heavily influenced by Roman products. The inlaying of copper strips on small bronzes became common only in the Roman imperial period and was used primarily on small figures of divinities. Similarly, the calm, composed demeanor of the figure and the delicate rendering of his facial features display an almost Classical refinement. Such an appearance stands in contrast to the more abstract and energetic traditions of art in the region, which persisted through the period of Roman rule.

The use of Roman styles to depict a provincial deity not only shows the influence of Roman preferences and conventions but may also reflect a more general Roman ideology of artistic production. For the Romans, certain styles were seen as particularly appropriate for certain subjects. The Classical spirit used for this bronze, which found its origin in Greek sculpture of the fifth century B.C., was generally considered to befit religious figures. That this underlying concept of the relationship between style and subject was manifest in a locally cast bronze figure of a local god demonstrates how pervasive Roman concepts and tastes were in the provinces.

MMM

PLATE 191

Relief of a Cavalryman

Greek, 5th century B.C.
Terracotta, 11¾ x 16¾ x 2³/₁₆ in. (29.9 x 42.6 x 5.5 cm)
Promised bequest of Jane Davis Doggett, M.F.A. 1956

An armed cavalryman rides at the walk toward the right on this fragmentary relief. Dressed in a short chiton with sleeves and a bronze cuirass molded to fit his body, he is either barefoot or wears thin-soled sandals whose painted lacings have worn away. Traces of both a beard and a helmet, possibly Thracian as is common for Greek cavalry, survive. The horseman rides bareback, guiding his mount with bridle and reins. Part of an unidentified object is preserved to the right of the horse.

In the J. P. Lambros Collection in Athens before 1912, the relief is said to have come from Locri, a south Italian site known for its terracotta votive plaques of the Late Archaic and Early Classical period. A Locri plaque showing an armed warrior leading his horse, now in the Museo Archeologico Nazionale in Reggio Calabria, provides a parallel. Both may be votive plaques or possibly from a funerary monument. In style the Doggett relief is slightly later than the 490–470 B.C. date of the Reggio plaque and the majority of the Locri plaques, but it predates the armed cavalry of the Parthenon frieze (442–428 B.C.).

SBM

Antiquités égyptiennes, grecques et romaines: Collections de feu M. Jean P. Lambros d'Athenes . . . Sale cat., Paris, Hôtel Drouot (June 17–19, 1912), p. 20, pl. 8, lot 110.

PLATE 192

Head of Aphrodite

Greek, Hellenistic, second half 2nd century B.C.
Marble, 8½ x 5¼ x 7½ in. (21.6 x 13.3 x 19.1 cm)
Promised bequest of Jan Mayer

This marble head, turned to the left, represents a youthful female at approximately life-size. Fleshy cheeks and a rounded chin give her face a heartlike form, into which almond-shaped eyes are deeply set above a straight nose (broken off at the end) and a small mouth framed by full lips. She wears her hair in thick waves brushed to both sides and back from a central part and held in place by a single fillet, with a few tendrils escaping around the ears. The hair is drawn into a loose knot at the back of the head. The head's essential features associate it with a large corpus of similar depictions of Aphrodite, the Greek goddess of love, surviving from antiquity. These heads in some cases remain attached to their original nude or seminude bodies. Many of the extant pieces appear to be Hellenistic and Roman-period reproductions of the renowned Aphrodite of Knidos made by the sculptor Praxiteles in the mid- to late fourth century B.C. This head differs, however, from the Knidian model in sporting a single rather than a double fillet. In this regard, it bears a closer resemblance to the Aphrodite found on the Greek island of Melos (commonly known as the Venus de Milo), now in Paris. Many scholars consider this statue a variation on the Praxitelean theme dating to the closing decades of the second century B.C. A similar date would fit the Yale head,

though the style of carving—with its emphasis on the contrasting textures of hair and skin and the interplay between areas of light and shadow—favors a place of manufacture in Asia Minor.

RAG

PLATE 194

Stater of Carthage

Carthage, 350–270 B.C.
Obv.: Head of Tanit l.; Rev.: Horse standing r.
Electrum, 7.39 gm, 6:00, 19 mm
Promised gift of Mary and James H. Ottaway, Jr., B.A. 1960

The wealth of Carthage in antiquity is implicit in her enduring coinage in gold and electrum (an alloy of gold and silver). Staters of this type were produced over a long period, and their abundance compares favorably with the almost nonexistent precious-metal coinage of her rival Rome during the same period. The head of Tanit, a Carthaginian lunar goddess related to Astarte or Ishtar, clearly owes something to Syracusan models, and this is no surprise since the Carthaginians had a long-standing presence in neighboring Sicily. The cavalry of the Carthaginians was also famous and feared, and the horse of the reverse may symbolize her equestrian prominence.

WEM

PLATE 195

Stater of Tarentum

Tarentum, 280–270 B.C.
Obv.: Male figure r. crowning horse l.; above, GU (Greek); between horse's legs, ARI / STI / P (Greek); Rev.: Boy riding dolphin r. holding bow in l. and arrow in r.; beneath, elephant r.
Silver, 6.36 gm, 12:00, 21 mm
The Peter R. and Leonore Franke Collection; Ruth Elizabeth White Fund

PLATE 196

Stater of Tarentum

Tarentum, 270–250 B.C.
Obv.: Horseman riding r. crowned by Victory. Behind, SI (Greek); below, OS (Greek); Rev.: Boy holding cantharos in r. and trident in l. riding dolphin l.
Silver, 6.59 gm, 5:00, 20 mm
Promised gift of Mary and James H. Ottaway, Jr., B.A. 1960

These two staters, part of a long series from Tarentum whose types remained stable for over two centuries, help to date one another. The first, with its elephant, makes reference to the Epirote king Pyrrhus's invasion of Italy and taking of Tarentum; its weight of less than seven grams shows that it was part of a peninsula-wide reduction in weight that is also reflected in the second coin.

Both coins show the names of the individuals responsible for their production on the obverse.

WEM

N. K. Rutter et al., *Historia numorum* (London: British Museum Press, 2001), no. 1000.

PLATE 197

Sestertius of Caligula

Rome, A.D. 37

Obv.: C CAESAR AVG GERMANICVS PONT MAX TR POT (Greek). Head of Gaius laur. l.; Rev.: AGRIPPINA / DRVSILLA / IVLIA / S C (Greek). Securitas standing facing r. leaning on column with cornucopiae in l. arm, Concordia extending patera in r. and holding cornucopiae in l. arm, and Fortuna holding cornucopiae in l. and rudder in r.

Orichalcum, 28.1 gm, 6:00, 35 mm

Ruth Elizabeth White Fund

The emperor Gaius succeeded the unpopular Tiberius on March 18, A.D. 37, in his twenty-fifth year. He had had the nickname "Caligula" since boyhood, when he accompanied his father Germanicus on campaign in the east; as a five-year-old he had come home with his mother, Agrippina, bearing his father's ashes. (The Gallery's painting *Agrippina Landing at Brundisium with the Ashes of Germanicus* [fig. 1], by Benjamin West, shows Agrippina with only two of the four children.) This piece, struck at the mint of Rome in the first year of Caligula's reign, shows the emperor laureate facing left, his bust unadorned in standard Julio-Claudian style; the head features the forward-swept neck curls typical of his portraits and known from the Gallery's bust in the round (fig. 2).

Figure 1. Benjamin West, *Agrippina Landing at Brundisium with the Ashes of Germanicus*, 1768. Oil on canvas, 64½ x 94½ in. (163.8 x 240 cm). Yale University Art Gallery, Gift of Louis M. Rabinowitz

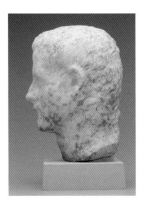

Figure 2. *Portrait Head of Caligula*. Roman, A.D. 37–41. Marble, probably Luna, 13 x 8¼ x 9¼ in. (33 x 21 x 23.5 cm). Yale University Art Gallery, Funded by Peggy and Richard Danziger, LL.B. 1963, George Hopper Fitch, B.A. 1932, Allen Grover, B.A. 1922, the Leonard C. Hanna, Jr., B.A. 1913, Fund, the H. John Heinz III Charitable Trust, and the H. J. Heinz Family Fund

The coin was acquired as a comparandum to the bust, but its reverse is also of considerable interest. It portrays the sisters of the emperor—Agrippina (A.D. 15/16–59). Drusilla (A.D. 16/17–38) and Julia (A.D. 17/18–41/42), each identified by a labeling legend, with the attributes of Securitas, Concordia, and Fortuna, respectively. All these are natural concepts to be invoked at the start of a reign—*securitas* (freedom from worry), *concordia* (harmony, usually with respect to the armies), and good fortune. The literal identification of the emperor's sisters with these personifications was an extraordinary step, never repeated.

WEM

H. Mattingly, *Coins of the Roman Empire in the British Museum* (London, 1923), vol. 1, cxlv–cxlvi and 152, nos. 36–37.

C. H. V. Sutherland, *Roman Imperial Coinage*, 2d ed. (London: Spink, 1984), vol. 1.

PLATE 198

Portrait of the Emperor Commodus as a Boy

Roman, A.D. 172/73

Marble, 13 x 15 x 7½ in. (33 x 38.1 x 19.1 cm)

Ruth Elizabeth White Fund

Commodus was born in A.D. 161, the same year in which his father, Marcus Aurelius (ruled A.D. 161–80), became emperor. Commodus was one of thirteen or fifteen children of Marcus Aurelius and his wife, Faustina the Younger. As the only son of Marcus Aurelius to survive his father, Commodus succeeded him as emperor at Marcus's death in A.D. 180. Hated as a tyrant, Commodus was assassinated in A.D. 192.

The portrait shows a boy between nine and twelve years of age. He wears a tunic covered by a cloak pinned at the shoulder with a circular brooch. The cloak is a military garment called a *paludamentum*, which when worn by a child indicates imperial rank. The identification as Commodus is based on the portrait's similarity to inscribed images on coins and medallions. A portrait type like this young Commodus appears on the reverse of coins of his father Marcus Aurelius struck in A.D. 172/73, at the time that both father and son were given the title *Germanicus*. The title honored the success of Marcus's German campaigns, also celebrated on the column of Marcus Aurelius in Rome. The only example of its type and linked to a particular event in the young prince's life, this portrait is a unique historical document. As a portrait of an imperious imperial child, it shows a skilled artist's ability to convey an individual's character as well as his appearance and elevated status.

Known as the Fawley Court Commodus, the portrait comes from an English country house of that name. It was purchased in Mexico City in 1944 by Father Joseph Jarzebowski, a prominent Marian priest who had fled Germany in World War II. After the war, Father Jarzebowski brought the portrait to Fawley Court, where he founded Divine Mercy College, a school for Polish Boys.

SBM

K. Fittschen, *Prinzenbildnisse Antoninischer Zeit* (Mainz: Phillip von Zabern, 1999), 56–57, cat. no. J1, pl. 85 (Commodus as *Germanicus*).

PLATE 199

Pseudo-Autonomous Copper Coin of Cyzicus

Cyzicus, 2nd–3rd century A.D.
Obv.: KVZIKOS (Greek), Head of city—goddess laureate r.; Rev.: KVZIKENON NEOKORON (Greek), Demeter standing l. holding grain stalks downward in r. and torch in l.
Copper, 13.72 gm, 6:00, 30 mm
The Peter R. and Leonore Franke Collection; Ruth Elizabeth White Fund

While most coins of the provinces bore renditions of a member or members of the imperial house, some "pseudo-autonomous" ones were struck on the nominal authority of the *polis*, in this case Cyzicus on the Black Sea coast. Demeter was the city's principal cult figure; she carries the grain stalks that are symbolic of her aspect as a goddess of fertility and the torch she uses in searching for her daughter Persephone, who spends half the year in the underworld.

WEM

PLATE 200

10-Assaria of Claudius II

Sagalassus, A.D. 268–70
Obv.: AVT K M AVR KLAVDION (Greek) from lower l. Bust laureate, draped, and cuirassed r. seen from behind. Countermark: Tyche standing l. holding rudder and cornucopiae, the whole in circular incuse; Rev.: SAGALASSEON (Greek) from upper r. Ares advancing r. holding transverse spear in r. and extending l. In field, large I.
Bronze, 17.51 gm, 12:00, 31 mm
The Peter R. and Leonore Franke Collection; Ruth Elizabeth White Fund

The coinage of Sagalassus, along with that of some other mints in Pisidia, represents the last gasp of Rome's provincial coinage, which came to an end in the A.D. 270s everywhere except Egypt. By this time the inflation that led to massive reforms under the emperor Diocletian was rampant, and coins were frequently revalued. The denomination of this coin, indicated by the large Greek numeral "I" on the reverse, was ten *assaria*, or asses. At 17.51 grams this implied a nominal as of 1.75 grams, about one-seventh of its weight at the beginning of the century.

Countermarks (small punches with images) were often applied to coins to revalidate or revalue them, or to redefine an area of circulation. The countermark on this coin is found on others of Sagalassus and is likely to represent a revaluation (upward) of the value mentioned on the reverse.

WEM

PLATE 202

Column with a Capital Depicting the Adoration of the Magi

French, Saint-Martin de Savigny (Rhône), ca. 1150–60
Limestone, 54 x 19 in. (137.2 x 48.3 cm)
Gift of Ambassador and Mrs. Joseph Verner Reed, Jr., B.A. 1961

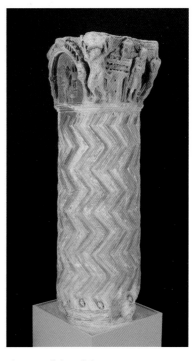

Figure 1. Full view of plate 202

This squatly proportioned pillar (fig. 1) consists of a richly ornamented columnar support surmounted by a historiated capital. It is incised with zigzag grooves, covering the entire surface. In the capital zone, angels in the manner of Roman imperial victories stand at the four corners. Between them unfolds a familiar scene of Christian art, the Adoration of the Magi. The Virgin with the Child is seated within an arched enclosure, in front of a sturdy masonry wall. At the apex of the arch, an oblong device, now hollowed out through damage, perhaps once exhibited the star of Bethlehem. The space to the right (that is, the viewer's left) is occupied by the first of three Wise Men, shown kneeling to proffer his gift against a background of agitated vegetation. The second Magus stands behind a pair of spiky trees at the center of the next side. The third, who brings up the rear of the procession on the following and last of the four faces of the capital, is seen emerging from an elaborate, turreted building, presumably the palace of Herod (Matthew 2:12).

The pillar stems from Saint-Martin at Savigny, a now-destroyed Benedictine monastery located some twenty miles west of Lyon in southeastern France. Ilene H. Forsyth conjectures that this pillar, along with other fragments of sculpture from the site now scattered in several European and American collections, formed a part of a cloister arcade. The style and carving technique owe much to Roman sculpture of the first centuries of our era, of which conspicuous examples are found in the Rhône Valley and nearby areas of Provence, and southern Burgundy. The sculpture of

the north porch of the church of Saint-Fortunatus at Charlieu, near Roanne, north and west of Savigny, is perhaps the work of the same artisans, and variants can be found at other sites of the region. The church of Saint-André-le-Bas at Vienne, which bears an inscription with the date 1152, furnishes an approximate chronological marker for the execution of the Yale column.

WC

Mémoire d'une abbaye disparue, Saint-Martin de Savigny (Lyon: Musée Historique de Lyon, Hôtel Gadagne, 1997), 100–101, no. 43, with earlier bibliography.

PLATE 203

Unknown artist

(Italian, probably Paduan)

Study after a Roman Sacrificial Relief: The Suovetaurilia, ca. 1485

Pen and brown ink over black chalk on vellum, pricked for transfer, 6⁹⁄₁₆ x 11¼ in. (16.7 x 28.6 cm)
Promised gift of Lionel Goldfrank III, B.A. 1965

This drawing, by an unidentified artist, is apparently the earliest known copy after a Julio-Claudian relief unearthed in Rome in the fifteenth century. Depicting the *suovetaurilia*, the lustral sacrifice of a pig (*sus*), a sheep or ram (*ovis*), and a bull (*taurus*), the ancient relief was in the Palazzo San Marco (Palazzo Venezia), Rome, perhaps originally in the collection of Pietro Barbo. It passed in the early sixteenth century into the possession of the Venetian cardinal Domenico Grimani, whose family sent it to Venice in 1587. Appropriated by Napoléon in 1797, the relief is today in the Louvre, Paris.

The old inscription attributes the drawing to Andrea Mantegna, and while that idea cannot be sustained, the drawing is by one of Mantegna's contemporaries. The classical grandeur of the sculptural model is lost, as the draftsman has cast the figures in the slightly timid, weightless manner characteristic of northern Italian drawings of the fifteenth century. The parallel hatching is reminiscent of that in Mantegna's drawings, and similarities have also been noted between the *Suovetaurilia* and other drawings from the circle of Francesco Squarcione, who encouraged his pupils to copy ancient sculpture; an attribution to the Paduan school has accordingly been suggested. The Yale drawing is independent of the better-known copies of the sculpture by Amico Aspertini and others,[1] but it is close in spirit to a copy in the Louvre by a Venetian artist, perhaps Girolamo Mocetto, which suggests that the Roman relief was well known in northern Italy. Indeed, the Yale drawing's contours are pricked so that the design could be copied further. The sheet comes from the so-called Antonio II Badile Album, a collection of drawings organized by the eponymous artist about 1500.

JJM

1. See Phyllis Pray Bober and Ruth Rubenstein, *Renaissance Artists and Antique Sculpture: A Handbook of Sources* (London: Harvey Miller, 1986), no. 190, to which can be added a copy by Girolamo da Carpi, sold New York, Christie's (January 26, 2006), lot 2.

PLATE 204

Neri di Bicci

(Italian, Florence, 1418–1492)

Virgin and Child Enthroned with Saints Martin of Tours and Blaise, 1476

Tempera and gold on panel, 50 x 50 in. (127 x 127 cm)
Gift of Barbara and Robert Liberman, B.A. 1965

In addition to creating pigmented sculptural reliefs and paintings for private devotion, Neri di Bicci received numerous commissions over the course of his long career for major altarpieces both in Florence and throughout Tuscany. Most of these are recorded in the artist's *Libro di ricordanze*, but the entries in that invaluable source of information about Renaissance studio practices end in April 1475, seventeen years before Neri di Bicci's death. A large part of the master's output, therefore, remains undocumented, and the Yale *Virgin and Child Enthroned with Saints Martin of Tours and Blaise* falls among this portion of his work.

An inscription running across the base of the frame—salvaged from the original frame of the altarpiece and incorporated here into an otherwise modern structure—reads "Questa tavola a facto fare Francesco di Cristofano Giadini da Piens[a] dobrigo aveva cholla chiesa e dilimosine anno domini MCCCCL a di XX di Giugno" (Francesco di Cristofano Giadini of Pienza had this painting made for his obligations to the church and for charity on the 20th day of June, 1480). Many of the characters in this inscription, however, were coarsely repainted at an early date, and the surviving fragments of overpainted original lettering indicate the patron's name as Donato di Pagolo di Lorenzo da S[co] Martino a[] P[], and the date to have been 1476 rather than 1480. Since neither of the bishop saints—Martin of Tours at the left and Blaise at the right, identified by inscriptions beneath their feet and by their conventional attributes, the iron comb with which Saint Blaise was tortured before his martyrdom and the beggar with whom Saint Martin shared his cloak—were namesakes of the donor, it must be presumed that they refer instead to the dedication of the church for which this altarpiece was painted. Saint Martin clearly represents the community in which this church stood, possibly the village of San Martino alla Palma, a parish five miles southwest of Florence.

LBK

PLATE 205

Desiderio da Settignano

(Italian, Florence, 1429/32–1464)

Neri di Bicci

(Italian, Florence 1418–1492)

Virgin and Child, ca. 1460–65

Polychrome and gilt stucco relief, 16½ x 13¼ in. (41.9 x 33.7 cm)
Purchased with a gift from Nina Griggs

In his account book (*Libro di ricordanze*) covering the years 1453 to 1475, the painter Neri di Bicci mentions his gifted younger contemporary, the sculptor Desiderio da Settignano, four times, three in connection with relief sculptures of the Virgin and Child that he,

Neri, was engaged to gild and polychrome. The specific objects recorded in these entries cannot be identified with confidence, but they must refer to examples of two relief compositions by Desiderio that were among the most popular of their kind in fifteenth-century Florence and that survive today in numerous stucco casts. Among these, at least two—one in the Louvre, Paris, and the present example—were pigmented by Neri di Bicci, and of those two, the Yale version is by far the better preserved, with nearly all its original paint and gilded surfaces intact and unimpaired by abrasion or other damages.

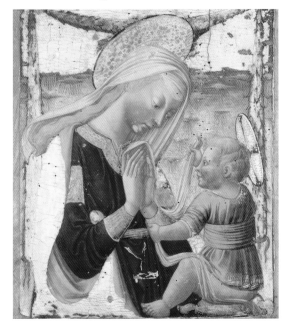

Figure 1. Neri di Bicci, *The Virgin Adoring the Child*, ca. 1465. Tempera on panel, 18⁷⁄₁₆ x 16⅜ x ¾ in. (46.8 x 41.6 x 1.91 cm). Yale University Art Gallery, Bequest of Maitland F. Griggs, B.A. 1896

Following the immense popularity of pigmented stucco reliefs of the Virgin and Child created by the founding generation of Renaissance sculptors—especially by Donatello and Lorenzo Ghiberti—younger artists like Desiderio da Settignano, Antonio Rossellino, and Benedetto da Maiano perfected a lower-relief style and geometrically organized compositions that could be more easily and accurately replicated, and they entered into commercial relationships with painters' studios to decorate their products and expand their opportunities for sales. Neri di Bicci seems to have been Desiderio's painter of choice, and even after the sculptor's untimely death in 1464, Neri was pigmenting and selling reliefs by him. Neri also, and probably somewhat later, produced two painted panels copying the composition of the present relief: one of these is in the Musée des Beaux-Arts, Dijon, and the other is also in the Yale University Art Gallery (fig. 1).

LBK

PLATE 206

Donatello (Donato di Niccolò di Betto Bardi)
(Italian, Florence, 1386/87–1466)
Matteo di Giovanni
(Italian, Siena, 1430–1495/99)
Virgin and Child, 1457–59
Polychrome and gilt stucco relief, 23½ x 15 in. (59.7 x 38.1 cm)
Purchased with a gift from Nina Griggs

The vogue for pigmented stucco reliefs of the Virgin and Child reached its peak in Florence in the middle decades of the fifteenth century, when they were produced in great numbers in every major sculptor's studio and decorated by nearly every major and minor painter in the city. The art form probably originated with the great architect, sculptor, and inventor Filippo Brunelleschi, but it flourished at the hands of his sometime collaborator Donatello and his sometime rival Lorenzo Ghiberti. The reliefs were not intended as mechanical replicas of distinguished or famous originals but were designed from the first as reproducible works of art, anticipating the invention of printmaking later in the century.

The present relief is a late work by the most innovative and idiosyncratic sculptor of the quattrocento, Donatello. It is recorded in more than a dozen known casts, none of which survive in anything like the excellent state of preservation of this example. Although the blue and red of the Virgin's cloak have been renewed and the flesh tones of both figures have been repaired, all the gilded surfaces are original and intact, as is the red-lake glazed decoration on the Virgin's tunic. The punch tools used to embellish the two halos and the outer margin of the gold ground reveal the gilder (and painter) to have been the prominent Sienese master Matteo di Giovanni, establishing a date for the relief during the period of Donatello's residence in Siena between 1457 and 1459. As one of the few fifteenth-century reliefs that can be even approximately, let alone precisely, dated, the discovery of the Yale *Virgin and Child* represents an important addition to the history of Florentine Renaissance sculpture.

LBK

The Master of the Holy Kinship (Meister der Heiligen Sippe)

(German, Cologne, active ca. 1475–1510)

PLATE 207

Saints James the Greater and John the Evangelist, ca. 1505–7

Oil on panel, 19 x 12^{15}/$_{16}$ in. (48.3 x 32.9 cm)
Pending partial purchase and partial gift of Robert and Virginia Stern, parents of Adam C. Stern, B.A. 1982, in honor of all the families in Europe who were dispossessed during the Holocaust period 1933 to 1945

PLATE 208

Saints James the Lesser and Philip, ca. 1505–7

Oil on panel, 19 x 12^{15}/$_{16}$ in. (48.3 x 32.9 cm)
Pending partial purchase and partial gift of Robert and Virginia Stern, parents of Adam C. Stern, B.A. 1982, in honor of all the families in Europe who were dispossessed during the Holocaust period 1933 to 1945

Saints James the Greater and John the Evangelist and *Saints James the Lesser and Philip* are two panels from an altarpiece heptaptych that originally portrayed the twelve apostles flanking an image of *Christ and the Virgin Enthroned*. The center panel from this complex is now in the Rheinisches Landesmuseum in Bonn, while the remaining apostles are divided among the John G. Johnson Collection at the Philadelphia Museum of Art (*Saints Peter and Andrew*), the Museum of Fine Arts, Boston (*Saints Matthew and Thomas*), and the Heinz Kisters collection at Kreuzlingen (*Saints Simon and Jude*). A final pair of apostles—*Saints Bartholomew and Matthias*—was formerly in the Kaiser Friedrich Museum at Magdeburg but was destroyed during World War II.

Saint James the Greater, the older brother of John the Evangelist, is identified by his pilgrim staff and cockleshell pinned to his hat, allusions to the importance of his shrine at Campostela in Spain as one of Europe's premier pilgrimage destinations. Saint John beside him is portrayed as a young man blessing a chalice, in reference to the legend of a test of his faith by poisoning. Saints James the Lesser and Philip, who share a feast day (May 1), are both identified by the instruments of their respective martyrdoms: a fuller's club and a cross.

The Meister der Heiligen Sippe, or Master of the Holy Kinship, was one of the last Late Gothic artists in Cologne and among the most prolific painters of that distinguished school. He began his career as a follower of Stephan Lochner before absorbing influences from his great German contemporary the Master of the Saint Bartholomew Altar and the Netherlandish painters Hugo van der Goes and Hans Memling. The apostles altarpiece of which the present panels formed part is to be numbered among his last efforts.

LBK

PLATE 209

Jacopo Carucci, called Pontormo

(Italian, Florence, 1494–1557)

Virgin and Child, known as the Madonna del Libro, ca. 1545–46

Oil on panel, 31^{3}/$_{4}$ x 25^{1}/$_{4}$ in. (80.7 x 64.1 cm)
Maitland F. Griggs, B.A. 1896, Fund

Jacopo Pontormo was the most revolutionary and influential Florentine painter after Michelangelo, and although his works of the 1520s are among the best-known paintings of the sixteenth century, Pontormo spent the last decade of his life working on frescoes in the choir of San Lorenzo that were destroyed in the eighteenth century. The *Madonna del Libro* is probably the artist's latest extant painting. The picture is now a fragment, but the full composition is known from at least twenty-five sixteenth-century copies, which also serve as testaments to the work's significance.

The familiar name of the painting comes from the large book that the Virgin held at her right side—Michelangelo's Sistine ceiling sibyls are the formal and typological model—and the panel once included, at upper right, Saint Joseph as a carpenter and other figures. The Virgin and Child sit before the walls of Florence, which are similarly depicted in Pontormo's *Portrait of a Halberdier* (J. Paul Getty Museum, Los Angeles) and in another work associated with the 1530 siege of the city, Andrea del Sarto's *Porta ai Pinti Madonna*. To some degree, the *Madonna del Libro* pays homage to Andrea's lost painting, which, having been spared in the siege, was apparently seen as a kind of protective icon of Florence and was copied many times.

The *Madonna del Libro* is probably the unfinished "quadro di Nostra Donna" that was in Pontormo's house at his death. Long thought lost, the panel came to light in 2001. Its sheer quality, the technique of both painting and underdrawing, and even the construction of the panel (matching that of the contemporary *Giovanni della Casa* in the National Gallery of Art, Washington, D.C.) identify this as the sole surviving fragment of Pontormo's original, one of the most important rediscoveries of Renaissance art in recent years.

JJM

PLATE 210

Francesco Vanni

(Italian, Siena, 1563–1610)

The Rest on the Flight into Egypt, known as the Madonna della Pappa, ca. 1595

Oil on canvas, 60 x 48 in. (152.4 x 121.9 cm)
Maitland F. Griggs, B.A. 1896, Fund

Francesco Vanni was the leading Sienese artist of his time, responsible for major altarpieces in virtually every church in his native city, in addition to one of the original altarpieces in the new basilica of Saint Peter in the Vatican, other works for Roman patrons including Cardinals Paolo Camillo Sfondrato and Cesare Baronio, and paintings for cities across Tuscany and beyond. The present

work is one of the most highly esteemed paintings of Vanni's entire career. Known as the *Madonna della Pappa*, it illustrates a moment from the apocryphal story of the Flight into Egypt when, warned that King Herod would slaughter the newly born, the Holy Family fled into the wilderness. Vanni depicts the miraculous appearance of an angel bearing a bowl of porridge (*pappa*) for the infant Christ.

A small private altarpiece or even perhaps a cabinet picture intended for a collector rather than a chapel, the *Madonna della Pappa* bears all the principal characteristics of Vanni's art. The scene is depicted with the touching intimacy so common in Counter-Reformation painting, the naturalism of which—the napkin tied around Christ's neck as a bib, his coral teething bracelet, the porcelain bowl, and golden spoon—was understood as enabling the viewer to identify with the scene, thereby increasing the picture's devotional efficacy. Vanni's naturalism, however, is tempered by high-minded artifice: in the gauzy, impressionistic landscape of the background, for example, or in the virtuoso depiction of the angel's clothing with the ravishing colors that Vanni adopted from Federico Barocci, his primary artistic model. The combination of naturalism and idealism seen here recalls that in the art of Vanni's sometime associate Annibale Carracci, who is likewise credited with moving art away from the mannered style of the previous generation and founding the Baroque period.

JJM

PLATE 212

Jacopo Zucchi

(Italian, Florence, ca. 1540–ca. 1596)

The Assembly of the Gods, 1575–76

Oil on copper, 18¾ x 15⅝ in. (47.6 x 39.7 cm)
Gift of Edmund P. Pillsbury, B.A. 1965

This work is recorded as having been painted in 1575–76 as part of a set of nine copper plates that decorated a cabinet or writing desk in the study of Cardinal Ferdinando de' Medici at the Villa Medici in Rome. The only one of the nine plates to survive, it is also the earliest known painting in oil on copper by Zucchi, who must be counted among the originators of the technique, which is notable for fine brushwork and luminous colors like those seen here.

Despite the crowded composition, the iconography is for the most part clear. Jupiter is at upper center, with Minerva having been born from his brain. Saturn, with his scythe, is to one side of Jupiter, while on his other side, underneath the arc of the Milky Way, are Mars, Apollo, Venus, and Mercury. Diana is beside Mercury, above the bearded colossal head of Atlas. Pluto is at lower left, below the figure of a Mother Goddess (probably Vesta or Ops), while the figures at center are Neptune with his trident, Juno with her peacock, and a man with a hat who is perhaps Bacchus. Ceres and Flora are above him to the left. The composition has been alternately catalogued in both early and modern sources as *The Assembly of the Gods* or *The Birth of Minerva*, and while the gods shown here are those whom Renaissance writers like Vincenzo Cataro considered part of the council that helped Jupiter govern the universe, the specific meaning of the panel—if any was intended—remains obscure.

The painting is a gift from Edmund P. Pillsbury, formerly curator of European art at the Gallery, who in 2005 also presented the Gallery with a drawing by Zucchi, an *An Allegory of Architecture: A Male Figure with Two Putti* (pl. 213).

JJM

Unknown artist, published by Charles le Vigoureux
(French, 1547–1605)

PLATE 215

Dieu arreste Jeremie pour Prophete, & luy faict voir un pot bouillant & une verge d'Amandier fleurie (God Calls Jeremiah to Be a Prophet and Shows Him a Boiling Pot and a Branch of a Flowering Almond Tree) (Jeremiah 1), no. 1 from *The Story of Jeremiah*, ca. 1580

PLATE 216

Jeremie montre quel est le pouvoir de Dieu par l'exemple d'un Potier, & predict la ruyne de Jerusalem (*Jeremiah Shows the Power of God by the Example of a Potter, and Predicts the Ruin of Jerusalem*) (Jeremiah 18–20), no. 2 from *The Story of Jeremiah*, ca. 1580

Woodcuts with hand coloring and stencil, from a series of six, each approx. 14³⁄₁₆ x 18⅞ in. (36 x 47.9 cm)
Everett V. Meeks, B.A. 1901, Fund

In Paris from about the middle of the sixteenth century until about 1620 an enormous number of woodcuts were produced in an area centered on the rue Montorgueil, on the Right Bank of the Seine, to the north of the church of Saint-Eustache. Perhaps 350 different images from the rue Montorgueil are known now, although there must have been well over a thousand, perhaps several thousand. The prints were in effect poor people's tapestries, and because they would usually have been tacked on a wall, they would have been damaged and eventually discarded. A single album in the Bibliothèque Nationale de France contains about 250 of these prints, and some one hundred others are known. Only a very few of these images exist in more than one impression.

Most of the images are divided into two sections by architectural elements that are an integral part of the composition. Thus, in the first print of Yale's Jeremiah series (pl. 215), on the left Jeremiah is on his knees looking at God, who appears in a cloud above, the pot at his right, the almond branch at his left. In the right half, Jeremiah is seen heading toward a place where people are worshipping false gods, and he is to predict their ruin. The Yale *Jeremiah* series, which includes four woodcuts in addition to the two shown in the present exhibition (see fig. 1 for the fourth print in the series) is typical of Montorgueil production in its biblical subject, medium, size, and hand coloring, and in being a set of six. The figures are monumental, deriving ultimately from Michelangelo. The style is essentially classical, although the desire to maximize narrative incident makes in some cases for a crowded result. The bold, even strident, contemporary coloring is also typical, with

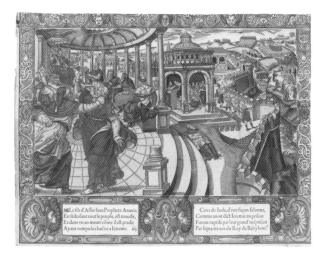

Figure 1. *Ananias faux Prophete, seduit le peuple & rompt la chaisne de Jeremie, le peuple de Juda est captif en Babylone* (*Ananias the False Prophet Seduces the People and Breaks Jeremiah's Chain, the People of Judah Is Captive in Babylon*) (Jeremiah 28–30), no. 4 from *The Story of Jeremiah*

purple, orange, and gray-blue predominating. L'Image St. Pierre is one of a half dozen publishers' addresses appearing on the group of Montorgueil prints. The shop was established probably in the mid-1570s; Charles le Vigoureux took it over about 1579.

SB

Sale cat., Chartres, France, Galerie de Chartres (October 17, 2004), lot 33.

PLATE 217

Abraham Bloemaert

(Dutch, 1566–1651)

Landscape with Vertumnus and Pomona, ca. 1600

Oil on canvas, mounted on board, 34 x 39 in. (86.4 x 99.1 cm)
Gift of John Walsh, B.A. 1961

The tale of Vertumnus and Pomona, principally known from Ovid's *Metamorphoses*, became a favorite subject of Dutch artists in the seventeenth century, but this is among the earliest painted versions. The nymph Pomona, devoted to the art of gardening, left the woods to reside in an enclosed garden; busying herself there, she shunned the contact of men. She was, however, beloved by the god Vertumnus, who after Pomona's repeated rejections disguised himself as an old woman and used the wiles of language to ingratiate himself with the nymph, winning her over when he resumed his youthful shape. A contemporary exegesis by the painter and writer Karel van Mander took Pomona to symbolize virtue, which was to be attained through great effort. Given the prominent vegetables in the foreground here, the depiction of the virtuous-but-conquered nymph of gardening might also be read as a mythological analogue to a Dutch proverb of the time: "Cucumbers are like virgins; they mustn't be kept too long."

The painting is the work of the Utrecht artist Abraham Bloemaert and reflects the Mannerist mode of his early career, when his primary influences were Bartholomaeus Spranger and Cornelis Cornelisz. van Haarlem, whose signed and dated *Holy Family* of 1590 at the Gallery can be seen as a useful point of comparison. The manner in which the *Vertumnus and Pomona* is painted, with stylized forms emerging as bright pools of color against the

dark ground of the picture, compares closely to Bloemaert's works of the 1590s, including the *Moses Striking the Rock* of 1596 at the Metropolitan Museum of Art, New York, and the large *Deluge* at the Gallery long misattributed to Joachim Wtewael but now recognized as an important early work by Bloemaert.

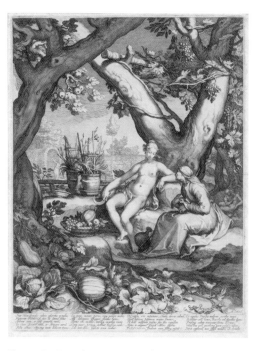

Figure 1. Jan Saenredam, *Vertumnus and Pomona*, 1605. Engraving, 18½ x 14³⁄₁₆ in. (47 x 36 cm). Yale University Art Gallery, Everett V. Meeks, B.A. 1901, Fund

The *Vertumnus and Pomona* was reproduced in an engraving of 1605 by Jan Saenredam, an impression of which has also recently been acquired by the Gallery (fig. 1).

JJM

Marcel G. Roethlisberger, *Abraham Bloemaert and His Sons: Paintings and Prints* (Doornspijk, Netherlands: Davaco, 1993), vol. 1, 108, 133–34, cat. no. 86; vol. 2, fig. 151.

PLATE 218

Filippo Evangelisti

(Italian, 1684–1761)

Saint John the Baptist, 1730

Red and white chalk, 21¾ x 16 in. (55.3 x 40.6 cm)
Gift of John Walsh, B.A. 1961, in memory of Frederick R. Mayer, B.A. 1950

Relatively little is known about the Roman painter Filippo Evangelisti. He trained under Benedetto Luti and, emerging from Luti's studio, won first prize in the Clementine drawing competition at the Accademia di San Luca in 1705. About 1718, Evangelisti entered into a partnership with Marco Benefial, and for almost thirty years Benefial, among the most talented painters of his generation, painted works that were exhibited under Evangelisti's name. The unusual association of the two painters may have been political, for Benefial had a history of conflict with the Accademia, while Evangelisti enjoyed the patronage and protection of Cardinal Pierfrancesco Corradini, the papal datary and one of the the most powerful figures in the papal court.

This *Saint John the Baptist* is an example of the academic figure studies that were the mainstay of Roman draftsmanship in the eighteenth century. The lamb and landscape, iconographical motifs that identify the figure as Saint John, might be described as props that barely mask the sheet's probable origin as a study of a live model in the studio. Indeed, the staff that the figure holds has relatively little to do with the reed cross that Saint John usually carries and is instead the sort of pole that academic models used in order to preserve steady poses for drawing classes; similar examples might be found in life drawings by all of Evangelisti's contemporaries, which were usually made at the same large scale used in this drawing.

The sheet comes from the collection of Anthony M. Clark, who was largely responsible for reviving the study of eighteenth-century Roman art. It has been presented by John Walsh in memory of Frederick Mayer, a longtime member and former Chair of the Gallery's Governing Board.

JJM

On Evangelisti, see especially Giorgio Falcidia, "Per una definizione del 'caso' Benefial," *Paragone* 29, 343 (1978): 24–51.

PLATE 219

Charles de La Fosse

(French, 1636–1716)

Saint Cecilia, ca. 1700

Oil on paper, laid down on panel, 16¼ x 13¼ x 2 in. (41.3 x 33.7 x 5.1 cm)
Gift of Mr. and Mrs. Edward A. Friedman, B.A. 1971, and Mr. and Mrs. Gary D. Friedman, B.A. 1973

Charles de La Fosse, the principal decorative painter in France in the generation after Charles Le Brun, was responsible for major projects including paintings throughout the château and chapel of Versailles and at the Invalides. He rose to the position of chancellor at the Royal Academy and was an associate of the theorist Roger de Piles. He generally avoided the theoretical debates that characterized the French academic world of his time, but La Fosse was, by virtue of his works, associated with the rise of *Rubénisme*, the movement away from the severe Poussin-inspired art of the earlier Academy, and toward the painterly, colorful style (inspired by the work of Peter Paul Rubens) that foreshadowed the development of French Rococo painting after 1700. La Fosse frequently followed Rubens's practice of producing both drawings and oil sketches as preparatory studies for his paintings; the present work is one such example of his painterly approach to design.

Showing Cecilia, the patron saint of music, seated at her organ with her eyes cast toward heaven, this sketch is related to a picture now in the Hôtel de la Marine, Paris, where it is paired with La Fosse's *King David Playing His Harp*; details of their commission and original location are not known. The pose of Saint Cecilia remains the same from the present sketch to the finished painting, but adjustments to the fall of the drapery across the saint's legs and changes to the organ suggest that this is a preparatory sketch rather than a later *ricordo*, as has previously been proposed. The sketch is probably the *Saint Cecilia* by La Fosse that is

listed in the inventory of the Comte de Vaudreuil, the most important collector of French art in late eighteenth-century Paris.

JJM

Clémentine Gustin-Gomez, *Charles de La Fosse, 1636–1716* (Dijon: Faton, 2006), vol. 1, 153; vol. 2, 83–84.

PLATE 220

Pier Leone Ghezzi

(Italian, 1674–1755)

Portrait of Gennaro de Scà, April 8, 1748

Pen and brown ink, 10¹⁵⁄₁₆ x 7¹³⁄₁₆ in. (27.8 x 19.8 cm)
Inscribed: (lower left) in pen and brown ink: *V.D. Gennaro de Scà [?] Maestro / dell Cad. d. Figlioli dell. Duca / d. Matalona fatto da me Cav. / Ghezzi li 8 Aprile 1748*
Purchased with a gift from Frederick Goldstein, B.A. 1955, in honor of Suzanne Boorsch

Pier Leone Ghezzi was trained by his father, the painter Giuseppe Ghezzi, to draw with pen and ink without making corrections, and this skill surely played a key role in the younger Ghezzi's eventual specialty of drawn caricature portraits. The word "caricature," deriving from the Italian *caricare*, to load, or charge, was first applied to a certain kind of drawing by Annibale Carracci, who worked in Bologna in the late sixteenth and early seventeenth centuries. Ghezzi, however, was the first artist who can really be called a professional caricaturist. Ghezzi made painted portraits and also history and religious subjects, but his fame rests in the caricatures, and he is considered the father of the genre. Over the course of more than sixty years, from 1693 until his death in 1755, Ghezzi portrayed most of the important members of Roman society as well as prominent visitors to the city. Well over two thousand of these amusing—but never malicious—caricatural drawings survive.

Happily for posterity, Ghezzi, as well as signing his drawings, habitually identified his subjects and even specified the exact date when the portrait was made. The subject of Yale's drawing, Gennaro de Scà—the last name is difficult to read, but that is what it seems to be—is identified as the tutor to the younger son of the Duke of Matalona, a member of a branch of the Carafa family of Naples. The name "Gennaro" is typically Neapolitan. The tutor is shown in profile—as were most of Ghezzi's caricatures—skullcap on his head, book in his left hand, his right hand tucked into his coat at chest level. Ghezzi did not travel to Naples, so the portrait must have been made in Rome.

SB

PLATE 222

Jacques-Louis David

(French, 1748–1825)

Statue of Flora Seen from the Front, in the Palazzo Giustiniani, Rome, ca. 1775–80

Red chalk, 9⁷⁄₁₆ x 5⁷⁄₁₆ in. (24 x 13.8 cm)

Inscribed: lower left, in pen and brown ink, in David's hand: *nel palazzo / giustiniani*; lower center and lower right, in pen and brown ink: *ED* and *JD* [monograms of David's sons Eugène and Jules]

The Lawrence and Regina Dubin Family Collection, Gift of Dr. Lawrence Dubin, B.S. 1955, M.D. 1958, and Regina Dubin

Having won the Prix de Rome in 1774, Jacques-Louis David spent from November 1775 to July 1776 at the French Academy there; he had a second stay between October 1784 and August 1785. Rome shaped David, and his austere classicism in turn shaped European art of the late eighteenth century. He made hundreds of drawings of antiquities like this one of a statue of Flora then in the famed Giustiniani collection, which eventually comprised more than six hundred works. This collection was well known through a lavish publication of the early 1630s, in two volumes, with 322 full-page engravings—the first publication of its kind. David chose a different angle from that in the engraving by Luca Ciamberlano (fig. 1), and he omitted the pedestal and plinth. The statue remained in the Giustiniani collection into the twentieth century, although its present whereabouts are unknown.

Figure 1. Luca Ciamberlano (Italian, 1570/80–after 1641), *Statue of Flora,* from *Galleria Giustiniani del marchese Vincenzo Giustiniani* [Rome, ca. 1631], vol. 1, pl. 50. Engraving, 14¹³⁄₁₆ x 9⁵⁄₁₆ in. (37.6 x 23.6 cm). Yale University, Beinecke Rare Book and Manuscript Library

Back in Paris, David took apart his Roman sketchbooks and remounted the drawings in large albums, mostly four on a sheet, following a methodical order—single figures of men, standing, seated, reclining, then figures of women, in the same order, then pairs of people, and so on. The critic Étienne-Jean Delécluze later described how he and David used to look through "large books in which David had reassembled the studies he had made in Rome

when he was studying antiquity in order to escape the academic manner," and Rosenberg and Prat wrote that "David hoped, in creating these albums, to find the images and ideas that would permit him to create the works he had dreamed of." Shortly after the artist's death, David's two or three albums were broken up into twelve smaller ones and sold. Seven are now in public collections. Two—including no. 6, from which the present drawing comes—were dismembered and the drawings dispersed; the other three are presumed to be privately owned.

SB

Galleria Giustiniani del marchese Vincenzo Giustiniani [Rome, ca. 1631], vol. 1, no. 50; see also Giulia Fusconi, ed., *I Giustiniani e l'antico,* exh. cat. (Rome: L'Erma di Bretschneider, 2001), 526–27, nos. 1, 50.

Angela Gallottini, *Le sculture della collezione Giustiniani,* vol. 1, *Documenti* (Rome: L'Erma di Bretschneider, 1998).

Pierre Rosenberg and Louis-Antoine Prat, *Jacques-Louis David, 1748–1825, Catalogue raisonné des dessins,* 2 vols. (Milan: Leonardo Arte, Mondadori Electa Spa, 2002), no. 680, and see p. 786, no. 43, top left; quotations from Delécluze and the authors, p. 405.

PLATE 223

Pierre-Paul Prud'hon

(French, 1758–1823)

Une famille dans la désolation (A Grief-Stricken Family), 1821

Oil on canvas, 14¹⁵⁄₁₆ x 12¹⁄₁₆ in. (37.9 x 30.6 cm)

Purchased with the Leonard C. Hanna, Jr., B.A. 1913, Fund and a gift in memory of James Sherman Pitkin

Pierre-Paul Prud'hon is often characterized as the last great painter of the Rococo style in France, although his career coincides with the ascendancy of Neoclassicism as championed by Jacques-Louis David and his pupils. Onto the stoic, virile subject matter they popularized, largely drawn from the literature of Roman antiquity, Prud'hon grafted a preference for allegorical and poetic themes and a lyrical elegance derived from the tradition of painters like François Boucher and Jean-Honoré Fragonard. He was a great favorite at the Napoleonic court, being appointed drawing master to the empress in 1810, and remained in undiminished critical favor during the Bourbon Restoration.

Une famille dan la désolation (*A Grief-Stricken Family*) was initially conceived by Prud'hon as a collaboration with his pupil and longtime mistress Constance Mayer. On May 26, 1821, Constance Mayer took her own life, and Prud'hon, devastated, finished the painting and exhibited it at the Salon of 1822 (no. 1045). There the painting created a sensation, in part owing to the tragic circumstances of its creation. Equally important, however, was its ambivalent nature as a genre painting and sociorealist commentary, and the fact that it was the first such painting submitted to the Salon not by a professional genre painter (who enjoyed a relatively low academic status) but by an artist admired among the highest ranks of officially sanctioned history painters. Its appearance effectively established and legitimized a new category of subject that was to become singularly influential among a younger generation of Romantic artists, led by Théodore Gericault and Gustave Courbet.

The ultimate, Salon version of *Une famille dans la désolation* has not been seen publicly since 1922, and its present whereabouts are unknown. This fully autograph oil sketch by Prud'hon is the only known visual record that can fully communicate the grace and power of the original.

LBK

PLATE 224

Charles Marville

(French, 1816–1879)

Rue d'Écosse, 1865–69

Albumen print, 12¾ x 10½ in. (32.4 x 26.7 cm)
Everett V. Meeks, B.A. 1901, Fund

This view down the tiny rue d'Écosse, located in the 5th arrondissement on the Rive Gauche in Paris, was one of dozens of photographs of Old Paris taken by the illustrator-turned-photographer Charles Marville. It is from the body of work for which Marville is perhaps best known: a documentary project under the auspices of the City of Paris (namely, Baron Georges-Eugène Haussmann, prefect of the Seine), for which Marville was commissioned to take photographs of the small streets of Paris that were slated to be destroyed in Napoléon III's sweeping urbanization projects of the Second Empire.

Rue d'Écosse is from an album of sixty-seven of these photographs that date from 1865 to 1869 documenting the university quarter of Paris—the center of intellectual life in France from medieval times to the present—much of which was demolished at this time to make room for the grand Parisian boulevards, like Saint-Germain and Saint-Michel. All the original albums prepared for the French government and deposited in the archives were destroyed in the 1871 fire at the Hôtel de Ville. The images (including this one) were reprinted by Marville from his original glass-plate negatives in 1873.

Marville's photograph of the rue d'Écosse, like so much of his best work, is rich with formal contrasts that reveal his aptitude for architectural depiction: two-dimensional elements are juxtaposed against three-dimensional elements, height against depth, dry against wet, shadow against light, solid against void. Characteristic of Marville's work in this photograph is the photographer's use of humans and human accessories (such as the cart at the left) to indicate scale.

Charles Marville was one of the photographers to whom Nadar (Gaspard-Félix Tarnachon) referred as the French "primitives," beginning his career in photography by taking topographical views of Paris in the early 1850s. Unlike many of his contemporaries, Marville enjoyed a long and successful career as a photographer: his first calotypes date from 1851, and his wet-plate collodion work reaches in date to his death in about 1879. Unfortunately, the shadow of Eugène Atget's far-greater fame as the next generation's photographic documenter of Paris has somewhat obscured Marville's earlier achievements of the 1860s.

EH

PLATE 227

Edgar Degas

(French, 1834–1917)

Dancer Ready to Dance, with Right Foot Forward, 1882–95

Wax and mixed media, 22 x 13¾ x 8¼ in. (55.9 x 34.9 x 21 cm)
Gift from the Estate of Paul Mellon, B.A. 1929, L.H.D. Hon. 1967

The study of movement fascinated Edgar Degas, whose hundreds of artworks in all media consider bodies—of dancers, horses, bathers, and others—from seemingly every angle and moment in time. This wax sculpture of a dancer, found in the artist's studio after his death and the source for later bronze casts of the same pose, reveals Degas thinking about the body's preparations just before assuming a formal dance position. The model's arms stretch to create a sweeping downward curve, while her head turns to form an elegant profile reminiscent of the artwork of Jean-Auguste-Dominique Ingres, Degas's early role model; meanwhile, her left hip bulges as her foot plants itself firmly in the ground, melding into a soft pile of wax pieces, layered by the artist's hand. Her right toe moves forward—soon to be fully pointed. She may be preparing for the position known as a *tendu en avant,* though Degas takes his figure just to the point before the act of naming, and the strict codification of the ballet, begins.

In a similar way, Degas's early masterpiece at the Gallery, the painting *False Start,* from about 1869–72, captures the bodies of horses in states of extreme tension just before the start of the race. While his investigation of movement in his paintings became well known to the Parisian viewing public through the Impressionist exhibitions of the 1870s and 1880s, Degas almost never exhibited his sculpted models, which he continually revised in the privacy of his studio. Even financial difficulty did not prevent his steadfast inquiry into form, and sometimes Degas inserted everyday materials into his sculptures in order to save money on the wax, as in this work, where pieces of cork can be seen lodged in its base.

SGF

Jennifer R. Gross, ed., *Edgar Degas: Defining the Modernist Edge* (New Haven: Yale University Art Gallery, 2003).

PLATE 233

Pablo Picasso

(Spanish, 1881–1973)

Tête de fou (Head of a Jester), 1905

Bronze, 16 x 14½ x 8 in. (40.6 x 36.8 x 20.3 cm)
Promised gift of Thomas Jaffe, B.A. 1971

Pablo Picasso sculpted *Tête de fou (Head of a Jester)* during his early years in Paris, when he settled into the Bateau-Lavoir studio in Montmartre after his permanent departure from Barcelona in 1904. The figure belongs to Picasso's "Rose period" of 1904–5, in which he made works that featured circus performers, harlequins, and saltimbanques and abandoned the underclass figures of his preceding "Blue period." Picasso originally conceived of the sculpture as a portrait of his close friend, the poet Max Jacob; he molded it in

clay after the two spent an evening at the Cirque Médrano in the spring of 1905. Picasso soon added the jester's cap, transforming his subject into a more generalized representation of a circus figure.[1] Yet Picasso's rethinking wonderfully embodies the nature of their friendship and Jacob's importance within Picasso's own lively troupe of friends during the Bateau-Lavoir days. Known as the "bande à Picasso," their circle also included poets Guillaume Apollinaire and André Salmon.

The continuing appeal of *Head of a Jester* lies in the figure's inscrutable expression, jauntily framed by a fool's cap that curves with a rhetorical flourish. The heavily worked, rough surface, indebted to Auguste Rodin's powerful figures and similar to the early sculpture of Henri Matisse, simultaneously captures and deflects light, so that the jester's expression appears fickle and ever-changing. Significantly, *Head of a Jester* is the first sculpture by Picasso to enter the Yale University Art Gallery collection. It also recalls the first Picasso gift to the Gallery, a Vollard print of saltimbanques entitled *The Bath*, conceived in the same year of 1905, and given in 1941 by Katherine Dreier and Marcel Duchamp as one of several hundred objects in the Société Anonyme Collection, which established the modern art collection at Yale.

SGF

1. Marilyn McCully, ed., *Picasso: The Early Years, 1892–1906* (Washington, D.C.: National Gallery of Art, 1997), 46.

PLATE 234
Pablo Picasso
(Spanish, 1881–1973)

Femme assise (Marie-Thérèse), 1936

Oil on canvas, 28¾ x 23½ in. (73 x 59.7 cm)
Charles B. Benenson, B.A. 1933, Collection

In this vibrant painting of a woman seated by a window, Pablo Picasso employs the radical formal divisions first explored in his Cubist paintings to subvert the traditional strategies of portraiture. While premodern artists sought to convey the essence of a subject's character through their features, Picasso deconstructs and transforms the face into both frontal and profile view, as if to suggest the multiple sides of each personality. Two clumps of hair, one blue and one green, function like a set of parentheses that bracket the two "faces" and loosely reunite them into a heart-shaped form. A third, phantom profile of a man wearing a hat meanwhile emerges to her right. Picasso often used this profile to signify the artist's presence in his work, and here it acts like a reflection of the painter seated at the canvas before his sitter.

Picasso's breakdown and reconstruction of the woman's features also relates to his investigations in sculpture during the 1930s. The monumental female heads of this decade, made in his newly purchased château in Boisgeloup and inspired by his companion Marie-Thérèse Walter, likewise emphasize the play of profile and frontal view, as well as the eloquence of negative space, seen here in the vivid red void between her "faces." Furthermore, the bulbous, individualized shapes that make up the sculpture heads are echoed in the charismatic details of the painting, such as the boatlike hat that perches atop the oval forms of her head, or the

striped and solid circles that represent her breasts. The vibrant colors that define these various shapes also suggest Matisse's impact on Picasso and their artistic interchange that was especially intense in this decade.

SGF

PLATE 236
Alfred Maurer
(American, 1868–1932)

Apples and Nuts, 1927–28

Opaque watercolor, 17¹¹⁄₁₆ x 21⁷⁄₁₆ in. (45 x 54.4 cm)
Gift of George Hopper Fitch, B.A. 1932, and Denise Fitch

My main concern in painting is the beautiful arrangement of color values—that is, harmonized masses of pigment. . . . It is necessary for art to differ from nature, or we would at once lose the raison d'être of painting. Perhaps art should be the intensification of nature.
—Alfred Maurer, 1916, at show of his work in the Forum Exhibition

Alfred Maurer was born in 1868 in New York City, the son of the German immigrant and illustrator Louis Maurer, one of the premier lithographers in the Currier and Ives firm. In 1897, twenty-nine-year-old Alfred made his first trip to Paris, followed by a second in 1904–6, when, in his late thirties, he became one of the first American artists to explore in his own work the ideas and spirit of modernism springing up around Europe. On that trip, Maurer became intimately involved with Leo and Gertrude Stein and their circle and, by 1905, a frequent visitor to their home. In 1909, Alfred Stieglitz gave Maurer a one-man show at Stieglitz's New York gallery 291.

The outbreak of World War I in 1914 forced Maurer to leave Paris. He returned to his father's home in New York, where he struggled to find recognition for his art. The year 1925 marked a shift in Maurer's fortunes when the dealer Erhard Weyhe purchased 255 of his paintings and sponsored one-man exhibitions of Maurer's work at his New York bookstore/gallery.

Soon after, in 1927, a new brilliance of color emerged in Maurer's work, signaling a revisiting of the lessons he had learned from the Fauves, which can be seen in the luscious still life *Apples and Nuts*. The brownish greens and golds of Maurer's apples and the pinky flesh color of his nuts are not the ordinary hues one would associate with these fruits but, rather, interpretations, or—to use Maurer's own term—*intensifications* of those colors. These brilliant color effects are further strengthened by Maurer's technique: by using a minimum of binder Maurer imparts his composition with the chalky look and feel of an oil or pastel. Evident as well in this composition are lessons learned from Paul Cézanne and Henri Matisse, whose work Maurer was first exposed to on his visits to the Steins' Paris home. The influence of these two fin-de-siècle modern masters is unmistakable in this watercolor, which combines Cezanne's collapsing of three-dimensional space with Matisse's wallpaper patterning.

In 1928 Alfred's father, Louis, was recognized and celebrated as the last of the living Currier and Ives artists. Once again, his

father's longevity and continued recognition in the art world overshadowed Alfred's own hope for great success. In 1932, five months after his one hundredth birthday, Louis Maurer died; less than three weeks later, Alfred hung himself.

EH

PLATE 237

Joseph Stella

(American, born Italy, 1877–1946)

Jungle Foliage, ca. 1918–19

Pastel on gauze-covered paper, 25 x 18⅝ in. (63.5 x 47.3 cm)
Gift of George Hopper Fitch, B.A. 1932, and Denise Fitch

Joseph Stella executed this exquisite pastel in about 1918–19, just a year before he painted his masterwork, *Brooklyn Bridge* (fig. 1), also in the Gallery's collection. In Stella's work of this period (1916–22) there is a marked attempt to imbue the natural and manmade worlds with spiritual meaning, to create a symbolic language of form. This is especially evident in his depiction of tropical flowers, a subject Stella returned to consistently throughout his career, concurrently with his industrial landscapes and portraits. It is in these tropical foliage studies that Stella seemed to express most fully and successfully what for him was an inextricable link between sensuality and spirituality.

Figure 1. Joseph Stella, *Brooklyn Bridge*, 1919–20. Oil on canvas, 84¾ x 76⅝ in. (215.3 x 194.6 cm). Yale University Art Gallery, Gift of Collection Société Anonyme

Stella acknowledged a preference for the medium of pastel, which allowed him to use pure pigments in a more direct way than watercolor or oil. The unique support of *Jungle Foliage*—a sheet of paper covered with gauze—adds a further, tactile dimension and vibrancy to the work: the toothy texture of the gauze surface picked up flecks of raw pastel as Stella drew, giving the work a luscious, optical liveliness.

Jungle Foliage shares with *Brooklyn Bridge* many of the qualities that marked Stella's work of the late 1910s—including a strong central vertical axis. In both compositions, Stella leads the viewer's eye upward out of a weighty, nearly illegible, darkness to a gradually lightening and thinning crescendo of color—in the case of this pastel, an explosion of ecstatic blues, greens, oranges, pinks, and reds of the jungle foliage.

EH

PLATE 240

Gerald Murphy

(American, 1888–1964, B.A. 1912)

Bibliothèque (Library), 1926

Oil on canvas, 72½ x 52⅝ in. (184.2 x 133.7 cm)
Purchased with a gift from Alice Kaplan in memory of Allan S. Kaplan, B.A. 1957, and with the Leonard C. Hanna, Jr., B.A. 1913, Fund

In the 1920s, Yale-educated Gerald Murphy epitomized the modern American to the brilliant circle of avant-garde European artists and American expatriates in France—among them Ernest Hemingway, Pablo Picasso, Fernand Léger, Igor Stravinsky, Man Ray, Jean Cocteau, and Cole Porter—who gathered around him and his wife, Sara, at their home, "Villa America," on the French Riviera.

Beginning in 1922, Murphy's meticulously rendered paintings of machine and consumer images were included in the important Salon des Indépendants exhibitions, winning praise for their audacity, objectivity, and precision. The death of Murphy's father in 1931 put Mark Cross, the family business, into jeopardy, and the family reluctantly returned in 1932 to New York, where the artist took over the management of the company. Murphy's short but brilliant decade as a painter had ended. He never returned to Europe and never again took up a brush.

Of the thirteen oil paintings that Murphy is known to have created, only seven survive. *Bibliothèque* is the most personal. Set within a black painted frame, the composition incorporates references to his father's library—architectural columns and capitals, books, a globe, a classical bust, and a magnifying glass. Using a style that lies midway between realism and abstraction, Murphy transformed a personal iconography into shapes and patterns that abstracted their specific emotional content. Inspired in part by the Purist aesthetic of Amédée Ozenfant and Le Corbusier, who sought to create out of the chaos following World War I an art of architectonic classicism and purity, *Bibliothèque* portrays a world of eternal values—literature, classical architecture, philosophy. Heroic in scale, with flat planes of muted colors, and rhymed sequences of rounded and linear forms, the immaculate edges and perfect profiles create an image of elegance and modernity.

HAC

PLATE 242

Kurt Schwitters

(German, 1887–1948)

Merzbild mit Regenbogen (Merz Picture with Rainbow), 1920/39

Montage and mixed media on plywood, 61⅝ x 47¾ x 10½ in. (156.5 x 121.3 x 26.7 cm)

Charles B. Benenson, B.A. 1933, Collection

This assemblage, or *Merzbild* (Merz picture), was one of the numerous artworks that grew out of Kurt Schwitters's Merz installations, projects in which the artist adapted entire buildings through his collage aesthetic. The original *Merzbau* (Merz building) was begun about 1918 in Hannover but was destroyed during World War II. Subsequent *Merzbau* projects were begun in Norway and England during the artist's exile from Germany as an enemy of the Nazi state but were also eventually disassembled.

Merz, a term derived from the German word for commerce (*kommerz*), expressed the artist's and his peers' dismay and distrust of Weimar Germany and its inflation and eventual destruction of the German economy during the 1920s. These abstract works on paper and sculptures were composed of cultural detritus he scavenged and reassembled into integrated yet complex compositions. This literal reassembly of newspaper and object fragments was the artist's means to re-create a holistic culture in a fragmented and illogical economic, political, and cultural landscape. Through this process, Schwitters also aspired to unite the world of aesthetics with his experience of the physical world.

This work is one of the largest examples of *Merzbild* ever made by the artist. It is believed that the work was begun in 1920 in the artist's Hannover studio and then was shipped to him while in exile in Norway and finished in the late 1930s. The incorporation of the rainbow is an expressly optimistic gesture for Schwitters, whose palette in this series of constructions tended toward dark colors and reflected the artist's somber, even negative, view of the modern world.

Schwitters was an active member of the Société Anonyme, Inc., an international artists' organization founded in 1920 in New York by Katherine Dreier, Marcel Duchamp, and Man Ray, whose works are the core of the Yale University Art Gallery's modern collection. Dreier first saw Schwitters's work at the Der Sturm gallery in Berlin in 1920. They became friends and remained correspondents from 1925 until Schwitters's death in 1948. The Société Anonyme exhibited Schwitters's work extensively in America, and the twenty-two of his works in the Société Anonyme Collection at the Yale University Art Gallery testify to his strong interest in the American avant-garde and his deep creative and personal relationship with Dreier.

JG

PLATE 246

Emil Nolde

(German, 1876–1956)

Tingel-Tangel III, 1907/15

Lithograph from the 1915 edition, with added color, 12¹³⁄₁₆ x 18¹¹⁄₁₆ in. (32.5 x 47.5 cm)

Gift of Thomas P. Perkins III, B.A. 1957, in honor of Henry A. Ashforth, Jr., B.A. 1952

Emil Nolde's *Tingel-Tangel III* is among a series of thirty-one transfer lithographs the artist made in 1907 that marked his first foray into the medium of lithography. The simplicity of the transfer process allowed Nolde the opportunity to learn lithography in the simplest way possible—to get used to working with tusche, and to observe how stones were prepared and printed. Compared to his masterful etchings and woodcuts, however, even Nolde recognized these first lithographs (all printed from one stone in black ink) as disappointing and flat.

In 1915, Nolde selected eleven of the thirty-one lithographs from 1907. Building on his successful 1913 experiments in color lithography, Nolde decided to rework these 1907 compositions. This impression of *Tingel-Tangel* is one of the prints Nolde successfully "transformed" in 1915 with the addition of color (in the case of this impression, a lavender and a blue)—printed from additional stones over the original black-and-white impressions.

Tingel-Tangel was undoubtedly based on Edvard Munch's 1895 lithograph of the same title, which also pictured female performers sitting on stage with legs apart, staring straight out at the audience (and the viewer). Tingel-Tangel cafés were popular throughout turn-of-the-twentieth-century Germany. They were places where the waitresses and entertainers occasionally doubled as prostitutes, and where lower and upper classes mixed company—as is evidenced in this print that pictures workmen in caps sitting beside men in suits and bowler hats. Years later, in 1934, Nolde recalled of his visits to the Tingel-Tangel cafés, "I drew and drew: the light of the rooms, the superficial glitter, all the people, whether bad or good, whether demi-monde or totally ruined. I drew this 'underbelly' of life with its makeup, with its slippery mud and its corruption."

EH

PLATE 247

George Grosz

(German, 1893–1959)

Drinnen und draussen (Inside and Outside), 1926

Oil on canvas, 31½ x 46¾ in. (80 x 118.8 cm)

Promised gift of Dr. and Mrs. Herbert Schaefer

In this noteworthy example of German Expressionism, George Grosz's bifurcated composition schematizes the social divisions that destabilized Germany's Weimar Republic, when after defeat in World War I, workers and embittered veterans suffered from unemployment and hyperinflation, and their discontent weakened the fragile constitutional order. Out in the street, a peg-legged war veteran asks passersby for change, while rich businessmen chomp cigars indoors. In Grosz's satirical vision, society's pervasive faults

are easier to see than any agent that might redeem them—a pessimism amply justified by the eventual triumph of Hitler, who exploited the republic's weakness to rise to absolute power. In this turbulent period, Grosz's insufficiently heroic portrayal of the German working class led to his break with the Communist Party.

Relentlessly close, detailed observation powers his critique. Here the various renderings of the characters' mouths and jaws efficiently sketch a social typology. The beggar has a gaunt sneer verging on a grimace, while the seated gentleman's chubby cheeks and lips swell up to enclose his cigar. Behind him the florid-faced storyteller rears back in self-satisfaction, pushing his chin back into his neck and thus forming a double chin and a flap of fat that spills over his collar. Of the two women attentively flanking him, the left purses her lips and the right offers a toothy grin. Stage left, the monocled bon vivant tongues his teeth as a stray lock of hair falls down his forehead.

Grosz assimilated formal achievements of recent avant-gardes into his own more socially critical work. The bustling streetscape recalls Ernst Ludwig Kirchner's Expressionist scenes, with the latter's wild color toned down and replaced by the ruthless filling-in of detail (such as the beggar's wrinkled shirt and the strolling woman's buttocks). Cubism's multiple viewpoints appear, as in the two tables at right whose tops push up separately against the picture plane instead of receding together in a unified space. Grosz also lightly weaves the two scenes together. The front table, like the cigar-chomper's gaze, begins to spill over toward the beggar, who is anyway not separated from them by a solid line, but by a narrow swath of brick wall that wanders leftward into the foreground and is filled out with patches of sky blue.

BL

PLATE 249
Roberto Matta
(Chilean, 1911–2002)

Untitled, 1943–44
Mixed-media drawing, 15⁵⁄₁₆ x 19 in. (39 x 48.3 cm)
Gift of Thomas T. Solley, B.A. 1950

Roberto Matta's untitled drawing of 1943–44 is a welcome addition to the Gallery's collection, which can boast very few Surrealist works on paper of its caliber. It was executed within the first decade of Matta's artistic development, during the time when the artist was a formal member of the Surrealist movement and four years after he had emigrated to America. Finding in art what Nancy Miller has described as "an instrument of revolution as well as revelation," Matta used the Surrealist technique of automatism, or automatic drawing, in his explorations of form, as in this drawing that pictures several varyingly posed, disembodied, writhing female torsos. The composition is highly sexually charged, with its repeated female pelvises ensnared in a spiderweb-like landscape.

Though painting became Matta's principal medium as early as 1938, the artist was always a prolific draftsman, working primarily in colored pencils or pastels on large sheets of crisp white paper, as with this drawing. Consistent with his best works of the period, this work is a pictorial analogy for the psyche—what Matta referred to as a "psychological morphology."

Born in Santiago, Chile, in 1911, of mixed Spanish and French descent, Matta was encouraged to study architecture. He became apprenticed to Le Corbusier in 1934 but did not take to architecture. Later that year he traveled to Spain, where he met Salvador Dalí. Dalí encouraged Matta to show some of his drawings to André Breton, who, in turn, encouraged Matta to join the Surrealist movement, which he did officially in 1937.

EH

Philip Guston
(American, born Canada, 1913–1980)

PLATE 251
Untitled, 1951
Brush and black ink, 18½ x 23⅝ in. (47 x 60 cm)
Anonymous gift

PLATE 252
Untitled, 1962
Black ink, 26 x 39½ in. (66 x 100.3 cm)
Anonymous gift

At critical moments during his notably varied artistic career, Philip Guston focused his creative energies on what he saw as the more direct and lucid process of drawing as a means to work through problems in his painting. This ink drawing from 1951 (pl. 251) was one of a group of works that preceded the artist's first forays into wholly nonobjective painting, such as the untitled work from 1955–56 also included in the current exhibition (pl. 253). As in that painting, Guston characteristically creates a dense network of short and jagged marks that appears to peter out around the edges of the composition. Guston's avowed trepidation upon entering what was for him an entirely novel mode of image making is registered in the artist's calligraphic line, whose repeated arcs and angled intersections suggest a desire to invest his art with some communicative capacity even as these very letterlike forms defy any sort of three-dimensional pictorial illusion.

In 1962 Guston had his first retrospective at the Guggenheim Museum in New York, and this event led to another major artistic reassessment in which a concentration on drawing once more presaged a stylistic shift in his painting. In the untitled work from 1962, the artist loosens up the linear circuitry of his earlier works, allowing for a new sense of spatial depth and even the connotation of recognizable forms within what still remains ostensibly an abstract composition. Whereas Guston's line in the 1951 drawing is often open-ended and made up of small interlocking passages, here the artist allows his pen to flow more fluidly upon the paper, producing long, wavering shapes of varying degrees of density and finish. This new allusiveness is most evident in the weblike grid in the center of the composition (which elucidates the structure of his prior centrally composed abstractions) and the "thingly" forms that circulate around it, recalling doors, windows, bottles, and perhaps most obviously a dark, masklike oval in the upper right-hand corner that recalls some of the artist's earliest works that sometimes employed commedia dell'arte iconography. As an artist who struggled with what he called the need for a sense of "tangibility" in his work,

Guston, especially in his drawings, explored ways to invest his art with signs of reference, such as the abecedarian shapes that constitute his earliest abstract drawings or the more suggestive forms that teeter on the brink of recognizability in his later examples.[1]

RS

1. Guston, quoted in Jan Butterfield, "Philip Guston—A Very Anxious Fix," *Images and Issues* 1 (1980): 34.

PLATE 253

Philip Guston

(American, born Canada, 1913–1980)

Untitled, 1955–56

Oil on canvas, 76 x 72 in. (193 x 182.9 cm)
Promised gift of Carolyn and Gerald Grinstein, B.A. 1954

In 1955–56, Philip Guston was considered one of the leading representatives of the Abstract Expressionist movement. This untitled painting is a characteristic example of the artist's abstract work during the mid-1950s, in which short, thickly applied brushstrokes are woven together to produce a shimmering and vibrating effect upon the canvas, investing the painting with an organic vitality.

Unlike many of his New York School colleagues such as Jackson Pollock and Willem de Kooning, who emphasized the dynamic application of paint and covered the entirety of their canvases with what was often called an "all-over" composition, Guston's paintings exhibit a decidedly meditative slowness and deliberateness in which a centrally located form appears to gradually emerge from the vestigial edges of the work. Many contemporary observers paid special attention to the artist's characteristic palette of this moment, dominated by deep reds and chalky pinks, which one reviewer described as "the color of blood" and compared to "exposures of nerve-threaded flesh."[1] Small traces of blue and green heighten the vibrancy of the reds, making the image appear to glow from some internal light source behind the painting. The luminously undulating surface and fleshy palette of this work, while devoid of any recognizable imagery, nonetheless presents itself as an abstract surrogate for the human figure.

This painting was created at a moment when nonrepresentational art was often celebrated as a model of unadulterated authenticity within a world that appeared increasingly deceptive and fragmented. The "purity" of abstract art was most famously illustrated by a painting's acknowledgment of the inherent flatness of the canvas, achieved through the artist's rejection of the representation of three-dimensional space. Guston's quivering surface, realized in part by the traditional method of using halftones to suggest perspectival modeling (so that the lighter pink passages are seen as more distant than the darker red ones), disregards this anti-illusionistic aesthetic of modern painting. Yet in its drive toward a sense of "corporeality,"[2] as the artist himself stated, the painting can be seen to literalize the modernist aesthetic ideal of the work of art as an objective, even lifelike presence, as real as any other object in the world.

RS

1. Leo Steinberg, "Month in Review," *Arts* 30 (June 1956): 44.

2. Quoted in Dorothy Miller, ed., *12 Americans* (New York: Museum of Modern Art, 1956), 36.

Alberto Giacometti

(Swiss, 1901–1966)

PLATE 254

Standing Figure in Box, 1948–49

Oil on canvas, 10½ x 6¼ in. (26.7 x 15.9 cm)
Gift of Molly and Walter Bareiss, B.S. 1940s

PLATE 255

Buste de Diego (Bust of Diego), 1957

Bronze, 24½ x 10 x 6 in. (62.2 x 25.4 x 15.2 cm)
Charles B. Benenson, B.A. 1933, Collection, Courtesy of Bruce W. Benenson

PLATE 257

Untitled, 1946–47

Graphite, 23¼ x 17⅞ in. (59.1 x 45.4 cm)
Gift of Molly and Walter Bareiss, B.S. 1940s

In the mid-1940s the Swiss artist Alberto Giacometti began creating sculptures of human figures that were remarkable for their highly elongated forms and strongly modeled surfaces. In *Buste de Diego (Bust of Diego)* (pl. 255), one of the artist's many portraits of his brother, the sitter's individual features are reduced to a few predominant attributes—a protuberant brow, a sharp, upturned nose, and a large, bulbous chin that echoes a tuft of hair jutting out over his neck—amid an otherwise anonymous torso and head. The artist's characteristic subtractive method of sculpting, removing small daubs of wet plaster from the original model, invests his finished bronze casts with a sense of nervous energy and structural precariousness. Moreover, the furrowed and rutted surface of his sculpture activates the space around the work, so that it seems to compress and besiege the attenuated figure.

This integral role of the surrounding space for Giacometti's sculpture is most evident in many of the artist's drawings and paintings, as in this untitled drawing from 1946–47 (pl. 257) and *Standing Figure in Box* (pl. 254), an oil from 1948–49. In both works, the inclusion of faint rectangular frames encompassing their respective subjects—a dynamically scrawled bust of a man and a hazy full-length portrayal of a female—indicates the sort of spatial expansiveness the artist wanted to impart around his sculptures. Often associated with existential philosophy, Giacometti's works have typically been interpreted as expressions of the inherent alienation of the human condition in modern society and depictions of "the void" at the heart of existence.[1] Turning such traditional artistic means as line and sculptural modeling into symbols of anxiety and loss, Giacometti was able to express in his art what many people saw as the fragile and decimated state of Western civilization in the wake of World War II. Yet the lack of individualistic representation in these works also insinuates the interconnectivity and fundamental universality of all human life, a conviction that can also be understood as a more optimistic response to the horrors of the war and its political aftermath.

RS

1. See, for instance, Jean-Paul Sartre, "Giacometti in Search of Space," *Art News* 54 (September 1955): 26–28, 63–65.

PLATE 258

Wayne Thiebaud
(American, born 1920)

Candy Sticks, 1964

Watercolor and graphite, 11¼ x 15 in. (28.6 x 38.1 cm)
Bequest of Susan Morse Hilles

Although Wayne Thiebaud has depicted the human figure, drawn and painted vertiginous images of the streets of San Francisco, and, more recently, made a series of works inspired by the rural landscape of northern California, his signature images are of food. He is known for his hot dogs, pieces of pie, ice-cream cones, candy apples, gumballs in their machines, and especially cakes. The food is quintessentially American and middle class; it is always prepared rather than fresh, and its severe frontal presentation — which implies, although it never shows, the cafeteria or candy store — is part of the content of the work. Thiebaud, always working in a realist mode, nonetheless tends toward abstraction through his radical simplification; the triangles of pie wedges, circles of cakes, or cylinders of these candy sticks are fundamental and universal geometric shapes. The objects are shown in groups but are otherwise isolated, with little or no context; they are solid and their colors are bold, and Thiebaud's formal and classical treatment imparts an intensity and monumentality to his commonplace subjects. There are nonetheless subtleties: here the candy is depicted foreshortened, in a row that is not perfectly aligned, with one stick slightly higher than the others, on a surface that is probably a table but is imprecisely defined; the blue background also gives nothing away. Thiebaud began making images of food about 1961, and this watercolor was made just a few years later. Susan Morse Hilles, who put together a significant collection of contemporary art in the 1950s and 1960s and who was a longtime member of the Governing Board of the Gallery, acquired this watercolor at the time it was made, and although over several decades she gave away a great number of works of art, she kept this quintessential example of Thiebaud's work throughout her life.

 SB

PLATE 259

Wayne Thiebaud
(American, born 1920)

Drink Syrups, 1961

Oil on canvas, 24⅛ x 36 in. (61.3 x 91.4 cm)
The Twigg-Smith Collection, Gift of Thurston Twigg-Smith,
B.E. 1942

Wayne Thiebaud emerged on the American art scene with a highly acclaimed one-man show at the Allan Stone Gallery in New York in 1962. The sellout installation included this painting, *Drink Syrups*, along with other visions of distinctly American products — guilty pleasures like cakes, pies, and doughnuts; processed foods like lunch meats and hot dogs; or favorite childhood toys such as gumball machines. In *Drink Syrups*, four identical dispensers offer a rainbow array of flavors, the least appealing being the mysterious green flavor. Chalk-white bases and round tops frame the dense,

sucrose-laden syrups, in a play of purity and artificiality. Edited from Thiebaud's image is any indication of the subject's context and the lively soda fountain atmosphere of the drugstore, where children and their parents enjoyed their favorite flavor mixed with carbonated water. Rather, the objects rise stoically before a shadowy gray background, organized by a heavy horizon line. With its lakelike blue foreground, Thiebaud's still life resembles a landscape and hovers between traditional genres of painting.

 The painting's extreme reduction of form and stark layout, and its strong, theatrical lighting, recall Thiebaud's early training as a commercial artist in his native California in the late 1930s, which included a stint at the Walt Disney Studios. These visual strategies also work to position his painting between realism and Surrealism, as his popular, familiar objects appear to inhabit a quiet place of memory and lost time. Indeed, in the early 1960s, bottled soft drinks and a growing bottling industry were rapidly replacing the sociable milieu of the local soda fountain of the 1950s. Thiebaud's deeply empathetic homage to these cultural icons soon to be relegated to obsolescence conveys a nostalgia for American life that sets him apart from the more ironic approach of his Pop Art colleagues like Andy Warhol and Roy Lichtenstein.

 SGF

Stuart Davis
(American, 1894–1964)

PLATE 260

Ana, 1942

Gouache, 16½ x 16½ in. (41.9 x 41.9 cm)
Promised gift of Mary Jo and Ted Shen, B.A. 1966, M.A. Hon. 2001

PLATE 261

Study for *Ana*, 1942

Graphite, 16 x 16½ in. (40.6 x 41.9 cm)
Gift of Mr. and Mrs. Gifford Phillips, Class of 1942, by exchange

PLATE 262

Eleven study photographs for *Ana*, 1942

Gelatin silver prints, each 2⅛ x 2½ in. (5.4 x 6.4 cm)
Gift of Mr. and Mrs. Gifford Phillips, Class of 1942, by exchange

Eight months after the United States entered World War II, Stuart Davis received a commission from *Fortune* for the cover of the October 1942 issue of the magazine, which was devoted to "Steel, Allocations, and Scrap." Davis wrote to his cousin, "Was out to the biggest scrap handlers in the U.S. at Jersey City and made sketches and photographs. When I put my art philosophy on the material it will probably look like a flower garden by flash-bulb" (pl. 262). His statement encapsulates his approach to abstraction, which remained grounded in contemporary reality.

 Ana (pl. 260), the gouache Davis submitted to *Fortune*, synthesizes the scrap into an abstract design. He selectively enlarges and repeats forms, like the perforated wedges of old boilers, at left and right. His playful recombination of shapes is epitomized

by the coil of metal clinging to the central magnet. Ready to be dispersed across the picture plane, this bristling form embodies Davis's energetic manipulation of shapes and patterns in his works of this period. The artist's delight in his own assemblage can perhaps be gleaned from the punning notation "CU. FT." (cubic feet or "feat") on a scrap bin to the right of the magnet.

The gouache's title can be understood as another example of word play, perhaps on Davis's notion of "analogical" content—content not limited to the subjects suggested by his references to contemporary America. Much like scrap metal, Davis's meanings are mutable. The title may also refer to the black figure at the lower left, who resembles a freed slave. Davis's inclusion of the Statue of Liberty in a preparatory sketch (pl. 261), and the discarded chains at the bottom left and center of *Ana*, underscore this notion of liberation. Painted by an artist with strong antifascist convictions, and set in a scrap yard involved in the war effort, *Ana* couches a suggestion of freedom amid a tangled, malleable assemblage that also conjures destruction as readily as redemption.

AKL

Letter quoted is from the Estate of Stuart Davis Archives, collection of Earl Davis, and was made available by Mark Rutkoski and Ani Boyajian, editors of *Stuart Davis: A Catalogue Raisonné* (New Haven: Yale University Art Gallery and Yale University Press, 2007). See also Lowery Stokes Sims, *Stuart Davis: American Painter*, exh. cat. (New York: Metropolitan Museum of Art, 1991).

Stuart Davis
(American, 1894–1964)

PLATE 263

Curve Go Slow, 1922

Oil on artist's board, 15¼ x 11½ in. (38.7 x 29.2 cm)
Gift of Mr. and Mrs. Gifford Phillips, Class of 1942, by exchange

PLATE 264

Combination Concrete #2 (Black and White Version), 1956

Casein on canvas, 60 x 45 in. (152.4 x 114.3 cm)
Gift of Mr. and Mrs. Gifford Phillips, Class of 1942, by exchange

PLATE 265

Combination Concrete #2, 1956–58

Oil on canvas, 71 x 53 in. (180.3 x 134.6 cm)
Charles B. Benenson, B.A. 1933, Collection

PLATE 266

Study for Composition Concrete, ca. 1957

Gouache and traces of graphite, 8⅞ x 4⅝ in. (22.5 x 11.8 cm)
Gift of Mr. and Mrs. Gifford Phillips, Class of 1942, by exchange

"The Amazing Continuity," emblazoned by Stuart Davis on a painting in 1951, articulates his working method throughout the 1950s of appropriating his own past art to make formally innovative new art. That practice has parallels in the themes and variations of jazz, a modern American art form he loved. Both *Combination Concrete #2* and the study for *Composition Concrete* riff on a landscape that he painted more than thirty years earlier in

Gloucester, Massachusetts. *Curve Go Slow* (pl. 263) incorporates cautionary road signs, "CURVE" and "GO SLOW." Here he melded his personal interpretation of Cubism with his experience of mapping topography, gained as an army cartographer during World War I: white dashes on blue indicate waterways; yellow stippling on green suggests land; and a Y-shape in the upper left represents a tree.

Thirty-four years later, Davis translated the landscape into a larger, linear black-and-white design (pl. 264). He repeated "CURVE" and "GO SLOW" and overlaid this armature with lines that form shapes, squiggles, letters, and numbers. At left, "1922" acknowledges the date of his landscape source, while the words "NEW" and "DRAWING" affirm this drawing's status as an autonomous work of art and its structure—on which he would continue to build—to be his true subject.

On November 15, 1956, Davis "projected" this scaffold onto a bigger canvas (pl. 265). He used a hot palette of repeating colors that interact in unexpected ways with the armature. The colors vibrate spatially within a larger red field that penetrates the planes, creating a syncopated rhythm akin to jazz. This brilliant variation on his earlier compositions voices a new relationship between color and line, surface and depth. The lively interaction of letters, spaces, words, and shapes in *Combination Concrete #2* echoes the spirit of concrete poetry, a form of visual poetry pioneered by close friends like the poet Bob Brown. Satisfied with *Combination Concrete*, Davis converted a rectangle that appears in the lower left of the black-and-white version into a celebratory exclamation mark. More than two years after he began this painting, Davis finally announced that he had "finished" it; he described the process as "an exhausting ordeal."

The delay was caused in part by a mural commission for the lobby of the research center of the H. J. Heinz Company in Pittsburgh. The small size of the study for *Composition Concrete* (pl. 266) belies the conceptual ambition of this energetic gouache, made by Davis in preparation for the mural (now in the Carnegie Museum of Art, Pittsburgh). At seventeen feet high, it is the tallest work by the artist. In a *Time* magazine interview, Davis explained, "The title *Composition Concrete* refers to 'concrete music'—sounds recorded on tape, which is cut and spliced in patterns to make a composition." Yet another in the series of musical interludes inspired by *Curve Go Slow, Composition Concrete*'s matrix derives from the left half of *Combination Concrete*; the Y-shaped tree form is visible against a triangular shape above the center; the "CU" of "CURVE" appears at the middle of the right edge.

In both versions of *Combination Concrete*, "1922," placed sideways at left, acknowledges *Curve Go Slow*; that date has been transformed into interlocking shapes in the study and mural *Composition Concrete*. When the mural was installed in 1958 in a new building, Davis cleverly reinterpreted the numbers as "a scrambled 1957" that represents "the year it was painted, the year the building went up, and 57 Varieties." His statement pays tribute to the Heinz Company's famous ad slogan and, through word play, to the jazz pianist Earl Hines: "Fifty-seven Varieties" was among the first important solos he recorded. His legendary left-hand technique, used to break up stride rhythms without ever losing the beat, adds meaning to Davis's selection of the left half of *Combination Concrete* as the tem-

plate for *Composition Concrete*. For Davis, Hines represented "the achievement of an abstract art of real order. His ability to take an anecdotal or sentimental song and turn it into a series of musical intervals of enormous variety has played an important part in helping me to formulate my own aspirations in painting." The artist achieved those aspirations in this series of variations on a theme.

RJF

Except as indicated, quotations are from the artist's calendar entries and a letter in the Estate of Stuart Davis Archives, collection of Earl Davis, generously made available by Mark Rutkoski and Ani Boyajian, editors of *Stuart Davis: A Catalogue Raisonné* (New Haven: Yale University Art Gallery and Yale University Press, 2007). See also Lowery Stokes Sims, *Stuart Davis: American Painter,* exh. cat. (New York: Metropolitan Museum of Art, 1991).

PLATE 268

Stuart Davis

(American, 1894–1964)

Lesson One, 1956

Oil on canvas, 52 x 60⅛ in. (132.1 x 152.7 cm)
Charles B. Benenson, B.A. 1933, Collection

Lesson One had its "originating impulse" in what Stuart Davis called "the dynamic American scene" and in particular "the landscape and boats of Gloucester, Mass." On the left side, flat areas of color allude to trees, buildings, anchored boats, a mast, water, and sky. These elements first appeared in a line drawing that Davis translated into shapes in a gouache made in 1955. He projected that composition onto this canvas on March 5, 1956. By late October, Davis had obliterated the right side of his earlier design. Only the tip of a cloud above the vertical slice of a building and the bow of a boat suggest what lies behind a black rectangle marked with a monumental white *X,* overlaid with "Speed" in red script.

Davis incorporated letters and words for design purposes, but he also used them to amplify his theoretical ideas. An *X* appears frequently in his paintings as a shorthand reference to "external relations." He declared in *Art News* that his inspiration came from "the Excitement and Impact of contemporary culture," not from the "Subjective Feelings" that motivated Abstract Expressionism, which dominated the New York art scene. While working on *Lesson One*, Davis had made a sketch of the composition with the rectangle at right filled with diagonal ovals evoking the drips characteristic of action painting. He reasoned: "The acceptance of 'Speed' as a proper category of contemporary Subject must not be naively interpreted in a Naturalistic way as 'Drip' or identified as an equation Speed of Brush equals Idea of Speed." Instead, "Speed" affirms his belief in "Contemporary Culture as a Subject," especially "New Lights, Speeds, Sounds, Communications and Jazz in general, as the Ornaments of daily Experience." Inscribed on this canvas, "Speed" asserts that a painting must have the instantaneous impact of a billboard glimpsed from a fast-moving car. *Lesson One* — with its vivid color, dramatic bifurcation, and eye-catching lettering — delivers that visual punch.

RJF

Quotations are from Stuart Davis's published and unpublished writings. The artist's calendar entries and art theory papers in the Estate of Stuart Davis Archives, collection of Earl Davis, were generously made available by Earl Davis, the artist's son, and Mark Rutkoski and Ani Boyajian, editors of *Stuart Davis: A Catalogue Raisonné* (New Haven: Yale University Art Gallery and Yale University Press, 2007).

PLATE 269

David Smith

(American, 1906–1965)

Untitled, 1954

Double-sided drawing in black ink, 10⅛ x 7¾ in. (25.7 x 19.7 cm)
Inscribed: (recto) 5/15/54
Promised gift of Evelyn H. and Robert W. Doran, B.A. 1955

Deemed by many the greatest American sculptor of the twentieth century, David Smith also produced paintings early in his career, photographs, and, particularly, throughout his life, a prodigious output of drawings, which paralleled the intellectual and formal concerns of his sculpture. Like much of his work during the 1950s, the forms on both sides of this drawing are abstract yet strongly anthropomorphic. Some of Smith's drawings can be seen as related

Figure 1. David Smith, *Man and Woman in the Cathedral*, 1956. Steel, 85½ x 18½ x 20½ in. (217.2 x 47 x 52.1 cm). Yale University Art Gallery, Gift of Susan Morse Hilles

to a particular sculpture, but most are simply the result of, in Smith's words, the "life force" of the artist. Numerous pieces of sculpture of the 1950s embody just the same kinds of forms as the brushed marks on the recto of this drawing; the Gallery's seven-foot-high *Man and Woman in the Cathedral*, of 1956 (fig. 1), is a prime example. The lines in pen on the verso also have counterparts in the sculpture of this decade, in steel bent into more linear configurations.

Some excerpts from a lecture on drawing Smith gave in 1955, developed from the notes he used in teaching, distill — far better than any other writer's words — his commitment to and passion for the medium:

If it is pompous, artificial, pretentious, insincere, mannered, it is so evident, so quick to be detected, and like the written line, it is a quickly recognized key to personality. If it is timid, weak, overbold or blustering, it is revealed much as one perceives it in the letter or a signature. . . . The pureness of statement, the honesty of expression, is laid bare in a black-and-white answer of who that mark-maker is, what he stands for, how strong his conviction, or how weak. . . . Drawings usually are not pompous enough to be called works of art. They are often too truthful. Their appreciation neglected, drawings remain the life force of the artist. Especially is this true for the sculptor, who, of necessity, works in media slow to take realization. And where the original creative impetus must be maintained during labor, drawing is the fast-moving search which keeps physical labor in balance.

SB

For the 1955 lecture, see *David Smith, Sculpture and Drawings* (Munich: Prestel, 1986), 154–55.

PLATE 270

David Smith

(American, 1906–1965)

Isabella, 1956

Stainless steel, 36 x 8 in. (91.4 x 20.3 cm)
Promised gift of Mr. and Mrs. Henry A. Ashforth, Jr., B.A. 1952

Isabella's restrained verticality suggests a simplified human figure. Its intimate scale, just three feet tall, allows a viewer to tower over it, and in spite of this shift in scale, the viewer cannot grasp *Isabella*'s form in one glance. The form unfolds in time as one circles the work—a common characteristic of modernist sculpture in general and of David Smith's work in particular.

A disk occupies the symbolic position of a human head, but its shape is highly abstracted. Viewed at some distance, its profile is circular, but up close we can make out flattened edges and angles around its perimeter, residual traces of its having been cut from a large sheet of metal. At its center, in place of a face, there is a twisting, irregular shape with five tips, formed by the space left over after cutting out the disk. Smith had long been interested in the possibility of drawing in space; in his earlier *Agricola* series, slender strands of steel carved lines in the air much as a drawing pen marks paper. With *Isabella*, the drawn figure now appears in the air itself, as the five-tipped shape is drawn *with* space rather than *in* it.

The strength of steel was essential to Smith's work, as seen here in the contours of the cutout and in the ragged, beaten left edge of the vertical strut. Of steel, he said: "What it can do in arriving at a form economically, no other material can do. The metal itself possesses little art history. What associations it possesses are those of this century: power, structure, movement, progress, suspension, destruction, brutality."[1] Industrial metal had captivated Smith ever since the first trains roared through the placid grain fields of his Decatur boyhood. With *Isabella*, he shows his adeptness at wrestling it into the shape of a humanist icon.

Isabella occupies a middle position between David Smith's earlier work, in which he used curving, linear forms to shape empty space (the *Agricolas*), and his later work exploring a monumentality of abstract geometry (as in *Bec-Dida Day*, pl. 271). Over the course of his career, Smith combined beauty and brutality into a wide range of effects.

BL

1. David Smith, "The New Sculpture," symposium paper given at the Museum of Modern Art, New York, February 21, 1952. Published in Garnett McCoy, ed., *David Smith* (New York: Praeger, 1973), 84.

PLATE 271

David Smith

(American, 1906–1965)

Bec-Dida Day, 1963

Steel, 89 x 65 x 18 in. (226.1 x 165.1 x 45.7 cm)
Charles B. Benenson, B.A. 1933, Collection

David Smith, the sculptor most associated with the Abstract Expressionist generation, is especially noted for his welded steel constructions. Smith had worked as a welder in an automobile factory as a young man. Later, impressed by the welded sculpture of Pablo Picasso and Julio González, he turned to this technique for his own art and developed a unique vision informed by his early experience in the world of industry.

The dominant circular form of *Bec-Dida Day* is the end of a large steel drum. The linear elements welded to the top of the circle and in the triangular support below it are segments of I-beams, and the base is made of rolled steel. These remnants of industry afford Smith a vocabulary for his sculptural exploration of geometry and balance. The circle, a recurring motif throughout Smith's oeuvre, is precariously positioned off the apex of its support, poised to roll down the side with only the weight of the I-beam on top to counter the downward pull.

The frontal composition of *Bec-Dida Day* is characteristic of Smith's mature work, as are its painted surfaces. The yellow, blue, and red polychrome, however, is unusually bold and creates a distinctly playful effect. Looking at *Bec-Dida Day* from the blue side of the circle does not prepare the viewer for the surprising change to bright yellow on the reverse surface. Smith's use of color in this sculpture allowed him to call attention to its three-dimensionality while maintaining his preferred frontality of form.

The base of the sculpture is inscribed with a signature and date on one side and "Bec-Dida Day" on the other. Named for the artist's two daughters, Rebecca and Candida, it is one of many works that Smith titled after his children.

PF

Martin Puryear
(American, born 1941, M.F.A. 1971, D.F.A. Hon. 1994)

PLATE 273

Untitled, 1982

Maple sapling, pear wood, and yellow cedar, 59 x 66 x 5 in.
(149.9 x 167.6 x 12.7 cm)
Promised gift of the Neisser Family, Judith Neisser, David Neisser,
Kate Neisser, and Stephen Burns, in memory of Edward Neisser,
B.A. 1952

PLATE 274

Untitled, 1994

Edition 1/2, with one artist's proof
Bronze, 15 x 16 x 5½ in. (38.1 x 40.6 x 14 cm)
Promised gift of Evelyn H. and Robert W. Doran, B.A. 1955

Throughout his practice, Martin Puryear has endeavored to create
a marriage of abstract elements of great economy that directly
articulate sculptural form. This eloquent work untitled work from
1982 (pl. 273) is one of a series of forty wall-mounted "ring" sculp-
tures the artist developed in the late 1970s and early 1980s.

Many of these rings were made of laminated strips of wood,
but this work was created through the "grafting" of a yellow cedar
and a maple sapling. The saplings were then intertwined to form a
circle. The seamless joining of the young trees occurs at the mid-
point between two knobs of pear wood that function as visual end-
points to the circular flow of the form. The maple sapling retains
its rough bark while the yellow cedar has been carefully stripped to
reveal a contrasting smooth, raw surface. The graceful interface of
the two trees suggests a harmonious osmosis, a kinship and accord
possible despite the genetic difference of species.

Commonly recognized as an image that defines purity and
wholeness, the circle is a motif that has appeared consistently in
Puryear's oeuvre. It first outlined the perimeter of yurtlike architec-
tural structures and bound together the vertical elements that
defined their volumetric interiors and drawn surfaces. This
engaged play between interior and exterior, volume and line, form
and surface is consistent in the artist's work whether he is using
natural or manmade materials.

Known for his meticulous, handcrafted sculptures, Puryear
has also translated handmade forms into cast bronze, as seen in the
untitled work from 1994 (pl. 274); in addition, another bronze has
been acquired by the Gallery (pl. 272), along with a copy of his
editioning of the book *Cane* by Jean Toomer.

JG

Sylvia Plimack Mangold
(American, born 1938, B.F.A. 1961)

PLATE 277

Untitled (Taping Three Edges, so as to Paint the Tape of Those Edges . . .), 1977

Acrylic and graphite, 20 x 30 in. (50.8 x 76.2 cm)
Gift of Sylvia Plimack Mangold, B.F.A. 1961, in honor of
Richard S. Field

PLATE 278

Untitled (Tape Down Dimensions, Paint Internal Color, Paint Tapes which Mark Out Picture to Paint . . .), 1977

Acrylic and graphite, 20 x 30 in. (50.8 x 76.2 cm)
Gift of Sylvia Plimack Mangold, B.F.A. 1961, in honor of Richard
S. Field

Sylvia Plimack Mangold's *Untitled (Taping Three Edges, so as to
Paint the Tape of Those Edges . . .)* and *Untitled (Tape Down
Dimensions, Paint Internal Color, Paint Tapes which Mark Out Picture
to Paint . . .)* are part of a groundbreaking series of paper/tape
images that the artist began in 1975. These and the other similarly
titled drawings of the series (including *Paint the Tape, Paint the
Paper, Paint the Tape* and *Painted Tape, Painted Wall, Painted Again
and Wiped Out*) initially appear to be composed of actual pieces
of paper and tape, but in fact are cleverly planned trompe l'oeils —
simulations created primarily with graphite and acrylic. Though
seemingly simplistic, the works in this series are some of the most
conceptually mature works of the mid-1970s.

The Gallery's drawings consist of neatly painted squares
of simulated three-quarter-inch-wide masking tape that create
"frames" just inside their twenty-by-thirty-inch rectangular paper
supports. Though not necessarily intended as such, the drawings
are an interesting pair — the first (pl. 277) attracts the viewer's eye
to its "taped" borders (or frame); the second (pl. 278) focuses
attention on the loosely brushed yellow field (or subject) within
its simulated borders. Plimack Mangold's paper/tape drawings
actively play upon the decades-old artistic practice of preparing a
sheet of paper for a watercolor or oil drawing by masking off an
area with pieces of tape to create a frame or crisp edge (when the
work is finished, the tape is pulled up). Cleverly, this is apparently
how the artist created these drawings: using *real* pieces of masking
tape placed exactly three-quarters of an inch apart in order to paint
the crisp, trompe l'oeil borders of simulated masking tape between.

The first drawing consists of a painted double border of
"tape" (with exactly three-quarters of an inch between) along the
upper, lower, and right edges of the sheet, and a single border of
"tape" exactly three-quarters of an inch from where the inner left
edge would naturally be. At the upper and lower right corners
Plimack Mangold neatly "crossed" and "cut" the "taped" edges; at
the upper and lower left corners she left the ends of the "tape" in a
"torn," unfinished-looking state. As her title states, she has deliber-
ately created a double border along three edges of the sheet "so as
to paint the tape of those edges." Indeed, though the drawing is

composed entirely of acrylic paint and graphite, the only area of the sheet that *appears* painted is the three-quarter-inch swath of space between the double "taped" border, which is freely brushed with a thin layer of white acrylic.

In the second drawing, Plimack Mangold painted a single border of "tape" along all four edges and, as in the first drawing, left a strip of blank sheet just where one would expect the left "taped" edge to be; instead, that "taped" edge is shifted exactly three-quarters of an inch to the left. Again, at the upper and lower right corners, she neatly "overlapped" and "trimmed" the "tape"; at the upper and lower left corners, the ends of the "tape" are "ripped." Next, she filled these borders—the entire interior of the sheet—with a loosely brushed field of yellow acrylic. Finally, she carefully overpainted the borders with a textured acrylic so that they look even more like real pieces of masking tape. Again, as Plimack Mangold's title suggests, the artist has "tape[d] down dimensions, paint[ed] internal color, [and] paint[ed] tapes which mask out picture to paint."

The focus of the first drawing, then, is that narrow, loosely brushed three-quarter-inch strip of space between the double "taped" border; the focus of the second drawing is the inner field that is framed by the "taped" edges, but which is, like the inner field of the first drawing, nothing. Though painted, it is a blank ground, devoid of any traditional content. Hence, the artist challenges our perceptions of what she has pictured by its identification as subject matter. As John T. Paoletti has remarked: "This device of moving the frame inside . . . calls attention to surface, to painting, to the dialogue between illusion and reality which ultimately sharpens our understanding of how we see what we see."[1]

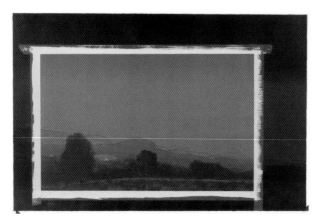

Figure 1. Sylvia Plimack Mangold, *View of Shunnemunk Mountain*, 1980. Twelve-color lithograph from eight plates, with hand painting in ink, 20³⁄₁₆ x 32⅛ in. (52.9 x 81.6 cm). Yale University Art Gallery, Purchased with the aid of funds from the National Endowment for the Arts and the Susan Morse Hilles Matching Fund

The year 1977 was a transitional one in Plimack Mangold's oeuvre, as her work shifted from pure paint/tape conceptions to works that included traditional subject matter (landscapes)—albeit landscapes framed by tape (see fig. 1). Curiously, after two years of painting fields masked off by simulated pieces of tape that seemingly prepare a ground, Plimack Mangold begins to fill that ground. The "tape" has focused her attention, and become her window on the world.

EH

1. John T. Paoletti, "Sylvia Plimack Mangold: Uses of the Past," *Arts Magazine* 57 (May 1983): 93.

PLATE 281

Sol LeWitt

(American, 1928–2007)

Wall Drawing #11, 1969

Graphite, dimensions variable

Gift of Anna Marie and Robert F. Shapiro, B.A. 1956

This is one of Sol LeWitt's earliest wall drawings and only the second to be realized in New York at the Paula Cooper Gallery. LeWitt debuted *Wall Drawing #1* there a year earlier in 1968, and thereafter his next nine wall drawings were executed in Los Angeles, Düsseldorf, Rome, and Paris. The artist also created an ink drawing (fig. 1) that accompanied *Wall Drawing #11*, a work now in the collection of the Museum of Modern Art, New York (where LeWitt both worked and later had his first American retrospective in 1978).

Figure 1. Sol LeWitt, *Plan for Wall Drawing*, 1969. Pen, ink, and pencil on paper, 20⅞ x 20¾ in. (53 x 52.7 cm). The Museum of Modern Art, New York, D. S. and R. H. Gottesman Foundation (1019.1969)

The handwritten text inscribed below the ink drawing remains one of the artist's most lucid and succinct statements about how his wall drawings were conceived, should be executed, and then considered. What follows is a transcription of that text:

> The wall drawing was executed by Adrian Piper, Jerry Orter and Sol LeWitt on the south wall of the smaller room of the Paula Cooper Gallery, 96 Prince Street. It is part of an exhibition for the benefit of the Art Workers Coalition that was compiled by Lucy Lippard. The drawing is 16' 8" x 6', composed of four sections, each 8'4" x 3', and was drawn with 9H graphite sticks. The drawing is the width of the wall, the height of each section (3') is dictated by the maximum length that a line can be easily drawn using a 45 degree right triangle as a guide. Each of the four sections has three crossing lines super-imposed on one another (vertical, horizontal, diagonal left to right, and diagonal right to left—45 degrees; representing the basic directions that lines can be drawn). These lines are drawn as lightly and as close together as possible (¹⁄₁₆").

The tonality of the drawing should be equal since there are an equal number of lines in each segment. However the properties of the wall, in some cases, dictate the darkness of the line (e.g. if there is a trace of grease or foreign substance, or if the wall bulges out). The pressure exerted by the draftsmen is not always equal, nor is the distance between the lines always the same, accounting for darker areas. These deviations are acceptable and beyond the scope of planning. They are inherent in the method. The wall drawing is perceived first as a light tonal mass—light enough to preserve the integrity of the wall plane—and then as a collection of lines. Neither the wall drawing, this drawing in ink, or the photographic record of the wall drawing are definitive but all are of equal importance. The wall drawing is temporary and will be removed at the discretion of the Paula Cooper Gallery.

One of the original draftsmen for *Wall Drawing #11*, Adrian Piper, went on to become a major artist in her own right, one who has also blended drawing, language, photography, and mixed media into a rich body of work with strong conceptual underpinnings. A mere four months after she helped LeWitt and sculptor Jerry Orter execute *Wall Drawing #11* at the Paula Cooper Gallery, Piper, who was then still a student at the School for the Visual Arts in New York, solely executed *Wall Drawing #23* and *Wall Drawing #24* for LeWitt's important September 1969 exhibition at the Virginia Dwan Gallery.

JR

Eva Hesse

(American, 1936–1970, B.F.A. 1959)

Eva Hesse's sculpture stands among the most significant artistic achievements of the 1960s. Borrowing from the Minimalist vocabulary of repetition and seriality, but eschewing its coolness, she used nontraditional materials to create haunting works that evoke layered emotions of fragility, sensuality, eroticism, and loss. The four pieces discussed below were created as studies for later finished works.

PLATE 282

Untitled, 1966

Acrylic paint, cord, papier-mâché, and wood, 7½ x 7½ x 4 in. (19.1 x 19.1 x 10.2 cm)
Inscribed: (on back) "for Sol Eva Hesse, 1966"
The LeWitt Collection, Chester, Conn.

During her stay in Germany in 1965, Eva Hesse abandoned painting on canvas and began an engagement with three-dimensional space. In New York in 1966, she made a series of small, rectangular plywood reliefs enclosing circles of wound cord, some of which appeared in arrangements involving serial progressions in size and in the amount of space between the panels. This relief was originally intended to be part of a multipartite relief of three increasingly large panels, each with a full circle of cord. In the following years, Hesse further explored the circle motif in gridded circle drawings and reliefs made with grommets and washers.

PLATE 283

Study for *Schema*, 1967

Latex, 2½ x 9½ x 9½ in. (6.4 x 24.1 x 24.1 cm)
The LeWitt Collection, Chester, Conn.

In this study for *Schema*, 1967 (Philadelphia Museum of Art), Hesse poured and tried out ratios of clear rubber and chemical thickener to cast a sheet of rubber. It was a long process: each layer was applied with a brush, with a wait of thirty minutes to one hour between coats while the material dried on the radiator. The nine lumpy little semispheres were dried in a muffin tin in the oven or radiator and not affixed to the mat. Unlike the larger scale of *Schema* with its 144 units, the units on this test piece have an independent presence adding to the work's sense of fragility and impermanence.

PLATE 284

Untitled, 1967–68

Mixed media, 14⅝ x 10¼ x 10¼ in. (37.2 x 26 x 26 cm)
The LeWitt Collection, Chester, Conn.

Hesse's discovery of new materials played a major role in her later work. In 1967, she began to experiment with latex rubber. The six pieces here were test pieces for or related to later works, among them *Sans II* (Daros Collection, Zürich; Museum Wiesbaden, Germany; San Francisco Museum of Modern Art; Whitney Museum of American Art, New York), *Tori* (Philadelphia Museum of Art), and *Repetition 19* (Museum of Modern Art, New York). Hesse gave the units as gifts to Sol LeWitt, whose idea it was to isolate and display them in a glass pastry case he had found in a store on the Bowery. The juxtaposition of unlike forms enclosed within a closed box led some critics to consider this to be among Hesse's most Surrealist works.

PLATE 286

Untitled, 1967

Acrylic, wood shavings, and glue on Masonite with rubber tubing, 12 x 10 x 2½ in. (30.5 x 25.4 x 6.4 cm)
Gift of Robert Mangold, B.F.A. 1961, M.F.A. 1963, and Sylvia Plimack Mangold, B.F.A. 1961, in memory of Eva Hesse, B.F.A. 1959, and in honor of Helen A. Cooper

This relief is probably a study for *Constant* (Collection Tony and Gail Ganz, Los Angeles), one of Hesse's strongest pieces from this period. Black rubber extrusions, tubing that has been formed by being forced through a small opening after a previous heating of the material, are pushed through a dense black square whose surface bears the obsessive imprint of the artist's fingers. The four-by-four grid of knotted tendrils protrudes into space, almost obscuring the pattern on the softly crusty surface, and creating an exuberant presence that evokes the artistic process so central to Hesse's work.

HAC

PLATE 294

Frank Stella

(American, born 1936)

Pergusa Three, 1982

Ten-color relief-printed etching and woodcut on handmade paper,
66⅜ x 51½ in. (168.6 x 130.8 cm)
Gift of Sharon and Thurston Twigg-Smith, B.E. 1942

Frank Stella has been making prints for decades, working most
consistently and fruitfully with Kenneth Tyler at Gemini G.E.L.
(and later at Tyler Graphics). Stella's prints of the 1960s through
the early 1980s were to a large extent based upon imagery first
developed in his paintings, and they utilized just one or two print
media, as is the case with this print.

Pergusa Three is from Stella's *Circuits* series of 1982, a print
series developed simultaneously with a metal-relief painting series
of the same name. The titles of the prints correspond to the paint-
ings, and are names of circuits – or auto-racing tracks – that Stella
visited in the late 1970s: Talladega (in Alabama), Pergusa (in
Sicily), Imola (in Italy), and Estoril (in Portugal). The iconogra-
phy of the prints (and paintings) is unquestionably reminiscent of
the racetrack – from their intricate, winding paths, to their interior
curlicues, to their sheer massive size.

Pergusa Three was created during a pivotal year in Stella's
career – the date of his first print retrospective – an event that
inspired Stella to move away from a strict adherence to the imagery
of his canvases and to begin to explore printmaking as a medium
in its own right. The year 1982 brought tremendous printmaking
activity for Stella: that year, he realized no fewer than thirty exam-
ples, some with several variants. *Pergusa Three* is a significant addi-
tion to the Gallery's growing collection of lithographs and relief
prints by the artist – until this gift, a collection that was heavily
weighted to his production of the 1950s, 1960s, and 1970s. It joins
two other Stella prints from the 1980s, also gifts to the Gallery from
Sharon and Thurston Twigg-Smith: *Then Came a Dog and Bit the
Cat*, of 1984, from the series *Had Gadya*, and *La penna di hu*, of 1988.

EH

PLATE 303

Robert Morris

(American, born 1931)

Untitled (Version 1 in 19 Parts), 1968/2002

Felt, 8 ft. 7 in. x 85 in. x 44 in. (261.6 x 215.9 x 111.8 cm)
Janet and Simeon Braguin Fund

At about 8½ feet tall, Robert Morris's felt piece is a little bit more
than human in scale. Its soft felt, evoking the human body, looks
invitingly touchable. As the felt tumbles from the wall to the floor,
we in the gallery find ourselves in the same space as the piece. No
picture frame, no pedestal, separates the viewer from the artwork.

This is because Morris, like his artistic peers, was against the
illusionistic, the idealized, and the abstract. He thought that a
gestalt (that is, any visual shape or figure of the artist's design) was
just the result of consciousness filtering out the real into an unreal
schema. It was better to put the work's material right into the

space of the viewer, who needed to be addressed bodily, not just
visually. The floppiness of Claes Oldenburg's sculptures had helped
lead in this direction, toward what Morris called "anti-form."

But this felt piece is not haphazardly or carelessly thrown
together. For display, it is carefully assembled according to plan.
What we see is, in fact, a display copy, a version of the work cre-
ated by the artist for Yale. The original is kept in storage so that
its sensitive material does not deteriorate. Each time the work is
assembled, it is a type of performance. It is relevant to note that in
the late 1960s, about the time of this piece, Morris was involved
with performance art.

Here, the artist's mind does not endow the work once and for
all with a timeless form via carving, casting, or welding. Instead,
the form of the piece comes from the continuous counteraction
between gravity's downward pull and the hooks holding the felt up
on the wall, which both act upon the felt according to the latter's
own properties. This is how the piece exists not only in our own
space, but in our own time as well.

BL

PLATE 307

Richard Artschwager

(American, born 1923)

Portrait II, 1963

Formica on wood, 68 x 26 x 13 in. (172.7 x 66 x 33 cm)
Promised gift of Anna Marie and Robert F. Shapiro, B.A. 1956

A chest of drawers that does not open topped by a mirror that does
not shine, *Portrait II* is an important early sculpture by Richard
Artschwager, an exemplar of his art's celebration of functions it
cannot perform. Its significance is semiotic, signing "dresser" even
while it refuses to store a single sock. At the same time, its pres-
ence is surreal. Standing shoulder to shoulder with the viewer, it
stakes its claim at portraiture, as much through the severity of its
expression (the overly upright proportions and suppression of
details) as through its blank refusal to reflect the visage of the
viewer who looks into the face of this dresser. "I was trying to
make something that would get confused with the space you
yourself occupy," Artschwager told an interviewer.[1] Similar to the
sculpture itself, this is a deceptively simple statement. Occupying
physical space to play hard with conceptual and perceptual experi-
ence, Richard Artschwager engages us in a consideration of what is
most strange about reality, by representing it at its most familiar.

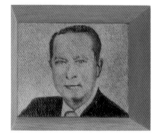

Figure 1. Richard Artschwager, Untitled (*Diptych*), 1963. Acrylic on celotex, each
14 x 16 x 7¼ in. (35.6 x 40.6 x 18.4 cm). Yale University Art Gallery, Gift of Eve and
Norman Dolph, B.E. 1960, in honor of Paul Weiss and George Heard Hamilton

Living and working in New York, where he originally established himself as a furniture maker, Artschwager first emerged within the context of Pop Art when he began to apply the industrial materials and craft techniques of his factory production to painting and sculpture. Framed in wood, *Portrait II* is clad in Formica. His paintings, such as the Gallery's Untitled (*Diptych*) (fig. 1), also 1963, feature the use of Celotex, a fibrous board used in ceiling construction.[2] Synthesizing this odd amalgam of means are the modes of mechanical reproduction, appropriation, and signification — Formica, for instance, is a photo-based picture of wood — by which Richard Artschwager's work has critically advanced front lines of contemporary art since the 1960s.

IS

1. Artschwager speaking about his early sculpture, quoted in Steve Griffin, "Four Artists," *951: An Art Magazine* (November 1975): 16.

2. Artschwager was originally attracted to the impression of instant brushwork that a certain pattern of Celotex gave his paintings. Since that pattern is no longer manufactured, Artschwager works with artisan papermakers to create a working substitute. The Yale University Art Gallery's *Geo. W. Bush*, 2002, is painted on such a surface.

Chuck Close

(American, born 1940, B.F.A. 1963, M.F.A. 1964, D.F.A. Hon. 1996)

PLATE 312

Janet, 1989

Oil on canvas, 36 x 30 in. (91.4 x 76.2 cm)
Promised bequest of Jon and Mary Shirley

PLATE 313

Self-Portrait/White Ink, 1978

Etching in white ink on black wove paper, surface-rolled, 44½ x 35½ in. (113 x 90.2 cm)
Gift of Mr. and Mrs. Harrison H. Augur, B.A. 1964, in honor of Richard S. Field

PLATE 314

Self-Portrait/Black Ink, 1977

Etching in black ink on white wove paper, 44½ x 35½ in. (113 x 90.2 cm)
Gift of Mr. and Mrs. Harrison H. Augur, B.A. 1964, in honor of Helen A. Cooper

PLATE 315

Self-Portrait, 2000

Daguerreotype, 8½ x 6½ in. (21.6 x 16.5 cm)
Gift of Leslie and Chuck Close, B.F.A. 1963, M.F.A. 1964, D.F.A. Hon. 1996

PLATE 316

Untitled Torso (K. W.), 2000

Full-plate daguerreotype diptych, each image 8 x 6⅛ in. (20.3 x 15.6 cm)
Purchased with a gift from Peggy and Richard M. Danziger, LL.B. 1963, and the Annual Fund

For almost forty years Chuck Close has examined in his art the pictorial translation of the visible world, primarily through the creation of large portraits depicting a subject's face set against a neutral background. *Janet* (pl. 312), a portrait of the painter Janet Fish (who was a classmate of Close's at the Yale School of Art in 1964), is characteristic of the sort of work Close executed during the 1980s in which the sitter's visage is constructed out of small squares of equal size that appear to be brightly colored abstract compositions when viewed individually but coalesce into a recognizable image when seen from a distance. A similar organizing structure is also evident in the two etched self-portraits from 1977–78 (pls. 313–14) in which a black-and-white photographic likeness emerges out of a compact grid in which each square is filled with diagonal hatch-marks whose varying degrees of proximity connote areas of darkness or lightness depending on the color of ink Close uses. (One version is printed on white paper with black ink, and the other version, made from a plate with the opposite registration, is printed on black paper with white ink.) In Close's art the grid serves as a basic tool that allows the artist to translate a photograph into another medium, whether it is a painting or print, by dividing the original image into small units that can be rendered into colorful abstract daubs (as in *Janet*) or diagonally etched squares. By highlighting this act of transference and by choosing the conventionally expressive subject of the human face, Close acknowledges the inevitable mediation that occurs in any form of visual representation, even those based on such presumably objective methods as the grid and photography.

As a technology that simultaneously appears as a direct, objective documentation of reality and is nonetheless a highly selective transcription of it, photography can be seen to epitomize Close's artistic project, and it is understandable that the medium has played a central role in Close's work from the start of his professional career. Beginning about 2000 in works such as *Self-Portrait* (pl. 315) and *Untitled Torso (K. W.)* (pl. 316) the artist began experimenting with the daguerreotype, an early form of photography that yields a unique, nonreproducible, and typically small image on a reflective metal plate. In *Untitled Torso (K. W.)*, a nude female body cropped at the head and thighs and shown from both the front and back emerges spectrally from a black background. Devoid of any identifying features, the image suggests a scientific document as much as a traditional art photograph. Yet by working in the obsolete medium of the daguerreotype the artist invests the image with a degree of historical curiosity and a sense of mystery that transcends the visual precision and apparent objectivity of the image. Similarly, Close's use of abstraction in *Janet* can be understood as a means to apply an arguably outdated mode of image making (that is, abstraction) as a way to reinvigorate the act of beholding a figurative painting. In all of his work Close encourages the viewer to look closely and ponder the ways in which reality is visually represented, both manually and technologically.

RS

PLATE 322

Louise Bourgeois

(American, born France, 1911, D.F.A. Hon. 1977)

Ode à l'oubli (Ode to Forgetfulness), 2004

Edition 24/25, with 7 additional artist's proofs
Hand-sewn cloth book printed with lithographic ink, containing
thirty-six pages, each page 10⅝ x 13⅜ in. (27 x 34 cm)
Gift of Francis H. Williams in honor of Jennifer R. Gross

Ode à l'oubli (Ode to Forgetfulness) was inspired by a collection of
household linens and clothing that Louise Bourgeois had saved
since her childhood. She grew up in the 1920s near Paris, where
her parents owned a tapestry restoration workshop. From a young
age, the artist worked repairing tapestries, a task that honed her
skills of close observation as well as nurtured in her an apprecia-
tion for the weave of cloth, its construction, and the use of color to
create pattern and design. In as much as the weaving of the indi-
vidual threads composed the large-scale lush images of these tapes-
tries, Bourgeois's tracings of the threads of images and words that
have haunted her memory and dreams since that time have formed
the vocabulary of images that inhabit her oeuvre. This consistently
evocative practice is evident throughout Ode à l'oubli, a striking
unfolding of abstract forms—spirals, grids, and triangles. These
patterns are juxtaposed with phrases that express the elusive and
deceptive nature of memory in her recollection and comprehension
of the experience that evades and manipulates her perception of
the world.

The edition of twenty-five books (plus seven artist's proofs)
was made as variations on an original book that the artist conceived
using her treasured collection of swatches of cloth. A seamstress,
Mercedes Katz, created the first book, from which fabrics were
printed to create the remaining works in the edition. Solo Impression,
a lithography studio in New York City, completed the series.

JG

PLATE 323

Helen Frankenthaler

(American, born 1928, D.F.A. Hon. 1981)

Tales of Genji III, 1998

Fifty-three-color woodcut from eighteen woodblocks (seventeen
maple, one mahogany) and two stencils on gray TGL handmade
paper, irreg. 46½ x 42 in. (118.1 x 106.7 cm)
Gift of the artist

In 1973, twelve years after Helen Frankenthaler had made her first
print, she turned to woodcut, and it is no exaggeration to say that
it was this artist's act of taking up this oldest of printmaking media
that launched its resurgence in the last quarter of the twentieth
century. Woodcut had been used by few artists of note since the
German Expressionists, and it had almost never been used for
abstraction. In 1982, Richard Field, then curator of prints, draw-
ings, and photographs at the Yale University Art Gallery, wrote,
"Who could have imagined, just ten years ago, that serious art
could be coaxed from such an obviously clumsy, totally antimod-

ernist medium? Yet, we are in the midst of a new experimentation
with the earliest form of printed image."

The six woodcuts of the series Tales of Genji of 1998 were
inspired by both ukiyo-e prints and the eleventh-century romance
by Murasaki Shikabu. Among the most painterly of the artist's
woodcuts, the Tales of Genji series was the result of three years of
intense collaboration and experimentation; Frankenthaler worked
with woodcutter Yasuyuki Shibata and also with papermaker Tom
Strianese. Each print was made following the model of a painting
on wood that Frankenthaler made expressly for this purpose.
Shibata cut and painted the blocks using water-based inks that
yield the look and effects of paint, and Strianese created handmade
papers, also made specially for the project, each of a different color,
that simulated the look of the original planks of wood. In the
more than thirty years since she began working in this medium,
Frankenthaler has continued to stretch its possibilities to produce
prints that are both beautiful and innovative, ranging from the
serene calm of her early woodcuts to monumental and technically
extraordinary works such as the Tales of Genji.

SB

Richard S. Field, "On Recent Woodcuts," Print Collector's Newsletter 13, no. 1
(March–April 1982): 1.

Judith Goldman, Frankenthaler: The Woodcuts (Naples, Fla.: Naples Museum of Art,
2002), cat. no. 20.

Index of Artists, Donors, Lenders, and Acquisition Funds

Plate numbers are given in italics and preceded by the page number on which they appear.

Adams, Robert, *Newly Completed Tract House, Colorado Springs, Colorado*; *Colorado Springs, Colorado*; *Out a Front Window, Longmont, Colorado*; *The Center of Denver, Ten Miles Distant*; from *The New West*, 88–89, *pls. 72–75*, 365

Adelson, Jan and Warren, 107, *pl. 94*, 110, *pl. 98*, 368, 370

Albers, Josef, *Skyscrapers A*, study for; *Skyscrapers A*, 26, 300, *pl. 287*, 302, *pl. 289*

Altschul, Arthur G., B.A., 1943, 25, 109, *pl. 96*, 369

Ames, Elizabeth, B.A., 1979, 25, 68, *pl. 46*, 357

anonymous gift, bequest, 35, *pl. 4*, 40, *pl. 11*, 53, *pl. 28*, 54–55, *pl. 29*, 235, *pl. 223*, 262, *pl. 248*, 263, *pl. 250*, 264, *pls. 251–52*, 348, 353, 354, 398–99, 403–4

Arneson, Robert, *Last Gasp*, 333, *pl. 318*

Arp, Jean, *Resting Leaf*, 313, *pl. 298*

Artschwager, Richard, 20, *Portrait II*, 322, *pl. 307*, 412–13; *Untitled (Diptych)* (acrylic on celotex, Yale University Art Gallery), 412, fig. 1

Ashforth, Mr. and Mrs. Henry A., Jr., B.A., 1952, 22, 25, 280, *pl. 267*, 283, *pl. 270*, 408

Atget, Eugène, *Capucines* (*Nasturtiums*), 102, *pl. 89*, 367–68

Augur, Julia Childs and Harrison H., B.A. 1964, 23, 328–29, *pls. 313–14*, 413

Baker, Richard Brown, B.A. 1935, and Collection, 18, 22, 290, *pl. 276*, 298, *pl. 285*, 311, *pl. 296*, 333, *pl. 318*

Baldessari, John, 23, *Solving Each Problem as It Arises*, 312, *pl. 297*

Baltz, Lewis, 23, *Pacific Grove*, from *Public Places*; *Interior, 33*, and *Interior, 34*, from *Park City*, 90–91, *pls. 76–78*, 365

Barclay, John, B.A. 1936, by exchange, 47, *pl. 20*

Bareiss, Molly and Walter, B.S. 1940s, 15, 18, 22, 23, 24, 126, *pl. 118*, 165, *pl. 148*, 199 and 201, *pl. 185 with detail*, 240–41, *pls. 228–29*, 266, *pl. 254*, 269, *pl. 257*, 380–81, 404

Basquiat, Jean-Michel, *The Ankle*, 336–37, *pl. 321*

Bellows, George, 26, *Lady Jean* (graphite on paper), 110, *pl. 98*, 370; *Lady Jean* (oil on canvas, Yale University Art Gallery), 370, fig. 1

Benenson, Bruce W., 266, *pl. 255*

Benenson, Lawrence B., and Collection, 243–44, *pls. 231–32*, 254, *pl. 241*, 256, *pl. 243*

Benenson, Charles B., B.A. 1933, and Collection, 15, 21, 22, 26, 172–79, *pls. 156–62*, 182–83, *pls. 164–65*, 243–44, *pls. 231–32*, 246–47, *pls. 234–35*, 254–56, *pls. 241–43*, 266, *pl. 255*, 278, *pl. 265*, 281, *pl. 268*, 284, *pl. 271*, 313, *pl. 298*, 336–37, *pl. 321*, 381, 400, 402, 404, 406–8

Benson, Richard M., *Lay This Laurel*, 59, *pl. 33*, 61, *pl. 35*, 355–56, 355, fig. 1

Bey, Dawoud, M.F.A. 1993, 22, *Man Looking at Pants on Fulton Street, Brooklyn, NY*, 97, *pl. 84*

Bloemaert, Abraham, *Landscape with Vertumnus and Pomona*, 229, *pl. 217*, 396

Bochner, Mel, 23, *12 Photographs and 4 Diagrams (N+1 Center Sets)*, 303, *pl. 290*

Boltanski, Christian, 20, *La fête de Pourim*, 324, *pl. 310*

Bonnard, Pierre, *Le châle jaune (The Yellow Shawl)*, 251, *pl. 238*

Boston, City of, *City Medal for Females*, 78, *pl. 61*, 360

Bourgeois, Louise, *Ode à l'oubli (Ode to Forgetfulness)*, 339–41, *pl. 322 with detail page 338*, 414

Braguin, Janet and Simeon, Fund, 23, 62, *pl. 37*, 88–89, *pls. 72–75*, 90–91, *pls. 76–78*, 94–95, *pls. 81–82*, 98, *pl. 85*, 99, *pl. 86*, 112, *pl. 100*, 301, *pl. 288*, 303, *pl. 290*, 312, *pl. 297*, 318, *pl. 303*, 320, *pl. 305*, 343, *pl. 324*, 365–66, 370, 412

Brewster, John, Jr., 25, *Comfort Starr Mygatt and Lucy Mygatt*, 30, *pl. 1*, 348

Brixey, Doris M., and Nathalie Penrose Swetland, by exchange, 47, *pl. 20*

Browning, Jedediah, attributed to, *Continuous Bow-Back Windsor Chair*, 34, *pl. 2*

Bry, Doris, and the Doris Bry Inadvertent Collection, 23, 80, *pl. 64*

Buchner, Audrey Lam, B.A. 1994, 23, 120–21, *pls. 108–11*, 372

Buist, Jean M., D.V.M., 25, 45, *pl. 19*, 350–51

Burrows, Larry, *In Prayer, Operation Prairie, near Dong Ha, Vietnam*, 63, *pl. 38*, 356–57

Cantor, Jay E., 25, 38, *pl. 7*, 349

Carpenter Foundation, 24

Carucci, Jacopo, called Pontormo, *Virgin and Child*, known as the *Madonna del Libro*, 222, *pl. 209*, 394

Cassatt, Mary, *The Lamp* (drypoint, softground etching, and aquatint), 107, *pl. 94*, 368; *The Lamp* (black chalk and graphite, Yale University Art Gallery), 368, fig. 1; *Boy with Golden Curls (Portrait of Harris Whittemore, Jr., B.A. 1918)*, 110, *pl. 97*, 369

Cézanne, Paul, *Bouteille, verre, et citrons (Bottle, Glass, and Lemons)*, 238, *pl. 226*

Chasanoff, Allan, B.A. 1961, 23, 96, *pl. 83*, 366

Chen Jiayan, *Birds by a Lotus Pond*, 136, *pl. 122*, 373–74

Ciamberlano, Luca, *Statue of Flora*, from *Galleria Giustiniani del marchese Vincenzo Giustiniani* (engraving, Beinecke Rare Book and Manuscript Library, Yale University), 398, fig. 1

Clark, James H., Jr., B.A. 1958, 22, 26, 300, *pl. 287*, 302, *pl. 289*

Clemens Fund, Walter H. and Margaret Dwyer, B.A. 1951, 107, *pl. 94*, 368

Close, Chuck, 20, 22, *Janet*, 326–27, *pl. 312 with detail*, 413; *Self Portrait/White Ink*, 328, *pl. 313*, 413; *Self-Portrait/Black Ink*,

329, *pl. 314*, 413; *Self-Portrait*, 330, *pl. 315*, 413; *Untitled Torso (K. W.)*, 331, *pl. 316*, 413

Close, Leslie and Chuck, B.F.A. 1963, M.F.A. 1964, D.F.A. Hon. 1996, 330, *pl. 315*, 413

Conner, Lois, M.F.A. 1981, 22, *Mirrors, Paris, France*, 103, *pl. 90*, 367

Cooper, Peter B., B.A. 1960, LL.B. 1964, M.U.S. 1965, and Field C. McIntyre American Decorative Arts Acquisition Fund, 46, *pl. 20*

Cornell, Joseph, Untitled (*Grand Hôtel de l'Étoile*), 314, *pl. 299*

Coyle, Mr. and Mrs. Frank J., LL.B. 1943, 46, *pl. 20*

Crawford, Celia Faulkner, 22, 323, *pls. 308–9*

Crawford, Ralston, 25, *From the Bridge*, 84, *pl. 68*, 363

Cress, Jake, *"Oops" Chair*, 115, *pl. 105*, 371

Danjen, Antoine, *Cup*, 40, *pl. 10*

Dann, Olive Louise, by exchange, 47, *pl. 20*

Danziger, Peggy and Richard, LL.B. 1963, 22, 23, 24, 144, *pl. 130*, 146–47, *pls. 132–36*, 148–49, *pl. 137*, 150–51 and 153, *pl. 139* with detail, 191, *pl. 176*, 331, *pl. 316*, 375–78, 384, 413

David, Jacques-Louis, *Statue of Flora Seen from the Front, in the Palazzo Giustiniani, Rome*, 234, *pl. 222*, 398

Davidson, Joan, 24

Davis, Stuart, 25, 26, *Ana*, 272, *pl. 260*, 363, 405–6; *Ana*, study for, 273, *pl. 261*, 363, 405–6; *Ana*, eleven study photographs for, 274, *pl. 262*, 363, 405–6; *Curve Go Slow*, 276, *pl. 263*, 363, 406–7; *Combination Concrete #2 (Black and White Version)*, 277, *pl. 264* with detail page 275, 363, 406–7; *Combination Concrete #2*, 278, *pl. 265*, 363, 406–7; *Composition Concrete*, study for, 279, *pl. 266*, 363, 406–7; *Punch-Card Flutter #3 (Black and White Version)*, 280, *pl. 267*, 363; *Lesson One*, 281, *pl. 268*, 363, 407

Dayton, Ruth and Bruce B., B.A. 1940, 23, 24, 118, *pl. 107* with detail pages 116–17, 137, *pl. 123*, 371–72, 374

De Havenon, Georgia and Michael H., B.A. 1962, 23, 169, *pl. 151*

Degas, Edgar, *Dancer Ready to Dance, with Right Foot Forward*, 239, *pl. 227*, 399; *Dancer Rubbing Her Knee (Dancer in the Role of Harlequin)*, 240, *pl. 228*; *Danseuse debout, le bras droit levé (Standing Dancer, Right Arm Raised)*, 241, *pl. 229*

Desiderio da Settignano, and Neri di Bici, *Virgin and Child*, 217, *pl. 205*, 392–93

Deutsch, Davida Tenenbaum and Alvin Deutsch, LL.B. 1958, 25, 69–74, *pls. 47–55*, 58, 78, *pls. 61–62*, 357–61

Devereaux, Richard and Elizabeth, B.A. 1981, 23, 101, *pl. 88*, 367

diCorcia, Philip-Lorca, M.F.A. 1979, 22, *Tokyo*, 93, *pl. 80*

Dodge, Edward Samuel, *Harriet E. Hulse (Mrs. William J. Felthousen)*, 75, *pl. 58*

Dodge, John Wood, *Mrs. Ezra Nye (Nancy Freeman Fessenden)*, 75, *pl. 59*; *Self-Portrait*, 76–77, *pl. 60* with detail

Doggett, Jane Davis, M.F.A. 1956, 24, 205, *pl. 191*, 389

Donatello (Donato di Niccolò di Betto Bardi), and Matteo di Giovanni, *Virgin and Child*, 218, *pl. 206* with detail, 393

Doran, Evelyn H. and Robert W., B.A. 1955, 22, 282, *pl. 269*, 288, *pl. 274*, 407–9

Doyle, William M. S., *Young Lady in a Sheer White Dress*, 72, *pl. 52*

Dubin, Dr. Lawrence, B.S. 1955, M.D. 1958, and Regina Dubin, 23, 162, *pl. 145*, 234, *pl. 222*, 379–80, 398

Duffy, Mr. and Mrs. James E., B.S. 1951, 22, 46, *pl. 20*

Dummer, Jeremiah, *Tankard*, 40, *pl. 11*

Dunning, Robert Spear, *Still Life with Honeycomb*, 24, 50, *pl. 25*, 352

Durandelle, Louis-Émile, *Le nouvel Opéra de Paris, sculpture ornementale (The New Paris Opera, Ornamental Sculpture)*, 237, *pl. 225*

Eakins, Thomas, *John Biglin in a Single Scull* (watercolor on paper), 19, 25, 52, *pl. 27*, 353; *John Biglin in a Single Scull* (oil on canvas, Yale University Art Gallery), 353, fig. 1; *Trotting Horses: Fairman Rogers's Four-in-Hand*, 39, *pl. 9*, 349–50; *A May Morning in the Park (The Fairman Rogers Four-in-Hand)* (oil on canvas, Philadelphia Museum of Art), 350, fig. 1

Ellsworth, David, *Intersphere in Green*, from the *Solstice* series, 113, *pl. 101*

Erlenmeyer Painter, *Alabastron with Typhon*, 204, *pl. 190*

Ernst, Max, *Fille et mère (Daughter and Mother)*, 256, *pl. 243*; *La forêt (The Forest)*, 257, *pl. 244*

Evangelisti, Filippo, *Saint John the Baptist*, 230, *pl. 218*, 396–97

Evans, Walker, *Main Street, Saratoga Springs, New York*, 81, *pl. 65*, 362; *Steel Mill Workers' Houses*, 82, *pl. 66*

Faience Manufacturing Company, *Vase*, 48, *pl. 21*

Falk, Jr., Mr. and Mrs. Myron S., B.A. 1928, 23, 118, *pl. 106*

Falola Edun, or his father, Fagbite Asamu, *Helmet Mask with Two Male Figures and a Pangolin*, 180–81, *pl. 163*, 381–82

Feininger, T. Lux, *Bauhaus Stage*, 258, *pl. 245*

Fessenden, Jerald Dillon, B.A. 1960, 25, 51, *pl. 26*, 352

Fitch, George Hopper, B.A. 1932, and Denise Fitch, 22, 248–49, *pl. 236–37*, 400–401

Fleischer, Arthur, Jr., B.A. 1953, LL.B. 1958, 23, 65–67, *pls. 40–45*, 365

Fogg III, Joseph G., B.A. 1968, 25, 57, *pl. 31*, 58, *pl. 32*, 355

Folds, Katherine Atwater, family, colleagues, and friends of, 46, *pl. 20*

Francis, John F., *Dessert Still Life*, 50, *pl. 24*, 351–52

Frank, Robert, *City Fathers–Hoboken, New Jersey*, from *The Americans*, 64, *pl. 39*; *Hoover Dam, Nevada*, 86, *pl. 70*, 364

Frank, Robert, *Alberto Giacometti, Paris*, 268, *pl. 256*

Franke, Peter and Leonore, 23, 209, *pl. 195*, 212, *pls. 199–200*, 389, 391

Frankenthaler, Helen, D.F.A. Hon. 1977, *Tales of Genji III*, 22, 342, *pl. 323*, 414

French, Mrs. Robert R., by exchange, 47, *pl. 20*

Friedlander, Lee, 22, *New York City*, 92, *pl. 79*

Friedman, Mr. and Mrs. Edward A., B.A. 1971, 231, *pl. 219*, 397

Friedman, Mr. and Mrs. Gary D., B.A. 1973, 231, *pl. 219*, 397

Friends of American Arts at Yale, 46, *pl. 20*

Garvan, Mabel Brady, Collection, by exchange, 47, *pl. 20*, 106, *pl. 93*

Gerry, Elbridge, 72, *pl. 51*

Ghezzi, Pier Leone, *Portrait of Gennaro de Scà*, 232, *pl. 220*

Giacometti, Alberto, *Standing Figure in Box*, 266, *pl. 254*; *Buste de Diego (Bust of Diego)*, 267, *pl. 255*; Untitled (1946–47), 269, *pl. 257*

Gifford, Sanford Robinson, 25, *A Twilight in the Catskills*, 25, 54–55, *pl. 29*, 354; *Camp of the Seventh Regiment, near Frederick, Maryland, in July 1863*, study for, 24, 57, *pl. 31*, 355

Glackens, William J., *Seated Woman*, 111, *pl. 99*

Goldfrank, Lionel, III, B.A. 1965, 24, 214–15, *pl. 203 with detail*, 392

Goldstein, Frederick, B.A. 1955, 232, *pl. 220*, 397

González, Julio, *La petite faucille (Small Sickle [Figure of a Woman]*), 308, *pl. 293*

Goodman, Mr. and Mrs. Andrew J., B.A. 1968, 25, 50, *pls. 24–25*, 60, *pl. 34*, 351–52, 356

Goodridge, Eliza, *Julia Porter Dwight*, 74, *pl. 56*, 359; *Elizabeth Russell Fiske*, 74, *pl. 57*, 359

Goodridge, Sarah, *Anna Powell Mason Perkins (Mrs. Henry Bromfield Rogers)*, 74, *pl. 55*, 358–59

Goodyear, Frank H., Jr., B.A. 1966, 90–91, *pls. 76–78*, 365

Gorky, Arshile, Untitled (recto; ca. 1946), 262, *pl. 248*

Gowin, Emmet, *Nancy, Danville, Virginia*, 99, *pl. 86*

Gray, Ethne and Clive Family Foundation, 23, 268, *pl. 256*

Greene, S. H. and Sons, *Grover Cleveland and Thomas A. Hendricks Bandanna*, 79, *pl. 63*, 361–62; *James A. Garfield and Chester A. Arthur Bandanna* (printed cotton, Yale University Art Gallery), 361, fig. 1

Griggs, Nina, 24, 217, *pl. 205*, 218, *pl. 206 with detail*

Griggs, Maitland F., B.A. 1896, Fund, 222, *pls. 209–21*, 394–95

Griggs, Mr. and Mrs. N. Lee, Jr., B.A. 1951, 107, *pl. 94*, 368

Grinstein, Carolyn and Gerald, B.A. 1954, 22, 265, *pl. 253*, 404

Grosz, George, *Drinnen und draussen (Inside and Outside)*, 260–61, *pl. 247*, 402–3

Guston, Philip, Untitled (1951), 264, *pl. 251*, 403; Untitled (1962), 264, *pl. 252*, 403; Untitled (1955–56), 265, *pl. 253*, 403

Hamilton, Polly W., M.A. 1941, PH.D. 1948, 22, 242, *pl. 230*

Hanna, Leonard C., Jr., B.A. 1913, Fund, 26, 47, *pl. 20*, 65–67, *pls. 40–45*, 137, *pl. 123*, 142–43 and 145, *pl. 131 with detail*, 152, *pl. 138*, 154–57, *pls. 140–41*, 158, *pl. 142*, 235, *pl. 223*, 253, *pl. 240*, 317, *pl. 302*, 374, 377–78, 398–99, 401

Hartog Master, *Figure of a Warrior*, 198, *pl. 183*, 387

Havemeyer, Loomis, PH.B. 1910, M.A. 1912, PH.D. 1915, 47, *pl. 20*

Haverstick, Iola C., Fund for American Art, 25, 46, *pl. 20*, 84, *pl. 68*, 363

Heade, Martin Johnson, *Two Hummingbirds with Their Young*, 25, 51, *pl. 26*, 352

Heath, Dwight B. and Anna Cooper, 22, 188, *pls. 171–73*, 383

Heinz Family and Fund, The, 63, *pl. 38*, 356–57

Henry, Edward Lamson, *Memories*, 25, 60, *pl. 34*, 356

Hesse, Eva, 20, 26, 411; Untitled (1966), 295, *pl. 282*, 411; *Schema*, study for, 296, *pl. 283*, 411; Untitled (1967–68), 297, *pl. 284*, 411; Untitled (1967), 299, *pl. 286*, 411

Hewitt, Dr. Benjamin Attmore, B.A. 1943, PH.D. 1952, 25, 34, *pl. 3*

Hill, Leonard F., B.A. 1969, 25, 74–75, *pls. 56–57*, 59, 359

Hilles, Susan Morse, 18, 22, 25, 270, *pl. 258*, 308, *pl. 293*, 405

Hine, Lewis W., *Cotton Pickers, Denison, Texas*, 100, *pl. 87*, 366–67

Hofmann, Hans, Untitled (1941), 263, *pl. 250*

Holy Kinship (Meister der Heiligen Sippe), Master of the, *Saints James the Greater and John the Evangelist; Saints James the Lesser and Philip*, 220–21, *pls. 207–8*, 394

Homer, Winslow, *At Anchor*, 53, *pl. 28*, 353; *The Sutler's Tent*, 58, *pl. 32*

Horchow, Mr. and Mrs. S. Roger, B.A. 1950, 24, 83, *pl. 67*, 362–63

Horn, Roni, Untitled (*Gun*), 25, 343, *pl. 324*

Horowitz, Raymond J. and Margaret, 23, 111, *pl. 99*

Hoyer, Todd, *X Series*, 113, *pl. 103*

Hughes, Erika and Thomas Leland, B.A. 1945, LL.B. 1949, 22, 187, *pls. 169–70*, 189, *pl. 174*, 198, *pl. 183*, 200, *pl. 184*, 382–83, 387

Huntington, Archer B., M.A. 1897, by exchange, 24, 112, *pl. 100*, 370

Hutchinson III, George C., B.A. 1957, 86, *pls. 70–71*, 364–65

Inness, George, 23, 49, *pl. 23*

Itō Jakuchū, *Cockatoo*, 161, *pl. 144*, 379

Itō Shinsui, *The Lion Dance (Kagamijishi)*, 162, *pl. 145*, 379–80

Jaffe, Thomas, B.A. 1971, 22, 24, 184, *pl. 166*, 195, *pl. 181*, 245, *pl. 233*, 252, *pl. 239*, 382, 386, 399–400

Jahn, Johann Michael, attributed to, 38, *pl. 8*

Japan Foundation Endowment of the Council on East Asian Studies, 24, 142–43 and 145, *pl. 131 with detail*, 169, *pl. 143*, 379

Kaneshige Tōyō, *Fresh Water Jar (Mizusashi)*, 165, *pl. 148*, 380–81

Kanō Mitsunobu, circle of, *The Twenty-four Paragons of Filial Piety (Nijūshikō)*, 154–57, *pls. 140–41*, 378

Kaplan, Alice, 25, 26, 253, *pl. 240*, 401

Kaplan, Estate of Alice M., 190, *pl. 175*, 383–84

Karel, Betsy, 23, 65–67, *pls. 40–45*

Katcher, Jane and Gerald, LL.B. 1950, 23, 25, 30, *pl. 1*, 36, *pl. 5*, 37, *pl. 6*, 348–49

Kaufman, Mr. and Mrs. George M., 25, 44, *pl. 18*, 350

Kienholz, Edward, and Nancy Reddin, *The Silver Fish and the Multitudes Have Lunch and Other Myths*, 325, *pl. 311*

Kinney, Mr. and Mrs. Gilbert H., B.A. 1953, M.A. 1954, 335, *pl. 320*

Koenigsberg, Lisa, M.A. 1981, M.PHIL. 1984, PH.D. 1987, and David Becker, B.A. 1979, 22, 112, *pl. 100*, 379

Kossack, Steven M., B.A. 1972, 166–67, *pl. 149 with detail*

Kramarsky, Werner H. and Sarah-Ann, 23, 345, *pl. 326*

Kuhn, Walt, *Chorus Captain*, 108, *pl. 95*, 368–69

La Farge, John, *Cherry Blossoms against Spring Freshet*, 25, 46–47, *pl. 20*

La Fosse, Charles de, *Saint Cecilia*, 231, *pl. 219*, 397

Lane, Saundra B., 88–89, *pls. 72–75*, 365

Lee, Jr., Natalie H. and George T., B.A. 1957, 23, 25, 38, *pl. 8*

Léger, Fernand, *Nature morte (Still Life)*, 252, *pl. 239*

Levin Discretionary Funds, President Richard C., 59, *pl. 33*, 61, *pl. 35*, 355–56

Levitt, Helen, *New York*, 101, *pl. 88*, 367

LeWitt, Sol, 20, 22, *Wall Drawing #11*, 294, *pl. 281*, 410–11; *Four Colors in Four Directions*, 301, *pl. 288*; *Wall Drawing # 614*, 304–5, *pl. 291*; *Plan for Wall Drawing* (pen, ink, and pencil on paper, Museum of Modern Art, New York), 410, fig. 1; and Carol, 26; LeWitt Collection, 295–96, *pls. 282–84*, 411

Li Huasheng, *Fisherman's Song at the Wu Gorge*, 139, *pl. 126*

Liberman, Barbara and Robert, B.A. 1965, 216, *pl. 204*, 392

Libertson, Mr. and Mrs. Herbert, 24, 163, *pl. 146*

Loebig, Misses Emilie L and Olga V., by exchange, 47, *pl. 20*

Longhi, Rosemarie and Leighton R., B.A. 1967, 161, *pl. 144*, 379,

Lord, Pamela, 23–24, 100, *pl. 87*, 366–67

Lovell, Whitfield, *Ode*, 23, 334, *pl. 319*

Luce, Henry, Foundation, 137, *pl. 123*, 374

Luce, H. Christopher, B.A. 1972, 130–35, *pl. 121 with details*, 137, *pl. 123*, 373–74

Lyons, Nathan, Untitled, from *After 9/11*, 23, 65–67, *pls. 40–45*

M. G. B. (American, 19th century), 48, *pl. 21*, 351

MacDonald, Mrs. John D., 24, 170–71, *pls. 152–55*

Magnusen, Erik, *Compote*, 106, *pl. 93*

Malbone, Edward Greene, *Mary Hooper* (*Mrs. Alexander Schaw, Mrs. James Fleming*), 72, *pl. 53*, 358

Mangold, Robert, *Six Working Drawings for the WXV Models of 1968*, 20, 22, 292–93, *pl. 280*

Mangold, Sylvia Plimack, Untitled (*Tape Down Dimensions, Paint Internal Color, Paint Tapes which Mark Out Picture to Paint…*); Untitled (*Taping Three Edges, so as to Paint the Tape of Those Edges…*), 291, *pls. 277–78*, 409–10; *View of Shunnemunk Mountain* (twelve-color lithograph from eight plates, with hand painting in ink, Yale University Art Gallery), 410, fig. 1

Mangold, Sylvia Plimack, B.F.A. 1961, and Robert Mangold, B.F.A. 1961, M.F.A. 1963, 20, 22, 26, 299, *pl. 286*, 411

Marden, Brice, *Tu Fu Dog I*, 298, *pl. 285*

Marshall, John, *Yale Bowl*, 112, *pl. 100*, 370

Martin, Agnes, *Valentine*, 290, *pl. 276*

Martin, Dana K., B.A. 1982, 164, *pl. 147*, 379–80

Marville, Charles, *Rue d'Écosse*, 236, *pl. 224*, 399

Mason, Jane and Arthur, 25, 113, *pls. 101–2*, 114, *pl. 104*, 371

Matisse, Henri, *Le serf* (*The Serf*), 243, *pl. 231*; *La danse* (*The Dance*), 306–7, *pl. 292*

Matta, Roberto, Untitled (1943–44), 262, *pl. 249*, 403

Matteo di Giovanni, and Donatello (Donato di Niccolò di Betto Bardi), *Virgin and Child*, 218, *pl. 206*, 393

Maurer, Alfred, *Apples and Nuts*, 248, *pl. 236*, 400–401

Mayer, Frederick, 15, 22; Jan, 24, 202, *pls. 186–87*, 206, *pl. 192*, 387–89

McIntyre, Field C., 46, *pl. 20*

McLanahan, Alexander K., B.A. 1949, 24, 64, *pl. 39*, 81, *pl. 65*, 362

McNeil, Robert L., Jr., B.S. 1936S, 23, 56, *pl. 30*

Meatyard, Ralph Eugene, Untitled (1960), 96, *pl. 83*, 366

Meeks, Everett V., B.A. 1901, Fund, 102, *pl. 89*, 107, *pl. 94*, 227, *pl. 214*, 228, *pls. 215–16*, 236–37, *pls. 224–25*, 367–68, 395–96, 399

Mellon, Paul, B.A. 1929, L.H.D. Hon. 1967, 15, 18, 19, 25, 52, *pl. 27*, 353; Estate of, 39, *pl. 9*, 238–39, *pls. 226–27*, 251, *pl. 238*, 349–50, 399

Merriman, Daniel, by exchange, 47, *pl. 20*

Metzinger, Jean, *Femme au compotier* (*Woman with a Fruit Bowl*), 242, *pl. 230*

Monet, Claude, *Camille on the Beach at Trouville*, 105, *pl. 92*

Monsky, John R., B.A. 1981, and Jennifer Weis Monsky, B.A. 1981, 25, 79, *pl. 63*, 361–62, 361, fig. 1

Moore, Mrs. Paul, by exchange, 47, *pl. 20*

Morgan, John Hill, B.A. 1893, LL.B. 1896, M.A. Hon. 1929, Fund, 56, *pl. 30*, 76–77, *pl. 60 with detail*, 359

Morris, Robert, Untitled (Version 1 in 19 Parts), 318, *pl. 303*, 412

Mott, J. L., Ironworks, New York, 36, *pl. 5*, 348–49

Mu Xin, *Dawn Mood at Bohai*; *Spring Brilliance at Kuaiji*, 141, *pls. 128–29*, 374–75

Murphy, Gerald, *Bibliothèque (Library)*, 25, 26, 253, *pl. 240*, 401

Neisser Family: Judith Neisser, David Neisser, Kate Neisser, and Stephen Burns, 22, 286–87, *pl. 273*, 409

Neri di Bicci, *Virgin and Child Enthroned with Saints Martin of Tours and Blaise*, 216, *pl. 204*, 392; *The Virgin Adoring the Child* (tempera on panel, Yale University Art Gallery), 393, fig. 1; and Desiderio da Settignano, *Virgin and Child*, 217, *pl. 205*, 392–93

Nevelson, Louise, *Dawn's Wedding Feast*, Hanging Columns from, 315, *pl. 300*

Noguchi, Isamu, *Galaxy Calligraphy*, 289, *pl. 275*

Nolde, Emil, *Tingel-Tangel III*, 259, *pl. 246*, 402

Nolen, Eliot, B.A. 1984, and Timothy P. Bradley, B.A. 1983, 23, 82, *pl. 66*

Oneille, Antoine, *Pitcher*, 41, *pl. 12*

Ordway, Katharine, Collection, by exchange, 47, *pl. 20*; Fund, 84, *pl. 68*, 108, *pl. 95*, 160, *pl. 143*, 334, *pl. 320*, 363, 368–69, 379

Ottaway, Mary and James H., Jr., B.A. 1960, 25, 208–9, *pls. 194, 196 with detail*, 389–90

Papageorge, Tod, M.A.H. 1979, *Opening Day, Yankee Stadium*; *From the Mets Dugout, Shea Stadium* from *American Sports*, 24, 94–95, *pls. 81–82*, 366

Peale, Raphaelle, *Commander Samuel Woodhouse*, 23, 73, *pl. 54*

Pearson, Ronald Hayes, *Pendant*, 113, *pl. 102*, 371, 379–80

Peloubet, Mr. and Mrs. Sidney W., by exchange, 47, *pl. 20*

Pennicuik, Kathryn E., by exchange, 47, *pl. 20*

Perkins, Thomas P., III, B.A. 1957, 259, *pl. 246*, 402

Phillips, Mr. and Mrs. Gifford, Class of 1942, by exchange, 23, 25, 26, 273–77, *pls. 261–63, 264 with detail*, 279, *pl. 266*, 405–7

Picabia, Francis, *Une horrible douleur* (*A Horrible Pain*), 254, *pl. 241*

Picasso, Pablo, *Tête de fou* (*Head of a Jester*), 245, *pl. 233*, 399–400; *Femme assise* (*Marie-Thérèse*), 246, *pl. 234*, 400; *Le peintre dans son atelier* (*The Artist in his Studio*), 247, *pl. 235*

Pillsbury, Judith L., and Henry A. Pillsbury, B.A. 1958, M.A. 1960, 233, *pl. 221*

Pillsbury, Edmund P., B.A. 1965, 24, 224–26, *pls. 211–13*, 395

Pontormo, see Carucci, Jacopo

Pool, Sarah Burke, and Mary J. Pool, *Album Quilt*, 37, *pl. 6*, 349

Prakapas, Dorothy and Eugene, B.A. 1953, 23, 258, *pl. 245*

Procaccini, Camillo, *The Transfiguration*, 227, *pl. 214*

Prud'hon, Pierre-Paul, *Une famille dans la désolation* (*A Grief-Stricken Family*), 235, *pl. 223*, 398–99

Prussin, Labelle, PH.D. 1973, 22, 185, *pl. 167*, 382

Pryor, Samuel F., IV, B.A. 1977, 22, 314, *pl. 299*

Puryear, Martin, M.F.A. 1971, D.F.A. Hon. 1994, *Le prix*, 285, *pl. 272*, 409; Untitled (1982), 286–87, *pl. 273*, 409; Untitled (1994), 288, *pl. 274*, 409

Raku Chōjirō, *Tea Bowl*, known as *Kaedogure* (*Twilight by the Maples*), 147, *pl. 134*, 375

Ramage, John, *Elbridge Gerry*, 72, *pl. 51*, 358

Reddin, Nancy, and Edward Kienholz *The Silver Fish and the Multitudes Have Lunch and Other Myths*, 325, *pl. 311*

Reed, Ambassador and Mrs. Joseph Verner, Jr., B.A. 1961, 24, 213, *pl. 202 with details*, 391–92, fig. 1 (full view)

Rinehart, Jonathan, B.A. 1952, 22, 104, *pl. 91*

Robitaille, Louis, *Sugar Bowl and Cover*, 41, *pl. 13*

Rodin, Auguste, *Le main crispé* (*The Clenched Hand*), 244, *pl. 232*

Rosenblum, Stewart G., J.D. 1974, M.A. 1974, M.PHIL. 1976, 25, 48, *pl. 22*, 351

Rosenkranz Charitable Foundation, 24, 141, *pls. 128–29*, 374–75

Ross, Laura and James J., B.A. 1960, 22

Ross, Judith Joy, 22, *Nancy Tate, Protesting the War in Iraq, Bethlehem, Pennsylvania*; *Susan Ravitz, Protesting the War in Iraq, Easton, Pennsylvania*, 62, *pls. 36–37*; *Untitled*, from *Easton Portraits*, 98, *pl. 85*

Rowson, Susanna, Academy, *Mourning Embroidery*, 22, 68, *pl. 46*, 357; and Haswell Academy, *Medal*, 78, *pl. 62*, 360–61

Rubin–Ida Ladd, Nathan, Family Foundation, 122–23, *pl. 112 with detail*, 128–29, *pl. 120*, 168, *pl. 150*, 372–73

Rudkin, John Mark, B.A. 1951, 24, 107, *pl. 94*, 368

Ruscha, Edward, 23, *Cut Lip*, 311, *pl. 296*; *Level*, 319, *pl. 304*

Ryman, Robert, *Resident*, 344, *pl. 325*

Saint-Aubin, Gabriel de, *Les deux amants* (*The Two Lovers*), 233, *pl. 221*

Sakwa, Hap, *Open Vessel*, 114, *pl. 104*

Salle, David, *Nearby a Finch Was Covering Itself with Pale Dust*, 335, *pl. 320*

Schaefer, Dr. and Mrs. Herbert, 260, *pl. 247*, 402–3

Schloss, Simone, 22, 124–25, *pls. 113–17*

Schulte, Anthony M., B.A. 1951, 24, 107, *pl. 94*, 368

Schwitters, Kurt, *Merzbild mit Regenbogen* (*Merz Picture with Rainbow*), 255, *pl. 242*, 402

Scully, Susannah Keith, 25, 34, *pl. 2*

Serra, Richard, B.F.A. 1962, M.F.A. 1964, 22, 344, *pl. 325*; *Sinker*, 345, *pl. 326*

Setze, Josephine, Fund, 40, *pl. 10*, 41, *pls. 12–13*

Seymour, John and Son, *Tambour Desk*, 32–33 and 35, *pl. 4 with detail*, 348

Shamos Family, 289, *pl. 275*

Shapiro, Joel, 19, 20, 22, *Untitled* (1977), 292, *pl. 279*; *Untitled* (2000), 310, *pl. 295*; Foundation, 22

Shapiro, Anna Marie and Robert F., B.A. 1956, 20, 294, *pl. 281*, 316, *pl. 301*, 322, *pl. 307*, 324, *pl. 310*

Sheeler, Charles, *California Industrial*, 83, *pl. 67*, 362–63; *Contact Sheet*; *Industrial Site* (gelatin silver prints, The Lane Collection, Museum of Fine Arts, Boston), 362–63, figs. 1–2

Shen, Mary Jo and Ted, B.A. 1966, M.A. Hon. 2001, 25, 26, 272, *pl. 260*, 405–7

Shinn, Everett, 25, *The Orchestra Pit, Old Proctor's Theatre*, 109, *pl. 96*, 369

Shirley, Jon and Mary, 22, 326–27, *pl. 312*, 413

Shutt, George A., Class of 1954, and Nancy P. Shutt Acquisition Fund, 22, 63, *pl. 38*, 356–57

Simon, Mary Heidentroder, attributed to, *Album Quilt*, 37, *pl. 6*

Simpson, William Kelly, B.A. 1947, M.A. 1948, PH.D. 1954, 196–97, *pl. 182*, 386

Sisley, Alfred, *Bords du Loing, Saint-Mammès* (*The River Loing at Saint-Mammès*), 24, 104, *pl. 91*

Smith, E. B., Jr., B.A. 1966, friends of, 46, *pl. 20*

Smith, David, *Untitled* (1954), 282, *pl. 269* (recto), 407–8; *Isabella*, 283, *pl. 270*, 408; *Bec-Dida Day*, 284, *pl. 271*, 408; *Man and Woman in a Cathedral* (steel, Yale University Art Gallery), 407, fig. 1

Smith, Tony, *Untitled* (1962), 317, *pl. 302*

Smith, Mrs. Harvey K., by exchange, 47, *pl. 20*

Solario, Andrea, attributed to, 224, *pl. 211*

Solley, Thomas T., B.A. 1950, 192–94, *pl. 177 with detail, pls. 178–79*, 203, *pl. 189*, 257, *pl. 244*, 262, *pl. 249*, 384–85, 388, 403

Spiky Garland Group, 199 and 201, *pl. 185 with detail*

Stebbins, Theodore E., Jr., B.A. 1960, and Susan Ricci, 22, 24, 49, *pl. 23*

Steiner, Ralph, *Automobile Wheel and Headlight*, 23, 80, *pl. 64*

Stella, Frank, *Pergusa Three*, 309, *pl. 294*, 412

Stella, Joseph, *Jungle Foliage*, 249, *pl. 237*, 401; *Brooklyn Bridge* (oil on canvas, Yale University Art Gallery), 401, fig. 1

Stern, Robert and Virginia, 220–21, *pls. 207–8*, 394

Stetson, Charles, B.A. 1900, by exchange, 47, *pl. 20*

Stiner, Nancy, 25, 48, *pl. 21*, 351

Strickland, Harold A., Jr., Collection, 24, 194, *pl. 180*, 204, *pl. 190*, 207, *pl. 193*, 385–86

Sumiyoshi School, *Scene from the Battle of Yashima*, 158, *pl. 142*

Susman, Ellen and Stephen, B.A. 1962, 22, 180–81, *pl. 163*, 381–82

Swan, Mrs. Thomas Walter, by exchange, 47, *pl. 20*

Swetland, Nathalie Penrose, and Doris M. Brixey, by exchange 47, *pl. 20*

Szarkowski, John, *Grain Elevators I, Minneapolis*, 85, *pl. 69*

Thiebaud, Wayne, *Candy Sticks*, 270, *pl. 258*, 405; *Drink Syrups*, 271, *pl. 259*, 405

Tisdale, Elkanah, *William Brown* and *Ann Brown* (*Mrs. Joseph Vernet*), 71, *pls. 49–50*, 357–58

Torii Kotondo, *Combing Hair* (*Kamisuki*), 163, *pl. 146*, 379–80; *Natsuko in Summer*, 164, *pl. 147*, 379–80

Trellis Fund, 23, 24, 88–89, *pls. 72–75*, 365

Truitt, Anne, *Amur*; *April*, 323, *pls. 308–9*

Trumbull, John, *The Death of General Warren at the Battle of Bunker's Hill, June 17, 1775*, study for (pen, ink, wash, and graphite on paper), 26, 56, *pl. 30*, 354; *The Death of General Warren at the Battle of Bunker's Hill, June 17, 1775*, study for (oil on canvas, Yale University Art Gallery), 354, fig. 1; *The Vernet Family* (oil on canvas, Yale University Art Gallery), 358, fig. 1

Tuttle, Richard, *Untitled* (1967), 316, *pl. 301*

Twigg-Smith, Laila, by exchange, 319, *pl. 304*

Twigg-Smith, Sharon and Thurston, B.E. 1942, 20, 22, 271, *pl. 259*, 306, *pl. 292*, 309, *pl. 294*, 321, *pl. 306*, 325, *pl. 311*, 405, 412

Vanni, Francesco, *The Rest on the Flight into Egypt*, known as the *Madonna della Pappa*, 223, *pl. 210*
Vermeule, Cornelius Clarkson, 203, *pl. 188*, 388
Viola, Bill, *Study for Emergence*, 24, 332, *pl. 317*

Walsh, John, B.A. 1961, 19, 22, 24, 229–30, *pls. 217–18*, 332, *pl. 317*, 396–97
Wang Duo, *Five Tang Poems*, 130–35, *pl. 121 with details*, 373
Wang, Lulu C. and Anthony W., B.A. 1965, 25, 115, 371
Wardwell Family, 22, 186, *pl. 168*, 382–83
Waterbury, Collection of Ruth and David, B.A. 1958, 25, 113, *pl. 103*
Weaver, Holmes, attributed to, *Card Table*, 34, *pl. 3*
West, Benjamin, *Agrippina Landing at Brundisium with the Ashes of Germanicus* (oil on canvas, Yale University Art Gallery), 390, fig. 1
Westermann, H. C., *Imitation Knotty Pine*, 321, *pl. 306*
Wetmore, Edith Malvina K., by exchange, 47, *pl. 20*
Wheeler, Professor Robert George, PH.D. 1955, and Cecilia Whorf Wheeler, 25, 42–43, *pls. 14–17*
Wheeler, J. Davenport, B.A. 1858, by exchange, 47, *pl. 20*
White, Ruth Elizabeth, Fund, 203, *pl. 188*, 209, *pl. 195*, 210–12, *pls. 197–201*, 388–91
White, Reid, B.A. 1957, and Laird Trowbridge White, 23, 24, 315, *pl. 300*
Whitney, Collection of Mr. and Mrs. John Hay, B.A. 1926, M.A. Hon. 1956, 22, 105, *pl. 92*
Whittemore, Robert N., B.S. 1943, 23, 110, *pl. 97*, 369
Wiley, William T., *Mona Lisa Wipe Out or "Three Wishes,"* 23, 320, *pl. 305*
Williams, Francis H., 22, 339–41, *pl. 322 with detail page 338*, 414
Williams, Mrs. Norman, by exchange, 47, *pl. 20*
Winogrand, Garry, *Dealey Plaza, Dallas*, 87, *pl. 71*, 364–65
Wu, Dr. Clyde and Helen, 24, 138–40, *pls. 124–27*
Wu, Dr. and Mrs. David, 24
Wu, Nelson I., 136, *pl. 122*, 373
Wu, Dr. and Mrs. Roger, 24
Wu Changshuo, *Bamboos; Lotuses*, 138, *pls. 124–25*
Wu Guanzhong, *A Sea of Clouds*, 140, *pl. 127*
Wurtele, Margaret and C. Angus, B.A. 1956, 22, 285, *pl. 272*

Yosa Buson, *Spring Mountain, Passing Rain*, 160, *pl. 143*, 379

Zucchi, Jacopo, *The Allegory of Architecture: A Male Figure with Two Putti*, 225, *pl. 212*; *The Assembly of the Gods*, 226, *pl. 213*, 395

Photograph Credits

© Robert Adams, courtesy Fraenkel Gallery, San Francisco and Matthew Marks Gallery, New York: pls. 72–75, pp. 88–89

© The Josef and Anni Albers Foundation/Artists Rights Society (ARS), New York, photo Tom Jenkins: pl. 287, p. 300; pl. 289, p. 302

Art © Estate of Robert Arneson/Licensed by VAGA, New York, N.Y.: pl. 318, p. 333

© 2007 Artists Rights Society (ARS), New York: pl. 248, p. 262

© 2007 Artists Rights Society (ARS), New York/ADAGP, Paris: pl. 230, p. 242; pl. 238, p. 251; pl. 239, p. 252; pl. 241, p. 254; pls. 243–44, pp. 256–57; pl. 249, p. 262; pls. 254–55, pp. 266–67; pl. 257, p. 269; pl. 293, p. 308; pl. 310, p. 324

© 2007 Artists Rights Society (ARS), New York/VG Bild-Kunst, Bonn: cover (back); pl. 242, p. 255; pl. 298, p. 313

© 2007 Richard Artschwager/Artists Rights Society (ARS), New York: fig. 1, p. 412; photo courtesy Anna Marie and Robert F. Shapiro: pl. 307, p. 322

Photo Gavin Ashworth, courtesy Jane and Gerald Katcher: pl. 1, p. 30; pl. 5, p. 36; pl. 6, p. 37

Courtesy John Baldessari: pl. 297, p. 312

Courtesy Lewis Baltz: pls. 76–78, pp. 90–91

© 2007 The Estate of Jean-Michel Basquiat/ADAGP, Paris/ARS, New York: pl. 321, pp. 336–37

Art © Lester Beall/Licensed by VAGA, New York, N.Y.: pl. 306, p. 321

Courtesy Richard Benson: pl. 33, p. 59; pl. 35, p. 61; fig. 1, p. 355

Courtesy Dawoud Bey: pl. 84, p. 97

Courtesy Mel Bochner: pl. 290, p. 303

Art © Louise Bourgeois/Licensed by VAGA, New York, N.Y.: pl. 322, pp. 338–41

© 2002 Larry Burrows Collection: pl. 38, p. 63

Courtesy Chuck Close: pls. 314–16, pp. 328–31; photo courtesy Jon and Mary Shirley: pls. 312–13, pp. 326–27

Courtesy the Colorado Springs Fine Arts Center: pl. 95, p. 108

Courtesy Lois Conner: pl. 90, p. 103

Photo Alex Contreras: pl. 91, p. 104; pl. 151, p. 169; pls. 169–70, p. 187; pl. 174, p. 189; pl. 183, p. 198; pl. 184, p. 200

Art © The Joseph and Robert Cornell Memorial Foundation/Licensed by VAGA, New York, N.Y., photo courtesy Samuel F. Pryor IV: pl. 299, p. 314

Courtesy John Crawford: pl. 68, p. 84

Courtesy Jake Cress: pl. 105, p. 115

Art © Estate of Stuart Davis/Licensed by VAGA, New York, N.Y.: pls. 260–68, pp. 272–81

© Philip-Lorca diCorcia, courtesy the artist and Pace/MacGill Gallery, New York: pl. 80, p. 93

Photo Tom DuBrock: pl. 4, pp. 32–33; pl. 28, p. 53

Courtesy David Ellsworth: pl. 101, p. 113

© Walker Evans Archive, The Metropolitan Museum of Art: pls. 65–66, pp. 81–82

Courtesy T. Lux Feininger: pl. 245, p. 258

Photo Elizabeth Felicella, Yale University Art Gallery, Louis Kahn building, view of west window-wall, 2006: p. 14

© Robert Frank: pl. 70, p. 86; pl. 256, p. 268; from *The Americans*: pl. 39, p. 64

© 1998 Helen Frankenthaler and Tyler Graphics, Ltd.: pl. 323, p. 342

Courtesy Lee Friedlander: pl. 79, p. 92

Photo Christopher Gardner: pl. 112, pp. 122–23

Photo courtesy Mr. and Mrs. Andrew J. Goodman: pl. 25, p. 50

© Emmet and Edith Gowin, courtesy Pace/MacGill Gallery, New York: pl. 86, p. 99

Art © Estate of George Grosz/Licensed by VAGA, New York, N.Y.: pl. 247, pp. 260–61

© 2007 The Estate of Philip Guston: pls. 251–52, p. 264; photo Richard Nicol: pl. 253, p. 265

© The Estate of Eva Hesse, courtesy Hauser & Wirth, Zürich and London: pls. 282–84, pp. 295–97; pl. 286, p. 299

© 2007 The Hans Hofmann Trust/Artist Rights Society (ARS), New York: pl. 250, p. 263

Art and photo courtesy Roni Horn Studio: pl. 324, p. 343

Courtesy Todd Hoyer, photo Robert Fogt: pl. 103, p. 113

© Nancy Reddin Kienholz, courtesy L.A. Louver Gallery, Venice, Calif.: pl. 311, p. 325

© The Lane Collection, courtesy Museum of Fine Arts, Boston: figs. 1–2, pp. 362–63

Courtesy Laurence Miller Gallery, New York: pl. 88, p. 101

© 2007 Estate of Sol LeWitt/Artist Rights Society (ARS) New York: pl. 281, p. 294; pl. 288, p. 301; pl. 291, pp. 304–5; fig. 1, p. 410

© Whitfield Lovell, photo courtesy DC Moore Gallery, New York: pl. 319, p. 334

Courtesy of Nathan Lyons: pls. 40–45, pp. 65–67

© 2007 Robert Mangold/Artist Rights Society (ARS) New York: pl. 280, pp. 292–93

Courtesy Sylvia Plimack Mangold: pls. 277–78, p. 291; fig. 1, p. 410

© 2007 Brice Marden/Artist Rights Society (ARS) New York: pl. 285, p. 298

Courtesy John Marshall: pl. 100, p. 112

© 2007 Agnes Martin/Artist Rights Society (ARS) New York: pl. 276, p. 290

© 2007 Succession H. Matisse, Paris/Artist Rights Society (ARS) New York: pl. 231, p. 243; pl. 292, pp. 306–7

Photo courtesy Jan Mayer: pl. 192, p. 206

© The Estate of Ralph Eugene Meatyard, courtesy Fraenkel Gallery, San Francisco: pl. 83, p. 96

© 2007 Robert Morris/Artists Rights Society (ARS), New York: pl. 303, p. 318

Art © Estate of Honoria Murphy Donnelly/Licensed by VAGA, New York, N.Y.: cover (front); pl. 240, p. 253